DATING AND INTERPRETING THE PAST IN THE WESTERN ROMAN EMPIRE

Brenda Dickinson at La Graufesenque
(photo: Joanna Bird)

DATING AND INTERPRETING THE PAST IN THE WESTERN ROMAN EMPIRE

ESSAYS IN HONOUR OF BRENDA DICKINSON

edited by David Bird

OXBOW BOOKS
Oxford and Oakville

Published by
Oxbow Books, Oxford, UK

ISBN 978-1-84217-443-2

Cover image: Casts of fragments of a Drag 37 from La Graufesenque with cursive mould signature CALVO within the decoration (and a potter's stamp PATRIC on a strap handle). By courtesy of Allard Mees (after A W Mees, 1995, *Modelsignierte Dekorationen auf südgallischer Terra Sigillata*, Forschungen und Berichte zur Vor- und Frühgeschichte in Baden-Württemberg 54 (Stuttgart), Taf 17.1)

This book is available direct from:

Oxbow Books, Oxford, UK
(Phone: 01865-241249; Fax: 01865-794449)

and

The David Brown Book Company
PO Box 511, Oakville, CT 06779, USA
(Phone: 860-945-9329; Fax: 860-945-9468)

or from our website

www.oxbowbooks.com

A CIP record of this book is available from the British Library

Library of Congress Cataloging-in-Publication Data

Dating and interpreting the past in the Western Roman Empire : essays in honour of Brenda Dickinson / edited by David Bird.
 p. cm.
English, French, and German; summary in English, French, and German.
Includes bibliographical references.
ISBN 978-1-84217-443-2 (hardback)
1. Pottery, Roman--Europe. 2. Rome--Civilization. I. Dickinson, Brenda M. II. Bird, D. G. (David G.)
NK3850.D38 2011
937'.06--dc23
 2011040528

Printed and bound in Great Britain by
Short Run Press, Exeter

Contents

Introductory

Potters and Potteries

List of Tables

Contributors

The late PROFESSOR W GEOFFREY ARNOTT
University of Leeds

EDWARD BIDDULPH
BA, MA, MIfA, Oxford Archaeology, Janus House, Osney
Mead, Oxford, OX2 0ES, e.biddulph@oxfordarch.co.uk

DAVID BIRD
BA, PhD, FSA, 14 Kings Road, Guildford, Surrey, GU1
4JW; davidgeorgebird@ntlworld.com

JOANNA BIRD
BA, FSA, 14 Kings Road, Guildford, Surrey, GU1 4JW;
joanna.bird4@ntlworld.com

PAUL BOOTH
BA, FSA, MIfA, Oxford Archaeology, Janus House, Osney
Mead, Oxford OX2 0ES; p.booth@oxfordarch.co.uk

ARIANE BOURGEOIS
Maître de Conférences, 18 passage d'Enfer, 75014,
Paris, France; Ariane.Bourgeois@univ-paris1.fr

GILBERT BURROUGHES
FSA, Ambleside, Chediston, Halesworth, Suffolk IP19OAQ;
geburroughes@aol.com

H E M COOL
Barbican Research Associates, 16 Lady Bay Road, West
Bridgford, Nottingham NG2 5BJ; hilary.cool@btinternet.
com

GEOFFREY DANNELL
BSc(Econ), FSA, FCA, 28-30 Main Street, Woodnewton,
Peterborough PE8 5EB; geoffrey.dannell@btinternet.
com

MARGARET DARLING
M Phil, FSA, MIfA, 3 Club Yard, Blacksmith Lane,
Harmston, Lincoln LN5 9SW

WIM DE CLERCQ
Department of Archaeology and Ancient History of Europe,
Ghent University, Blandijnberg 2, B-9000 Gent, Belgium;
w.declercq@ugent.be

RICHARD DELAGE
PhD, Chargé d'études INRAP, 37 rue du Bignon, CS 67737,
35577 Cesson-Sévigné, France; richard.delage@inrap.fr

JOHAN DESCHIETER
Espenhoek 18, 9520 Sint-Lievens-Houtem, Belgium; johan.
deschieter@gmail.com or johan.deschieter@hotmail.com

PROFESSOR MICHAEL FULFORD
FBA, Department of Archaeology, School of Human
and Environmental Sciences, University of Reading,
Whiteknights, PO Box 227, Reading RG6 6AB;
m.g.fulford@reading.ac.uk

KAY HARTLEY
27B Hanover Square, Leeds, West Yorkshire, LS3 1AW;
kay.hartley72@googlemail.com

R W HOPKINS
19 Rawlings Rd, Llandybie, Ammanford, Carmarthenshire
SA18 3YD; rhwm1@btopenworld.com

INGEBORG HULD-ZETSCHE
DR. PHIL
huldzet@aol.com

RAPHAEL M J ISSERLIN
The Open University and University of Hull

RALPH JACKSON
BA, DLITT, FSA, Department of Prehistory and Europe,
British Museum, London WC1B 3DG; rjackson@
thebritishmuseum.ac.uk

VIV JONES
BA, MA
vivjonespots@tiscali.co.uk

ASSOCIATE PROFESSOR ENO KOÇO
PhD, 106 Church Avenue, Leeds, LS6 4JT, England;
enokoco1@hotmail.com

R S LEARY
158 Holme Rd, West Bridgford, NG2 5AF

YOANNA LEON
CEMES-CNRS, Université de Toulouse, 29 rue Jeanne
Marvig, F31055 Toulouse cedex 4, France; leon@cemes.
fr

ESTER VAN DER LINDEN
MA, PROF, Schrijnenstraat 14, 6524 RA Nijmegen,
Netherlands; e.van.der.linden@hazenbergarcheologie.nl

The late PROFESSOR R H MARTIN
University of Leeds

THIERRY MARTIN
4, boulevard de la mairie, 81200 - Aussillon, France; thierry.
martin.b@orange.fr

ALLARD MEES
FSA, Römisch-Germanisches Zentralmuseum, Ernst-Ludwig-Platz 2, D-55116 Mainz, Germany; mees@rgzm.de

J M MILLS
1 Prospect Place, Seavington St Mary, Somerset TA19 0QW

DR GWLADYS MONTEIL
Department of Archaeology, University Park, University of Nottingham, Nottingham, NG7 2RD; gwladys.monteil@nottingham.ac.uk

VERENA VOGEL MÜLLER
DR. PHIL, I, Augusta Raurica, Giebenacherstrasse 17, CH-4302 Augst, Switzerland; verena.vogel@bl.ch

RYAN NIEMEIJER
MA, Radboud University Nijmegen, Netherlands; r.niemeijer@let.ru.nl

ROBERT PITTS
BA, 27 Northbury Avenue, Ruscombe, Berkshire, RG10 9LH; robert.pitts@btinternet.com

MARINUS POLAK
MA, PhD, Radboud University Nijmegen, Netherlands; m.polak@let.ru.nl

LOUISE RAYNER
BA, MSc, MIfA, Archaeology South-East, 2 Chapel Place, Portslade, BN41 1DR; louise.rayner@ucl.ac.uk

DEBORA SCHMID
DR. PHIL, I, Augusta Raurica, Giebenacherstrasse 17, CH-4302 Augst, Switzerland; debora.schmid@bl.ch

FIONA SEELEY
MA, MIfA, FSA, Museum of London Archaeology, Mortimer Wheeler House, 46 Eagle Wharf Road, London, N1 7ED; fseeley@museumoflondon.org.uk

PHILIPPE SCIAU
CEMES-CNRS, Université de Toulouse, 29 rue Jeanne Marvig, F31055 Toulouse cedex 4, France; sciau@cemes.fr

CHARLOTTE THOMPSON
BA, MA
charlottesophia@gmail.com

MICHEL THUAULT
Archéologue, 48210 Les Vignes, France

JEAN-LOUIS TILHARD
Docteur en Sciences Humaines de l'Université de Poitiers, 1 rue Froide, F16000 Angoulême, France; jean-louis.tilhard@wanadoo.fr

FABIENNE VILVORDER
Centre de Recherches d'Archéologie Nationale (Université Catholique de Louvain-la-Neuve, Avenue du Marathon 3, B-1348 Louvain-la-Neuve, Belgium; vilvorder@arke.ucl.ac.be

MARGARET WARD
MA, MIfA
Chester; wards.christleton@virgin.net

JANET AND PETER WEBSTER
8 Cefn Coed Avenue, Cardiff CF23 6HE; WebsterPV1@cardiff.ac.uk

FELICITY C WILD
MA, FSA, 30 Princes Road, Heaton Moor, Stockport, SK4 3NQ; felicity.wild@btinternet.com

JOHN PETER WILD
MA, PhD, FSA
J.P.Wild.58@cantab.net

Abstract

This volume presents a collection of more than 30 papers in honour of Brenda Dickinson, mostly concerning samian studies but also touching on Brenda's other interests.

The introductory section begins with Koço's paper on a drone holding note in multipart unaccompanied singing, which may well go back to the Roman period. Arnott establishes that Lesbia's pet bird (Catullus) was a house sparrow. Martin (R) concentrates on language and style in the 'British' speeches in Tacitus. Ward offers thoughts on publishing samian, and Isserlin considers the implications of the likely lifespan of timber buildings for the dating of associated finds.

The first main section concerns potters and potteries. Mees argues convincingly that a pottery bust from La Graufesenque represents the potter Cal(v)us in his role as a priest. Dannell shows that evidence from London used to support a pre-AD 60 starting date for Drag 37 was misinterpreted. The work of the Montans potter Salvius is summarised by Martin (T), while Delage presents the evidence for a potter Servus VI of Lezoux and links with other potters that throw light on the organisation of the industry. Deschieter, De Clercq and Vilvorder examine the evidence for mould-decorated beakers made by Ebaras in a samian tradition in the Argonne. Huld-Zetsche summarises the evidence for the East Gaulish potter Cintugnatus, demonstrating work at a number of different production centres. Schmid and Vogel Müller describe an imitation samian production site (including two kilns) in Augst. Finally, Burroughes presents a potter's eye view of the approach to reproducing samian.

The middle section groups papers on decoration, stamps and other marks. Bird (J) shows that decoration including arena scenes with bulls on South Gaulish samian involves carefully chosen motifs, including those originally intended for other purposes. Jones highlights a rare representation of an owl. Bourgeois and Thuault gather the evidence for 23 samian stamps from Le Rozier (near La Graufesenque) that are either unreadable groups of letters or pictorial marks. Tilhard (with Sciau and Leon) presents the evidence leading to the recognition of a later 1st century producer of decorated samian with an intradecorative stamp Dagom(...) from a production site near Brive. Pitts suggests prototypes for some early Lezoux designs on La Graufesenque products. Hopkins presents a selection of newly identified *poinçons* on Central Gaulish samian, and in some cases demonstrates that there are a number of similar but different examples represented in the literature by just one catalogue entry. P and J Webster offer a detailed analysis of the range of *poinçons* used on samian, concluding that there is always a desire to convey a general impression of *romanitas*. Wild (F) provides five examples of samian potters' signatures including the little-known potters Eppillus, Tetturo or Tetturus and Tetlo or Tetlonis. Jackson examines the likely explanation for some samian vessels stamped with versions of a collyrium-stamp of Lucius Julius Senex. Hartley records coarseware mortaria from the area near Millau, some from a late 3rd century production site. Seeley presents three locally-produced unguentaria from London, one with roller-stamped decoration. Finally Wild (J P) demonstrates the existence of makers' marks on textiles, although it is not possible to be certain about the reason(s) for the marks.

The final section considers the use of samian and other pottery in illuminating aspects of life and death. Booth provides quantified data for samian use in a single region of rural Roman Britain, making possible analysis of the percentage of samian at sites and the types of vessel in use. Polak, Niemeijer and van der Linden record and interpret a large body of South Gaulish terra sigillata from the Roman fort at Alphen aan den Rijn, founded in AD 40/41, raising many interesting questions. Biddulph gathers and interprets data from burials in SE England to consider the likely expenditure involved on the basis of samian used as grave goods. Cool and Leary provide and analyse a data set of samian in burials associated with a variety of Romano-British site types and dates, indicating the potential for understanding more about what the pots actually meant to the people who used them. Mills offers the fascinating suggestion that some old vessels were used by plate spinning entertainers. Thompson provides datasets and analysis for all graffiti on samian from London. Monteil presents and analyses evidence from London for sizes in later samian vessels and discusses samian dining 'services' and the usage of cups, plates and dishes. Finally, Darling searches for evidence for possible *clibani* and related cooking methods in Roman Britain and concludes that more may be found among odd lumps of coarse pottery, but what is recorded probably relates only to outsiders (eg the military).

Attention is drawn to the note on references in the editor's preface.

Cet ouvrage rassemble une collection de plus de 30 articles en hommage à Brenda Dickinson, surtout sur les études de céramique sigillée mais aussi sur d'autres domaines auxquels Brenda s'intéresse.

La section d'introduction commence avec l'article de Koço sur la note continue d'un bourdon dans chant polyphonique non accompagné, qui pourrait bien dater de l'époque romaine. Arnott établit que l'oiseau familier de Lesbie (Catulle) était un moineau franc. Martin (R) se concentre sur la langue et le style des discours 'britanniques' de Tacite. Ward offre ses pensées sur la publication de la céramique sigillée et Isserlin examine les implications de la durée de vie probable des bâtiments en bois sur la datation des trouvailles associées.

La première des sections principales concerne les potiers et leurs ateliers. Mees défend de façon convaincante qu'un buste en céramique de La Graufesenque représente le potier Cal(v)us dans son rôle de prêtre. Dannell démontre que les témoignages Londoniens utilisés pour corroborer que Drag 37 avait débuté avant 60 av. J.-C. ont été mal interprétés. Les travaux du potier montanais Salvius sont résumés par Martin (T) tandis que Delage présente des témoignages concernant un potier de Lezoux, Servus VI et ses relations avec d'autres potier éclairant ainsi comment s'organisait l'industrie. Deschieter, De Clercq et Vilvorder examinent les témoignages de vases décorés au moule fabriqués en Argonne par Ebaras dans la tradition sigillée. Huld-Zetsche résume les témoignages du potier de la Gaule de l'est Cintugnatus, démontrant qu'il a travaillé sur un certain nombre de sites de production. Schmid et Vogel Müller décrivent un site de production d'imitation de sigillée (y compris deux fours) à Augst. Finalement Burroughes présente la vision d'un potier sur la façon dont on aborde la reproduction de sigillée.

La section du milieu rassemble des articles sur le décor, les estampilles et autres marques. Bird (J) montre que les décors comprenant des scènes d'arènes avec taureaux sur des sigillées de la Gaule du sud impliquent des motifs soigneusement choisis, y compris ceux destinés à l'origine à d'autres fins. Jones met en évidence une rare représentation d'une chouette. Bourgeois et Thuault rassemblent les témoignages de 23 estampilles sigillées du Rozier (près de la Graufesenque) qui sont soit des groupes de lettres illisibles, soit des marques picturales. Tilhard (avec Sciau et Leon) présente des témoignages qui ont mené à l'identification d'un producteur de sigillée décorée avec une estampille intradécorative Dagom (...) en activité près de Brive dans la deuxième partie du premier siècle. Pitts propose des prototypes pour certains motifs Lezoux anciens sur les produits de La Graufesenque. Hopkins présente une sélection de *poinçons* récemment identifiés sur de la sigillée de la Gaule centrale, et dans certains cas démontre qu'il existe un nombre d'exemples, similaires mais différents, représentés dans la littérature par une seule entrée au catalogue. P et J Webster offrent une analyse détaillée d'une gamme de *poinçons* utilisés sur la sigillée et concluent qu'on souhaite dans tous les cas transmettre une impression générale de *romanité*. Wild (F) fournit cinq exemples de signatures de potiers de sigillée y compris des potiers peu connus comme Eppillus, Tetturo ou Tetturus et Tetlo ou Tetlonis. Jackson examine la raison probable pour laquelle certains récipients sigillés étaient estampillés avec des versions d'un cachet au collyre de Lucius Julius Senex. Hartley répertorie des mortiers de la zone proche de Millau, certains d'un site de production de la fin du troisième siècle. Seeley présente trois flacons à onguent Londoniens, produits localement, l'un avec un décor estampillé à la mollette. Finalement Wild (J P) démontre l'existence de marques de fabricants sur des textiles, bien qu'il soit impossible d'être certain de la/des raison/s de leur présence.

La dernière section examine l'usage fait de la sigillée et d'autres céramiques afin d'éclairer certains aspects de la vie et de la mort. Booth fournit des données quantifiées sur l'usage de la sigillée dans une seule région de la Bretagne romaine rurale, rendant possible l'analyse du pourcentage de sigillée selon les sites et types de vaisselle utilisés. Polak, Niemeijer et van der Linden répertorient et interprètent un important corpus de terre sigillée de la Gaule du sud provenant du fort romain d'Alphen aan den Rijn fondé en 40/41 ap. J.-C., et soulèvent maintes questions intéressantes. Biddulph rassemble et interprète des données de sépultures du sud-est de l'Angleterre pour évaluer les éventuelles dépenses encourues sur la base des sigillées utilisées comme mobilier funéraire. Cool et Leary fournissent et analysent une série de données de sigillée d'inhumations associées à des sites romano-britanniques de divers types et dates démontrant qu'il est possible de mieux comprendre ce que les pots signifiaient effectivement pour ceux qui les utilisaient. Mills offre la suggestion fascinante que de vieux vases étaient utilisés par des amuseurs qui faisaient tourner les assiettes. Thompson fournit des séries de données et une analyse de tous les graffitti sur sigillée de Londres. Monteil présente et analyse des témoignages londoniens sur la taille des récipients de la sigillée tardive et discute des 'services' de table sigillés et de l'utilisation de tasses, d'assiettes et de plats. Finalement Darling recherche des témoignages d'éventuels *clibani* et autres modes de cuisson associés en Grande-Bretagne romaine et conclut qu'on pourrait en trouver davantage dans des morceaux de poterie grossière, mais ce qui est répertorié ne concerne probablement que des outsiders (ex.des militaires).

Nous attirons votre attention sur la note à propos des références dans la préface de l'éditeur.

Die mehr als 30 in diesem Band vorgelegten Beiträge zu Ehren von Brenda Dickinson behandeln zumeist Studien zu Terra sigillata, schließen aber auch Brendas andere Interessen ein.

Der einführende Abschnitt beginnt mit Koços Beitrag zu einem Bordun in mehrstimmigem, unbegleitetem Gesang, der durchaus auf die Römische Kaiserzeit zurückgehen könnte. Arnott stellt die These auf, dass Lesbias Hausvogel (Catullus) ein Haussperling war. Martin (R.) konzentriert sich auf Sprache und Stil in Tacitus „britischen" Reden. Ward liefert Überlegungen zur Publikation von Terra sigillata, und Isserlin erörtert die Auswirkungen der wahrscheinlichen Lebensdauer hölzerner Bauten auf die Datierung von Begleitfunden.

Der erste Hauptabschnitt behandelt Töpfer und Töpfereien. Mees argumentiert überzeugend, dass eine Keramikbüste aus La Graufesenque den Töpfer Cal(v)us in seiner Rolle als Priester darstellt. Dannell zeigt, dass aus London herangezogenes Material zur Unterstützung einer Anfangsdatierung von Drag 37 vor 60 n. Chr. falsch interpretiert wurde. Das Werk des Töpfers Salvius aus Montans wird von Martin (T.) zusammengefaßt, während Delage die Belege für einen Töpfer namens Servus VI aus Lezoux und seine Verbindungen zu anderen Töpfern vorlegt, mit deren Hilfe die Organisation dieses Handwerks beleuchtet wird. Deschieter, De Clercq und Vilvorder untersuchen die Belege für formverzierte Becher, die von Ebaras in Terra sigillata-Tradition in den Argonnen hergestellt wurden. Huld-Zetsche faßt die Belege für den ostgallischen Töpfer Cintugnatus zusammen, anhand derer sie aufzeigen kann, dass er an mehreren Produktionszentren gewirkt hat. Schmid und Vogel Müller beschreiben eine Augster Produktionstätte (darunter zwei Öfen) für imitierte Terra sigillata. Abschließend präsentiert Burroughes einen Ansatz zur Reproduktion von Terra sigillata aus Sicht eines Töpfers.

Der mittlere Abschnitt umfaßt Beiträge zu Dekoration, Stempeln und anderen Markierungen. Bird (J.) kann anhand von Verzierungen, die Arenaszenen mit Stieren auf südgallischer Sigillata beinhalten, aufzeigen, dass diese sorgsam ausgewählte Motive umfassen, darunter solche, die ursprünglich für andere Zwecke vorgesehen waren. Jones stellt die seltene Darstellung eine Eule vor. Bourgeois und Thuault stellen Belege für 23 Sigillatastempel aus Le Rozier (bei La Graufesenque) zusammen, bei denen es sich entweder um unlesbare Buchstabengruppen oder bildhafte Zeichen handelt. Tilhard (mit Sciau und Leon) präsentiert das Material, dass zur Erkennung eines Produzenten verzierter Sigillata des späteren 1. Jhs. n. Chr. mit intradekorativem Stempel Dagom(...) aus einem Produktionszentrum bei Brive geführt hat. Pitts deutet die Möglichkeit an, dass Prototypen für einige frühe Lezoux Motive von Produkten aus La Graufesenque stammen. Hopkins legt eine Auswahl neu identifizierter Stempel auf mittelgallischer Sigillata vor und kann in einigen Fällen aufzeigen, dass eine Reihe ähnlicher aber unterschiedlicher Exemplare in der Literatur durch lediglich einen Katalogeintrag bezeugt sind. P. und J. Webster tragen eine detaillierte Analyse des auf Terra sigillata gebräuchlichen Stempelspektrums bei und kommen zu dem Schluß, dass dabei immer das Bestreben nach Vermittlung eines generellen Eindrucks von *romanitas* vorhanden ist. In Wilds (F.) Beitrag werden fünf Beispiele von Töpfersignaturen vorgestellt, darunter die wenig bekannten Töpfer Eppillus, Tetturo oder Tetturus und Tetlo oder Tetlonis. Jackson versucht zu erklären, warum eine Reihe von Terra sigillata Gefäßen mit verschiedenen Versionen eines Collyriumstempels des Lucius Julius Senex versehen wurden. Hartley erfaßt Reibschüsseln in Schwerkeramik aus der Gegend um Millau, darunter einige von einem Produktionsplatz des späten 3. Jhs. Seeley stellt drei vor Ort produzierte unguentaria aus London vor, darunter eines mit Rädchenverzierung. Zum Abschluß belegt Wild (J. P.) die Existenz von Herstellermarkierungen auf Textilien, wobei jedoch die Gründe für die Kennzeichnung noch nicht schlüßig geklärt sind.

Der Schlußabschnitt behandelt die Möglichkeiten, die Terra sigillata und andere Keramik für die Untersuchung von Aspekten von Leben und Tod zu bieten haben. Booth legt quantifizierte Daten zur Nutzung von Terra sigillata aus einer ländlichen Region des römischen Britannien vor, anhand derer sich die prozentualen Anteile von Terra sigillata pro Fundplatz und die in Gebrauch befindlichen Gefäßtypen untersuchen lassen. Polak, Niemeijer und van der Linden stellen auf Grundlage der Aufnahme und Interpretation einer großen Materialsammlung südgallischer Sigillata aus dem 40/41 n. Chr. errichteten römischen Kastell Alphen aan den Rijn zahlreiche interessante Fragen. Biddulph untersucht auf Grundlage von aus südostenglischen Grabfunden gesammelten Daten die wahrscheinlichen Kosten für Terra sigillata als Grabbeigaben. Anhand einer Datensammlung von Terra sigillata aus Grabfunden verschiedener romano-britischer Fundplatzarten unterschiedlicher Zeitstellung zeigen Cool und Leary das Potential für ein besseres Verständnis der Frage dessen, was die Gefäße denen bedeuteten, die sie genutzt haben. Mills wartet mit dem faszinierenden Vorschlag auf, dass manche alte Gefäße von Tellerdrehern genutzt wurden. Monteil untersucht anhand von Funden aus London die Maße später Terra sigillata Gefäße und diskutiert Terra sigillata Tafelgeschirre und die Verwendung von Bechern, Tellern und Schüsseln. Zum Abschluß sucht Darling nach Hinweisen für mögliche *clibani* und ähnliche Zubereitungsmethoden in Britannien und kommt zu dem Schluß, dass weiteres Material vielleicht unter dem einen oder anderen Klumpen Grobkeramik zu finden sein könnte, dass aber das bislang aufgenommene nur mit Außenseitern (z. B. dem Militär) in Verbindung zu bringen ist.

Es sei auf die Anmerkungen zu Literaturverweisen im Vorwort des Herausgebers hingewiesen.

Übersetzung: Jörn Schuster

Brenda Dickinson

Brenda Dickinson is a household name in Roman archaeology for her work on the high quality red, glossy tableware, which in Britain is known familiarly as samian, but on the continent as terra sigillata or terre sigillées. Recruited by Brian Hartley to assist him in the preparation of his index of samian potters' stamps in the Department of Classics in Leeds in 1964 (in succession to Felicity Wild), she has spent the last 40 years and more working on the potters' stamps, and also on the wider field of excavated samian assemblages including both decorated and plain wares.

Initially the focus of her work as research assistant to Hartley was in the capture of stamp data, including the taking of rubbings of the stamps, from museum and site collections in Britain and on the continent. Increasingly, however, the pressure from excavators in Britain, anxious to have the dating input to their site chronologies which samian could provide, led to her preparing reports not only on stamps, but also on entire samian assemblages from individual excavations. While much of this work at the outset was done collaboratively with Hartley, a significant quantity of research in Brenda's name alone flowed from the end of the 1970s. By the mid-1980s there was a regular stream of publications by Dickinson as sole author and, up to the early 2000s, about a dozen or so publications, including joint-authored work, appeared each year. After the expiry of the initial grants held by Hartley to produce the Index, the work was funded by English Heritage and its predecessor body between 1974 and 1994 as part of publicly-funded support of rescue archaeology in Britain. Pressure on public funds led to the issuing of Planning Policy Guidance Note 16 in 1990 and the start of excavation, post-excavation and publication funding by developers. Up to that point it had been an assumption, almost a law of nature, that the Leeds operation of Dickinson and Hartley would report the samian stamps from each and every relevant Romano-British, or late Iron Age and Romano-British site which was being prepared for publication. Of course, Hartley and Dickinson by no means held a monopoly on the publication of samian assemblages in Britain, not least because the demand for reports on samian far outweighed their capacity to deliver, but the resource of the Index, with the information it could provide on dating, was, understandably, much sought after, its significance recognised by the funding provided by, *inter alia*, the national heritage agencies of Cadw, English Heritage and Historic Scotland.

Brenda's retirement from Leeds University in 1994 was a technical one since she has continued to report and research samian as a consultant ever since. Through the numerous reports listed in her bibliography, she has already contributed massively to our knowledge and understanding of samian, particularly, but not exclusively, in Britain. While indications of the directions which research on this material might take are evident from early on in her career (eg Dickinson and Hartley 1971), the resource that has been gathered, especially when taken in the context of the collective wave of samian reporting since the 1960s, provides an exceptionally rich resource for researching a whole range of topics from the chronologies of the potters and their workshops through to the distribution and marketing of their wares and the implications of site assemblages for understanding acculturation and change in social practice. The published (and unpublished) samian resource from Britain, not least because of its geographical range and representation through the settlement hierarchy, is probably the best from any province of the Roman Empire. Within this the potters' stamps, and the potential they provide of linking together work which shares the same die, and thus, by inference, occupies a restricted time frame, hold pride of place.

The promise of the publication of the index of stamps on samian ware, generally known as The Leeds Index, has been heralded for more than a generation – references to its forthcoming publication can be traced back to the 1970s. However, retirement did not provide Hartley with sufficient time to see the work through to publication and, at the time of his death in 2005, the Index was still only very much in a draft form. Although Brenda was herself retired, she was still actively publishing and she very willingly rose to the challenge of bringing the Index to publication. She has worked full-time on it since early 2006. As this collection of essays, celebrating her contribution to samian studies in particular, and to scholarship in general, goes to press, the eighth volume of *Names on Terra Sigillata* itself is nearing completion. Publication of the ninth and final volume is expected by the end of 2012. While taking on a challenge of this scale is itself an exceptional undertaking, not least when retirement has so much to offer someone like Brenda with her rich and diverse interests from cricket to opera, it is the more remarkable because of her tenacity and commitment to keep up the schedule in the aftermath of major surgery and its associated, energy-draining, post-operative therapies. Already, with 70 per cent of the Index in the public domain, scholarship has an extraordinarily rich resource with which to fuel the study of the Roman economy and to assist excavators across western Europe with establishing the dating of their own material and thus their sites and assemblages. We contributors and our colleagues in Britain and Europe, as well as future generations of archaeologists and scholars, are remarkably fortunate; we owe an enormous debt of gratitude to Brenda for what she has already achieved and is still accomplishing.

Michael Fulford
Department of Archaeology
University of Reading

Compiled by Louise Rayner

1968

Dickinson, B, Hartley B R, and Pearce, F, 1968. Makers' stamps on plain samian, in *Fifth report on the excavations of the Roman fort at Richborough, Kent* (ed B W Cunliffe), Rep Res Comm Soc Antiq London 23, 125–48, Oxford

1971

Dickinson, B M, and Hartley, K F, 1971. The evidence of potters' stamps on samian ware and on mortaria for the trading connections of Roman York, in *Soldier and Civilian in Roman Yorkshire* (ed R M Butler), 127–42, Leicester

1977

Hartley, B R, and Dickinson, B, 1977. The samian ware, in A Rogerson, *Excavations at Scole, 1973*, East Anglian Archaeol 5, 155–72

Hartley, B R, and Dickinson, B, 1977. Samian stamps, in T R Blurton, Excavations at Angel Court, Walbrook, 1974, *Trans London Middlesex Archaeol Soc* 28, 55

1978

Dickinson, B, and Hartley, B R, 1978. The samian, in G H Smith, Excavations near Hadrian's Wall at Tarraby Lane 1976, *Britannia* 9, 37–41

[Hartley, B R, and Dickinson, B], 1978. Identification of samian stamps in *Southwark excavations 1972–74* (eds J Bird, A Graham, H Sheldon and P Townend), London Middlesex Archaeol Soc/Surrey Archaeol Soc Joint Pub 1, 95–6, 199, 225, 261–2, 332–3, 436–7, 469–70, 481, London

1979

Dickinson, B, 1979. Note on stamp, in A Boddington, Excavations at 48–50 Cannon Street, City of London, 1975, *Trans London Middlesex Archaeol Soc* 30, 18

Dickinson, B M, 1979. Samian stamps, in P T Bidwell, *The legionary bath house and basilica and forum at Exeter, with a summary account of the legionary fortress*, 182–4, Exeter

Hartley, B R, and Dickinson, B M, 1979. Samian stamp, in W McIsaac, I Schwab and H Sheldon, Excavations at Old Ford, 1972–1975, *Trans London Middlesex Archaeol Soc* 30, 62

1981

Dickinson, B, 1981 (1984). The samian ware, in K Scott, Mancetter village: a first century fort, *Birmingham Warwickshire Archaeol Soc Trans* 91, 8–9

Dickinson, B M,1981. The potters' stamps: appendix 2, in V G Swan, Caistor-by-Norwich reconsidered and the dating of Romano-British pottery in East Anglia, in *Roman pottery research in Britain and North-West Europe: papers presented to Graham Webster* (eds A C Anderson and A S Anderson), Brit Archaeol Rep Int Ser 123, 145, Oxford

Hartley, B, and Dickinson, B, 1981. The samian stamps, in C Partridge, *Skeleton Green: a Late Iron Age and Romano-British site*, Britannia Monogr Ser 2, 266– 8, London

Hartley, B R, and Dickinson, B, 1981. Samian ware, in I MacIvor, M C Thomas and D J Breeze, Excavations on the Antonine Wall fort of Rough Castle, Stirlingshire, 1957–61, *Proc Soc Antiq Scot* 110, 243–7

1982

Dickinson, B M, and Hartley, B R, 1982. Stamped samian, in P Bennett, S S Frere and S Stow, *The archaeology of Canterbury vol 1: excavations at Canterbury Castle*, Canterbury Archaeol Trust and Kent Archaeol Soc, 93–4, Maidstone

Dickinson, B M, 1982. The stamped samian, in P Bennett, S S Frere, and S Stow, *The archaeology of Canterbury vol 1: excavations at Canterbury Castle*, Canterbury Archaeol Trust and Kent Archaeol Soc, 129–31, Maidstone

Dickinson, B M, and Hartley, B R, 1982. The samian stamps, in *Excavations at Catsgore 1970–1973: a Romano-British village* (ed R Leech), Western Archaeological Trust Excavation Monogr 2, 151–2, Bristol

Hartley, B R, and Dickinson, B, 1982. The samian, in J S Wacher and A D McWhirr, *Early Roman occupation at Cirencester*, Cirencester Excavations 1, 119–46, Cirencester

1983

Dickinson, B M, 1983. Samian, in R Miket, *The Roman fort at South Shields: excavation of the defences 1977–1981*, 53–60, Newcastle-upon-Tyne

Bird, J, and Pengelly, H, with Dickinson, B, and Hartley, B R, 1983. The samian ware, in A E Brown and C Woodfield, with D C Mynard, Excavations at Towcester, Northamptonshire: the Alchester Road suburb, *Northamptonshire Archaeol* 18, 68–72

1984

Dickinson, B M, 1984. The potters' stamps and the decorated ware, in *Verulamium Excavations: vol 3* (ed S S Frere), Oxford Univ Comm Archaeol Monogr 1, 175–97, Oxford

Dickinson, B M, 1984. Samian potters' stamps, in M Farley, A six hundred metre long section through Caerwent, *Bull Board Celtic Stud* 31, 243

Dickinson, B M, 1984. The stamped samian, in P S Mills, Excavations at Roman Road/Parnell Road, Old Ford, London, E3, *Trans London Middlesex Archaeol Soc* 35, 30

Dickinson, B M, and Hartley, B R, 1984. The samian stamps, in K R Crouch and S A Shanks, *Excavations in Staines 1975–6: the Friends' Burial Ground site*, Joint Publ 2, London Middlesex Archaeol Soc and Surrey Archaeol Soc, 34–8

1985

Dickinson, B, 1985. The potters' stamps, in P T Bidwell, *The Roman fort of Vindolanda at Chesterholm, Northumberland*, Historic Buildings Monuments Comm England Archaeol Rep 1, 166–7 and microfiche, London

Dickinson, B M, 1985. Samian potters' stamps, in P N Clay and J E Mellor, *Excavations in Bath Lane, Leicester*, Leicestershire Museums, Art Galleries and Record Service Archaeol Rep Ser 10, 61–2, Leicester

Dickinson, B M, 1985. Potters' stamps, in J Hinchliffe, with C Sparey Green, *Excavations at Brancaster 1974 and 1977*, East Anglian Archaeol 23, 74–5, Dereham

Dickinson, B, 1985. The samian potters' stamps, in G Parnell, The

Roman and medieval defences and the later development of the Inmost Ward, Tower of London. Excavations 1955–77, *Trans London Middlesex Archaeol Soc* 36, 52

Dickinson, B M, and Hartley, B R, 1985. Samian ware, in A R Wilmott and S P Q Rahtz, An Iron Age and Roman settlement outside Kenchester (Magnis), Herefordshire: excavations 1977–1979, *Trans Woolhope Naturalists' Field Club* 45 (1), 134–41 and microfiche 3, 1:60–77

Dickinson, B, 1985 (1986). Samian, in H Wheeler, The Race Course cemetery, in J Dool and H Wheeler et al, Roman Derby: excavations 1968–1983, *Derbyshire Archaeol J* 105, 256–7

Dickinson, B, 1985 (1986). Samian, in R Annable and H Wheeler, The West Gate excavations 1968, in J Dool and H Wheeler et al, Roman Derby: excavations 1968–1983, *Derbyshire Archaeol J* 105, 36–7

Dickinson, B, 1985 (1986). Samian, in H M Wheeler, North-West sector excavations, in J Dool and H Wheeler et al, Roman Derby: excavations 1968–1983, *Derbyshire Archaeol J* 105, 79–90

Dickinson, B, 1985 (1986). North-West sector samian, appendix 1, in J Dool and H Wheeler et al, Roman Derby: excavations 1968–1983, *Derbyshire Archaeol J* 105, 315–8

Hartley, B R, and Dickinson, B, 1985 (1986). The samian ware, in J Dool, Derby Racecourse: excavations in the Roman industrial settlement, 1974, in J Dool and H Wheeler et al, Roman Derby: excavations 1968–1983, *Derbyshire Archaeol J* 105, 181–8

Dickinson, B M, 1985. The samian stamps from the cremation groups, in R Niblett, *Sheepen: an early Roman industrial site at Camulodunum*, Counc Brit Archaeol Res Rep 57, microfiche 1: A13–14, London

Dickinson, B M, 1985. The potters' stamps on samian ware, in R Niblett, *Sheepen: an early Roman industrial site at Camulodunum*, Counc Brit Archaeol Res Rep 57, microfiche 2: E1–6, London

Hartley, B R, and Dickinson, B M, 1985. The samian pottery from Saxon contexts, in S West, *West Stow: the Anglo-Saxon village*, East Anglian Archaeol 24, 82

Hartley, B R, and Dickinson, B M, 1985. Identification of samian stamps, in R B White, Excavations in Caernarfon 1976–77, *Archaeol Cambrensis* 134, 78–9

1986

Bird, J, Dickinson, B, and Hartley, B, 1986. Samian and samian stamps, in *Archaeology at Barton Court Farm, Abingdon, Oxon* (ed D Miles), Oxford Archaeol Unit Rep 3 / Counc Brit Archaeol Res Rep 50, microfiche 7:B9–B13, Oxford

Dickinson, B M, 1986. Samian pottery from the civil settlement, Doncaster, in P C Buckland and J R Magilton, *The archaeology of Doncaster: 1 The Roman civil settlement*, Brit Archaeol Rep Brit Ser 148, 117–42, Oxford

Dickinson, B, 1986. Potters' stamps and signatures on samian, in L Miller, J Schofield and M Rhodes, *The Roman quay at St Magnus House: excavations at New Fresh Wharf, Lower Thames Street, London*, London Middlesex Archaeol Soc Spec Paper 8, 186–98

Dickinson, B M, 1986. The samian potters' stamps, in *Baldock: the excavation of a Roman and pre-Roman settlement, 1968–72* (eds I M Stead and V Rigby), Britannia Monogr Ser 7, 202–12, London

Dickinson, B M, 1986. Samian, in D Gurney, *Settlement, religion and industry on the Fen-Edge: three Romano-British sites in Norfolk*, East Anglian Archaeol 31, 28, 74–5, 111–4, Dereham

Dickinson, B, 1986. The samian, in A McWhirr, *Houses in Roman Cirencester: Cirencester Excavations III*, Cirencester Excav Comm, 156–7, Cirencester

Dickinson, B M, 1986. The samian stamps, in D Allen, Excavations in Bierton, 1979, *Records of Buckinghamshire* 28, 58–9

Dickinson, B, 1986. The samian stamps, in M Millett, An early Roman cemetery at Alton, Hampshire, *Procs Hampshire Field Club Archaeol Soc* 42, 51–3 and 58

Dickinson, B M, 1986. Samian potters' stamps, in D J Rudkin, The excavation of a Romano-British site by Chichester Harbour, Fishbourne, *Sussex Archaeol Collect* 124, 65–7

Dickinson, B, and Hartley, B R, 1986. Samian stamps, in M Millett and D Graham, *Excavations on the Romano-British small town at Neatham, Hampshire, 1969–1979*, Hampshire Field Club Monogr 3, 66–8, Winchester

1987

Bird, J, and Dickinson, B, 1987. The samian from Marlowe Avenue and no 15A Dane John, in S S Frere, P Bennett, J Rady and S Stow, *Canterbury excavations: intra- and extra-mural sites, 1949–55 and 1980–84*, The Archaeol of Canterbury 8, 329–33, Maidstone

Dickinson, B M, and Hartley, B R, 1987. The samian stamps from Boudiccan groups, in M Millett, Boudicca, the first Colchester potters' shop, and the dating of Neronian samian, *Britannia* 18, 113–6

Dickinson, B M, and Hartley, B R, 1987. The samian, in R J Buckley and J N Lucas, *Leicester town defences: excavations 1958–1974*, Leicestershire Museums, Art Galleries and Records Service, 75–8, Leicester

Dickinson, B, and Hartley, B R, 1987. Samian stamps, in C S Green, *Excavations at Poundbury, vol 1: the settlements*, Trust for Wessex Archaeol / Dorset Nat Hist and Archaeol Soc Monogr Ser 7, microfiche 3, D5–7, Dorchester

1988

Bird, J, and Dickinson, B, 1988. The samian, in T W Potter and S D Trow, Puckeridge-Braughing, Hertfordshire: the Ermine Street excavations, 1971–1972, *Hertfordshire Archaeol* 10, 97–109

Dickinson, B, 1988. Samian stamps, in D Jackson and B Dix, Late Iron Age and Romano-British settlement at Weekley, Northamptonshire, *Northamptonshire Archaeol* 21, microfiche 143

Dickinson, B M, 1988. Samian potters' stamps, in B Dix, and S Taylor, Excavations at Bannaventa (Whilton Lodge, Northants), 1970–71, *Britannia* 19, 330

Dickinson, B M, 1988 (1989). Stamped and decorated samian, in G D Thomas, Excavations at the Roman civil settlement at Inveresk 1976–77, *Proc Soc Antiq Scot* 118, 165–6 and microfiche 1:A7–B9

Dickinson, B M, 1988. Stamps (South Gaulish only), in M J Darling and M J Jones, Early settlement at Lincoln, *Britannia* 19, 32

Dickinson, B M, and Hartley, B R, 1988. Selected Dr 29s, in M C Bishop and J N Dore, *Corbridge: excavations of the Roman fort and town, 1947–80*, English Heritage Archaeol Rep 8, Historic Buildings and Monuments Commission, 221–8, London

Dickinson, B M, and Hartley, B R, 1988. Samian potters' stamps from Corbridge, in M C Bishop and J N Dore, J N, *Corbridge: excavations of the Roman fort and town, 1947–80*, English

Heritage Archaeol Rep 8, Historic Buildings and Monuments Commission, 243–6, London

Dickinson, B M, and Hartley, B R, 1988. Samian pottery, in E Martin, *Burgh: the Iron Age and Roman enclosure*, East Anglian Archaeol 40, 30–4, Ipswich

Hartley, B R, and Dickinson, B, 1988. Stamp information, in H Pengelly, Samian ware from Great Chesterford, in J Draper, Excavations at Great Chesterford, Essex, 1953–5, *Proc Cambridgeshire Archaeol Soc* 75, 18–25

1989

Dickinson, B M, 1989. Samian potters' stamps from Chichester, in *Chichester Excavations* 6 (ed A Down), 105–9, Chichester

Dickinson, B, 1989. The potters' stamps, in P V Webster, The pottery, in J Britnell, *Caersws vicus, Powys: excavations at the Old Primary School 1985–86*, Brit Archaeol Rep Brit Ser 205, 81–2, Oxford

Dickinson, B M, 1989. Samian ware, in D R Evans and V M Metcalf, Excavations at 10 Old Market Street, Usk, *Britannia* 20, 23–67

Hartley, B R, and Dickinson, B M, 1989 (1991). The samian ware, in C Woodfield, with C Johnson, A Roman site at Stanton Low on the Great Ouse, Buckinghamshire, *Archaeol J* 146, 180–3 and microfiche 2/53–6

1990

Dickinson, B, 1990. Samian potters' stamps, in D S Neal, A Wardle and J Hunn, *Excavation of the Iron Age, Roman and medieval settlement at Gorhambury, St Albans*, English Heritage Archaeol Rep 14, 200–1, London

Dickinson, B, 1990. The samian ware, in M R McCarthy, *A Roman, Anglian and medieval site at Blackfriars Street, Carlisle*, Cumberland Westmorland Antiq and Archaeol Soc Res Ser 4, 213–36, Stroud

Dickinson, B, 1990. Samian stamps, in J C Driver, J Rady and M Sparks, *Excavations in the Cathedral precincts, 2: Linacre Garden, Meister Omers and St Gabriel's Chapel*, The Archaeol of Canterbury 4, 125, 166–7, Maidstone

Hartley, B R, and Dickinson, B M, 1990. Samian, in S West, *West Stow, Suffolk: the prehistoric and Romano-British occupation*, East Anglian Archaeol 48, 89–91, Ipswich

1991

Dannell, G B, and Dickinson, B M, 1991. Samian ware, in T Wilmott, *Excavations in the middle Walbrook valley, city of London, 1927–1960*, London Middlesex Archaeol Soc Spec Paper 13, 78–83

Dickinson, B, 1991. Samian potters' stamps, in N Holbrook and P T Bidwell, *Roman finds from Exeter*, Exeter Archaeol Rep 4, 46–55, Exeter

Dickinson, B, 1991. The samian ware, in J Taylor, The Roman pottery from Castle Street, Carlisle, in M R McCarthy, *The Roman waterlogged remains and later features at Castle Street, Carlisle: excavations 1981–2*, Cumberland Westmorland Antiq Archaeol Soc Res Ser 5, 344–65, Kendal

Dickinson, B M, 1991. Samian pottery, in P S Austen, *Bewcastle and Old Penrith: a Roman outpost fort and a frontier vicus: excavations 1977–78*, Cumberland Westmorland Antiq Archaeol Soc Res Ser 6, 112–35, Kendal

Dickinson, B, 1991. Samian potters' stamps, in J Lancley and E L Morris, Iron Age and Roman pottery, in P W Cox and C M Hearne, *Redeemed from the heath: the archaeology of Wytch Farm Oilfield (1987–90)*, Dorset Nat Hist Archaeol Soc Monogr Ser 9, 119, Dorchester

Dickinson, B, 1991. The potters' stamps, in C M Hearne and R J C Smith, A Late Iron Age settlement and Black-Burnished Ware (BB1) production site at Worgret, near Wareham, Dorset 1986–7, *Proc Dorset Nat Hist Archaeol Soc* 113, 74

1992

Dickinson, B, 1992. The samian potters' stamps, in N Holbrook and P T Bidwell, Roman pottery from Exeter 1980–1990, *J Roman Pottery Stud* 5, 50–4

Dickinson, B, 1992. Samian ware, in I D Caruana, Carlisle: excavation of a section of the annexe ditch of the first Flavian fort, 1990, *Britannia* 23, 51–8

Dickinson, B M, 1992. Samian, in *Iron Age and Roman salt production and the medieval town of Droitwich: excavations at the Old Bowling Green and Friar Street* (ed S Woodiwiss), Counc Brit Archaeol Res Rep 81, 58–61, 154, and microfiche 1:G13–2:C12 and 3:B11–12, London

Dickinson, B M, 1992. The samian ware, in J Hinchcliffe and J H Williams, with F Williams, *Roman Warrington, excavations at Wilderspool 1966–9 and 1976*, Brigantia Monogr 2, 120–3, Manchester

Dickinson, B, 1992. Samian ware, in D R Evans and V M Metcalf, *Roman Gates, Caerleon*, Oxbow Monogr 15, 97, Oxford

Dickinson, B M, and Hartley, B R, 1992. The samian ware, in J Hinchcliffe and J H Williams, with F Williams, *Roman Warrington, excavations at Wilderspool 1966–9 and 1976*, Brigantia Monogr 2, 31–41 Manchester

1993

Dannell, G B, Dickinson, B, and Hartley, B R, 1993. Provisional list of stamps on Drag 29 in the collections of F Hermet and D Rey, *Annales de Pegasus* 2, 1992–3, 34–8

Dickinson, B M, (with contributions by P V Webster) 1993. The samian ware, in J D Zienkiewicz, Excavations in the *Scamnum Tribunorum* at Caerleon: the Legionary Museum site 1983–5, *Britannia* 24, 87–98

Dickinson, B, 1993. Samian, in *Navio: the fort and vicus at Brough-on-Noe* (ed M J Dearne), Brit Archaeol Rep Brit Ser 234, 84–5, Oxford

Dickinson, B, 1993. The samian potters' stamps, in K Blockley, with F Ashmore and P J Ashmore, Excavations on the Roman fort at Abergavenny, Orchard Site, 1972–73, *Archaeol J* 150, 223–4

Dickinson, B, 1993. Samian potters' stamps from Chichester, in A Down and J Magilton, *Chichester Excavations* 8, 151–4, Chichester

Dickinson, B M, 1993. The potters' stamps, in M C Bishop, Excavations in the Roman fort at Chester-le-Street (Concangis), Church Chare 1990–91, *Archaeol Aeliana* 21, 44

Dickinson, B M, 1993. The samian stamps, in P J Casey and J L Davies, *Excavations at Segontium (Caernarfon) Roman fort, 1975–1979*, Counc Brit Archaeol Res Rep 90, 234–42, London

Dickinson, B M, 1993–4 (1996). Samian ware, in A S Esmonde Cleary and I M Ferris, Excavations at the New Cemetery, Rocester, Staffordshire 1985–1987, *Trans Staffordshire Archaeol Hist Soc* 35, 73–95

Dickinson, B M, and Bird, J, 1993. The samian, in M J Darling and D Gurney, *Caister-on-Sea: excavation by Charles Green (1951)*, East Anglian Archaeol 60, 154–9 and microfiche Tab 21–2, Dereham

Dickinson, B M, and Hartley, B R, 1993. Samian ware and illustrated samian, in J Monaghan, *Roman pottery from the*

fortress: 9 Blake Street, The Archaeol of York, the pottery 16 (7), 722–5, 745–69, York

1994

Dannell, G B, and Dickinson, B M, 1994. The samian, in R J Williams and R J Zeepvat, *Bancroft: a late Bronze Age/ Iron Age settlement, Roman villa and temple-mausoleum*, Buckinghamshire Archaeol Soc Monogr Ser 7 (2), 507–12, Aylesbury

Dannell, G B, Dickinson, B, and Pengelly, H, 1994. The samian (MK44), in R J Zeepvat, J S Roberts and N A King, *Caldecotte, Milton Keynes: excavation and fieldwork 1966–91*, Buckinghamshire Archaeol Soc Monogr Ser 9, 192–3, Aylesbury

Dickinson, B M, 1994. Samian stamps from key phases and discussion of the stamped samian from Site 5, phase 2A, in P Clay and R Pollard, *Iron Age and Roman occupation in the West Bridge area, Leicester: excavations 1962–1971*, 60–4, Leicester

Dickinson, B M, 1994. Samian, in P Ellis, J Evans, H Hanaford, G Hughes and A Jones, Excavations in the Wroxeter hinterland 1988–1990: the archaeology of the Shrewsbury bypass, *Trans Shropshire Archaeol Hist Soc* 69, 85–7

Dickinson, B, 1994. Potters' stamps on samian ware, in M G O'Connell and J Bird, The Roman temple at Wanborough, excavation 1985–1986, *Surrey Archaeol Collect* 82, 137–8

Dickinson, B M, and Hartley, B R, 1994. The samian ware, in P Bidwell and S Speak, *Excavations at South Shields Roman fort: vol I*, Soc Antiq Newcastle upon Tyne Monogr Ser 4, 206–8, Newcastle-upon-Tyne

Hartley, B R, Pengelly, H, and Dickinson, B, 1994. Samian ware, in *Roman Alcester; southern extramural area 1964–1966 excavations. Part II: finds and discussion* (eds S Cracknell and C Mahany), Roman Alcester ser 1/Counc Brit Archaeol Res Rep 97, London, 93–119

1995

Bird, J, and Dickinson, B, 1995. The stamped Italian and samian ware, in K Blockley, M Blockley, P Blockley, S S Frere and S Stow, *Excavations in the Marlowe Car Park and surrounding areas, part II: the finds*, Archaeol of Canterbury 5, 798–809, Canterbury

Dickinson, B M, 1995. The stamped samian, in R M J Isserlin, Roman Coggeshall II: excavations at 'The Lawns' 1989–93, *Essex Archaeol and Hist* 26, 93

Dickinson, B, 1995. Note on the samian potters' stamp, in A Dunwell and I Ralston, Excavations at Inveravon on the Antonine Wall, 1991, *Proc Soc Antiq Scot* 125, 557–8

De Clercq, W, and Deschieter, J, with contributions by Bird, J and Dickinson, B, 1995. Prospections à Steene-Pitgam: analyse d'un ensemble de terre sigillée, *Archéologie de la Picardie et du Nord de la France, Revue du Nord* 31, no. 333, 75–105

Hartley, B R, and Dickinson, B, 1995. The samian, in D N Riley, P C Buckland and J S Wade, Aerial reconnaissance and excavation at Littleborough-on-Trent, Notts, *Britannia* 26, 267–9

1996

Dickinson, B, 1996. Samian potters' stamps, in R P J Jackson and T W Potter, *Excavations at Stonea, Cambridgeshire 1980–85*, 421–7, London

Dickinson, B, 1996. Potters' stamps on samian ware, in B Philp, *The Roman villa site at Orpington, Kent*, Kent Monogr Ser 7, 68, Dover

Dickinson, B M, 1996. The stamped and decorated samian, in N Holbrook and A Thomas, The Roman and early Anglo-Saxon settlement at Wantage, Oxfordshire: excavations at Mill Street 1993–4, *Oxoniensia* 61, 137–8

Dickinson, B M, 1996. Samian ware from Strensham, in R A Jackson, J D Hurst, E A Pearson and S Ratkai, Archaeology on the Strensham to Worcester aqueduct, *Trans Worcestershire Archaeol Soc* 15, 11

Dickinson, B M, 1996. Samian pottery, in J May, *Dragonby: report on excavations at an Iron Age and Romano-British settlement in North Lincolnshire: vols 1 and 2*, Oxbow Monogr 61, 591–7, Oxford

Dickinson, B, 1996. Terra Sigillata Stempel, in C Bridger, *Das Römerzeitliche Gräberfeld 'An Hinkes Weisshof', Köln*, 52–3

Dickinson, B M, 1996. The samian stamps, in A G Marvell, Excavations at Usk 1986–1988, *Britannia* 27, 101–2

Dickinson, B, 1996. The samian ware, in T Gregory, *A Romano-British farmyard at Weeting, Norfolk* (ed D Gurney), East Anglian Archaeol Occas Paper 1, 27–8

Dickinson, B, Boon, G C, and Evans, D R, 1996. Samian ware, in *Excavations in Cowbridge, South Glamorgan, 1977–88* (eds J Parkhouse and E Evans), Brit Archaeol Rep Brit Ser 245, 166–71, Oxford

1997

Dickinson, B M, [1997]. Unpublished computer catalogue of samian stamps from Silchester in Reading Museum

Croom, A T, and Dickinson, B, 1997. The Roman pottery, in B Langton and N Holbrook, A prehistoric and Roman occupation and burial site at Heybridge: excavations at Langton Road, 1994, *Essex Archaeol and Hist* 28, 12–46

Dickinson, B M, 1997. Samian and catalogue of samian, in J Monaghan, *Roman pottery from York*, The Archaeol of York 16 (8), 943–8 and 950–66, York

Dickinson, B M, 1997. Catalogue of samian stamps, in P M Booth, *Asthall, Oxfordshire: excavations in a Roman small town 1992*, Thames Valley Landscapes Monogr 9, 112, Oxford

Dickinson, B M, 1997. The samian pottery from the 1960–63 excavations, in S M Elsdon, *Old Sleaford revealed*, Oxbow Monogr 91 / Nottingham Studies in Archaeol 2, 81–4, Oxford

Dickinson, B, 1997. Note on samian ware, in *A multi-period salt production site at Droitwich: excavations at Upwich* (ed J D Hurst), Counc Brit Archaeol Res Rep 107, 72 and microfiche 62–7, York

Dickinson, B M, 1997. Decorated samian and potters' stamps, in A R Wilmott, *Birdoswald*, English Heritage Archaeol Rep 14, 256–67, London

Dickinson, B, 1997. The samian, in A G Marvell and H S Owen-John, *Leucarum: excavations at the Roman auxiliary fort at Loughor, West Glamorgan 1982–1984 and 1987–1988*, Britannia Monogr Ser 12, 296–315, London

Dickinson, B, and Mills, J, 1997. The samian ware, in A Wilmott, *Birdoswald: excavations of a Roman fort on Hadrian's Wall and its successor settlements: 1987–92*, English Heritage Archaeol Rep 14, 256–67, London

1998

Arthur, P, with additions by Dickinson, B, 1998. Samian, in J R Timby, *Excavations at Kingscote and Wycomb, Gloucestershire: a Roman estate centre and small town in the Cotswolds*, 238–9, Circencester

Dickinson, B, 1998. Catalogue of stratified decorated samian,

in J R Timby, *Excavations at Kingscote and Wycomb, Gloucestershire: a Roman estate centre and small town in the Cotswolds*, 241, 243 Circencester

Bird, J, de Clercq, W, Deschieter, J, and Dickinson, B, 1998. Terra sigillata uit Merendree als maatstaf voor chronologie, *VOBOV Info: Tijdschrift van het Verbond voor Oudheidkundig Bodemonderzoek in Oost-Vlaanderen* 78, 34–45

Dannell, G, Dickinson, B, and Vernhet, A, 1998. Ovolos on Dragendorff form 30 from the collections of Frédéric Hermet and Dieudonné Rey, in *Form and Fabric: Studies in Rome's material past in honour of B R Hartley* (ed J Bird), Oxbow Monogr 80, 69–109, Oxford

Dickinson, B, 1998. Fabric Type E 1: samian wares, in P Leach, *Great Witcombe Roman villa, Gloucestershire. A report on excavations by Ernest Greenfield 1960–1973*, Brit Archaeol Rep Brit Ser 266, 62–3, Oxford

Dickinson, B M, and Hurst, D, 1998. Roman imported wares: samian, in H Dalwood, V Buteux and E Pearson, Archaeology on the Astley to Worcester Aqueduct, *Trans Worcestershire Archaeol Soc* 16, 18–9

Evans, J, with contributions by Dickinson, B, Hartley, K, King, A, and Millett, M, 1998. The Roman pottery, in D Longley, N Johnstone and J Evans, Excavations on two farms of the Romano-British period at Bryn Eryr and Bush Farm, Gwynedd, *Britannia* 29, 206–26

1999

Dickinson, B, 1999. Samian, in C J Going and J R Hunn, *Excavations at Boxfield Farm, Chells, Stevenage, Hertfordshire*, Hertfordshire Archaeol Trust Rep 2, 84–7, Hertford

Dickinson, B, 1999. The samian: Site B, in D Gurney, A Romano-British salt-making site at Shell Bridge, Holbeach St Johns: excavations by Ernest Greenfield, 1961, in *Lincolnshire salterns: excavations at Helpringham, Holbeach St Johns and Bicker Haven* (eds A Bell, D Gurney and H Healey), East Anglian Archaeol 89, 45–6

Dickinson, B M, 1999. The samian, in A C Bell, The Romano-British salt-making site at Shell Bridge, Holbeach St Johns: excavations 1983, in *Lincolnshire salterns: excavations at Helpringham, Holbeach St Johns and Bicker Haven* (eds A Bell, D Gurney and H Healey), East Anglian Archaeol 89, 78

Dickinson, B M, 1999. Fabric class S, samian, in S C Palmer, Archaeological excavations in the Arrow Valley, Warwickshire, *Trans Birmingham Warwickshire Archaeol Soc* 103, 106–7

Dickinson, B M, 1999. Samian potters' stamps: comments on the stamps from the Shires and Causeway Lane, in A Connor and R Buckley, *Roman and medieval occupation in Causeway Lane, Leicester: excavations 1980 and 1991*, Leicester Archaeol Monogr 5, 102–7, Leicester

Dickinson, B M, 1999. Samian stamps, in R P Symonds and S Wade, *Roman pottery from excavations in Colchester 1971–86*, Colchester Archaeol Rep 10, 120–36, Colchester

Dickinson, B, 1999. The samian stamps, in M Bedwin and O Bedwin, *A Roman malt house: excavations at Stebbing Green, Essex, 1988*, East Anglia Archaeol Occas Paper 6, 16, Chelmsford

Dickinson, B M, and Croom, A T, 1999. The samian ware, in P Bidwell, M Snape and A T Croom, *Hardknott Roman fort, Cumbria, including an account of the excavations by the late Dorothy Charlesworth*, Cumberland Westmorland Antiq and Archaeol Soc Res Ser 9, 77–82, Kendal

2000

Dickinson, B M, 2000. Samian, in K Buxton and C Howard-Davis, *Bremetenacum: excavations at Roman Ribchester 1980, 1989–1990*, Lancaster Imprints 9, 202–24, Lancaster

Dickinson, B M, 2000. Samian ware, in I Caruana, Observations in the vicus of Stanwix Roman fort on the site of the Miles MacInnes Hall 1986, *Trans Cumberland Westmorland Antiq and Archaeol Soc* 100, 62–6

Dickinson, B M, 2000. Samian potters' stamps, in E Price, *Frocester: a Romano-British settlement, its antecedents and successors*, 129–131, Stonehouse

Dickinson, B, 2000. Stamps, in E W Sauer, Alchester, a Claudian 'Vexillation Fortress' near the western boundary of the Catuvellauni: new light on the Roman invasion of Britain, *Archaeol J* 157, 58–61

Dickinson, B, 2000. The samian (with contributions by G Dannell), in *The Roman baths and macellum at Wroxeter: excavations by Graham Webster, 1955–85* (ed P Ellis), English Heritage Archaeol Rep 9, London, 282–302

Dickinson, B, and Hartley, B 2000. The samian, in *Roman Castleford: excavations 1974–85 volume III: the pottery* (eds C Philo and S Wrathmell), West Yorkshire Archaeol 6, 5–88, Wakefield

2001

Dickinson, B M, 2001. Samian, in M Flitcroft, *Excavation of a Romano-British settlement on the A149 Snettisham Bypass 1989*, East Anglian Archaeol 93, 59

Dickinson, B M, 2001. Samian ware, in P Leach, with C J Evans, *Fosse Lane, Shepton Mallet 1990. Excavation of a Romano-British roadside settlement in Somerset*, Britannia Monogr Ser 18, 144–9, London

Dickinson, B, 2001. Illustrated samian ware, in P Booth and J Evans, *Roman Alcester: northern extramural area, 1969–1988 excavations*, Roman Alcester Ser 3 / Counc Brit Archaeol Res Rep 127, 185–7, York

Dickinson, B, 2001. Samian ware, in P M Booth, J Evans and J Hiller, *Excavations in the extramural settlement of Roman Alchester, Oxfordshire, 1991: A41 (formerly A421) Wendlebury-Bicester dualling*, Oxford Archaeol Monogr 1, 277–85, Oxford

Dickinson, B, 2001. Samian ware from Rossington Bridge, in P C Buckland, K F Hartley and V Rigby, The Roman pottery kilns at Rossington Bridge: excavations 1956–1961, *J Roman Pottery Stud* 9, 36–9

Hartley, B R, and Dickinson, B, 2001. The evidence for the date of the potters' stamps from Culip IV, in X Nieto and A M Puig, *Excavacions arqueològiques subaquàtiques a Cala Culip, 3. Culip IV: la terra sigil.lata decorada de La Graufesenque*, Monographies del Centre d'Arqueologia Subaquàtica de Catalunya 3, 21–32, Girona

Dickinson, B, Hartley, B, and Pengelly, H, 2001. Samian ware, in A S Anderson, J S Wacher and A P Fitzpatrick, *The Romano-British small town at Wanborough, Wiltshire*, Britannia Monogr 19, 179–209, London

2002

Dickinson, B M, [2002]. Unpublished catalogue and database of the samian stamps in the Römermuseum Augst

Dickinson, B, 2002. Catalogue of South Gaulish samian stamps, in G Webster and J Chadderton, *The legionary fortress at Wroxeter: excavations by Graham Webster 1955–85*, English Heritage Archaeol Rep 10, 149–55, London

Dickinson, B M, 2002. Catalogue of stamped sherds, in P R Wilson, *Cataractonium: Roman Catterick and its hinterland: excavations and research 1958–1997*, Counc Brit Archaeol Res Rep 129, 438–41, York

Dickinson, B, and Webster, P V, 2002. A group of Flavian samian from Caerleon, in *Céramiques de la Graufesenque et autres productions d'époque romaine: nouvelles recherches: hommages a Bettina Hoffmann* (ed M Genin and A Vernhet), 247–57, Montagnac

Dickinson, B, 2002. Samian potters' stamps, in D Lakin, with F Seeley, J Bird, K Rielly and C Ainsley, *The Roman tower at Shadwell, London: a reappraisal*, Museum London Archaeol Service Stud Ser 8, 48–9, London

Dickinson, B, 2002. Samian potters' stamps, in R Taylor-Wilson, *Excavations at Hunt's House, Guy's Hospital, London Borough of Southwark*, Pre-Construct Archaeol Ltd Monogr 1, 51, London

Hartley, B R, and Dickinson, B, 2002. Samian ware from Catterick Bypass (site 433), in P R Wilson, *Cataractonium: Roman Catterick and its hinterland: excavations and research 1958–1997*, Counc Brit Archaeol Res Rep 128, 280–316, York

Hartley, B R, Pengelly, H, and Dickinson, B, 2002. Samian ware from Catterick 1972 (site 434), in P R Wilson, *Cataractonium: Roman Catterick and its hinterland: excavations and research 1958–1997*, Counc Brit Archaeol Res Rep 128, 316–22, York

2003

Dannell, G B, Dickinson, B M, Hartley, B R, Mees, A W, Polak, M, Vernhet, A, and Webster, P V, 2003. *Gestempelte südgallische Reliefsigillata (Drag 29) aus den Werkstätten von La Graufesenque, gesammelt von der Association Pegasus Recherches Européennes sur La Graufesenque*, Römisch-Germanisches Zentralmuseum Mainz Kataloge Vor- und Frühgeschichtlicher Altertümer 34, Mainz

Dickinson, B, 2003. Samian Ware, in N Holmes, *Excavation of Roman sites at Cramond, Edinburgh*, Soc Antiq Scot Monogr 23, 41–7, Edinburgh

Dickinson, B, 2003. (Contributions), in S Willis, Samian, in *Settlement, burial and industry in Roman Godmanchester: excavations in the extra-mural area: The Parks 1998, London Road 1997–8, and other investigations* (ed A Jones), Brit Archaeol Rep Brit Ser 346, 149–53, Oxford

Dickinson, B, 2003. Potters' stamps, in J D Hill and G Lucas, Later Iron Age and Roman pottery : the excavated assemblage, in C Evans, Britons and Romans at Chatteris: Longwood Farm, Cambridgeshire, *Britannia* 34, 224

Webster, P, and Dickinson, B, 2003. The samian ware, in H James, *Roman Carmarthen, Excavations 1978–1993*, Brit Monogr Ser 20, London

2004

Bird, J, Dickinson, B, and Hartley, B, 2004. The decorated samian, in T Blagg, J Plouviez and A Tester, *Excavations at a large Romano-British settlement at Hacheston, Suffolk in 1973–4*, East Anglian Archaeol 106, 155–8, Ipswich

Dickinson, B, 2004. Samian potters' stamps, in L Dunwoodie, *Pre-Boudican and later activity on the site of the forum*, Museum of London Archaeol Service Stud Ser 13, 50, London

Dickinson, B, 2004. Samian potters' stamps, in E Howe and D Lakin, *Roman and medieval Cripplegate, City of London: archaeological excavations 1992–8*, Mus London Archaeol Service Monogr 21, 111–112, London

Dickinson, B, 2004. Potters' stamps, in B Burnham and H Burnham, *Dolaucothi-Pumsaint: survey and excavation at a Roman gold-mining complex 1987–99*, 109, Oxford

Dickinson, B, 2004. Name stamps and graffito, in B Burnham and H Burnham, *Dolaucothi-Pumsaint: survey and excavation at a Roman gold-mining complex 1987–99*, 119, Oxford

2005

Dickinson, B, 2005. P-14 unmasked, and what happened next, in *An archaeological miscellany: papers in honour of K F Hartley* (eds G B Dannell and P V Irving), *J Roman Pottery Stud* 12, 97–105, Oxford

Dickinson, B, 2005. Samian stamps, in F Seeley and J Drummond-Murray, *Roman pottery production in the Walbrook valley: excavations at 20–28 Moorgate, City of London 1998–2000*, Museum of London Archaeol Service Monogr Ser 25, 169–71, London

Dickinson, B, 2005. The samian potters' stamps, in B Philp, *The excavation of the Roman fort at Reculver, Kent*, Kent Monogr Ser 10, 160–2, Dover

Dickinson, B, 2005. Decorated and stamped samian, in M C Bishop, A new Flavian military site at Roecliffe, North Yorkshire, *Britannia* 36, 164–6

2006

Dickinson, B, 2006. Catalogue of samian stamps, in R Bluer and T Brigham, with R Nielsen, *Roman and later development east of the forum and Cornhill*, Museum of London Archaeol Service Monogr 30, 118–21, London

Dickinson, B, 2006. Samian potters' stamps, in R Niblett, with W Manning and C Saunders, Verulamium: excavations within the Roman town 1986–88, *Britannia* 37, 133–4

2007

Dickinson, B, 2007. Samian potters' stamps, in D Williams, Green Lane, Wanborough: excavations at the Roman religious site 1999, *Surrey Archaeol Collect* 93, 208

Dickinson, B, 2007. Identifications of samian stamps, in J Bird, Catalogue of the Roman pottery found before 1995, in R Poulton, Farley Heath Roman temple, *Surrey Archaeol Collect* 93, 84–98

2008

Dickinson, B, 2008. The samian, in J G P Erskine and P Ellis, Excavations at Atworth Roman villa, Wiltshire, 1970–75, *Wiltshire Archaeol and Natur Hist Mag* 101 (CD Rom)

Dickinson, B, 2008. The samian stamps, in N Bateman, C Cowan and R Wroe-Brown, *London's Roman amphitheatre, Guildhall Yard, City of London*, Mus London Archaeol Service Monogr 35, 187, London

Hartley, B R, and Dickinson, B M, 2008 – *Names on terra sigillata: an index of makers' stamps and signatures on Gallo-Roman terra sigillata (samian ware)*, Bull Inst Classical Stud Supplement 102, London

This book was originally planned to mark Brenda Dickinson's 70th birthday in 2008 (a landmark that came as a surprise to many people – one comment was 'I thought she was a good 15 years younger'). It should also have marked a well-earned retirement but since 2006 she has been working harder than ever to achieve publication of the 'Leeds Index'. Unfortunately, it has taken longer than I would have liked to bring the book to fruition. Too little time was available from the start of the project to achieve the originally intended publication date; indeed some of the papers had still not been written by then. It should, however, be noted that there were others that were completed as early as August 2007. The original suggestion that a Festschrift should be produced came from Raphael Isserlin, but he was unable to find the time to pursue the idea himself and so, newly retired, I took on the project. This was partly because I thought I would have plenty of spare time (my first mistake) and partly because I could not think of a suitable paper to offer Brenda myself and therefore thought that editing her Festschrift would be an appropriate contribution. Had I realised what was involved I am sure that I would have tried much harder to find a suitable subject …

Brenda was, of course, Brian Hartley's right-hand woman, but the contribution she has made in her own right to the study of samian ware is widely recognised. It is pleasant to recall how many people responded with great enthusiasm to the invitation to contribute; 'about time', 'very well-deserved' and similar reactions were the common themes. A number of distinguished scholars who were unable to contribute sent their best wishes for Brenda and emphasised that a Festschrift was long overdue. How frequently she had done people favours over the years, over and above the call of duty, was also commonly remembered. Her assistance had regularly extended not only to samian expertise but also to proof reading and help with English. This caused problems for a number of contributors, who found themselves in the unusual position of being unable to ask Brenda for help!

Because of the wide range of subject matter in the papers it was difficult to find a title for the volume. There was a school of thought that it should be called *Stamp Collecting for Girls*, but reason prevailed in the end. That title was, however, used for a cover to a list of contributors which was presented to Brenda at the British Academy in 2008 on the occasion of the launch of the first two volumes of the Index. The presentation was accompanied by a witty and erudite speech from Rien Polak. One advantage of telling Brenda about the book before it was complete was that it became possible to check certain things that really needed her expertise.

Naturally a major part of the book concerns samian studies, but the contributions touch on several of Brenda's

This fragment of authentic samian pottery (Antonine, A.D. 150–180), found in St. John's Wood, London, attests the popularity of CRICKET with both sexes in Roman Britain (drawing by Howard Comfort, 1971)

other interests. It was not however possible to include a paper relevant to crosswords, or cricket, but the late Howard Comfort's 1971 Christmas card, reproduced here, will help to fill the gap. I am sure that Brenda (who was once happily distracted at a meeting of Pegasus, thanks to the wonders of modern text messaging, with the news that Australia were following on) will be pleased to see it receiving the wider attention it deserves. Contributions on Tacitus and Catullus (Martin and Arnott), and references to Homer (Ward) are appropriate for one 'who read Catullus when gaining her first class [degree] in Classics at Leeds' (Professor Geoffrey Arnott), and music (Koço), cookery (Darling) – and what it might be served in (Monteil), clothes (Wild) and owls (Jones) are also represented.

The result is an entertaining mix of papers that should give archaeologists pause for thought about what we usually cannot find in the archaeological record. A drone holding note in multipart unaccompanied singing (Koço) might seem a long way from samian studies or archaeology, but it may well go back to the Roman period if not earlier, and should remind us of an aspect of daily life in the Empire which inevitably we rarely consider. Another aspect of entertainment rarely considered is illuminated by the possible plate spinners (Mills), while the later British parallels cited for Lesbia's pet sparrow (Arnott) must surely make us aware that there were similar pets in Roman Britain.

Archaeology is about people, hence one appeal of samian stamps: they provide actual names for the people involved (who then often gain nicknames as they become Brenda's close friends – Calvus ('bless him'), for instance, now even better known from his portrait bust (Mees). Many others are gathered here, including some relatively new, in the three main sections of the book. There is not sufficient space to introduce each paper individually (that would

take an essay in itself), but together they add a great deal to knowledge in several different fields. Within them the experience of a practical potter (Burroughes) may perhaps be singled out as providing an insight likely to be more in tune with the approach of a Roman-period potter trying to replicate something seen than someone working from the specialist or modern scientific point of view.

Many of the contributors have at one time or another been part of the Black Hand Gang (see first paragraph in Dannell, this volume), and will cherish happy memories of Alain Vernhet's hospitality and the multi-national scholarly meetings at La Graufesenque. These produced very important results, and such cooperation continues to be an essential part of the study of a product so widely distributed in the western Empire (and beyond). It is reflected in the contributions by leading foreign scholars in this book.

Acknowledgements

Although I have (literally) lived with samian for well over 30 years and am a fully paid-up member of the Black Hand Gang, I would not claim any greater expertise. Fortunately, the extensive knowledge and experience of my wife, Joanna Bird, was always available when needed, as was that of Geoffrey Dannell, who provided much of the drive to get the project started (as he did for the publication programme of the Leeds Index). I would also like to thank Thomas Bird, for his language skills. Louise Rayner took on the thankless task of compiling a bibliography of Brenda's work (with help from Robert Hopkins); it is nevertheless likely that there are several missing references. Many will be unknown to Brenda herself, thanks to the unfortunate tendency of some report authors not to let specialists know that their work has been printed (often after many years in cold storage). Thanks are also due to Jude Plouviez and Rachael Seager Smith for assistance with some references, to Paul Bidwell and Philip Kenrick, and to Gilbert Burroughes for helping with transport. Our original publisher, Michael de Bootman, provided enthusiastic and patient support throughout the preparation process, in defiance of the state of his health. We are very grateful also to David Brown and Oxbow for taking on the project at a late stage, and to the Roman Research Trust for a generous grant that helped to make such a large publication possible.

A note on references in the book

References to classical authors are to the standard texts except where otherwise indicated. The foreign bibliographies are presented in the appropriate language, as it seems to me that it would be illogical to do otherwise. Similarly text references to illustrations, wherever they occur, use the actual reference that appears in the work cited (Taf, Abb, etc).

Where individual potter's names are followed by Roman numerals, the following rule applies: upper case numerals (eg Paternus II) indicates a potter named following the various typologies of decorated samian ware (such as Stanfield and Simpson, *Central Gaulish potters*, 1958); lower case numerals (eg Calvus i) are applied to homonymous potters identified by their stamps and listed in the Leeds Index. It should be stressed that the two systems operate independently, so that Potter II is not necessarily the same as Potter ii.

Throughout the book standard samian forms are referred to by abbreviations (Déch[elette], Drag[endorff], Ritt[erling], Lud[owici], etc) for consistency.

David Bird

1 Vocal Iso(n)

Eno Koço[1]

Introduction

This study is concerned with the vocal *iso(n)* repertory, used, on the one hand, in the oral traditions of the *multipart unaccompanied singing* (IMUS) of the south-west Balkans or more specifically south Albania, north Greece and a small part of Macedonia, and on the other hand in Byzantine chant. The vocal iso(n) is an important component of these traditions, which are still practiced today in the south-west Balkan area. The paper attempts to present evidence on various manifestations of the practice in their particular geographical regions and to further determine the historical roots of these traditions.

An ison, a drone holding-note, comes from the Greek and is the voice that provides the drone in a Byzantine chant (Eastern Christian Chant). The latter is the liturgical music of the Orthodox Churches, whereas the IMUS has developed as a secular repertory. In Albanian, the same word for the same function in the oral traditional IMUS is spelt *iso*. Both versions of the spelling will be used throughout this survey, *ison* in the sense of the Byzantine chant and *iso* to refer to the south Albanian IMUS. An intermediate form of spelling with the use of brackets, *iso(n)* will also be used in order to characterise a liaison between the two linguistic forms. In both types the iso was never written down, but in Byzantine ecclesiastical chants the ison is a written neume, the earliest scored records of which can be found only from the beginning of the 19th century. The vocal iso(n), as the tonal foundation of the singing and a constant reference tone for the soloists' melodic phrases, is widely practiced today in some pockets of the north–eastern Mediterranean.

The research aims also to study the relationship, if any, between secular and religious practices, that is the iso(n) used in the oral traditions of the IMUS and that of the Byzantine Chant. The former vocal iso repertory is broadly used in the multipart (two- and three-part) singing with iso of the rural and urban areas of the south-west Balkans and is profane, whereas the latter is widely practiced today in Byzantine churches all over the world. The Byzantine liturgical singing of the Arbëresh Diaspora of south Italy and Sicily, which has been passed down orally from the 15th century to the present day, as well as non-liturgical singing, will also be discussed here. The three unaccompanied forms of singing, two of which use the ison (the IMUS and the Byzantine chant) and the third, the Arbëresh, which does not, will be analysed separately, then comparisons will be made at the end.

It is important to point out that there are a number of studies which suffer from a one-sided point of view made one-sided through national amour-propre. Multipart singing in Albania is usually considered to be an Albanian phenomenon, whereas in Greece it is thought of as being Greek. In fact, the multipart singing of the Albanian and Greek, as well as Aromanian and some Slavic populations is more intrinsically bound to the *region* than to any ethnic group. The distinct sound of the iso(n) singing echoes the internal and external historic influences on the region, interwoven with complex modal idioms. As a result, in the regions of south Albania and north Greece, a distinct and rich Levantine sound developed, echoing the voices and instrumental music of the East.

Although in Western references there is no mention that the use of iso(n) is to be found before Late Byzantine times, the possibility cannot be excluded that the drone was used in previous centuries. This study does not attempt to prove that the iso(n) was practiced continuously from the ancient Greek period and its Esoteric music theory. It is also hard to prove that the iso was an element of ancient south-west Balkan multipart singing since there is little evidence to support such an assumption. There are several questions to be raised but not all of them can yet be given answers:

- What could be the age of the iso(n) used in the south-west Balkans?
- Was the ison used during Koukouzel's time (born *c* 1280, died 1360–75)?
- To which period does the IMUS belong: the period of Antiquity, Christianity or the Middle Ages?
- Are the IMUS just folk songs and dances from the Albanian-Greek Ottoman milieu or are they

secular music connected with the Byzantine and post-Byzantine period?

- How much has today's singing, of both Byzantine chant and IMUS, been affected by Turkish music?
- Has the IMUS been affected by Byzantine music?

Iso(n)/drone music can be both vocal and instrumental, although for this paper the focus of my investigation will be directed towards the vocal iso(n)/drone. I prefer to use the term 'multipart' for this type of drone singing instead of the more commonly used term, 'polyphonic'. The latter, in my view, is not entirely correct since the iso, being a firm tone, 'has no part in the melodic unfolding' (Emsheimer 1964, 44). The term 'polyphonic' is used not only in Albania, but in the Balkans and beyond. It should be stressed that the south Albanian and northern Greek peoples as well as the Aromanian people living next to each other and employing the same word for the 'iso(n)', use the term 'polyphony' or 'polyphonic' as a literal translation from the ancient Greek *polyphōnos* (many-voiced) without any connotations of musical technique. Therefore, if you ask an ordinary Albanian in the street what the term *polyphony* or *polyphonic* means, he/she will answer that it is a many-voiced or multipart singing. He/she does not know that the scholarly meaning of this term is not referring to a literal translation from the Greek (many-voiced) but to a concept of medieval European polyphony (independence of voice and rhythmic parallelisms). The term *polyphony* or *polyphonic*, which was used as a scholarly notion and was introduced during the first half of the 20th century into the Albanian scene, was intended to designate a musical technique and style in which all or several of the musical parts move to some extent independently. Thus, the Western term for *polyphony* and the Albanian or Greek *polyphony*, as it is still used nowadays, are not comparable to one another for musical-theoretical reasons. However, the ordinary south Albanian would still prefer to use the expression *këngë me iso* (the Iso songs) or *Lab* songs rather than *polyphonic* songs, although this ambivalent term imposed on the regional culture as an institutionalisation of the folk festivals syndrome has persisted down to the 21st century and other regional musical concepts are preserved along with it.

The IMUS is not an isolated phenomenon. It has survived in many local musical traditions of north European and non-European traditional music such as Scottish bagpipe tunes, Latvian folksongs of the old variety – the dainas, Sicilian multi-part singing, Georgian folk polyphony and Indian music. It is a practice that corresponds to folk music in more than one part of the world. Vocal multipart singing styles with or without a drone have been preserved in the oral traditions of the Balkans including Bulgaria, Macedonia, Serbia, Croatia, Bosnia-Hercegovina and the northern Mediterranean zone including Italy, Sicily, Sardinia, Corsica and Portugal. However, the iso used in various styles of the multipart unaccompanied singing of south-west Balkan rural and urban societies is identified by its own musical grammar and melodic formulae.

On the Byzantine ison a more thorough perception is given by Kenneth Levy who explains:

'To western ears the most striking Byzantine performing practice is the use of an Ison or drone to accompany liturgical singing. This is still heard in Orthodox churches. The earliest creditable evidence for the practice goes back to perhaps 1400. It was well established in the mid-15th century and was described in 1584 by the German traveller Martin Crusius[2]: 'more utriculariorum nostrorum, alius vocem codem sono tenet, alius, *Dra Dra*, saltatorium in modum canit'. There are indications that ison singing (or perhaps simple parallel polyphony) extends back farther than the 15th century, but there is no independent Byzantine polyphony of the kind that developed in the west' (Levy 1980, 561).

The members and congregations of Orthodox religious practitioners and the members of traditionalist IMUS communities do not acknowledge any relationship between the two repertoires, but a slight relationship may be suggested, based on what has been revealed as traces of microtonic intervals, modal character, free rhythms, improvised ornamentations, intoning process and, above all, the iso(n), all of which are found in both 'schools'. A number of researches have been conducted by Greek and non-Greek scholars, dealing with the use of the ison and other components related to the Byzantine chant. There is clearly a predisposition by some scholars to seek the existence of the Byzantine ison further back in the 13th or 14th centuries during Koukouzel's time.[3] Conversely, another scholar, Dimitri Conomos, states that 'the introduction of the drone, or Ison singing, so familiar in contemporary Greek, Arabic, Romanian and Bulgarian practice, is not documented before the 16th century, when modal obscurity, resulting from complex and ambiguous chromatic alterations which appeared probably after the assimilation of the Ottoman and other Eastern musical traditions, required the application of the tonic, or home-note, to mark the underlying tonal course of the melody' (Conomos 1982, 1).

As far as the unaccompanied multipart singing is concerned, Hoerburger noted that the ison singers were to be found within the Greek part of Southern Epirus, but only among refugees from the Albanian area (Stockmann 1963, 44). Samuel Baud-Bovy and Rudolf Brandl invested a great deal of effort into studying the music of the Epirus in general and that of IMUS in particular. Amongst the Greek scholars, Spyridon Peristeris carefully investigated the Epirotic IMUS during the period from 1951 to 1956. On this very type of singing, it should be pointed out that a meticulous study of the Cham (Albanian Çam)[4] song was made in 1957 by Doris Stockmann, Wilfred Fiedler and Erich Stockmann who carried out an expedition not in Chameria (Çamëri), an area situated on the present Greek side of the border, but in three different places in Albania (Fier, Babicë and Skelë, near Vlorë) where the Chams were spread out and settled after the Second World War. De Gaudio mentions that 'a type of polyvocality ... as far as the character of the 'drone' in the 'accompanying' voice and the new type of final cadential cell is concerned, is to be found among some Albanian *Albanophones* situated on

the western areas of the province of Cosenza' (De Gaudio 1993, 145).

Trako, an Albanian scholar of the Academy of Religious Music in Bucharest, dealt with the role and function of the iso(n) in traditional choral music by describing it as a 'pedal'. 'The tonalities of the Korçare music', according to Trako, 'are always shaped, based on and made to revolve around Byzantine and Gregorian medieval scales with most of them involving pentatonic scales' (Trako 1943, 2–3). Examining the different types of diaphonic instruments such as *cyla-diare*, *bishnica* and *gajde* (folk instruments with two pipes, one for the tune and the other for the drone/ iso), which are played in the manner of polyphonic songs, Ramadan Sokoli points out that this kind of 'iso/pedal was an earlier practice than the ison used in the *Papadike* and *Heirmological* practice of Byzantine liturgical song' (Sokoli 1965, 135). Ahmedaja (2001, 269) states that 'traces of these [drone] features can be noticed in the Arbëresh songs'. Shupo indicates three main possible ways the iso was introduced into Albanian unaccompanied multipart singing: first, as a continuation from ancient Greek culture; second, as a derivation from Byzantine music which itself was also based on the ancient patterns; third (the most complex and debatable), as a result of Arabic musical influence on the south-western part of Europe. There is also a fourth, less credible approach, according to Shupo, which associates the iso origin with the period of the Ottoman occupation (Shupo 2004, 23–4).

Kruta, in my opinion, should be given special credit for his studies on the iso question, in recognition of his regular field research expeditions to South Albania and his meticulous observations. He also explored the possible existence of the iso in south Italy, among the Arbëresh people, who were the followers of both the traditional and Byzantine music of Albania and Morea.[5] Kruta dismisses categorically the suggestion of some non-Albanian scholars that the iso/drone evolved alongside the multipart unaccompanied singing through the Byzantine liturgy, and states that 'the drone does not come from Byzantium'. He reinforces this opinion 'from the fact that there is no evidence that the traditional music of other Balkan nations, such as Serbia, Macedonia, Bulgaria, Romania and particularly Greece, used the bourdon, although they were influenced by the Byzantine or Bogomil liturgy. Thus, if the iso had penetrated into South Albanian traditional song from the Byzantine chant, it would have also diffused to the central Albanian regions, and, certainly, to the other traditional songs of the Balkan peoples' (Kruta 1991, 69). Although Kruta's statement seems to be a logical explanation, there is still room for discussion on this issue.

The early growth of the Iso(n) and the IMUS

It has been argued and generally accepted that the drone came into the Balkans from the East and that, as Anthony Baines states, it 'probably became established during the early growth of musical systems in western Asia, though there is no strong evidence for it before Hellenistic times' (Baines 2006). The 'Eastern' theory, which is the dominating one, has to do mainly with the ison used in the Byzantine chant. There are music manuscripts which provide the earliest hints of the practice, of how and when it started to be written.

The beginnings of the IMUS, in my view, were a blend of pagan and Christian elements. This does not necessarily mean that its usage goes back to the pre-Christian era or before the period when Christianity was introduced into south-west Balkan shores. In several parts of this region, its inhabitants continued to practice their ancient pagan rituals despite the introduction of new religions. The iso(n) has been orally transmitted and has evolved to both univocal Byzantine monody and the south-west Balkan oral traditions of multipart singing. Its penetration into liturgical singing and secular multipart singing used in the south-west Balkans, with its function as a sustained final tone in relation to the melody, should have occurred roughly at the same period, the Late Medieval, although it cannot be excluded that the drone used in multipart unaccompanied singing may have started earlier.

When the ison was initially used in Byzantine chant, it only sustained the chant in a straight line in a pedal-note fashion. As in the IMUS the drone was an unchangeable underlying tone, which is different from the present-day Greek chant; its main role, apart from functioning as the key (basic) note was to allow for participation. In Mount Athos, as in Grotaferrata, where Late Byzantine Period singing is practiced, the practitioners are trying to preserve the earlier tradition of Byzantine chant in which the harmony does not change, so the ison is a basic one and does not have a harmonic or rational role, but it is, more than anything else, participatory. The drone/ison reflects the way one participates in the singing. It is of a heterophonic design, which means nothing but humming along. A later form of drone, based on tetrachord and pentachord mode changes or vertical harmonisation, elaborated by the different schools of thought who formalized it, started later, after the Byzantine classical period (Classical Byzantine Chant covers the period from the 9th to the 15th century, from the end of Iconoclasm to the fall of Constantinople in 1453).

In multipart unaccompanied singing the drone serves as a tonal basis over which two or three harmonised voices or soloists interact with each other. As a whole, the IMUS preserves some very specific features: on the one hand it uses the microtonal intervals (which are extensively employed also in the Byzantine music) and, on the other, pentatonic systems; on top of the above combinations the drone is added, which makes the type of singing quite complex and extravert. The multipart songs with iso (Albanian *këngë me iso*) constitute the basis of this category of vocal organization and the voices of the solo singers over the drone/iso, which are perceived in a horizontal rather than in a vertical modal relationship, and which tend to develop (in some cases more than others) independently of each other. The iso remains a constant reference sound. The south-west Balkan region evolved distinctive styles of

its own, clearly indigenous, which were shaped by modal structures of a pentatonic spectrum of a relatively narrow range. Established as a result of the ancient trade routes in this geographical fringe area of the south-west Balkans, multipart pentatonic singing structures were shaped and a drone-based tonality was added, creating a more advanced musical architecture of this type of singing. The gradual IMUS formation belongs to a local, south-west Balkan process; it is more of a regional occurrence than ethnic, although during the history of the IMUS development in some places more than the others it was also associated with local ethnic traditions and customs. Where the south Albanians are now located, the IMUS seems to have been preserved with some jealousy and fanaticism, favoured also by the surrounding mountainous terrain, which has, to some extent, isolated the region from external influences.

The repertoire of this multipart unaccompanied singing existed throughout the Middle Ages and the drone feature is assumed to have reached the folk music of the Balkans from the Indian subcontinent through the Byzantine and later Ottoman conquest of the peninsula. There was also a contingent of Gypsy or Roma nomadic people spreading from Asia Minor into Europe and entering the Balkans in the 14th century or earlier who brought with them, as well as their tunes, modes and instruments, also the notion of the instrumental drone.

Analysing the diffusion of the IMUS of the south-west Balkan area, I would put its nucleus, as the focal point of the unaccompanied multipart singing, in the regions inhabited by the former Chaonian, Molossian and Thesprotian peoples, all of them being the most famous among the tribes of Epirus. The IMUS epicentre seem to be located south of the Vjosa river in the area identified by the Romans as Epirus Vetus, from where its waves widen in concentric circles in other directions, north, east and somewhat less towards the south, where different ethnic populations used to live in mutual partnership. The Toskëri and Labëri regions, as well as those of the Greek-speaking and Aromanian-speaking geographical areas, share the same way of singing, but apart from the language they differ in some specific, clearly identified, styles and features. This type of group singing of multi-ethnic origin was well formed during the Byzantine period and coexisted as a secular tradition and way of life with the general Byzantine culture together with other of its branches such as the architecture of churches and monasteries, the painting of murals and icons, and the writing of codices.

The different stylistic approaches developed along with the self awareness of populations, their languages and later on, religions. The iso itself also acquired various shapes and local configurations, but it may be said that it remained a unifying factor of the multi-part traditions and styles of singing within their inherent ethnic and geographical differences. According to the studies of the Albanian scholars, two distinctive styles emerged as the most prominent: the Lab and the Tosk. However, apart from these distinctive styles, there are other regional styles, which represent in a way some considerable differences between the various styles of the IMUS. Greeks and Aromanians, outside and inside the present borders of Albania, also practice the IMUS and although the singing is related to the Tosk or Lab groups, it cannot be categorised as such, since the above designations belong only to the Albanian ethnic groups.

On The Byzantine Ison

Although Byzantine liturgical music gradually progressed through its hymns, chants and Oktoechos system, it took several centuries to be introduced into the remote churches of the south-west Balkans, south Albania and north Greece, and to develop through different phases of a notation system before a new element emerged: the ison. There is an argument between most Western and Greek musicologists as to whether the ison and microtones used in Byzantine chant today, were also known to Greek classical music theorists and practitioners. Many Western scholars defend the theory that both microtones and ison came in after the Turkish conquest of the Eastern Roman Empire, and argue that the integration of the chromatic intervals, ison and singing styles into Byzantine liturgical singing was a relatively late process, that is, post-medieval. Greek musicologists, on the other hand, believe that ison predated the Turks and has its roots in ancient Greek music. A number of questions may be raised: when did the process of Orientalisation take place? Was it due to the impact of other Eastern liturgical music or was it the result of exposure to Ottoman music? More importantly: does present-day Byzantine music sound like that of the Byzantine Empire period (before 1453) which in turn may have sounded like ancient Greek music?

The ison, as mentioned above, was never written down as notation for most of its existence and the earliest record in scores is apparently as late as the 19th century. Oliver Strunk points out that: 'we have no clear testimony to the practice of the ison singing – the improvised addition of a bourdon-like second voice – until after the Turkish conquest. Again during the period we are considering it was a purely diatonic music' (Strunk 1977, 300).

The notable modern scholar, Egon Wellesz (1885–1974), 'had to refute as strongly as possible the notion that Byzantine music represented a continuation of ancient Greek music. He pointed to the evidence in studies of literature, liturgical developments, and the fine arts indicating the enormous significance of the Near East, though in studies of music there was a scarcity of reliable research in this vast area' (Velimirović 1976, 269).

Being originally monophonic or monodic, Byzantine chant was not harmonized, but a drone-singing or choral ison was added below the melody in order to accompany liturgical singing and also to sustain the 'root' of the Tone (that the choir intones and chants). This was a fundamental change in Byzantine church music, breaking the existing barriers of monophonic tradition. The introduction of Oktoechos in Byzantine chant, which goes back to the 6th century AD, dealt with the principles of composition

based on modal formulae. Later on, the *organa* (vocal organum) was added to these chants and later still they began to be accompanied by a drone bass. Other scholars theorise that the earliest practice of the drone may have begun as early as the 7th century during the Arab conquest of Palestine and Syria (632–750) or in pre-Turkish/Ottoman times. This must remain an open question, but it is much clearer that the post-Byzantine and modern Greek chanting was influenced by Middle Eastern and Turkish/Ottoman practice.

Different views over the necessity of adaptation of a polyphonic language to Byzantine chant or leaving it intact and uncorrupted by Western or Eastern influences have always been a question of principle, of a doctrine of the Byzantine liturgy. The addition of a second accompanied voice, for example, to the Byzantine traditional monophonic tune functioning as a variable ison, as well as other polyphonic effects such as the ascending major thirds in a heterophonic style (usually towards the final cadences), have attempted to change the perception that the Byzantine chanting is supposed to be strictly monophonic.

In some recently issued CDs featuring, among others, the music of Koukouzel, one can hear a light ison which it is believed to be 'closer' to the classical Byzantine chant. I am keen to defend the view that no ison existed during Koukouzel's time. However, if a kind of ison had started to be employed in the classical Byzantine chant, this should have been a simple and a light accompaniment to the melody being held throughout the chant and without moving along to the essential skeletal melodic tones (tetrachords).

Nowadays, the reconstructions of ancient Byzantine tunes are quite often done by incorporating an ison in them with the intention of creating a pleasant moulding, similar to a presupposed earlier stylistic form of the ison practice, or making them sound more remote but at the same time more fashionable. This is obviously done with good intentions to show the best of the Byzantine chant legacy and also to relate it to classical Byzantine chant, or even to the supposedly ancient Greek classical music. For academic purposes of a given study, it is, of course, interesting and tempting to research various stylistic approaches and shades of an ison, sometimes mutating it into an Occidental, organum-like refined bass, but any attempt to synthetically associate it with an ancient origin would have need of stronger evidence and more importantly would have to fit the consciousness and awareness of the people who practiced it at the time. Ison practice in the Byzantine Chant of the 14th–15th centuries up to the present day altered gradually in areas of structural intonation and singing intervals, unlike the classical Byzantine Chant practiced from roughly the 9th to the 15th centuries, which was unaffected by the more complex non-diatonic trends of Ottoman musical traditions.

The tendency to introduce new features into the old tunes during the long process of consolidation of Byzantine liturgical music has shown that despite the intonation variations in a certain period of its development,

it has managed to remain 'traditional' based on the oral transmission of the music. On the other hand, new attempts by the inheritors of Byzantine traditions to adapt other polyphonic models as well as the ison to the contemporary world, should be taken, in my view, as a tentative way for broadening the spectrum of the concept of Byzantinism, probably in the direction of experimentation in choral singing.

Arbëresh liturgical music

Investigating the possibility of a liturgical iso(n) tradition among the Arbëresh of south Italy and Sicily, Kruta notes that:

> 'an important fact which makes more complex the genesis of the drone and puts a question mark over its early existence in the Byzantine chant, is linked with the polyphonic song of the Orthodox Church of the Arbëresh of Italy, which, despite its ancient tradition, does not identify an ison. ... At least until the 14th century when the migration movements of Arbëresh towards Italy started, the Byzantine liturgical chant in south Albania developed without iso' (Kruta 1991, 68–9).

Kruta's assessment is accurate. During my visit to Sicily in the summer 2006, I think I was able to identify that no such ison ever existed in the Byzantine liturgy of the Arbëresh Diaspora who inhabit five small towns in the province of Palermo. The main centre of this Arbëresh musical patrimony – the Byzantine church of the Piana degli Albanesi in Sicily (known as Piana dei Greci before 1914), has its own specific repertoire which is entirely handed down orally and is melodically different from the Neo-Byzantine liturgy. The latter employs an ison, whereas Arbëresh Byzantine musical practice does not. Neo-Byzantine music uses the hard and soft chromatic intervals (augmented seconds) in its Eight Tones (Oktoechos) modal system, whereas the Arbëresh Byzantine musical tradition has its own specific organisation of this system, not affected by the Neo-Byzantine. During the Ottoman occupation of the Balkans, from the 15th century onwards, the new components of Byzantine singing, the harmonic and modal (i.e. the ison and augmented second), became very important, whereas for Arbëresh Byzantine singing outside the Balkans but as part of north-eastern Mediterranean practice, the ison component is treated as a modern feature. In Sicily, Calabria and in the abbey of Grottaferratta, in particular, classical Byzantine chant is still practiced in liturgy, whereas in nearly all monasteries of the Greek Orthodox Church they use Neo-Byzantine music.

The oral tradition of the Arbëresh liturgical chant is said to be based on the classical Byzantine, medieval style of chant, without Ottoman influences. The Arbëresh possess a vast patrimony of this repertoire, which even today is still orally transmitted. Garofalo writes that 'until a few decades ago songs were sung only in Greek. Different translations into Italian and Albanian were used only recently. Believers (who usually do not know Greek) usually read editions

in Greek transliterated into Roman type with parallel translation into Italian' (Garofalo 2004, 276). Attempts to transcribe several versions of the Albanian oral tradition of the Byzantine chant brought to Calabria and Sicily in the 15th century have been made by Arbëresh scholars such as Falsone (on the Sicilian variant), Giordano (on the Calabrian variant) and Di Salvo. Some of these musical compositions belong to Koukouzel's period or Koukouzel himself. Lorenzo Tardo was an Arbëresh monk from Contessa Entellina and founder of the *Scuola Melurgica* of the *Badia Greca*. He makes clear that the Orthodox Albania of the 1930s certainly adopted the system and the chant of its neighbouring country, Greece, based on written or printed music of the post-Byzantine period. However, he is interested in the Byzantine orally transmitted chant, as he states:

> 'All of these Byzantine songs, used before in Albania, in Morea, in the Near East, and then transmitted and jealously preserved (as perhaps being something sacred and rather exaggerated) in the new places of Sicily, represent a monument of an incomparable value that, for their unaltered tradition, give a great prominence to the Byzantine *melurgical* art. The liturgical melodies, in their general complexity, belong to the end of the 13th century and the beginning of the 14th. The Albanians, loathing their Muslim slavery, left their homeland soil, not taking with them the ultimate musical pattern of Constantinople, nor the scholarly and wise art of the refined *protopsalti* [precentors, who help facilitate worship], but rather a provincial, mountainous and archaic tradition' (Tardo 1938, 111).

Papàs Ferrari, another dedicated Arbëresh musicologist and Albanologist, tries to make it clear that the Byzantine chant which developed in the south-west Balkans did not identify with the mainstream Constantinopolitan musical liturgy. Although both Byzantine musical traditions lived side by side, they had significant differences: the Constantinople musical liturgy, which was a written music, was more exposed to Ottoman music and became more 'oriental', whereas the south-west Balkan Byzantine tradition still sounded like the Byzantine music of the Byzantine period. The former was established in the Balkans with its centres in Constantinople and Mount Athos, and the changes toward a more 'middle-eastern' approach occurred slowly and were hardly noted. The latter, totally oral and more 'primitive', moved to a new land, south Italy and Sicily. It should be stressed that while in Calabria this tradition has almost disappeared or become Latinised, in Sicily it is still preserved in the villages with care and fanaticism.

> 'But, near to a more appropriate popular music of any kind, another type of liturgical chant of a traditional popularized background, which was orally transmitted and without any kind of written tradition, it should have existed in Albania in the 15th and 16th century. ... In fact, it is not perhaps known to many people that the liturgical song of the Italo-Albanian Churches of Byzantine rite of southern Italy and Sicily, is identified not with the Byzantine liturgical songs of the printed texts in Greece and elsewhere, but stands as an artistic patrimony of its own' (Ferrari 1978, 15).

Coexistence of IMUS and Byzantine chant

The IMUS is a musical legacy of the Albanian and non-Albanian populations who have lived for centuries in the south-west Balkans. It is an oral tradition of an archaic origin and has never been practiced as a written music. It has been and still is practiced by music lovers who, generally, belong to those particular areas where the singing styles of ethnic groups have been preserved. The IMUS practitioners represent a particular group tradition and feel that they are the authentic heirs of that culture.

Byzantine music of the Great Cathedrals has been represented by educated *psaltis* (cantor or chanter) and *protopsaltis* and has been a written music – the neumes of different periods. The ison, although it was not a written neume until the early 19th century, corresponds to each Mode (Tone) as its basis and changes when the melody requires it. However, there is no strict rule for this since in slow pieces, despite the movement up and down of the melody, the ison may remain fixed on the base.

The iso(n) practice, which associates these two completely different cultures, was introduced into the south-west Balkans presumably from different eastern directions. The territory of the south-west Balkans served as a melting pot for both of the iso(n) practices and traditions. From the early 14th century the Constantinople schools found it difficult to exercise their teaching in an isolated or even cut-off area of Epirus, and when the ison began to be elaborated in the main centres of the Byzantine Empire, it took a substantial time to be absorbed by the cantors of the Epirus region. The two modes of iso(n), introduced into the south-west Balkans through the eastern routes in the 13th and 14th centuries, were only in the process of their formation and did not reach Italian shores as a consolidated element of Byzantine chant or traditional secular multipart singing. That is why only segments of holding notes of a drone type could be found in Arbëresh multipart singing, whereas evidence of the use of the ison in Byzantine chant in the early stage of Albanian emigration is difficult to verify.

Since the IMUS is a product of Byzantine-era tradition, its accommodation to Byzantine culture in general and folk music culture in particular must be taken into consideration. Kosta Loli gives his version of the folk multipart repertories and Byzantine liturgical traditions:

> 'Byzantine music, ecclesiastical and secular, develops within its own creative and performing conservative rules. The Epirotic polyphonic song also developed within unwritten musical polyphonic rules in a concrete Orthodox geographic area. Both musical cultures coexist in separate frameworks and styles. Together they also find their way towards agreement' (Loli 2006, 22–3).

Given the fact that the iso(n) singing pedal employed in the church singing was also used in multipart secular

singing with the same function and the same name, with similar improvised ornamentation patterns and the use of micro-tones, it can be suggested that an interrelationship of multipart unaccompanied singing and Byzantine liturgical or secular music could have existed. Being the strongest bond between these two forms of singing, not excluding other components mentioned above, the iso(n) served in the best way to convey the feeling of the music that was practiced in the south-west Balkans.

Ramadan Sokoli remarks that:

'at the beginning of each *pleqërishte* (old men) singing, usually the leader of the group briefly marks the tone of the iso by oscillating his voice in a 'gruppetto' form around this tone, which terminates with a descending glissando' (Sokoli 1965, 129).

Observing the intoning process among Prespa singers, Sugarman interprets it in a different way:

'Before beginning the song proper, he or she intones the syllables *e-o*. This intonation serves in part as a signal that someone is about to sing and those others in the room should curtail their conversations and prepare to join in on the drone' (Sugarman 1997, 64).

In discussing a record on Hymns of the Epitaphios and Easter, which included church services as well as folk songs from various Greek provinces and islands, Velimirović points out that:

'the second band contains a practice not observed in most churches, that of singing the intonation for the mode prior to the chanting. These intonations are found in mediaeval manuscripts but are never heard now in 'normal' services. It is therefore of substantial interest to observe these intonations as they lead into the hymns' (Velimirović 1978, 384).

Another supposition could be that this intonation is a replacement of an accompaniment formerly played by the lyre of the anterior of primitive Christian origin with a vocal passage sung before the psalm.

Returning to the Arbëresh singing, liturgical and non liturgical, a strong reason why it did not employ a clear iso(n) as in its country of origin is, I would like to reiterate, that this new component of multipart singing was only on the eve of its formation as a sustained droning sound, whereas in the Balkans the iso(n) developed conspicuously and took on an important role. In Byzantine singing, initially as a foundation of the mode, the ison stayed on the same note, unchanged, but later it took the role of harmonic function. In contrast, in the IMUS of the south-west Balkans, the iso dwelt within the framework of a pentatonic and archaic origin of singing, but it developed largely towards various stylistic forms and structures. The Albanian linguist Eqrem Çabej notes that:

'Albania is also the land where Oriental-Islamic tunes are mingled with the Byzantine tunes found here, which became familiar to the people through the church.

Differentiation between them becomes more difficult because Arabo-Islamic tunes were formerly mingled in the Orient with Byzantine tunes. . . . More apparent are the influences of medieval Byzantine tunes on liturgical and religious song and its dissemination from here to the profane song of the Albanians of Italy and also to the church song of the Orthodox Christians of south Albania (Çabej 1975, 128–9).

In an article on the polyphonic songs of North Epirus, Peristeris makes two interesting observations:

'Some of their musical elements, such as the Ison or the Ghyristis melody on the tonic and subtonic, are also found in Byzantine church music, which leads to another question: could these local folk songs have been influenced by Byzantine music in those countries where Byzantine civilisation had flourished?' (Peristeris 1964, 52).

As far as the 'Ghyristis melody on the tonic and subtonic' is concerned, I would take Peristeris' proposal with some reservation since the primary role of these degrees or tonalities is mainly connected with the diatonic and chromatic modes of the south-west Balkans rather than the pentatonic. *Tonic* and *subtonic* melodic formulae, which are derived from tonic and subtonic tonalities, are distinct as being the most important degrees of the mode. However, when it comes to the question of whether 'these local folk songs have been influenced by Byzantine music in those countries where Byzantine civilisation had flourished', we can share several opinions with Peristeris, while leaving also room for differences. The proposal made by Peristeris in 1958 was re-evaluated twenty five years later by Baud-Bovy, who remarks that as a result of:

'these vocal polyphonic features, in one form or another, being practiced over the whole Tosk region of Albania (south of the river Shkumbin), which is quite marginal in Epirus, one might be tempted to accept one of Spiridon Peristeris' hypotheses (1964, 52) and consequently to see in this polyphony a survival from a grassroots tradition, which would not necessarily exclude the possibility of its being influenced by Byzantine religious music since the region was predominantly orthodox' (Baud-Bovy 1983, 55).

The IMUS Appropriation

In this closing part of my survey I will focus only on the coexistence of IMUS with powerful and dominant administrations, cultures and ideologies such as the Byzantine, Ottoman and Communist. There was a time when IMUS lived as part of the musical expression of a multi-ethnic culture of a large Eastern Orthodox community of the south-western Balkan peoples. This was because no nation states existed and ethnicity was harder to define. At the dawn of its formation as *indigenous* cultural contexts, the IMUS embedded languages and social activities practiced in the Byzantine world interacted with this

culture. The iso itself did not play the same role as it did in a later period; its sound production was much softer and its mission was only to participate in rather than support the contrapuntal melodies. Around the year 1350, when the ethnic composition of the region began to change, especially during the Ottoman era with the definition of the new administrative territories and islamisation of a part of the Albanian population, the IMUS not only progressed to a more elaborated formal structure but its Albanian character emerged as a distinctive feature. The multipart singing, which started as a pan-south-west Balkan phenomenon where different ethnic populations were contributors to its formation, aimed to serve as a unifying and identifying factor for the Albanians. Since the regional cultures were constantly borrowing from each other, the Albanians felt that they had every right to give a new emphasis to their ancestral musical patrimony through the adoption of some new elements to their shared musical culture, such as the strengthening of the ison and giving the IMUS an epic character.

The embracing of the Muslim religion cannot be treated as an act of appropriation of IMUS since the practitioners belonged to the same cultural group, but with two religions, and it did not change the core of IMUS; it simply created a stronger Albanian variant of this repertory. The newer dynamics given to IMUS should be understood not as a contribution of the Ottomans to the Albanian song profile and the Muslim religion not as a deviation from the monotheistic Orthodox religion of the south-west Balkans. Exactly the opposite occurred. Although, religion, not ethnic descent or language, was the first criterion for identification in the Ottoman *millet* system (in which the population was politically segmented according to religion), the IMUS proved able to survive and flourish as a pre-Ottoman culture. This was an exceptional example of a well-consolidated musical culture.

Albanian musical and poetical culture could not, however, develop entirely independently without being influenced by other regional ethnical cultures, the Greek in particular. In the 18th and 19th centuries the frontiers between ethnic populations, especially between Albanians and Greeks, were very difficult to determine. The process of consolidation of Albanian ethnicities, which led to a national identity, had, to a certain degree, some impact on other regional musical cultures. However, as the Albanian lexicon has borrowed a great many words from a variety of other languages, it has also shared musical and poetical idioms with its neighbours. Samuel Baud-Bovy notes that:

'the North Epirote songs are an exceptional phenomenon within the Greek repertoire in that they feature this strange polyphony, this triphony to be precise, which is a characteristic of the men's songs from the Cham people recorded by Mr and Mrs Stockmann. We can therefore be certain that the above actually originated from Albania and were adopted by the Greeks, given that both peoples had lived for long periods in close cultural symbiosis. Having established the Albanian

origin of this rhythmic type of Epirote songs we will naturally assume a similar infiltration in the case of the 5/8 rhythm of Peloponnesian dances. It is said, in fact, that at a certain period, at the end of the 14th century in particular, significant Albanian settlements came to populate the Peloponnesus. Compared with the refugee songs of North Epirus, those of Peloponnesus testify assimilation of the local repertoire: the pentatonism was superseded by heptatonism and the tyrant of the Greek song, the iambic verse of fifteen-syllables, replaced the eight-syllable with the seven-syllable trochaic verse. We believe we have demonstrated that, based on its structure, this song is, in fact, alien to Greece, despite that during the centuries it was progressively and perfectly Hellenised' (Baud-Bovy 1972, 159 and 161).

Jane Sugarman, who has conducted field research into the music of the Prespa community (an Albanian-speaking minority living in the districts around Lake Prespa, in the north-east of Slavic Macedonia), describes their multi-part singing in this way:

'Neither of the polyphonic textures characteristic of south Albanian singing is unique to Albanians. The Lab style is shared with Greeks in the north-western district of Epirus, while the Tosk styles are common among Aromân communities from the Kolonjë region of Albania, the so-called Fârşeroţii, and among Slavs from the Kastoria district of northern Greece. Macedonians in the lower villages of the Prespa district also formerly sang in this style. Pentatonic, drone-based polyphonic singing is thus a practice common to all the rural, pre-Ottoman linguistic groups living within and adjacent to southern Albania. As is true for many world areas, musical styles may be specific more to geographic regions than to individual ethnic groups' (Sugarman 1997, 356).

The Prespa community, like several other ethnic communities, gradually changed its former religion to Islam, but its music remained the same as it was in the pre-Ottoman period (allowing for the natural process of transformation) and did not adopt substantial features of Ottoman styles; it has continued up to the present day to be practiced as pentatonic, drone-based polyphonic singing. The fact that the Prespians or other south-west Balkan populations converted to Islam had almost no impact on their music and singing; the musical styles of this region, where three or more different nations are encountered, are specific and innately shared with the Christian Orthodox Albanians and their Greek neighbours. Leaving aside religious identity it is important to emphasise that the communities of the south-west Balkans to this day still cultivate their local and regional musical tradition; this is indigenous and far older than the Ottoman practices introduced into Albania with the arrival of the Turks in the Balkans.

Of a different nature were the institutionalization of cultures, in general, and a desire to appropriate the IMUS, in particular, for national and ideological identifications

during the years of totalitarianism in Albania. It is a fact that during this period special attention was given to folklore, and the IMUS was one of the best models to represent the epic-historic tradition as part of the organisation of massive national celebrations. Although Albanian theoretical studies were inclined to depict the IMUS as only Albanian, they did not accuse other ethnic populations of falsely appropriating their cultural legacy. They considered the non-Albanian contributions only as a 'borrowing' process on their part. This is because the Albanians felt comfortable with and were already the owners of this kind of music-making. However, there was a different kind of appropriation, a doctrinal nationalist one. The IMUS was often conceived by the totalitarian nationalist ideology as an isolated phenomenon, thoroughly Albanian (Tosk or Lab), or sometimes simply called *polifonia labe* (the Lab polyphony) and not as a broader musical and regional multipart concept as well as a shared practice with the non-Tosk, non-Lab and non-Albanian cultures. Although Albania had been only politically and not physically isolated from nearby regions, the IMUS had been treated as a national and cultural identity, in which case, the totalitarian ideology acted as a cultural appropriation.

Since 1991, with the migratory movements of the south Albanians towards other countries and the splitting up of some of the IMUS groups who kept the tradition alive, this practice is undergoing a kind of momentary crisis. It cannot be said that the archaic form of this tradition is now being jeopardised since the IMUS is still alive in the souls of the ethnic populations of south Albania. Perhaps a new tradition will emerge, as a less festival-type practice (away from the imposed teachings and choreographies of the former socialist type). Meanwhile, in Greek Epirus, in a band extending from the Ionian sea to the west, the Kalamas (Thiamis) river to the south, and up to Konica to the east, where I had the opportunity to visit a few places, I noticed that a great deal of effort was being made to create a new tradition of amateur IMUS groups, aiming to promote and research this genre, and issuing CDs as well as organizing folk festivals, which was a fairly new occurrence. Thinking about these late developments on both sides of the frontier, I asked myself whether this was a new phase where an intercultural communication could be transformed into a cultural appropriation. Was it a kind of contest to determine which group was the authentic heir to the tradition, and which was the appropriator? In the past, both Communist and Hellenistic nationalist ideologies did not help in establishing the right conception that the IMUS culture is mostly a regional occurrence based upon different ethnicities.

In the last twenty five years or so, some new theories have emerged in connection with another form of appropriation of IMUS, a religious one, or more specifically, of the Byzantine Christian Church. Brandl, in a paper given at the 1989 Tirana Symposium developed this theory and emphasised the role of roughness or dissonant diaphony and its similarities to the sounding of church bells (Brandl 1990). His conclusion that the popular saying, 'it should sound like bells', had to be understood as 'church bells and not sheep bells' is a proposal which clearly suggests that the choral style of IMUS has appropriated the sound of the bells of the Byzantine Christian Church. Parallels between the multipart singing of different peoples and church bells or Byzantine music occur in other authors' proposals and some of these, such as in the case with the sounding of the church bells, do not allow the establishment of precise valid assessments once removed from their indigenous cultural contexts – the agro-pastoral character. This way may take on meanings that are different from the environmental archaic background from which they originated, or, may, perhaps, be deprived of meaning altogether. It is seen as a tendency for religious appropriation of secular musical traditions. The adoption of Christian or Muslim elements as a common sort of cultural appropriation would have been a natural process of cultural exchange. The iso(n) was one of those elements which has been absorbed both ways, by folk culture and ecclesiastical culture.

Regardless of any predisposition towards appropriation, the shared musical and ethnographical traditions of the south-west Balkans are the attributes and assets of the ethnic populations of this region. The *fustanella* (a pleated kilt or dress), claimed by both Albanians and Greeks as their traditional national costume, is associated with their practices and some mutual influences of their common history, and is regarded by both as their pride and mark of identity. But, it is not just the *fustanella*; there are other components, such as the instrumental kaba or moirologi, saze or koumpaneia (of mainly Gypsy professional ensembles), çamiko or tsamiko, llauta or laouto, the Pyrrhic dance, tetratonic and pentatonic tunes, klephtic songs, tonic and subtonic tonalities, common trochaic and iambic verses and, above all, the iso(n), secular and ecclesiastical, which represent the continuity of ancient musical cultures.

Notes

1. This study has been kindly supported by a research grant from the Arts and Humanities Research Council. Brenda's Festschrift offers me the privilege, opportunity, and responsibility to give something back for her kindness and generosity in choosing to help me write about several musical topics in English. Over many years she tried hard catching slips, and improving phrases and paragraphs of my 'Albanian' standard English, in this way bringing several of my writings to completion. I would like to thank you from the bottom of my heart, dear Brenda.

2. Martin Crusius (1526–1607). His *Turcograeciae libri octo*, published in 1584 in Basel, mentions reports of having heard the drone sound

3. Jan Koukouzel (Koukouzelis), a distinguished composer of the 14th century, became famous in the imperial court of Constantinople for his remarkable voice.

4. In this paper the versions Çam, Çamëri will be used in an Albanian context, and Cham, Chameria, in non-Albanian.

5. Morea is a term applied only to the Peloponnesus but in colloquial Albanian it is often extended to include the whole of southern Greece.

Bibliography

Ahmedaja, A, 2001. Music and identity of the Arbëreshë in southern Italy, in *Music and minorities. Proceedings of the 1st international meeting of the International Council for Traditional Music* (June 25–30, 2000) (eds S Pettan, A Reyes and M Komavec), Ljubljana

Baines, A C, 2007. Drone (i), in Grove Music Online (http://www.oxfordmusiconline.com/ public/book/omo_gmo)

Baud-Bovy, S, 1972. Sur une chanson de danse balcanique, *Revue de Musicologie*, 58(2), 153–61, Paris

Baud-Bovy, S, 1983. *Essai sur la chanson populaire grecque*, Athens

Brandl, M R, 1990. Schwebungsdiaphonie in Epirus and its related styles in the light of Psychoacoustic, in *Kultura Popullore [Traditional Culture]*, 1, 59–63, Tirana

Conomos, D, 1982. Experimental polyphony 'According to the … Latins', in Late Byzantine Psalmody, in *Early music history* 2 (ed I Fenlon), 1–16, Cambridge

Çabej, E, 1975. *Studime Gjuhësore [Linguistic Studies]* 5, Prishtina

De Gaudio, I C, 1993. *Analisi delle techniche polifoniche in un repertorio polivocale di tradizione orale: I vjersh delle comunità albanofone della Calabria*, Modena

Emsheimer, E, 1964. Some remarks on European folk polyphony, *J Int Folk Music Council* 16, 43–6, Cambridge

Ferrari, G, 1978. *L'Albania e la musica liturgica bizantina*, Scuola Grafica Salesiana, Palermo

Garofalo, G, 2004. Music and identity of Albanians of Sicily: Liturgical-Byzantine chant and devotional musical tradition, in *Manifold identities, studies on music and minorities* (ed U Hemetek, G Lechleitner, I Naroditskaya and A Czekanowska), Int Counc Traditional Music, chap 24, 271–288, Cambridge

Kruta, B, 1991. The Bourdon-Iso in the Albanian polyphony and some questions of its ethno-genesis, *Kultura Popullore* 1, 51–72, Tirana

Levy, K, 1980, Music of the Byzantine rite, §16: Byzantium and the west, in *The New Grove dictionary of music and musicians* (ed) S Sadie, Macmillan Publishers Limited, London

Loli, K, 2006. *The Epirotic polyphonic songs*, Ioannina

Peristeris, S, 1964. Chansons polyphoniques de l'Epire du nord, *J Int Folk Music Council* 16, 51–3

Shupo, S, 2004. *The Crossroads of the Albanian Polyphony*, unpub MS

Sokoli, R, 1965. *Folklori Muzikor Shqiptar [Albanian Musical Folklore]*, Instituti i Folklorit, Tirana

Stockmann, D, 1963. Zur Vokalmusik der südalbanischen Çamen, *J Int Folk Music Council* 15, 38–44

Strunk, O, 1977. *Essays on music in the Byzantine world*, New York

Sugarman, J C, 1997. *Engendering song, singing and subjectivity at Prespa Albanian weddings*, Chicago and London

Tardo, L, 1938. *L'Antica melurgia bizantina*, Scuola Tip. Italo Orientale 'S. Nilo', Grottaferrata

Trako, K, 1943. The traditional music of Korça, *Tomori* [newspaper], 29–30 January 1943, Tirana

Velimirović, M, 1976. Egon Wellesz and the study of Byzantine chant, in *Musical Quarterly* 62(2), 265–77

Velimirović, M, 1978. Byzantine hymns of the Epitaphios and Easter. Record Reviews, in *Ethnomusicology* 22(2), 383–4, Champaign, Illinois

2 Lesbia's pet bird

W Geoffrey Arnott[1][†]

The identity of Lesbia's pet *passer* (Catullus 2, 3; cf Juvenal 6.7–8, Martial 1.7, 109.1, 4.14.13–14) still puzzles scholars. Catullus said that the bird recognised Lesbia and played with her (2.2, 2.9 *ludere*), allowing her to hold it in her lap (2.2 *in sinu tenere*, cf 3.8 *nec sese a gremio illius mouebat*), nipping her fingers (2.3–4 *primum digitum dare appetenti et acris ... incitare morsus*), and chirping to her (3.10 *ad solam dominam usque pipiabat*) before it succumbed to an early death. Pre-20th century scholars and editors assumed that here *passer* had its common meaning of House Sparrow (*Passer domesticus*), but this identification was fiercely challenged by Dissel (1909, 65–6) and Schuster (1928, 95–100), who pointed out that House Sparrows normally do not respond to domestication, and they went on to identify Lesbia's *passer* as a Blue Rock Thrush (*Monticula solitarius*), a bird that is more easily tamed, becomes attached to its owner and has a fluty warble, although sometimes it dies early when so confined. Furthermore, this Thrush is still called *passero* in modern Italy. Unfortunately, however, the presence of *passer-* there in that bird's modern name does not go back to Catullus' time, but derives from the presence of *passer solitarius* first in the vulgate version of *Psalm* 101.8, where it appears as a literal translation of a Hebrew expression that in no way relates to the Blue Rock Thrush, as Fehling (1969, 219–24) clearly demonstrated. The Blue Rock Thrush in no way resembles a Sparrow; it is much larger (200mm ~ 140mm long), and in shape and general appearance it looks and sounds more like a Blackbird (*Turdus merula*) but is coloured an attractively dark blue.

Many scholars have since either espoused the Blue Rock Thrush interpretation, or suggested other non-Sparrow identifications, largely because they believed that House Sparrows could not be domesticated, being allegedly intractable and unfriendly to strangers (for example Keller 1913, 80, 90; Steier 1929, 1629; Thompson 1936, 270; Jennison 1937, 117; Fordyce 1961, 87–8; André 1967, 120; Pollard 1979, 135. Hünemörder (2001, 807) sits on the fence!). However, this belief that House Sparrows can never be tamed is a fallacy. Although adult House Sparrows do not respond to attempts at domestication, fledgling Sparrows do. If the fledgling is removed or falls from its nest shortly after hatching and before bonding with its parents, that bird can then become as tame a pet as a Budgerigar and behave exactly like Lesbia's *passer*, which consequently we must presume that she domesticated, having found or been given it as a fledgling. It is remarkable that most scholars who oppose the Sparrow identification appear to be ignorant both of this ornithological fact and of three English literary sources that lovingly describe the successful domestications of House Sparrows, as follows.

(1) John Skelton, a laureate of Oxford, Cambridge and Louvain, around 1505 composed his poem *The Boke of Phyllyp Sparowe* (whose title may be modernised into *The Book of Philip Sparrow*), about a tame House Sparrow belonging to Jane Scrope, a Yorkshire girl from Bentley in her early twenties, whom Skelton, then the rector of Diss in Norfolk but himself probably a Yorkshire man by birth, seems to have befriended in his forties when she was in retreat at the Benedictine priory of Carrow in Norwich. She is the imagined narrator of Skelton's poem, from which I quote the relevant passages, modernising the spelling, but closely following Kinsman's edition of the poem (1969):

115	It was so pretty a fowl,
	It would sit on a stool,
	And learned after my school
	For to keep his cut [= distance]
	With 'Philip, keep your cut!'
120	It had a velvet cap,
	And would sit upon my lap,
	And seek after small worms,
	And sometime white bread crumbs;
	And many times and oft
125	Between my breastes soft,
126	It would lie and rest . . .
138	And when I said, Phip, Phip,
	Then he would leap and skip
140	And take me by the lip.

159 For it would come and go
160 And fly so to and fro;
 And on me it would leap
 When I was asleep,
 And his feathers shake,
 Wherewith he would make
165 Me often for to wake
 And for to take him in
167 Upon my naked skin

171 He did nothing, perdie [= assuredly],
 But sit upon my knee.
 Philip, though he were nyse [? = foolish],
 In him it was no vice.
175 Philip had leave to go
176 To pike (= pick) my little toe.

These passages contain two remarkable coincidences between Skelton's and Catullus' poems. The House Sparrow, as mentioned above, doesn't try to emulate the Blue Rock Thrush's flutelike notes: it chirps (Witherby *et al* 1943, 147; Bannerman 1963, 343; Summers-Smith 1963, 26–7, 43–4 and 1988, 158–9; Clement 1993, 445; *BWP* 1994, 300–1). This is the sound made both by Catullus' *passer* (23.10: *pipiabat*) and by Scrope imitating the call of her Sparrow (138: phip phip). And while Catullus' *passer* nibbled Lesbia's finger (2.3–4), Skelton's nibbled Scrope's little toe.

(2) Secondly, the 19th-century 'ploughman' poet and wild-life observer John Clare wrote an unpunctuated prose account of a House Sparrow which he had domesticated, in his *Nature Notes* (Tibble and Tibble 1971, 2012):

> 'When I was a boy I kept a tamed cock sparrow 3 years it was so tame that it would come when calld & flew where it pleased when I first had the sparrow I was fearful of the cat killing it so I usd to hold the bird in my hand towards her ... & I venturd to let it loose in the house ... she [sc the cat] grew so fond of the sparrow as to attempt to caress it the sparrow was startld at first but came to by degrees & venturd so far at last [as] to perch upon her back ... but in the spring of the third year my poor tom Sparrow for that was the name he was calld by went out and never returnd I went day after day calling out for tom ... but none answerd the name for he would come down in a moment to the call & would perch upon my hand to be fed.'

(3) Thirdly, Mrs Clare Kipps in 1953 wrote *Sold for a farthing*, a short book about Clarence, her tame cock Sparrow. In its time it was a bestseller. The author, then a widow, described how in July 1940 she was returning from duty as an air-raid warden to her bungalow in the London suburbs, when she saw on her doorstep a helpless fledgling Sparrow less than a day old that had fallen or been ejected from its nest, still naked and blind. She carefully revived it, wrapping it in flannel, as she sat by her open fire and dripped a single drop of warm milk every few minutes down its throat. Putting it in a pudding-basin which she placed in her airing-cupboard, she expected it to die that same night. Next morning, however, she heard a faint but continuous call coming from the cupboard, and found the bird warm, alert and crying for its breakfast. She fed it on soaked bread mixed with Bemax, hard-boiled egg yolk and halibut-liver oil. On the third day its eyes opened and it seemed to accept her as its natural guardian. When its feathers began to grow, the bird was released at night from the cupboard, and slept on Mrs Kipps' pillow. She intended to set the bird free as soon as it could fly and feed itself, but then she found that the fledgling was disabled; its right wing and left foot were deformed, so it was never able to fly, although it could scramble on foot throughout the bungalow. As soon as it was able to feed itself, Mrs Kipps, now accepted by the bird as its foster-parent, could leave it alone in one room of her house, with food and milk in each corner, while she attended to her wardening duties. When she returned home, the bird immediately recognised her voice and step, and as soon as the door of its room was opened, it rushed to her and scrambled on to her shoulder, chattering excitedly. It answered to calls of 'Boy', and every morning rushed at its mistress, tail spread and wings outstretched, and held down her hand with one claw while hammering it with its beak, pecking, pinching and scolding her. The bird now slept at night in Mrs Kipps' bed, snuggling under the eiderdown. To her surprise, even before it was fully fledged, it kept this resting-place perfectly clean. Since visitors (including children) now came to see this strange pet, for its safety Mrs Kipps bought a large cage whose door was kept open, and the Sparrow immediately adopted it (and Mrs Kipps' bed) as its own personal territory, which it defended fiercely with beak and claw. When a delayed action bomb caused severe damage to the bungalow, apparently it preserved itself from any hurt by perching on the swing in its cage. It enjoyed excellent health for ten years, but eventually died of old age at 12 years, 7 weeks and 4 days.

Note

1 This paper expands my brief discussion of this problem in Arnott 2007, 227–8, sv *Strouthos* 1b. It is pertinent to note here, however, that the Italian subspecies of the House Sparrow with its chestnut crown (*Passer domesticus italiae*) has recently been reclassified as either a hybrid of House and Spanish Sparrow, or a subspecies of Spanish Sparrow (*P. hispaniolensis*).

Bibliography

André, J, 1967. *Les noms des oiseaux en latin*, Paris
Arnott, W G, 2007. *A to Z of ancient bird names*, Abingdon
Bannerman, D A, 1963. *The birds of the British Isles,* Vol 1, Edinburgh and London
BWP 1988, 1994. = *Handbook of the birds of Europe the Middle East and North Africa: The birds of the Western Palearctic* (chief ed S Cramp), 5, 903–14 and 8, 289–308, Oxford
Capponi, F, 1979. *Ornithologia Latina*, Genoa
Clement, P, with Harris, A and Davis, J, 1993. *Finches & sparrows*, London

Dissel, K, 1909. Der Sperling der Lesbia, *Neue Jahrbücher für das Klassische Altertum* 12, 65–66

Fehling, D, 1969. Noch einmal der passer solitarius und der passer Catulli, *Philologus* 112, 217–24

Fordyce, C J (ed), 1961. *Catullus: a commentary*, Oxford

Hünemörder, C, 2001. Sperling, *Der Neue Pauly* 11, 807

Jennison, G, 1937. *Animals for show and pleasure in ancient Rome*, Manchester

Keller, O, 1913. *Die antike Tierwelt* 2, Leipzig

Kinsman, R S (ed), 1969. *John Skelton: Poems*, Oxford

Kipps, C, 1955. *Sold for a farthing*, London

Pollard, J, 1979. *Birds in Greek life and myth*, London

Schuster, M, 1928. Der *passer* Catulls, *Wiener Studien* 46, 95–100

Steier, A, 1929. Sperling, *Real-Encyclopädie der klassischen Altertumswissenschaft* IIIA2, 1628–32

Summers-Smith, J D, 1963. *The House Sparrow*, London

Summers-Smith, J D, 1988. *The Sparrows*, Calton, Staffs

Thompson, D'A W, 1936 (1891). *A glossary of Greek birds*, 2 edn, Oxford

Tibble, J W, and Tibble, A (eds), 1970 (1951). *The prose of John Clare*, repr, London

Witherby, H F, Jourdain, F C R, Ticehurst, N F, and Tucker, B W, 1943 (1940). *The handbook of British birds*, vol 1, revised repr, London

3 Britons speaking in Tacitus

R H Martin[†]

When J G C Anderson's edition of Tacitus' *Agricola* was published in 1922, its title-page stated that it was a revised and largely rewritten edition of Furneaux's edition of 1898. In his Preface Anderson stated that the most notable advance in his edition was due to the advance in the historical interpretation of the narrative, 'resulting from the progress in archaeological inquiry'. Though Anderson's own expertise was in epigraphy and the archaeology of Anatolia, he was aware that any adequate future edition of the *Agricola* must display expert knowledge both of Tacitus' Latin and of Romano–British archaeology. Almost half a century was to pass before those requirements were met, in the edition of Ogilvie and Richmond (1967). Since then archaeology has produced an immense amount of new detail, but the *Agricola,* or (more precisely) those chapters (18–38) that give a narrative account of the seven years when Agricola was governor of Britain (AD 78 to 84 according to Ogilvie and Richmond (1967, 317–20), AD 77 to 83 according to a number of scholars including A R Birley (2005, 77–93)) provide an invaluable framework within which the 'facts' of archaeology can be placed. Of the 21 chapters that cover the period of Agricola's governorship of Britain roughly two-thirds are devoted to his final year – the year that saw the battle of Mons Graupius – and well over half of those chapters are occupied by the pre-battle speeches in *oratio recta* – delivered by the two opposing commanders, Calgacus and Agricola.

The pre-battle exhortation is a well-established convention of Greco-Roman historiography, common in Sallust and in Livy, who has a notable example (Livy 21.40–41 and 43–44) of Hannibal and Scipio addressing their troops. Though the speeches between the same two commanders before the battle of Zama in 202 BC (30.30.3–31.9) are not addressed to their troops, but are spoken to each other in a private parley, they are of additional interest, because they are closely drawn from the Greek of Polybius (writing in the 2nd century BC: for Livy's use of Polybius see Walbank 1957, 397–8 and, more generally, Walsh 1974). It might be expected that the convention of opposing speeches in *oratio recta* would have been followed by Tacitus in his

major historical works, *Histories* and *Annals,* but this is not the case: the speeches of Calgacus and Agricola in the *Agricola* are the only examples in the whole of Tacitus where a Roman general and his non-Roman counterpart both deliver pre-battle speeches in *oratio recta.*

Though Tacitus may have heard a detailed account of the battle of Mons Graupius from Agricola himself, it is inconceivable that he could have any knowledge of what Calgacus might have said on that occasion, if indeed the British leader delivered any speech. In fact, modern scholars accept that all pre-battle speeches are inventions of the historian; that applies equally to speeches recorded in *oratio recta* and *oratio obliqua.* In the *Agricola,* in addition to the speech of the otherwise unknown Calgacus in chapters 30–32, there is in *oratio obliqua* in chapter 15: an account of the discussion by unnamed Britons of the grievances that led to the Boudican revolt in AD 60 (for that date rather than AD 61 – the date given by Tacitus in *Annals* 14.29ff – see Syme 1958, 762–6 (= appendix 69) and Birley 2005, 48–9).

In the later Books of the *Annals* there are two further speeches by Britons, a short speech in *oratio recta* by the captured Caratacus before the emperor Claudius at Rome (*Annals* 12.37) and a short speech *in oratio obliqua* by Boudica (Boudicca seems to be Tacitus' spelling of her name) at *Annals* 14.35, followed by a short speech, also in *oratio obliqua,* by Suetonius Paulinus (Tacitus' spelling of the name; for the spelling Paullinus see Birley 2005, 47, n103) at *Annals* 14.36.1–2, both delivered before their decisive battle, fought probably close to Watling Street.

In what follows these 'British' speeches are examined in some detail. Accepting that they are unquestionably Tacitus' own compositions, I shall concentrate on a number of aspects of Tacitus' language and style. Four such elements are of particular importance:

1. for over a hundred years, beginning with an article in *Philologus* in 1867 by E Wölfflin, a major interest of Tacitean scholarship has been in tracing the development of his style, particularly in changes in

his vocabulary. As the British speeches cover both the earliest and latest periods of Tacitus' writing (from *Agricola* to *Annals* 13–16), it is necessary to consider whether unusual Latin words merely reflect the passage of time in the writer's vocabulary or represent a conscious decision by the author;

2. more recently J N Adams (1973, 124–44) has revealed a number of small, but important, lexical differences between Tacitus' narrative style and that in his speeches;

3. though Tacitus' style is unique, some of its elements draw heavily on his predecessors, including Livy and, above all, Sallust; at times these 'echoes' are both intended and extensive, as in the character description of Sejanus at the beginning of *Annals* 4, modelled on Sallust's description of Catiline at *Catiline* 5.1–8;

4. the speech of Calgacus at *Agricola* 30–32 constitutes a remarkable indictment of Roman imperialism, but it must not be assumed that this expresses Tacitus' own point of view. One of the lessons of rhetorical training, which had been part of Tacitus' education at Rome, was to compose speeches giving both sides of political debates. Calgacus' speech is only one – though perhaps the most memorable – example of an anti-Roman speech (a detailed survey of the subject is given in Fuchs 1964). Numerous examples of this attitude can be found in Sallust, and it is not surprising that Calgacus' speech contains a number of Sallustian echoes.

The chronological order of the speeches to be discussed is (i) Caratacus' appearance before Claudius in Rome in AD 50; (ii) the Boudican revolt, probably beginning in AD 60; (iii) the battle of Mons Graupius in AD 83 or 84 (for the latter date see Ogilvie and Richmond 1967, 317–20; for the earlier date see now Birley 2005, 77–8). But the four considerations mentioned in the previous paragraph make it preferable to take the passages under discussion in the order of the dates of the publication of Tacitus' works, as far as these are known, namely *Agricola* then *Annals* 12 and 14. The speeches of Calgacus and Agricola in *Agricola* 30–32 and 33.2–34 have in common an extensive employment of rhetorical devices such as anaphora and antithesis and a degree of balance (*concinnitas*) that is untypical of Tacitus' mature narrative style. In general I have not listed these features, since they will be obvious to any attentive reader. A second feature has already been noted, namely the disproportionately large space accorded to the account of Agricola's last year as governor; that clearly reflects Tacitus' intention to mark Agricola's final year in Britain and the battle of Mons Graupius as the climax of his father-in-law's career. One further fact concerning these and other pre-battle speeches needs to be stated: it seems now to have been established that it was impossible for a general to address an army of more than five thousand men, even in favourable conditions, much less on the field of battle (see Goldsworthy 1996, 146–7). There are indeed examples of generals riding round to address separate bodies of their troops, but, when Tacitus explicitly mentions

this happening, he describes it as contrary to the normal practice, for example at *Histories* 5.16.2 *exhortatio ducum* (sc Cerialis and Civilis) *non more contionis apud uniuersos, sed ut quosque suorum aduehebantur*. We must therefore acknowledge the paradox that the historian regarded the pre-battle hortatory address to the *whole* army as being the norm, though the actuality was different, namely that if a general *did* give a pre-battle hortatory address, it could only have been to separate groups. One further inference, moreover, can be made with some certainty. If, for any reason, battle tactics had to be varied from what was normal, this had to be conveyed to the appropriate officers. This was the case for the battle of Mons Graupius, when Agricola decided that auxiliary forces should form the centre of the front line, with the legions as a second line behind them in reserve (see Goldsworthy 1996, 134, with fig 2). Moreover, as the battle progressed and the Roman front line became increasingly extended, it was suggested to Agricola that the legions should be called into battle (*Agricola* 35.4: *arcessendas plerique legiones admonebant*). Though Agricola rejected this advice and dismounted and took up a position on foot in front of the standards (*dimisso equo pedes ante uexilla constitit*), this passage shows that even in the middle of a battle it was possible for communication to be made between the commander and *plerique*; *plerique* cannot refer to fighting soldiers in general, but must signify officers whose duty it would be to implement the general's orders.

The speeches

Calgacus' Speech (Agricola 30–32)

The speech begins (30.1) *Quotiens causas belli et necessitatem nostram intueor, magnus mihi animus hodiernum diem consensumque uestrum initium libertatis toti Britanniae fore*. Ogilvie's note states that the opening words are *inspired* (my italics) by the beginning of Cicero's *pro Marcello* and by Sallust *Catiline* 58.18 (Ogilvie and Richmond 1967, 254). It is not clear whether Ogilvie's 'inspired by' implies 'are a deliberate echo of'; that is doubtful, but *hodiernus dies,* which, though common in Cicero (and elsewhere), occurs in Tacitus only here, must be intentionally emphatic. Two further small points in this sentence may be noted: (i) Ogilvie observes of *animus est* that it is followed with accusative and infinitive on the analogy of *spes est* or *confido*. While that is true, there seems to be no parallel in any other author of *animus est* so used. (ii) Though *intueor* in the sense of mental observation is common in other authors, elsewhere in Tacitus it is always used of physical observation; this, according to Gerber-Greef's *Lexicon Taciteum* (1893) is the sole example in Tacitus of its use in the sense of mental observation. This first sentence of Calgacus' speech thus shows two features that will be seen to recur elsewhere in the 'British' speeches, namely an echo of another author (here Cicero) and some examples of particularly Tacitean Latin. In the rest of this chapter Calgacus develops the

geographical theme that he and the assembled Britons form the last line of defence of liberty, since beyond them there is only the sea, and that too is controlled by the Roman fleet; even their geographical remoteness is an attraction to the Roman advance, since *omne ignotum pro magnifico est.* That thought is a commonplace, but it is expressed as a typically Tacitean aphorism. Calgacus continues: submission to the Romans will not save the Britons, for the Romans are *raptores orbis.* This powerful phrase is built on Velleius Paterculus 2.27.2, where the Romans are described as *raptores Italicae libertatis.* Velleius' phrase not only has the first recorded prose use of *raptor,* but whereas an objective genitive dependent on *raptor* normally expresses a concrete object, *libertatis* in Velleius, and *orbis* in Tacitus, are abstract concepts. The chapter then ends with another Tacitean aphorism: *ubi solitudinem faciunt* (sc *Romani), pacem appellant.*

In the next chapter Calgacus depicts what a life of slavery under the Romans will be like. He seems to be surprisingly well informed of the details (see Ogilvie at 31.2 on *recentissimus quisque*), while at 31.4 (*Brigantes femina duce exurere coloniam, expugnare castra ... potuere*) he (or, less probably, Tacitus) gets his historical facts wrong, since the details clearly refer to Boudica and Camulodunum, not to Cartimandua and the Brigantes. Finally, in chapter 32 Calgacus contrasts the factors that encourage the Britons (the presence of *coniuges, parentes, patria*) with the position of the Romans, fighting in a strange and foreign land, with untrustworthy allies ready to desert at the first opportunity: for the Britons the alternative is clear – fight for victory or endure for ever the tortures of slavery.

Between the end of Calgacus' speech and the beginning of Agricola's, Tacitus describes the noisy and enthusiastic reception the Britons give to their leader's speech. In those few lines the phrase *armorum fulgores* deserves comment. The singular *fulgor* is widely used of the flash of armour or any metal object, particularly armour (so *auri fulgor et argenti* at *Agricola* 32,3*).* But the plural *fulgores* is confined almost exclusively to meteorological description of flashes of lightning; so its plural use here is both unusual and notable.

Agricola's Speech (Agricola 30–32)

Ogilvie's introductory note to this speech says 'Agricola may well have made a speech before the battle' (Ogvilvie and Richmond 1967, 265). If the evidence produced by Goldsworthy (1996, 146–7) is valid, Agricola could not have addressed the whole of his army. But he will certainly have conveyed to his officers the tactics and the unusual disposition of the battle-line that he intended to employ against the enemy, and he may also have spoken to his officers words of encouragement and, perhaps, some reference to the vital issues at stake. Whether Ogilvie is right in believing that some elements of such a speech are detectable in Tacitus' version is uncertain, but a number of points – in addition to some crucial textual points (especially *septimus* for *octauus* at 33.1; *et timentium* for

dementium at 34.2 and *torpor* for *corpora* at 34.3) – are noteworthy.

The vocative plural *commilitones* (33.2), though common in (for example) Caesar, Livy and Suetonius, occurs in Tacitus only here and in *Histories* I. In the same sentence is the unique expression *auspiciis imperii Romani,* which seems to be designed (by Tacitus) to avoid mention of the now dead (and disgraced) Domitian; at 33.4 *omniaque prona uictoribus,* repeated by Tacitus at *Histories* 3.64.1 may, or may not, be a deliberate imitation of Sallust *Jugurtha* 114.2 (*omnia uirtuti suae prona*). At 34.1 *ceterorum Britannorum fugacissimi* (where logic would have required *ceteris ... fugaciores*) imitates a common Greek idiom, clearly reflecting the syntactical choice of Tacitus, not that of the Roman general. At 34.2 Ogilvie says of *siluas saltusque* 'as often in Virgil'. That might seem to imply that it is a deliberate echo, but that is not the case – cf *Annals* 2.14.2 with Goodyear's note (1981 *ad loc*), where examples from other authors are given; 34.3 *spectabilis* is not in Sallust or Livy, and is in Tacitus only here and at *Annals* 16.21.1, where it is an emendation. The last colon of Agricola's speech (*adprobate rei publicae numquam exercitui imputari potuisse aut moras belli aut causas rebellandi*) deserves more attention than it has received. First, the verb *rebellare,* though common in Livy, does not occur in Cicero, Caesar or Sallust, and is found in Tacitus only here and at *Annals* 12.50.2, where it is an emendation; secondly, *imputare* in the sense of 'put the blame on someone' is a usage much favoured by Tacitus, but occurs only here and at 27.1 in the *Agricola* and in a number of examples in *Histories.* But, most importantly, it is quite inappropriate that a general who is about to send his army into what he believes will be a decisive battle should end his exhortation with an appeal to his men to prove that no blame, either military or political, can be ascribed to any failure on the part of the army. That remark is Tacitus' *post euentum* criticism of the deceased and discredited Domitian for failing to allow Agricola to complete the final subjugation of Britain.

The remaining speeches

The remaining speeches to be considered are (1) Caratacus' speech before Claudius in Rome in AD50 or 51; (2) Boudica's speech in AD60 or 61 before the battle against Suetonius Paulinus, probably on or near Watling Street; (3) Suetonius' pre-battle speech on the same occasion. Caratacus' speech is in *oratio recta*; the speeches of Boudica and Suetonius are both in *oratio obliqua.* All three speeches come from the *Annals,* and though the exact date of publication of Tacitus' works is not known, there must have been an interval of at least fifteen years between the *Agricola* and the later books of the *Annals.* Allowance must also be made for the fact that for the *Annals,* in contrast with the *Agricola,* Tacitus had access to the formal records of the Proceedings of the Senate, the *Acta Senatus* (see Talbert 1984, 313–34).

Unlike the shadowy figure of Calgacus, Caratacus had figured prominently in the preceding chapters of the *Annals*

because of the fierce resistance he had organized against the Romans in Wales. Though it is uncertain in which year he was brought to Rome to appear before Claudius, there can be little doubt that the pageant of the occasion took place more or less as Tacitus describes it in 12.36 and 37. That seems to be guaranteed by the subsequent reaction of the senate, as recorded in 38.1: 'the senate was summoned and its members spoke in extravagant terms about the capture of Caratacus'. On one point there is general agreement among modern scholars: whether or not Caratacus did deliver an oration (and if so, whether it was or was not in Latin) the speech that Tacitus gives him in *Annals* 12.37.1–3 is Tacitus' own composition. A number of linguistic details support that view: *dedignari* (37.1) is not used in prose till the post-Augustan period; Caratacus is unlikely to have employed a Latin word that had come into use only recently. At 37.2 the four-fold asyndeton *equos, uiros, arma, opes* may echo Sallust's *arma, tela, equi, uiri* at *Jugurtha* 51.1 or (more probably) Nepos *Hamilcar* 4.1 *equis, armis, uiris, pecunia* (but with Tacitus' substitution of the more elevated *opes* for *pecunia*); Caratacus is unlikely to have been conscious of the echo of Sallust or Nepos, or of the subtle distinction between *pecunia* and *opes*. At 37.2 *seruitutem* needs comment; *seruitus* is the normal classical word for 'slavery' (and, as such, is the word commonly used by Tacitus in the *Agricola*), but in *Histories* and *Annals* Tacitus mostly uses *seruitium* in narrative, but *seruitus* (as here) in *oratio recta*. 37.3 *inclarescere* is used by Tacitus only here and at *Agricola* 42.4 (another elevated passage); *supplicium mei* (instead of the more usual *supplicium meum*) can best be paralleled from Tacitus (see *fama sui* at *Annals* 2.13.1, and Goodyear's note *ad loc*); in *aeternum exemplum clementiae* the first two words are an echo of Seneca *Epistulae* 58.19.9, while *clementia* was claimed by Claudius as an imperial virtue – a claim that Tacitus often treated with irony (eg at 12.11.2 and 3).

The reader may wish to know what happened subsequently to Caratacus. Cassius Dio at 61.33.3 says 'he wandered round the city and, seeing its size and grandeur, exclaimed 'When you have so many possessions like these, why do you covet our tiny tents?' Tacitus has nothing to match this statement; for him what was memorable was Caratacus' proud demeanour in adversity – Tacitus' sympathy for such an attitude is clear from the words he gives to another non-Roman, the Bosporan Mithridates, at *Annals* 12.18.2.

Both the speeches of Boudica (*Annals* 14.35) and Suetonius Paulinus (*Annals* 14.36.1–2), delivered before their battle on or near Watling Street in AD 60 or 61, are in *oratio obliqua* and, by contrast with the two pre-battle speeches at *Agricola* 30–34, are extremely short (twelve and nine lines respectively). Boudica's speech, despite its brevity, is highly rhetorical, with balanced phrases, including tricola and anaphora. She says nothing of the general causes that have led the Britons to rebel – those reasons have already been ventilated by unidentified Britons in chapter 15 of the *Agricola* – but speaks with great passion of the personal indignities inflicted on herself and

her daughters: *confectum uerberibus corpus, contrectatam filiarum pudicitiam* – those words closely echo what Tacitus had himself written in his narrative at 31.1 (*uxor ... Boudicca uerberibus adfecta et filiae stupro uiolatae sunt*); it would be interesting to know where Tacitus got those details from. She next passes to the reasons that give the Britons a good prospect of success: the gods are on their side (*adesse ... deos iustae uindictae* – those words recall a phrase in *Agricola* 15.5: *iam Britannorum etiam deos misereri*. The hand of Tacitus is also shown by one or two linguistic points. For *senecta* at the end of 25.1, instead of the classical *senectus*, see Woodman and Martin (1996 *ad loc*) on *Annals* 3.23.1: Tacitus increasingly prefers 'the more poetic *senecta*' in the later books of the *Annals* (ie Books 13–16). In the next sentence *uindicta* in the sense of 'vengeance' does not occur before Livy and Ovid, and in Tacitus six of the seven examples occur in *Annals* (for details see Woodman and Martin 1996, 191); and in the final sentence note the assonance of *uincendum ... uel cadendum* and the alliteration and assonance of *uiuerent uiri et seruirent*. Perhaps too a typically Tacitean trait of syntax may be noted throughout the chapter: in spite of the historic introductory verb *testabatur* two subjunctives in primary sequence follow (*relinquant ... ausa sit*), before Tacitus reverts to historic tense subjunctives (*expenderent ... uiuerent ... seruirent*).

The speech of Suetonius is brief and to the point, but lacks the rhetorical figures that Boudica had employed; Tacitus describes it as 'a mixture of exhortations and entreaties' (*Annals* 36.1: *exhortationes et preces miscebat*). He begins by urging his men to ignore the *sonores barbarorum*; *sonor* is a poeticism for *sonus* (for details see Goodyear (1972 *ad loc*) on *Annals* 1.65.1). There then follows a cluster of Livian echoes: in 36.1 the only parallels for *imbelles inermes* are, apparently, Livy 9.4.13 and 28.23.2; in the next sentence *totiens fusi agnouissent* clearly echoes Livy 3.67.5 *totiens fusi fugatique ... et se et uos nouere*; in 36.2 the only parallels for *proelia profligarent* seem to be Livy 10.20.14 and 28.2.11; and in the same section for *praedae immemores* the only parallel is *immemores praedae* at Livy 41.4.7.

The battle and its outcome are described in *Annals* 14.37. Boudica's fate is recorded in Tacitus in four words: *Boudicca uitam ueneno finiuit*, where the alliteration and assonance are perhaps meant to recall the last words of her pre-battle speech (35.2 *uiuerent uiri et seruirent*). Dio has a different version of Boudica's death: she died of illness ... and was given a costly burial (62.12.6). Though the details of Dio's diffuse account are probably fictitious, that does not guarantee the truth of Tacitus' version, but the resolve Boudica showed in her suicide may have reminded Roman readers of the death by poisoning of another resolute non-Roman woman, Cleopatra (*non humilis mulier*). Poenius Postumus, *praefectus castrorum,* who had disobeyed the orders of his superior, Suetonius Paulinus, took his life in a more military fashion: *se ipse gladio transegit*.

The title of this contribution ('Britons speaking ... ') does not fully describe its contents, since only three of the

five speakers I have considered are Britons. But the two pre-battle speeches by Romans provide important contrasts with their British opponents, and the two pairs of opposing speeches afford a contrast with each other. The two speeches in the *Agricola* are long and in *oratio recta,* whereas the two speeches in *Annals* 12 are short and in *oratio obliqua.* Caratacus' speech in *Annals* 12 is also short and is the only one of the five speeches where it is possible that the Briton may actually have delivered a speech – though not in the highly idiomatic Tacitean Latin of the *Annals.* As modern scholars have never doubted that all five speeches are Tacitus' own composition, the details I have assembled may seem only to state the obvious. But there is, I hope, something to be gained by seeing how Tacitus has utilised his material. The difference in length between the speeches in the *Agricola* and the *Annals* is readily explained by the difference in their genres – the expansiveness allowed to biography and the concision practised by some (but not all) Roman historians. But differences also emerge between the individual British speakers and their Roman counterparts. The speech of Calgacus draws heavily on the stock of anti–imperial literature (for details see Fuchs 1964), while Boudica's speech has echoes of what Tacitus himself had already written in the *Agricola* and in the immediately preceding narrative in *Annals* 14.31.1. Caratacus' *oratio recta* speech before Claudius (whether he did in fact make a speech) is demonstrably composed by Tacitus. The two pre-battle speeches by Roman generals (Agricola and Suetonius Paulinus) have in common their absence of any anti-imperial sentiment, but differ in that Suetonius' speech, despite its brevity, makes a considerable use of Livian echoes, whereas (despite Ogilvie's references to Livy and Sallust (Ogilvie and Richmond 1967, 265)) echoes of those two authors are – given the length of Agricola's speech – meagre).

Bibliography

Note: as the Oxford Classical Texts of Tacitus' *Histories* and *Annals* (both published almost a century ago) do not carry section or paragraph numbers within chapters, I have used the reference numbers accepted by all recent editors.

Adams, J N, 1973. The vocabulary of the speeches in Tacitus' historical works, *Bull Inst Classical Stud* 20, 124–44

Birley, A R, 2005. *The Roman government of Britain*, Oxford

Fuchs, H, 1964 (1938). *Der geistige Widerstand gegen Rom*, repr, Berlin

Gerber, A, and Greef, A, 1893. *Lexicon Taciteum*, Leipzig

Goldsworthy, A K, 1996. *The Roman army at war*, Oxford

Goodyear, E R D, 1972, 1981. *Tacitus, Annals I and II*, Cambridge

Ogilvie, R M, and Richmond, I A, 1967. *Tacitus, Agricola*, Cambridge

Syme, R 1958. *Tacitus* (2 vols), Oxford

Talbert, R J A, 1984. *The Senate of Imperial Rome*, Princeton

Walbank, E W, 1957. *A historical commentary on Polybius*, 1, *commentary on books I–VI*, Oxford

Walsh, P G, 1974. *Livy*, Greece and Rome: New Surveys in the Classics, 8, Oxford

Wölfflin, E, 1867. Tacitus, *Philologus* 25, 92–134

Woodman, A J, and Martin, R H, 1996. *The Annals of Tacitus, Book* 3, Cambridge

4 A northern odyssey: the first 26,000 samian vessels, and still counting

Margaret Ward

Introduction

Brenda, I owe you many thanks for all the help that you have given me over the years. I am particularly grateful for all your reports on potters' stamps. I hope that this offering may compensate a little for all those that you have contributed to site reports which remain unpublished. I also hope that as a fellow-classicist you will enjoy the literary and, specifically, classical allusions that lie scarcely submerged in this paper. Well, you will find that you have yourself to thank for your part in this epic! You took the role of a protagonist in encouraging my first attempts at dealing with what might have seemed a monstrous whirlpool of samian ware ('And not waving, but drowning ...' is the poetic aphorism that springs to mind). In the late 1970s, in my first job after university, I was faced with barrow-loads of sherds from the Chester fortress at Abbey Green, whose excavation and post-excavation work were to stretch to gigantic proportions. It was then that you and Brian stepped in heroically with all your experience, expertise and much-needed mentoring. Brian in 1979 helped the learning process by encouraging me in an overview of samian ware, and your own research on the samian ware from York and elsewhere, with statistical analysis set forth by histogram and table, proved fascinating (Dickinson 1971). Brian then introduced me to an even earlier graph, that for Richborough (Dickinson *et al* 1968). And so it goes on. Having opened my database today, it only remains for me to say, thanks a million, Brenda – or thanks 26,032 times, at the present (2009) vessel count!

This paper aims to address a few of the episodic concerns and issues that have arisen during the publication process of samian reports in recent years. The account of the personal 'odyssey' that underlies this paper is written from the viewpoint of a samian specialist working on finds from British sites. This account will bring to the surface some of the Clashing, or Wandering, Rocks that have been encountered along the way, but it is intended also to signal some possible routes forward and avenues for progress towards a congenial destination. It is also intended that the personal approach may have some entertainment value, as well as, hopefully, prove itself useful. And so, first, to present a synopsis of the background. 'The North' referred to in the title signifies this view from northern England in the eyes of a specialist long based in Chester, but a North-Easterner in origin, raised to see 'The South' as anything beyond the river Tees and Yorkshire. Samian ware was first encountered alluringly from school in County Durham, during numerous trips to Hadrian's Wall and also as a volunteer at the Piercebridge excavations of the 1970s. There, attention was first captured when the site director at that time strolled onto the site, picked up a small sherd and uttered casually the enchanting words, 'Ah, Cinnamus. Ovolo 3. 150 to 170,' before making his impressive exodus to the next trench and the next tray, there to discuss the latest seminal work. This was the work of one Brian Hartley, who had reviewed Roman Scotland on the basis of the samian ware, in *Britannia* 1972. 'O brave new world, that hath such people in't,' I thought, with A-Level set texts, ancient and modern, lodged forever in the memory. From the perspective of the teenager standing there in that sodden trench on a forlorn North-Eastern day, it appeared that a context could be dated more reliably from those nice pieces of glossy red pottery than from the corroded Flavian coin that might accompany them. I was enthralled. The little odyssey was under way. The ensuing years would be spent not on Homer's 'wine-dark sea,' but in a trail of red dust.

The '26,000 vessels' mentioned in the title are the maximum numbers of vessels (not sherds) entered into a computer database in the years since the once futuristic date of 1984. Most of the finds were made in the north of England, but the database covers material identified personally from two hundred sites scattered unevenly around the country, from locations as far north as Cramond (Edinburgh), and as far afield as Anglesey (north-west Wales), Swindon and Cambridge – sites far south of Teesdale! There would be a few thousand more entries, but they were recorded in the early 1980s on a home computer, a Commodore 64, and written in BASIC (Ward 1986). As yet, they have not been transferred from the truly floppy

discs of the 1980s onto the less floppy discs of the '90s, or into the unfathomable depths of today's hard drive. In 1985, Microsoft and Windows had arrived, monopolizing the market; Office provided a new avenue for development and Access databases facilitated the analysis of large assemblages.

The entries in the present Access database are listed by phase where available and by context, fabric, vessel form and date of production, etc (see Appendix). Every sherd is assigned a date-range, such as *c* AD 70–110 or *c* 120–200, rather than the more traditional epochs (Flavian–Trajanic, Hadrianic–Antonine, etc). They are listed as being products of South, Central and East Gaulish workshops and are sub-categorised within those groups according to diagnostic details or their diverse fabrics (eg Montans, Les Martres-de-Veyre and the various East Gaulish wares). Further sub-categories include plain, stamped, or decorated sherds, as well as those that were worn from use, repaired, re-used or burnt. Weights of individual sherds are listed, along with rim and footring diameters and percentages. Brief notes on the decoration and potters' stamps are provided in the database, ascribing them to named potters where possible, but greater detail is given in Word files for publication in the site reports. Brenda provided reports on potters' stamps and signatures between 1978 and 2003, and this information has been catalogued for publication with reference to the definitive corpus (Hartley and Dickinson 2008). This is, of course, the compendium representing several thousand potters that Brenda is now bringing to fruition and was the source of Brian Hartley's seminal work on Roman Scotland in 1972, that had first come to my attention in that sodden trench. Since 2003 the present writer has endeavoured to provide whatever stamp information has been possible without the availability of the 'Leeds Index.' At the time of writing, the first four volumes of the Index have been published and their invaluable aid leads us to await the remainder (and crucially, an electronic version) with great anticipation.

And so, having explained the origins of the work that lies behind this present paper, I would now like to bring to the surface three of the issues encountered during the publication process in recent years.

Publication of completed reports

In 2008, only 10% of the sites for which I had written samian reports since 1980 had seen publication. Many other specialists, samian and otherwise, have a similar record of reports stored for decades in the depths of filing cabinets scattered around the country. 'Rosy-fingered dawn' and the full light of the sun await those that find the way out of dark caverns, whether Homeric, Platonic or bureaucratic, and we must not lose hope of it. 2008 saw the publication of the Piercebridge excavations. This project had long ago been side-lined by English Heritage in the list of sites to be published. Excavations that had begun at the Holme House villa site in 1969 finished in the area of the late fort in 1981. However, the director,

Peter Scott, had sadly passed on in 1987, by which time the work was already being overseen for editing elsewhere. Then, in 2006, after almost twenty years, it was revived by Durham County Council (David Mason) and Barbican Associates (Hilary Cool). Just over two years later, it saw the light of day, 'when rosy morning glimmer'd o'er the dales' (Homer, *Odyssey* 9, transl Pope). The excavations were finally published as a hefty monograph with an on-line version (Cool and Mason 2008), including a catalogue of samian ware selected from 7018 sherds that represented a maximum of 5433 vessels. A summary of the samian assemblage, along with the other finds, is to be found in the printed volume. It includes stamp reports by Brenda Dickinson and comments from Brian Hartley, as well as comments on the later wares from Joanna Bird and various continental specialists, amongst them the late P-H Mitard concerning the samian mortaria.

In Chester and North Wales, as elsewhere, publication can have its difficulties. At Chester, the backlog of unpublished reports has been a problem for forty years, and in North Wales some Units have had considerable difficulty publishing pottery reports in recent times. The publication in a major national journal of fort vici in Wales did not include pottery, reports on it being available from the Historic Environment Record (HER). The archaeological Units are agreed that it is sad that pottery reports should remain unpublished, because both national and local journals decline to publish them. It appears that it is not only pottery and finds reports that are being looked on unfavourably by the editors of periodicals (see Durham *et al* 2009, 10), for excavation reports too are facing bias, with preference being given to syntheses and wider assessments of evidence. One major example of a split report was the publication of the Museum site at Caerleon: the site report and some of the pottery appears in *Britannia* (Zienkiewicz 1993), with the rest of the pottery appearing in the *Journal for Roman Pottery Studies* (Zienkiewicz 1992a) and the glass to be found in a county periodical (Zienkiewicz 1992b). This problem appears to have become commonplace in recent times and the question arises as to how this kind of information should be best placed in the public domain. The Study Group for Roman Pottery (SGRP) may well accept for publication in its periodical (*JRPS*), or possibly for e-publication, material that would otherwise never see the light of day, even if pottery reports have to stand apart from site reports, as in the case of the Caerleon Museum site.

All parties approached (Study Group, Units and specialists) are agreed that the important point is for the information to be *readily* available and not tucked away unadvertised in a local HER. The Society for the Promotion of Roman Studies and the Institute for Archaeologists might also be approached concerning such matters: IfA certainly aims to promote appropriate standards within commercial archaeological organisations. 'Curators' are now beginning to require Units to make their archaeological 'grey literature' available through the Online Access to the Index of Archaeological Investigations (OASIS). This

is a collaborative venture between English Heritage, the Archaeology Data Service (ADS), the Archaeological Investigations Project at Bournemouth University (AIP) and various other organisations, including Historic Scotland (though not Cadw). Information is disseminated through such organisations as the Association of Local Government Archaeological Officers (ALGAO) and the Council for British Archaeology (CBA). The project aims, then, to make grey literature readily available for research. One cannot help wondering if e-publication might be the way forward for the ever-increasing mass of unpublished pottery and finds reports, and this is an avenue being pursued by the Roman Finds Group (RFG) (see Durham *et al* 2009, 11).

Editorial policy

Academic and professional bodies could also help in regard to the promotion of appropriate standards, as a matter of principle. Specialist reports are amended by editors in degrees varying from very minor to relatively major changes, some texts having been modified during a process in which they have gone through several sets of editors. This may be one of the hazards of commercial archaeology: exhausted budgets can lead to post-excavation projects being side-lined for years, before being rushed out. Desktop publishing seems also at times to have led to a decline in professional standards of presentation in regard to graphs and charts. Previously, they would have been re-drawn by professional draughtsmen, but they can now be cut-and-pasted from the specialist report. This practice is strangely at variance with the fact that the modern draughtsman is usually a trained and skilful user of specialised computer programmes. Ironically, it would seem here that *more* involvement by post-excavation managers and editors would produce a considerable improvement in the presentation. Some of the problems encountered during the editorial process would certainly be eliminated if a final version of the text were submitted to specialists for checking. However, this does not always happen and, in the case of local publications, specialists are frequently left unaware that their work (edited or otherwise) is in print. Perhaps specialists as a group should be exchanging their own, standardised contracts with the Units, in return for those regularly presented to the specialists for signing; indeed the IfA Finds Group is currently considering this matter and a legally binding specialist contract is to be prepared.

It should be stressed here that specialists do not object to their reports being edited. It can be, and usually is, a great blessing both for the reader – and for the writer. Errors inevitably creep into reports and need to be edited out. I, for one, am inclined to write a surfeit of arcane, inchoate and probably unintelligible minutiae – and am glad of rigorous editing.

Fabrics, forms and quantities

In writing samian reports in the modern world, quantification and its publication is an area in which questions require answers from the very outset. In order to bring to the surface some of the issues encountered 'between a rock and a hard place,' it may be enlightening to give more of the personal background to the present point of view.

My first taste of Roman pottery and samian studies came in summer vacations from university, during extra-mural courses at Corbridge under the aegis of John Gillam (on the pottery front) and Brian Dobson (on the frontier).There was also cursory contact with samian ware at undergraduate degree level in the Faculty of Classics. In the Department of Classical Art and Archaeology, samian ware (or rather terra sigillata) was occasionally mentioned in passing, primarily as being a poor relation of Greek vases and as a descendant of relief-decorated 'Megarian bowls' (a term that is arguably as much a misnomer as 'Samian ware'). The side-effect of the art-history way of thinking could be that the student was induced to admire, entranced, the art-work and to discuss, entrancingly, the subject-matter (whether Lotus-eaters, Sirens, Circe, or, less alluringly, Polyphemus and the motley crew), then to identify and date the potters from their styles – and steer well clear of the unwashed plain stuff in dilapidated boxes mouldering in yet another dark cavern, namely the back of a store. The approach in the Greek and Roman History department was more incisive and thought-provoking (although terra sigillata could still be reduced to two sentences, if the student referred to Finley 1973, 137). An undergraduate dissertation on the education of Roman emperors, supervised by C R (Dick) Whittaker, resulted in a viva at the friendly, if awe-inspiring, hands of Joyce Reynolds and Moses Finley (one of those iconic figures for whose presence, and, in his case, knighthood, this country may thank the McCarthyist witch-hunts of the 1950s). I am told that the days of undergraduate vivas, not to mention professorial involvement in them, are long gone. But it had seemed that 'There were giants in the earth in those days,' and lessons learnt from them were long-lasting. One such lesson will be returned to later.

An opportunity to learn intensively about samian studies came in the late 1970s and the opportunity afforded to me then is greatly to be advocated for the future. My employer at the time, later known as Chester Archaeology, sent me to Newcastle University to work intensively for a fortnight on a large assemblage of samian ware from Northgate Brewery 1974–5 in the Chester fortress, with Kevin Greene acting attentively and astutely in the role of Homer's original (and human) Mentor. This was an excellent way to learn and is highly recommended to any would-be specialist, of whom there appear at present to be few. All it requires is two people with sufficient enthusiasm, commitment and, importantly, time, whether it be to learn or to help to learn, plus a large assemblage of sherds, a good selection of textbooks, and preferably some sort of funding! It was from Kevin that the process of picking up and looking at each sherd was learnt, and then to analyze the collection both by phase and as a whole, not merely by context. As a consequence, I too now want to see in a samian report the overall numbers of sherds and vessels, forms and fabrics, as well as the usual detailed information on stamps and decoration.

It was, next, 'the Leeds team' of Brian and Brenda who helped with identifying potters by their stamps and potters' styles by their decoration, showing me the chronological variations in forms, the subtle differences in potters' stamps, and, by peering minutely, the unpredictably multifarious variations in fabrics. Who other than a dedicated samian specialist could have taught me from the beginning not always to expect the obvious from this allegedly 'highly standardised' pottery? Would I, in the early 1980s, working my way through thousands of sherds from Chester and, in my spare time, Piercebridge, otherwise have recognised that a vessel, with a dullish brown-red slip on an extremely pale fabric, could be from Lavoye? (Ward 2008a, 173 fig 9.5, no 4.) I would never again assume that all Argonne products will show the 'standard,' bright orange appearance that I, working soporifically on auto-pilot in the course of these long ventures, had come to expect. Brian and Brenda had taught me to observe, to look beyond the obvious – and to stay awake.

In attempting, then, to find a reliable means of quantifying these huge masses of samian ware in the late 1970s, I avoided the choice between what seemed two equally disconcerting hazards and at first calculated both minimum and maximum numbers of vessels (see Bulmer 1979, 50; 1980, *passim*). It soon became clear that, of the two, the estimation of minimum numbers was the less accurate and far more misleading method, especially in the case of small, plain fragments of similar date, origin and form. For example: in one late context, twenty Central Gaulish fragments of indeterminate form that were produced at some point in the Hadrianic–Antonine period (*c* AD 120–200) definitely did *not* represent one and the same vessel, there being many different variations in their fabric and general appearance. Although it was unlikely, on the other hand, that they represented as many as twenty vessels, the variations in their appearance suggested a number far closer to twenty than to one. Willis (2005, 5.2.2) has noted that, although the 'numbers of vessels represented' method has that potential problem (the multiple counting of sherds from the same vessel), it arises primarily amongst the less easily distinguishable plain wares. The present writer, having adopted the use of the maximum numbers method as being the lesser of the two evils, continues still to employ it in tandem with EVEs (Estimated Vessel Equivalents). The EVEs method is a means by which one can estimate the proportion of each pot that is present in an assemblage, based on measurements of rim and/or footring percentages.[1] On the other hand, the maximum numbers of vessels method has proven helpful to the present writer when wishing to compare, for example, specific vessel forms within a group. Maximum numbers certainly need to be regarded with caution, as they are often closer to a sherd count than to actual vessel numbers. However, they have at least provided this specialist with a relatively consistent means of comparison since the days before EVEs became standard practice for what appears to be the rest of 'the pottery world.'

Despite the reservations that were mentioned above, the products of the samian industry were, in relative terms, highly standardised, and their study and publication have developed along standardised lines over the last century. The samian specialist's goal in a report must surely be to provide reliable objectivity, and the standardisation of samian ware and samian studies supports this well, lending itself easily to computerisation when numerical date-ranges are used. It must be stressed that the use of such dates should not be thought more precise than the more traditional use of epochs; they do, however, facilitate computer analysis. This particular database is recorded using Microsoft's Access for the liberating scope that it offers, rather than Excel which easily corrupts, essential though Excel is in constructing graphs. Histograms representing samian assemblages chronologically have been concocted, though infrequently, by various specialists for over forty years. One of the earliest examples was that (referred to above) by Brian Hartley, Brenda Dickinson and Felicity Pearce (now Wild) for Richborough in 1968, followed by examples from Kevin Greene with adjustments (1975); then myself (Bulmer 1979; 1980), Geoff Marsh (1981) and Peter Webster (1990; 2003), and onwards to the present day.

In order to make the samian report consistent and integrate it with 'Other Roman Pottery' reports, I have usually been asked in recent years to record weights and also the measurements for EVEs, EVEs having now been adopted as the standard means of 'other pottery' comparisons and that advocated by other finds specialists. Hilary Cool has put it, again succinctly (pers comm), that knowing what a thing is and knowing what date it is, these are just the foundation blocks on which we build; to understand fully how something is being used, we have to look at it in context: of the site, the things it is being used with, etc. To do this properly, we need to be able to compare across sites and, to do that, we need a method of counting that is not site or context specific – and it is the EVEs method that has become the accepted means for doing so. Lack of compatibility is said to have hindered synthetic analysis of both samian assemblages and their contribution to the finds array (Willis 2005, appendix 4.1; Cool 2006, 244, 280). So it is that samian specialists are being asked not to look at samian ware as being separate from the rest of the pottery supply, or indeed from other finds, but to consider it with the greater good in mind.

It is now almost thirty years ago that a joint approach to samian ware and other Roman pottery from the probable mansio in Chester was published experimentally (Ward and Carrington 1981). This examined fluctuations in the absolute frequency of vessel-types and fabrics over time and in the relative frequency of certain vessel-types and fabrics. Since that tentative experiment early in this odyssey, 'the circling years disclose' how colleagues have helped in the weaving of reports and '…mix'd the various thread: where as to life the wondrous figures rise;' their collaboration has produced, in this writer's experience, no delicate shroud, but, rather, a 'rich tapestry, stiff with interwoven gold' (*Odyssey* 1.2 and 4, transl Pope). The interchange of ideas has involved not only site directors,

project managers and 'Other Roman Pottery People,' but also numismatists, epigraphists and finds' specialists concerning counters, spindle-whorls, metal rivets and much else – and I am greatly indebted to them for sharing their knowledge and experience. All have enriched the blend, illustrating how samian studies can support and be supported by other material evidence, and how invaluable this interweaving is.

The importance of such interaction having been accepted, my own hesitation about recording for EVEs when first asked to do so by Jerry Evans and Ruth Leary, was soon overcome. To continue the Homeric analogy, the prospect was manifestly no fearsome Scylla or Charybdis, no 'rock and a hard place.' Measuring rim (and footring) percentages was found to take little time and was easily tagged on to the weighing process. An added bonus in measuring the proportion of rim diameters for EVEs can be that specialists have access to information on sizes of vessel that they might otherwise not have. It may be noted here that it is difficult for anyone other than the specialist to perform this task, unless every individual sherd is marked with an individual number – and few northern Units have sufficient staff to do that. Specialists will soon find it quicker to measure the rimsherds than to mark every sherd themselves! It has thus far been a moot point as to who should measure EVEs. Clearly, if the samian specialist is required to analyse quantities by EVEs, then he or she will find it better to have the figures readily, and reliably, available. 'Self-service' is the most efficient course of action. And here again, the small northern Units rarely have enough staff for yet another task. A small unit has to buy in more help in order to fulfil the overall brief set by the curator (for example, the County Archaeologist); it is the Unit's contractual responsibility to fulfil the brief, whatever the size of the Unit – and whatever the means. The only real constraint is that a cost has to be set on the brief and commercial Units will hope to make a profit if the tender is won. In actuality, it is not so much the Unit that finances a samian report, but 'the client' (usually the developer). So far in this specialist's experience, the client has always been willing to pay the estimated costs, including that of measurement for EVEs. Nor have there been problems with Units over expenditure on the provision of a database and indeed the Units warmly welcome, and appear to prefer, presentation of data in this way. From the specialist's point-of-view, the database certainly saves time in the larger collections, whether in order to calculate EVEs and vessel numbers, in sorting by phase or fabric, or in summarising types of vessel, etc. Furthermore, easy access to all this information clearly helps to provide a more efficient report.

The adoption of EVEs leaves me, nonetheless, with three problems, varying in degrees of triviality.

- Firstly, in the case of all those sherds where no rim survives: does one simply not record their evidence at all? As often happens on upland sites or in rural locations, the abraded and eroded groups frequently include no measurable rimsherds and entire collections

can register as 0.00 EVEs. It has been suggested that a specialist using so-called 'expert knowledge' (a phrase rarely, if ever, used by specialists themselves in any field of work) could also estimate the proportion of a vessel represented by any sherd, especially in the case of decorated pieces. However, this would require yet more, precious, and costly, time, and it would surely add yet another level of still more vague approximation. It would also introduce an element that is not present in the 'other Roman pottery' and this would surely invalidate the point of the exercise, namely, to make an estimation comparable with that made for the rest of the pottery.

At any rate, because of the way in which it is possible to identify form from small, non-rim sherds of samian ware, the maximum vessel method seems better for comparisons within and between samian assemblages, especially those reported on by the same specialist. This method seems the more helpful when comparing in particular such data as specific (and therefore very limited) samian forms within a group, or when comparing small samian assemblages across sites. It may be suggested that the two methods of quantification are best used side-by-side according to need, though such duality is, yet again, time-consuming.

- The second matter is whether estimates based on rims alone can be compared with those based on rims and bases. The statisticians' answer has been, theoretically, in the affirmative. However, the practical answer is said to be uncertain without further practical tests. In theory, too, the combined use of rim and base percentages is better, in that it gives more data and therefore a better estimate. Accepting the premise that samian bases can indeed be sorted to much the same level of form detail as can rims, we still have to ask whether there is a relative bias between bases and rims (in other words, whether bases really do provide estimates that are consistent with those from rims). This leaves it unclear, for the moment, as to whether one assemblage from which rim and base percentages were required, can be compared directly with one from which rim measurements only were wanted. Again, one might argue that unless you can apply these measurements to the other Roman pottery also, one risks not comparing like with like.

It is manifestly important that we should preserve our own integrity, alongside that of the data. Here, the axiom attributed (perhaps erroneously) to Disraeli, but made famous by Mark Twain, springs to mind, namely that there are three degrees of veracity (or, according to Twain, three kinds of lies): "lies, damned lies, and statistics." We have to be careful not to twist the facts of figures into a fiction that we may wish to believe and that we then lull ourselves into believing – and so 'prove' our own pet theory.

- The third, and most significant, issue is that EVEs have as yet been employed but rarely in samian reports. The consequence is that comparisons between published

collections are, for the time being, extremely difficult. However, the basic point remains that maximum vessels and also sherd counts are relatively meaningless when comparing two or more *total pottery* assemblages. Most 'other pottery' specialists in Britain are using EVEs and, surely, this fine tableware, which is but one element of the pottery array, should be treated as such and not set in 'splendid isolation.' Samian ware needs to be reported on in such a way that not only its special characteristics may be presented to their best effect, but that its data can be compared meaningfully with other ceramics. We have yet to decide and to agree precisely what samian data needs to be published. In this respect, we are all 'learning the ropes' and in this we can make concerted progress, by learning from each other across the disciplines. Here, we may like to recall Odysseus, 'the man for wisdom's various arts renown'd' (*Odyssey* 1, transl Pope): the man of many devices, the bright spark, who wandered far and wide for ten years. Many were the men whose cities he saw – and (significantly) whose way of thinking he learned.

Matters arising 'en route'

Since it should, then, go without saying that we need to learn from, and cooperate with, each other in this venture, what should a samian report now contain? It needs to be accompanied by an archive which records all sherds and vessels listed by phase and context, including information on fabrics, forms, decoration, potters' stamps and comments on use and re-use, together with weights and measurements. Experience indicates that this information is most easily collated and analysed by means of a computerised database. This will then form the basis from which vessels can be selected for a publishable catalogue of vessels, their selection being made according to their intrinsic interest and/or their significance in terms of provenance. The publication will provide enough basic information to enable colleagues working on any aspect of the pottery assemblage or other finds to integrate data from the samian ware with that from other pottery and, where applicable, other artefacts. It will also provide a comprehensive summary of each collection, phased or otherwise, with tables, graphs and illustrations being presented as appropriate.

Concerning illustration in general, Units have been known to offer the possibility of digital photography and this needs due consideration. Graphite rubbings, too, may well be published rather than drawings. However, attention should be drawn to the fact that not all samian rubs well – especially that from upland sites in Wales and the North, where, Peter Webster (pers comm) has pointed out vividly, rubbing usually results in transferring more powdered samian to the back of the rubbing than it does graphite to the front! Nor are all samian specialists inherently adept at rubbing. For the future, perhaps those Units willing to publish rubbings may consider using their own, possibly more adept, staff, and also perhaps their own materials.

Many northern Units, however, prefer to stay with the tradition of drawings – and thus keep their well-trained and highly skilled draughtsmen in their chosen vocation (notwithstanding the fact that, as mentioned above, the modern draughtsman is also a skilled user of specialised computer software). Whatever the medium, most potters' stamps will need to be illustrated for the time being, until we see publication of all volumes of the 'Leeds Index,' containing as they do the stamp illustrations. Thereafter, we can look forward to the Index appearing digitally, so that we can search, for example, for an elusive and as yet unidentified potter with an E and SS in the middle of his name.

At excavations in some of the larger cities, it is not thought feasible (due to the quantity of finds) to ask samian specialists to report on all vessels. Consequently, the specialists receive only the 'special' sherds from Roman contexts (generally, the decorated and stamped vessels) and thus see no plain wares from most contexts. But if a small piece of a plain dish of mid- to late-Antonine Drag form 31R that was repaired, is found in association with, let us say, a large part of a beautifully moulded bowl of Trajanic date, surely from the archaeological point of view both vessels deserve the same attention, dating and proper publication? If faced with the loss of such significant information from either item, this would be cause for great sadness, in that fully comprehensive recording has been possible at excavations in other large cities. It is hopefully the case that someone in all the large cities has been following in Geoff Marsh's footsteps of 1981 and has been recording, for instance, the evidence of repair and re-use, as is done for cities and settlements elsewhere. In this respect and also on a much larger scale, Steve Willis's work has been exemplary, indicating how much samian ware can tell us (eg Willis 2005). His work is particularly revealing for the potential of plainware. We need to bear in mind that on almost all sites there is much more plainware than there are moulded bowls. Indeed, there are many more (literally) plain sherds than there are those bearing stamps or decoration. Surely, the information provided by the mass of plain sherds should not be lost, or disregarded. It is invaluable to see in samian reports, information on all vessels, plain and otherwise, phased and unphased. The present writer has long advocated that such information should provide details of wear and use, including graffiti and repairs, re-working and re-use (eg Bulmer 1979, 49–50). The importance of recording this information has been seen elsewhere (eg Marsh 1981, Willis 2005). As is also the case with coin-wear, it is highly significant information that can tell us so much about a site.

Here, the outcome of recent excavations at Stockton Heath, Wilderspool, may be an instructive instance and Earthworks Ltd has kindly allowed discussion before final publication. Work took place in the area of the well-known industrial site near Warrington, at which military involvement in the earlier Roman period has long been recognised. The finds recovered from the recent excavation revealed a remarkable preponderance of Hadrianic samian

ware and a striking paucity of South Gaulish products: amongst a maximum of 151 vessels, only four were from South Gaul, each of them found in 2nd-century or later contexts, and one of them an early 2nd-century product from Montans. However, perhaps the most striking feature of the collection was that over 5% of the samian ware was repaired or had seen attempts at repair. Willis (2005, 11.5.2), recorded a similar proportion (in those collections large enough to be statistically reliable) only at the fort of Strageath, amongst material associated with the Antonine occupation there. He also gives an average as low as 2% for repairs from a total of nine reputedly military sites, in six general locations. Unfortunately, the sample from 'unadulterated' vicus sites is not viable for comparison, there being only one, very small group listed: two repairs in a total of only 58 vessels (94 sherds) from Birdoswald's western vicus (see Willis 2005, Table 73 and Appendix 11.1). At any rate, the proportion of samian repairs at Stockton Heath was relatively great and it may reflect a specific local industry with military involvement there.

Repair-work on samian ware has been recorded at several other sites that were engaged in metal-working or other industrial activity with evident or presumed military involvement. These sites have included Prestatyn, Holt, Middlewich and Wigan (Ward 1989, 154; 1998, 52, 73; 2008b, 144; and report unpublished). Samian repairs may also have been carried out in a metal workshop excavated at Tofts Field in the so-called Vicus North, at Piercebridge (Ward 1993, 20–21; 2008a, 193), though contemporary military activity is unproven. It would clearly be useful to continue the research begun by Steve Willis into the national distribution of samian repairs and sort them according to geographical location, site type and period of occupation, as well as by vessel form, date of manufacture and type of repair (rivet or cleat?). It has long been hoped that in the course of this on-going odyssey, there will be an opportunity to analyse all the used, re-used or repaired vessels recorded in the database since the early 1980s (*cf* Ward 2008a, 191 fig 9.16) and to compare them with overall models when published. The results should be rewarding, and, in the light of other specialists' research, may help to resolve others' questions and matters arising (see Willis 2005, section 11, *passim*).

Acquaintance with Moses Finley, Joyce Reynolds and Kevin Greene convinced me long ago that a broader approach to the complexity of what is now termed 'material culture' has much to offer the archaeologist as well as the historian. It also broadens one's personal horizons. Looking as I still do from all-too-narrow a perspective, I find that I would dearly like to see more evidence as to how samian ware fits in with the rest of the material culture on sites in Roman Britain. I find the ever-enquiring mind asking many a question for many a site, both on the small and the large scale. On the smaller scale, what do graffiti on samian vessels tell us alongside those on other materials in an assemblage? How did the repaired samian ware fit in with other repairs and with the evidence of metals and metal-working on a site? And all these 'circling years'

on in this odyssey, I find myself still remembering from Piercebridge an enigmatic object, a tiny pyramidal item, recovered from an apparently medieval wall: what was it and how did it arrive in the wall? Was it re-worked in medieval times, rather than in the Roman period? Could it have been used for some colouring, cosmetic or medicinal purpose? (Ward 2008a, 193). And on the larger scale, how does the dating evidence of samian ware compare with that of the coins from the same site, or indeed from a group of sites? Then, further: how does that evidence compare across a frontier, or across a region? The list of questions seems endless and ever-widening. As Finley, a 'robust' primitivist (Greene 2007b, 133), would write, 'The answer depends....' (Finley 1967, 9), or as he would so frequently and minimalistically conclude his lectures, 'The answer is: we just don't know.' However, questions need asking, whatever the answers, and it should be possible for anyone to consider them from information that is placed in the public domain.

The view-point reached in this northern odyssey

The daily task of timetabled report-writing is now to be regarded as a professional service and it is one that is provided by this specialist sometimes at the request of local societies, but mostly for professional Units that are based north of London. From this present view-point, I find myself again meandering back over the circling years to the moment of revelation in that sodden trench, when first I heard of the inspirational work going on at Leeds. I look back also to what seems a previous age, like that of the Titans, to Moses Finley, and to Joyce Reynolds, those examiners of my undergraduate viva, whose words of wisdom have remained with me. On learning of my first job as an on-site finds' assistant in Chester and of my on-going interest in samian ware, Joyce urged me always to seek the wider perspective: not to become too narrowly focussed on the small fragments, the single bowl, or indeed the single site, in front of me. That lesson has remained with me ever since, though, personally, I am still striving to attain that wider perspective.

The separation of samian ware from contextual information and from other finds is, of course, not always the specialist's doing, and we can all quote numerous instances to illustrate that point. Nevertheless, we, though specialists, should not be tempted to venerate samian ware as a thing apart. There has been a traditional tendency to regard samian studies as a separate discipline in its own right, and the archaeological element of my undergraduate degree certainly encouraged the Art History approach to fine pottery. However admirable that approach is, there is a growing feeling that samian specialists should not be lulled, like the Lotus-eaters, into isolation, but should pull together with the rest of the oarsmen. Whatever the problems and minor irritations may be, these are only Clashing Rocks that may be anticipated from afar and avoided where it is best to do so; far greater hazards lie ahead in our world, than faced the world of Odysseus. By keeping the greater good

in mind, we will surely increase our mutual understanding, as well as disseminate more information about the sites and regions in which we work. Certainly, the study of samian ware excavated on British sites has as much to tell us about the history and occupation of those sites, as does that of other finds (see Cool in Cool and Mason 2008, 241–69). It is for this reason, primarily, that full details of samian vessels should be recorded: not merely their makers and their date and place of origin, but also their quantity, their condition, the evidence of wear and repair, use and re-use, burning and so on. This fine tableware needs to be seen as it was, as a significant part of the corpus of daily life in Roman Britain. Its study needs to be integrated into the material evidence of a site as a whole, if we are to gain a clearer understanding of life on that site, or indeed in Roman Britain and its part in our history.

To end with a few literary, or philosophical, thoughts: Finley's conclusion concerning the world of Odysseus (1967, 164) was that, 'In [those] succeeding centuries, the miracle that was Greece unfolded. Homer having made the gods into men, man learned to know himself.' The congenial (if not cathartic) destination of our own epic voyage through life in the archaeological world is one where samian specialists, pottery people, finds' staff, excavators, project managers, researchers, historians, and thus the world at large, understand more, collectively, about our history, and ourselves. One's own personal journey may (as T S Eliot wrote in a particularly dark hour in 1917), 'lead you to an overwhelming question … Oh, do not ask, "What is it?" Let us go and make our visit.' In the course of our trip and all that we may visit on the way, we will find many a question and many an answer, if we keep our sights set on 'the wide horizon's grander view' (S Longfellow).

Note

1 Kevin Greene (2007a, 489) has called for explicit explanations of the methodology involved, resulting from his frequent experience of uncertainty about and misunderstanding of the EVEs method. His succinct explanation is therefore repeated here. This method provides an objective means of calculating the minimum number of vessels present: essentially, since the rim of a complete pot has a circumference of 100%, four rim-sherds of a specific vessel form retaining 20%, 10%, 30% and 40% of their original circumferences add up to 100%, or one EVE, and therefore a minimum of one pot, rather than four.

Acknowledgements

Thanks owed to Brenda were recorded at the start of this paper. Janet Webster is to be thanked for her assistance with an early version, given at a seminar, and Felicity Wild for her kind remarks on it. Kevin Greene and David Shotter gave the paper attention from their own wider perspective and Clive Orton made supportive comments on the statistical approach. Dorothy Thompson added helpful criticisms from her stand-point as an ancient historian (and as the first chronologically in the line of mentors).

Christopher Ward made constructive contributions and Peter Webster provided invaluable suggestions and much-appreciated support throughout.

Appendix

Access database of samian sherds: the column headings:

Record no.
Site/Trench
Context
Sherd no.
Phase
Other information (where available)
Fabric (South Gaulish, Central Gaulish or East Gaulish)
Products of Les Martres-de-Veyre (in Central Gaul)
Form (catalogue numbers, mostly Dragendorff's)
Vessel type (eg dish, bowl, cup)
Plain/stamped/decorated vessel
Weight (gm)
Comments (in note form)
Production start-date (of range)
Production end-date (of range)
Numbers of sherds
Numbers of vessels (actual numbers)
Rim sherds (number)
Rim %
Rim diameter (in cm)
Footring sherds (number)
Footring %
Footring diameter (in cm)
Complete profile
Condition (wear, graffito, repair, secondary use, burning)
Same as sherds in other contexts
Catalogue no. (from the detailed catalogue in the report for publication)

For terminology, see for instance Bulmer 1979 and Webster 1996

Bibliography

Bulmer, M, 1979 (1980). An introduction to Roman samian ware, with special reference to collections in Chester and the north-west, *J Chester Archaeol Soc* 62, 5–72

Bulmer, M, 1980. Samian, in D J P Mason, *Excavations at Chester, 11–15 Castle Street and neighbouring sites 1974–8, a possible Roman posting house (mansio)*, Grosvenor Museum Archaeological Excavation and Survey Report 2, *passim*

Cool H E M, 2006. *Eating and drinking in Roman Britain*, Cambridge

Cool, H E M, and Mason, D J P (eds), 2008. *Roman Piercebridge: Excavations by D W Harding and Peter Scott 1969–1981* Architectural Archaeol Soc Durham Northumberland Monogr 7 (http://www.barbicanra.co.uk/PiercebridgeCA.pdf)

Dickinson, B M, Hartley, B R, and Pearce, F, 1968. Maker's stamps on plain samian, in B W Cunliffe (ed), *Fifth Report on the Excavations of the Roman fort at Richborough, Kent,* Rep Res Comm Soc Antiq London 23, 125–48, Oxford

Dickinson, B M (with Hartley, K F), 1971. The evidence of potters' stamps on samian ware and on mortaria for the trading

connections of Roman York, in *Soldier and civilian in Roman Yorkshire: essays to commemorate the nineteenth century of the foundation of York* (ed R M Butler), 128–42, Leicester

Durham, E, Hall, J, and Wardle, A, 2009. Testing the water! *Lucerna* 37, 12–13

Eliot, T S, 1917. *Prufrock and other observations*

Finley, M I, 1967. *The world of Odysseus*, (rev ed), Harmondsworth

Finley, M I, 1973. *The ancient economy*, London

Greene, K T, 1974 (1975). The samian pottery, in P J Casey, Excavations outside the north-east gate of Segontium, 1971, *Archaeologia Cambrensis* 123, 62–7

Greene, K T, 2007a. Review of F Seeley and J Drummond-Murray, Roman pottery production in the Walbrook valley: excavations at 20–28 Moorgate, City of London, 1998–2000, *Antiquity* 81, 312, 489–490

Greene, K, 2007b. Archaeological data and economic interpretation, in *Ancient economies, modern methodologies: archaeology, comparative history, models and institutions* (eds P F Bang, M Ikeguchi and H G Ziche), Edipuglia 12, 109–36, Bari

Hartley, B R, 1972. The Roman occupation of Scotland: the evidence of the samian ware, *Britannia* 3, 1–55

Hartley, B R, and Dickinson, B M, 2008 –. *Names on* terra sigillata: *an index of makers' stamps and signatures on Gallo-Roman* terra sigillata *(samian ware)*, Bull Inst Classical Stud Suppl 102, London

Homer, *The Odyssey* (transl Alexander Pope, 1726)

Marsh, G, 1981. London's samian supply and its relationship to the Gallic samian industry, in *Roman pottery research in Britain and north-west Europe* (eds A C Anderson and A S Anderson), Brit Archaeol Rep Int Ser 123, 173–238, Oxford

Ward, M, 1989. The samian ware, in K Blockley, *Prestatyn 1984–5, an Iron Age farmstead and Romano-British industrial settlement in north Wales*, Brit Archaeol Rep Brit Ser 210, 139–154, Oxford

Ward, M, 1993. A summary of the samian ware from excavations at Piercebridge, *J Roman Pottery Stud* 6, 15–22

Ward, M, 1998. Some finds from the Roman works-depot at Holt, *Studia Celtica* 32, 43–84

Ward, M, 2008a. The samian ware, in Cool and Mason 2008, 169–296 (catalogue available online at http://www.barbicanra.co.uk/PiercebridgeCA.pdf)

Ward, M, 2008b. Samian ware in M Williams and M Reid, *Salt: life and industry. Excavations at King Street, Middlewich, Cheshire 2001–2002*, Brit Archaeol Rep Brit Ser 456, 117–158, Oxford

Ward, M, and Carrington, P, 1981. A quantitative study of the pottery from a Roman extra-mural building at Chester, in *Roman pottery research in Britain and north-west Europe* (eds A C Anderson and A S Anderson), Brit Archaeol Rep Int Ser 123(i), 25–38, Oxford

Ward, S, 1986. Samian ware on a home computer, *Archaeological Computing Newsletter* 8, 6–9

Webster, P, 1990. The Caerleon samian project, *Archaeology in Wales* 30, 17–18

Webster, P V, 1996. *Roman samian pottery in Britain*, Counc Brit Archaeol Practical Handbook in Archaeology 13, York

Webster, P, 2003. An early fort at Caerwent?, in *The archaeology of Roman towns. Studies in honour of John S Wacher* (ed P Wilson), 214–20, Oxford

Willis, S, 2005. *Samian pottery, a resource for the study of Roman Britain and beyond: the results of the English Heritage funded samian project. An e-monograph*, Internet Archaeol 17 (http://intarch.ac.uk/journal/issue17/willis_toc.html)

Zienkiewicz, J D, 1992a. Pottery from excavations on the site of the Roman Legionary Museum, Caerleon, 1983–5, *J Roman Pottery Stud* 5, 81–109

Zienkiewicz, J D, 1992b. Roman glass vessels from Caerleon: Excavations at the Legionary Museum Site 1983–5, *Monmouthshire Antiq* 8, 1–9

Zienkiewicz, J D, 1993. Excavations in the *scamnum tribunorum* at Caerleon: the Legionary Museum site 1983–5, *Britannia* 24, 27–140

5 Calibrating ceramic chronology: four case studies of timber building sequences, and their implications

Raphael M J Isserlin

References to samian vessels in Classical Literature are rare, mentions of the sherds with which the terra sigillata specialist is presented, rarer still – perhaps this instance explains why (it is not for the faint-hearted):

> '…*Nobilitantur his quoque oppida, ut Regium et Cumae. Samia testa matris deum sacerdotes, qui Galli vocantur, virilitatem amputare nec aliter citra perniciem, M. Cælio credamus… Quid non excogitat vita fractis etiam testis utendo…*'

> '…Towns like Regium and Cumae are also highly esteemed for these [pottery vessels]. With a sherd of samian, priests of the mother of the gods, who are called Galli, cut off their manhood – the only means of avoiding dangerous results (let us believe Marcus Cælius!)… What will they think of next? Even by using broken potsherds…' (Pliny, Historia Naturalis 35.46).

This passage concludes with a description of the manufacture of *opus signinum* flooring. Ever since reading what is both proof text for feminist Roman archaeology and guide to home improvement, I have never viewed samian in quite the same way. Nor, surely, will the honorand of this volume on learning that a *Gallus* has been identified at Catterick, N Yorkshire, for which she had actually handled the samian sherds (!), so there is a direct, personal (if surprising) link with praxis in what in many ways was still *Magna Graecia* (*cf* Cool 2002, 41).[1] Terra sigillata reporting always seemed so blameless and workaday; how mistaken one can be. The procedures advocated in this paper are of a rather different kind. Still, they do incorporate experimental data, and some might regard the results as dangerous.

Introduction

The increasingly accurate ceramic chronologies now established for the Roman period in the North-Western provinces, for terra sigillata especially, represent the result of over a century of research and are not easily broken – not that this is either the intention or the outcome of this paper.[2] If terra sigillata in these provinces is thereby privileged over that from any other is not for me to say. But I would suggest that in at least one part of temperate Europe, contexts producing this material have not always been exploited to fullest advantage, and that may have some bearing on the matter. Let me explain.

The degree of confidence expressed in pottery dating depends on the type of material involved (verifiable) and the ceramicist concerned (anecdotal, especially at conferences). Theoretically, bias towards dating 'early' or 'late' can be identified, calibrated and compensated for, in order to arrive at an absolute, definable, norm. Terra sigillata specialists are well aware of the implications, since tying a site down to a particular year can have important historical consequences – or disastrous ones if misapplied. Such days of normalization (in mathematical terms, 'canonical synthesis') lie perhaps a while off yet, but a statistically-based trial-run towards establishing that norm was attempted some years ago for samian from London. Although (and perhaps *because*) the material examined was very small and not always suitable for dating, it nonetheless concluded that 5–10 vessels were required to date a context with any degree of accuracy, depending on circumstances (Orton and Orton 1975, 287; *cf* Orton 1982, 101, 227) – an intriguing thought. The ultimate quantifiable samian group is surely Pompeii house VIII.5.9, room f (Atkinson 1914) – the quintessential sealed, closed, assemblage with a *terminus ante quem*, it has long formed an important referent for samian studies in Britain (eg Hartley 1969, 236: 'still lying packed in its crate, as it had arrived in the town…'). Yet analysis of the material culture of Pompeiian households concluded that 'almost no information exists on the state of the deposit or on the condition of structure and decoration of this house' at the time of excavation in 1881–2, although House VIII.5.9 did display signs of late occupancy (Allison 2004, 135; Allison nd). Research into 30 Pompeiian houses shows that there were several phases of dislocation, and that artefact distribution does not conform to anticipated norms – the picture is far more complicated. Attempts to distinguish between, for example, use, discard, storage, and abandonment deposits are not convincing (Allison 2004, ch

9) and even less so when pottery's own formation record is taken into consideration (Peña 2007). And nuanced reassessment of ceramics at Pompeii as a whole shows the terra sigillata was initially shipped via Narbo to Ostia in all probability, before being mixed with other items such as *Firmalampen* that we know of (and what else that we do not, eg even more intrinsically datable pottery, or items of metal or glass, abstracted AD 62–79, or in excavation?) and only thence to Pompeii (Peña and McCallum 2009, 189) where it may have remained for some time. That same research – which shows this is actually an *open* assemblage – has also verified the totals for samian (90 pieces, not 76) and lamps (37, not 36). The various stages of repackaging and transhipment are of indefinite duration, and in terms of dating their impact might have a slight 'knock-on' effect for the North-Western provinces which could, depending on the rapidity of trade, be cumulative, especially with increasing distance and further points of transhipment, warehousing and repackaging en route. It is worth thinking through the implications for the year AD 79, significant as a marker-date for Pompeii, Verulamium and Chester; do insular chronologies have to be finessed a little to synchronize them?

Research on the speed with which coinage traveled from Italy to Britain (Hobley 1998) suggests there may be scope to build a little delay into the distribution system – a topic whose workings are not often explicitly discussed with regard to pottery. When it is AD 79 in Italy is it still 78 or 77 in Britain? Conversely is AD 79 in Britain still 79 in Italy, or is it already 80 or 81 there...? Do we apply Occam's Razor (or its ceramic equivalent: *cf* Pliny, *supra*) to the archaeology we get, merely to replicate the history we already know? The internal documented chronology of the Agricolan campaigning is problematic enough. Perhaps we should not add another variable. Perhaps we should (Jones 2009).

More generally, late 20th-century research into dating had two contrasting outcomes. On the one hand, the merits of dendrochronology (Baillie 1995) in pinpointing, sometimes to the year, the date of timber structures associated with ceramic assemblages, with concomitant effects for the study of those assemblages, are well known (eg Richardson 1986, 96–8). That accuracy may well appear to be of a greater order than the relatively precisely-dated ceramic assemblage that accompanies it. On the other hand, it has been observed that economic conditions affect the amount of pottery produced and so available for entry into the archaeological record. That 'precise' ceramic dating might thus become 'fuzzy' at certain times is less often appreciated. But it has been suggested for the Roman period on the basis of purely ceramic evidence (the deductive method) and demonstrated for the medieval period, using ceramic *and also* documentary evidence (the inductive method), which tends one to the conclusion that both cause and effect are genuine (Going 1992; Orton 1985). At many sites in temperate Europe, tree-ring dating is not possible as building timbers decayed long ago, but *information* regarding wooden structures is still present

in the form of postholes and beamslots, and that is what this article uses.

It does so in order to test the accuracy and limits of 'fuzzy' and 'precise' ceramic dating, examining cases from one rural and three urban sites. The first part of this text reviews attitudes to dating (mainly urban) timber buildings, and demonstrates how dates might be calibrated in a replicable fashion. It then suggests how that replicable calibration might validate or modify site sequences, and application reveals definable 'joins' and 'gaps' at Verulamium Insula XIV, Chichester, Chelmsford, and Whitton, independently of any vagaries in the ceramic record. The results suggest that in certain circumstances we may be able to achieve a surprising degree of precision.

As a further test of method, an Appendix suggests how these 'joins' and 'gaps' can be applied to rural sites where settlement mobility is a factor. How accurately sites can be identified and dated has considerable implications for our understanding of population levels. Again, there are reasons to be optimistic.

Dating the dates, Part 1: dated data, or dated daters?

So used have Roman archaeologists become to validating sites and structures by means of reference to the pottery, and so proficient are they now in developing artefact chronologies, that they are rather apt to overlook a basic truth. Dating is a two-way process. Back in the 1960s, before the impact of tree-ring dating, two Cambridge graduates, Brian Hartley and John Hurst, ranked the basic dating aids for the Roman and medieval periods respectively. The ranking of coins and small finds represents the only real variance in their treatment of these two branches of historic archaeology, but it is salutary to note that finewares (including samian) appear only in the bottom third (Table 5.1).

The absence from Hartley's list of architectural evidence from masonry buildings – moulded stone; brick; and tile (whether relief-patterned, or flanged tegulae) – may seem somewhat surprising. After all the Roman period is also a branch of Classical Archaeology. But the researches of Tom Blagg (eg 2002), Ernest Black (1985) and Peter Warry (2006) into these eminently datable forms of evidence lay some decades ahead, and although they may not yet always achieve the level of accuracy of (say) coarse pottery, they can be of some dating value, if in a demonstrably primary structural context (for discussion of which, see below) and may improve further still in the same way as coarsewares have in the last quarter-century of so.

As for timber structures, it had yet to be recognized that it could be equally legitimate to validate the finds by reference to the buildings, or rather the waterlogged components thereof. The presence of a suitably wet environment is the prerequisite for this other, and converse, part of the dating process. By and large such timbers as have been used for creating and refining a chronology by means of tree-ring analysis have been increasingly

Dating aid	Ranking	
	Roman	Medieval
Historical accounts	1	2
Inscriptions	2	-
Architectural evidence	-	3
Comparison with datable sequences or examples elsewhere	-	4
Coins	3	= 1
Small finds	-	= 1
Imported finewares	4	-
Coarse pottery	5	-
Typology	-	5

Table 5.1: Dating aids for the Roman and medieval periods, ranked in order of diminishing reliability (sources: Hartley 1966; Hurst 1963)

routinely retrieved from what are now the wetter parts of urban sites – though their sequences may not have started off in such conditions – and from a few forts that were not built over. But back in the 1960s, Brian's mentor in matters Romano-British, Sir Ian Richmond, treated the survival of waterlogged timbers as mere curiosities (Richmond 1961). Not enough 'wet' sequences had been excavated.

Subsequently Malcolm Todd produced a position statement showing how the process of dating Roman sites by relative means developed, in particular how excavations on the German *limes* led to the refinement of samian chronology, and focussing on the application of tree-ring dating to the subject (Todd 1982, 36). Comparison with that written by Sir George MacDonald is instructive (Macdonald 1935). Todd's ranking is:

- Historiated events identifiable in the archaeological record
- Inscriptions recording construction or consecration
- Coins
- Pottery (usually finewares)
- Certain scientific dating techniques.

Had Brian Hartley revised his paper on dating now, I feel sure that not only would dendrochronology as an absolute means of dating have entered his list (and have reason to do so – I recall him mentioning its emerging potential back in 1977), but that it would have occupied a place near the very top. But relatively little consideration was given to determining the 'right sort of deposit' whence useful dating material might derive.

The next step, determination of context, like the retrieval of datable timbers, was chiefly the result of developments in urban archaeology, and in particular seriation. By the late 1970s, it was clear that the selection of datable material could be determined either by the position of a deposit in the stratigraphic sequence, or its functional characteristics. I refer in particular to development of the Harris Matrix. The key text by Harris and Reece (1979) outlines the principles for determining which finds are unlikely to be residual on grounds of stratigraphic sequence. Crummy

and Terry (1979, 54–55) define two classes of deposit on functional grounds:

Class I, with material unlikely to be residual (more useful for dating: occupation layers; destruction levels; undisturbed midden deposits; grave goods; primary fills in some pits and ditches; coin hoards; kiln dumps and loaded kilns; pits and ditches containing thick tips of conjoining pottery), and:

Class II, wherein material is residual (less useful for dating). But some pottery forms survive for 50 years or more in a domestic environment (eg Perrin 1996, 188–90; see also Wallace 2006 on samian. Peña (2007, 39–60) is an overall processual survey).

In the 1980s the balance began to tilt significantly towards ever-greater precision. One urban synthesis, when treating of the dating of waterlogged Roman timber and other, non-waterlogged structures, put dendrochronology *before* pottery or coins, to which it attached equal weighting, depending on context – which shows how far matters had progressed (Milne 1985, 34–43 and esp 43). The dating of much pottery from early London rests on a combination of dry-land and waterfront sites (Richardson 1986, 96–98; Davies *et al* 1994, 9; Groves 1996). Indeed tree-ring dating has been used to correct the value of excavated samian groups that taken in isolation can suggest a later construction-date (Brigham 1990, 160–74; note however that this is contested territory, *cf* the recent summary in Wallace 2006, 259–60). At much the same time, further statistical study of a batch of London samian identified three stages at which samian entered the archaeological record (Orton 1982, 102):

- Recently imported (average age at deposition = <25 years)
- Breakages balanced by new imports (average age at deposition = 30 years); and
- Breakages exceeding fresh imports (average age at deposition = 40 years).

Lurking behind these stages of supply and replacement of pottery is the spectre of economic cycles (Going 1992).

This paper is therefore intended as something of a response to the thoughts of a former tutor who was also for many years a colleague of the recipient of the present volume. It takes as its point of departure a remark by one of Britain's leading dendrochronologists: 'Finally, remember, the trees don't lie – and they were there!' (Baillie 1995, 160, *cf* also 15), thereby pointing up the potential historical bias in coins and documents, two of the items on the above list (Table 5.1) – though (uninscribed) pottery rarely lies either. As Roman coins are a well-known source of propaganda, and impartiality is scarcely a feature of Roman writers (we can dismiss Tacitus' claims to write *sine ira et studio*: *Histories* 1.1), Mike Baillie may well have a point.

Dating the dates, part 2: some ground rules for validation

It is probably fair to say that a great deal of the modern ceramic dating of sites in South-Eastern England (and further afield?) rests on the excavation of a 'dry' site. Verulamium Insula XIV was meticulously dug and published by Professor S S Frere and his team before dendrochronology provided any means of cross-checking pottery dates (Frere 1972). Not, in the event, that this mattered – it produced no waterlogged timbers. Nearly all of Insula XIV was investigated, and its stratigraphic sequence runs for 200+ years. The dating (Frere 1972, 14, 19–25, 28–41, 43–54, 60–73, 81–98, 102 and 106–12) rested on the opportune presence of coins (rare); samian (not as rare); and coarsewares (still less rare). Such a list should strike a certain resonance with the reader – scarcely surprising since the samian analysis was undertaken at Leeds.

It is probably also fair to say that Verulamium Insula XIV is a site that has no historiated dates, other than the Boudican disaster of AD 60/1 whose traces are clearly visible in the soil (Frere 1972, pl I), and – by association – the Agricolan intervention of AD 79, which resulted in the construction of a forum in the neighbouring insula. Strictly speaking both of these events depend on literary sources in the first instance for their dating (eg Tacitus, *Annals* 14.32; *Agricola* 21), the latter subsequently reinforced by the chance finding of an inscription of AD 79 that is not only fragmentary but unstratified (Frere 1983, 69–72). It is not often appreciated that it is divorced from any archaeological context. In other words, for urban tenements in Roman Britain – and the North-Western provinces – Insula XIV is perfectly normal in having no 'real' history to speak of. And, as is also fairly typical of Romano-British urban tenements, most of its buildings were of timber, with earth-fast foundations. That has considerable implications for us: timbers in contact with moist ground rot (in structural terms, their components fail predictably), and require replacing.

How long it took for timbers to decay in the ground was indeed a topic considered in Philip Barker's *Techniques of archaeological excavation* (1977). Written by the chief advocate of the increasingly popular technique of open-area excavation, and excavator of the later phases of the Wroxeter baths basilica, it appeared five years

after *Verulamium volume I*. While it cited that work as an achievement (Barker 1977, 21), it did not discuss its timber building sequence, being really concerned to demonstrate technical aspects of the excavation of other sorts of timber building, in particular surface-built and waterlogged structures. But it did summarise a series of experiments undertaken at the Building Research Centre, which show that the speed of decay for timbers set in damp earth (<20% moisture) varies with species and size (Barker 1977, 85–7). Although this textbook has been used for over 30 years, many have ignored the implications of this particular section, and *Verulamium volume II* (Frere 1983) duly returned the compliment by not considering these other aspects of timber building at all. Back in the 1970s–early 1980s, there were two schools of digging timber buildings amongst certain Romanists – those that recognised ethereal timber buildings and post-pads, and those that didn't, preferring only cut features (so continuing the tradition of Ian Richmond). The advent of full-time (rescue) excavation has eclipsed these differences.

The seeds of this paper were sown by repeated comparison of Barker's and Frere's texts over many years, and in particular the niggling problem of quite how accurate Roman ceramic dating might be when the failure– and replacement-rate of earth-fast timbers is taken into account (a topic that could well have appealed to Richmond, who was already relating the replacement of decaying timbers to the <20-year occupation of Hod Hill fort: Richmond 1961, 24 and 26 n 4).

When the present author was a postgraduate he decided as a *ballon d'essai* to see how regular the replacement rate of timber buildings was at the Watling Street frontage of Insula XIV – that is, the most crucial part. Ordinarily this would merely have required recourse to an overall phasing table, which volume I lacked. But one was easily enough compiled from information in the various subheadings of the excavator's account, which assigned the timber structures to Period II, and the stone ones to Period III. Tabulation yielded the following result (Table 5.2).

The early (pre-Boudican) levels (Period I) are included here for the sake of completeness, but are henceforth omitted from the study, because the Boudican destruction of AD 60/1 means that the first replacement of timbers, Period I to IIA, is not going to be due to decay. Another reason for doing so is that reassessment suggests that the origins of Verulamium are problematic (eg Haselgrove and Millett 1997, 293–94), meaning that the settlement's start date of AD 43 might be revised, thus potentially prolonging (or curtailing) the duration of Period I, which is based solely on the historic date of the Claudian Conquest and the possibility of an early military presence at the site (now, the existence of a Claudian fort, postulated since the 1960s, is queried and another interpretation suggested: Creighton 2006, 125–8}.

But the published report considered the sequence in terms of *construction periods,* not *occupation periods.* Basing the site chronology on that additional element of duration (Table 5.2), and accepting the excavator's

Period	Published date	Duration (years)	Remarks
I	43–60	17	Burnt down
II A	60–75	15	Rebuilt
II B	75–105	30	Rebuilt
II C	130–150	20	Rebuilt
II D	150–155/60	5–10	Burnt down
III	275	125	Rebuilt in stone

Table 5.2: Verulamium Insula XIV: replacement rates of timber buildings (source: Frere 1972, 7–8, and fig 4)

Period	Date	Duration (years)	Remarks
II A	60–75	15	Rebuilt
II B	75–105	30	Rebuilt
Hiatus	105–130	25	*Vacant land-lot*
II C	130–150	20	Rebuilt
II D	150–155/60	5–10	Burnt down
Hiatus	155/60–275	120–25	*Vacant land-lot*
III	275–400	125	Rebuilt in stone

Table 5.3: Verulamium Insula XIV: post-Boudican land-use (source: Frere 1972, 7–8 and fig 4, amended)

dates without any reservation, a very different picture of *discontinuous land-use* emerges (Table 5.3).

According to this, Insula XIV is not quite the very model of Romano-British urbanism we might expect, for the two episodes of discontinuity last for a total of *c* 150 years. The original report briefly acknowledges one episode, but it is not treated as a separate 'historical' entity in its own right (Frere 1972, 98) while the other is not really treated at all. Is there any way to check this somewhat surprising picture?

The experiments alluded to earlier (Morgan 1975, 18–19) show that after 18 years, 15% of oak timbers of the size used at Insula XIV (where at least one component was of oak: Frere 1972, 8) decay sufficiently to require severe repairs, or a complete rebuild. By our calculations, timber buildings were probably replaced on average every 17–18 years! So conventional dating of the individual phases, based on coins, samian, and coarse ware, is correct, because (not that this was ever in any doubt) experimentally-derived data support it independently – *Q.E.D.*

The published chronology seems to exceed the claimed accuracy of 'often to within 5–10 years' (Frere 1972, 5: in commercial terms, 'manufacturer's advertised tolerance'), although it would obviously be unwise to press matters as far as a single year. But the basic principle of the dendrochronologist stands: as with sites where waterlogged timbers are preserved, so on sites with drier ones – the trees that make up timber buildings don't lie, even if we can't count their rings. It seems possible that a certain amount of dead reckoning is probably in order, *providing we don't rely on it absolutely to the exclusion of all other information.*

There is however a more profound surprise in store. The sequence at Insula XIV from Periods IIA to the beginning of Period III lasts for 215 years (AD 60–275). Rounding up slightly from an anticipated timber replacement rate of *c*

18 years to one of *c* 20, purely for the sake of arithmetical convenience, we might expect nine or ten timber structural phases – instead, there are *just four*. Waterlogged or no, timbers do not lie any more than the trees from which they come – *so where are the other five or six structures?*

There are no signs of them, and the report makes no mention of surface-built structures using post-pads or sill-beams. We are forced to consider two very hypothetical possibilities: either that all the evidence for these was missed during excavation, or that, when structures were rebuilt, they were so precisely sited as to remove every single beam-slot and posthole from the immediately preceding one. Neither possibility is very likely. So instead it seems that the 'missing' building phases were never there in the first place and the report did not really deal with either of the two major gaps in occupation that our analysis suggests. The reason for this discontinuity is tied up with the wider nature of the Roman economy, and I do not wish to say any more of that here: it must be reserved for a further publication. Suffice it to repeat: Frere's construction dates are rock-solid. Not surprising.

Dating the dates, part 3: working from 'the known' to 'the unknown'

I would now like to apply the basic premise of the previous case study to a more interesting puzzle – the North-West quadrant of Chichester. Here too, the procedure of validating problematic sequences by means of timber decay and replacement rates can have considerable implications. Again, the excavator's report lacks a phasing table but one can be constructed from internal data – though with rather more effort this time. I present the early parts of the sequence only (Table 5.4).

The excavator's unadjusted chronology presents a site with no less than four Claudian timber buildings

Period	Excavator's unadjusted date	Duration (yrs)	Remarks	Possible adjusted date
1.1	Claudian	?		?Augustan
1.2	Claudian	6/7	Structure 1	?Augustan/Tiberian
		6/7	Structure 2	Tiberian
		6/7	Structure 3	?Gaian
1. 3	Claudian	6/7	Structure 4	Claudio-Neronian
2.1	Claudian-Neronian		[Kilns]	Claudio-Neronian
3.1	Early Flavian-late 1st century			Early Flavian-late 1st century
3.2	Flavian		Timber building	Flavian

Table 5.4: Chichester NW quadrant: replacement rates of timber buildings (source: Down 1987, 119, 124–30)

(one of which might relate to a military episode), and one Flavian. The Verulamium case study into decay and replacement rates suggests that erecting four buildings in 26 years (ie, replacing them every 6/7 years from AD 43–69) is very unlikely – garden sheds last longer! Yet this has been accepted unquestioningly (eg Wacher 1995, 261). The historical implications of erecting and tearing down buildings so rapidly have simply not been grasped. Either there really is rapid replacement for reasons that are not clear or we should 'decompress' this sequence, even if that means accepting the possibility of relabelling or down-dating some 'Claudian' structures and phases as pre-Claudian (the Neronian pottery-making episode is reasonably well-dated).

As a tentative step (the nature of the timbers is not stated) applying the 20-year rule of thumb, a proposed adjusted date is given in the right-hand side of Table 5.4. Of itself all this would mean nothing. But it so happens that some Chichester samian predates the 'historic' year AD 43, and one piece is dated to AD 20+ (Dannell 2005, 66, 74 and pers comm). Accepting this revised dating (or a version thereof) puts Chichester contemporary with the evidence now emerging from nearby Fishbourne dated 10 BC–AD 25 (Manley and Rudkin 2005a, 80–3; Manley and Rudkin 2005b). More broadly it also means Chichester could now synchronise with the planned layout of Silchester, dated by imports to *c* 15 BC–AD 40/50 (Fulford and Timby 2000, 14, 16 and 546, 566).

If Chichester lay in *Gallia Belgica* or *Germania Inferior*, its buildings (and finds) would be accepted unhesitatingly as indicating activity under Augustus, Tiberius and Caligula. The '20-year rule of thumb' for timber decay-rates works perfectly well at Tongeren across the North Sea: the Hondstraat site by its main road has three timber building phases: one of *c* 10 BC (?military under Augustus); one Tiberian; and one mid-1st century (ie, Claudio-Neronian); followed by destruction in AD 69/70, and that is even taking a military phase into account (Vanderhoeven *et al* 2001, 62). So pushing the excavator's military phase at Chichester to slightly earlier might support John Creighton's notion of increasing influence in Britain under Gaius, even some sort of military presence (Creighton 2006, 53–69). Current views of the English Channel or North Sea as Stalwart Defence (as in 1805–1815 and 1939–45) prevent us from

doing so. Classical texts do not. If parts of the island began to resemble a Roman province as Strabo tells us (*Geography*, 4.5.3), and the archaeological evidence supports it independently, surely we should change our paradigm and take what we see at face value? *Imperium sine fine* was the spirit of the Augustan Age, after all.

Here we must await further confirmation by more modern excavation to see if this is mere hyperbole. The work of people like John Creighton suggests that it may not be. (How surprising is that?).

The power of 20 (or XX): part 1

Urban tenements can be rebuilt fairly regularly even in the smaller towns, as excavations at Chelmsford show, where a whole series of earth-fast timber buildings uncovered in a craftworkers' quarter of the town awaits publication. A portion of the sequence at Site AG 75, predating the transition to stone, is here presented in advance of publication, with the ceramic dating on the left-hand side (Table 5.5).

For reasons to do with economics, specifically trade cycles (*cf* Going 1992), the pottery dating is at times imprecise, and some adjustment is using the '20-year rule of thumb' on the right-hand side for these less clear episodes. On these grounds Caesaromagus presents a more 'normal' picture of urban economic life than Verulamium Insula XIV – though the cultural milieu is rather different. The apparently regular replacement of timber buildings presents a site with some high degree of continuity, higher indeed than a 'proper' town. Some might find that surprising – personally, I do not.

The power of 20 (or XX): part 2

Let us now consider a hypothetical structure built of oak in AD 50, just after Colchester began (in 49; possibly London and maybe Silchester too); quite a few rural settlements also start 'mid-1st century' but excavators are cautious here in their dating, there being no historiated 'marker dates' whatever for rural sites. Barring external circumstances, we might using the '20-year rule of thumb' anticipate predictable failure of the earth-fast structural components, so requiring replacement in or near the years AD 70, 90,

Period	Unadjusted ceramic date	Duration (yrs)	Remarks	Adjusted date
IV.2	60/65–85/90	25–30	Building	c 60/65–c 85/90
V.1	85/90 – early 2nd century	15–20	Building	c 85/90–c 100/105
V.2	Early 2nd century – 120/25	15–25	Rebuilding (extension)	c 100/105–c 120/125
VI.1	120/125 – Mid-2nd century	25–30	Building	c 120/125–c 150
VI.2	Mid-2nd century	20	Rebuilding	c 150–c 170
VI.3	Mid–later 2nd century	20	Rebuilding	c 170–c 190
VI.4	Later 2nd century – 210	20	Building (infilling)	c 190–c 210
VII.1	Early–mid-3rd century	25–30	Rebuilding	c 210–c 235/40

Table 5.5: Chelmsford Site AG 75: replacement rates of timber buildings (source: Isserlin and Wickenden forthcoming)

110, 130, 150, 170, 190, 210, 230, 250, 270, 290, 310, 330, 350, 370, 390 and 410 (!); that is 19 episodes in all, including the original building (what an impact on woodland resources, unless they are properly managed).

Not all sites will present such a picture, especially those in South-East England, because of destruction by Boudica. She might reasonably be regarded as *force majeure*, but following subsequent reconstruction in the year 60, all that is required is a mere 10-year recalibration of the basic sequence, giving the result AD 60, 80, 100 … 420 (?). (The reader will grasp the point.) It would be possible to modify this 20-year span by using, say, a '30-year rule of thumb', in which case the number of rebuilds is reduced to 13. How many of the maximum 19 hypothetical phases using the '20-year rule of thumb' could be detected in the archaeological record or accurately dated by finds may for some be a matter of personal conviction but there are ways of overcoming that bias (see below). The basic principle stands; whatever the start date, the requisite number of structures should be there, be it in town or country, and if not explanation is required. And that affects finds and pottery assemblages, including samian.[3]

Such a principle could be used – cautiously – in what has been termed the 'organic crescent', that is any of more temperate parts of the North-Western provinces where a tradition of earth-fast timber building exists (*Gallia Belgica, Germania Inferior, Helvetia*) or indeed areas beyond them (*Germania Libera* or *Barbaricum*) where the trees don't lie but do decay predictably (a concept based on deposit survival; the phenomenon covers Britain, and the North Sea coastal areas of North-West Europe through to the Baltic and south Scandinavia: Carver 1993, 13 and fig 1). But in certain circumstances it might even extend into the Classical World 'proper' – Luni on the Adriatic presents a phase of Byzantine-period structures using perishable materials and postholes, but it is uncertain whether these reflect the presence of Germanic invaders or a type of architecture right at the lower end of the vernacular scale, and so far only contacted in 6th-century levels (Ward-Perkins 1981, 97).

I wrote at the start that dating is a two-way process and so it is, but it is also really a matter of looking at what you don't have as well as what you do. We should really be thinking in terms of the *anticipated* and the *actual*: taking into account *anticipated* structural sequences with their pottery assemblages, and examining those that are *actually present* – and reconciling the differences, performing some degree of calibration in our overall synthesis. That essentially relies on the premise of *unbroken sequences* – in Britain from AD 43–410, or beyond (on either side). The question is how to detect them, and what to do with them when you've got them. Unbroken sequences might imply unbroken (and not necessarily distinguishable) artefact populations. There may be times when items are in greater or lesser supply (see below) or pottery styles change more or less rapidly while a site is occupied. In theory the result of finely-dated sequences becomes the problem of how to detect annual change (or at least more frequently than pottery, even samian, might permit), or *any* sort of change if pottery or coin is not necessarily there, but we can be sure that people were. In this context the suggestion that certain artefacts recurring in combinations can reveal end-of-4th-century signatures, is worth noting (Cool 2000, 51, *cf* Cool and Baxter 2002). Is the same principle apparent in the countryside?

The power of 20 (or XX): part 3

On these grounds, in a search for 'long sequence' we examine a rural site that presents a picture of continual occupation for some 370 years, from AD 30–340 (Jarrett and Wrathmell 1981, a site report pulled from the library shelf purely at random). There are five timber building phases in the first 105 years before the transition to stone, which some might see as marking the creation of a villa. The full sequence is given for completeness (Table 5.6).

Arithmetic suggests the *timber* buildings last an average of 21 years each – again astonishingly close to an anticipated replacement rate of 20 years using 'dead-reckoning'. The implications of this 'rule of thumb' for rural archaeology are particularly intriguing; virtual and actual building rates match, whether in a 'small town' like Chelmsford or a rural site like Whitton. What you see is what you get … if you have a long-enough sequence.

Phase	Date	Duration (yrs)	Remarks
I	30–55	25	Building in Timber
II	55–70	15	Rebuilding in Timber
III	70–95	25	Rebuilding in Timber
IV	95–115	20	Rebuilding in Timber
V	115–135	20	Rebuilding in Timber
VI	135–160	25	Rebuilding in Stone
VII	160–230	70	Rebuilding in Stone
VIII	230–280	50	Rebuilding in Stone
IX	280–300	20	Rebuilding in Stone
X	300–340	40	Rebuilding in Stone

Table 5.6: Whitton, S Wales: replacement rates of timber buildings (source: Jarrett and Wrathmell 1981)

Conclusion

This paper has been something of an exercise in epistemology. It has examined, and where necessary 'decompressed', sequences of timber buildings from several different urban sites. It has done so by matching two different sorts of data: those derived from the study of how fast earth-fast timbers decay, and those from excavation reports that say how long timber buildings lasted, in order to test the accuracy of published statements regarding dating. As a result, by using *all* the data to hand in the archaeological record and showing when buildings are replaced (or not), published date-ranges can be calibrated. Excavators' assumptions regarding continuity can be confirmed by use of this rigorous procedure – or in one instance if not verifiably overturned, certainly highlighted as a major feature which needs to be addressed.

That better definition of joins and gaps in context has considerable implications for the study of artefact chronologies. It should be possible, once longevity and residuality (not the same thing) are taken into account, to show (and to quantify) not only what sorts of artefact are present in an assemblage appropriate to a particular class and date of site (*cf* Willis 2005), but also what are not. It is up to the finds specialist to take these points on board, not only in pondering the status and functioning of a site, but also the supply and longevity of terra sigillata.

This narrow study has moreover confined itself to sites in Britain, supplied by the Gaulish kilns, but a broader one based on (re)analysis of sequences at similar sites with timber phases in neighbouring North-Western Provinces could very probably have yielded the same sorts of result, in terms of delimiting joins and gaps in occupation. It has also confined itself to sites where timber buildings exist – mainly the early levels of sites, and moreover all from the Lowland Zone of Britain. Masonry buildings might be thought to be another matter altogether. These are less often replaced and occur in the Highland Zone (or the upper levels of site sequences). One might therefore despair that it may not be possible to date (dis)continuous occupation of these as accurately.[4] Still, those who have to treat of terra sigillata and other forms of evidence from the later levels of sites in Britain – or indeed its Highland Zone – may take heart from the corpus of terra sigillata largely derived from the Mediterranean, an area where timber structures are rare (Oxé *et al* 2000). Such an astonishing achievement shows what can be done.

Appendix: Dating rural sites

Up to now we have been navigating our way by familiar landmarks and maps (so to speak). We ought to be able to do so by compass. What I would like to do is to suggest some implications; for if trees and timber buildings don't lie, then looking at (and for) the joins and the gaps between phases and sites, we should be able to populate (and date) a 'virtual' and an 'actual' landscape.

Not all rural sites are long-lived or consist of structures superimposed at a single focus, like Whitton. Some, perhaps most, 'wander'. The persistence of sites in the same place (continuity) implies deliberate policy, and this has implications for our understanding of agencies controlling where persons stay or go within a landscape. Only with a transition to building in stone does the possibility of a statement of permanent residence and enduring political power arise. The need to question assumptions of classical urban stability is now being recognised (eg Purcell 2005), and the same should apply to the Mediterranean countryside. The concepts of gaps in British rural occupation sequences and of settlement shift were raised at a very general level rather earlier but few reports on Roman sites address either topic in detail, and certainly not using the principles advocated here (C Taylor 1983, 83, 97). One such exception is Barton Court Farm, Oxon, where the report explicitly recognises a gap of 'a century or more' between settlement phases (1st century BC –1st century AD; 1st–2nd century AD; late 3rd–4th century AD: Miles 1984, 49 and fig 4). Another example of this phenomenon within the same region (though not commented on) is Frocester Court villa, Gloucs (Price 2000), which presents a series of three timber buildings from the later 1st century until AD 275 (Periods 3.1–3) followed by rebuilding in stone (Period 3.4).

So – where are the missing phases? Surface scatters of pottery and other material elsewhere within the same territory (estate, *pagus*) may represent these, and that requires greater precision in dating if chronologies of shift are to be understood. If we cannot demonstrate continuity from one structural phase to another which itself may be

precisely dated, we must think in terms of buildings being replaced away from their original site, or the settlement being abandoned. Our paradigm of timber decay cannot stop being valid merely because the area of analysis has shifted – if physical laws are immutable, explanations are necessary. Certainly we may envisage, in areas of timber building, episodic processes of settlement shift and a much more mobile landscape.

Let us turn to developments in *Galla Belgica*. In the Aisne Valley, Picardy, the overall balance of samian from surface assemblages has been used as a guide to dating the underlying stratigraphy (Haselgrove 1985, quoted in Orton *et al* 1993, 214). In that province settlement shift occurs approximately every 25 years (eg Roymans 1996, 53) and 'apparently cyclical' rebuilding of many settlements in early medieval northern Europe also occurs every 25 years or so (Hamerow 2002, 105). That is ascribed to the death of the head of a household and the new generation establishing a new farmstead; or a need to avoid soil impoverishment. Perhaps we too should consider social practice as a mechanism for relocation: basal posts might decay but providing the roof is sound, the integrity of a timber superstructure may not be affected as it is the truss, not the posts, that keeps the walls together (I am grateful to Dr Pauline van Rijn for this point). Nonetheless signs of decay might present in the interior of a house especially the lower portions of the walls: in some societies this is linked with uncleanliness, and repair, even dismantling of the structure, is the solution (*cf Leviticus* 14.34–45).

According to our now-familiar 'rules of thumb', a single farmstead built *c* AD 50, and relocating every 20–30 years should produce 13–19 discrete sites. [5] While these could be identifiable by fieldwork, recent work casts doubt on the ability of ceramic experts always to date assemblages sufficiently precisely, and this in turn affects interpretation. There are times when pottery is scarce, meaning there are good reasons to expect gaps in the ceramic record, and that might affect detection rates for, say, fieldwalking (Going 1992, fig 5). It is to this that we now turn. There are seven of these episodes of ceramic scarcity affecting building dates, thereby, for a theoretically continuous site of AD 50–410, reducing the number of potentially ceramically recognisable and datable site rebuilds on a 20-year replacement cycle to 12 before fieldwork has even started (and so for 25- or 30-year replacement cycles, the episodes of ceramic scarcity reduce the potential number of ceramically datable site rebuildings to 10 and 7 respectively).

Thus, of 13 to 19 possible phases of building activity potentially discernible as field scatters of pottery, we may be missing five to seven potential sites simply because of 'market conditions' before fieldwork has even begun. The odds appear stacked against us, especially were such conditions to combine with other circumstances: should we consider at such times the additional possibility of turf or cob structures whose inhabitants used no pottery whatever for several decades, and so 'invisible' to fieldwalking? We need a case study in surface collection to examine the concept of the anticipated and the actual a bit further

(essentially the approach of Groube and Bowden 1982, but there worked over a much longer time-scale).

Essex offers the advantages of ceramic compatibility with Chelmsford (Caesaromagus) and a published set of criteria for fieldwalking. Traditionally, villas and the colonia of Camulodunum dominate the regional historical narrative, rather than isolated farmsteads or 'small towns'. By 1994, 1,000 hectares (2,471.05 acres) of the county's total 367, 384-acre landmass (148, 678 hectares) had been surface-collected, as dictated by the needs of development. The signature assemblage of a typical Roman site comprised pottery (*c* 21g / hectare; small, abraded and undiagnostic, but spanning the entire period from the early 1st to the late 4th centuries); tile (113g); and brick (2.55g), and occasional fragments of lava and pudding-stone quern (Medlycott and Germany 1994, esp 16–17, 27–8; tables 2 and 4). But the Essex survey did not date individual sites within the Roman period so that we cannot differentiate trends, given the small pottery assemblages, for ceramic building material (total 115.5g) was five times more likely to be collected than pottery. If sites used thatch or shingles as roofing material, or were occupied at a time of pottery shortage, they might well escape notice altogether. But we can at least be thinking in terms of our numbers of hypothetical timber buildings – the area is chronically short of building stone – and comparing what we ought to have with what we actually get in such a 'Roman' landscape.

In terms of comparable material culture, the most common identifier of early Imperial sites in the *suburbium* around Rome, is terra sigillata (and marble wall veneers); it is more restricted inland (Witcher 2006, 109). In Essex, fieldwalking in the late 1980s–90s was carried out inland, not on the coast, and so was biased towards the Boulder Clay (which comprises 34% of the county), with less on the sands and gravels (21%). In the Westland north of the mouth of the Meuse, multi-tier fieldwork suggests 2 sites/km², and probably contemporaneous (Bloemers 1983, 171; but see also Bloemers 1989, 187, where 1 site/0.185–0.455 km² is given). Certainly any serious discrepancy from the territory of the *Cananefates* would require explanation (I bring in this comparable region because the soil conditions may not be so different). Settlement density in the Essex Coast might well be higher than we think (and perhaps approach that on the opposite coast of the North Sea).

Etrurian villas used many sorts of building stone, along with adobe and thatch, which might in theory mean less visible sites were missed. Building material also formed the signature for stone-starved Essex sites, but this was ceramic roofing not walling material, and as said, outstripping the pottery assemblages found. In Essex, 1 Roman site / 40 hectares walked was identified, i.e. 1 site/ 0.4km² (that total is revised from 40 to 38 hectares in Medlycott 2005, 7. The data now available in Timby *et al* 2007 do not change the picture presented here). No consideration was given to building materials other than tile (neither marble veneers were reported nor finewares per se)[6] and no further chronological distinction was made within the Roman period. It would be interesting to attempt further refinement

on the basis of samian ware as much for compatibility as for chronology but the opinion is that the Essex pottery as a whole either is too abraded to allow this or apparently just not there (which begs many more questions). The modest Dutch assemblages apparently present no such difficulty (Bloemers 1983), and other researchers have claimed on the basis of subsequent multi-tiered fieldwork in the same Essex Clay plateau that rural population declined in the Romano-British period (Framework Archaeology 2008, 143, 150). We cannot provide detailed chronological trajectories from fieldwalking it seems (some might think otherwise) – that is apparently up to excavation to refine. Nonetheless, it provides a *sort of* cultural control – just as *Domesday* might provide a reflection of the carrying capacity of the land using pre-industrial technology. In Essex, fieldwalking identified 29 Roman sites (out of a total of 160 of *all* periods): 24 on Boulder Clay; 3 on sand and gravel; 1 on Brickearth; and 1 on London Clay.

Such an observed total of 29 Roman fieldwalking sites could perhaps be considered against the theoretical total of rebuildings dictated by settlement shift. Assuming stable population, a single farmstead relocating every 20–30 years might produce 13–19 separate foci. All that fieldwalking has produced slightly over the equivalent of two farms and their shifting foci! Fieldwalking might triple the total of sites then known in the Essex County HER to 52, 000 sites of all periods. And if 25% of the sites discovered by fieldwalking *are* Roman, one might anticipate that of a notional total of 52,000 sites for the county of all periods, 13,000 would pro rata be of the Roman period. It ought to be possible to define some overall chronological trends in rural settlement from such a total.

But (assuming 13 phases of separate settlement shift for a single farm, each obligingly spaced 20 years apart during the Roman period, and so dividing by 13), that potential 13,000-site total really means we could be looking at a maximum of 1,000 farmsteads and villas in Essex. By comparison *Domesday*, a potential arbiter of sorts, lists 840 manors (Powell 1990, 5–6). So not only are we not too far off that limit in the Roman period, we might quite possibly have *exceeded* the total number of settlement units in 1086 by < *c*20%. Which does *not* mean we should stop fieldwork; the maximum may not have been reached (for the suggestion that the overall Roman population exceeded *Domesday*: C Taylor 1983, 106).

Conclusion: seeing the wood and *the trees*

The above is perhaps a minimalist case – not all Essex buildings were of timber, and if the exercise of surface collection were to be repeated over a long period the total of sites could be revised upwards. And periods of ceramic shortage (or the use of thatch or shingle) could mean that we might miss six of these 13 sites. And as the veracity of *Domesday* itself is in dispute, we could revise its *own* total upwards too using the results of sites from fieldwalking (but for the appalling rarity of Late Saxon wares in surface collection).

So being cautious, we might boost this total of Roman sites in Essex by (say) 100%. Indeed reassessment of the Essex fieldwalking programme in the light of subsequent work suggests that this premise is broadly correct; the technique of surface collection found 46% of sites subsequently presenting with subsurface cut features upon stripping of the topsoil, or 1 site/38 ha walked. The technique can (and should be) validated by other techniques (*cf* Medlycott 2005, 8), which may themselves require calibration. A 15km-long linear transect on clay was notably unproductive of late-Iron Age and Roman sites, and Roman sites appear to decline during the Roman period, possibly because the land was marginal (Dale *et al* 2005).

How does this picture of settlement density compare with that round Rome, the Metropolis? Its hinterland would (one assumes) be exploited as much as possible for the purposes of feeding the city, just as in Britain it would be exploited equally intensively, but for the purposes of paying taxes to Rome. Fieldwalking in Etruria has identified 3 sites / km^2 in the *suburbium* and 0.1 site / km^2 inland. In the coastal areas, villas rather than farms dominate the first centuries BC/AD; both decline by the 2nd century (Witcher 2006, 110, 113). In terms of overall settlement density, as 1 km^2 = 100 hectares (or 100,000m^2), Essex presents with 1 site actually contacted/38 ha surface-walked, or 1 site/2.63 km^2. For reasons stated above, we might upgrade that total by (say) 100% to 1 potential site/1.315 km^2. Already we are beginning to approach the Dutch level of 2 sites/km^2, suggesting that we may yet determine the carrying-capacity of a landscape-type using pre-Industrial agricultural technology.

There are sites and sites of course, and Essex is not Etruria (let nobody tell you otherwise). But nonetheless – with a lot of ifs, buts and gaps, and lying behind it all, the Roman pottery with its precise dating when enough of it *can* be contacted, and (no doubt) quantities of our decaying trees that don't lie when it *cannot* be – the level of settlement density in the remoter part of the civitas of the Trinovantes as a whole (and the hinterland of *Colonia Claudia Victricensis Camuloduno* in particular) probably compares reasonably well in our simulation not only with the Netherlands but also with the interior of Etruria, where the field-evidence is rather more plentiful, more visible, undoubtedly more stylish – and partly dated by samian.[7]

Now that *is* surprising. Or not, given the zeal the Romans had for exploiting things (and people). What I *do* find surprising is that nobody has tried to use the information on timber decay-rates (see the main part of this paper) for any purpose whatever in Roman archaeology. It is not exactly rocket-science, and if I can cope with the maths, anyone can. What we do need to do is to identify a rural settlement whose movements can be tracked *on the ground*.

Notes

1 There is a further connection, in that a pit full of samian dated pre-AD 10 was uncovered at Cumae in 1873 (Oxé *et al* 2000, 32). For the recipient of this volume, who has been working

on samian dated *c* AD 50–65 from a pit at La Graufesenque, the 'Fosse Malaval', this will have a certain resonance.

2 For a broader approach, see Biers 1992. The present text excludes literature on dating in other than English, with one exception, which is translated into French. (Incidentally the French phrase '*préciser une date*' nicely captures this desire for accuracy).

3 Some may find this outrageous. But Brian Hartley, who like the recipient of this paper knew a thing or two about samian chronology, would often quote 'Silver Blaze', a Sherlock Holmes story of 1892: '...Is there any point to which you would wish to draw my attention?'. 'To the curious incident of the dog in the night-time.'. 'The dog did nothing in the night-time.'. 'That was the curious incident,' remarked Sherlock Holmes...'.

4 Neal (2003) is an example of reassessment of the chronology of a masonry building at Verulamium. Here two separate periods (building with mosaics and corn-drying oven that allegedly cut it) have been shown to be a single set of structural features – a hypocaust into which an overlying mosaic has collapsed. Assessment of the mosaic and the associated finds have downdated the remains from late 4th-century to Severan/3rd-century.

5 Such 'natural' settlement shift might be difficult to distinguish from the forced relocation of settlements. Tracking them – shifting or forced – is no small problem; the author knows of no studies using predictive models. Movement within a unit could be eg linear (as with many medieval villages) or cyclical (as at Mingies Ditch, Oxon in the Iron Age (Allen and Robinson 1993, fig 40)), or random. In the period under consideration sheer settlement density might restrict the number of available (or permitted) relocation sites in the landscape. But if sites were relocated as at Vorbasse in central Jutland, where settlement shifted within a very limited zone (*cf* Randsborg 1991, 75 and fig 43), then not only would material collected during fieldwalking be greater, but distinctions would be broadly visible within the assemblage.

6 For a guesstimate restricting the availability of marble to the top 10% of rural sites: Isserlin 1998, 146. That hierarchically-based rarity might be borne in mind when considering the apparent rarity of samian.

7 It might be possible to boost the Essex total still further. The total of 1,000 potential farmsteads and villas for Essex should be compared with the most recent exercise which has identified *c* 28,000 probable and 117,000 possible Roman rural sites nationally (J Taylor 2007, 13, 23).

Acknowledgements

This paper has been scrupulously read by Dr M G Spratling and C R Wallace, who also struggled with my dreadful bibliography. I thank them, and Drs E C Harris and J Timby for information and also Ms M Medlycott, and Drs P Halkon, F Kemmers, P van Rijn and P R Wilson for comment on the text. I am especially grateful to Dr Pauline van Rijn (of BIAX Consult, Amsterdam, a specialist in archaeological timbers) for discussion about timber buildings. Of course, none of them should be considered responsible for the use made of their comments, or the views expressed here – or for the epigraph at the start of the paper.

Bibliography

Allen T G, and Robinson M A, 1993. *The prehistoric landscape and Iron Age enclosed settlement at Mingies Ditch*, Oxford Archaeol Thames Valley Landscapes 2, Oxford

Allison, P, 2004. *Pompeian households. An analysis of the material culture*, Cotsen Inst Archaeol, UCLA, Monogr 42, Los Angeles

Allison, P, nd [2004]. *Pompeian households. An online companion*, (http://www.stoa.org/projects/ph/house?id=30); accessed 15.07.09

Atkinson, D, 1914. A hoard of samian ware from Pompeii, *J Roman Stud* 4 (1), 26–64

Baillie, M G L, 1995. *A slice through time: dendrochronology and precision dating*, London

Barker, P A, 1977. *Techniques of archaeological excavation* (1st ed), London

Biers, W R, 1992. *Art, artefacts and chronology in classical archaeology*, London

Black, E W, 1985. The dating of relief-patterned flue-tiles, *Oxford J Archaeol* 4, 353–76

Blagg, T F C, 2002. *Roman architectural ornament in Britain*, Brit Archaeol Rep Brit Ser 329, Oxford

Bloemers, J H F, 1983. Acculturation in the Rhine/Meuse Basin in the Roman period: a preliminary survey, in *Roman and native in the Low Countries: spheres of interaction* (eds R Brandt and J Slofstra), Brit Archaeol Rep Int Ser 184, 159–210, Oxford

Bloemers, J H F, 1989. Acculturation in the Rhine/Meuse Basin in the Roman period: some demographical considerations, in *Barbarians and Romans in north-west Europe from the later Republic to late Antiquity* (eds J C Barrett, A Fitzpatrick and L Macinnes), Brit Archaeol Rep Int Ser 471, 175–234, Oxford

Brigham, T, 1990. The late Roman waterfront in London, *Britannia* 21, 99–183

Carver, M O H, 1993. *Arguments in stone: archaeological research and the European town in the first millennium*, Oxford

Cool, H E M, 2000. The parts left over: material culture into the fifth century, in *The Late Roman transition in the North: papers from the Durham Archaeology Conference 1999* (eds T Wilmott and P A Wilson), Brit Archaeol Rep Brit Ser 299, 47–65, Oxford

Cool, H, 2002. An overview of the small finds from Catterick, in *Cataractonium. Roman Catterick and its hinterland* (ed P Wilson), Counc Brit Archaeol Res Rep 128, 24–43, York

Cool, H E M, and Baxter, M J, 2002. Exploring Romano-British finds assemblages, *Oxford J Archaeol* 21, 365–80

Creighton, J, 2006. *Britannia. The creation of a Roman province*, London

Crummy, P, and Terry, R, 1979. Seriation problems in urban archaeology, in *Pottery and the archaeologist* (ed M Millett), 49–60, London

Dale, R, Maynard, D, and Compton, J, 2005. Archaeology on the mid-Essex clay. Investigations on the A130 by-pass: A12 Chelmsford by-pass to the A127 Southend Arterial Road, 1991–4 and 1999–2002, *Essex Archaeol Hist* 36, 10–54

Dannell, G, 2005. A Study in Scarlet: samian pottery and the Claudian invasion, in *An archaeological miscellany: papers in honour of K F Hartley* (eds G B Dannell and P V Irving), *J Roman Pottery Stud* 12, 64–82, Oxford

Davies, B, Richardson, B, and Tomber, R, 1994. *A dated corpus of early Roman pottery from the City of London*, Counc Brit Archaeol Res Rep 98, York

Down, A, 1981. *Chichester Excavations 5*, Chichester

Framework Archaeology, 2008. *From hunter gatherers to*

huntsmen. A history of the Stansted landscape, Framework Archaeology Monogr 2, Oxford

Frere, S, 1972. *Verulamium excavations vol I*, Rep Res Comm Soc Antiq London 28, London

Frere, S, 1983. *Verulamium excavations vol II*, Rep Res Comm Soc Antiq London 41, London

Fulford, M G, and Timby, J R, 2000. *Late Iron Age and Roman Silchester, excavations on the site of the Forum-Basilica 1977, 1980–6*, Britannia Monogr 15, London

Going, C J, 1992. Economic 'long waves' in the Roman period? A reconnaissance of the Romano-British ceramic evidence, *Oxford J Archaeol* 11, 93–117

Groube, L M, and Bowden, M C B, 1982. *The archaeology of rural Dorset: past, present and future*, Dorset Natur Hist Archaeol Soc Monogr 4, Dorchester

Groves, J, 1996. Ceramic studies – dating, in G Milne and A Wardle, Early Roman development at Leadenhall Court, London and related research, *Trans London Middlesex Archaeol Soc* 44, 14–27

Hamerow, H F, 2002. *Early medieval settlements*, Oxford

Harris, E, and Reece, R, 1979. An aid for the study of artefacts from stratified sites (= Contribution à l'étude des artefacts provenants de sites stratifies), *Archéologie en Bretagne* 20–1, 27–34

Hartley, B R, 1966. Dating town buildings and structures, in *The civitas capitals of Roman Britain* (ed J S Wacher), 52–9, Leicester

Hartley, B R, 1969. Samian ware or terra sigillata, in *The archaeology of Roman Britain* (eds R G Collingwood and I A Richmond), 235–251, London

Haselgrove, C, and Millett, M, 1997. Verlamion reconsidered, in *Reconstructing Iron Age societies: new approaches to the British Iron Age* (eds A Gwilt and C Haselgrove), 282–96, Oxford

Haselgrove, C, Millet, M, and Smith, I, 1985. Inference from the ploughsoil, in, *Archaeology from the ploughsoil* (eds C Haselgrove, M Millet and I Smith), 7–30, Sheffield

Hobley, A, 1998. *An examination of Roman bronze coin distribution in the Western Empire AD 81–192*, Brit Archaeol Rep Int Ser 688, Oxford

Hurst, J G, 1963. White Castle and the dating of Medieval pottery, *Medieval Archaeol* 6–7, 135–55

Isserlin, R M J, 1998. A spirit of improvement? Marble and the culture of Roman Britain, in *Cultural Identity in the Roman Empire* (eds J Berry and R Laurence), 125–55, London

Isserlin, R M J, and Wickenden, N P, forthcoming. *Excavations at Caesaromagus III: The tenements and other sites in the NW quarter:* Counc Brit Archaeol Res Rep

Jarrett, M G, and Wrathmell, S, 1981. *Whitton: an Iron Age and Roman farmstead in South Glamorgan*, Cardiff

Jones, R H, 2009. Chasing the army: the problem of dating camps, in *First contact. Rome and northern Britain* (eds D J Breeze, L M Thomas and D W Hall), Tayside Fife Archaeol Comm Monogr 7, 21–7

Macdonald, G, 1935. The dating value of samian ware: a rejoinder, *J Roman Stud 25*, 187–200

Manley, J, and Rudkin, D, 2005a. *Facing the palace – excavations at Fishbourne (Sussex, UK), 1995–99*, Sussex Archaeol Collect 141

Manley, J, and Rudkin, D 2005b A Pre-A.D. 43 Ditch at Fishbourne Roman Palace, Chichester, *Britannia* 36, 55–99.

Medlycott, M, and Germany, M, 1994. Archaeological fieldwalking in Essex; interim results, *Essex Archaeol Hist* 25, 14–28

Medlycott, M, 2005. *Archaeological fieldwalking in Essex, 1986–2005*, (www.planarch.org/downloads/library/archaeological_fieldwalking_in_essex.pdf); accessed 07/2009

Miles, D, 1984. *Archaeology at Barton Court Farm, Abingdon, Oxon*, Counc Brit Archaeol Res Rep 50, London

Milne, G, 1985. *The Port of Roman London*, London

Morgan, J W W, 1975. The preservation of timber, *Timber Grower* 55, 17–26

Neal, D S, 2003. Building 2, Insula XXVII from Verulamium: a reinterpretation of the evidence, in *The archaeology of Roman towns* (ed P R Wilson), 195–202, Oxford

Orton, C, 1982. *Mathematics in Archaeology*, Cambridge

Orton, C, 1985. Diffusion or impedance – obstacles to innovation in Medieval ceramics, *Medieval Ceramics* 9, 21–34

Orton, C, and Orton, J, 1975. It's later than you think: a statistical look at an archaeological problem, *London Archaeol* 2 (11), 285–7

Orton, P, Tyers, P, and Vince, A, 1993. *Pottery in archaeology*, Cambridge

Oxé, A, Comfort, H, and Kenrick, P, 2000. *Corpus Vasorum Arretinorum (Antiquitas Reihe 3, Bd 41)*, Bonn

Peña, J T, 2007. *Roman pottery and the archaeological record*, Cambridge

Peña, J T, and McCallum, M, 2009. The production and distribution of pottery at Pompeii: a review of the evidence; part 2, the material basis for production and distribution, *American J Archaeol* 113 (2), 165–201

Perrin, J R, with Wild, F and Hartley, K F, 1996. The pottery, in D Mackreth, *Orton Hall Farm: a Roman and Early Saxon farmstead*, E Anglian Archaeol 76, 114–204, Cambridge

Powell, W R, 1990. *Essex in Domesday Book*, Chelmsford

Price, E G, 2000. *Frocester: a Romano-British settlement, its antecedents and successors*, Gloucester

Purcell, N, 2005. Statics and dynamics: ancient Mediterranean urbanism, in *Mediterranean urbanization, 800–600 BC* (eds R Osborne and B Cunliffe), Proc Brit Acad 126, 249–72, Oxford

Randsborg, K, 1991. *The first millennium AD in Europe and the Mediterranean*, Cambridge

Richardson, B, with Green, C M, 1986. Pottery, in L Miller, J Schofield and M Rhodes, *The Roman quay at St Magnus House, London. Excavations at New Fresh Wharf, Lower Thames Street, London 1974–78*, London Middlesex Archaeol Soc Spec Pap 8, 96–138, London

Richmond, I A, 1961. Roman timber building, in *Studies in building history. Studies presented to B.H. St. John O'Neil* (ed E M Jope), 1–26, London

Roymans, N, 1996. Regional dynamics in the romanisation of Belgic Gaul and the Rhineland area, in *From the sword to the plough: three studies on the earliest romanisation of Northern Gaul* (ed N Roymans), 9–126, Amsterdam

Taylor, C C, 1983. *Village and farmstead: a history of rural settlement in England*, London

Taylor, J, 2007. *An atlas of Roman rural settlement in England*, Counc Brit Archaeol Res Rep 151, York

Timby, J, Brown, R, Biddulph, E, Hardy A, and Powell, A, 2007. *A slice of rural Essex: recent archaeological discoveries from the A120 between Stansted Airport and Braintree*, Oxford Wessex Monogr 1, Oxford

Todd, M, 1982. Dating the Roman Empire, in *Problems and case studies in archaeological dating* (ed B Orme), 35–56, Exeter

Vanderhoeven, A, Martens, M, and Vynckier, G, 2001. Romanization and settlement in the central part of the *Civitas*

Tungrorum, in *The impact of Rome on settlement in the Northwestern and Danube Provinces* (eds S Altekamp and A Schaefer), Brit Archaeol Rep Int Ser 921, Oxford

Wacher, J, 1995. *The towns of Roman Britain* (2nd ed), London

Wallace, C, 2006. Long-lived samian?, *Britannia* 37, 259–72

Ward-Perkins, B, 1981. Two Byzantine houses at Luni, *Papers British School at Rome* 49, 89–98

Warry, P, 2006. A dated typology for Roman roof tiles (*tegulae*), *J Roman Archaeol* 19, 246–65

Willis, S, 2005. *Samian pottery, a resource for the study of Roman Britain and beyond: the results of the English Heritage funded samian project. An e-monograph*, Internet Archaeol 17 (http:// intarch.ac.uk/journal/issue17/willis_toc.html)

Witcher, R, 2006. Settlement and society in early imperial Etruria, *J Roman Stud* 96, 8–123

6 The portrait of the potter Calus: a potter priest at La Graufesenque?

Allard Mees

Introduction

Brenda Dickinson's work on the samian of La Graufesenque has long been marked by her admiration for the potter Calvus. It was never thought, however, that her exclamation 'C(alvus) B(less) H(im)' would one day be echoed by one of the most intriguing finds from the production site.

Fifteen fragments of a bust made of red terra sigillata with an inscription *CALVS* written in yellow slip on the base rim were found in 1981 close to the *fanum* in La Graufesenque (Figs 6.1–3).[1] The portrait-head (hereafter referred to as a bust) had an estimated height of *c* 21cm. Remains of more, considerably smaller, letters can be observed on the neck of the bust. An examination in the conservation laboratories at the Römisch-Germanisches Zentralmuseum Mainz in 1996 established that the fragments stem from more than one bust.[2] The base rim also has slip on the underside, indicating that the bust was designed as a stand-alone portrait. Among the samian fragments there are parts of an arm, suggesting that the head was put on a permanent torso, which might also have been made out of samian. In this case, the head could be separated from the torso. Switching heads on statues was a well known phenomenon in the 1st century AD (Pliny, *Historia Naturalis* 35.4–5; Stewart 2003, 47). The hard clay and shiny slip is of the very recognisable normal type of samian that was generally produced in the Claudio–Neronian period.[3]

The bust showing the name of CALVS can be related to the potter Calus in La Graufesenque who produced decorated and plain samian. It is possible that the many stamps with the name Calvus belong to the production of the same potter. In Latin epigraphy it was common that the letter combination 'VV' written in capitals was avoided and only a 'V' was used. Thus, two very similar name versions were in use: Calus and Calvus. It is therefore hard to determine whether they refer to the same potter or not. Matters are made even more complicated by the fact that the name of Calvus occurs on samian datable from the middle of the 1st century AD into the beginning of the 2nd century AD. Such a very long career for a potter seems highly unlikely. For practical reasons, the Leeds Index of Potters'

Stamps has treated each name version separately: Calus i, Calus ii and Calvus i. This name convention is followed here (Hartley 1991, passim; Hartley and Dickinson 2008, 178–195). The products of the Tiberian potter Calus i, which are known from the Tiberian Fosse Cirratus (La Graufesenque), are – as we shall see later in this article – most likely irrelevant for the identification of our bust (Polak 2000, 190).

The plain ware of Calus ii is hardly known from dated sites. A plain vessel find from Templeborough indicates that he must have been active in early Neronian times (Polak 2000, 190, C7). Additionally, his mould signatures identify him as a Neronian–early Flavian mould-maker (Mees 1995, 72, Taf 15–17; Polak 2000, 190). There is no evidence for a start of his mould-making activities in pre-Neronian times. The site records for his moulded ware contain Flavian Nijmegen-Ulpia, Nijmegen Canabae and an early dump at York (Mees 1995, 72; Dickinson and Hartley 1993, 748, 2647). This suggests a continuation of his work until *c* AD 80. The distribution of his mould-signed decorated ware is typical of the Neronian and early Flavian period, with a centre of gravity in Gallia Belgica and Gallia Lugdunensis (Fig 6.4). Since there are no stamps or mould-signed decorations of Calus ii occurring in dated sites after AD 80, this suggests that the workshop which used the name Calus worked only up to that date. The conclusion following from this is that Calus ii stamps are datable between *c* AD 50 and 80.

Calvus i is datable over a much longer period. His plain ware is unearthed in a burnt layer of AD 61 in London and in Camulodunum as well (Polak 2000, 190–1). The end of his career may be marked by finds in graves in Heddernheim and Köln, where Calvus i products were buried together with coins of Trajan (Polak 2000, C15, C40). Therefore, Calvus i can be dated between AD 60 and 110, which fits well with the decoration on form Drag 29s that go with his stamps (*Corpus* 2002, Calvus).

To sum up: there were two names simultaneously in use between AD 60 and 80: one spelt Calus and one spelt Calvus. It is safe to conclude that the person signing

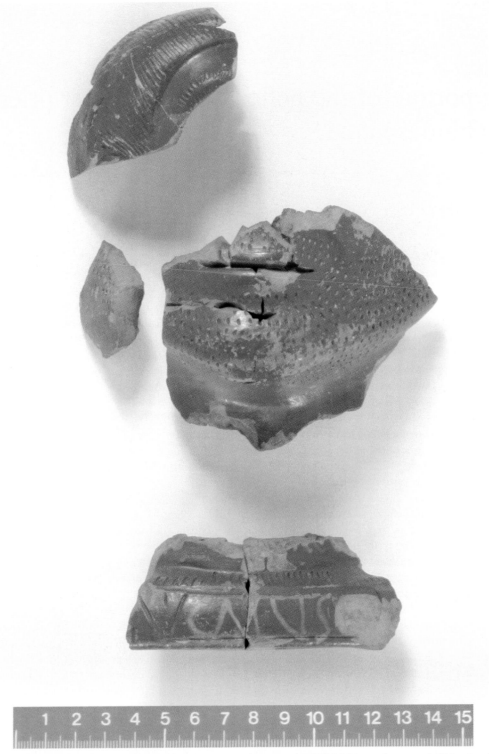

Fig 6.1: Portrait-head of the potter Calus (Fouilles La Graufesenque / RGZM Mainz; photograph V Iserhardt/K Hölzl)

moulds with *calvs.f*, *CALVS* or *CALVO* (see below) started a specialisation in mould-making from AD 60 onwards. After 80 these signed decorations do not occur any more at any dated site. The variations in writing the names (*CALVS* and *calvs.f*) cannot be used as a dating argument, since both versions occur in the same decoration series (Table 6.1; Mees 1995, Taf 15,1).

It is generally assumed that this sort of specialisation

on more difficult – and more expensive – forms can be seen in the later stage of the career of other potters at La Graufesenque, suggesting a higher-ranked position in their later production period (Polak 2000, 152). This fits with the observation that one of the vessels signed *CALVO* within the decoration was actually not produced by him: there was a stamp of the potter Patricius attached to the rim (Mees 1995, Taf 17,1). This strongly points towards a higher-

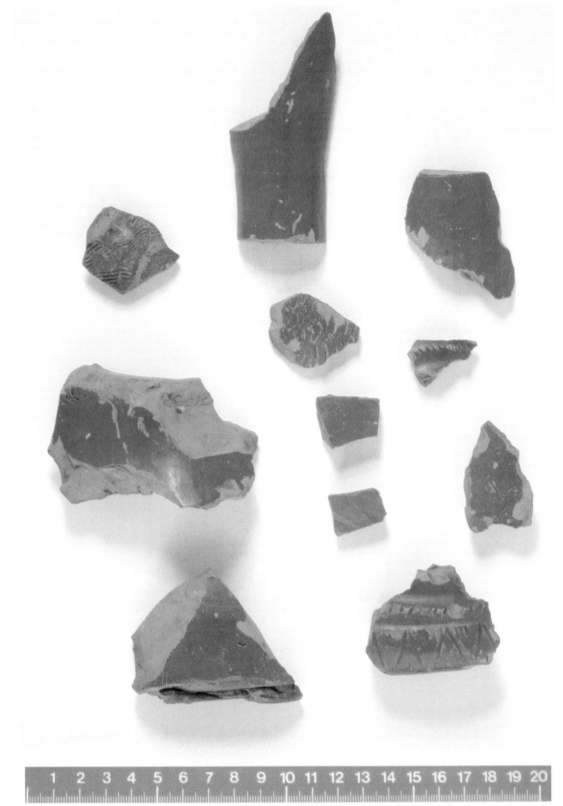

Fig 6.2: Additional fragments found together with the head of the potter Calus (Fouilles La Graufesenque/RGZM Mainz; photograph V Iserhardt/K Hölzl)

ranked position within the potters' hierarchy from that time onwards. Our bust would fit well within that scenario. From the fact that he belonged to the approximately 90 out of a total of nearly 500 potters who were able to cope with the sophisticated production process of decorated mould-made samian, Calus must have been one of the more important persons at the production site of La Graufesenque.

Fig 6.3: Location of the findspot of the head of Calus (after Polak 2000, 24, fig 2, 10)

Fig 6.4: Distribution map of decorated samian of the potter Calus (Mees 2007, pl 22)

Mees 1995, Taf. 15,1 Mees 1995, Taf. 15,3 Knorr 1942, Abb. 2

Knorr 1942, Abb. 1

Mees 1995, Taf. 16,2 Mees 1995, Taf. 16,1

Mees 1995, Taf. 16,3 Mees 1995, Taf. 16,3 Online Corpus 0005971

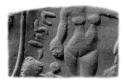

Mees 1995, Taf. 16,8 Online Corpus 0005971 Mees 1995, Taf. 16,7

Fig 6.5: Signatures in small capitals (see text) of Calus ii on decorated samian (signatures taken from Mees 1995, Taf 15–17)

Different mould signatures

Calus signed his decorated moulds in two different styles of handwriting, distinguished here as large and small capitals. As there are not only signatures reading (large capitals) *CALVS* and (small capitals) *calvs.f* associated with the same type of decoration, but also one showing the Gallo-Celtic variant of his name, (large capitals) *CALVO*, we can only conclude that the *formula* of a signature was – like most of the small-capital mould signatures in La Graufesenque – not kept very strict. However, a more detailed examination of the handwritings may give us a clue as to which version is closest to the letters written on the base rim of the bust (Table 6.1; Figs 6.5; 6.6).

In particular, the decoration with both types of signature

Allard Mees

Signature	Description	Reference
calvs.f	small capital letters	Mees 1995, Taf 15, 1; 2; 3; Taf 16, 1; 2; 3; 4; 5; 6; 7; 8; Online Corpus nos 0005971; 1000872
CALVO	large capitals	Mees 1995, Taf 17, 1; Online Corpus no. 2000477
CALVS	large capitals	Mees 1995, Taf 15, 1; 4
CALVS PAS(?)	large capitals	Mees 1995, Taf 16, 9
calvs.f + CALVS	small and large capitals	Mees 1995, Taf 15, 1

Table 6.1: Mould signatures of Calus

Mees 1995, Taf. 15,4

Mees 1995, Taf. 15,1

Mees 1995, Taf. 17,1

Online Corpus 2000477

Mees 1995, Taf. 16,9

Fig 6.6: Signatures in large capitals (see text) of Calus ii on decorated samian (signatures taken from Mees 1995, Taf 15– 17)

(those written in large capitals *CALVS/CALVO* and written in small capitals *calvs.f*) suggests that if there were two different people behind the different handwritings they were at least working in the same workshop. The ovolo which occurs on Drag 30 vessels with the small capital signatures also appears on Drag 37 decorations with signatures in large capitals.

The reading of the signature *CALVS PAS* (?) remains uncertain. However, a tentative explanation could be that this inscription refers to two potters: Calus and Pas(sienus). A remarkable fact is that most of the signatures *CALVS/ CALVO* written in large capitals appear in decoration with a very clear religious connotation. One of the vessels with a signature in large capitals shows the deities Diana,

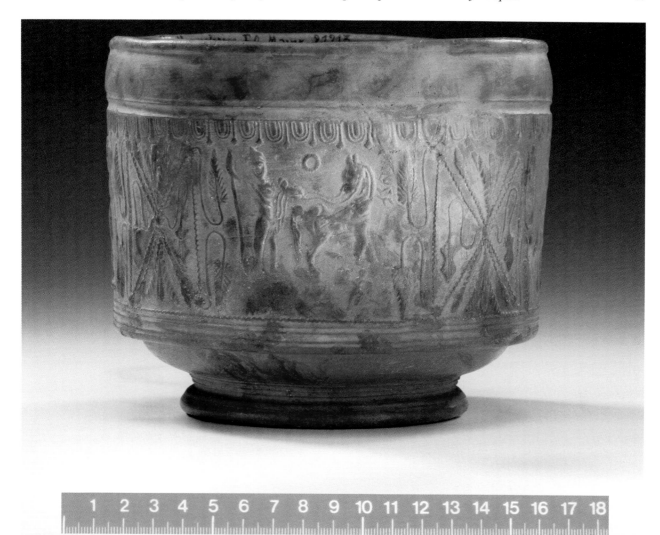

Fig 6.7: Marbled decorated samian vessel from Mainz, signed with small capitals (see text) calvs.f. (RGZM, photograph V Iserhardt/K Hölzl)

Dionysus and Venus among other religious figures which appear on other vessels in a sanctifying ritual context (Mees 1995, Taf 17, 1 and front cover plate). The same point is valid for the decoration where he wrote his name *CALVS* in large capitals underneath a Dionysiac panther (Mees 1995, Taf 15, 1; 4; Jung and Fecher 2006). Hence it is obvious that the vessels signed in large capitals with *CALVS* or *CALVO* were made for special religious occasions. One of these vessels has a highly unusual spout, which indicates that it could also have been used for a religious *libatio* (Mees 1995, Taf 17, 1). Therefore it seems that the real difference between the usage of the signatures *CALVS* and *calvs.f* is the religious environment. When a decoration had a clear religious connotation, the signature written in large capitals was used.

A close look at the letters of the signature on the base rim of the bust suggests that the 'U' is of another type than the 'U' recognisable in the *CALVS* signatures written in large capitals. But since the writing utensils for a small-capital mould signature and slip application are totally different, it would be unwise to draw conclusions from this.

Marbled slip

The collections of the Römisch-Germanisches Zentral-museum in Mainz preserve a copy of a yellowish marbled Drag 30 with an intradecorative signature of Calus written in small capitals (the original was lost in the bombing of Mainz during World War II: Mees 1995, Taf 16, 1 (Inv no. 021213; Fig 6.7)). This vessel is proof that the workshop of Calus was able to produce marbled slip, and would have had access to the special clay needed to produce the yellow colouring for it which was dug at a site called Vignes in the Vallée du Tarn, near the samian production site of Le Rozier (Picon 1996). Decorated and plain marbled samian was sold primarily to the Mediterranean area and is rarely found north of La Graufesenque (Fig 6.8; Table 6.3). Marbled slip was not exclusively used by the workshop of Calus. Nearly 90 ateliers knew how to produce it (Table 6.3).

Marbled slip was mainly used in the Claudian–early Flavian period and there is no proof that the technique was already widely in use in Tiberian times. The argument for a Tiberian starting date (Genin 2006) is based on a stamp

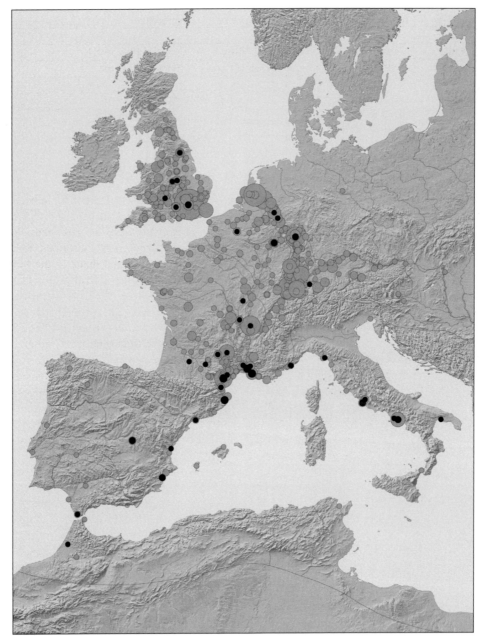

Fig 6.8: Distribution of marbled plain samian from La Graufesenque (black) against the total export of decorated samian (grey) (Mees 2007, pl 2; data on marbled ware kindly provided by G B Dannell)

on a marbled vessel from a Claudian deposit which is said also to occur on a unmarbled vessels in a Tiberian deposit. This might give a clue to the general dating of such a potter, but certainly not to the use of marbled slip. A list of potters recorded in the Leeds Index of Potters' Stamps as having produced plain marbled samian (kindly provided by G B Dannell) clearly shows the basically Neronian–early Flavian dating of this slip technique (Table 6.3). Out of 170 known stamped examples, only seven were made by potters who may have started their career in Tiberian times, but whose products were mainly exported in Claudian–Neronian times. One piece of the potter Votornus found at Tarragona is recorded in the literature and may be dated to the Tiberian period, but the original has never been examined (Tarrats Bou 1992, 256).

There are more examples found in La Graufesenque of yellowish slip letters written on the red samian slip. Among them are a piece which looks like a ladle handle with yellow slip dots (Inv no. G90 S64.2; Fig 6.9) and several fragments of a Drag 18 dish with an unidentified text on it, written with yellow slip (Figs 6.10–11). Both have in common, however, that they cannot be dated with non-ceramic evidence and their meaning is unknown.

Was there a religious function of the Calus bust?

The main pointer towards the function of the bust is its findspot: close to the *fanum* (Fig 6.3). This location suggests a connection with some sort of religious activity. An inscription related to the goddesses of the Caunonnes

flamen	reference	*cassidanos*	reference
Crescens	Marichal 1988, Mar 74	Agedillos	Marichal 1988, Mar 11
Lucius	Lambert 2002, L-30e	Aion (?)	Marichal 1988, Mar 4
Primus	Lambert 2002, L-30e	Legitumus	Marichal 1988, Mar 4; Mar 8
P[...]	Lambert 2002, L-30h	Montanos	Marichal 1988, Mar 2; Mar 11; Mar 19
Sabinus	Lambert 2002, L-30h	Tritos	Marichal 1988, Mar 2

Table 6.2: List of priests occurring in the dockets from La Graufesenque

has been found in the vicinity (David 2007, 178). A little statue of a female goddess, identified as Minerva, and a bird, both made in terra sigillata technique, have also been found in the neighbourhood of the *fanum* (Conti 1998, 150; Vernhet 1993, 178; Schaad and Vernhet 2007, 120, fig 164). Since the bust was not found close to a kiln, there is no reason to believe that it may be linked with the occasionally depicted 'genius of a kiln', a little statue on top of a kiln depicted on classical Greek vases (Milne 1965, 102–113; Brijder 1984, 79, no. 10).

We know from two examples among the docket lists found at La Graufesenque, that potters could have a religious function. One firing list starts with a statement that Lucius was a *flamen* at firing time, the other docket clearly mentions two *flamines*: Sabinus and P[...] (Fig 6.12; Lambert 2002, L30e; L30h). Since on the same position within other *borderaux de enfournement* the expression *cassidanni* followed by potters' names occurs, it is generally accepted that the the Gaulish word *cassidanos* can be translated as 'priest' (Marichal 1988, Mar 2, 4, 8, 11, and 19; Lambert 2002, 111, L-30b). Although knowledge of the Gaulish language is scanty, it is easy to discern two parts within this word. The first section, *cassi*, can be translated as *magistratus sacrarum rerum*. The second part, *dannos*, is thought to be derived from the Gaulish word *don*, meaning 'noble' (Lambert 2002, 110). The priests are all named with their cognomen only, which underlines their peregrine status. Special attention should be paid to the fact that on four dockets the names of two priests are preserved (there can be no doubt about the occurrence of two different priests on Lambert 2002, 136, L-40; the dockets Marichal 1988, Mar 2, 4, and 11, and Lambert 2003, L-30e most likely give two names written after each other). This may fit with a tentative reading of the signature *CALVS PAS* (?) as Calus and Pas(sienus) (Mees 1995, Taf 16, 9). Passienus usually shortened his name by writing PAS (Mees 1995, Taf 169–70). The priest Sabinus mentioned in the docket noted above might well have been the same potter Sabinus who decorated a huge jug displaying a sanctifying scene at an altar. The name of Sabinus is written above this religious motif (Mees 1995, front cover). Other examples of his decorated ware also have – like Calus – very clear Dionysiac connotations (Mees 1995, Taf 168, 3–4; 170, 1; 172, 3).

That a potter could be a priest in pottery villages was nothing exceptional. Clear evidence from *ostraka* found in a temple in Ismant el-Kharab (ancient Kellis) indicates that in a small village a potter could become an important local priest (Fig 6.13; Worp 2004, O.145). The so-called 'Law of Roman Priests of Narbonensis' (*Lex de flaminio provinciae Narbonensis*), inscribed on a bronze plaque found at Narbonne and dated to the Vespasianic period, clearly states that the official priests of the province had the right to set up statues only after their full annual *cursus* (CIL 12, no. 6038). These priests had to pay for such statues from their own pocket (Fishwick 1999, 258). Since similar laws are known from Mellaria, Corduba, Bulla Regia and other places (Fishwick 1999, 256), it is clear that from the beginning of Vespasian's reign, the position of priests was firmly regulated. As a *terminus post quem*, this would well fit with the proposed Neronian-Flavian dating of the head of our Calus bust.

Priests were usually chosen to serve for strictly defined periods. In fact the docket lists from La Graufesenque themselves seem to be reflecting a cyclical counting of firings, which could well match the serving period of the potter priests mentioned in those dockets. After the priest's name Crescens on one of the dockets, there is a 'III' written, obviously indicating 'priest for the third time' (Marichal 1988, 108; Fuelle 2000, 83; Strobel 1992, 43, rejects the idea of any sort of *lustrum* at La Graufesenque). The docket mentioning the priests Sabinus and P[...] can also be completed with a similar repeat number behind the name of Sabinus. Since the next line in this docket shows a calendar date: *XVII K Augustas oneratus est furnus sextus*, the clear conclusion is that the *flamen* indications in the same docket were at least a part of the given dates of each kiln load (Vernhet and Bémont 1991, 12). That priests in La Graufesenque were probably chosen for one year, is a phenomenon known not only from the Narbonne *Lex de flaminio provinciae Narbonensis* but also throughout the Roman Empire (Geiger 1913, 53; Riewald 1920, 1652). It is reported in inscriptions, which show us a *sacerdos annua* (CIL 2, no. 3279;) or a *flamen annuus* (AE 1911, 0022; AE 1968, 0591). From the Greek part of the Roman world examples include an ἀρ[χι]εραβάμευον τρίς (IGR 3, no. 925) and an ἀρ[χι]ραάμευον τῶν [Σ]εβαστῶν τὸ τρίτον (IGR 3, no. 831). Repeat service was also indicated in a similar way to the La Graufesenque dockets: *flamen II* (CIL 2, no. 9773) or *flamen IIII* (CIL 2, no. 3571).

A *cursus* of one year makes sense if one takes into account the seasonal nature of pottery manufacture, where firing started in May and continued until 7 October at the latest (Marichal 1988, 97; Vernhet and Bémont 1991, 14;

Fig 6.9: (above) Ladle handle with yellow slip dots found at La Graufesenque (Fouilles La Graufesenque, photograph Bob Pitts)

Fig 6.10: Fragments of a dish Drag 18 from La Graufesenque with an unidentified text on it. The text is written with yellow slip (Fouilles La Graufesenque, photograph Bob Pitts/K Hölzl)

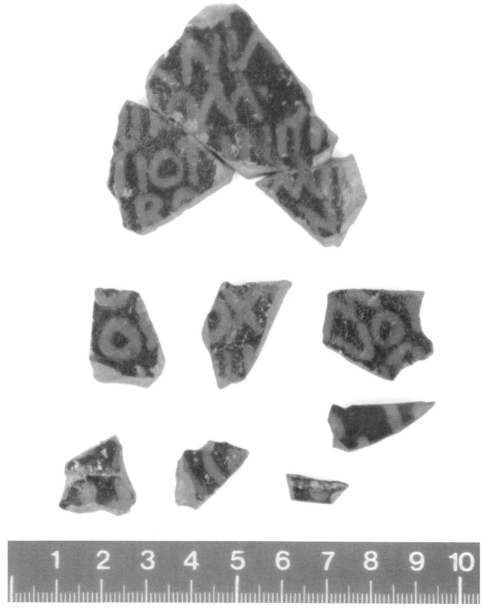

Fig 6.11: Fragments of a dish Drag 18 from La Graufesenque with an unidentified text on it. The text is written with yellow slip (Fouilles La Graufesenque, photograph Bob Pitts/K Hölzl)

Bémont and Vernhet 1993, 21). The Gaulish adjectives to kiln loads (*tuΘos*): *cintux, allos, tritios,* etc (Lambert 2002, 102–9), fit well with a scheme based on a priest's service of possibly one year. They may indicate the kiln load number within the priest's *lustrum* period. Although the few Latin dockets do not preserve the word *lustrum*, the expression *luxtos* in *tuΘos alos luxtos casidanoje]ne Legitimu* may well be considered as an equivalent period superior to the kiln load series numbers (Marichal 1988, 98–9). It is therefore very likely that *luxtos* can be interpreted as the Gaulish equivalent for *lustrum* (Fuelle 2000, 91; Lambert 2002, 112). The only other possible candidate for a *lustrum*-expression would be the celtic word *autagis* (Marichal 1988, 98, no. 1; Lambert 2002, 112). However, it seems more likely that *autagis* means something like 'order of

things', hence in the context of its occurrence on the docket Mar 1 it would indicate: first series of kiln firings, no. 21 (Strobel 1992, 43, n 97).

That the chosen priests were probably also active potters at the same time is shown on two different dockets where Crescens and Tritos are not only listed as being priests, but also recorded as potters delivering pots (Marichal 1988, Mar 2 and 74). However, they should not be confused with the real organiser of the kiln load. This is nowadays thought to be the potter given by the base stamp (Marichal 1988, 106; Polak 1998, 119). The potter priests Agedillos (Marichal 1988, Mar 11) and Montanus (Marichal 1988, Mar 19) are also listed as delivering vessels on other dockets (Agedillos: Marichal 1988, Mar 2, 3; 19, 3; and 35, 8. Montanos: Marichal 1988, Mar 7, 8 and 16, 5). This

Fig 6.12: Composition of a kiln load, written on a Drag 15/17, stamped OF.RVFI. Starting with the text: FLAMINE P[| SABINO FLAMINE [| ... (Polak 1998, 116, fig 1)

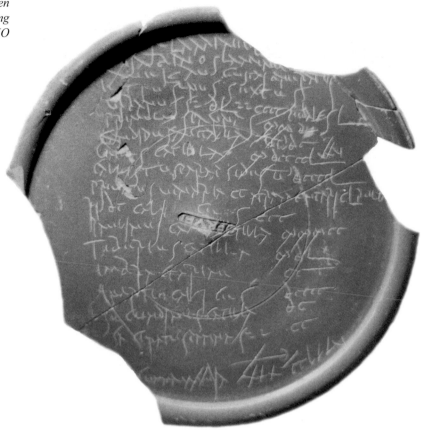

Fig 6.13: Ostrakon from the temple in Kellis, mentioning the potter Psais as a priest (Worp 2004, no. 245)

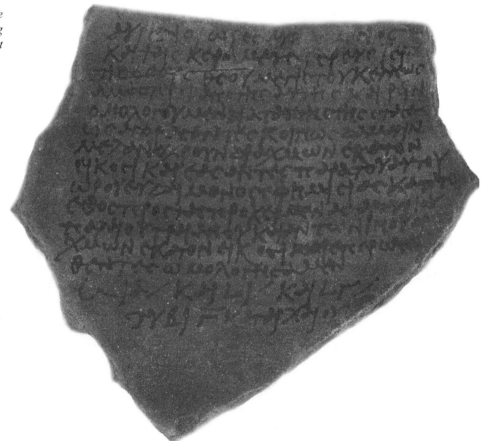

Potter	Die	Form	Dating	Site
Abitus	10a	Ritt 8	45-65	La Graufesenque
Acidus	1-		Neronian	Narbonne
Acutus i	25-	Dish	25-50	Rabastens
Albanus	1-	Dish		Elche
	1-	Dish	60-80	Nimes
Amandus ii	12-	Drag 27		Ampurias
	15a	Drag 18		La Graufesenque
Aper i	5b	Ritt 1		Fos-sur-Mer
	7b	Ritt 9		La Graufesenque
	7b	Drag 27		London
	7-	Dish		Peyrestortes
	11-		50-70	Naples
Apronius i	Unc 1	Ritt 8	20-45	La Graufesenque
Aquitanus	2a	Drag 29	40-65	La Graufesenque
	5a	Drag 18		London
	12a	Drag 27g		La Graufesenque
Ardacus ii	4a'	Drag 27	30-65	Silchester
	4a"	Drag 16 var.		Arles
	4-			Narbonne
	7c	Drag 29		Fos-sur-Mer
	Inc-	Drag 24		Segobriga
Artius	4a	Drag 18		Rodez
Attius i	5-	Ritt 5	Tiberian-Claudian	Mainz
Aucius	Unc 2	Ritt 1	Neronian-Flavian	Neuss
Bassus & Coelus	11-	Drag 27	Neronian-Flavian	Trier
Bionis	2a	Drag 29(?)	55-75	La Graufesenque
	2a	Drag 33		La Graufesenque
	4a	Drag 29		Pompeii
	6-	Drag 16		no provenance
Bollus ii	4a	Drag 15/17 (2)		Trier
	4a	Drag 16		Rodez
	4a	Drag 16		Trier
	4a	Drag 18		Tarragona
	4-			Ampurias
	7-			Ampurias
	Inc-	Dish		Autun
Cabucatus	2a	Drag 29	40-75?	Ostia
Cal-	1a	Drag 27(2)		Roanne
Calus ii	MS	Drag 30		Mainz
Carus ii	13'			Ampurias
Castus i	2-	Drag 18	40-70	La Graufesenque
	10a	Drag 18		Represas
	10-			no provenance
	10-	Drag 18?		Mancetter?
	10-			La Villa Joyosa
	17-	Drag 24		La Graufesenque
	17-	Drag 18		La Graufesenque
	24'	Ritt 8		Bordighera
	Inc-	Drag 15/17		Elche
Celer iii	8a	Drag 15/17 or 18	Neronian-Vespasian	Arles
	8-	Dish		Rome
Chrestus	1a	Ritt 8	Claudian-Neronian?	La Graufesenque
Cosius Iucundus	1a'?	Dish		Fos-sur-Mer
Cocus i	4'	Drag 15		Nimes
	4'	Drag 15	Claudian-Neronian?	Autun
Copiro	1a	Drag 18	Neronian-Vespasian	La Graufesenque
Cosius Vrappus	1a	Ritt 9	50-65	Segobriga
Cosoius	5a	Drag 27g	45-65	La Graufesenque
Crestio	17-	Dish	45-75	Narbonne
Crucuro i	2a	Drag 27		La Graufesenque
	2d	Drag 27	75-110	La Graufesenque

Table 6.3: List of stamps occurring on marbled samian, recorded in the Leeds Index of Potters' Stamps (data kindly provided by G B Dannell) (continued over the next two pages)

Potter	Die	Form	Dating	Site
Damonus	8b	Drag 18	20-60	Banasa
	13-	Cup		Glanum
	15-			Narbonne
Dontio	10a	Drag 24	Neronian-Flavian?	London
Fabus i	5-	Drag 27	Claudius-Neronian?	Segobriga
Felicente	1a	Drag 18	50-70	Arles-Trinquetaille
Felix i	2c	Drag 15/17 or 18	Neronian-Vespasian?	La Graufesenque
Firmo ii	4a'	Drag 27g	Neronian-Vespasian?	Fos-sur-Mer
Gallivanus ii	10-		45-65	Elche
Germanus i	2a	Drag 18		La Graufesenque
	21a	Drag 27g		La Graufesenque
	28	Drag 29	55-85?	La Graufesenque
Germanus i–And–	1a	Drag 27g	Neronian-Vespasian?	La Graufesenque
Gratus i	1-	Dish	?	Narbonne
Ingenuus ii	Uncertain	Drag 24		Elche
Iucundus iii	5a	Drag 29	Neronian-Flavian?	Arles-Trinquetaille
M. Iulius Seve–	2a	Drag 27	Neronian-Flavian?	La Graufesenque
Iustus i	4-	Drag 27	Neronian-Flavian?	Ampurias
	7b	Drag 27g		La Graufesenque
Licinus	7a	Drag 18 (5)	Claudian-Vespasian.	La Graufesenque
		Hermet 9		La Graufesenque
	7-			Narbonne
Logirnus	3-	Dish	Neronian-Vespasian?	Narbonne
Lucceius i	2-	Drag 27		London
	3-		Neronian-Flavian?	Trion
M- ii	2-	Ritt 9	Neronian-early Flavian	Narbonne
Maccarus i	41-	Hermet 9	Tiberian-Claudian	La Graufesenque
Maponus	2a	Drag 18	60-75	Leicester
Martius ii	2a	Drag 18/31	Neronian-Domitian?	Fos-sur-Mer
Masclus	13b'	Drag 24	Neronian-Vespasian	La Graufesenque
	18-	?		Narbonne
Matugenus ii	1a	Drag 18	Neronian	La Graufesenque
		Drag 27g (2)		La Graufesenque
Memor	Inc.	Drag 27	Neronian-Vespasian	Narbonne
Modestus i	2b	Drag 15/17	40-65	La Graufesenque
	2h	Drag 15/17 or 18		La Graufesenque
Mommo	9e	Cup	Neronian-Vespasian	Belo
	9i	Drag 18		Ventimiglia
	9-	Dish		Narbonne
	Inc.	Drag 18		Ostia
Murranus	26-	Drag 27	Neronian-Vespasian	La Graufesenque
	Nominative	Ritt 8		St-Bauzile (Béziers)
Nequres	Nominative	Drag 15/17	Neronian-Vespasian?	Pompeii
		Drag 27		Pompeii
Pater i	8-	Drag 18	Neronian	Ampurias
Patricius i	4a	Drag 15/17R or 18R	Neronian-Flavian	La Graufesenque
	5a	Drag 15/17 or 18		La Graufesenque
Perrus	12b	Ritt 8 or 9	Claudian-Neronian?	La Graufesenque
		Drag 27		Ostia
Pollio i	2a	Drag 15/17R	Flavian?	La Graufesenque
Ponteius	1a	Drag 15/17R or 18R	Neronian-Flavian	York
Pontus	8a	Drag 18R	Neronian-Flavian	London
	8d	Drag 18R		La Graufesenque
	24a	Ritt 8		London
Primus iii	12n'	?	Claudian-Vespasian?	Sagunto
	12u	?		Ostia
	12v	Drag 18		La Graufesenque
		Drag 18		no provenance
	12x	Drag 29		Fos-sur-Mer
	12z	Drag 15/17 or 18		La Graufesenque
		Drag 18		La Graufesenque
	12aa	Drag 15/17 or 18		La Graufesenque
	12-	Dish		Pompeii

Potter	Die	Form	Dating	Site
	16-	?		Pompeii
	18-	Drag 18		Cirencester
		Drag 27		Köln
		Dish		Rome
		?		Elche
	21a	Drag 27g		La Graufesenque
	21d	Drag 27		Fos-sur-Mer
	22d	Drag 24		La Graufesenque
	25d	Ritt 1 Variant		no provenance
	46-	Dish		Ampurias
	Nominative	?		Ampurias
Pudens i	3a	Dish	Neronian-Flavian	Fos-sur-Mer
Regenus	6a	Drag 29	Claudian-Neronian	La Graufesenque
Rufinus iii	13a	Drag 15/17R or 18R (4)	Neronian-Flavian?	La Graufesenque
Rufus iii	4a	Drag 27g (4)	Neronian?	La Graufesenque
Rusticus	4-	?	Claudian-Neronian	Narbonne
Sabinus ii	8g	Drag 27g	Neronian	Le Rozier
	Inc.-	Drag 27		Elche
Scotnus	5-	Drag 24	Tiberian-Neronian	Taranto
Scottius i	7b	Drag 18	Tiberian-Claudian	La Graufesenque
Secundus ii	10-	Drag 27	Flavian?	Rome
Senicio	5b'	Ritt 9	Tiberian-Neronian	La Graufesenque
Senilis?	?	Dish	Neronian-Vespasian?	La Graufesenque
Senomantus ii	7a	Drag 27g	Tiberian-Claudian	Bavay
Severus iii	24a	Drag 29	Neronian-Flavian	Rome or Subiaco
Silanus	1a	Drag 24	Tiberian-Claudian	Arles
Silvanus i	11-	Cup	Claudian-Flavian	La Graufesenque
	11-	Drag 18		Konstanz
Silvinus ii	9a	Drag 15/17R or 18R	Flavian?	La Graufesenque
Silvius i	8b	Drag 24	Neronian-Vespasian?	La Graufesenque
	8c"	Drag 27		La Graufesenque
Sulpicius	12-	Drag 27?	Claudian-Neronian?	Luni
Tertius iii	11c	Drag 15/17R	Neronian?	La Graufesenque
	12c	Drag 15/17		Mainz
Tertius iii–G–	1a	Drag 18R	Neronian?	La Graufesenque
	1-	Dish R?		Ampurias
Tulo	1a	Ritt 8	Neronian?	no provenance
Virthus	9a	Drag 29	Neronian-Flavian	La Graufesenque
Vitalis i	2b	Drag 27	Neronian	Lectoure
	2c	Drag 18		Arles
	2g	Drag 18		Arles
	3a	Drag 27g		La Graufesenque
Vitalis ii	23b or' or"	Drag 27g	Neronian-Flavian?	La Graufesenque
Votornus	4b	Drag 27	Tiberian	Tarragona

reflects the organisation of the industry at La Graufesenque, in which many potters contracted out the firing of their production and therefore appear in different docket lists (Polak 1998, 120).

The fact that a potter priest was designated only over a certain period might explain why the head of Calus was designed as a removable head. Also the fact that there is a fragment from another head fits with the idea that these two heads were thought of as temporary statues for the time of their elected period. The making of such a statue in La Graufesenque in samian instead of stone would have required mainly creativity, not money.

Was Calus a guild magister?

Another explanation for this head could be that the potter Calus is depicted here as a *magister* of a potters' guild. At least in Arezzo, there was an *ordo catilarii* and we may assume that similar social structures existed at La Graufesenque (Mees 2002, 228–32). The reverse of a docket with a list of persons stating that there are also *ex or*[*dine*] persons could well be a proof of the existence of such groups within a larger *collegium* at La Graufesenque (Marichal 1988, Mar 34). There were clearly defined periods in these guilds for which a board was elected. This could fit with the temporary character of the head.

The clear evidence from epigraphical sources where guilds place statues and inscriptions with the name of their benefactor also supports this interpretation (Meiggs 1960, 315; Zimmermann 2002, 120; Stewart 2003, 158). Such guilds were usually led by a board and only occasionally by a single magistrate (Royden 1988, 233). An inscription from Nijmegen, which mentions a single potter *magister* as president of the potters' guild, may reflect the situation in the smaller guilds (CIL 13, no. 13.8729). The possibility discussed above that this could be the portrait bust of a *flamen* is not incompatible with the priest being active in a potters' *collegium*. It would be unusual, but not entirely without parallels (Waltzing 1900, 424–7. Strobel 1992, 41 rejects the idea, but AE 1911, 0022 provides an example: *magist(e)r / dendrophororum flame[n] / annuus*).

Guilds also occasionally presented statues of an emperor at his birthday, made out of varying materials (Meiggs 1960, 325–6). As has been suggested (*Midi Libre*, 15 March 2005), in the case of the Calus head only a bearded emperor Caligula would be a possible candidate as the emperor represented. However, since the relevant name was Gaius and not Calus, this conflicts with the name of Calus written on the base rim of the head. As discussed above, the dating of marbled slip hardly allows for any pre-Claudian date. Another argument against an interpretation of this bust as a statue of a guild functionary is, that although guilds occasionally dined in temples, a very small *fanum* like the one in La Graufesenque could hardly serve as a dining place (Zimmermann 2002, 120).

Conclusion

The most likely conclusion must be that the bust is a portrait of the well known potter Calus from La Graufesenque, datable to between AD 60 and 80. Its most obvious function can be related to its findspot near a *fanum*. Its functionality as an exchangable statue head, combined with the epigraphic evidence from the dockets found at La Graufesenque and in Roman Egypt, makes it difficult to avoid the conclusion that the potter Calus was acting as a chosen priest for a certain period in order to call for the blessings of the gods on one of the biggest businesses in antiquity. The documented kiln firings of approximately 30,000 vessels each were in economical terms high-risk enterprises. If the gods could help in reducing this gigantic risk, it was certainly worth keeping on friendly terms with them. And it apparently worked, resulting in millions of samian vessels covering the whole of the western part of the Roman empire as a daily tangible expression of ongoing romanisation in the 1st century AD.

Notes

1 Inv.Nr. G81.S63.2b. The bust was published first in Conti 1998, 150 without further discussion. In a newspaper article, an identification with the emperor Caligula was proposed (*Midi Libre* 15 March, 2005). This interpretation was repeated in Balty 2007, 244, which appeared when this article was in print. To arrive at that conclusion, a reading GAIVS would be necessary, but an L is clearly identifiable. Also the suggested pre-Claudian dating does not seem to fit with the archaeological evidence for the dating of the use of marbled slip, discussed in this paper. The identification as Caligula is also unlikely because of the beard. Emperors like Augustus and Caligula had for a short time a 'beard of mourning' when a beloved relative had died (Man 1899, 30–34; Boschung 1989, 72). These beards were worn only for a very few days and only rarely became a portrait type. On the other hand, any dating of a peregrine portrait based on parallels with the hair style of an emperor is also not convincing, since there are many examples known of persons wearing beards during the Flavian period. At this time, none of the emperors wore beards (Man 1899, 30–34).

2 One fragment from the back of a head with hair on it is of an entirely different thickness, shows a somewhat different hair style and also does not have slip on the inside (Fig 6.2, top left). Another piece of the bust (Fig 6.1, top left) was chemically analysed and turned out to have a somewhat different composition (Sciau *et al* 2007, 250). The fragments were brought to Mainz by Michel Feugère (RGZM Werkblatt-Nr. 96/40) and offered to Mrs Künzl and the author for publication with the consent of Alain Vernhet, to whom I am very grateful for his permission. The fragment of a head made out of samian, found in 1965 about 50m away from the head fragments presented here, stems from another bust (Schaad 2007, 79, fig 62).

3 A visual classification of samian clays has been described by K Roth-Rubi (1992) which was later adjusted by M Polak (2000, 45, n 11).

Bibliography

AE = *L'Année Epigraphique*, 1888–

Balty, J-Ch, 2007. Description et regroupement des fragments, identification et destination des bustes, in Schaad 2007, 241–6

Bémont, C, and Vernhet, A, 1993. Le graffite des nones d'octobre, *Annales de Pegasus* 1992–1993, 19–21, Millau

Boschung, D, 1989. Die Bildnisse des Caligula auf Grund der Vorarbeiten des Hans Juckel, *Das römische Herrscherbild*, 4(1), Berlin

Brijder, H A G, 1984. Ancient Greek and related pottery, *Procs Internat Vase Symposium in Amsterdam 12–15 April 1984*, Amsterdam

CIL 2 = Hübner, A E M (ed), 1869. *Inscriptiones Hispaniae Latinae*, Corpus Inscriptionum Latinarum 2, Berlin

CIL 12 = Hirschfeld, O (ed), 1888. *Inscriptiones Galliae Narbonensis Latinae*, Corpus Inscriptionum Latinarum 12, Berlin

CIL 13 = Mommsen, O, Hirschfeld, A, and Domaszeski, A (eds), 1907. *Inscriptiones Germaniae Inferioris. Miliaria Galliarum et Germaniarum*, Corpus Inscriptionum Latinarum 13(2.2), Berlin

Conti, L, 1998. *Le sanctuaire gallo-romain de La Graufesenque (Millau, Aveyron)*, unpub mémoire de maîtrise, Université de Toulouse-Le-Mirail, Toulouse

Corpus = Dannell, G B, Dickinson, B M, Hartley, B R, Mees, A W, Polak, M, Vernhet, A, and Webster, P V, 2002. Gestempelte südgallische Reliefsigillata (Drag. 29) aus den Werkstätten von La Graufesenque. Gesammelt von der Association Pegasus, Recherches Européennes sur La Graufesenque, *Kataloge Vor- und Frühgeschichtlicher Altertümer* 34, Mainz

David, J-L, 2007. La plaquette votive, in Schaad 2007, 178–81

Dickinson, B M, and Hartley, B R, 1993. Samian ware and illustrated samian, in J Monaghan, *Roman pottery from the fortress: 9 Blake Street*, The Archaeol of York, the pottery 16(7), 722–5, 745–69, York

Fishwick, G, 1999. Flavian regulations at the sanctuary of the Three Gauls? *Zeitschrift für Papyrologie und Epigraphik* 124, 249–60

Fuelle, G, 2000. Die Organisation der Terra sigillata-Herstellung in La Graufesenque. Die Töpfergraffiti, *Münstersche Beiträge zur antiken Handelsgeschichte* 19, 62–99

Geiger, F, 1913. *De sacerdotibus augustorum municipalibus*, Dissertationes philologicae Halenses 22(1), Halle

Genin, M, 2006. La sigillée marbrée des ateliers de La Graufesenque: état de la question. *Société Française d'Étude de la Céramique Antique en Gaule. Actes du Congrès de Pézenas 25–28 Mai 2006*, 231–43, Marseille

Hartley, B R, 1991. The new index of potters' stamps on samian ware (terra sigillata) *Annales de Pegasus 1990–1991*, 18–25, Millau

Hartley, B R, and Dickinson, B M, with Dannell, G B, Fulford, M G, Mees, A W, Tyers, P A, Wilkinson, R H, 2008. *Names on* terra sigillata. *An index of makers' stamps and signatures on Gallo-Roman* terra sigillata *(samian ware)*: 2, (B to Cerotcus), Bull Inst Classical Stud Suppl 102 (2), London

Hermet, F, 1934. *La Graufesenque (Condatomago). I. Vases Sigillés. II. Graffites*, Paris

IGR = Cagnat, R, Toutain, J, Lafaye, G, and Victor, H (eds), 1906–1927. *Inscriptiones Graecae ad res Romanas pertinentes* (4 vols), Paris

Jung, P, and Fecher, R, 2006. Vier schüsseln der Form Drag. 37 mit Ausgüssen und Henkeln (Drag. 37sh) aus Mainz und Rottweil, in *1000 gestempelte Sigillatan aus Altbeständen des Landesmuseums Mainz. Ergebnisse einer Lehrveranstaltung am Institut für Vor- und Frühgeschichte der Universität Mainz im Sommersemester 2005* (eds P Jung and N Schücker), Universitätsforschungen zur prähistorischen Archäologie 132, 41–54, Bonn

Knorr, R, 1942. Frühe und späte Sigillata des Calus, *Germania* 26, 184–191

Lambert, P-Y, 2002. *Recueil des inscriptions Gauloises (R.I.G.) II.2. Textes gallo-latins sur instrumentum*, Gallia Suppl 45, Paris

Man, A, 1899. *Paulys Realencyclopädie der classischen Altertumswissenschaft* (Dritter Band), 30–4.

Marichal, R, 1988. *Les graffites de La Graufesenque*, Gallia Suppl 47, Paris

Mees, A W, 1995. *Modelsignierte Dekorationen auf südgallischer Terra Sigillata*, Forschungen und Berichte zur Vor- und Frühgeschichte in Baden-Württemberg 54, Stuttgart

Mees, A W, 2002. *Organisationsformen römischer Töpfer-Manufakturen am Beispiel von Arezzo und Rheinzabern*, Römisch-Germanisches Zentralmuseum Monogr 52, Mainz

Mees, A W, 2007. Diffusion et datation des sigillées signées et décorées de la Graufesenque en Europe. L'influence de l'armée sur l'évolution du pouvoir d'achat et du commerce dans les provinces romaines. *Société Française d'Étude de la Céramique Antique en Gaule. Actes du Congrès de Langres*, 156–208, Marseille

Meiggs, R, 1960. *Roman Ostia*, Oxford

Midi Libre 2005: Ce buste de Caligula qui tarabuste les chercheurs [15 Mars]

Milne, M J, 1965. The Poem entitled 'Kiln', in *The techniques of painted Attic pottery* (ed J V Noble), 102–13, New York

Online Corpus = http://www.rgzm.de/samian

Picon, M, 1996. Quelques observations sur l'origine des vernis jaunes des sigillées marbrées de La Graufesenque, *Annales de Pegasus 3, 1994–1996*, 53–57

Polak, M, 1998. Old wine in new bottles, in *Form and fabric. Studies in Rome's material past in honour of B.R. Hartley* (ed J Bird), Oxbow Monogr 80, 115–121, Oxford

Polak, M, 2000. *South Gaulish terra sigillata with potters' stamps from Vechten*, Rei Cretariae Romanae Fautorum Acta, Suppl 9, Nijmegen

Riewald, P, 1920. Sacerdotes (III. sacerdotes municipales). *Paulys Realencyclopädie der classischen Altertumswissenschaft* (Zweiter Halbband), I 1, 1631–1653

Roth-Rubi, K, 1992. Chronologische Gliederung des Zeit-abschnittes 10–45 nach Chr. an hand des Fundmaterials von Zurzach (AG Schweiz), *Rei Cretariae Romanae Fautorum Acta* 31/32, 515–22

Royden, H L, 1988. *The magistrates of the Roman professional collegia in Italy from the first to the third century AD*, Biblioteca di studi antichi 61, Pisa

Schaad, D (ed), 2007. *La Graufesenque (Millau, Aveyron). Volume I:* Condatomagos, *une agglomération de confluent en territoire rutène IIe s. a.C. – IIIe s. p.C.*, Editions de la Fédération Aquitania. Études d'archéologie urbaine. Pessac

Schaad, D and Vernhet, A, 2007. Les données archéologiques, in Schaad 2007, 61–214

Sciau, Ph, Mirguet, C, Bouquillon, A, and Chabanne, D, 2007. Analyses des fragments des bustes, in Schaad 2007, 248–54

Stewart, P, 2003. *Statues in Roman society: representation and response*, Oxford

Strobel, K, 1992 (1994). Produktions- und Arbeitsverhältnisse in der südgallischen Sigillatenindustrie: zu Fragen der Massenproduktion in der römischen Kaiserzeit, *Specima Nova Universitatis Quinqueecclesiensis de Iano Pannonio Nominatae. A Pécsi Janus Pannonius Tudományegyetem Törtentei Tanszékének Évkönyve* 8, 27–57

Tarrats Bou, F, 1992, *Terra sigil.lata del Passatge de Cobos (Tarragona): les marques de terrisser*, in Miscel.lània Arqueològica a Josep M. Recasens, Tarragona

Vernhet, A, 1993. Aveyron et Lozère, in C Bémont, M Jeanlin, and Chr Lahanier, *Les figurines en terre cuite gallo-romaines*, Documents d'Archéologie Française 38, Paris

Vernhet, A, and Bémont, C, 1991. Un nouveau compte de potiers de La Graufesenque portant mention de flamines. *Annales de Pegasus 1990–1991*, 12–14

Waltzing, J-P, 1900. *Étude historique sur les corporations professionnelles chez les Romains vol 4*, Louvain

Worp, K, 2004. *Greek ostraka from Kellis: O. Kellis, nos. 1–293*, Dakleh Oasis Project Monogr 13, Oxford

Zimmermann, C, 2002. *Handwerkervereine im griechischen Osten des Imperium Romanum*, Römisch-Germanisches Zentralmuseum Monogr 57, Mainz

7 The origins of the samian form Dragendoff 37: '*The Weight of the Evidence*'

G B Dannell

I cannot embarrass Brenda in this celebratory volume for her 70th birthday by revealing that she has been a friend for over 40 years. After excavating at Lezoux, and becoming Brian Hartley's assistant, she joined the group of volunteers who have worked on the collections at La Graufesenque (Aveyron, France) in the first years of its activity, and has been a devoted member of that 'Black Hand Gang' ever since, their graphite rubbings now entering the public domain through the efforts of Dr Allard Mees and the Römisch-Germanisches Zentralmuseum Mainz, making an inestimable contribution to samian studies (*cf* Dannell *et al* 2003). I can well remember the day when our colleague Alain Vernhet walked across the grass of the *Depôt de Fouilles* bearing a tattered cardboard tray on which sat a small form Drag 37, which when examined, proved to have an internal stamp. Since Drag 37 is among those samian forms generally found not to be stamped internally, Brenda's response of 'Ah Bon!' was made with deep feeling to a most unexpected encounter. This paper (part of whose title derives from that of a novel by Michael Innes) is offered with the most sincere appreciation for her scholarship, perseverance, humour and fellowship.

Oswald and Pryce (1920, 95), following Ritterling (1913, 231), noted that Drag 37 was first made in the reign of Nero. In 1987 Martin Millett offered a novel suggestion, that in fact the form not only was Neronian, but that it was made before the Boudican Fire of AD 60/61 (Millett 1987, 98, 123). More recently the basis for this proposition has been rather overlooked and not investigated further (*cf* Dannell *et al* 1998, 70), but as the proposition has begun to enter the samian canon as fact, a rather more complete assessment is required, using evidence most of which was not available to Millett at the time of his paper (*cf* Willis 2005, 5.4.2.3, chart 4; Monteil 2005, 96).

Before entering into the detail, it may be as well to make a few observations about the debate between 'new' and 'traditional' dating methodology related to samian studies. First, it must be stated quite clearly that chronological analyses are constantly evolving, and have been doing so ever since samian was first studied. Therefore, there can

be no inherent prejudice against innovative methodology which may further illuminate our understanding of all aspects of production, distribution and deposition. However, Monteil's view of datation (2005, 96: 'Samian chronology is still very traditional and the methodology often forcefully defended') is at odds with the reality of what has evolved, and particularly that used in *Names on Terra Sigillata* (Hartley and Dickinson, 2008–), the introduction to which should be read carefully by all students of the subject.[1] There, and in all of the reports dependent upon the massive volume of data it contains (*c* 300,000 stamps), the basis has been to take the earliest date at which a stamp occurs in historically dated contexts, and equally its absence in similar circumstances, indicating a lack of currency. The number of such contexts clearly varies over the period of production of samian ware, and their integrity is also variable. One can make the broad statement that samian occurring at the sites of Roman forts in Britain must post-date AD 43; that, more controversially (see below), samian found in layers sealed by the Boudican burning of *c* AD 60/61, pre-dates that fire; and one should be able to say that all samian found at Vindolanda should be post *c* AD 91–2 at the latest, following epigraphic evidence from the site (*cf* Birley 2002, 72–3, 77–9: circularity in the argument for dating based upon the pottery evidence may be tempered by the discussion revolving around Ferox). The series of *termini ante*, or *post, quos* from such deposits have been used to suggest the most likely date of the start of a potter's floruit, in terms of the earliest date at which it is likely that his work 'hit the market' and continued in supply. We cannot know how long it took for individual products to travel to their various points-of-sale, nor how long pottery was stored, or its life in use, and to that extent there must by definition be some blurring at the edges of such dating. In the case of decorated ware there is also the vexed question of the life of moulds.[2] However, that is not a reason for abandoning the methodology, and more importantly it remains a measure by which the efficacy of other techniques should be judged. If the 'traditional' methodology is considered to be inadequate, then one can

point to very large variations in the discrete marketing of samian products which can lead to skewed results using other methods of evaluation.[3] It is a fact that specialists in samian ware are dealing with populations which can be tested against statistical standards like χ^2, seriation or correspondence analysis, but inevitably the results are only as good as the data input.

This leads back to the point about the Boudican fires recognized in Colchester, London and Verulamium. In all cases, the event is marked in archaeological terms by a thick layer of reddened daub derived from the wooden buildings which were destroyed at the time. So far so good; it might be thought that this ought to provide an exact horizon, which can be associated with an historical event. However, in actuality it may not be so. The material described in excavation reports as 'Boudican' or 'pre-Boudican' is itself the matter of a *subjective* assessment of stratigraphy, disturbance or intrusion, as well as the normal deficiencies and hazards of archaeological technique. Some of the discussion below revolves around these matters. That is not to presume, as in the game of 'Monopoly', that there is 'a Get out of Jail Free Card' for any evidence which does not fit with 'traditional' dating, but to underline the fact that only cumulative data should be adduced, and that individual sherds which challenge accumulated wisdom need to be weighed in the balance of probability with extreme care. It remains an axiom, that 'the site dates the pottery', not vice versa, which is why these relationships are so critical.

Part of the difficulty outlined above relates to the culture of much modern excavation and the conditions in which it is undertaken, accompanied by an increasing ignorance of the significance of artefacts, the study of which has been out of fashion for the last few decades. Consequently, the chance that an individual pottery sherd which is 'out of its context' will be recognized immediately upon discovery, is much less than it used to be. By the time pottery gets to the stage of an archival report, its context is established as a matter of record. Further, an increasing tendency not to publish collateral artefact evidence with archaeological reports, nor to take advantage of the internet to make it available, is a worrying inhibition to judging the validity of conclusions relating to dating.

It is with these caveats in mind that the emergence of Drag 37 must be approached. Of the five sherds which Millett identified (1987), four are diagnostic, and of these, three come from a single site: Fenchurch Street, London (Lviii 160, site code FSE76); two others have an ovolo present, the first from Colchester (Millett's Ciii), which cannot now be located, and the other from Verulamium (Millett's Vv), which unfortunately, is too small to be identified and is therefore not illustrated. On examination of the Fenchurch Street material at the London Archaeological Archive and Research Centre (LAARC), it was found that there was other decorated samian in the relevant bags, and this is also reviewed in Table 7.1, where Millett's examples are shown in bold type.

There are a number of matters which pertain to the

dating of Millett's collection. The pieces from Fenchurch Street are clearly the most important, since they form a group. The first point of interest is that contrary to all of the other samian which the author has seen from Boudican fire deposits, not a single piece here is even singed. This immediately raises some doubt, and reference to the paper archive for the site (which is in exemplary condition) confirms those forebodings (see Appendix, where extracts from the documentation are published in full).

To return to the London pieces identified by Millett and consider them with the additional information from Appendix 1, it will be seen that context 48 contains a Drag 35. This form has been shown by Alain Vernhet to be a Flavian addition to the repertoire (*cf* Vernhet 1976). The Drag 29 from Lezoux cannot be dated closely. However, its slip is bright and the fabric is hard-fired, which suggests that it too belongs to the Flavian period, rather than earlier. Context 71 is noted as containing a *dupondius* of Vespasian. This ought to be enough to show that the levels concerned are contaminated by Flavian material, and the Drag 37s within them cannot necessarily be considered as being pre-Boudican. The clear implication of the record is that although the Fenchurch Street material identified at the time of excavation by Andy Boddington, the director, derives from the Boudican burning, it is not necessarily *in situ* (*cf* Frere 1972, 9, for a similar problem of interpretation). This would account for the fact that contexts 48 and 113 share pieces from the same vessel.

The context of the Colchester sherd is also open to some doubt. Millett confessed to having to do a certain amount of re-interpretation of the evidence – and that cannot be entirely satisfactory (Millett 1987, 108). There is not a single dated context elsewhere for this ovolo appearing before the Flavian period. M Crestio worked at varying times both with Mercator i (they appear to have shared a mould-maker, or perhaps worked together and shared some poinçons: *cf* Knorr 1919, Textbild 36 and Knorr 1952, Taf 19F) and with C Valerius Albanus (they shared an ovolo: *cf* Mees 1995, Taf 2.8 and Taf 41.5). The ovolo appears on stamped vessels in the Cala Culip IV wreck (*cf* Nieto and Puig 2001, fig 116, Da 17) and at Holt (*cf* Grimes 1930, fig 40, 71).

There is another problem with other material from Colchester, which needs to be confronted. The samian report on the South Gaulish material from excavations in 1971 to 1986 (Dannell 1999) has a code attached representing the dating periods for each individual vessel. Some of these are manifestly in contradiction with the text, so some caution is needed in using the report. Only one sherd causes major difficulty (pers comm Philip Crummy, who was very kind in a patient re-examination of the evidence). No. 269 is unexplained. The context appears sound, but the ovolo is not known anywhere else at this period. It appears on the splendid cover to the Cala Culip IV volume (Nieto and Puig 2001) on a Drag 37 stamped in the mould by Crucuro.

At this point it may be useful to consider some rather more substantial deposits dated to the Boudican fire: the

Context	No. on figs	Form	Discussion
FSE 76 (48)	1	29	A bowl cast from a mould associated with Iustus i and Iucundus iii (*cf* Dannell *et al* 2003, Iucundus iii G2, with an internal stamp of Iucundus iii (die 5b") and a mould stamp of Iustus i (die 15a)). The current bowl has a similar lower zone to that design. This is one of the more recognizable styles associated with Iustus i (it appears on both Drag 29 and 37) with scrolls typically containing opposed hares above narrow panels of infilling and terminating in stipuled cordate buds and other vegetation (cf Knorr 1912, Taf VII.3 for an upper zone from the same mould; also Fig 7.2, 8, and Fig 7.2, 9, which has the Iustus i ovolo as well). South Gaulish.
FSE 76 (48)	2	37	The ovolo can just be seen, and is double-bordered, with the tongue to the right of the egg, and the triangular tip is tucked to the left under the egg. This is a very well-known ovolo; there are many examples both on Drag 30, and on Drag 37, where it was used on bowls signed by Memor (*cf* Atkinson 1914, pl 74 and more recently, Mees and Dzwiza 2004, Abb 2a:E2a), and in one instance it is associated with a rather battered sherd with a mould-stamp, which has been read as 'OFMO' and attributed to Mommo (*cf* Fig 7.2, 10). It also seems to be on bowls from Espalion, with a mould-stamp of Dagom[...] (*cf* Tilhard and Moser 1991, fig 40.8, and Mees 1995, Taf 253). South Gaulish.
FSE 76 (71)	3	37	The nearest associations for this design are with the Memor/Mommo ovolo above, but in a more worn form, which is rather more thick and less distinct, and also appears on a Drag 37 from La Graufesenque signed below the decoration by Tetlo[nis?] (Depôt de Fouilles, G88 V66.2, with many thanks to Alain Vernhet). The rosette of seven beads and the palmate frond are on Drag 30s from La Graufesenque (*cf* Fig 7.2, 11 and 12); the basal wreath and lanceolate leaf are on Drag 37 (*cf* Fig 7.2, 13 and 14). The gladiator is a new type for these potters. It is not entirely impossible for the ovolo on no. 2 above to have come from this bowl. South Gaulish
FSE 76 (71)	4	29	This is a fairly banal design, with little in the way of diagnostic features, but similar details are found in the work of Rufinus iii (*cf* Dannell *et al* 2003, Rufinus iii: bird, G2.905; oblique wavy-line panels, E7.906; leaf, G2.3072). This is not to say that the bowl can be attributed to him. A cursory look through the repertoire of Drag 29s which bear his stamps points to a number of mould-making establishments to which he had access, or perhaps for which he worked as a bowl-maker. South Gaulish.
FSE 76 (71)	5	29	An equally uninformative piece of rim, the interest being that it comes from the Lezoux potteries, and is in a hard, bright, orange slip with orange micaceous paste. Unfortunately, very little ware from Lezoux is published for this period, but the style of composition is from the same period as no. 4 above (*cf* Boon, 1967, pl. VI.10 for something similar from Caersws (I am indebted to Robert Pitts for reminding me of this likeness)). Lezoux.
FSE 76 (113)	6	37	The kneeling archer in a medallion with corner tendrils ending in lanceolate leaves is again a common theme. There are some examples stamped by C. Valerius Albanus (*cf* Mees 1995, Taf 2.1 and 6; Taf 3.1 and 6), who seemed to favour this type of design (*cf* Mees 1995, Taf 2.10; Taf 3.3). South Gaulish
C8 (125)	7	37	A double-bordered ovolo, with the tongue to the right of the egg and a four-pronged attached tip pointing slightly to the right. It has been associated with the mould-stamps of M. Crestio and Crucuro (*cf* Mees 1995, Taf 38.2b for M. Crestio, and Taf 50.2 for Crucuro). South Gaulish.

Table 7.1: The relevant samian ware from Fenchurch Street (FSE 76) and Colchester (C8: 13, West Stockwell Street (cf Dunnett 1969). Millett's examples are highlighted in bold (see text)

Colchester Pottery shops (Hull 1958, 153–6, 198–202), No. 1 Poultry, London (Bird forthcoming) and the Verulamium deposits resulting from the Boudican burning (*cf* Frere 1972, 13–23 and fig 83). None of these contain examples of Drag 37.[4] The period immediately after the catastrophe in Britain is not well represented in the historically dated samian record. In Britain there are levels associated with the new dispositions of Petilius Cerialis, *c* AD 70/71

(primarily Carlisle, and York: *cf* Dickinson and Hartley 1993, no. 2640 (Fig 7.2, 15)). However, on the continent, the best deposits are those taken to represent the destruction associated with the Batavian revolt of *c* AD 69–70 (*cf* Pferdehirt 1986, where the evidence is reviewed in great detail): Aislingen, Augsburg, Burghöfe Geschirrdepot, and that of the Oberwinterthur Keramiklager, which have similar relevance to those of the Boudican layers and have sufficient decorated samian to be meaningful.[5] At the Hüfingen fort, said to be abandoned under Vespasian, only 10% of the decorated vessels are Drag 37 when compared to the 90% of Drag 29 (Pferderhirt 1986, Tab 5).

At York, only a single piece of samian is illustrated for Period 1 (Dickinson and Hartley 1993, 745, no. 2640 and fig 277), a Drag 37.[6] At Augsburg, there are no Drag 37s in the destruction deposit of AD 69. At Oberwinterthur there is a single small sherd of Drag 37, with an ovolo associated with Germanus i, otherwise the evidence is entirely weighted towards the Neronian period. While it is theoretically possible for Germanus i to have made Drag 37 before AD 70, it is unlikely (see discussion of the London bowl, Fig 7.4, 23). His early output seems to have been of Drag 29, and from moulds shared with Albus ii dates to *c* AD 55–70 (*cf* Hermet 1934, pl 106.12 and 18).

The next issue is what evidence is there for the emergence of Drag 37? Two small vessels, both with ovolos, offer the first insight: Nos. 16 and 17 (Fig 7.3. For No. 16, from Cirencester, see Holbrook 1998, 124; the excavation was carried out by Tim Darvill. The report does not identify this important vessel, a rubbing of which was provided by Brenda some years ago). The ovolo on No. 16 is very well known on a variety of forms (Déch 67/8, Drag 11 (at least six) and Drag 30, Hermet 7 and 15: *cf* Dannell *et al* 1998, 77 and fig 1, GG). The range of forms suggests that this ovolo was in use from *c* AD 45/50 to 70/75. It has not been recorded in association with a signature, but what must be the same basic type is known with an applied hollow rosette, signed by Masclus (*cf* Mees 1995, Taf 104.1). The ovolo on No. 17 certainly appears on moulds stamped or signed with the names of Martialis (*cf* Boon 1965, fig 1, 29), Masclinus (*cf* Mees 1995, Taf 104.1), and Phoebus (on a Hermet 7 (La Graufesenque G88 J66); given that this form was not produced in any quantity, and the Masclus connection, it would suggest that Phoebus was working with him at this time). It has a broken inner border. The intact ovolo was used on Drag 30s signed in the mould with the names of Albinus iii and Masclinus (*cf* Mees 1995, Tafn 4 and 104). Up until now it has been seen exclusively on Drag 30. It is on two vessels from the York fortress (Dickinson and Hartley 1993, 2662 and 2664), and on No. 18 from Newstead (unpublished rubbing by Grace Simpson). Masclinus was presumably the son of Masclus i, and both were operating into the early Flavian period. The association of the putative father with a wide range of decorated forms makes it quite likely that *pere et fils* could have been involved in the evolution of Drag 37.

Another piece in the jigsaw is provided by Iustus i, who has already appeared in this tale.

Some years ago, a Drag 37 was recorded from Ruscino, with an internal stamp of Martialis i (Die 10a) (Fiches and Genty 1980, stamp 351). Unfortunately, it was not illustrated, and perhaps because of that it never made a stir among samian specialists. Then came the appearance of Alain Vernhet at la Graufesenque and his cardboard tray bearing a Drag 37, stamped internally by the same Martialis (Die 6a), and decorated in the style of Iustus i, including his very individual ovolo (No. 19). It is, as can be seen, of equal interest that Martialis i, who made the bowl, finished it with a rouletted rim, in the style of Drag 29. While going through the rest of the collection, another, similar one was found (Die 10a), (No. 20). There can be no doubt about the connection with the manufacturing technique of Drag 29 – the usual basal facets are clearly cut on the two bowls from la Graufesenque. Two similar vessels have been noted: one from Lyons (No. 21) and another (No. 22) from London, which turned up on a set of unpublished drawings by J A Stanfield (among the best he, or anyone else, has ever produced). It might be relevant that Martialis i was a bit of an eccentric, since he also stamped both Drag 35 and 36 (Dies 16a and 6a respectively), a definite aberration! The circle can now be closed by remembering that a Martialis plain-ware stamp (die 11c), and presumably that of the same man, was impressed in a Drag 30 mould with the Masclinus ovolo (Mees 1995, Taf 103.4).

So, there are three names involved with these apparently early Drag 37s, and in order of stylistic development they probably rank as Masclus i/Masclinus; Martialis i and finally Iustus i. That the latter was predominantly, if not exclusively a Flavian worker, is confirmed by his provision of moulds for Iucundus iii (Dannell *et al* 2003, Iucundus iii G2). Their separate work appears in the shipwreck of Cala Culip IV, reckoned to date to after *c* AD 80 (Nieto and Puig 2001, fig 10, where the dating evidence of potters' stamps is provided in summary form by Brenda Dickinson and the late Brian Hartley).

There is thus little to suggest that Drag 37 was produced as early as AD 60, but it must have appeared somewhere just before AD 70, and developed very quickly, given that the Pompeii hoard of AD 79 contains so many examples. The earliest forms discussed here are all small bowls (two, those from Cirencester and Ruscino, are recorded as having handles, which usually accompany a spout), and this may imply that Drag 37 was not seen originally as a replacement for Drag 29, but rather as a specialised vessel in its own right. The shape of the earliest 37s is also revealing. Two very characteristic vessels have been illustrated. The first is an interesting bowl from the unpublished Stanfield drawings (profile, No. 23a). It has an ovolo which is again extremely well-known, this time from the work of Germanus i, as is the nautilus motif (*cf* Hermet 1934, pl 99.38 and pl 102.43; a smilar nautilus motif is on a Germanus i-stamped Drag 29 from Gloucester: GL 136, die 13a). The second (No. 24) is from Pompeii, but not from the hoard (*cf* Déchelette 1904, fig 64). The ovolo in its latest manifestation is almost certainly that associated with the signature of Calvo (Calvos = Calvus i?) and Mercator (*cf*

Illustration No.	Fig. No.	Drag form	Inventory No.	Site	Repository
1	Fig 1	29	FSE76 [48]	London	LAARC
1a	Fig 2	29	FSE76 [113]	London	LAARC
2	Fig 1	37	FSE76 [48]	London	LAARC
3	Fig 1	37	FSE76 [71]	London	LAARC
4	Fig 1	29	FSE76 [71]	London	LAARC
5	Fig 1	29	FSE76 [71]	London	LAARC
6	Fig 2	37	FSE76 [113]	London	LAARC
7	Fig 2	37	Site C8 (125)	Colchester Stickwell St	CEM
8	Fig 2	29	S 433	London	MoL
9	Fig 2	37	Unmarked	Lyons	MCGR
10	Fig 2	37	6205L	London	MoL
11	Fig 2	30	1001755*	la Graufesenque	DdF
12	Fig 2	30	1001753*	la Graufesenque	DdF
13	Fig 2	37	2000145*	la Graufesenque	MF
14	Fig 2	37	G 91 Divers	la Graufesenque	DdF
15	Fig 2	37	7999	York Fortress	YAT
16	Fig 3	37	1980/137 (40)	Cirencester Tower St.	CAT
17	Fig 3	37	G 77 S77	la Graufesenque	DdF
18	Fig 3	30	Pit 2 (Curle excavation, unpub)	Newstead	NMAS
19	Fig 3	37	G 75 T33.2	la Graufesenque	DdF
20	Fig 3	37	Unmarked	la Graufesenque	DdF
21	Fig 3	37	Unmarked	Lyons	MCGR
22	Fig 3	37	Unmarked	London	LAARC; drawing by J A Stanfield
23	Fig 3	37	Unmarked	London	LAARC; drawing by J A Stanfield
23a	Fig 4	37	Unmarked	London	LAARC; drawing by J A Stanfield
24	Fig 4	37	Unmarked	Pompeii	Déchelette 1904, fig 64

Table 7.2: Key to illustrations. Abbreviations: CAT = Cirencester Archaeological Trust; CEM = Colchester and Essex Museum; DdF = Depôt de Fouilles; LAARC = London Archaeological Archive Resource Centre; MCGR = Musée de la Civilisation Gallo Romaine, Lyons; MF = Musée Fenaille, Rodez; MoL = Museum of London; NMAS = National Museum of Antiquities, Scotland; YAT = Yorkshire Archaeological Trust (drawings and rubbings from the LAARC are published with permission)

Mees 1995, Tafn 17 and 131). However, earlier in its life it appears on an extensive range of Drag 30s of *c* AD 55–70, almost certainly connected with Calvus i (*cf* Dannell 2006, 97, ovolo I). Both bowls show strongly incurved lips with lip diameters of *c* 16.5cm (the exact scaling is not clear). Morphologically, it would appear that they are early in the series, as noted by Déchelette for the Pompeii bowl.

Why Drag 37 became the preferred samian bowl form is intriguing. Discussions with contemporary makers of samian copies suggest that there is (perhaps contrary to expectation) little difference in the production time of the two types (I am grateful to M. Gérard Morla of Lezoux and my colleague Gilbert Burroughes for very similar comments). However, a hemisphere is known to be a particularly robust shape, without angular stress points, and probably had a lower potential for breakage, both in the kiln and during transportation, thus offering competitive advantage. Fashion may also have played a part. The larger decorative zone of Drag 29 is below the carination, and therefore does not display as well as the surface available on Drag 37. This is particularly important when larger figure-

types are used in compositions, such as mythological figures or gladiators. That Drag 37 had replaced Drag 29 by *c* AD 90 at the latest, at the La Graufesenque workshops at least, is shown by the evidence from Vindolanda (Birley 2002, 72–3, 77–9). There, only six sherds of Drag 29, as opposed to some hundreds of Drag 37, have been found among the South Gaulish samian excavated up until 1995.

It cannot be coincidence that all of Millett's identifiable sherds are associated with potters whose work appears in the Cala Culip wreck. Surprises are not new to archaeological research, and one may yet emerge, but for the present, 'The Weight of the Evidence', as Michael Innes put it, remains with Drag 37 having emerged some time shortly after the death of Nero.

Notes

1 Now being edited at the University of Leeds, by Brenda and her assistant, Rosemary Wilkinson, in the Department of Classics under the direction of Dr Roger Brock. The project is coordinated by Professor Michael Fulford of the University

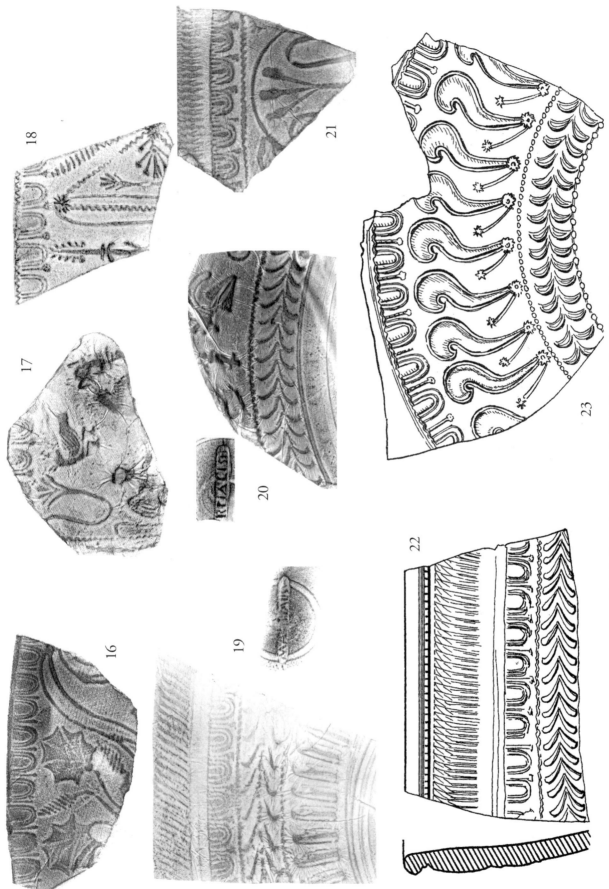

Fig 7.3: Examples of Dragendorff 37 (for details see Table 7.2)

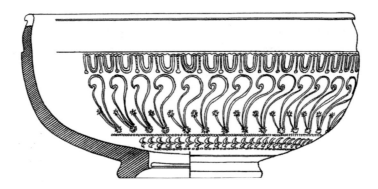

23a

24

Fig 7.4: Examples of Dragendorff 37 (for details see Table 7.2)

of Reading, and partnered with Dr Falco Deim and Dr Allard Mees of the Römische-Germanisches Zentralmuseum Mainz. Dr Paul Tyers has given his unstinted support in matters of information technology. The project was initially funded by a generous grant from the British Academy, and is now supported by the AHRC.

2 The situation in South Gaul is not that of Trier (*cf* Huld-Zetsche 1993, 52–6, in her discussion of 'Spätere Ausformungen'). However, a number of moulds found in the Fosse Malaval at La Graufesenque, stamped by Gallicanus ii (die 2a) and signed with an enigmatic 'N', have decorative compositions more akin to late Tiberian–early Claudian material than to the Neronian group with which they were associated, so some caution is required (*cf* Dannell *et al* 2003, Gallicanus i, B8, G33–5).

3 To give four examples:
 • Recent examinations of the collections at Lyons and Nantes show that Lezoux was the Central Gaulish supplier of preference from the beginning of its production; surprisingly the products of Les Martres-de-Veyre, the same distance away, are very scarce if not absent;
 • While Drag 24/5 is noted to have been found both at Corbridge and Rottweil in Flavian contexts, in general

production waned by *c* AD 70 (cf Polak 2000, 117–8), yet as Polak notes the form is found in the Flavian wreck at Cala Culip, where it forms 14.2% of the plain samian recovered, far above its normal representation elsewhere at the time (Nieto *et al* 1989, fig 81.3);
 • There is the question of differential terminal dates for specific forms at production centres, so that a Drag 15/17 from Les Martres-de-Veyre does not have the same dating equivalence as one from South Gaul when considering form alone in an assemblage;
 • Finally, an admittedly smaller quantity of samian, recently published from the promontory site of Le Yaudet, revealed that in the Antonine period Curle 15 was favoured almost to exclusion over Drag 31 (Dannell 2005, 231).

4 The piece cited by Millett (1987, 123, no. 80), is very small indeed. The ovolo cannot be ascribed, and it is not absolutely certain that the form is Drag 37, rather than Drag 30. It has not been retrieved.

5 Aislingen: cf Pferdehirt 1986, Tab 5, where the percentage of Drag 29 : Drag 37 is 95.5% : 4.5%.
 Augsburg: cf Tremmel 2004, 34 (dealing with Phase 3, which is the last period before a large destruction layer, related to the end of the military presence in Augsburg):

Mees, A W, 1995. *Modelsignierte Dekorationen auf Südgallischer Terra Sigillata*, Mainz

Mees, A W, and Dzwiza, K, 2004. Ein Depotfund Reliefverzierter Südgallischer Terra Sigillata-Schüsseln aus Pompeiji, *Jahrbuch des Römische-Germanischen Zentralmuseums* 51, 381–586

Mees, A W, forthcoming. Das Keramiklager Oberwinterthur – die reliefverzierten Sigillaten. Jahrbuch des Römisch-Germanischen Zentralmuseums, Mainz

Millett, M, 1987. Boudica, the first Colchester potters' shop, and the dating of Neronian samian, *Britannia* 18, 93–123

Monteil, G, 2005. *Samian in Roman London*, unpub PhD dissertation, Birkbeck College, Univ London

Oswald, F, and Pryce, T D, 1920. *An introduction to the study of terra sigillata*, London

Nieto, J, Jover, A, Izquierdo, P, Puig, A M, Alaminos, A, Martin, A, Pujol, M, Palou, H, and Colomer, S, 1989. *Excavacions archeològiques subaquàtiques a Cala Culip, 1.* Sèrie Monogràfica del Centre d'Investigacions Arqueològiques 9, Girona

Nieto, X, and Puig, A M, 2001. *Excavacions arqueològiques subaquàtiques a Cala Culip, 3. Culip IV: la terra sigil. lata decorada de la Graufesenque*, Monografies del Centre d'Arqueologia Subaquàtica de Catalunya 3, Girona

Pferdehirt, B, 1986. Die römische Okkupation Germaniens und Rätiens von der Zeit des Tiberius bis zum Tode Trajans. Untersuchungen zur Chronologie südgallischer Reliefsigillata. *Jahrbuch des Römisch-Germanischen Zentralmuseums* 33, 223–320

Polak, M, 2000. *South Gaulish terra sigillata with potters' stamps from Vechten*, Rei Cretariae Romanae Fautorum Acta Supplementum 9, Nijmegen

Ritterling, E, 1913. Das frührömische Lager bei Hofheim im Taunus. *Annalen des Vereins für Nassauische Altertumskunde und Geschichtsforschung* 4, Wiesbaden

Tilhard, J-L, Moser, F, and Picon, M, 1991. De Brive à Espalion: bilan des recherches sur un nouvel atelier de sigillée et sur les productions céramiques de Brive (Corrèze), *Société Française d'Etude de la Céramique Antique en Gaule: Actes du Congrès de Cognac*, 229–258

Tremmel, B, 2004. *Die Holzbauten des 1. Jahrhunderts n. Chr. im Kastellvicus von Augusta Vindelicum / Augsburg*, unpublished dissertation (Microfiche-Druck [Tectum Verlag, Marburg 2004] bzw. Augsburger Beitr. z. Archäologie 5)

Vernhet, A, 1976. Création flavienne de six services de vaisselle à la Graufesenque', *Figlina* 1, 13–27, Lyons

Willis, S, 2005. *Samian pottery, a resource for the study of Roman Britain and beyond: the results of the English Heritage funded samian project. An e-monograph*, Internet Archaeol 17 (http://intarch.ac.uk/journal/issue17/willis_toc.html)

8 Un décorateur de Montans méconnu: Salvius

Thierry Martin

Salvius est un potier montanais dont le *floruit* coïncide avec le troisième quart du I^{er} siècle de notre ère. Mais il convient de reconnaître que l'on disposait jusqu'à présent de fort peu de renseignements sur son activité de *figulus* au sein de la manufacture tarnaise, tant nombre d'estampilles qui lui avaient été attribuées dans le passé appartenaient en fait, soit au potier montanais Salvetus, soit à un homonyme de La Graufesenque (Oswald 1931, 279). Par ailleurs, jusqu'au début des années 1980, la seule information disponible concernant son statut de décorateur se limitait à une indication lapidaire mentionnant la découverte à Montans, dans le courant de la seconde moitié du XIX^e siècle, d'un moule estampillé SALVIVS (Lacroix 1886–1887, pl 6), donnée qui devait être reprise dans la documentation publiée par la suite, et cela sans plus de commentaire (CIL 13, n° 1001.118; Déchelette 1904, I, 136 et 298, n° 168; Rossignol 1906, 261; Oswald 1931, 279). La découverte en 1981 à Montans sur le plateau du Rougé, dans le comblement d'un petit four à chambre de cuisson circulaire (Martin 1996, fig 16; Martin 1999, fig 14a–b; Martin 2006, fig 3, 1), de trois moules de Drag 29b, l'un signé SALVI sur le fond interne, les deux autres estampillés SALVIVS sous la plage décorée, apporte d'utiles, bien que peu nombreuses, précisions sur la nature de quelques schémas ornementaux utilisés par ce décorateur peu connu de Montans contemporain de la fin de la période julio–claudienne et du début des Flaviens.

La publication de ces trois documents constituera une très modeste contribution à l'hommage collectif plus que mérité que nous rendons aujourd'hui à notre collègue et amie Brenda Dickinson, qui par ses travaux, toujours empreints d'une rigueur scientifique exemplaire qui ne s'est jamais démentie, a tant contribué et contribue encore à faire progresser l'étude de la *samian ware* et celle de ses potiers.

On voudra bien trouver, ci-dessous, la description de ces trois pièces montanaises, dont l'analyse n'avait jamais été faite, et les quelques enseignements que l'on peut tirer de leur examen.

1 – Moule de Drag 29b (n° inv 1702– 2813, Fig 8.1, 1 = Martin 1999, fig 11), caractérisé par un bord de section triangulaire, que souligne une moulure externe bien marquée. Le fond est percé d'un petit trou circulaire, destiné à faciliter l'opération de démoulage; celui-ci présente par ailleurs sur sa face externe trois redans, dont deux sont bien prononcés. A l'intérieur, près de la jonction paroi-fond dont elle épouse la forme circulaire, signature manuscrite SALVI réalisée *ante cocturam* à l'aide d'une pointe mousse (Fig 8.1, S1); au-dessous et à l'opposé on distingue le chiffre II, de même facture, qui est une marque de série, plutôt qu'une indication de module. Décor: présence d'une ligne de perles assez espacées P1 (Fig 8.2) en limite haute du registre supérieur, lequel est occupé par un rinceau voluté dont l'axe principal est timbré de paires de rosettes P5 placées à intervalles réguliers; dans les boucles, astragale à trois éléments P4 d'où part une tige spiralée ornée d'une grande rosace à huit pétales P6 (composition similaire, sinon identique: Tilhard 1978, pl 5, 50; cf aussi, pour la rosace, Tilhard 1997, fig 4, 32; Tilhard 2004, pl 182, 585). Baguette médiane lisse entre deux lignes de perles P1. Le registre inférieur est occupé par une palissade qui fait alterner des godrons P13 et des bandes verticales de bifols P8 emboîtés (Duprat *et al* 1977, pl 17, 9).

2 – Moule de Drag 29b (n° inv 1700–2814, Fig 8.1, 2 = Martin 1990, fig 3, 3 = Martin 2005, fig 20, 3), présentant un bord de section triangulaire ; à la différence du moule précédent, on n'observe pas de moulure externe sous celui-ci. La section du fond, percé en son centre, est légèrement concave et ne présente pas de redans à l'extérieur comme sur la matrice précédente. Sous la plage décorée, estampille rectangulaire SALVIVS, avec les deux premières lettres (SA) très légèrement décalées vers le haut (Fig 8.1, S2). Décor: ligne de perles P2 en limite haute du registre supérieur dont le décor superpose deux frises de *penicilla* P11 régulièrement disposés. Baguette médiane lisse entre deux lignes de perles P2. Le registre du bas présente une suite de panneaux que séparent des pilastres composés d'un godron P14 placé entre deux lignes cordées verticales P3 surmontées d'un bifol P9 (Nieto Gallo 1958, fig 75, 6 = Martin 2005, fig 12, 4); l'intérieur de chaque panneau est

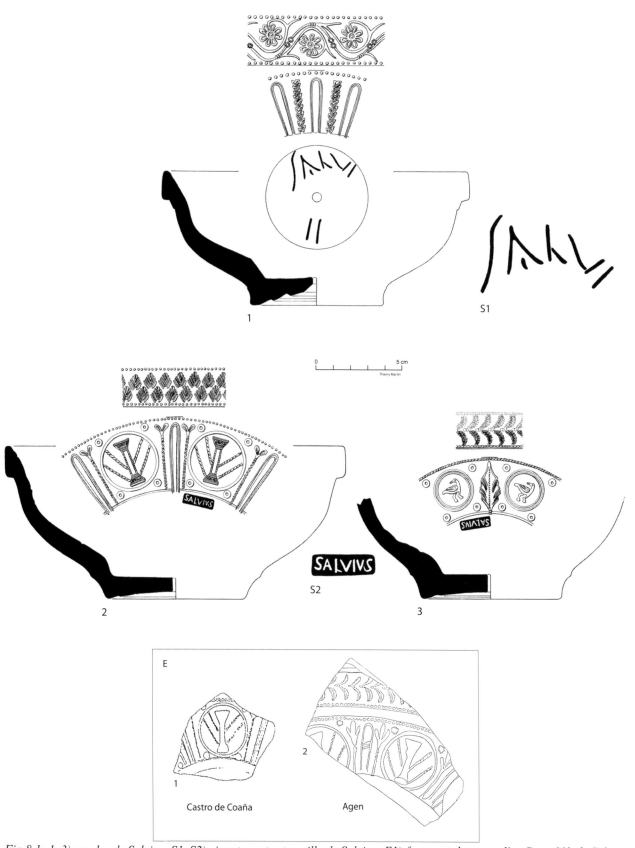

Fig 8.1: 1–3) moules de Salvius; S1–S2) signature et estampille de Salvius; E1) fragment de panse d'un Drag 29b de Salvius réalisé avec le moule N° 2, provenant du Castro de Coaña dans les Asturies (d'après Fernández Ochoa 1982); E2) fragment de panse d'un Drag 29b attribuable au style II de Salvius découvert sur le site du Carmel à Agen (d'après Duprat et al 1977)

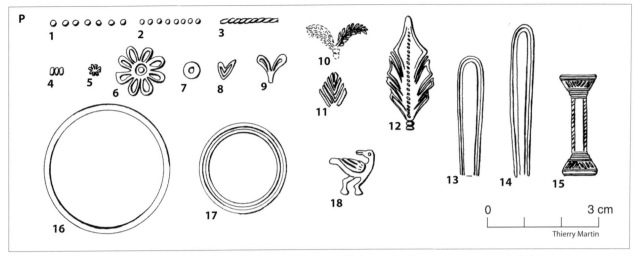

Fig 8.2: 1–15) motifs de démarcation et poinçons utilisés par le décorateur montanais Salvius

occupé par un médaillon simple contenant une colonne P15, avec de part et d'autre deux lignes cordées P3 obliques; dans les écoinçons et en garniture, quatre petits cercles ocellés P7, motif qui est attesté sur le registre inférieur d'un Drag 29b de Lectoure estampillé IVLLI (Larrieu 1960, fig 3,7), et qui est présent également (même disposition) sur la panse d'une forme carénée montanaise de Périgueux (Carponsin-Martin et Tilhard 2001–2002, 243, 4). Pour mémoire, il convient de signaler la découverte, lors de la fouille du Castro de Coaña dans les Asturies, d'un fragment de panse appartenant à un Drag 29b au décor absolument identique (Fig 8.1, encadré E1), lequel a plus que probablement été réalisé avec ce moule montanais de Salvius (Garcia y Bellido 1941, 215, fig 16, en bas à gauche = Fernández Ochoa 1982, fig 6, Co 23 = Maya Gonzalez 1988, fig 59F = Martin 2005, fig 20, 3).

3 – Fragment d'un moule de Drag 29b (n° inv 1701–2815, Fig 8.1, 3), dont il manque le bord et une partie du haut de la plage décorée, sous laquelle figure, à l'envers, une estampille rectangulaire SALVIVS (Fig 8.1, S2). La morphologie du fond est similaire à celle du moule N° 2 et l'examen des deux pièces montre clairement que celles-ci ont été tournées par le même individu. Décor: probablement une ligne torsadée P3 en limite haute du registre supérieur, lequel est agrémenté d'une frise de bifols emboîtés P10 (Peynau 1926, pl 8, 51; Tilhard 1977, pl 3, 25). Baguette médiane lisse comprise entre deux lignes cordées P3. Le registre du bas propose un schéma décoratif qui présente bien des similitudes avec celui de la zone inférieure du moule précédent : succession de panneaux agrémentés d'un médaillon double P17 contenant un oiseau dextrogyre à tête réflexe P18 proche d'Osw 2249, avec petits cercles ocellés P7 dans les écoinçons; les panneaux sont séparés par une feuille palmée P12, laquelle se caractérise en particulier par une nervure médiane en pointillés et deux perles à sa base (probablement Tilhard 1985, 416, 2).

Parmi les rares *comparanda* relevés dans la documentation consultée, on signalera plus particulièrement un fragment de la panse d'un Drag 29b trouvé lors des

fouilles du site du Carmel à Agen (Duprat *et al* 1977, pl 18, 13), dont le décor, attribuable à la main de Salvius, est une synthèse de ceux qui ornent les moules N°s 2 et 3: le registre supérieur présente en effet la même frise de bifols P10 qui agrémente le haut du moule N° 3, alors que celui du bas propose une composition décorative qui reproduit, à quelques détails près, celle du registre inférieur du moule N° 2 (Fig 8.1, encadré E2).

Commentaire

L'examen de ces trois documents montre, à l'évidence, que les moules N°s 2 et 3 appartiennent au même groupe stylistique et qu'ils sont contemporains: même facture ; même estampille rectangulaire SALVIVS ; structures décoratives très proches, avec emploi de la même variété de cercle ocellé P7 pour orner les écoinçons des panneaux. C'est également à cette même série qu'appartient le Drag 29b recueilli lors des fouilles du Carmel à Agen. Par ailleurs nous considérons, pour l'heure, que ces trois moules sont tous bien l'œuvre de Salvius, et ce malgré les différences de facture, de style et de marquage qui caractérisent le moule N° 1, et qu'il n'y a pas lieu d'attribuer éventuellement les moules N°s 2 et 3 à l'un des ouvriers de Salvius qui aurait utilisé un *sigillum* libellé au nom de son maître pour marquer les pièces qu'il décorait, pratique qui a été observée sur des moules de l'officine montanaise des Iullii, laquelle il est vrai employait une main-d'œuvre pléthorique. Pour notre part, nous pensons en effet que ces dissemblances sont simplement liées à des différences de chronologie, la fabrication du moule N° 1, avec signature manuscrite *ante cocturam* SALVI, étant antérieure, probablement d'une décennie au moins, à celle des deux autres, comme le suggère sa structure décorative qui s'inscrit dans une tradition stylistique encore nettement d'inspiration claudienne (registre supérieur occupé par un rinceau ; panse ornée d'une palissade continue). Tout au plus, pour les différencier, pourrait-on proposer d'attribuer à un 'style I' de Salvius le décor du moule N° 1 et de ranger

ceux des deux autres dans un'style II', en attendant que de nouvelles découvertes viennent compléter la documentation à leur sujet et de voir s'il est permis d'établir un lien entre eux. Pour le reste, on retiendra que l'étude de ces trois matrices a permis d'établir un premier corpus, il est vrai très embryonnaire, de 15 poinçons utilisés par Salvius, dont trois sont des motifs de démarcation (P1–P3). La recherche dans la documentation publiée a livré par ailleurs peu de parallèles autorisant à le compléter de manière significative, lesquels se limitent à de très tares occurrences (Agen, Périgueux et peut-être Bordeaux), la plus surprenante, au demeurant anecdotique, étant le fragment de panse du Drag 29b trouvé anciennement sur le Castro asturien de Coaña, une pièce qui, de toute évidence, a été réalisée à l'aide du moule N° 2 estampillé SALVIVS trouvé en 1981 à Montans.

Voilà, brièvement et de manière très synthétique, ce que l'on pouvait dire à propos de ces trois moules de Salvius, dont l'étude a permis de nous éclairer quelque peu sur la production ornée de ce décorateur montanais méconnu et de le sortir du quasi anonymat où ce dernier se trouvait depuis près de 2000 ans.

Bibliographie

Carponsin-Martin, C, et Tilhard, J-L, 2001–2002. Les céramiques sigillées trouvées à Périgueux : apport des fouilles récentes, *Aquitania* 18, 193–259

CIL 13 = Bohn, O, 1901, *Inscriptiones trium Galliarum et Germaniarum Latinae. Instrumentum domesticum I*, Corpus Inscriptionum Latinarum 13(3.1), Berlin

Déchelette, J, 1904. *Les vases céramiques ornés de la Gaule romaine (Narbonnaise, Aquitaine et Lyonnaise)*, 2 vols, Paris

Duprat, H, Lecarpentier, Y, et Turgal, B, 1977. *La céramique sigillée découverte lors des travaux du Carmel à Agen (47)*, rapport dactylographié

Fernández Ochoa, C, 1982. *Asturias en la epoca romana*, Monografías Arqueológicas 1, Madrid

Garcia y Bellido, A, 1941. El Castro de Coaña (Asturias) y algunas notas sobre el posible origen de esta cultura, *Archivo Español de Arqueología* 42, 188–216

Lacroix, F, 1886–1887. Des antiquités gallo-romaines dans l'arrondissement de Gaillac, *Revue du Tarn* 6, 82–4, 121–2, 216–8

Larrieu, M, 1960. Céramiques romaines du Musée de Lectoure, dans *Tauroboles, lampes romaines et céramiques romaines du Musée de Lectoure*, Auch, 43–59

Martin, T, 1990. *Montans, centre potier gallo-romain*, plaquette du CERAM, Montans

Martin, T, 1996. *Céramiques sigillées et potiers gallo-romains de Montans*, Montauban

Martin, T, 1999. Les procédés de fabrication des céramiques sigillées montanaises, *Annales des rencontres archéologiques de Saint-Céré* 6, 56–68

Martin, T, 2005. Périple aquitain, commerce transpyrénéen et diffusion atlantique des céramiques sigillées de Montans en direction des marchés du nord et du nord-ouest de la péninsule Ibérique, dans Nieto *et al* 2005, 21–62

Martin, T, 2006. Les ateliers de potiers gallo-romains de Montans, dans Menchelli et Pasquinucci 2006, 323–46

Maya Gonzalez, J L, 1988. *La cultura material de los castros asturianos*, Estudios de la antigüedad, 4(5), Barcelona

Menchelli, S, et Pasquinucci, M (dirs), 2006. *Territorio e produzione ceramiche. Paesaggi, economia e società in età romana. Atti del convegno internazionale, Pisa 20–22 ottobre 2005*, Instrumenta 2, Pisa

Nieto, X, Roca Roumens, M, Vernhet, A, et Sciau, P (dirs), 2005 *La difusió de la terra sigil.lata sudgàl.lica al nord d'Hispania*, Monografies del Centre d'Arqueologia Subaquàtica de Catalunya 6, Barcelona

Nieto Gallo, G, 1958. *El oppidum de Iruña (Alava)*, Diputacíon Foral de Alava, Vitoria

Osw = Oswald, F, 1936–37 *Index of Figure-Types on terra sigillata ('samian ware')*, Univ Liverpool Ann Archaeol Anthropol Suppl 23–4

Oswald, F, 1931. *Index of potters' stamps on terra sigillata 'samian ware'*, East Bridgford

Peynau, B, 1926. *Découvertes archéologiques dans le Pays de Buch. Deuxième partie: depuis la conquête romaine jusqu'à nos jours*, Bordeaux

Rossignol, E A, 1906. *Album céramique: Montans. Plan archéologique et objets en silex, bronze et or, et poteries gallo-romaines qui y ont été trouvés*, manuscrit, Archives départementales du Tarn, C. 593

Sireix, C (dir), 1997. *Les fouilles de la place des Grands-Hommes à Bordeaux*, Pages d'Archéologie et d'histoire Girondines 3, Bordeaux

Tilhard, J-L, 1977. *La céramique sigillée du Musée de Saintes, II : les vases à décor moulé*, Saintes

Tilhard, J-L, 1978. La céramique sigillée du Musée du Périgord. Catalogue des vases moulés, *Bulletin de la société historique et archéologique du Périgord* 105, 88–164

Tilhard, J-L, 1985. La céramique sigillée au Musée d'Agen, *Revue de l'Agenais* 112, 415–40

Tilhard, J-L, 1997. Les céramiques fines, dans Sireix 1997, 33–64

Tilhard, J-L, 2004. *Les céramiques sigillées du Haut-Empire à Poitiers d'après les estampilles et les décors moulés*, Société Française d'Etude de la Céramique Antique en Gaule Suppl 2, Saint-Paul-Trois-Châteaux

9 'Servus VI' potier(s) décorateur(s) de Lezoux

Richard Delage

1 Introduction: les Servi

De nombreux noms d'individus sont aujourd'hui connus à partir des estampilles et graffites apposés au sein des moules fabriqués à Lezoux. Dans la plupart des cas, ces noms ne se rencontrent que sous une forme déterminée, en association avec des décors présentant une cohérence stylistique et chronologique. C'est pour cela d'ailleurs, qu'ils ont été, par le passé, largement utilisés pour dénommer (et caractériser) des 'styles décoratifs'. Si cette fonction classificatoire est, aujourd'hui, quelque peu remise en cause, du fait de la mise en évidence, pour les officines majeures, de plusieurs noms de potiers associés aux mêmes groupes de décors, l'intérêt méthodologique des marques n'en reste pas moins grand (Delage 1999a).

Cela est bien évidemment le cas des estampilles, dont la forme et le libellé, figés sur l'outil (le poinçon-matrice) sont aisés à identifier. En revanche, pour les graffites la situation est, théoriquement, plus complexe puisque chaque marque, tracée à la main dans l'argile du moule, est unique. Tous les noms connus par le biais des 'signatures' cursives connaissent, ainsi, contrairement à ceux des estampilles, des variations parfois importantes de format et de libellé. Lorsqu'elles apparaissent toutes au sein d'un même groupe de décors homogènes, ces variations peuvent être déclarées sans conséquences, à l'image par exemple du cas de Sissus II. En revanche, lorsque des marques cursives utilisant un même nom sont associées à des décors qui, manifestement, n'entretiennent que peu de rapports stylistiques et/ou chronologiques, on perçoit bien alors toute la difficulté qui en résulte.

Le cas du nom Servus est, à cet égard, tout à fait illustratif. En effet, les travaux de classification des décors du Centre de la Gaule menés par G Simpson et G Rogers associent les marques cursives de Servus à pas moins de cinq styles décoratifs distincts (Stanfield et Simpson 1958; 1990; Rogers 1999). Précisons, d'emblée, que ces propositions peuvent être validées, aujourd'hui, sur la base de critères parfaitement objectifs (nature du répertoire des poinçons et des compositions, forme des moules, etc) pour au moins quatre de ces cinq groupes. Il

apparaît ainsi indéniable que ces marques sont l'œuvre de plusieurs individus et que, de ce fait, elles ne sont pas en mesure d'être utilisées, seules, pour attribuer un décor à l'un d'entre eux.

1.1 Panorama des 'styles' Servi

Servus I a été défini par J A Stanfield et G Simpson dans leur ouvrage *Central Gaulish Potters* paru en 1958 et validé par G Rogers dans ses travaux plus récents (1999). Il n'est officiellement représenté que par un seul vase comportant une signature cursive SERVI M. Les liens de ce décor avec le style d'Albucius ont été mentionnés dès la publication d'origine. Ils ne font aucun doute: même configuration ove+ligne-sous-oves et plusieurs poinçons en commun. A tel point, d'ailleurs, que des décors présentant plus d'affinités avec celui de Servus qu'avec la majorité de ceux d'Albucius ont été classés parmi les compositions de ce dernier (exemple: Stanfield et Simpson 1990, pl 122, nᵒ 29). En fait, Albucius et Servus I appartiennent bel et bien à la même entité de production, dont les compositions ne peuvent être distinguées en l'absence de marques épigraphiques.

La dénomination **Servus II**, quant à elle, est utilisée pour caractériser un groupe de décors dont le nombre de pièces publiées est suffisamment important pour que l'on soit en mesure d'en cerner, dans les grandes lignes, ses caractéristiques.[1] Les compositions sont pourvues de lignes ondulées et d'oves qui ne trouvent pas d'équivalent dans les répertoires des autres styles décoratifs du Centre de la Gaule: B027, B147 et B187.[2] Cela est vraisemblablement dû au fait que l'officine de fabrication des moules est originaire de Terre-Franche. Cette situation, relativement isolée du pôle principal de création qu'est Lezoux, ne favorise pas l'échange et la transmission des motifs décoratifs, tout particulièrement ceux qui ont été créés au sein même de l'atelier

Les marques utilisées sont une grande estampille SERV(I)M, ainsi que des marques cursives incomplètes SIIRV[---]. Quelques décors caractéristiques sont réunis

dans les ouvrages de référence (Stanfield et Simpson 1958; 1990; Rogers 1999), mais aussi, surtout, dans les travaux de M et P Vauthey portant sur Terre-Franche (Vauthey 1967; Vauthey et Vauthey 1993), qui présentent en plus d'illustrations de décors, un répertoire des poinçons les plus fréquents. Précisons que l'usage de cette dénomination a connu quelques errances par le passé, à la suite notamment de l'article de R Sauvaget portant sur des découvertes lézoviennes. En effet, la mise en évidence de marques cursives au nom de Servus à Lezoux, associées à des décors présentant quelques affinités avec ceux de Terre-Franche, mais plus encore de différences, a conduit l'auteur à définir un style de 'Servus II de Lezoux' (Sauvaget 1970; Sauvaget et Vauthey 1970). Ce travail constitue un exemple particulièrement illustratif de la difficulté de classer des décors présentant des caractéristiques complexes à partir de concepts relativement basiques tel que: un nom de potier = un style décoratif. Le problème fut partiellement résolu par G Rogers qui décida de dispatcher les décors lézoviens au sein des styles de Servus IV et Gemelinus/Servus V, ce qui eut pour conséquence de rendre à l'appellation 'SERVVS II' toute sa cohérence, tout en créant une autre confusion quant aux décors Servus du groupe Iullinus (Servus IV/V: *cf* ci-après).

Servus III est la dénomination utilisée pour désigner un groupe de décors qui fut, là encore, très tôt identifié sur la base de signatures cursives SER et SIIRVIM, et de l'usage systématique de l'ove B17 associé à la ligne-sous-oves de grosses perles A3. Aucun des autres styles décoratifs où B17 est attesté ne comporte une association similaire. Le répertoire des pièces connues est relativement faible et assez hétéroclite, témoignant d'une grande diversité du corpus des poinçons et des compositions.

Aussi bien les travaux de G Simpson que ceux de G Rogers ont mis en évidence la grande proximité de ces décors avec ceux de Casurius, au point qu'il n'est guère aisé, en cas de fragments dépourvus d'ove, de proposer une attribution à l'un plus qu'à l'autre. En l'absence d'étude de synthèse poussée sur Casurius et Servus III, mais aussi d'associations de marques avérées, il est encore difficile de se prononcer sur la nature des liens qui les unissent.

Servus IV/V a été défini, dans un premier temps, par G Rogers sous la forme d'une unique famille de décors (Servus IV: Rogers 1974), puis par la suite sous la forme de deux familles, dont l'une est liée à Gemelinus, sur la base d'un décor associant les deux noms (Rogers 1999, pl 45, n°1; Bet et Delage 1991, fig 10). D'après l'auteur, Servus IV se défini par l'usage de marques cursives de libellé SERVIM, SIIRVIM ou encore SERVI, associées aux oves B153 et B183, complétées de lignes-sous-oves A3. Le style Servus V/Gemelinus, quant à lui, comporte également des graffites SERVIM, mais aussi une estampille GEMELINIM, associés aux mêmes oves que précédemment mais soulignés, cette fois, par une ligne-sous-oves ondulée. G Rogers considère ce style V comme 'suffisamment différent [---] des quatres autres potiers qui signaient 'SERVI M'. En fait, l'étude de ces séries, à partir de plusieurs centaines de pièces, a montré que non seulement leurs répertoires de poinçons

présentaient de grandes affinités mais, en plus, qu'elles appartenaient à une plus vaste entité de production que l'on peut dénommer groupe Iullinus et qui comporte pas moins de sept noms de potiers différents! (Delage 1992; Delage 1999a, 330, fig 8). En définitive, les différences entre Servus IV et V sont bien plus modestes que leurs ressemblances, ce qui nous autorise, par soucis de clarté et de simplification, à les réunir.

1.2 Et un de plus!

De 1986 à 1988, Ph Bet dirigea la fouille d'un des secteurs les plus importants des ateliers de potiers antiques de Lezoux: la ZAC de l'Enclos (Bet et Gangloff 1987). De nombreux fours, des bâtiments et autres aménagements furent alors mis au jour, ainsi que des quantités très importantes de mobiliers, issus notamment de dépotoirs primaires et secondaires. L'un d'entre eux était présent à l'intérieur de la salle de chauffe d'un des plus grands fours à sigillée lézoviens dénommé F54–55.

Progressivement, les milliers de fragments qu'il comportait ont été inventoriés. De nombreux vases moulés de Doeccus, Iullinus, Caletus etc purent être identifiés. Ce travail, initié par Ph Bet, au cours des années qui suivirent, avec diverses collaborations dont G Rogers, permit un ultime enrichissement de l'ouvrage que ce dernier avait en chantier depuis plus de 15 ans. Nécessairement, à côté des pièces plus conventionnelles furent mis en évidence des décors rares, des associations de marques inédites, mais aussi des séries de composition parfois pourvues de marques inconnues.

En 1992, dans le cadre d'une recherche universitaire, j'avais isolé une de ces séries qui, lorsque je la présentais à G Rogers, l'intéressât fort. Elle comportait en effet pas moins de deux estampilles nouvelles de libellé GIPPIOFICINA et SERVI:MA:C:I. Il se souvint alors qu'il avait reçu, de longue date, de G Simpson, un frottis portant une marque de lecture difficile qu'il avait préféré laisser provisoirement de côté et qui, à la confrontation, s'avéra effectivement correspondre à celle au nom de Gippus trouvée sur la ZAC de l'Enclos.

Parallèlement à ces recherches, nous eûmes connaissance de l'existence d'un fragment conservé au Musée de Tournai (Belgique), et portant une marque cursive GIPPI OF.

Il n'en fallait pas plus pour que G Rogers inclut dans son volume II de *Poteries Sigillées de la Gaule Centrale*, une notice sous l'intitulé Gippus réunissant quelques décors caractéristiques. Précisons, d'emblée, qu'il était bien conscient qu'il s'agissait là d'un choix ambigü aboutissant à une notice hétérogène, mais la priorité était pour lui de présenter des documents inédits, me laissant le soin, par la suite, d'analyser et commenter ce cas difficile. Le choix de dénommer ce style: 'Servus VI' est venu en fait plus tard, lorsque l'étude des sigillées moulées des fouilles de Romagnat, site de Maréchal, permit la découverte d'un décor en tous points conforme à ceux de cette série et comportant une marque cursive au nom de SERVVS (Delage à paraître; *cf* également Liégard et

Fourvel 2000a; 2000b). Désormais, cet ensemble pouvait s'inscrire pleinement dans la lignée des Servi, d'où la nouvelle dénomination adoptée dans le cadre de ce travail de caractérisation. Précisons que le style de 'Gippus' en lui-même disparaît. Les estampilles GIPPIOFICINA sont liées désormais aux décors de Servus VI, tandis que la marque cursive GIPPIOF prend place au sein du groupe Iullinus, puisque le répertoire des poinçons et la composition du vase de Tournai ne peuvent être distingués d'autres productions signées IVLLINVS ou appartenant sans contestation possible à cette entité.

2 Servus VI : caractéristiques stylistiques

Comme tous les styles décoratifs cohérents du Centre de la Gaule, celui dit de 'Servus VI' se caractérise par trois paramètres principaux: un corpus de marques épigraphiques, un corpus d'oves+lignes-sous-oves (acronyme: LSO) et un corpus de poinçons qui comporte une partie primaire (à savoir celle où les poinçons sont associés aux deux premiers critères) et une autre secondaire (attribuée sur la base des précédents).

L'importance donnée au critère 'ove+LSO' lors du processus de caractérisation des groupes de décors est certainement, sur le plan méthodologique, l'aspect le plus novateur des recherches récentes. De nombreuses expériences ont, en effet, montré que l'association de ces deux éléments (et non leur prise en compte individuelle) était presque toujours propre à une famille de décors ayant un répertoire de motifs homogènes (Delage 1999a). Servus VI n'échappe pas à la règle.

2.1 Les marques épigraphiques

Les ensembles décoratifs relativement modestes des IIᵉ et IIIᵉ siècles sont, pour la plupart d'entre eux, soit dépourvus de marque soit n'en comportent qu'une seule. Servus VI fait figure d'exception, puisqu'il compte un corpus de trois marques intradécoratives différentes, relativement singulières, qui permet d'attester deux fois la présence de Servus, mais également d'autres noms tel Gippus ou à titre d'hypothèse Macrinus.

Estampille de libellé 'SERVI:MA:C:I'
Cette estampille comporte quatre lettres ou séries de lettres, séparées par trois points disposés verticalement (Fig 9.1a). Le premier groupe de lettres 'SERVI' fait indubitablement référence au nom Servus. Le second 'MA' peut être interprété de deux manières et se présente, ainsi, comme un 'jeu de mots' volontaire de la part du potier concepteur. Il peut, en effet, correspondre à l'abréviation de *manu* souvent utilisée avec un nom au génétif: 'de la main de Servus'. Mais il peut aussi être lié aux lettres suivantes et constituer de la sorte le début d'un autre nom, en l'occurrence MAC suivi d'une lettre indéterminée (les impressions les plus nettes de l'estampille, notamment celle sur moule, mettent en évidence à la suite des derniers points alignés une barre verticale pouvant correspondre à un 'I'. Toutefois, la

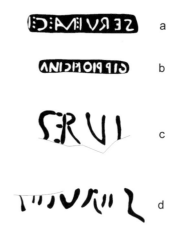

Fig 9.1: Signatures présentes sur les décors de Servus VI. a: estampille SERVI:MA:C:I; b: estampille GIPIOFICINA; c: marque cursive SERVI [?; d. SIIRVI[M] (échelle 1/1)

présence de celle-ci en bordure de cartouche est peut-être due a une mauvaise évaluation de l'espace disponible sur le poinçon-matrice au moment de sa fabrication, générant, ainsi, une lettre finale tronquée).

Plusieurs facteurs tendent à attribuer ce libellé au nom Macrinus. Le premier tient aux analogies existantes entre l'estampille sur sigillée moulée et celles utilisées par le potier Macrinus pour signer des vases lisses. En effet, parmi les collections lézoviennes sont conservées plusieurs marques dont le libellé évoque celui-ci. Tel est le cas, notamment, d'une estampille '.MAC.R.INIM' comportant des groupes de lettres séparées par des points (Bet 1988, vol 3, 160, réf 516–5, et vol 6, 288–9) ou encore des marques présentant une ligature MA similaire (Bet 1988, nᵒˢ 516–6 et 516–2). Le second facteur tient au fait que Macrinus est un nom de potier parfaitement attesté sur la ZAC de l'Enclos, y compris au sein du dépotoir ayant livré la majorité des pièces de Servus VI (structure F54/55). On se trouverait, ainsi, en présence d'une estampille comportant une association de noms de potier.[3] Notons que de telles associations sont très rares à Lezoux et d'un point de vue général au sein des ateliers du Centre de la Gaule (*cf* sur cette question l'étude récente de J-M Demarolle basée sur des corpus de marques publiées: Demarolle 2000). Sur sigillée moulée de Lezoux, celle-ci est un des rares exemples connus avec 'NAMIL-CROESI' (Bet et Delage 1991).

Estampille de libellé 'GIPPIOFICINA'
Cette marque comporte le nom Gippus au génitif associé à un développé long du complément *officina* (Fig 9.1b). Il s'agit là d'un cas relativement rare, puisque la majorité des marques connues utilise une abréviation courte (O, OF, OFF, OFIC, etc). Elle ne connaît pas d'équivalent sur sigillée lisse où le nom Gippus apparaît sous la forme de deux libellés très différents. F Oswald ne recense qu'une marque 'GIPPI.M' sur cinq formes différentes (Oswald 1936–7, 137, 390). Ph Bet, à partir des collections

Styles ou groupes stylistiques	Marques épigraphiques	B105 + LSO					
		A34	A2	A9	A10	A12	A13
SERVVS VI	GIPPIOFICINA	6, 9					
	SERVI:MA:C:I	17, 18					
	SERVIM	11					
ALBVCIVS	ALBVCI		X[1]				
	ALBVCI			X[2]			
	SERVIM			X[3]			
CENSORINVS	CESORINI				X[4]		
	MAMMIF (petite)				X[5]		
	MAMMIF (grande)				X[6]		
PATERNVS	PATERNFE					X[7]	
	LASTVCAF					X[8]	
AVNVS	AVN[I.M]						X[9]

Tableau 9.1: Styles ou groupes stylistiques dont au moins une des configurations Ove+LSO utilise l'ove B105. X1: Bruckner 1981, fig 23, n° 20; X2: Stanfield et Simpson 1958, pl 120, n° 2; X3: Stanfield et Simpson 1958, pl 123; X4: Rogers 1999, pl 28, n° 3; X5: Stanfield et Simpson 1958, pl 103, n° 4; X6: Piboule 1982; X7: Karnitsch 1959, pl 46, n° 3; X8: Delage 1999b, pl PAT36, AF29; X9: Rogers 1999, fig 9, n° 1

lézoviennes, en note deux: celle mentionnée par F Oswald et une autre sans point entre le I et le M (Bet 1988, notice 424).

Ce nom est également connu par le biais de marques cursives intradécoratives de graphie GIPPIOF (Rogers 1999, pl 46, n° 8; éventuellement Hochuli-Gysel *et al* 1991, fig 10, n° 13). Les poinçons associés à ces deux décors ne laissent aucun doute sur leur attribution. Ils s'intègrent parfaitement bien au sein du groupe stylistique dit de 'Iullinus'. La lecture de la marque de Coire (Suisse) n'est pas évidente, mais on retrouve quelques unes des caractéristiques de la marque du Musée de Tournai (Belgique), notamment la manière d'écrire les dernières lettres 'OF'.

On notera donc, avec intérêt, que non seulement toutes les marques sur vases moulés présentent un complément plus ou moins abrégé OFFICINA, mais également qu'elles sont les seules, puisque les estampilles sur forme lisse sont associées uniquement à la lettre 'M' pour *manu*.

Marques cursives au nom Servus

La seule marque cursive dont l'appartenance au style de Servus VI ne fait aucun doute est celle du décor de Romagnat (F) (Fig 9.6, n° 11). Elle a pour libellé SERVI (Fig 9.1c). Etant présente en limite de partie conservée, il n'est pas possible de savoir si elle est complète ou non, car certains graffites du groupe des Servi présentent un 'M' final nettement séparé de la marque, voire sur deux registres. L'usage du 'E' en capitale n'est pas très fréquent. Il n'est attesté qu'en quelques exemplaires pour Servus I (Stanfield et Simpson 1958, pl 124), Servus III (Rogers 1999, pl 110, n° 1; Bémont 1972, 74, pl 4) et Servus IV/V (deux à trois marques connues dont celle de la Coll. Plicque, MAN 66383: Déchelette 1904, I–2, 299; Bémont 1972, pl 4; Rogers 1999, pl 111, n° 1).

L'autre marque cursive que l'on peut associer à Servus est celle figurant sur une petite portion de décor conservée au Musée Dobrée à Nantes (F) (Guitton 1998, pl 66; Fig 9.1d et Fig 9.6, n° 12). Elle a pour libellé SIIRVI[M]. Tous les poinçons qui lui sont associés figurent dans le répertoire

primaire de Servus VI et sont absents de celui des autres familles Servus notamment celle utilisant la ligne A34 (Servus IV/V). L'attribution paraît donc assurée.

2.2 La configuration ove+ligne-sous-oves (LSO)

Les configurations ove+LSO associées aux différentes marques de la série sont toutes identiques, ce qui simplifie considérablement l'analyse et surtout, la reconnaissance des décors de Servus VI, que ce soit sur des tessons, des frottis ou des dessins (naturellement, lorsque ces derniers sont réalisés avec soin, car la ligne-sous-oves étant cordée, il est facile de la confondre avec une ligne ondulée en cas de mauvaise impression et de la dessiner de la sorte). L'ove est de type B105 et les lignes-sous-oves (LSO) et ligne intradécorative (LT) sont systématiquement de type A34 (Fig 9.3). Si ces motifs pris séparément sont utilisés par d'autres officines,[4] le Tableau 9.1 montre que seuls les décors de Servus VI les associent. Toutes les lignes-sous-oves utilisées sont très différentes les unes des autres et ne peuvent être confondues: A34 est la seule ligne cordée de la série; A2 est une ligne de petites perles oblongues; A9 et A10 sont des lignes de perles et pirouettes plus ou moins grosses; enfin, A12 et A13 sont des lignes de perles quadrangulaires, là encore, plus ou moins grosses.

De ce fait, en l'état actuel des connaissances, il convient de considérer que tous les décors comportant une configuration B105+A34 relèvent d'une attribution à Servus VI.

2.3 Répertoire des autres poinçons

Le répertoire primaire des poinçons est obtenu à partir de tous les décors recensés qui comportent la configuration B105+A34 et/ou une des estampilles du groupe (Figs 9.2 à 9.4). Sur les 62 décors recueillis dans le cadre de ce travail, 37 sont concernés. Ils permettent de recenser 44 motifs décoratifs, soit 89% du corpus total. Parmi ceux-ci, seuls six, pour l'essentiel des éléments non figurés, sont présents sur au moins un quart des décors. Il s'agit en premier lieu

de la rosette C144/147, qui constitue un des éléments de caractérisation les plus fiables des créations de Servus VI, tant sa fréquence est importante (presque la moitié des exemplaires), mais aussi des poinçons V07 (torsade), V06 (astragale) et V04 (moyen feston), ainsi que le motif végétal H117. Le seul poinçon figuré présent dans ce lot dominant est le cheval marin Osw (= Oswald 1936–7) 52a. La majorité des autres motifs n'est attestée au sein de ce répertoire primaire qu'en un à quatre exemplaires.

Le répertoire secondaire comporte, quant à lui, tous les motifs recensés sur la base des décors dépourvus de configuration Ove+LSO et de marques, mais dont la majorité du corpus de motifs utilisés, ainsi que la composition, sont en tous points conformes aux pièces précédentes (utilisation notamment de la ligne intradécorative A34). Dans le cas présent, il ne complète le répertoire primaire que de quatre nouveaux poinçons: les feuilles H75 et H77, ainsi que deux poinçons figurés: le satyre Osw 592 et le dauphin 2382.

Au final, les 62 décors du corpus de Servus VI permettent de recenser 48 motifs décoratifs, à savoir 21 motifs figurés, 25 motifs non figurés et deux motifs de configurations (Ove+LSO). Les plus fréquents sont les mêmes que ceux mis en évidence à partir du répertoire primaire, auxquels s'ajoutent la colonne P16/41, le satyre 709a et le poisson 2417, tous présents en neuf exemplaires ou plus. Le nombre de motifs à occurrences plutôt marginales (1 à 4

Tableau 9.2: Répertoire primaire des motifs de Servus VI. Abscisse: référence typologiques des poinçons (Oswald 1936–7; Rogers 1999; Rogers 1974); ordonnée: n° de décor du corpus

Nb d'occurrences au sein du corpus par tranches	Représentation	Réf. typo. des motifs + (nb d'occurrences exactes pour chacun d'entre eux)
20 à 29	+30%	V07 (20), C144/147 (27)
10 à 19	de 16 à 26%	P16/41 (10), 709a (10), V04 (12), H117 (12), V06 (13), 52a (16)
5 à 9	de 8 à 15%	2393 (5), 599 (5), 1917 (5), 1511 (6), H14/15 (6), 1732 (6), U32 (6), H129/134 (6), V02 (7), C215 (8), 2417 (9)
4	7%	Q58/59, 812, 1822k, V05,
3	5%	C170, T03/04, G173, G208, 1214, 1546, V03,
2	3%	107, V01, 4066, 1534/35, 1720, T23, J48/51, G73/74, G162, H77,
1	1%	592, 1840, 717, 1225, H75, 2382

Tableau 9.3: Fréquence d'utilisation des motifs du répertoire de Servus VI

Fig 9.2: Motifs figurés du répertoire de Servus VI (échelle 1/1)

attestations) demeure relativement élevé, puisqu'il atteint 58% du corpus.

2.3.1 Catalogue

1. Cheval marin Osw 52a. Ce motif est particulièrement courant à Lezoux, puisqu'il est présent au sein du répertoire d'une quinzaine d'officines. Il constitue certainement une création de Libertus I, reprise par Butrio, puis le groupe Paternus, Advocisus et de nombreux potiers contemporains de Servus VI (Doeccus, groupe Iullinus, etc).

2. Diane chasseresse Osw 107. Ce motif est connu dans

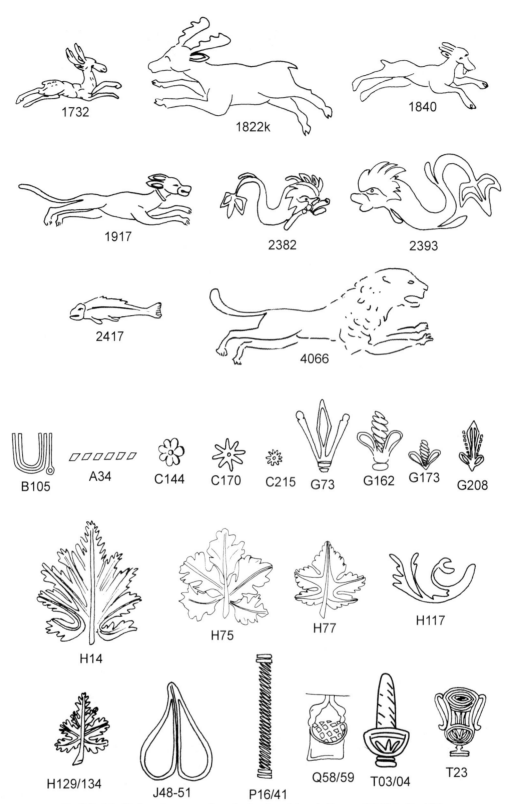

Fig 9.3: Motifs figurés et non figurés du répertoire de Servus VI (échelle 1/1)

le répertoire de Servus II et de quelques autres potiers des générations antérieures (Austrus, Libertus I) ou postérieures (Caletus).

3. Personnage du cortège dionysiaque, transportant un panier de fruits et une coupe Osw 592. Il est attesté

au sein de plusieurs officines antérieures à Servus VI (Carantinus I, groupe Quintilianus, X-6) ou contemporaines (notamment groupe Iullinus).

4. Personnage monté sur un piédestal Osw 599. Motif très courant, créé par l'officine de Libertus et repris

Fig 9.4: Motifs non figurés du répertoire de Servus VI (échelle 1/1)

par plusieurs générations de potiers. Il figure notamment parmi les contemporains de Servus VI, dans les répertoires du groupe Iullinus, de Doeccus et Priscus.

5. Représentation de Pan, monté sur un socle correspondant à un masque. Il est vu de face, nu, à l'exception d'un manteau qui pend à son bras gauche. Il tient dans la main gauche un vase et de la droite, il porte à ses lèvres une flûte. Il correspond au type Osw. 709a, un motif couramment utilisé par la plupart des grandes officines du IIᵉ siècle (la différence entre les types Osw 709a et Osw 709b réside principalement dans le fait que le premier a une tête presque de face alors que le second l'a de profil. Le motif utilisé par le ou les artisans de Servus VI correspond donc parfaitement à la première référence et non à la seconde, contrairement à ce que propose G Rogers dans sa notice: Rogers 1999, 132).

6. Figure de Pan nu, ithyphallique, marchant sur la droite, les jambes de profil, le buste de trois quarts et la tête tournée vers l'arrière. Il possède une chevelure ondulée ainsi qu'une barbe et arbore un visage grimaçant. Il correspond au type Osw 717 (précisons que, dans le cas de Servus VI, seuls les pieds du motif sont conservés. Leur particularité ne laisse toutefois aucun doute quant à l'attribution). Ce motif est un des plus utilisés par

les décorateurs de Lezoux, puisqu'il est associé à plus d'une vingtaine d'officines des IIᵉ et IIIᵉ siècle.

7. Représentation d'une Victoire en pied, portant un vêtement léger tenu à la taille et fendu sur le côté. Elle a les deux bras nus et porte dans la main droite une couronne accompagnée de rubans. De la main gauche, elle tient une palme de grande taille. Elle porte des ailes d'oiseau et est coiffée d'un chignon haut. Elle correspond à la référence Osw 812. Elle constitue un motif très courant pour une dizaine d'officines des IIᵉ et IIIᵉ siècles.

8. Tête de Pan, vue de profil Osw 1214. S'il est un motif qui connut un succès universel auprès des officines de Lezoux, c'est bien celui-ci, puisqu'il est référencé dans plus d'une quarantaine de corpus, dont celui de Servus VI. Son utilisation au sein des décors de ce dernier reste toutefois marginale, en comparaison de l'usage qu'en font la plupart des autres officines.

9. Masque de très grandes dimensions, vu de profil, tourné vers la gauche Osw 1225. Jusqu'à présent, ce motif très particulier, en raison de sa taille, n'était attesté par F Oswald que sur les décors de Butrio.

10. Félin courant vers la droite Osw 1511. Il a été recensé par G Rogers pour les répertoires de Butrio, Albucius ou encore du groupe Paternus.

11. Félin courant vers la gauche avec la tête tournée en

arrière: Osw 1534/1535. Peu d'attestations ont été mises en évidence mais elles couvrent une grande partie de l'activité du II^e siècle: de Butrio à Caletus.

12. Félin courant vers la gauche Osw 1546. Ce motif est présent essentiellement sur les décors libres de plusieurs styles décoratifs des deuxième et troisième quarts du II^e siècle, notamment Butrio, Albucius ou encore le groupe Paternus.

13. Cervidé Osw 1720. Motif essentiellement utilisé par les officines des années 140/180.

14. Cervidé de petite taille courant sur la droite Osw 1732. Il est un des motifs animaux les plus couramment utilisés par les potiers lézoviens et tous les grands styles décoratifs des II^e et III^e siècles l'ont utilisé dans leurs compositions.

15. Cervidé courant sur la gauche Osw 1822k. Ce motif n'est recensé par G Rogers que pour les styles d'Advocisus, Censorinus et Doeccus.

16. Chèvre courant sur la droite Osw 1840, utilisée par quelques potiers depuis Butrio, jusqu'aux officines du III^e siècle (Caletus, Namilianus).

17. Chien courant sur la droite Osw 1917. Poinçon largement utilisé depuis Libertus par les décorateurs lézoviens et ce, jusqu'au III^e siècle, notamment quelques styles proches de Servus VI: Doeccus, groupe Iullinus, etc.

18. Dauphin de petite taille, tourné vers la droite Osw 2382. Toutes les grandes officines lézoviennes du II^e siècle à Lezoux ont, là encore, utilisé ce motif.

19. Dauphin de grande taille, tourné vers la gauche Osw 2393. Commentaire identique au précédent.

20. Poisson Osw 2417. Ce motif a été utilisé par la plupart des officines entretenant plusieurs poinçons en commun avec le répertoire de Servus VI: groupe Paternus, Albucius, Iustus, Doeccus.

21. Lion courant sur la droite Rog (= Rogers 1999) 4066. Ce motif n'a été répertorié par G Rogers, en dehors de Servus VI, que sur les décors du groupe Cinnamus.

22. Ove Rog B105 composé de 2 orles et d'un bâtonnet dont la tige est fine et lisse avec une terminaison en boule percée d'un trou. Sur les attributions de cet ove à d'autres officines *cf* chapitre ci-dessus.

23. Ligne cordée Rog A34. *cf* chapitre ci-dessus.

24. Rosette à 7 pétales et cœur rond de type Rog C144/147. Ce motif, relativement basique, est très courant sur les décors des potiers du II^e siècle, notamment parmi les styles contemporains de Servus VI: Albucius, Doeccus ou encore le groupe Paternus.

25. Rosette à 8 pétales avec un petit cœur apparent, qui est susceptible de disparaître en cas d'impression de mauvaise qualité. L'attribution au type C167 proposé par G Rogers, dans sa notice Gippus, ne semble pas être la plus pertinente (Rogers 1999, 132). On lui préférera Rog C170, utilisé par ailleurs par l'officine de Doeccus.

26. Rosette de très petite taille composée de 10 pétales et d'un cœur marqué par un cercle. Elle ne connaît guère d'équivalent dans le catalogue de G Rogers, si ce n'est le motif présent sur les décors tardifs de Libertus II, à savoir Rog C215.

27. Motif stylisé comportant un cœur représenté par deux losanges imbriqués et des baguettes latérales en forme de fer de lance, Rog G73/74. Il est attesté pour les officines d'Advocisus, X-14 et celles du groupe Iullinus.

28. Motif composé d'un cœur torsadé et de deux parties latérales évidées qui prennent naissance sur lui. Ce motif présente des affinités avec Rog G162 mentionné par G Rogers pour des styles proches de Servus VI: Albucius et Iustus.

29. Motif de même composition que le précédent, mais plus petit et dépourvu de support à la base. L'attribution à un des types référencés par G Rogers n'est guère aisée, puisqu'il connut un grand succès au cours de la première moitié du II^e siècle et que, de ce fait, des dizaines de poinçons avec parfois d'infimes variantes furent en circulation. L'attribution au type Rog G173 est une des propositions les plus vraisemblables.

30. Motif floral composé de cinq éléments. Le corps central est losangé, les autres parties se répartissent symétriquement par rapport à lui. Des baguettes cordées bordent le corps central, alors que plus près de la base se tiennent deux petits pétales évidés. L'attribution au type générique G208 ne fait aucun doute. Ce motif est utilisé par de nombreuses officines, particulièrement celles des années 140–180 (*cf* Rogers 1974, 95).

31. Feuille pourvue d'une tige centrale et de multiples nervures qui en partent. Elle offre un profil très découpé qui correspond bien aux types Rog H14/15. Ces motifs de feuilles sont également couramment utilisés par une poignée d'officines contemporaines de Servus VI.

32. Feuille de type Rog H75. Ce motif est exclusivement utilisé par des officines contemporaines de Servus VI: groupe Paternus, groupe Iullinus et Iustus.

33. Feuille de type Rog H77 constituée sur le modèle de la feuille H75, mais de manière plus stylisée, avec cinq parties distinctes et une tige principale. Là encore, plusieurs potiers décorateurs contemporains l'utilisent plus ou moins fréquemment pour leurs compositions, notamment le groupe Iullinus et Iustus.

34. Motif de type Rog H117 représentant 'un rinceau de feuillage' (Déchelette 1904, 163, n° 1158). A l'image de G208, ce motif est régulièrement utilisé par des potiers de toutes les générations de décorateurs des II^e et III^e siècles: Plautinus, Quintilianus, Doeccus, Marcus, etc.

35. Petite feuille au profil découpé dont la tige principale s'épaissit à la base. Il correspond aux types Rog H129/134. Bon nombre d'officines présentant le plus de correspondances stylistiques avec Servus VI l'ont utilisé: Mercator II, Iustus, Doeccus.

36. Feuille cordiforme dont l'extrémité est légèrement décalée de l'axe de la tige centrale vers la gauche Rog J48–51. Ce motif est exclusivement utilisé par

des officines contemporaines de Servus VI: groupe Iullinus, Banvus, Mercator II, Iustus.

37. Fût de colonne torsadé avec deux tores pour base et chapiteau, correspondant vraisemblablement au motif P16/41. L'attestation incertaine de G Rogers au style de Iustus est aujourd'hui pleinement validée par la découverte de décors à Lezoux comportant la configuration B234+A34.

38. Ornement représentant une fontaine(?) composée de deux dauphins affrontés. Il appartient au type générique Rog Q58/59 que la plupart des officines importantes des deuxième et troisième quarts du II^e siècle ont utilisé.

39. Motif Rog T3/4. Il apparaît dans les corpus de six ou sept officines lézoviennes du II^e siècle.

40. Petit cratère à volutes très stylisé appartenant au type Rog T23. Ce poinçon n'est recensé par ailleurs qu'au sein du groupe Iullinus (famille Iullinus et proche Mercator II).

41. Motif composé d'une série de deux losanges emboîtés. Celui de l'extérieur est perlé et non jointif aux extrémités horizontales, alors que celui de l'intérieur est plein. G Rogers a référencé ce motif sous la dénomination U32 dont il n'attribuait l'usage, jusqu'à présent, qu'à l'officine de Iustus.

42. Double cercle d'environ 7,2 cm (V01).

43. Double cercle d'environ 5,8 cm (V02).

44. Double cercle d'environ 3,7 cm (V03).

45. Simple feston de 5,5 à 6 cm (V04).

46. Simple feston de 4 à 4,5 cm (V05).

47. Astragale composée de 3 éléments et 2 jointures (environ 1,2 cm) (V06). Ce motif est présent sur 13 décors (21% du corpus). Il n'a pas été possible de déterminer si les potiers ont utilisé plusieurs poinçons présentant des caractéristiques morphologiques similaires.

48. Torsade de taille et d'épaisseur variable (V07).

Notons, enfin, que le répertoire des motifs de la notice 'GIPPVS' de G Rogers comporte une attribution à la référence Osw 1784, à savoir un petit cervidé courant sur la gauche. Or, ce motif est absent des quelques décors qu'il a sélectionnés en illustration ainsi que de ceux pris en compte dans le corpus de cette étude. Il s'agit vraisemblablement d'une erreur d'attribution à moins qu'il n'y ait eu, à un certain moment, une confusion entre Osw 1784 et 1822k deux motifs formellement assez proches, mais dont la taille et le traitement de la musculature diffèrent.

2.3.2 Synthèse

Toutes les données recueillies sur les poinçons et leur assemblage témoignent de l'existence d'un atelier secondaire de fabrication de moules à sigillée, à savoir une officine peu innovante qui se contente d'appliquer les recettes des ateliers dominants et surtout, ne fait état que d'une faible créativité. Le répertoire des poinçons, par exemple, ne comporte aucune figure que d'autres officines n'utilisent pas également. Certains d'entre eux appartiennent au fonds commun des décorateurs lézoviens, qui se transmet de génération en génération. D'autres se retrouvent essentiellement au sein des officines contemporaines de Servus VI et ont de fortes chances d'avoir été conçus par les artisans ayant les compétences de 'modeleurs' travaillant au sein des plus importantes d'entre elles. En fait, le ou les potiers décorateurs de Servus VI semblent tout simplement ne pas créer eux-mêmes l'essentiel des motifs qu'ils utilisent, y compris ceux qui ne nécessitent pas de savoir graphique particulier, tels les motifs de remplissage, petites rosettes et motifs floraux, alors que bon nombre d'officines, y compris parmi les plus modestes, le font généralement.

La manière de concevoir les décors confirme également largement cette tendance. Les schémas de composition adoptés, ainsi que les associations de poinçons sont relativement simples et surtout, assez répétitifs. Bien que le répertoire comporte, en l'état actuel du corpus des décors, 48 occurrences qui se répartissent à peu près à part égale entre motifs figurés et non figurés, les potiers n'en utilisent de manière intensive que 20% d'entre eux. Il est possible qu'une telle partition du répertoire soit le témoin, en fait, de la possession par le ou les artisans de Servus VI d'un jeu restreint d'outils, qui se trouve complété occasionnellement (voire de manière temporaire) par d'autres.

3 Servus VI et ses relations avec d'autres officines lézoviennes

Les liens que l'on peut établir entre Servus VI et d'autres officines lézoviennes ne sont pas aisés à analyser. Cela tient, avant tout, aux observations effectuées précédemment: les correspondances que l'on peut établir sur la base des répertoires de motifs ne sont pas nécessairement l'indice d'étroites relations, mais plutôt de sources d'approvisionnement identiques. Dans ces conditions, les observations qualitatives prennent plus d'importance que celles reposant sur des données quantitatives. Les poinçons les plus utilisés par Servus VI, les associations les plus caractéristiques de ceux-ci, ainsi que les similarités de composition peuvent constituer des sources pertinentes de liens dont la nature doit être discutée.

3.1 Relations avec les autres styles Servi

La confrontation des caractéristiques stylistiques de Servus VI avec les autres familles de la série des Servi montre d'emblée que les relations avec Servus II et Servus III sont quasi-inexistantes. Ces styles n'appartiennent pas aux mêmes sphères d'influences, notamment parce que Servus II est lié aux ateliers de Terre-Franche, comme cela a été mentionné plus haut.

Les rapports avec Albucius/Servus I sont plus évidents. Ils ne tiennent pas vraiment au corpus des poinçons dans son ensemble (moins de 7% du vaste répertoire d'Albucius, sur environ 150 motifs, sont en commun avec Servus VI), mais plutôt à l'usage conjoint de l'ove B105 et de la rosette C144/147, à la pratique de lignes tracées dans

le moule pour compléter des compositions végétales ou encore à l'adoption d'un 'E' majuscule pour la marque cursive au nom de Servus. Les deux styles n'ont toutefois qu'une faible part de leur chronologie globale d'activité en commun, puisque celle d'Albucius/Servus I peut être située au cours du milieu du IIe siècle alors que celle de Servus VI est à placer au cours du troisième tiers de ce même siècle. En fait, les indices sont trop faibles pour que l'on puisse conclure en faveur d'une filiation ou d'une évolution d'un même artisan, mais ils sont suffisamment pertinents pour que l'on soit en droit de se poser la question.

Les relations avec le dernier des Servus (famille IV/V), ne sont pas non plus aisées à définir. Cette famille appartient au groupe Iullinus, un des plus importants du centre de production de Lezoux, dont l'activité est intense, variée et foisonnante d'inventivité. Les compositions comportant (notamment) les marques Servus sont celles qui utilisent les oves B153 et B183 associées à cinq types de LSO. Si des poinçons universels transcendent ces différentes configurations (ove+LSO) et offrent ainsi au groupe son homogénéité, l'observation attentive des corpus spécifiquement associés à chacune d'entre elles met bien en évidence des relations privilégiées entre Servus VI et les compositions de Servus IV/V utilisant la même ligne cordée, à savoir de type A34. Des poinçons comme H75, H77, T16 (proche de T23) sont presque exclusivement attestés pour B153–B183/A34. On peut noter également la présence d'une particularité liée aux Servus: l'usage de lignes tracées à la main dans le moule pour compléter un agencement. Ces indices, toutefois, ne sont guère plus déterminants que ceux mis en évidence lors de la confrontation avec Servus I. Notons également qu'un autre lien existe entre Servus VI et le groupe Iullinus: les marques au nom de Gippus qui apparaissent en l'occurence sur des décors d'une famille à laquelle est liée également la petite estampille 'IVLLINIM' (B156–B164/A34). Si, dans un cas, il s'agit d'une estampille (Servus VI) et dans l'autre de marques cursives (groupe Iullinus), toutes présentent un complément '*officina*', qui, comme cela a été souligné plus haut, ne se rencontre pas sur sigillée lisse. Ces signatures tissent donc, bel et bien, un lien entre les deux ensembles, qu'il est malheureusement, là encore, difficile d'interpréter. Si la marque cursive de Gippus avait été associée aux décors portant les configurations B153–B183/A34 de Servus IV/V, des hypothèses auraient pu aisément naître, mais, en la circonstance, elles font largement défaut.

3.2 Relations avec Iustus

Le style de Iustus demeure encore largement méconnu car le peu de décors illustrés dans les ouvrages de synthèse n'offre qu'un piètre aperçu de la diversité du répertoire des poinçons et des compositions. Plusieurs configurations (ove+LSO) peuvent être distinguées. L'une utilise, comme Servus VI, la ligne A34 en tant que LSO et ligne de démarcation (LT) des métopes. Elle comporte 13 motifs non figurés, dont plus de la moitié se retrouve dans le répertoire de Servus VI: notamment C170, H129/134, U32, etc. Le

répertoire des motifs figurés est, en revanche, très différent puisqu'il comporte plus de 25 motifs dont seulement 4 se retrouvent également chez Servus VI (0052a, 0709a, 1214 et 1840). Le fait que ce soient les motifs non figurés qui présentent le plus de correspondances n'est probablement pas anodin, car c'est toujours à partir d'eux que les liens les plus étroits entre deux groupes de décors peuvent être observés. Reste toutefois que la confrontation des schémas de composition et associations de poinçons ne révèle aucune donnée similaire. Il est probable, de ce fait, que les relations mises en évidence en ce qui concerne le corpus des motifs soient plus le fruit de la contemporanéité des officines et de leur implantation au sein du même secteur d'activité que de dépendances ou filiations.

3.3 Relations avec Doeccus

Avec plus de 180 poinçons, le répertoire de Doeccus apparaît comme un des plus importants du dernier quart du IIe siècle. Les compositions bénéficient d'une remarquable homogénéité de style et d'un foisonnement qui rompt avec les manières de bon nombre de contemporains. Un peu moins de 40% du répertoire de Servus VI connaît un équivalent dans celui de Doeccus. Parmi ces motifs en commun figure l'essentiel de ceux qui apparaissent le plus fréquemment au sein des décors de Servus VI: H117, P16/41, H14/15, U32, H129/134 pour les motifs non figurés et 52a, 599, 1732 et 2417 pour les motifs figurés (notons, toutefois, que les différences de dimensions des motifs ou de traitement des ornements comme par exemple, le pelage d'un animal, ne sont pas rares et ne laissent aucun doute sur le fait que les poinçons-matrices sont différents.

Cet examen seul pourrait nous permettre de conclure à des relations étroites entre les deux entités de production. Mais d'autres données permettent de nuancer considérablement cette proposition: aucun ove ou ligne-sous-oves n'est en commun, contrairement à ce qui a pu être mis en évidence pour Iustus et la confrontation des schémas décoratifs et des associations de poinçons n'offre guère de résultat positif. Enfin, aucun poinçon important n'est exclusivement en commun entre les deux styles. En fait, il y a tout lieu de croire que ces correspondances soient dues, là encore, à l'exceptionnelle richesse et qualité du répertoire de Doeccus, qui se compose aussi bien de poinçons du fonds commun du Centre de la Gaule que d'autres, créés par le ou les potiers décorateurs de l'officine.

3.4 Relations avec Mercator II

La confrontation des répertoires et compositions de Mercator II et Servus VI n'offre guère de points communs, à l'exception de quelques pièces plutôt atypiques. Tel est le cas, par exemple, d'une composition libre publiée par D Atkinson en 1942 (Fig 9.5a). La configuration B258+A34 qu'elle comporte n'est attestée que sur les décors de Mercator II.[5] Le registre principal, quant à lui, se compose d'animaux séparés les uns des autres par des torsades et des motifs H117, à l'image du décor N° 56 de Servus VI

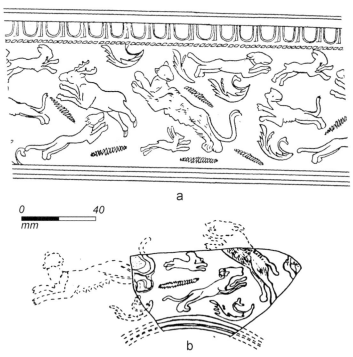

0 40
mm

a

b

Fig 9.5: Décors de comparaison. a: Wroxeter (GB) (Mercator II); b: Arras (F) (style indéterminé) (échelle 1/2)

(Fig 9.9). Le répertoire compte six motifs (1533/35, 1537, 1732, 1822k, 1840, 1917) dont un seul ne se rencontre pas, jusqu'à présent, au sein des créations en 'style libre' de Servus VI.

Ainsi, en l'absence d'ove, l'attribution de décors ayant ces caractéristiques n'est pas évidente à proposer. Prenons, par exemple, le cas d'un fragment trouvé à Arras (Nord, France; Thoen 1970, fig 1, n° 6; Fig 9.5b). Il est dépourvu d'ove et de LSO, comporte les motifs de remplissages torsadés V07 et H117, ainsi qu'un répertoire de quatre poinçons figurés identifiables dont trois se retrouvent dans le corpus de Mercator II et deux dans celui de Servus VI. Aucune attribution assurée ne peut donc être proposée pour cette pièce.

Précisions, enfin, que de toutes les officines utilisant notamment le motif H117, Mercator II et Servus VI sont les seules à l'apposer au sein de compositions en style libre.[6]

4 Conclusion générale

Le style de Servus VI se caractérise, en l'état actuel des connaissances, par un répertoire d'une quarantaine de motifs, des compositions relativement simples (métopes et agencement libre) et l'utilisation d'une seule configuration ove+ligne-sous-oves (LSO). Ces caractéristiques sont celles des officines lézoviennes de second ordre qui fondent leur activité sur des réseaux de diffusion des poinçons et sur une dynamique de création influencée par les ateliers majeurs. Mais ce qui rend Servus VI atypique, c'est avant tout son corpus épigraphique. En effet, la présence de trois marques originales à bien des égards au sein de ces

compositions finalement relativement banales, a de quoi surprendre.

Il s'agit d'une estampille portant mention d'officine au nom de Gippus, une marque associant deux noms, Servus et vraisemblablement Macrinus, et une cursive au nom de Servus qui s'inscrit dans une série de signatures aux caractéristiques identiques, mais apparaissant sur des décors qui ne le sont pas (quatre familles de décors différentes). Une telle série de marques, peu commune pour Lezoux, associée à une structure de production modeste, constitue un cas unique. Malheureusement, les éléments recueillis et analysés ne permettent pas d'en interpréter le sens de manière satisfaisante. L'étude du répertoire des poinçons montre que le ou les potiers décorateurs puisent largement dans un 'fonds commun' de motifs et que les relations que l'on peut établir sur cette seule base ne sont guère pertinentes. Toutefois, en prenant en compte des critères de toutes natures, il est possible de mettre en évidence des liens entre Servus VI et Albucius/Servus I, le groupe Iullinus/Servus IV–V et, dans une moindre mesure, Iustus, Doeccus ou encore Mercator II.

Assurément, l'étude de Servus VI ne révolutionnera pas nos connaissances sur l'artisanat de la sigillée à Lezoux. Mais elle a le mérite de contribuer à montrer combien les pratiques des potiers peuvent être régies par des structures collectives très organisées tout en bénéficiant, dans certains domaines, d'une grande liberté. N'oublions pas, en effet, que ces céramiques sont avant tout le fruit du travail d'hommes qui possèdent chacun leur propre personnalité, leurs compétences, leur singularité et que celles-ci sont susceptibles de laisser des traces à n'importe quelle étape de la chaîne opératoire de fabrication.

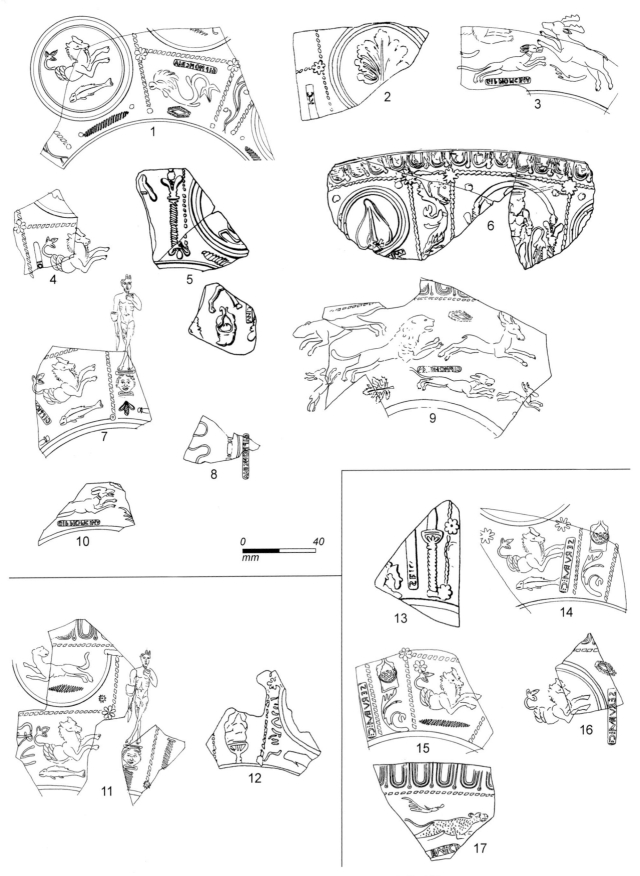

Fig 9.6: Décors signés de Servus VI (échelle 1/2)

4.1 Catalogue des décors (Figs 9.6 à 9.9)

Inv	Références archéologiques				Répertoire décoratif		Marque épigraphique	
	Site	Fouilles	Contexte	Biblio.	Motifs figurés (Oswald 1936-7, Rogers 1999)	Motifs non figurés (Rogers 1974)	Libellé	Nom
01	Terre-Franche (F)			Rogers 1999, fig 46, n°2	0052a, 2393, 2417	A34, C144/147, C215?, U32, V02, V04, V07	GIPPIOFICINA	GIPPVS
02	Lezoux (F)?			Rogers 1999, fig 40, n°2		A34, C144/147, H014/015, V02	[---]PPI---]?	
03	Lezoux (F)	ZAC de l'Enclos	C17, G-H/39	Delage 1992, inv. 1024	1917, 1822k, 4066	H117	GIPPIOFICINA	
04	Lezoux (F)	ZAC de l'Enclos	C17, DEP	Delage 1992, inv. 1140	0052a	A34, C144/147, V04	[---]OF[---]	
05	Chesterholm (UK)		HS	Pengelly, et Dickinson 1985, fig 65, n°17	0717	A34, G162, P16/41, Q58/59, V02, V07	[---]CINA	
06	Catterick (UK)		JXIII11, phase 5	Hartley et Dickinson 2002, fig 157, n°126	0599	B105, A34, C170, C215, H117, J48/51, G162, G208, P16/41, V03, V04	[---]CINA	
07	Lezoux (F)	ZAC de l'Enclos	C17, DEP	Delage 1992, inv. 0959	0052a, 0709a, 2417	A34, G173, V06	GIPPIOF [---]	
08	Lezoux (F)	ZAC de l'Enclos	C21, F54, H-I/43-44	Delage 1992, inv. 0917		V06	GIPPI[---]	
09	Laxton (UK)			Rogers 1999, fig 46, n°4	1546, 1720, 1732, 1917, 4066	B105, A34, H129/134, U32	GIPPIOFICINA	
10	Rouen (F)	Rue Bourg l'Abbé	US 1275	Lotti 1993	1917	H117	GIPPIOFICINA	
11	Romagnat (F)	Maréchal	US1114, 1117, 1300	réf. P330, Delage à paraître	0052a, 0709a, 1534/35, 2417	B105, A34, C144/147, C215, P16/41, V04, V07	SERVI [?	SERVVS
12	indéterminé (F)			Guitton 1998, fig 66, T891	2417	A34, C144/147, T03/04, V04?	SIIRVI[M]	
13	Carmarthen (UK)		C.8185, Area D	Webster et Dickinson 2003, fig 7-9, n°143		A34, C144/147, T03/04	SERV[---]	SERVVS/MACRINVS
14	Lezoux (F)	ZAC de l'Enclos	F91	Delage 1992, inv. 0989bis	0052a, 2417	A34, C170, H117, Q58/59, V04?	SERVI:MA:C:I	
15	Lezoux (F)	ZAC de l'Enclos	F91	Delage 1992, inv. 0989	0052a	A34, C144/147, H117, Q58/59, V07	SERVI:MA:C:I	
16	Lezoux (F)	ZAC de l'Enclos	C17, DEP	Delage 1992, inv. SN	0052a	B105, A34, U32, V02	SER[---]	
17	Lezoux (F)	ZAC de l'Enclos	C17, F55	Delage 1992, inv. 121.2	1511	B105, A34, H117	[---]:MA:C:I	
18	Clermont-Ferrand (F)	Maison de la Région		Derocles 1991	0709a, 1225, 2393	B105, A34, C144/147, G073/074, P16/41, V04, V06		
19	Clermont-Ferrand (F)	Maison de la Région		Derocles 1991	0052a, 0709a, 2393	B105, A34, C144/147, V04, V06		
20	Lezoux (F)	ZAC de l'Enclos	C17, I41p1	Delage 1992, inv. 1128	0812, 1732, 2393	B105, A34, C144/147, H014/015,		

Notes

1 La notice que G Rogers (1999) consacre à ce style comporte quelques erreurs. Les décors n[os] 5 et 9 sont pourvus de l'ove B153 qui n'a jamais été retrouvé associé avec l'estampille SERV(I)M ou encore avec des poinçons qui appartiennent uniquement au répertoire du 'véritable' Servus II (celui de Terre-Franche). En revanche, les compositions à l'ove B153+ligne ondulée sont nombreux pour Servus IV/V, ensemble lié au groupe Iullinus. Ils doivent donc lui être rattachés. L'attribution du décor n° 8 est également sujette à caution. Il comporte deux poinçons qu'on ne retrouve pas sur les autres décors de Servus II, ainsi qu'une petit boule à la jonction entre les lignes délimitant les métopes. Enfin, la pièce n° 12 doit être rattachée à une famille stylistique encore inédite proche de Iustus.

2 B147 est mentionné par G Rogers comme appartenant au répertoire de Primanus I. Or, ce style décoratif n'existe pas puisqu'il est défini sur la base d'une estampille de potier tourneur ayant (semble-t-il), exceptionnellement, apposé sa marque sur un vase issu d'un moule fabriqué par l'officine de Servus II.

3 Précisons qu'il est impossible de tisser un lien entre le nom Macrinus qui pourrait être présent sur l'estampille du groupe Servus VI et le graffite au libellé MACRINI écrit avant cuisson sur le fond d'un moule de Drag 37 (ou éventuellement de Drag 29 pour C Bémont) puisque cette pièce, en l'état, ne comporte pas de portion décorée (Bémont 1972, pl IV, n° 36132; Rogers 1999, 168, fig 40).

4 L'attribution hypothétique de l'ove B105 au répertoire de Iustus, mentionnée dans Rogers 1999, 151, doit être écartée. Elle repose, en fait, sur une reproduction de piètre qualité de l'ove B103, très courante sur les décors de Iustus et associée à plusieurs lignes-sous-oves (Rogers 1999, 59, n° 14).

5 L'ove B258 est également attesté pour le style de Caletus, mais celui-ci n'utilise jamais de ligne cordée que ce soit en LSO ou en LT. Notons également que l'attribution de l'ove est proposée sur la base d'un dessin qui ne comporte pas tous les détails du poinçon tels qu'ils apparaissent sur moule. Toutefois, ceux qui y figurent sont suffisamment caractéristiques pour que ce motif ne puisse être confondu avec un autre.

6 L'utilisation de H117/118 est attestée sur les décors de chasse d'Illixo, mais le répertoire des poinçons n'a guère de points communs avec Servus VI et Mercator II. Les quelques

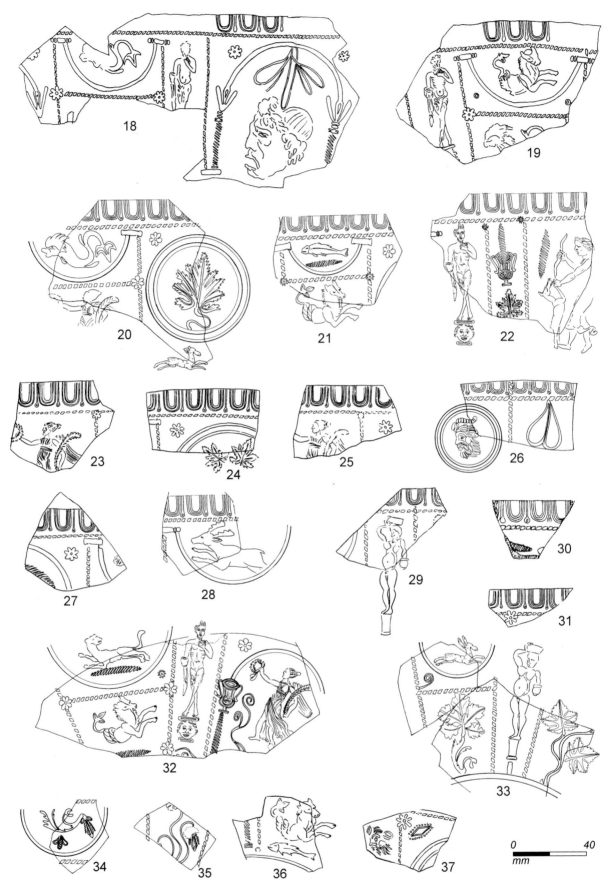

Fig 9.7: Décors de Servus VI (échelle 1/2)

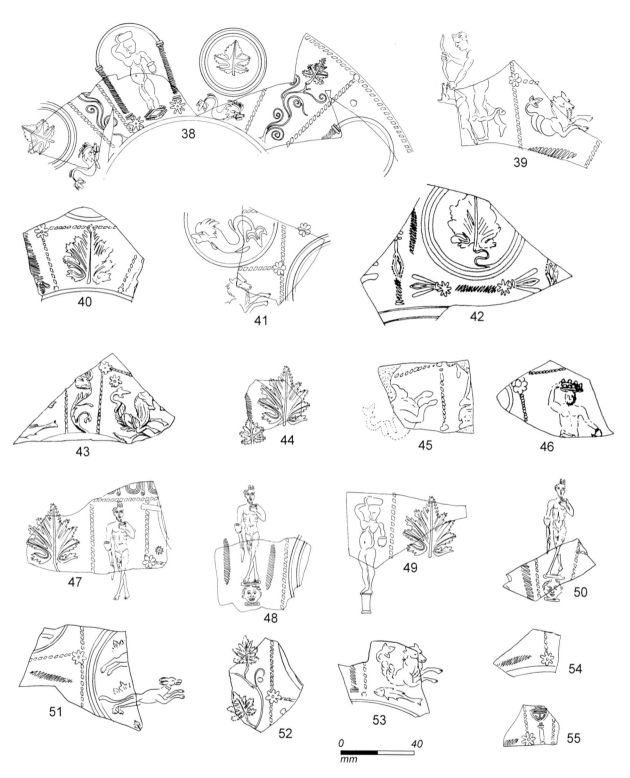

Fig 9.8: Décors de Servus VI (échelle 1/2)

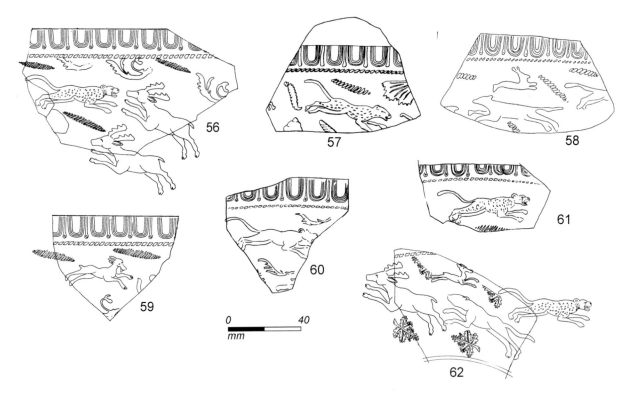

Fig 9.9: Décors de Servus VI (échelle 1/2)

compositions en style libre de Doeccus ou encore des styles du III^e siècle, tel celui de Cintinus, n'utilisent jamais H117, mais plutôt parmi les poinçons en commun avec Servus VI: H129/130/134. Mentionnons, enfin, la présence de H117 au sein des répertoires du groupe de Quintilianus qui ne conçoit pas de composition libre, ou encore de Plautinus et Sissus II dont les scènes de chasses sont très différentes de la tradition instaurée par Cinnamus et Paternus au sein de laquelle s'inscrit Servus VI. Enfin, notons que l'attestation de H117 à Eppilus est erronée, car le motif apparaît sur un moule recevant une signature après cuisson. Le moule appartient en fait au groupe Quintilianus.

Bibliographie

Atkinson, D, 1942. *Report on excavations at Wroxeter (the Roman city of Viroconium), 1923–1927*, Oxford

Bémont, C, 1972. Signatures sur moules sigillés de la Collection Plicque, *Antiq Nationales* 4, 63–82

Bet, P, 1988. *Groupes de production et potiers à Lezoux (63) durant la période gallo-romaine*, Thèse de l'Ecole Pratique des Hautes Etudes (IVè section), Paris, inédit

Bet, P, et Delage, R, 1991. Introduction à l'étude des marques sur sigillée moulée de Lezoux, *Société Française d'Etude de la Céramique Antique en Gaule: Actes du Congrès de Cognac*, 193–227

Bet, P, et Gangloff, R, 1987. Les installations de potiers gallo-romains sur le site de la Z.A.C. de l'Enclos à Lezoux (Puy-de-Dôme), *Société Française d'Etude de la Céramique Antique en Gaule: Actes du Congrès de Caen*, 145–58

Bruckner, O, 1981. *Rimska keramika u Jugoslovenskom delu provincije donje Panonije*, Beograd

Dannell, G B, 1991. Decorated samian, in N Holbrook and P Bidwell, *Roman finds from Exeter*, Exeter Archaeol Rep 4, 55–71

Déchelette, J, 1904. *Les vases céramiques ornés de la Gaule romaine (Narbonnaise, Aquitaine et Lyonnaise)*, Paris

De Boe, G, et Hubert, F, 1978. *Méthode et résultats du sauvetage archéologique à Pommeroeul*, Archaeologia Belgica 207, Bruxelles

Delage, R, 1992. *Caractérisation et classification d'une série de décors sur sigillée moulée du centre de production de Lezoux*, Mémoire de maîtrise, Université de Paris I-Panthéon-Sorbonne, inédit

Delage, R, 1999a. Réflexions sur la classification des décors sur sigillée du Centre de la Gaule des IIe et IIIe s: le rôle des marques épigraphiques et des différents critères d'analyse, *Société Française d'Etude de la Céramique Antique en Gaule: Actes du Congrès de Fribourg*, 311–37

Delage, R, 1999b. *Contribution à l'étude des sites de production du Centre de la Gaule et de leurs céramiques sigillées moulées*, Thèse de Doctorat, Université de Paris I-Panthéon Sorbonne, inédit

Delage, R, à paraître. Sigillée moulée du site de Maréchal à Romagnat (63)

Delmaire, R, 1976. *Etude archéologique de la partie orientale de la cité des Morins*, Arras

Demarez, L, Dudant, A, et Houbion, F, 1982. Terre sigillée et céramique fine de Pommeroeul, *Annales du Cercle royal d'Hist et d'Archéo d'Ath et de la région et Musées athois* 49, 55–80

Demarolle, J-M, 2000. Estampilles à deux noms sur sigillée lisse: la question des 'associations' de potiers, *Akten des 1. Trierer Symposiums zur antiken Wirtschaftsgeschichte*, Trierer Hist Forsch 42, 43–54

Derocles, P, 1991. *L'apport de la céramique sigillée à la compréhension des fouilles dites de la Maison de la Région (ancienne confiturerie Humbert): 1985–1986*, Mémoire de Maîtrise, Université de Clermont-Ferrand, inédit

Guitton, D, 1998. *Les céramiques sigillées, collections du Musée Dobrée (Nantes, Loire-Atlantique)*, Mémoire de maîtrise, Université de Nantes, inédit

Hartley, B R, et Dickinson, B, 2002. Samian ware from Catterick bypass (site 433), dans P R Wilson, *Cataractonium: Roman Catterick and its hinterland. Excavations and research, 1958–1997, part I*, Counc Brit Archaeol Res Rep 129, 280–316, London

Hochuli-Gysel, A, Siegfried-Weiss, A, Ruoff, E, et Schlatenbrand-Obrecht, V, 1991. *Chur in römischer Zeit II*, Antiqua 19, Basel

Karnitsch, P, 1959. *Die Reliefsigillata von Ovilava*, Linz

Liégard, S, et Fourvel, A, 2000a. Le site de Maréchal à Romagnat, *Bull de l'Assoc du site de Gergovie* 20, 35–43

Liégard, S, et Fourvel, A, 2000b. Le site de Maréchal à Romagnat, *Bull de l'Assoc du site de Gergovie* 21, 22–33

Lotti, P, 1993. *Rue Bourg l'Abbé (Rouen)*, DFS de Sauvetage urgent, SRA Haute-Normandie, Rouen

Osw = Oswald 1936–7

Oswald, F, 1936–7. *Index of figure types on terra sigillata ('samian ware')*, Univ Liverpool Ann Archaeol Anthropol Suppl 23–4

Pengelly, H, et Dickinson B,1985. The samian ware, in P Bidwell, *The Roman Fort of Vindolanda at Chesterholm, Northumberland*, Historic Buildings Monuments Comm England Archaeol Rep 1, 166–7 and microfiche, London

Piboule, A, 1982. *Néris-les-Bains. Vases sigillés ornés au moule du Musée Thermal*, Revue Archéologique SITES, hors-série 13, Avignon

Piton, D, 1990. La sigillée de Vendeuil-Caply (Oise) : II – Les vases moulés décorés, *Nord-Ouest Archéo* 3, 31–85

Popilian, G, 1973. La céramique sigillée d'importation en Olténie, *Dacia* ns 17, 179–216

Rog = Rogers 1999

Rogers, G B, 1974. *Poteries sigillées de la Gaule Centrale, I: les motifs non figurés,* Gallia Suppl 28, Paris

Rogers, G B, 1999. *Poteries sigillées de la Gaule Centrale, II: les potiers*, Cahier du Centre Archéologique de Lezoux **1**/Revue Archéologique SITES, hors-série 40 (2 vols), Lezoux and Gonfaron

Sauvaget, R, 1970. Le potier SERVVS II de Lezoux, *Rev Archéo du Centre* **9** (2), 127–42

Sauvaget, R, et Vauthey, M, 1970. Les deux SERVVS, un seul et même potier?, *Rev Archéo du Centre*, 9 (2), 143–4

Stanfield, J A, et Simpson, G, 1990. *Les potiers de la Gaule Centrale*, Revue Archéologiques SITES, hors-série 37, Gonfaron

Stanfield, J A, et Simpson, G, 1958. *Central Gaulish Potters*, Oxford

Thoen, H, 1970. La terre sigillée du Chantier de Bon Secours à Arras, *Septentrion* 2, 123–34

Vauthey, M, 1967. Répertoire des poinçons, style et art décoratif de Servus II, *Rev Archéo du Centre* 6, 230–56

Vauthey, M, et Vauthey, P, 1993. *Près de Vichy, l'atelier de potiers gallo-romains de Terre-Franche-sur-Allier*, Revue Archéologique SITES, hors-série 39, Gonfaron

Weber-Hiden, I, 1996. *Die reliefverzierte Terra Sigillata aus Vindobona, I: Legionslager und Canabae*, Wien

Webster, P, et Dickinson, B, 2003. The samian ware, in H James, *Roman Carmarthen, Excavations 1978–1993*, Brit Monogr Ser 20, London

10 Balancing between tradition and innovation: the potter EBΛRΛS and the mould-decorated beakers from the Argonne

Johan Deschieter, Wim De Clercq and Fabienne Vilvorder

Exactly 100 years ago, J Meunier and G Chenet discovered in the Argonne forests the workshop of the so-called 'gobeletier'. This apparently highly-skilled potter had become specialized in the production of beakers applying the manufacturing techniques of samian ware to a ceramic form that had its typological parallel in colour-coated ware. Drifting on the economically induced changes in pottery production, he obviously balanced between technological tradition and innovation. In recent years, new evidence has been brought to light which allows a better understanding of this late Antonine pottery production which probably represents the result of a lifespan achievement of one potter called Ebaras. We are therefore delighted to offer Brenda this paper about a rare though remarkable samian 'derivative' production, in recognition of her immense and matchless contribution to the study of samian pottery.

Introduction

In September 1908 Dr J Meunier, assisted by G Chenet, discovered about fifty semi-circular ceramic relief moulds at a Roman kiln site near a place called 'La Vérine' (in Lavoye) (Fig 10.1) (Chenet 1919; Chenet 1930, 67; Chenet and Gaudron 1955, figs 18–25). Their application turned out to be exclusively restricted to the decoration of beakers of which the technological production seemed to have incorporated elements of the manufacturing process of various wares, including samian pottery. This workshop became known in French literature as 'l'atelier du gobeletier' (the workshop of the beaker-maker) (Chenet and Gaudron 1955, 43; Hofmann 1968, 275–6). The name of the potter was not found in the production region itself. Professor De Maeyer of Ghent University was the first to bring a signed beaker into the spotlight (Fig 10.9): he published a beaker bearing a signature which he read as 'Eburus' and correctly identified it as an Argonne production. Moreover, in referring to its hybrid character he categorized it as 'Terra Nigra Sigillata'(De Maeyer 1933). Since then, an interesting new set of similar vessels has been brought to light on several settlements in northern

Gaul which makes possible a reassessment of the available evidence. Archaeological research in the Argonne has also produced new evidence for a similar beaker production at the site Avocourt 3, Le Prix-des-Blanches (Brulet *et al* 2003, 399–400).

The objective of this paper is, however, not to present in great detail an extensive study of this rare type of fine ware, but to attempt to present a provisional *status quaestionis* of a ceramic production which hitherto has received remarkably little interest from Roman pottery researchers. Although this specific pottery production is no doubt limited in quantity and restricted in time, its scientific interest is important, especially when observed from a technological and economic point of view. Apart from an updated distribution list, we will therefore focus the discussion on these more general aspects, documented by the most diagnostic finds. Furthermore, the name of the only known potter is adjusted, based on the discovery of some new dies.

Technological aspects

Fabric

The mould-decorated beakers share the same distinctive features of other, typical Argonne fine wares like samian ware, terra nigra and colour-coated ware. They are made in a siliceous clay with an even and clean matrix. Hand specimen analysis reveals a fine homogeneous fabric largely composed of achromatic, sub-angular to sub-rounded quartz grains, together with iron oxides, mica and clay pellets. In a reduced atmosphere this clay is medium-hard fired. Although there is some variation in the surface and core coloration which is due to the manufacturing process, the colours mostly cover a wide range of grey tones.

Manufacture

The most striking and distinctive characteristic of these beakers is of course their manufacturing process. The

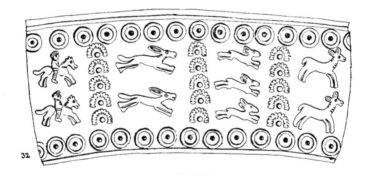

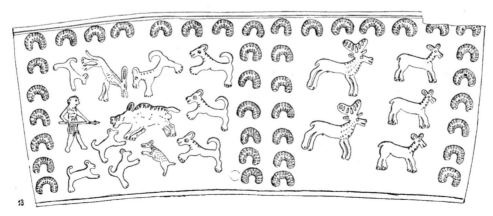

Fig 10.1: Plan of the so-called 'atelier du gobeletier' at La Vérine (Lavoye) and (below) two of the moulds found on this site during the 1908 excavations by Dr J Meunier (after Chenet and Gaudron 1955; scale 1:2)

method of production is to a certain extent similar to that of samian ware in its use of a mould with individual punches or poinçons for the application of a relief ornament on a pot (Fig 10.2, 2). However, the single most important feature of this specialized and highly skilled technology is the use of a two-jointed mould (Fig 10.2, 1). Rectangular strips of clay were pressed into the mould, and after drying the two halves were 'glued' together with barbotine, in order to form one, continuous decorative frieze. In a second stage, bases and rims were made separately and then joined onto the leather-hard, decorated body. So far, this technological line is fairly similar to the production-process of decorated samian forms. The introduction of moulding techniques in ceramic craftsmanship had become current in the Roman world by the 2nd and 1st centuries BC. It was to be the ideal instrument for mass production. Single or composite moulds were used for the production of clay figurines (Bémont *et al* 1993) and lamps (Goethert 1997, 16–18). Their application on wheel-thrown vessels is clearly illustrated by the glazed cups and flagons of Central Gaul (Greene 1978; Greene 1979, 86–105). In the 1st century AD samian workshops of South and Central Gaul, composite (two- and three-jointed) moulds were utilised to produce rare, but finely decorated *lagenae* (Hermet 1934, pl 116; Stanfield 1937, 170; Bet and Montinéri 1989, fig 12). Almost a century later, the use of this unique moulding technique was resumed in the workshop of the 'gobeletier' in the Argonne area.

Unlike samian vessels, the beakers were stacked in a kiln inside one another which resulted in a difference in colour between the body and the lower part of the beaker which has a slightly paler tinge. Fired in a reduced atmosphere, and followed by a second, reduced firing, the surface of the beakers very often became smoked, similar to the Belgic Ware produced earlier (terra nigra).

Typology

From a typological point of view the mould-decorated beakers belong to the repertoire of the colour-coated ware produced in the Argonne during the 2nd century AD (Chenet and Gaudron 1955, 56, fig 28; Vilvorder 1998, 269, fig 9; Vilvorder 1999, 87–92 and fig 10). This group of decorated ware consists exclusively of beakers. On the basis of pottery finds gathered from the production centre as well as from settlements in northern Gaul we are able to identify one dominant type of beaker. The most common form is the cornice-rimmed, globular beaker (Fig 10.2, 3–4): it directly imitates the contemporary colour-coated beakers of the type Hees 2 (Brunsting 1937) or Anderson 2 (Anderson 1980) which was also produced in the Argonne workshops from the end of the 1st till the end of the 2nd century AD (Fig 10.2, 5) (Blaskiewicz and Dufournier 1989). Dr Meunier's finds apparently showed the existence of another form with a more ovoid body, a pronounced conical neck and a marked ridge on the shoulder (Chenet 1930, Abb 4); however, this type seems to be an incorrect reconstruction of a complete profile

based on the refitting of different non-related fragments (Vilvorder 1998, 266). There is also quite a difference in size to be noted between the different complete beakers: the smallest examples (between 10 and 12cm high) are those from Ghent (Belgium; Fig 10.9) and Welzinge (the Netherlands; Fig 10.10), in contrast to the largest, a 22cm high beaker discovered in a tomb at the Roman cemetery of Mamer (Luxemburg; Fig 10.5).

Decoration

Generally, the scenes on the beakers represent hunting activities or running, hunted animals (deer, hares, boars, etc). It also seems as if this hunting took place within a circus setting. Some of the figure-types even directly refer to circus games. On the Mamer beaker (Fig 10.5) two gladiators are fighting each other while they are accompanied by three musicians playing their *tibia*, and the Liberchies beaker (Fig 10.6) shows us two gladiators fighting lions. All of these decorative themes were very fashionable in a lot of contemporary artistic expressions all over the Roman world (painting, mosaics, pottery, etc): they occur for example on decorated samian bowls from Central and East Gaul and on the colour-coated and barbotine decorated beakers produced in Köln (Oenbrink 1998). Non-figurative scenes with different sorts of rosettes and circular motifs occur on some moulds from the 1908 excavations (Chenet and Gaudron 1955, figs 21, 25–26 and 28) and on the pieces from Namur (Belgium; Fig 10.7) and Reims (France) (Joly 1993, fig 46, 33).

The upper and lower edges of the friezes are systematically delineated by a row of circles, rosettes, floral motifs or little arches. The decorative schemes are mostly divided into tightly packed panels (*cf* the Ghent beaker, Fig 10.9), while others show a more spaced-out character in a continuous free-style scene (*cf* the Welzinge beaker, Fig 10.10; also Chenet and Gaudron 1995, fig 19, no. 12, fig 20, no. 16 and fig 21, no 30).

When looking at the beaker moulds one gets the impression of two or more distinctive decorative styles (Chenet and Gaudron 1955, figs 18–25): all the fragments that were actually found in 1908 in the so-called 'atelier du gobeletier' (Chenet and Gaudron 1955, fig 26) show a simple and neatly arranged decorative layout with vertical or horizontal rows of a few repetitive figure-types and other motifs (Chenet and Gaudron 1955, figs 18–24); the style of these examples seems to join in well with the beakers mentioned in our catalogue. However, other mould pieces coming from excavations in the neighbourhood of the kiln site itself (Chenet and Gaudron 1955, fig 25) show different schemes of decoration with other figure-types and sometimes ovolo-like motifs (eg on ibid, no. 62). These poinçons seem to demonstrate stylistic links with the signed work of other Argonne potters or 'décorateurs' like Vitalis, Tocca, Tribunus or Gesatus. From the published evidence it is not clear exactly how these groups are related; though the latter group of moulds could be considered as the hesitant attempts of a mould-maker who was well

Fig 10.2:1: Sections of moulds from the 'atelier du gobeletier' (after Chenet and Gaudron 1955); 2: Manufacture of a mould-decorated vessel (after Chenet and Gaudron 1955); 3: Profile of the Ghent mould-decorated beaker; 4: Profile of the Liberchies mould-decorated beaker; 5: Profile of a roughcast colour-coated Argonne beaker. Scale 1:2

acquainted with the work of some of these 'master-potters', they could equally well represent an early phase in the stylistic development of one and the same mould-maker. In addition, the stamped pieces from Namur (Fig 10.7) and Mageroy (Belgium; Fig. 10.3, 4) suggest the association of other (unknown ?) potters or 'décorateurs' involved in the production of these beakers. Unfortunately these stamps remain unreadable. However, considering the division of labour in the production and finishing of samian bowls, it is not to be wondered at that several craftsmen were also active in the workshops where these beakers were made. This phenomenon is a fascinating topic which certainly requires more attention in future study of mould-decorated Argonne beakers.

Potters' stamps

During our survey of collections and excavated material we were able to catalogue five beakers with an intra-decorative stamp or signature:

1. IIBΛRΛS (Fig 10.3, 1; Fig 10.9, 4): a complete signature on the beaker from the Ghent University collection.
2. IIBΛ[.. (Fig 10.3, 2): fragment of a signature recently discovered at Liberchies (Belgium) (unpublished information).
3. IIB[.. (Fig 10.3, 3: Fig 10.8): fragment of a stamp in rustic capitals on the rim fragment from Wenduine (Belgium).
4. An oblong die with illiterate (?) text on a sherd found at the site of Mageroy (unpublished information; Fig 10.3, 4).
5. Part of an oblong die with retrograde (?) text on fragments of one beaker found in Namur (unpublished information, Demelenne 1999; Fig 10.3, 5; Fig 10.7).

The Ghent, Wenduine and Liberchies beakers provide us with some information concerning the name of a mould-maker. In his article on the beaker in the collection of the Ghent University, Professor De Maeyer suggested three different ways of reading this name: Ebaras, Ebarus or Eburus (De Maeyer 1933, 38). In later articles only the name of Eburus continued to be used and, although there is no obvious connection between them, the beaker signature was immediately linked to Eburus-stamped samian pottery from Blickweiler (Knorr and Sprater 1927, 109, no. 11). Looking at the orthography of other name signatures inscribed or stamped in samian moulds it is not exceptional to find a reverse V representing the letter A: this is clearly the case in the signatures of (Central) Gaulish potters like Rottalus (Delage 1996, fig 1), Paternus (Stanfield and Simpson 1990, pl 104, 3–6 and pl 106, 19–25), Aventinus (Stanfield and Simpson, 1990, pl 156, 1–2) or Ianuaris (Stanfield and Simpson 1990, pl 170, 4). It is very noteworthy that in the latter signature the mould-maker used the same letter to form V and A in one single name. This seems very significant in our reading

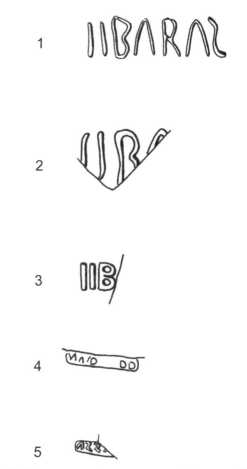

Fig 10.3: Signatures and stamps on mould-decorated beakers (scale 1:1): 1: Ghent; 2: Liberchies; 3: Wenduine; 4: Mageroy; 5: Namur

of the mould-signature on the Ghent beaker, making clear that the name Ebaras remains eligible as the true name of this mould-maker. One of the pieces which could settle this matter unambiguously, that is the rim fragment from Wenduine, is unfortunately broken off after the letter B (Fig 10.3, 3); however, the third letter of the Liberchies signature also shows a part an A or a reversed V (Fig 10.3, 2) and seems to confirm the interpretation as Ebaras.

Who was this mysterious 'gobeletier' Ebaras? Looking at the Ghent, Liberchies and Wenduine pieces we discover that he signed his moulds with at least two kinds of signatures, in script (Fig 10.3, 1–2) and in rustic capitals (Fig 10.3, 3). It is very difficult to get a clear view on the matter, a situation which is not least due to the lack of extensively published evidence from the Argonne itself; for example, according to B Hofmann a group of decorated samian vessels were discovered in Avocourt in the late 1970s, some of which bore motifs used by 'Eburus' or the 'gobeletier' from Lavoye (Hofmann 1979, 222). Unfortunately no further details or information is given related to these intriguing finds.

Without more, and up-to-date, information it remains impossible to assess exactly the degree of importance of such finds. Recent excavations in Avocourt (Prix-des-

Blanches) brought to light a mould fragment and fragments of a decorated beaker (Brulet *et al* 2003, 398–400, fig 69, 32). The presence of Lavoye products in other production centres of the Argonne is not surprising: there seems to have existed an output and exchange of moulds between the different Argonne workshops during the 2nd century AD (Hofmann 1979, 215). On an even wider scale moulds for the production of samian ware travelled as far as the workshops in Haute-Yutz (Stiller 1986, 222). But what was the position of Ebaras relative to the samian industry? Was he himself, perhaps at a certain stage of his career, a producer of samian moulds? If this was indeed the case why are there no known samian vessels or moulds bearing his name-stamp or signature? Or was his liaison only limited to the borrowing of certain poinçons from samian master-potters, like Tribunus (*c* AD 140–170) or Gesatus (*c* AD 160–195), his assumed contemporary? Unfortunately the stamps on the other two beaker fragments from Mageroy (Fig 10.3, 4) and Namur (Fig 10.3, 5) are illiterate or difficult to read. If these stamps include other names than that of Ebaras then this could imply that he is to be associated with a number of other potters, perhaps with a direct link to samian production. In order to solve (some of) these questions and problems we need to catalogue systematically all the figures and motifs occurring on the mould-decorated beakers: some of the figure-types are not yet integrated in the Hofmann repertoire (1968), while other poinçons turn out to be variations of existing figures appearing on samian vessels (Piton and Delebarre 1992/3, 273).

Chronology

Some published stratified beakers, like the finds of Vendeuil-Caply (France) (Piton and Delebarre 1992/3), Liberchies (Fig 10.6) and Wenduine (Fig 10.8), belong to contexts from the second half of the 2nd or early 3rd century AD. The earliest examples were discovered in the vicus of Liberchies where they could be assigned to 'l'horizon VIII', a stratigraphic entity which can be sharply dated between AD 110/120 and 165–175 (Vilvorder 2001a, 359–60). According to Trimpe Burger (1986, 39) a decorated Argonne beaker came to light in Aardenburg (the Netherlands) in an assemblage dated to the third quarter of the 2nd century. The latest beaker finds are represented by the Reims fragment which was recovered from an abundant mid-3rd century deposit (Joly 1993) and by the sherds from Ville-sur-Lumes (France), dated in the first half of the 3rd century (Rollet and Deru 2005, fig 38, 7–10). The possibility cannot be excluded that some of the later objects may be residual or have been in use for a long time before being deposited. Because these mould-decorated beakers were somewhat special they may therefore have had a longer life. A third, potentially useful chronological argument can be provided by the figure-types themselves. However, the dating of decorated Argonne ware and stylistic analysis of each individual mould-maker or 'potter' has always been a precarious affair and usually

leads towards a general date from about the middle till the end of the 2nd century AD (Raepsaet-Charlier *et al* 1977/8, 97). Within this ample time frame only a relative sequence of potters can be distinguished with Toccius, Tocca and Tribunus representing the first 'generation', followed by Germanus and Africanus (Hofmann 1969–1970, 32–3; Mitard 1986, 199).

To sum up, on the current evidence it is difficult to define a start- or end-date of the mould-decorated beaker production. In this respect, it seems sensible to date the lifespan of this pottery industry somewhere in the second half of the 2nd century AD. Future research in the Argonne production centres themselves and further study in depth based on a wider survey of beaker finds within consumer sites will undoubtedly contribute to the chronological narrowing of this specific ceramic activity.

Distribution (Fig 10.4)

Mould-decorated Argonne beakers occur in different archaeological contexts: broken pieces were discovered among domestic or other refuse on sites in Kortrijk (Belgium; Deschieter 1993, afb 5, 13 and 1995, fig 27), Braives (Belgium; Massart and Gustin 1981, fig 66, 84; Gustin and Massart 1985, fig 34, 30), Liberchies (Vilvorder 1987, fig 48, 5–6; Vilvorder 2001b, fig 96), Reims (Joly 1993, fig 46, 33) and Vendeuil-Caply (Piton 1983; Piton and Delebarre 1992/3, figs 3 and 4) while some of the complete beakers originate from funerary (or ritual) contexts like the pieces excavated in Liberchies (Fig 10.6); Werner 1979–1981), Ville-sur-Lumes (Duchêne and Duchêne 1994, fig 18) and Mamer (Fig 10.5; Krüger 1930, 9; Krier 1983, 207, no. 153). They appear to be a particularly rare fineware type; in settlements they are mostly represented in modest proportions and one would be inclined to interpret their presence as casual imports or as the belongings of individuals. However, despite the fact that the limited number of sites mentioned in our paper can only be used as a rough guide, it seems to be an expected pattern that this by-product of samian trade appears on settlements or in regions which give evidence for a significant import of 2nd century Argonne samian ware. It has already been argued that for their transport the Argonne pottery workshops greatly benefited from the nearby Meuse river and from the extensive road-network branching from the province's capital *Durocortorum* (Reims) (Raepsaet and Raepsaet-Charlier 1988, 66). One of the main arteries in the region was the road connecting Reims with the *caput civitatis Divodurum* (Metz) in the Mosel valley (Feller *et al* 1998, fig 2). Finally, the presence of the river Aisne, one of the main tributaries of the Seine, undoubtedly stimulated the transport and spread of Argonne pottery towards the Seine Basin (Blaskiewicz and Dufournier 1989, 258). Consequently, future mould-decorated beaker discoveries are certainly to be expected in the area enclosed by these two ancient traffic-arteries, that is modern northern France, Belgium and south Holland.

The nature of distribution of these beakers in northern

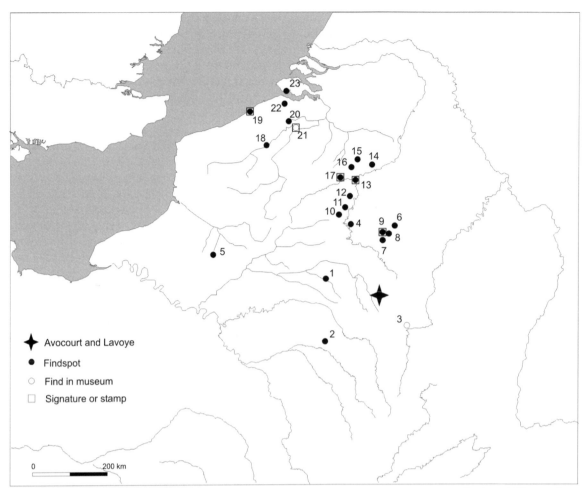

Fig 10.4:Distribution of mould-decorated beakers in northern Gaul. 1: Reims; 2: Morain; 3: Toul; 4: Ville-sur-Lumes; 5: Vendeuil-Caply; 6: Mamer; 7: Saint-Mard (Virton); 8: Arlon; 9: Bossu-en-Fagne; 10: Treignes; 11: Anthée; 12: Namur; 13: Braives; 14: Jodoigne; 15: Tourinnes-Saint-Lambert; 16: Liberchies; 17: Kortrijk; 18: Wenduine; 19: Merendree; 20: Ghent; 21: Welzinge (Vlissingen); 22: Aardenburg

Gaul on current evidence conforms to the pattern of Argonne samian ware. Because of their relatively short-lived production they can be used as sensitive trade indicators, revealing the real extent of exportation of Argonne samian during the later 2nd century. In this way one could explain their apparent absence in the Rhineland and also in Britain, two regions where, from the mid Antonine period onwards, Argonne samian declined dramatically. (In Britain, Argonne samian seems never to have been a very important element in pottery assemblages. According to Joanna Bird (pers comm) its distribution is likely to be concentrated in the South-East and in the military zone.)

Our distribution map is in this respect far from being complete and is merely intended as a first attempt to plot the already known find-spots of decorated Argonne beakers (Fig 10.4). The survey of consumer sites is largely based on a scan of published literature and a random inspection of the actual pottery available for study in collections. There must undoubtedly be more beaker finds which have not yet been published or which are in private collections unknown to us. Also the absence of any structured archaeological research in some regions has its effect on the geographical distribution. Another far from negligible factor which can distort the picture is the potential problem of identification: when found in a fragmentary state one would easily be inclined to classify non-decorated beaker pieces as terra nigra; moreover, it is not unlikely that some smaller, decorated sherds have already been integrated in quantified assemblages simply identified as being 'burnt samian ware'

The North Gaulish context

The wooded region of the Argonne has long been known for its Roman pottery industries producing all sorts of fine and coarse wares. Archaeological investigations undertaken since 1886 have revealed the specifically industrial nature of some of the sites such as Lavoye. What makes the Argonne significant in a wider context is the continuous production of Roman pottery from the late 1st to the 5th century AD (Feller *et al* 1998). Strategically situated in the western part of the *Civitas Mediomatricorum* and on the edge of the *civitates* of the Remi and the Leuci this area also benefited from its geographical location between the Meuse

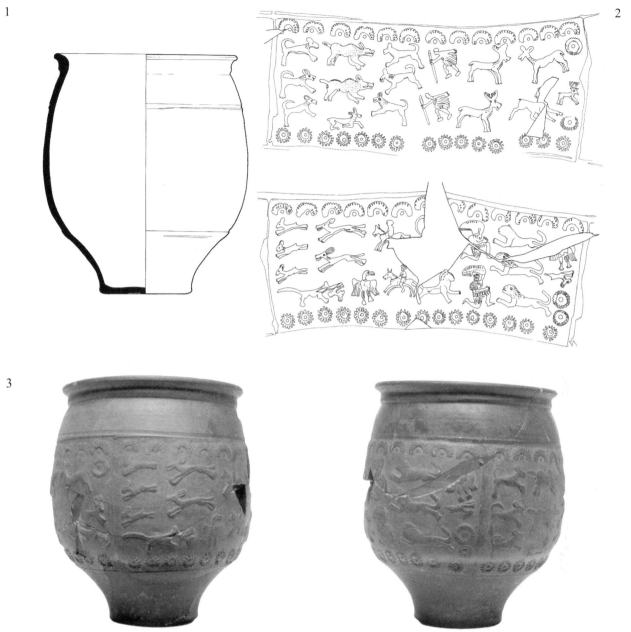

Fig 10.6: The beaker from the vicus of Liberchies (Belgium) (copyright Musée Royal de Mariemont). 1: Profile (scale 1:2); 2: The decorative frieze (scale 1:2); 3: Photographs of the mould-decorated beaker

out by its high-quality finish. The decorated scenes are delineated by a row of leaves on top (Hofmann 383) and a line of rosettes below (Hofmann 364). The frieze itself consists of four large panels with hunting scenes each separated by a vertical row of four circular motifs. The first panel shows two pairs of different lions (Hofmann 150 and ?171), an unidentifiable animal (smaller version of Hofmann 176), three musicians, two crouching men (Hofmann 53), one eagle (Hofmann 298) and one cat-like animal (Piton and Delebarre 1992/3, fig 6, no. 11). (The musicians or flute-players do not occur in any known catalogue of poinçons: the Mamer beaker is the only mould-decorated piece on which they are represented). The second panel comprises a combination of three types of deer (Hofmann 211, ?225, 237) and three dogs (Piton and

Delebarre 1992/3, fig 6, no.10). This scene is followed by a panel with two boars (Hofmann ?201B), surrounded by eight dogs (Hofmann 280), two men with staff (Hofmann 64) and two horsemen (Hofmann 142), while the final scene is crowded by running hares (Hofmann 292), foxes (Hofmann 264B), four mounted men (Hofmann 141), two feline creatures or dogs (?) (Piton and Delebarre 1992/3, fig 6, no. 11) and one eagle (Hofmann 298) holding a hare (?) between his claws. (This rare combination of an eagle Hoffman 298 holding prey also occurs on the Liberchies beaker (below)).

Liberchies (Belgium) (Fig 10.6)

Founded in the Augustan era, the Roman site of Liberchies

developed as a village on the important road connecting *Colonia* (Köln) with *Bagacum* (Bavay); this typical roadside settlement was morphologically characterized by a ribbon development with houses or constructions built end-on to the main road. Shortly after the demise of the small town during the 3rd quarter of the 3rd century, a small fortification (*burgus*) was erected within the former settlement which was succeeded in the 4th century by a stone *castellum* built some 600m to the west of the vicus (Brulet *et al* 2002).

Since archaeological investigation started within the settlement eight small beaker fragments have been recovered from different assemblages (Vilvorder 1987, fig 48, 5–6; Vilvorder 2001b, fig 96). However, the 1980 excavation campaign revealed an intriguing discovery: a complete mould-decorated beaker found together with other vessels and some metal and glass objects in the remains of a wooden box buried in a square pit of which the bottom was covered with animal bones (Werner 1979–1981). The context was dated in the late 2nd – early 3rd century. The decoration of this well preserved beaker represents one continuous frieze depicting a hunting scene. The only interruptions in this depiction are the two visible, vertical joints where the two halves of the frieze were fused together (Fig 10.6, 3).

The frieze is delineated at top and bottom by rows of arcades (Hofmann 480) and rosettes (Hofmann 441) (Fig 10.6, 2). The figure-types include two boars (Hofmann ?201B), surrounded by six dogs (Hofmann 252 and 280) and a doe at rest (Hofmann 237), two men with staff (Hofmann 64), a herd of deer (Hofmann 220, 231 and ?225), two rosettes, three hares (Hofmann 292), two foxes or dogs (Hofmann 264B), a feline creature or dog (?) (Piton and Delebarre 1992/3, fig 6, 11) with a prey in its mouth, an eagle (Hofmann 298), two horsemen (Hofmann 142), two or three lions (Hofmann 150), followed by two kneeling hunters with a net and three lions running to the left (Piton and Delebarre 1992/3, fig 6, 12). On top of two rosettes is an eagle (Hofmann 298) with a prey in its claws.

Namur (Belgium) (Fig 10.7)

In 1990 rescue excavations in the city of Namur revealed numerous traces of a riverside settlement, established on the left bank of the river Meuse. Among the archaeological structures were the remains of a cellar belonging to one of the buildings of the settlement. Several fragments of a mould-decorated beaker were recovered from the backfill of this cellar (Demelenne 1999, 91). Noticeable is the rouletted decoration on its shoulder. The upper edge of the frieze itself is delineated by rosettes (Hofmann 458) while in the lower part small arches (Hofmann 477) have been used. The decorative scene of the frieze shows no figurative motifs but seems to consist solely of different sorts of rosettes lined up in columns. This beaker is remarkable not only for its decoration but also because of its intradecorative stamp (Fig 10.3, 5) (*cf* above).

Wenduine (Belgium) (Fig 10.8)

The modern-day village of Wenduine is situated in the eastern part of the Belgian coastal plain; up to the present its territory has produced four Roman-period archaeological sites (Wenduine I –IV: Thoen 1978, fig 34). On the site of Wenduine I, located on the modern-day beach, a small but interesting piece from a mould-decorated beaker was recovered from the upper layer of a rubbish pit of which the lower deposits produced a notable quantity of mussel-shells, a small bronze oyster-fork and a Walters 80 dish fragment (Cools 1987, 103).

The surviving part of the decorated panel includes a discoid motif and two letters in rustic capitals IIB[.. (Fig 10.3, 3). The surface has a dark-grey colour while the core is bluish grey. The Wenduine context was dated by the excavator to around the middle or second half of the 2nd century AD. However, in view of its association with a Walters 80 form, it is not to be excluded that the beaker-sherd became buried in the late 2nd century.

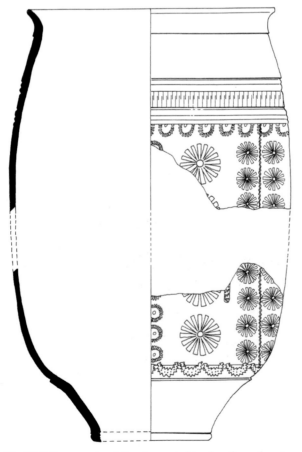

Fig 10.7:Fragments of the decorated beaker from the vicus of Namur (Belgium). Scale 1:2.

Ghent (museum collection of the University) (Fig 10.9)

In 1933 a small dark-grey, decorated beaker in the museum

Fig 10.8:The Wenduine sherd with stamp EB[.. (drawn by JD). Scale 1:2.

collection of Ghent University came to the attention of Professor R De Maeyer (Fig 10.9, 3). He was clearly aware of its unusual and distinctive character because he published a small article about it: in his paper he mentions the discovery of similar beaker-moulds by Dr Meunier in Lavoye and in referring to its specific fabric and technical features he called it *Terra Nigra Sigillata* (De Maeyer 1933). The Ghent University collection records do not specify its provenance but it is possible that this find came to light in northern Flanders since many Roman finds from

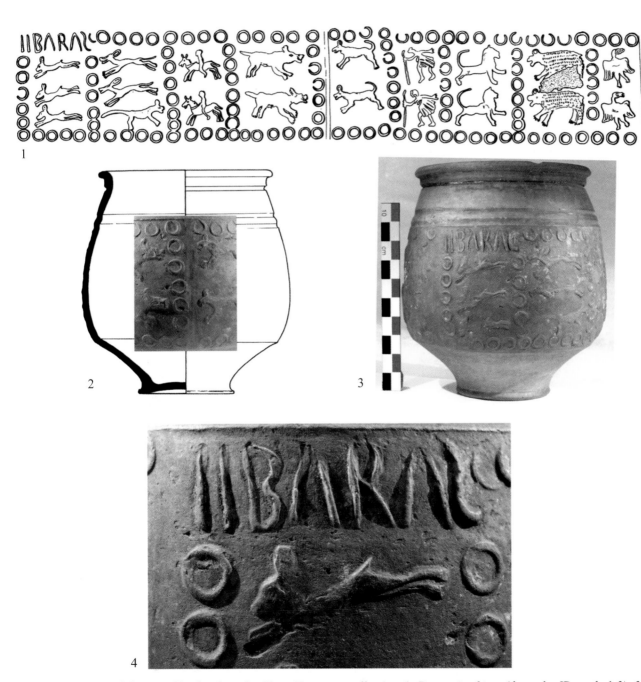

Fig 10.9:The mould-decorated beaker from the Ghent University collection. 1: Decorative frieze (drawn by JD, scale 1:2); 2: Profile of the beaker with photographic detail of one of the two joint-lines (copyright Ghent University, photograph by WDC); 3: Photograph of the beaker with signature and frieze (copyright Ghent University, photograph by WDC); 4: Close-up photograph of the signature EBARAS on the Ghent beaker (copyright Ghent University, photograph by WDC, scale 1:1)

Fig 10.10: The small mould-decorated beaker from Welzinge (the Netherlands) (copyright Provinciaal Archeologisch Centrum Zeeland, drawn by JD)

the collection originate from the neighbouring parts of Flanders (eg the coastal plain).

The upper and lower edges of the scenes are delineated by circles (Hofmann 468) which are also used to divide the decorated frieze into nine different panels. Two vertical joint-lines indicate the borders where the two moulded friezes were fitted together (Fig 10.9, 1). The first half of the frieze shows a sequence of four panels with a cursive signature reading IIBΛRΛS in the upper part of the panel with the hares (Fig 10.9, 4): three hares to left (Hofmann 292), two foxes or dogs running left (Hofmann 260 or 264B) and a feline creature or dog (?) (Piton and Delebarre 1992/3, fig 6, 11), two horsemen (Hofmann 141), two boars to right (Hofmann ?201B). The second half with five panels consists of two dogs to left (Hofmann 246 or 251), two men with staff (Hofmann 64), two lions to right (Hofmann 150), two bears to left (Hofmann 188) and two eagles (Hofmann 298).

Welzinge (Vlissingen) (the Netherlands) (Fig 10.10)

The only two known examples of mould-decorated beakers in the Netherlands come from the coastal area of Zeeland. In 1986 fragments of a small beaker were retrieved from peat-mixed spoil in Welzinge near Vlissingen (Isle of Walcheren) (Van Heeringen 1986, 5). The beaker's frieze consists of one continuous panel of repetitive figures and motifs: the main figure-types are a running deer (Hofmann 211) and a reclining panther (smaller than Hofmann 176). Between the legs of each deer appear two rosettes; the upper edge of the frieze is a row of alternating arched motifs (Hofmann 476 and 480). In reporting this find J A Trimpe Burger

refers to a similar decorated vessel recovered in 1976 from a context dated to the third quarter of the 2nd century in Aardenburg (Trimpe Burger 1986, 39). Unfortunately, in the present state of our survey we have not yet been able to recover this unpublished piece.

Acknowledgements

We wish to express our gratitude to the people who made it possible for us to study some material and who permitted its publication, while others gave helpful information concerning already published pottery finds: Saskia Bott (Musée du Malgré-Tout, Treignes (Belgium)), †Etienne Cools (Oostende (Belgium)), Professor Dr Xavier Deru (Université Charles-de-Gaulle – Lille 3 (France)), Robert van Dierendonck (Provinciaal Archeologisch Centrum Zeeland (the Netherlands)), Dr Jean Krier (Musée National d'Histoire et d'Art, Luxembourg), Jean Plumier (Ministère de la Région wallonne, Direction Générale de l'Aménagement, du Territoire, du Logement et du Patrimoine (Belgium)) and Dr Patrick Monsieur (Ghent University). Finally, we also would like to thank Joanna Bird for making comments and suggestions on our preliminary study of this type of pottery.

Bibliography

Anderson, A C, 1980. *A Guide to Roman Fine Wares*, Highworth

Arthur, P, and Marsh, G (eds), 1978. *Early Fine Wares in Roman Britain*, Brit Archaeol Rep British Ser 57, Oxford

Bayard, D, 1980. La Commercialisation de la céramique com-

mune à Amiens du milieu du IIIème siècle après J.-C., *Cahiers Archéologiques de Picardie* 7, 147–209

Bémont, C, and Jacob, J-P (eds), 1986. *La Terre sigillée gallo-romaine. Lieux de production du Haut-Empire : implantations, produits, relations*, Documents d'Archéologie Française 6, Paris

Bémont, C, Jeanlin, M, and Lahanier, C (eds), 1993. *Les figurines en terre cuite gallo-romaines,* Documents d'Archéologie Française 38, Paris

Bet, P, and Brulet, R, 1994. La Terre sigillée, in Brulet 1994, 103–9

Bet, P, and Montinéri, D, 1989. La céramique sigillée moulée tibéro-claudienne du site de la Z.A.C. de l'enclos à Lezoux, *Société Française d'Etude de la Céramique Antique en Gaule: Actes du Congrès de Lezoux 1989*, 55–69, Lezoux

Bet, P, Severs, L, and Vilvorder, F, 2001. La Terre sigillée, in Brulet *et al* 2001, 125–81

Bird, J, 1993. 3rd-century samian ware in Britain, *J Roman Pottery Stud* 6, 1–14

Blaskiewicz, P, and Dufournier, D, 1989. Diffusion des gobelets bruns d'Argonne entre la fin du Ier siècle et la fin du IIe siècle en Normandie, *Gallia* 46, 253–9

Bourgeois, J, 1994. La Céramique, in Cahen-Delhaye *et al* 1994, 59

Brulet, R (ed), 1981. *Braives gallo-romain I. La zone centrale*, Publications d'histoire de l'art et d'archéologie de l'Université Catholique de Louvain 26, Louvain-la-Neuve

Brulet, R (ed), 1985a. *Braives gallo-romain III. La zone périphérique occidentale*, Publications d'histoire de l'art et d'archeologie de l'Université Catholique de Louvain 46, Louvain-la-Neuve

Brulet, R (ed), 1985b. *Braives et la romanisation*, exhibition catalogue, Louvain-la-Neuve

Brulet, R (ed), 1987. *Liberchies I vicus gallo-romain: bâtiment méridional et la Fontaine des Turcs: fouilles de Pierre Claes*, Publications d'histoire de l'art et d'archéologie de l'Université Catholique de Louvain 54, Louvain-la-Neuve

Brulet, R (ed), 1994. *Braives-la-Romaine: bilan de vingt ans de recherches archéologiques dans l'agglomération gallo-romaine de Braives 1972–1992*, Collection d'archéologie Joseph Mertens 9, Louvain-la-Neuve

Brulet, R, Symonds, R, and Vilvorder, F (eds), 1999. *Céramiques engobées et metallescentes gallo-romaines*, Rei Cretariae Romanae Fautorum Acta Suppl 8, Oxford

Brulet, R, Dewert, J-P, and Vilvorder, F (eds), 2001. *Liberchies IV vicus gallo-romain : travail de rivière: fouilles du Musée de Nivelles (1986/87 et 1991/97)*, Publications d'histoire de l'art et d'archéologie de l'Université Catholique de Louvain-la-Neuve 101, Louvain-la-Neuve

Brulet, R, De Longueville, S, and Vilvorder, F (eds), 2002. *Liberchies, entre Belgique et Germanie. Guerres et paix en Gaule romaine*, exhibition catalogue, Morlanwelz

Brulet, R, Feller, M, Ansieau, C, Deru, X, Hus, J-J, Laduron, D, Mitard, P-H, Rekk, S, Severs, L, Verslype, L, and Vilvorder, F, 2003. Recherches sur les ateliers de céramique gallo-romains en Argonne : 2. Le site de production d'Avocourt 3 (Prix-des-Blanches), Zone fouillée, *Archaeologia Mosellana* 5, 301–451

Brunsting, H, 1937. *Het grafveld onder Hees bij Nijmegen, een bijdrage tot de kennis van Ulpia Noviomagus*, Amsterdam

Cahen-Delhaye, A, Clausse, R, Gautier, A, Lallemand, J, Lambert-Henricot, C, and Massart, C, 1994. *Un Quartier artisanal de l'agglomération gallo-romaine de Saint-Mard (Virton)*, Etudes et Documents, Série Fouilles 1, Namur

Chenet, G, 1919. Gobelets ovoïdes moulés d'Autry-Lavoye (céramique gallo-romaine d'Argonne), *Pro Alésia* 5 (22), 129–40

Chenet, G, 1930. Die Erforschung der gallorömischen Töpfereien in den Argonnen seit dem Anfang des zwanzigsten Jahrhunderts, *Germania* 14, 64–73

Chenet, G, 1938. L'industrie céramique gallo-belge et gallo-romaine en Argonne, *Revue des études anciennes* 40, 251–86

Chenet, G, and Gaudron, G, 1955. *La céramique sigillée d'Argonne des IIe et IIIe siècles*, Gallia Suppl 6, Paris

Cools, E, 1987. Ik ben een oestervorkje kwijt..., *Westvlaamse Archaeologica* 3, 103

Cüppers, H, Collot, G, Kolling, A, and Thill, G (eds), 1983. *La Civilisation romaine de la Moselle à la Sarre*, exhibition catalogue, Mainz

De Clercq, W, Deschieter, J, Hageman, B, Thoen, H and Vermeulen, F, 1998. Recent Romeins archeologisch onderzoek in de vallei van de Kale, grondgebied Land van Nevele: sites en structuren, in *VOBOV-Info: Tijdschrift van het Verbond voor Oudheidkundig Bodemonderzoek in Oost-Vlaanderen* 47. Themanummer. Een kijk op het archeologisch verleden van Het Land van Nevele, 28–33

De Clercq, W, Deschieter, J, Bird, J, and Dickinson, B, 1999. Analyse d'un ensemble de terre sigillée receuillie en surface à Steene-Pitgam (Nord), *Revue du Nord* 81, 75–105

Delage, R, 1996. Signature in forma et style décoratif: la céramique sigillée moulée confrontée aux problèmes de classification. L'exemple du vase signé ROTTALIM, *Sites* 61–62–63, 110–17

De Maeyer, R, 1933. Uit het Museumbezit der Gentsche Universiteit, *L'Antiquité Classique* 2, 37–41

Demanet, J C, 1999. Fouilles dans un établissement rural gallo-romain au lieu-dit Le Chasselon à Jodoigne (Bt), *Vie Archéologique* 51, 5–58

Demanet, J C, and Demanet, A, 1965. Fouille d'une construction du IIe siècle à Jodoigne, *Bulletin du Cercle Archéologique Hesbaye-Condroz* 5, 37–8

Demelenne, M, 1999. *La cave gallo-romaine de la place Marché aux légumes à Namur. Contribution à la connaissance du vicus sous le Haut-Empire*, unpub MA dissertation, Université Libre de Bruxelles

Deschieter, J, 1993. *Romeins Kortrijk II de zuidwijk : vondsten uit de periode 1969–1976*, Archeologische en Historische Monografiën van Zuid-West-Vlaanderen 29, Kortrijk

Deschieter, J, 1995. *Romeins Kortrijk III : de zuidwijk : vondsten uit de Abdij van Groeninge 1988–1992*, Archeologische en Historische Monografiën van Zuid-West-Vlaanderen 32, Kortrijk

Doyen, J-M, 1980. Treignes (Viroinval): rapport préliminaire de la campagne 1980, *Bulletin du Club Archéologique Amphora* 23, 36–42

Duchêne, P, and Duchêne, B, 1994. *La Nécropole gallo-romaine à incinérations de Ville-sur-Lumes (Ardennes-France) : les structures et la céramique*, Amphora 74

Feller, A, Brulet, R, Bocquet, A, Bausier, K, Charlier-Raepsaet, M-Th, Deru, X, Mitard, P-H, and Vilvorder, F, 1998. Recherches sur les ateliers de céramique gallo-romaines en Argonne: 1. Prospection-inventaire dans le massif de Hesse et le site de production des Allieux 1, *Archaeologia Mosellana* 3, 229–368

Goethert, K, 1997. *Römische Lampen und Leuchter*, exhibition catalogue, Trier

Greene, K, 1978. Mould-decorated Central Gaulish glazed ware in Britain, in Arthur and Marsh 1978, 31–60

Greene, K, 1979. *Report on the Excavations at Usk 1965–76: the Pre-Flavian Fine Wares*, Cardiff

Greene, K, 1986. *The Archaeology of the Roman Economy*, London

Gustin, M, and Massart, C, 1985. La céramique belge, in Brulet 1985a, 87–96

Hanut, F, and Henrotay, D, 2006. Le mobilier céramique des IIe et IIIe siècles du site "Neu" à Arlon/Orolaunum (province de Luxembourg, Belgique). Éléments pour la définition du faciès céramique de la partie occidentale du territoire trévire, *Société Française d'Etude de la Céramique Antique en Gaule; Actes du Congrès de Pézenas 2006*, 287–339, Pézenas

Heldenbergh, G, and Heldenbergh, R, 1971. Tourinnes-Saint-Lambert: un vicus gallo-romain: fouille d'un habitat du IIième siècle: rapport préliminaire, *Wavriensia* 20, 81–123

Hermet, F, 1934. *La Graufesenque (Condatomago)*, Paris

Hofmann, B, 1961. La Céramique argonnaise ornée au moule, *Rei Cretariae Romanae Fautorum Acta* 3, 23–33

Hofmann, B, 1968. Catalogue des poinçons pour moules à vases sigillées des décorateurs argonnais, *Ogam* 10, 273–307

Hofmann, B, 1969–1970. Verbindungen zwischen den Relief-schüsseln der Argonnen Töpfereien und Rheinzabern, *Rei Cretariae Romanae Fautorum Acta* 11/12, 30–33

Hofmann, B, 1979. L'Argonne témoin de l'évolution des techniques céramiques au cours du IIIe siècle, *Rei Cretariae Romanae Fautorum Acta* 19/20, 214–35

Joly, M, 1993. Etude de la céramique du dépotoir (US 844–358–896), Reims Fouilles Archéologiques. Site du Conservatoire National de Région de Musique et de Danse, rue Gambetta, Reims (Marne), *Bulletin de la Société Archéologique Champenoise*, 87 (4), 62–5

Knorr, R, and Sprater, F, 1927. *Die westpfälzischen Sigillata-Töpfereien von Blickweiler und Eschweiler Hof*, Speier am Rhein

Krier, J, 1983. Gobelet décoré de scènes de chasse, in Cüppers et al 1983, 207

Krüger, E, 1930. Vom römischen Luxemburg, *Trierer Zeitschrift* 5, 1–9

Lafon, X, 1986. La fin des ateliers, in Bémont and Jacob 1986, 183–93

Leuxe, F, 1979–1981. Etude du mobilier et du gobelet noir décoré, in Werner 1979–1981, 55–67

Massart, C, and Gustin, M, 1981. La céramique lissée, in Brulet 1981, 150–60

Mitard, P-H, 1986. Groupe d'Argonne, in Bémont and Jacob 1986, 194–207

Müller, G, 1968. *Das Lagerdorf des Kastells Butzbach. Die reliefverzierte Terra Sigillata*, Limesforschungen 5, Berlin

Oenbrink, W, 1998. Die Kölner Jagdbecher im römischen Rheinland. Form und Dekor, Funktion und Handelsgeschichte einer Kölner Geschirrproduktion im 2. Jahrhundert n.Chr., *Kölner Jahrbuch* 31, 71–252

Oswald, F, 1945. Decorated ware from Lavoye, *J Roman Stud* 35, 49–57

Piton, D, 1983. Quelques tessons de gobelets moulés, décorés, découverts à Vendeuil-Caply (Oise), *Revue Archéologique de Picardie* 3, 27–9

Piton, D, 1990. La Sigillée de Vendeuil-Caply (Oise) II – Les Vases Moulés Décorés, *Nord-Ouest Archéologie* 3, 31–85

Piton, D (ed), 1992–1993. *Vendeuil-Caply*, Nord-Ouest Archéologie 5, Berck-sur-Mer

Piton, D, and Delebarre, V, 1992–1993. La Céramique gallo-romaine de Vendeuil-Caply, in Piton 1992/3, 267–339

Raepsaet, G, 1987. Aspects de l'organisation du commerce de la céramique sigillée dans le Nord de la Gaule au IIe siècle de notre ère I : les données matérielles, *Münstersche Beiträge zur antiken Handelsgeschichte* 6, 1–29

Raepsaet, G, and Raepsaet-Charlier, M-Th, 1988. Aspects de l'organisation du commerce de la terre sigillée au IIe et au IIIe siècles de notre ère: négociants et transporteurs, *Münstersche Beiträge zur antiken Handelsgeschichte* 7, 45–69

Raepsaet-Charlier, M-Th, Raepsaet-Charlier, G, and Clausse, R, 1977–1978. Terre sigillée découverte à Vieux-Virton (Saint-Mard), *Le Pays Gaumais* 38/39, 25–105

Rollet, Ph, and Deru, X, 2005. L'Agglomération gallo-romaine des "Sarteaux" à Ville-sur-Lumes (Ardennes). La campagne de fouilles de juillet 1997, *Revue du Nord* 87, no. 363, 11–83

Stanfield, J A, 1937. Romano-Gaulish decorated jugs and the work of the potter Sabinus, *J Roman Stud* 27, 168–79

Stanfield, J A, and Simpson, G, 1990. *Les Potiers de la Gaule centrale*, Revue Archéologique SITES, hors-Série 37, Gonfaron

Stiller, G, 1986. Haute-Yutz, in Bémont and Jacob 1986, 221–3

Symonds, R P, 1990. The problems of roughcast beakers, and related colour-coated wares, *J Roman Pottery Stud* 3, 1–17

Thoen, H, 1967. De terra sigillata van Grobbendonk, *Noordgouw* 7, 105–59

Thoen, H, 1978. *De Belgische kustvlakte in de Romeinse tijd : bijdrage tot de studie van de landelijke bewoningsgeschiedenis*, Verhandelingen van de Koninklijke Academie voor Wetenschappen, Letteren en Schone Kunsten van België 40, Brussel

Trimpe Burger, J A, 1986. Een zeldzame beker van Romeins aardewerk te Welzinge, *Nehalennia* 62, 35–40

Vanderhoeven, M, 1969/1970. La Terre sigillée de la villa d'Anthée, *Annales de la Société archéologique de Namur* 55, 5–28

Vanderhoeven, M, 1977. *De terra sigillata van Grobbendonk : opgravingen 1971–1973*, Archaeologica Belgica 199, Brussel

Vanderhoeven, M, 1985. La Terre sigillée, in Brulet 1985b, 15–18

Vanderhoeven, M, and Vandenberghe, S, 1992. Versierde terra sigillata van Elewijt 2 (gem. Zemst, prov. Brabant), *Archeologie in Vlaanderen* 2, 143–73

Van Heeringen, R M, 1986. Archeologische Kroniek van Zeeland over 1986, *Rijksdienst voor Oudheidkundig Bodemonderzoek -offprints* 321

Vilvorder, F, 1987. La Céramique sans couverte, in Brulet 1987, 118

Vilvorder, F, 1998. La Céramique fine, in Feller et al 1998, 263–70

Vilvorder, F, 1999. Les Productions de céramiques engobées et métallescentes dans l'est de la France, la Rhénanie et la rive droite du Rhin, in Brulet et al 1999, 69–122

Vilvorder, F, 2001a. Les Contextes de référence et les horizons chronologiques, in Brulet et al 2001, 359–77

Vilvorder, F, 2001b. Les Gobelets moulés, in Brulet et al 2001, 199–200

Werner, G P, 1979–1981, Liberchies: fosse d'époque romaine à dépôt rituel et gobelet à engobe noir décoré de scènes de chasse en relief moulé, *Documents et Rapports de la Société Royale d'Archéologie et de Paléontologie de Charleroi* 58, 49–70

11 Der Wandertöpfer CINTVGNATVS

Ingeborg Huld-Zetsche
mit Pia Eschbaumer und Manuel Thomas

Seit 1964 arbeitet Brenda Dickinson – bis zu dessen Tod an der Seite von Brian Hartley – an einem neuen Corpus, das alle Töpferstempel auf Terra Sigillata aus nicht-italischen Werkstätten umfassen soll (Hartley und Dickinson 2008–). Der riesige Umfang dieses Werks hat bis heute eine Publikation verhindert; umso erfreulicher ist es, dass Brenda Dickinson soeben die Veröffentlichung eines ersten Teils zum Druck vorbereitet. Diese Materialsammlung wird eine unentbehrliche Grundlage zur Bestimmung von Terra-Sigillata-Stempeln und eine Quellensammlung für weiterführende Arbeiten und Forschungen zu Terra-Sigillata-Töpfern und den vielen damit verbundenen Fragestellungen – Organisation der Werkstätten, Handel, Chronologie usw. – sein. Denn wenn auch Brian Hartley und Brenda Dickinson in ihrem Corpus Kommentare und Auswertungen zu den einzelnen Töpfern beifügen, so ist ganz klar, dass eine eingehende Bearbeitung jedes einzelnen Töpfers im Rahmen einer Materialsammlung nicht in umfassender Weise erfolgen kann.

Inzwischen wissen wir, dass eine Reihe von Sigillata-töpfern in verschiedenen Töpfereien belegt sind, d.h. die Töpfer wechselten – zum Teil sogar mehrfach – ihren Arbeitsplatz. Nicht immer ist aber die geographische und zeitliche Abfolge ihrer Standorte klar, besonders dann, wenn ein Stempel in identischer Form an mehreren Produktionsorten verwendet wurde. Auf der Basis der bis dahin für den Index of Potters' Stamps (= IPS) zusammengetragenen Stempel hat Brian Hartley dieser Problematik schon 1977 einen Aufsatz gewidmet (Hartley 1977), in dem er neben anderen den ostgallischen Töpfer Cintugnatus als besonders deutliches Beispiel herausstellte; allerdings war es ihm damals noch nicht möglich, die Stationen dieses Töpfers und ihre Abfolge vollständig zu rekonstruieren.

Bei der Katalogisierung der Töpferstempel im Archäologischen Museum Frankfurt am Main stieß die Verfasserin erneut auf das Problem im allgemeinen und den Töpfer Cintugnatus im besonderen. Auf ihre und Manuel Thomas' Initiative hin fanden sich seit 2001 mehrere Archäologen aus Deutschland, Frankreich und Österreich zu einem Arbeitskreis zusammen, dessen einziges Thema dieser Töpfer Cintugnatus ist.[1] Er wurde ausgewählt, weil gerade von ihm besonders viele Stempeltypen sowie eine große Anzahl von Gefäßen mit diesen Abdrücken bekannt sind, und außerdem eine ganze Reihe von Töpfereien als Produktionsorte dafür genannt wird (Oswald 1931, 78 und 373; Hartley 1977, 255). Allerdings hätte das Projekt wenig Aussichten auf Erfolg, stünden nicht heutzutage als wichtige Hilfsmittel verschiedene Methoden der Scherben- bzw. Tonanalyse zur Verfügung, auf die Brian Hartley vor 30 Jahren noch nicht zurückgreifen konnte.[2]

Die bisherige Forschungsgeschichte zur Tätigkeit des Cintugnatus ist folgende:

- Seit 1896 ist der Stempeltyp CINTVGNATV für Rheinzabern bekannt; danach wurden für diese Töpferei noch mehrere weitere Exemplare publiziert (Harster 1896; Ludowici 1927, 212).
- 1911 hat R Forrer den Stempeltyp CINTVGNATV als Produkt der Töpfereien Heiligenberg (Forrer 1911, 232, Nr 13, Faks Taf 15, 13) und Ittenweiler vorgelegt (Forrer 1911, 238, Nr 219, Faks 215, Nr 219).
- 1917 gab es die erste Erwähnung von Stempelfunden dieses Namens aus Sinzig durch J Hagen (1917; es gibt keine Faksimiles für die Stempel des Cintugnatus, aber fünf Lesungen: 185 unter Nr 5).
- 1931 hat F Oswald in seinem Index der Töpferstempel mehrere Stempel des Cintugnatus ohne Faksimile aufgeführt; als Töpfereien zitiert er Lavoye, Ittenweiler, Heiligenberg, Rheinzabern und Sinzig (Oswald 1931, 78 und 373).
- 1948 nannte E Delort den Stempel CINTVGNATV auch für Chémery (Delort 1948, No. 19).
- 1955 wurden von G Chenet und G Gaudron die Töpfereifunde aus den Argonnen publiziert, darunter aus Lavoye auch Stempel des Cintugnatus (Chenet und Gaudron 1955, 185, fig 49, i, j, k).
- 1963 veröffentlichte M R Hull die Töpfereifunde aus Colchester, darunter einen Stempel des Cintugnatus unter dem Stichwort 'possibly Colchester' (Hull 1963, 85, no. 12, fig 48, no. 12).

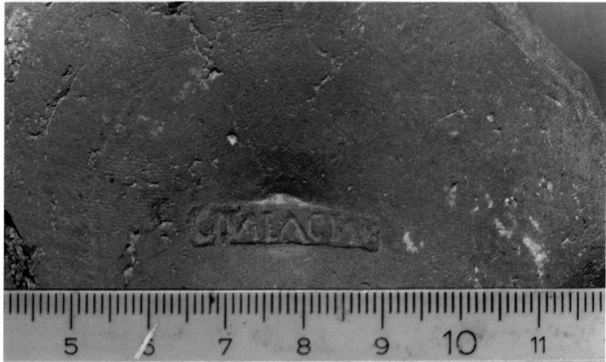

Abb 11.1:Brennkissen mit Eindruck des Stempels CINTVGN.F aus Sinzig. 1.1 Gesamtansicht; 1.2 Abformung des Stempels. Foto:Römisches Museum Remagen, Inv-Nr 1880

- 1969 legte Ch Fischer die Funde aus den Töpfereibetrieben von Sinzig vor, darunter sechs Stempeltypen des Cintugnatus (Fischer 1969, 41 Abb B 5–8; 42 Abb 7; 187 Abb 28, 4).
- 1977 schrieb B R Hartley den oben genannten Artikel zum Thema 'Wandertöpfer'. Die hier erwähnten Stempeltypen des Cintugnatus werden zwar nicht abgebildet, Hartley bezieht sich aber auf seine Materialsammlung und Gliederung im IPS. Seine Ergebnisse lauteten damals: 'Es gab zwei verschiedene Töpfer mit dem Namen Cintugnatus. Von ihnen

arbeitete 'Cintugnatus I' ausschließlich in Sinzig, während 'Cintugnatus II' von Chémery über Lavoye, Haute-Yutz, und dann wohl Heiligenberg-Ittenweiler nach Rheinzabern wanderte und dabei wenigstens fünf Stempeltypen benutzte' (Hartley 1977, 255). Die Reihenfolge der Töpfereien hat Hartley aufgrund von Veränderungen des Stempeltyps CINTVGNATV erschlossen, der für alle genannten Töpfereien zitiert wird. Doch mit Ausnahme des Stempels NTVGF für Lavoye konnte er die übrigen Stempeltypen keiner der Töpfereien zuweisen.

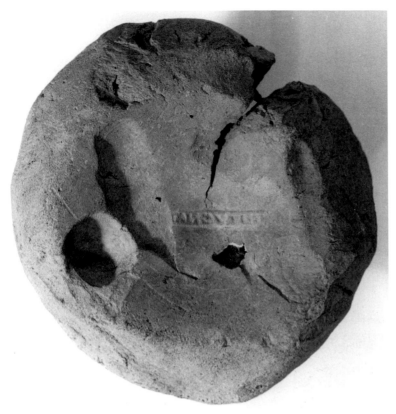

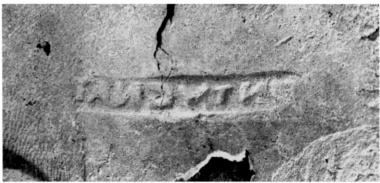

Abb 11.2: Brennkissen mit Eindruck des Stempels CINTVGNATV aus Rheinzabern. 2.1 Gesamtansicht; 2.2 Abformung des Stempels. Foto: Sammlung Manuel Thomas, Rheinzabern

Dem Arbeitskreis diente als Grundstock die umfangreiche Materialsammlung des IPS, die uns Brenda Dickinson freundlicherweise zur Verfügung gestellt hat. Unsere Analysen erfolgen aber zunächst einmal ausschließlich durch Autopsie. Zu diesem Zweck bemühen sich die Mitglieder des Arbeitskreises, in den ihnen zugänglichen Museen und Sammlungen möglichst viele gestempelte Scherben im Original zu sammeln und zu bearbeiten; dadurch konnten bislang rund 300 Stücke begutachtet werden. Ziele der Bearbeitung sind:

- Definition der verwendeten Stempeltypen und ihrer eventuellen Varianten. Auf Grundlage der jetzigen Materialbasis darf man davon ausgehen, dass alle über längere Zeit benutzten Stempelpunzen inzwischen erfasst sind. Dennoch bleibt es denkbar, dass künftige Ausgrabungen weitere Stempeltypen zutage fördern.

Es ist außerdem wichtig, mögliche Veränderungen eines Punzstempels durch Abnutzung, Verunreinigung oder Beschädigung im Vergleich möglichst vieler Originalstücke zu bewerten, um die von Hartley vorgeschlagene relative Abfolge der Töpfereien zu überprüfen bzw. zu korrigieren.

- Zuweisung der einzelnen Stempeltypen und ihrer Varianten an bestimmte Töpfereien. Hierzu dienen zunächst einmal Fehlbrände und Brennkissen aus den Töpfereien selbst, die aber nur vereinzelt vorliegen. Deshalb sind Ton- und Scherbenanalysen hier unverzichtbar. Auch eine makroskopische Bewertung der Scherbenqualität kann hilfreich sein für spätere Zuweisungen ohne chemische oder mikroskopische Analysen.

- Beurteilung der verschiedenen Stempel nach ihrem Schriftduktus. Dies könnte eine Antwort auf die Frage

liefern, ob es nur einen oder mehrere Stempelschneider gegeben hat.

- Erfassung der Gefäßformen für jeden Stempeltyp. Hierdurch kann geklärt werden, ob bestimmte Stempeltypen nur für eine bestimmte Gefäßform benutzt wurden, was wiederum Rückschlüsse auf die Organisation der Werkstätten zuließe.
- Kartierung bestimmter Stempeltypen und/oder aller Produkte aus einer einzigen Töpferei. Auf dieser Basis können möglicherweise Absatzmärkte erschlossen werden.
- Chronologische Einordnung der einzelnen Stempeltypen bzw. der Produkte einer einzelnen Töpferei. Voraussetzung dafür ist die Auswertung datierter Fundkomplexe mit Produkten des Cintugnatus. Nur so wird man die Wanderungen des Töpfers nachvollziehen können.
- Schließlich sind auch die Gründe für die Wanderungen von Töpfern zu untersuchen. Können wir aus archäologischer Sicht die Bedingungen für die Töpfer erkennen? Kennen wir die Verträge der Töpfer? Könnten wir für Cintugnatus gute Gründe für seinen häufigen Wechsel des Arbeitsplatzes angeben? Welche wirtschaftsgeschichtlichen Folgerungen können wir aus unseren Ergebnissen ziehen?

Bislang können wir noch für kaum eine der Fragen gültige Antworten liefern, was auch daran liegt, dass wir für einige Stempeltypen bzw. –varianten nur einzelne Stücke im Original aufspüren konnten.

Als wichtigste vorläufige Ergebnisse des Arbeitskreises können wir festhalten:

1. Es gab mindestens 13 verschiedene Stempel mit dem Namen des Cintugnatus, wobei drei davon entweder durch Abnutzung oder durch korrigiertes Schriftbild Veränderungen innerhalb einer Produktionsstätte bzw. zwischen zwei oder mehreren Produktionsorten zeigen.
2. Alle Stempel lassen sich einem *einzigen* Töpfer zuschreiben.

Das zweite Ergebnis ist zunächst einer Tonanalyse zu verdanken. Der Teller mit Stempel CINTVGN.F aus Colchester (Hull 1963, 85 no. 12; fig 48, no. 12) konnte dank der freundlichen Zusammenarbeit mit Paul R Sealey einer chemischen Analyse unterzogen werden. Sie ergab, dass der Stempel aus Haute-Yutz stammt. Die eindeutige Übereinstimmung dieses Stempels mit einem Stempeltyp aus Sinzig kann nur zu der Folgerung führen, dass er von demselben Töpfer benutzt wurde – mithin der Weg des Cintugnatus von Sinzig zunächst nach Haute-Yutz führte (Fischer 1969, 41, Abb B 5–8; 42 Abb 7; 187 Abb 28, 4). In Sinzig wurde dieser Stempel auch auf einem Brennkissen festgestellt (Abb 11.1). Außerdem hat ein weiterer Stempeltyp die gleiche abgekürzte Schreibweise CINTVGN.F, stammt aber nicht aus Sinzig, sondern aus

Haute-Yutz sowie aus einer noch nicht sicher bestimmten weiteren Töpferei. Diese Indizien dürften ausreichen, um hinter dem Namen Cintugnatus nur einen einzigen Töpfer zu sehen.

Der Weg des Töpfers wird aber, wenn überhaupt, erst nach Abschluß der Untersuchungen des Arbeitskreises nachzuvollziehen sein. Sicher scheint nur, dass Rheinzabern seine letzte Station war – das hat schon Hartley so gesehen; auch aus Rheinzabern gibt es ein Brennkissen mit dem Abdruck eines Stempels des Cintugnatus (Abb 11.2). Die von Oswald und Hartley benannten Töpfereien Sinzig, Chémery, Haute-Yutz, Heiligenberg/Ittenweiler, Lavoye und Rheinzabern sind bis auf Heiligenberg/Ittenweiler[3] durch Tonanalysen bestätigt, außerdem arbeitete Cintugnatus in weiteren Töpfereien (!), die allerdings noch nicht lokalisiert werden konnten.

Insgesamt können wir sagen, dass die Arbeit von mehreren Archäologen über einen einzigen Töpfer keineswegs auf Anhieb alle wünschenswerten Klarheiten erbringt. Es bedarf daher keiner Erklärung oder Entschuldigung, dass eine solche umfangreiche Arbeit nicht von Brian Hartley und Brenda Dickinson allein für jeden Töpfer geleistet werden konnte. Trotzdem wissen wir, dass die Idee und die Durchführung des ‚Index of Potters' Stamps‛ in Leeds eine wichtige und bewundernswerte Leistung ist. So soll unsere Ankündigung der Arbeit über Cintugnatus unser Dank an Brenda Dickinson sein.

Anerkennung

Brenda Dickinson erklärte sich ohne Zögern bereit, dem Arbeitskreis die bisherigen Unterlagen zu Cintugnatus zur Verfügung zu stellen. Alle Mitarbeiter des Arbeitskreises danken Brenda für diese vorbehaltlose internationale Zusammenarbeit.

Dem Arbeitskreis gehören an: Susanne Biegert (Bonn D), Antje Düerkop (Edinburgh GB), Pia Eschbaumer (Frankfurt am Main D), Ingeborg Huld-Zetsche (Oberursel D), Bertrand Hoerner (Lelling F), Jean-Paul Petit (Bliesbruck F), Silvia Radbauer (Oberhausen A), Markus Scholz (Mainz D), Gerwulf Schneider (Berlin D), Bernd Steidl (München D), Manuel Thomas (Rheinzabern D), Stephan Weiß-König (Kleve D). Mit Unterstützung der Kollegen Helmut Bernhard und Rüdiger Schulz von der Generaldirektion Kulturelles Erbe/Direktion Archäologie/Außenstelle Speyer traf sich der Arbeitskreis anfangs jährlich in der ‚Forschungsstelle Terra Sigillata‛ in Rheinzabern. Hilfe kam außerdem von weiteren Kollegen aus Belgien, Deutschland, Frankreich, Großbritannien und den Niederlanden.

Allen Museen und Kollegen in Deutschland, Österreich, Frankreich, Belgien, Niederlande und England, die unser Projekt auf vielfältige Weise unterstützten, sei an dieser Stelle herzlich gedankt.

Die Fotos des Brennkissens aus Sinzig und Rheinzabern wurden freundlicherweise von Kurt Kleemann, Römisches

Museum Remagen, und von Manuel Thomas, Rheinzabern, zur Verfügung gestellt.

Anmerkungen

1 Der Aufsatz entstand in enger Zusammenarbeit der Verfasserin mit Pia Eschbaumer und Manuel Thomas; Anregungen, Kommentare und Korrekturen der anderen Mitglieder des Arbeitskreises (vgl Annerkennung) wurden eingearbeitet.

2 Möglichst viele der von uns untersuchten gestempelten Stücke werden von G Schneider einer chemischen Analyse, von S Radbauer einer optischen Analyse unterzogen:

Die chemische Zusammensetzung der Scherben charakterisiert die vom Töpfer verwendete Masse wie ein Fingerabdruck. Dabei sind sowohl die Hauptelemente wie z.B. Silicium, Eisen, Calcium, Magnesium und Kalium, als auch Spurenelemente wie z.B. Chrom, Nickel, Rubidium, Zirkonium wichtig. Mit wellenlängendispersiver Röntgenfluoreszenzanalyse (WD-XRF) können kleine Fragmente von 2 bis 3 Gramm (mindestens 0,2 Gramm) auf etwa 20 bis 24 Elemente reproduzierbar und richtig analysiert werden. Herkunftsbestimmungen benötigen zum Vergleich Analysendaten von Keramikproben, deren Herstellungsort gesichert ist, sogenannte Referenzgruppen (Schneider 1978, 63–122). Für Terra Sigillata sind inzwischen die wichtigen Werkstätten in der Datenbank der Berliner Arbeitsgruppe Archäometrie erfasst.

Bei der optischen Beurteilung der Scherben nach ihren Eigenschaften dienen als wesentliche Unterscheidungskriterien Matrix, Porosität, Sortierung und Magerung. Die Scherben werden unter Zuhilfenahme eines Binokulars bei 40-facher Vergrößerung einem standardisierten Beschreibungsverfahren mit genormten Vergleichs- und Schaubildern unterzogen und in sog 'Scherbentypen' (engl 'fabrics') eingeteilt; die Klassifikation erfolgt am 'frischen Bruch'. Mit dieser kostengünstigen Methode kann an großen Materialmengen eine nachvollziehbare optische Zuweisung der Terra Sigillata-Scherben zu Produktionsstätten erreicht werden. (Zur Beschreibung der Methode und der Definition des Begriffes 'Scherbentyp' bzw 'fabric' vgl Peacock 1977; Orton *et al* 1993; Gassner 1997. Zur Anwendung bei Terra Sigillata vgl Tomber und Dore 1998, 25–41, Taf 223–226; Donat und Radbauer 1999; Gassner und Radbauer 2003).

3 Susanne Biegert hat die glatten Sigillaten aus Heiligenberg und Ittenweiler mit deren Tonanalysen aufgearbeitet; Cintugnatus konnte bei diesen Untersuchungen nicht belegt werden (Biegert 2003).

Literatur

Biegert, S, 2003. Chemische Analysen zu glatter Sigillata aus Heiligenberg und Ittenweiler, in *Römische Keramik. Herstellung und Handel*, (Hrsg B Liesen und U Brandl), Koll Xanten 2000, Xantener Berichte 13, 7–28, Mainz am Rhein

Chenet, G, und Gaudron, G, 1955. *La céramique sigillée d'Argonne des IIe et IIIe siècles*, Gallia Suppl 6, Paris

Delort, E, 1948. L'atelier de Satto. Vases unis 3,000 marques, *Mémoires de l'Académie Nationale de Metz* 2 ser 17, 95–127

Donat, P, und Radbauer, S, 1999. Klassifikation von Scherbentypen an Terra Sigillata. Fundort Wien, *Berichte zur Archäologie*, 2, 208–9

Fischer, C, 1969. Die Terra-Sigillata-Manufaktur von Sinzig am Rhein, *Rheinische Ausgrabungen* 5, Düsseldorf

Forrer, R, 1911. *Die römischen Terrasigillata-Töpfereien von Heiligenberg-Dinsheim und Ittenweiler im Elsaß*, Stuttgart

Gassner, V, 1997. Der Töpferofen von Carnuntum, in *Das Auxiliarkastell Carnuntum I* (Hrsg H Stiglitz und S Jilek), Sonderschriften Österreichisches Archäologisches Institut 29, 189–193, Wien

Gassner, V, und Radbauer, S, 2003. Produktionszuweisung bei Terra Sigillata durch Scherbenklassifizierung, in *Römische Keramik. Herstellung und Handel*, (Hrsg B Liesen und U Brandl), Koll Xanten 2000, Xantener Berichte 13, 43–75, Mainz am Rhein

Hagen, J, 1917. Römische Sigillatatöpferei und Ziegelei bei Sinzig, *Bonner Jahrb* 124, 170–91

Harster, W, 1896. Die Terra Sigillata-Gefäße des Speierer Museums, *Mitteilungen des Historischen Vereins der Pfalz* 20, 1–182

Hartley, B R, 1977. Some wandering potters, in *Roman pottery studies in Britain and beyond. Papers presented to John Gillam, July 1977* (Hrsg J Dore und K Greene), Brit Archaeol Rep Int Ser 30, 251–61, Oxford

Hartley, B R, und Dickinson, B M, 2008 –. *Names on* terra sigillata*: an index of makers' stamps and signatures on Gallo-Roman* terra sigillata *(samian ware)*, Bull Inst Classical Stud Suppl 102, London

Hull, M R, 1963. *The Roman potters' kilns of Colchester*, Rep Res Comm Soc Antiq London 21, Oxford

Ludowici, W, 1927. *Katalog V. Stempel-Namen und Bilder römischer Töpfer, Legions-Ziegel-Stempel, Formen von Sigillata- und anderen Gefäßen aus meinen Ausgrabungen in Rheinzabern 1901–1914*, Munich

Orton, C, Tyers, P, und Vince, A, 1993. *Pottery in archaeology*, Cambridge Manuals in Archaeology, Cambridge

Oswald, F, 1931. *Index of potters' stamps on terra sigillata 'samian ware'*, East Bridgford

Peacock, D P S, 1977. Ceramics in Roman and medieval archaeology, in *Pottery in early commerce: characterisation and trade in Roman and later ceramics* (Hrsg D P S Peacock), 21–33, London

Schneider, G, 1978. Anwendung quantitativer Materialanalysen auf Herkunftsbestimmungen antiker Keramik, *Berliner Beiträge zur Archäometrie* 3, 63–122

Tomber, R, und Dore, J, 1998. *The national Roman fabric reference collection. A handbook*, Museum London Archaeol Service, London

12 Eine Terra-Sigillata-ähnliche Keramikproduktion des 3. Jahrhunderts in Augusta Raurica

Debora Schmid und Verena Vogel Müller

Einleitung

Terra Sigillata gehört nicht unbedingt zu den Schwerpunkten im Forschungsprogramm von Augusta Raurica. Mit einer grossen Ausnahme: In den Jahren 1997–2003 hat Brenda Dickinson über 7000 in Augst und Kaiseraugst gefundene Terra-Sigillata-Töpferstempel bestimmt und in einer Datei festgehalten. Wir hoffen diese Daten in den nächsten Jahren in irgendeiner Form der Fachwelt zugänglich zu machen. Mit dem vorliegenden Artikel zu Ehren von Brenda möchten wir unsererseits einen kleinen Beitrag zum Thema 'Terra Sigillata aus Augusta Raurica' leisten. Die darin behandelte Keramikproduktion Kaiseraugst-Auf der Wacht wurde bereits summarisch in grösserem Zusammenhang vorgelegt (Vogel Müller und Schmid 1999; vgl auch Furger 1991, Nr 38; Sandoz 1987). Damals ging es vor allem um das Produktionsspektrum. Hier soll nun stärker auf den Werkstattbetrieb mit den Töpferöfen eingegangen und die produzierte Keramik detaillierter vorgestellt werden.

Das Quartier

Die Töpferei lag in der Kaiseraugster Unterstadt, in der Region 17C, in der Flur Auf der Wacht. Anlass der Notgrabungen 1981–1982.001, die zu ihrer Entdeckung führten, war der Bau von einigen Mehrfamilienhäusern. Die Kaiseraugster Unterstadt war ein Handels- und Handwerkerquartier und erstreckte sich westlich des späteren Castrums in der Niederung zwischen Violenbach, Ergolz und Rhein, an deren Ufern sich wohl Hafenanlagen und Lagerhäuser befanden. Nach Aufgabe eines frühclaudischen Militärlagers erfolgte die zivile Bebauung ab ca 100 n. Chr. in langrechteckigen Insulae mit Streifenhäusern, die im Vergleich zur Oberstadt von Augusta Raurica weniger luxuriös ausgestattete Wohnräume neben gewerblich genutzten Arealen und Räumlichkeiten aufwiesen (Abb 12.1). Ausser dem Töpferhandwerk ist in der Kaiseraugster Unterstadt als weiterer Gewerbezweig eine Glasmacherwerkstätte mit Schmelz- und Abkühlöfen nachgewiesen (Fischer 2009). Die vielen Sodbrunnen dienten der Wasserversorgung, die in Kaiseraugst nicht wie in der Augster Oberstadt mit Hilfe von Wasserleitungen erfolgte (Berger 1998, 191–3).

Befund des Gebäudes

In einem dieser Streifenhäuser, das im 2. und 3. Jahrhundert bewohnt wurde, war eine Töpferwerkstatt mit zwei Öfen installiert. Das Gebäude stiess mit einem kleinen Innenhof an die Glasstrasse, welche die Insula nach Südwesten begrenzte. Um den mit einem Kiesboden versehenen Hof mit Töpferofen 2 schlossen sich überdachte Gewerberäume an, wohl die Arbeitsräume der Töpfer. Gegen das Gebäudeinnere folgten Wohnräume und daran anschliessend ein grosser Innenhof. Die Bebauung gegen Osten bis zur Gwerdstrasse ist unklar. Töpferofen 1 wurde auf der ehemaligen Trasse einer südlich des Hauses gelegenen Gasse errichtet, die aufgegeben und gegen die Strasse hin mit einer Mauer überbaut wurde. Beide Öfen lagen in Räumen, die direkt an die Glasstrasse anstiessen (Abb 12.2).

Beide Töpferöfen waren vollständig verfüllt; diese Verfüllung setzte sich zur Hauptsache aus dem Abbruchschutt der aufgehenden Ofenkonstruktion, d.h. aus vielen Ziegelfragmenten, und aus Tonröhren und Brennhilfen zusammen. Zudem enthielt dieses Material eine auffällige Terra-Sigillata-ähnliche Ware, die nach dem Fundort benannte 'Wachtware'. Diese Ware muss in einem dieser beiden Töpferöfen gebrannt worden sein, ist doch kaum anzunehmen, dass das Ausschussmaterial eines Ofens weit weg transportiert wurde, sondern vielmehr in direkter Nähe oder in der näheren Umgebung abgelagert und nach Auflassung der Öfen in diesen entsorgt wurde. Aus diesem Grund fassen wir die beiden Töpferöfen zu *einer* Werkstatt zusammen und weisen die hier behandelte Produktion dieser zu, auch wenn dies hypothetisch bleiben muss, könnte die Ware doch auch in einem der weiteren Töpferöfen, die in der Kaiseraugster Unterstadt belegt sind, gebrannt worden sein (Müller 1989; Tomasevic Buck 1988). Neben der charakteristischen 'Wachtware' kann dieser Werkstatt keine weitere Produktion eindeutig zugewiesen werden; weder fanden sich im Fundmaterial viele Fehlbrände bestimmter

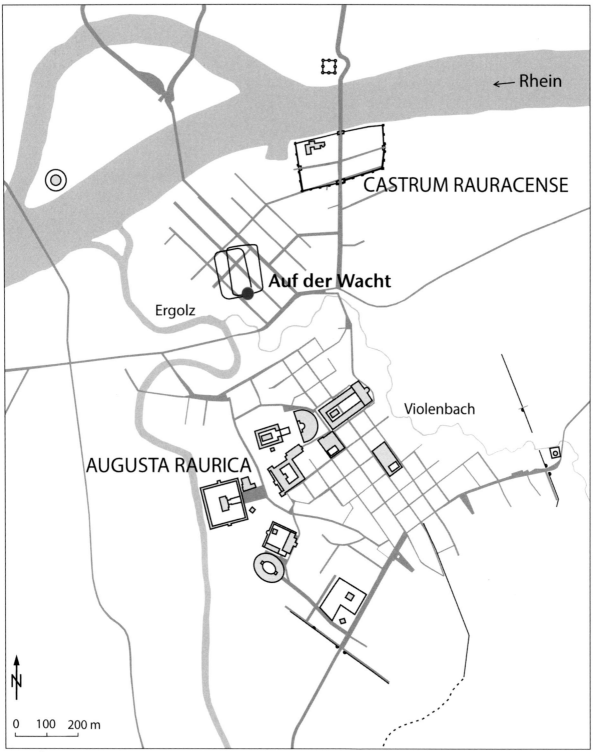

Abb 12.1: Übersichtsplan von Augusta Raurica mit der Lage des Quartiers innerhalb des Stadtgebiets. M 1:23 000 (Zeichnung Michael Vock, Ergänzung Debora Schmid)

Gefässformen oder -gattungen, noch waren grosse Serien von identischen Gefässformen zu beobachten.

Berücksichtigt wurde das Fundmaterial aus den Fundkomplexen, die den beiden Profilen durch die Töpferöfen zuweisbar sind (Profile 65 und 67) und aus denjenigen Fundkomplexen aus der näheren Umgebung der Öfen, die die charakteristische Ware enthielten. Vorgelegt werden hier nur die Brennhilfen und die als lokale Produktion anzusprechende Terra-Sigillata-ähnliche Ware.

Befund der beiden Töpferöfen

Beide Töpferöfen waren rechteckig und aus Leistenziegeln und Ziegelfragmenten gebaut. Bei beiden waren die

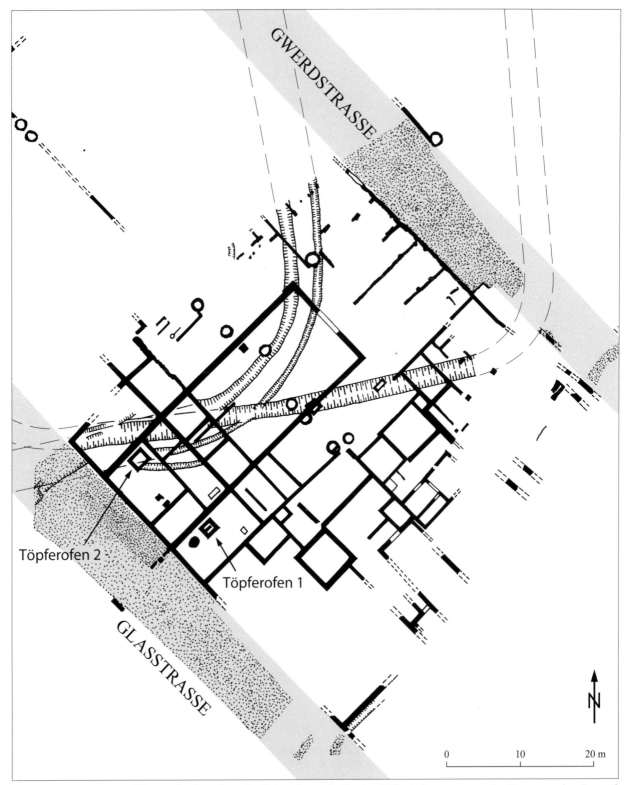

Abb 12.2: Kaiseraugst-Auf der Wacht. Grundriss des Gebäudes in der Region 17C mit den angrenzenden Bauten und umliegenden Strassen. M 1:500 (Zeichnung Urs Müller)

Heizkammer und die Lochtenne vollständig erhalten, Heizkanal und Bedienungsgrube teilweise, ein Grossteil der aufgehenden Ofenwand der Brennkammer jedoch nicht mehr vorhanden. Ofen 1 wurde von Nordwesten, Ofen 2 von Südosten befeuert. Beide waren wie die Bebauung der Insula rechtwinklig zur Strasse orientiert (Abb 12.3).

Der Unterbau der Lochtenne bestand bei Ofen 1 aus einer auf der Längsachse liegenden Zungenmauer und je drei schmalen Absätzen an den Längsseiten des Ofens (Abb 12.4). Die Lochtenne von Ofen 2 wurde von je drei, d.h. sechs seitlichen Zungenmauern getragen. Bei beiden waren die Zungenmauern und Absätze aus Leistenziegeln

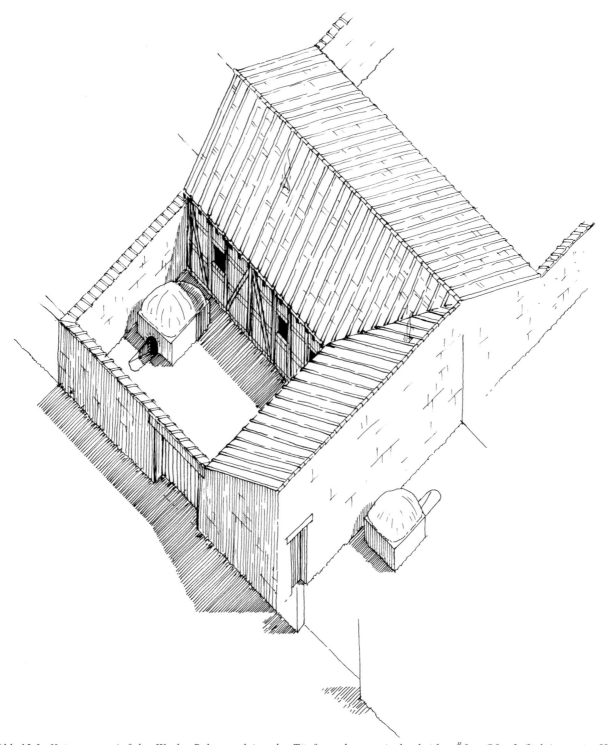

Abb 12.3: Kaiseraugst-Auf der Wacht. Rekonstruktion der Töpferwerkstatt mit den beiden Öfen. Ofen 2 (links) war im Hof eines Streifenhauses installiert, an den wohl die Arbeitsräume der Töpfer anschlossen. Ofen 1 war südlich des Hauses in eine ehemalige Gasse gebaut, die zur Strasse hin mit einer Mauer geschlossen war (Zeichnung Markus Schaub)

und Ziegelfragmenten gebaut und mit einem Gewölbe miteinander verbunden. Die Lochtenne von Ofen 1 wies vier Reihen mit je vier, d.h. 16 Pfeifenlöcher auf, die sich entlang der Ofenwand zwischen den Absätzen und gegen das Ofeninnere entlang der Zungenmauer befanden (Abb 12.4). Ofen 2 wies vier Pfeifenlöcher auf und eine Installation mit Zugröhren (Abb 12.5). Die grauschwarze Verfärbung

der Lehmverkleidung und der Ziegel von Ofen 1 sprechen für eine reduzierende Brandführung (Abb 12.4). Bei Ofen 2 war hingegen die Lehmverkleidung rötlich verfärbt, was – zusammen mit der Zugröhreninstallation (siehe unten) – auf eine oxydierende Brandführung hinweist.

Rechteckige Töpferöfen sind – wie generell in unserem Gebiet – hier weit weniger häufig als runde oder ovale:

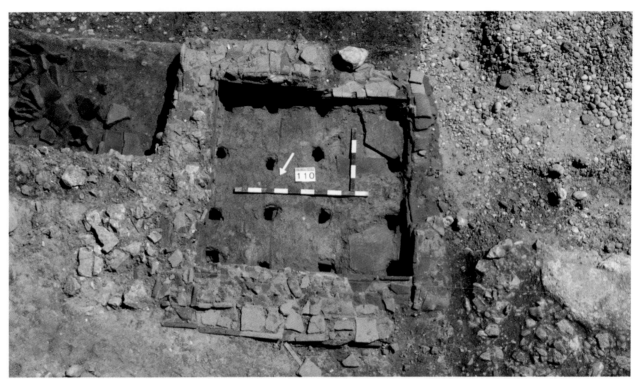

Abb 12.4: Kaiseraugst-Auf der Wacht. Der rechteckige, aus Leistenziegeln und Ziegelfragmenten errichtete Töpferofen 1 wies eine vollständig erhaltene Lochtenne mit 16 Pfeifenlöchern auf (Foto Dokumentation Ausgrabungen Augst/Kaiseraugst)

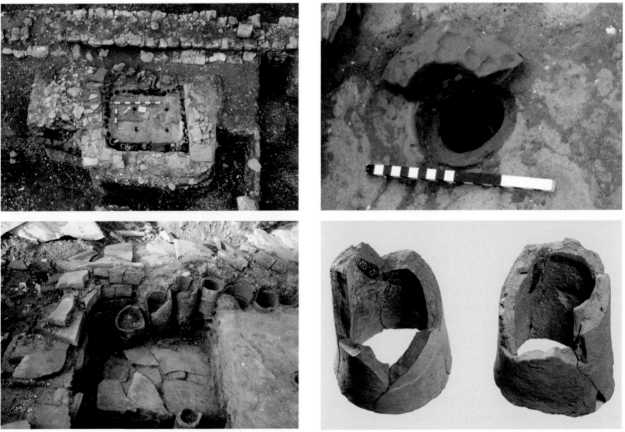

Abb 12.5: Kaiseraugst-Auf der Wacht. Töpferofen 2. Oben links: In den Pfeifenlöchern und entlang der Ofenwand befanden sich senkrecht stehende Zugröhren. Unten links: Detail der Zugröhren. Oben rechts: Detail eines Pfeifenlochs mit Zugröhre und von Hand geformtem Ring. Unten rechts: Detail zweier fragmentierter Zugröhren (links: Ton orangerot, verbrannt, Inv. 1982.532a–d, rechts: Ton orangerot, verbrannt, Inv. 1981.531a–d). (Oben und unten links: Fotos Dokumentation Ausgrabungen Augst/Kaiseraugst; unten rechts: Foto Susanne Schenker)

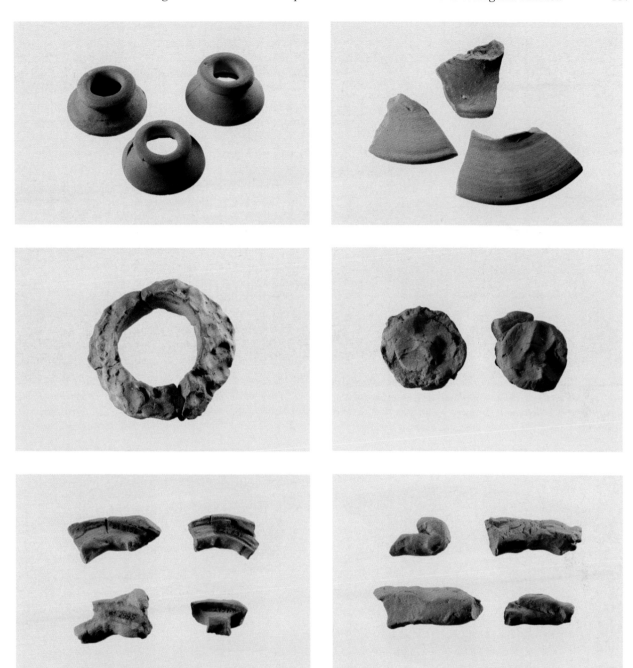

Abb 12.6: Kaiseraugst-Auf der Wacht. Die verschiedenen Typen von Brennhilfen. Oben links: Ringständer (1, 2 und 4). Oben rechts: Gelochte Scheiben (12, 13 und 14). Mitte links: Ring (3 Fragmente, Ton orangerot, Inv. 1982.585a–c). Mitte rechts: Batzen (Links Ton orangerot, Inv. 1981.3019. Rechts Ton orangerot, Inv. 1982.511). Unten links: Wülste mit Abdrücken von Gefässen (von oben links nach unten rechts: Ton orange, Inv. 1981.3156. Ton orange bis orangerot, Inv. 1982.636. Ton orange, mehlig, Inv. 1981.2995. Ton orange, mehlig, Inv. 1981.2797b). Unten rechts: Wülste mit Fingerabdrücken (von oben links nach unten rechts: Ton orange, mehlig, Inv. 1982.583. Ton orangerot, Inv. 1982.510. Ton orange, mehlig, Inv. 1981.4254. Ton orangerot, Inv. 1982.582). (Fotos Susanne Schenker)

Von den 48 hier nachgewiesenen römischen Töpferöfen weisen 42 eine runde bis ovale Form auf und nur sechs sind rechteckig (Schmid 2008).

Eine sehr nahe Parallele aus Augusta Raurica zum rechteckigen Grundriss der beiden Töpferöfen Kaiseraugst-Auf der Wacht und besonders zur Konstruktion der seitlichen Zungenmauern des Ofens 2 bildet der Töpferofen aus der Region 5B, der in die zweite Hälfte des 2. Jahrhunderts n. Chr. datiert wird. Bei diesem fehlen allerdings die Tonröhren. Produziert wurde in jenem einfache Gebrauchskeramik ohne Überzug. (Schatzmann 2003, 190–4, Abb 113).

Zugröhren

Die Brennkammer von Ofen 2 wies eine besondere Installation

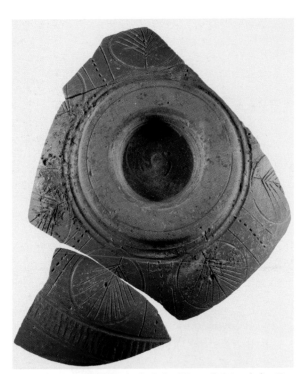

Abb 12.7: Terra-Sigillata-ähnliche Ware, Schüssel der Form Drag 37, hergestellt in der Töpferei Kaiseraugst-Auf der Wacht, gefunden bei einer Grabung im Innern des Kastells Kaiseraugst, Inv. 1976.7864a–c (Foto Susanne Schenker)

auf: Entlang der Ofenwand waren auf der Innenseite und in den vier Pfeifenlöchern der Lochtenne ursprünglich gegen 45 senkrecht stehende Tonröhren installiert (Abb 12.5). Mit Hilfe dieser sogenannten Zugröhren wurde einerseits der Luftzug in der Brennkammer reguliert, andererseits dienten die Röhren zur etagenartigen Unterteilung des Brennraums für eine optimale Raumausnutzung bei der Beschickung. Die Röhren waren an ihrer Basis mit von Hand angedrückten Tonwülsten fixiert, die sowohl für einen guten Halt der Röhren sorgten als auch ein Eindringen der Luft an den Röhren vorbei verhinderten. Auf dem oberen Ende einer jeden Tonröhre lag eine gelochte Tonscheibe, auf welche Ziegelplatten horizontal zu liegen kamen. Tonscheiben, zu einem Rund geformte Tonwülste und eine grosse Zahl von fragmentierten Ziegelplatten, die allerdings auch von der Ofenkonstruktion stammen können, sind im Versturzmaterial des Ofens vorhanden.

Die Installation solcher Röhren, kombiniert mit gelochten Tonscheiben und Tonwülsten unterschiedlichster Ausformung ist typisch für Töpferöfen, in denen Terra Sigillata gebrannt wurde. Aus den Sigillata-Produktionszentren sind die Inventare der Töpferöfen so gut bekannt, dass die genaue Installation rekonstruiert werden kann (z.B. Vernhet 1981, fig 10; Martin 1996, fig 29; Sölch 1993, Abb 5).

Bisher sind Belege solcher Röhreninstallationen in

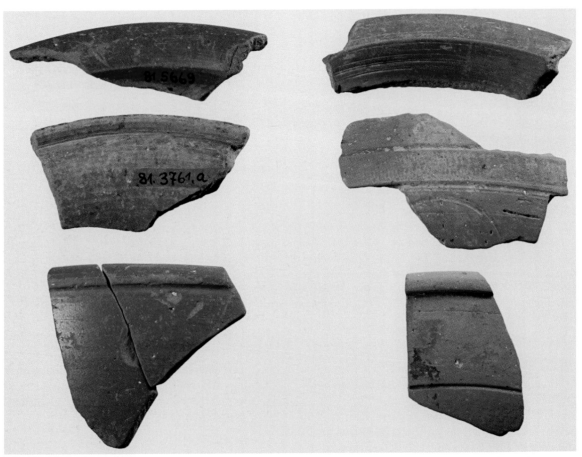

Abb 12.8: Kaiseraugst-Auf der Wacht. Farbbeispiele der Terra-Sigillata-ähnlichen Ware. (Von oben links nach unten rechts) 57, 67, 68, 33, 28, 27 (Fotos Susanne Schenker)

Töpferöfen in unserem Gebiet selten. Bekannt sind Beispiele aus Baden (Drack 1949, Abb 3 f), Oberwinterthur (Hedinger u.a. 1999, fig 5) und Vindonissa (Pauli-Gabi u.a. 2007, 90–2). In Baden wurde Terra Sigillata hergestellt, in den beiden anderen Töpfereien Terra-Sigillata-Imitation, also immer Keramik mit Überzug. In Augusta Raurica sind solche Röhren nur aus dem augusteischen Töpferofen des Fronto bekannt, in dem u. a. ebenfalls Terra-Sigillata-Imitation gebrannt wurde (Schmid 2003, 92–109). Ihr Vorkommen in der Werkstatt Kaiseraugst-Auf der Wacht kann als weiteres Indiz dafür gelten, dass die Terra-Sigillata-ähnliche Ware in dieser Töpferei produziert wurde.

Brennhilfen

Im Fundmaterial der beiden Töpferöfen fand sich eine Vielzahl von Brennhilfen, die sich in fünf Typen mit verschiedenen Funktionen unterscheiden lassen.

Ringständer, die klassischen, scheibengedrehten Brennständer, die in vielen Töpfereien gefunden werden, sind in der Töpferei Kaiseraugst-Auf der Wacht mit 11 Exemplaren vertreten (Abb 12.6, oben links; Abb 12.9, 1–11. Die Nummern 1–72 auf den Abb 12.9–12 entsprechen den Katalognummern im Text).

Bereits angesprochen wurden die sieben gelochten Scheiben, die auf der Töpferscheibe hergestellt wurden und als Ofeneinsatz, als sogenannte Etagenaufleger auf den Zugröhren dienten (Abb 12.6, oben rechts; Abb 12.9, 12–18).

Mit Hilfe der ebenfalls bereits erwähnten, von Hand geformten, sehr grob ausgeführten Ringe, von denen fünf nachgewiesen sind, wurde eine senkrecht gestellte Tonröhre an ihrem unteren Ende fixiert (Abb 12.6, Mitte links).

Tonbatzen von ungefähr runder Form, ebenfalls von Hand geformt, dienten einerseits als Brennständer, könnten aber auch zum Verschliessen einer Tonröhre oder eines Pfeifenlochs eingesetzt worden sein. In der Töpferei Kaiseraugst-Auf der Wacht sind zwei solcher Batzen nachgewiesen (Abb 12.6, Mitte rechts).

Von Hand geformte Wülste sind in sehr grosser Zahl (mehr als 70) vorhanden. Mit diesen Tonwülsten wurde beim Einsetzen eines Gefässes spontan aus weichem Ton der gerade benötigte Abstandhalter, der benötigte Brennständer oder die Standhilfe geknetet und eingesetzt. Zudem wurden solche Wülste ad hoc geformt, um zwei Tonröhren miteinander zu verbinden. Viele dieser Wülste weisen Abdrücke von Tonröhren (Abb 12.6, unten links), andere Fingerabdrücke auf (Abb 12.6, unten rechts).

Alle diese Brennhilfen sind typisch für das Inventar von Töpfereien, in denen Terra Sigillata oder Keramik mit Überzug hergestellt wurde (siehe unten Katalog, Vergleiche zu den verschiedenen Brennhilfen). Dies unterstützt die These, dass die Terra-Sigillata-ähnliche Ware in der Töpferei Kaiseraugst-Auf der Wacht hergestellt wurde.

Produktion

Wie schon erwähnt, fiel unter dem Fundmaterial im Umfeld beider Öfen und besonders zahlreich in der Verfüllung von Ofen 2 eine besondere Art von Keramik auf, die in Technik, Form und Verzierung Terra-Sigillata-Vorbilder nachahmt. Der Ton ist orange mit kleinen Kalkpartikeln, eher weich gebrannt, daher etwas mehlig, und der Überzug orange bis rotbraun, bei guter Erhaltung glänzend, manchmal aber nur noch als Verfärbung oder gar nicht mehr zu erkennen (Abb 12.8). Die Gesamtzahl der entsprechenden Scherben dürfte weniger als 200 Stück betragen, da es sich aber um charakteristische Stücke handelt, die sonst nirgendwo in grösserer Konzentration aufgefallen sind, liegt die Vermutung nahe, dass diese Ware in den beiden Töpferöfen gebrannt wurde. Es ist nicht auszuschliessen, dass darin auch noch andere Keramik produziert wurde, doch gibt es bei der geschilderten Ausgangslage dafür keine Anhaltspunkte.

Am eindeutigsten dieser Werkstatt zuzuweisen sind Schüsseln der Form Drag 37, bei denen das Relief durch Ratterblechbänder, Kammstichreihen, eingestempelte Kreise und Ritzmuster ersetzt ist (Abb 12.10–11, 24–41). Bei einigen der besser erhaltenen Stücke ist ein Metopenstil, z.T. mit Medaillons, zu erkennen (Abb 12.10, 29; 35–36). Ein gutes Beispiel dafür ist die in grossen Teilen erhaltene Schüssel Abb 12.7, die 1976 bei einer Grabung im Innern des Kastells Kaiseraugst gefunden wurde und die sicher aus derselben Produktion stammt: Dem Eierstab des echten Sigillata-Vorbildes entspricht ein Ratterblechband, die mit dem Zirkel eingeritzten Medaillons sind mit einem ebenfalls eingeritzten Blattmotiv gefüllt und anstelle der Perlstäbe finden sich Kammstichreihen und eingeritzte Linien. Ebenfalls in der Töpferei Kaiseraugst-Auf der Wacht hergestellt, wenn auch nicht sehr zahlreich vertreten, sind wohl Schüsseln der Formen Drag 38 (Abb 12.11, 43–45) und Niederbieber 19 (ohne Barbotinedekor, Abb 12.11, 46–49), sowie Reibschüsseln Drag 45/Niederbieber 22 (Abb 12.11, 50–52), da von ihnen Scherben mit dem typischen rotbraunen Überzug vorliegen, daneben aber auch weniger charakteristische Fragmente.

Unter den Schalen und Tellern gibt es ebenfalls einige Beispiele der für die 'Wachtware' typischen Machart. Besonders die Schalen Drag 36/Niederbieber 4b (Abb 12.12, 53–61, ohne Barbotinedekor) sind durchwegs von guter Qualität mit fest anhaftendem, glänzendem Überzug. Dies gilt auch für den einzigen Teller der Form Niederbieber 5b (Abb 12.12, 62) und für die Mehrzahl der Teller Drag 32 (Abb 12, 63–65), die allerdings sehr weich gebrannt sind. Zu den Tellern fehlten bisher Standringe (Vogel Müller und Schmid 1999, 51), die sie eindeutig als Nachahmungen von Sigillataformen definiert hätten. Bei der erneuten Durchsicht des Materials wurde nun eine flache Bodenscherbe entdeckt, die sich Bruch an Bruch an einen Standring fügt, und die zu einem Teller oder einer flachen Schale gehört (Abb 12.12, 65). Leider gibt es keinen anpassenden Rand, doch kommen aufgrund des mehligen Tons am ehesten Teller der Form Drag 32 in Frage. Drei der Ränder von Tellern Ludowici Tb/Niederbieber 3 (Abb 12.12, 66–67) haben einen eher orangen Überzug, der gut mit dem einiger Schüsseln Drag 37 übereinstimmt, die ja am sichersten den

beiden Töpferöfen zugewiesen werden können. Eine vierte Randscherbe dieser Form ist verbrannt. Hingegen weicht der Rand 68 (Abb 12.12) der Form Curle 15/Niederbieber 2 in der Farbe recht stark ab; er ist eher braun.

An Schälchen ist nur die Form Drag 33 vertreten (Abb 12.12, 71–72). Alle sind in der typischen Qualität mit rotbraunem Überzug gefertigt, mit Ausnahme eines leicht verbrannten Randes, dessen Überzug jetzt braun erscheint. Die in der gleichen Technik hergestellten, flachbodigen Teller mit eingebogenem Rand und die nur in der Randzone mit einem Überzug versehenen «rätischen» Reibschüsseln (Vogel Müller und Schmid 1999, 51 und Abb 44) sollen hier ausgeklammert werden, da sie keine Sigillataformen imitieren.

Datierung

Aufgrund der angeführten Vergleiche muss die 1999 vorgeschlagene Produktionszeit der Werkstatt Kaiseraugst-Auf der Wacht zwischen 230 und 280 n. Chr. (Vogel Müller und Schmid 1999, 50) wohl etwas nach unten korrigiert werden. Leider kann die Zusammensetzung der Fundkomplexe nichts zur Datierung beitragen, da diese stark vermischtes Material enthalten. Daher bleiben als Datierungsgrundlage nur die Typen der in Kaiseraugst nachgeahmten Sigillatagefässe. Sämtliche oben beschriebenen Formen kommen auch im Kastell Niederbieber vor (Oelmann 1914, Taf 1). Das ergibt einen groben Datierungsrahmen von 190–260 n. Chr., wobei ein früheres oder späteres Auftreten der verschiedenen Typen natürlich möglich bleibt. Bei der geringen Anzahl von Gefässen kann dem Fehlen einzelner Formen zwar kein allzu grosses Gewicht beigemessen werden, dennoch ist anzumerken, dass die als spät geltenden Formen Niederbieber 6b und 12 (Schucany u.a. 1999, 175 und Taf 74), wie auch die in Augst und Kaiseraugst offenbar spät auftretende Reibschüssel Drag 43/Niederbieber 21 (Martin-Kilcher 1987, 38f.), im hier vorgelegten Material fehlen. Die Nachbildungen der Reliefschüsseln Drag 37 lassen sich wegen der starken Vereinfachung des Dekors schlecht auf genaue Vorbilder aus Rheinzabern zurückführen, doch dürften diese aufgrund ihres Metopenstils wohl nicht zu den spätesten Erzeugnissen der dortigen Relieftöpfer gehören. Überhaupt ist Reliefsigillata nach der Mitte des 3. Jahrhunderts n. Chr. nur noch selten nach Augusta Raurica gelangt (Martin-Kilcher 1987, Kombinationstabelle S. 28). Nach diesen Überlegungen erscheint eine Datierung der in der Töpferei Kaiseraugst-Auf der Wacht produzierten Keramik in die erste Hälfte des 3. Jahrhunderts n. Chr. am wahrscheinlichsten. Dieser zeitliche Ansatz widerspricht der Benützungszeit des Streifenhauses bis ins 3. Jahrhundert nicht.

Zusammenfassung

In einem Streifenhaus der mittleren Kaiserzeit wurde in der Kaiseraugster Unterstadt, in der Flur Auf der Wacht, eine Töpferwerkstatt mit zwei rechteckigen Brennöfen eingerichtet. Ofen 2 wies eine für Terra-Sigillata-Töpferöfen typische Installation mit Zugröhren auf, die in Augusta Raurica bisher nur ein weiteres Mal belegt ist. In unserem Gebiet war dieser Typ generell selten und kam neben der Terra-Sigillata-Produktion (Baden) auch bei der Herstellung von Terra-Sigillata-Imitation zum Einsatz (Vindonissa und Oberwinterthur).

Neben diesen Zugröhren konnten der Töpferei Kaiseraugst-Auf der Wacht auch zahlreiche Brennhilfen zugewiesen werden, die ein breites Spektrum an Ofeneinsätzen zeigen, die oft für den Brand von Terra Sigillata oder Keramik mit Überzug gebraucht wurden.

Das Produktionsprogramm der Töpferei Kaiseraugst-Auf der Wacht ist nicht eindeutig zu identifizieren. Eine in der Verfüllung der beiden Öfen und in deren näherer Umgebung häufig vorkommende und im keramischen Fundmaterial von Augusta Raurica auffällige Terra-Sigillata-ähnliche Ware kann aber mit grosser Wahrscheinlichkeit dieser Werkstatt zugewiesen werden, was die für Terra-Sigillata-Töpferöfen typische Konstruktion von Ofen 2 bestätigt.

Die Produktion der Terra-Sigillata-ähnlichen Ware lässt sich aufgrund der Vergleichsbeispiele in die Zeit von 200–250 n. Chr. datieren. Hergestellt wurden in erster Linie Schüsseln der Form Drag 37 mit charakteristischen Ritz- und Einstichmustern.

Katalog

(Abkürzungen: BS = Bodenscherbe; M ü M = Meter über Meer; OK = Oberkante; RS = Randscherbe; UK = Unterkante; WS = Wandscherbe)

Töpferöfen

Töpferofen 1
Rechteckiger Töpferofen. Brennkammer, Heizkanal und Bedienungsgrube teilweise, Heizkammer vollständig erhalten. Die Einfeuerung erfolgte von Nordosten. Die erhaltene Gesamtlänge inkl Bedienungsgrube betrug 4,20m (Abb 12.4).

Brennkammer: Rechteckiger Grundriss. Ofenwand aus Leistenziegeln und Ziegelfragmenten auf die Trasse einer wohl aufgelassenen Gasse gebaut. Die erhaltene Leiste der Ziegel war gegen das Ofeninnere gelegt, mit der Leiste nach oben. Darauf, direkt neben der Leiste, als nächste Lage leistenlose Ziegel oder Ziegelfragmente. Nächstfolgende Lage Leisten der Ziegel gegen das Ofenäussere gerichtet. Ofenwand mit grauschwarz verfärbtem Lehm verstrichen. Innenmasse 1,35 × 1,60m, Aussenmasse 1,80 × 2,10m, erhaltene Höhe 0,35–0,40m, Wanddicke ca. 0,30–0,50m. OK Abbruchkrone 272.90, UK Brennkammer = OK Lochtenne 272.50–55m ü.M.

Heizkammer: Rechteckiger Grundriss. Auf kiesigsandiger, vermischter Schicht errichtet. Ofenwand aus Leistenziegeln und Ziegelfragmenten aufgebaut, mit grauschwarz verfärbtem Lehm verstrichen, Ziegel durch starke Hitze grauschwarz verbrannt. Auf der Sohle braungraue bis grauschwarze, ca. 0,10m dicke (Brand-

?)Schicht. Innenmasse wie Brennkammer. Wanddicke 0,30–0,50m. Höhe 0,50m. OK Heizkammer = UK Lochtenne = ca. 272.30, UK Heizkammer ca. 271.80m ü.M.

Unterbau Lochtenne: Auf der Mittelachse des Ofens aus Ziegelfragmenten gebaute Zungenmauer mit Lehmzwischenlagen. Ergibt links und rechts der Zungemauer je einen seitlichen Kanal. Zungenmauer durch Hitze rötlichbraun bis graubraun verfärbt. Entlang der nordwestlichen Ofenwand drei langschmale Absätze zur Auflage der Lochtenne, auf der südöstlichen nicht erhalten. Zungenmauer und seitliche Absätze waren über den beiden seitlichen Kanälen je mit einem Gewölbe miteinander verbunden. Länge Zungenmauer 1,20m, Breite Zungenmauer 0,40m, Breite seitliche Kanäle 0,40m, Länge Absätze 0,30–0,40m, Breite Absätze 0,10m. OK Zungenmauer = OK Absätze = UK Lochtenne ca. 272.30 m, UK Zungenmauer 271.90m ü.M.

Lochtenne: Aus grauschwarz verbrannten Ziegeln und Ziegelfragmenten, dazwischen durch die Hitze grauschwarzer Lehm. Dicke ca. 0,20–0,25m.

Vier Reihen mit je vier, d.h. 16 Pfeifenlöcher, die sich entlang der Ofenwand zwischen den Absätzen und gegen das Ofeninnere entlang der Zungenmauer befanden. Durchmesser 0,12–0,14m. OK Lochtenne = ca. 272.90, UK Lochtenne = ca. 272.70m ü.M.

Heizkanal: Nordwestliche Heizkanalwand aus Ziegelfragmenten gebaut, südöstliche nicht erhalten. Ziegel durch starke Hitze grauschwarz verbrannt. Abdeckung nicht erhalten. Wohl rechteckiger Grundriss. Erhaltene Länge 0,90m, erhaltene Höhe Einfeuerungsloch 0,55m. OK Einfeuerungsloch 272.50, UK Einfeuerungsloch 271,95m ü.M.

Brand: Reduzierend? (grauschwarz verfärbter Lehm).

Bedienungsgrube: Nur im Profil dokumentiert. Grauschwarz verfärbte, bis 0,20m dicke Schicht auf Sohle. Länge ca. 2,10m.

Gehniveau: Leicht lehmiger Sand, braungrau, mit kleinen Kalksteinbruchstücken, Kieseln, Ziegelfragmenten, Holzkohlepartikeln und Mörtelspuren vermischt. Ehemalige Trasse einer wohl aufgelassenen Gasse. Ca. 272,60–70m ü.M.

Verfüllung des Ofens: Wohl in einem Zug erfolgt, vollständig mit Ofenabbruchschutt (Ziegelfragmente von der aufgehenden Ofenkonstruktion), Scherben, Brennhilfen und Humus verfüllt.

Töpferofen 2

Rechteckiger Töpferofen. Brennkammer teilweise, Heizkammer vollständig erhalten. Heizkanal und Bedienungsgrube sind nicht erhalten. Die Einfeuerung erfolgte von Südwesten. Die erhaltene Gesamtlänge betrug ca. 2,50m (Abb 12.5, oben links).

Brennkammer: Rechteckiger Grundriss. Ofenwand aus Leistenziegeln und Ziegelfragmenten aufgebaut. Die erhaltene Leiste der Ziegel war gegen das Ofeninnere gelegt, mit der Leiste nach oben. Darauf, direkt neben der Leiste, als nächste Lage leistenlose Ziegel oder Ziegelfragmente. Nächstfolgende Lage Leisten der Ziegel

gegen das Ofenäussere gerichtet. Ofenwand mit rötlichbraun verfärbtem Lehm verstrichen. Innenmasse 1,40 × 1,60m, Aussenmasse 2,10 × 2,50m, erhaltene Höhe 0,20m; Wanddicke ca. 0,35–0,50m. OK Abbruchkrone 273.10, UK Brennkammer = OK Lochtenne 272.90m ü.M.

Heizkammer: Rechteckiger Grundriss. Auf lehmigsandige, mit Kies vermischte Schicht gebaut. Ofenwand aus Leistenziegeln und Ziegelfragmenten aufgebaut, mit rötlichbraun verfärbtem Lehm verstrichen. Auf der Sohle beigegraue bis grauschwarze, bis zu 0,20m dicke (Brand-?) Schicht. Innenmasse wie Brennkammer. Wanddicke Westmauer 0,36m, Ostmauer 0,50m. Höhe 0,80m. OK Heizkammer = UK Lochtenne ca. 272.70, UK Heizkammer 271.90m ü.M.

Unterbau Lochtenne: Beidseits je drei, d. h. sechs rechtwinklig zur Längsachse des Ofens stehende, aus Ziegelfragmenten gebaute Zungenmauern mit Lehmzwischenlagen. Die Zungenmauern sind durch die Hitze stark versintert und rötlichbraun bis graubraun verfärbt. Ergeben auf der Mittelachse des Ofens einen Mittelkanal. Zwischen den Zungenmauern zur Ofenwand hin abgeschrägte Züge. Die Zungenmauern waren über dem Mittelkanal mit einem Gewölbe miteinander verbunden. Breite Züge ca. 0,10–0,15m, Breite Mittelkanal 0,30–0,40m. OK Zungenmauern = UK Lochtenne ca. 272.70, UK Zungenmauern 272.10, UK Züge 272,30m ü.M.

Lochtenne: Aus 3 Lagen Ziegeln und Ziegelfragmenten, dazwischen durch die Hitze stark geröteter sandiger, beigerötlicher Lehm. Dicke ca. 0,20m. Vier im Viereck angeordnete Pfeifenlöcher, die direkt über den Zügen zwischen den seitlichen Zungenmauern lagen. Durchmesser 0,12–0,14m. OK Lochtenne ca. 272.90, UK Lochtenne ca. 272.70m ü.M.

In den vier Pfeifenlöchern und entlang der gesamten Ofenwand Reihe von dicht aneinander gefügten, ursprünglich gegen 45 senkrecht gestellte Tonröhren, die an der Stirnseite des Ofens und an der gegenüberliegenden Seite direkt über den Zügen verbaut waren. Durchmesser Röhren = ca. Breite Züge (Abb 12.5).

Heizkanal: Ansatz der südöstlichen Heizkanalwand und Einfeuerungsloch in der südwestlichen Heizkammerwand erhalten. Heizkanalwand aus Ziegelfragmenten gebaut. Abdeckung nicht erhalten. Wohl rechteckiger Grundriss. Erhaltene Höhe Einfeuerungsloch ca. 0,60m. OK Einfeuerungsloch 272.84m ü.M., UK Einfeuerungsloch unklar.

Brand: Oxydierend.

Bedienungsgrube: Nicht dokumentiert.

Gehniveau: Kiesboden. Ca. 291,60–65m ü.M. Später eingebrachter zweiter Kiesboden darüber, ca. 272.20m ü.M. Darüber nach Aufgabe des Ofens entstandene Schuttschicht u. a. mit Brennhilfen und Töpfereiabfall.

Verfüllung des Ofens: Wohl in einem Zug erfolgt, vollständig mit Ofenabbruchschutt (Ziegelfragmente von der aufgehenden Ofenkonstruktion), Scherben, Brennhilfen und Humus verfüllt.

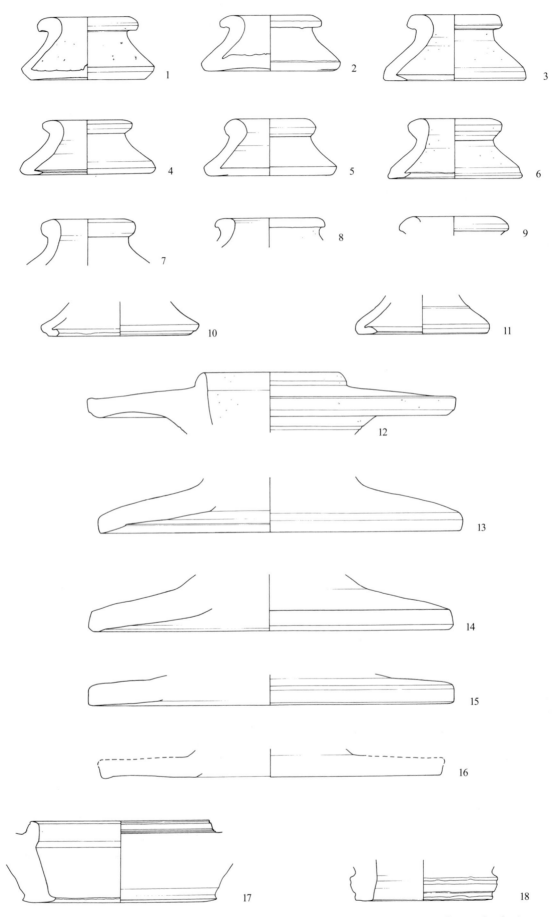

Abb 12.9: Kaiseraugst-Auf der Wacht. Brennhilfen. M. 1:3 (Zeichnungen Denise Grossenbacher)

Zugröhren

Scheibengedreht, sehr grob, Durchmesser innen 8–9cm, Wanddicke 1–1,5cm, ursprüngliche Länge (nicht vollständig erhalten) ca. 0,30m, erhaltene Länge 0,15m, oranger bis orangeroter Ton, graubraune bis ockerfarbene Oberfläche, teilweise versintert, teilweise leicht verzogen, viele Spannungsrisse durch hohe Temperatur. In Ofen 2 waren gegen 45 Röhren installiert (Abb 12.5).

Interpretation: Röhren zur Regulierung der Zugluft in der Brennkammer und zur Innenunterteilung des Brennraums.

Vergleiche: Vindonissa: Pauli-Gabi u.a. 2007, Abb 12 (gelocht); Baden: Drack 1949, Abb 4,1; Oberwinterthur: Hedinger u.a. 1999, Abb 6; La Graufesenque: Vernhet 1981, fig 9,1.2; Lezoux: Desbat 1993; Schwabegg: Sölch 1993, Abb 6; Rheinzabern: Rau 1977, Abb 2; Heiligenberg/ Ittenweiler: Forrer 1911, Abb 37f; Pfaffenhofen: Kellner 1968, Abb 2,1.3; Westerndorf: Kellner 1968, Abb 13,6.8– 10.12; Domecy-sur-Cure: Joly 1994, fig 2f; Dourbie: Mauné u.a. 2006, fig 10.

Brennhilfen

Ringständer

Scheibengedreht, häufigere Variante mit offenem Boden, oranger, mehliger Ton. Weniger häufig mit geschlossenem Boden, orangeroter Ton (Abb 12.6, oben links; Abb 12.9, 1–11).

Interpretation: Brennständer.

Vergleiche: Baden: Drack 1949, Abb 3f; Aegerten: Bacher/Suter 1999, Abb 9; Avenches: Castella/Meylan Krause 1999, Abb 7; Lausanne-Vidy: Luginbühl 2001, Abb VI.4,7–8; VI.25, 6–10; La Graufesenque: Vernhet 1981, fig 9,9–10; Montans: Martin 1996, fig 34; Lezoux: Bet und Delage 1993, fig 4; Dourbie: Mauné u.a. 2006, fig 10; Argonnen: Chenet 1941, pls 3–4; Pfaffenhofen: Kellner 1968, Abb 2,4–10.12; Westerndorf: Kellner 1968, Abb 9,1–2; 13,5.7; Schwabmünchen: Czysz 1988, Abb 94; Schwabegg: Sölch 1993, Abb 6; Czysz 1988, Abb 94; Rheinzabern: Rau 1977, Abb 2,2.

Abbildung 12.9, 1–11

1 Mit geschlossenem Boden. Ganz erhalten, orangeroter Ton. Inv. 1981.5705.
2 Mit geschlossenem Boden. 3 RS, 3 BS, orangeroter Ton. Inv. 1981.3494, 1981.6201a–d, 1982.580N.
3 Mit offenem Boden. Ganz erhalten, oranger, mehliger Ton. Inv. 1981.5706–5708.
4 Mit offenem Boden. Ganz erhalten, oranger, mehliger Ton. Inv. 1981.6235a–d.
5 Mit offenem Boden. 2 RS, 2 BS, oranger, mehliger Ton. Inv. 1981.4226a.b, 1981.4246a.b.
6 Mit offenem Boden. 1 RS, 4 BS, oranger, mehliger Ton. Inv. 1981.3788a–c, 1981.3797, 1982.634.
7 1 RS, oranger Ton. Inv. 1981.4246c.
8 1 RS, oranger Ton. Inv. 1981.2938.
9 1 RS, oranger Ton. Inv. 1981.4416.
10 Mit offenem Boden. 1 BS, orangeroter Ton. Inv. 1981.3477.
11 Mit offenem Boden. 2 BS, orangeroter Ton. Inv. 1981.2927a.b.

Gelochte Scheibe

Scheibengedreht, Durchmesser Scheibe ca. 33cm, Durchmesser Loch innen ca. 10cm, oranger, mehliger Ton, teilweise grau verfärbt (Abb 12.6, oben rechts; Abb 12.9, 12–18).

Interpretation: Ofeneinsatz, Etagenaufleger.

Vergleiche: Augusta Raurica: Venusstrasse-Ost, jüngere Töpferei (Alexander 1975, Abb 8); Augusta Raurica: Venusstrasse-Ost, ältere Töpferei (Alexander 1975, Abb 9; Schmid 2008); Pfaffenhofen: Kellner 1968, Abb 1; Westerndorf: Kellner 1968, Abb 13,4; Dourbie: Mauné u.a. 2006, 162; Argonnen: Chenet 1941, pl 3; Vindonissa: Pauli-Gabi u.a. 2007, Abb 13; Baden: Drack 1949, Abb 4,15; La Graufesenque: Vernhet 1981, fig. 9,1; Montans: Martin 1996, fig 33: gelochte Tonscheiben *in situ* direkt über den Pfeifenlöchern; Lezoux: Desbat 1993, fig 9; Schwabegg: Sölch 1993, Abb 6; Dourbie: Mauné u.a. 2006, fig 10: gelochte Tonscheibe mit oberer und unterer Fortsetzung als Tonröhre; Heiligenberg/Ittenweiler: Forrer 1911, Taf 8,8–9; Heiligenberg: Forrer 1911, Taf 11,25.

Abbildung 12.9, 12–18

12 Oranger, mehliger Ton. Inv. 1981.4234.
13 Oranger, mehliger Ton, teilweise grau verbrannt. Inv. 1981.4232.
14 Oranger, mehliger Ton. Inv. 1981.593.
15 Orangeroter Ton. Inv. 1981.5709.
16 Oranger, mehliger Ton. Inv. 1981.4233, 1982.512.
17 Oranger Ton. Inv. 1982.513, 1982.603.
18 Orangeroter Ton. Inv. 1981.3044.

Ring

Handgeformt, sehr grob, von unregelmässiger Form, innere Linie bildet regelmässigen Kreis. Durchmesser Ring ca. 19–20cm, Durchmesser Loch innen ca. 10cm. Orangeroter Ton (Abb 12.6, Mitte links).

Interpretation: Untere Fixierung einer Tonröhre.

Vergleiche: La Graufesenque: Vernhet 1981, fig 9,1; Dourbie: Mauné u.a. 2006, fig 10; Heiligenberg/Ittenweiler: Forrer 1911, Taf 8, 13–23.

Batzen

Handgeformt, sehr grob, von ungefähr runder Form. Durchmesser ca. 7–8cm, Höhe 2,5–3cm, oranger, mehliger Ton (Abb 12.6, Mitte rechts).

Interpretation: Brennständer, Verschluss einer Tonröhre oder eines Pfeifenlochs (?).

Vergleiche: Heiligenberg: Forrer 1911, Taf 11, 1–24; Taf 11, 13–15: Abdrücke von runden Objekten, von Tonröhren (?); Dourbie: Mauné u.a. 2006, fig 10; Baden: Drack 1949, Abb 3; La Graufesenque: Vernhet 1981, fig 9,1; Schwabegg: Sölch 1993, Abb 6; Heiligenberg: Forrer 1911, Taf 11,1–17.18–21; Heiligenberg/Ittenweiler: Forrer 1911, Taf 9,1–10; Westerndorf: Kellner 1968, Abb 13,13.

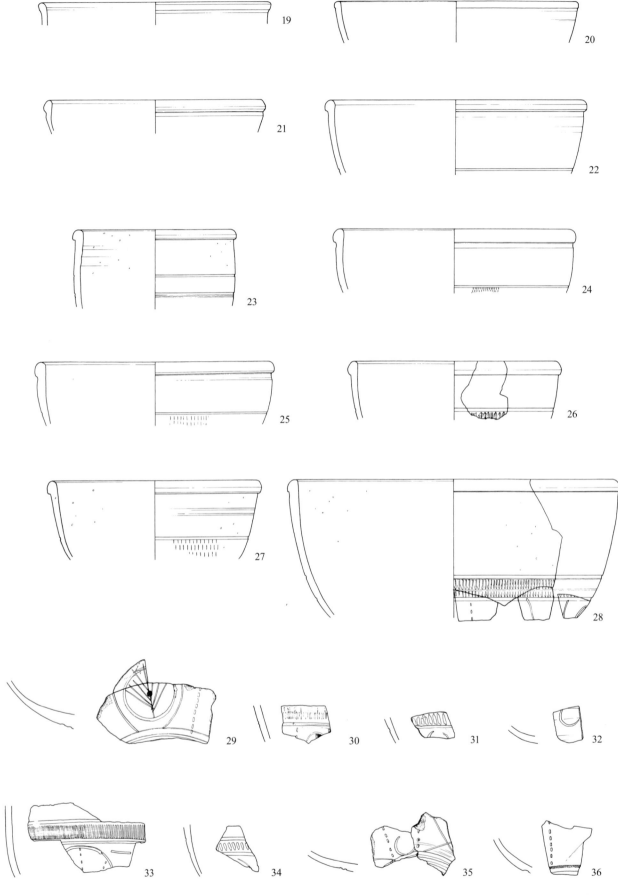

Abb 12.10: Kaiseraugst-Auf der Wacht. Terra-Sigillata-ähnliche Ware, Form Drag 37. M 1:3 (Zeichnungen Denise Grossenbacher)

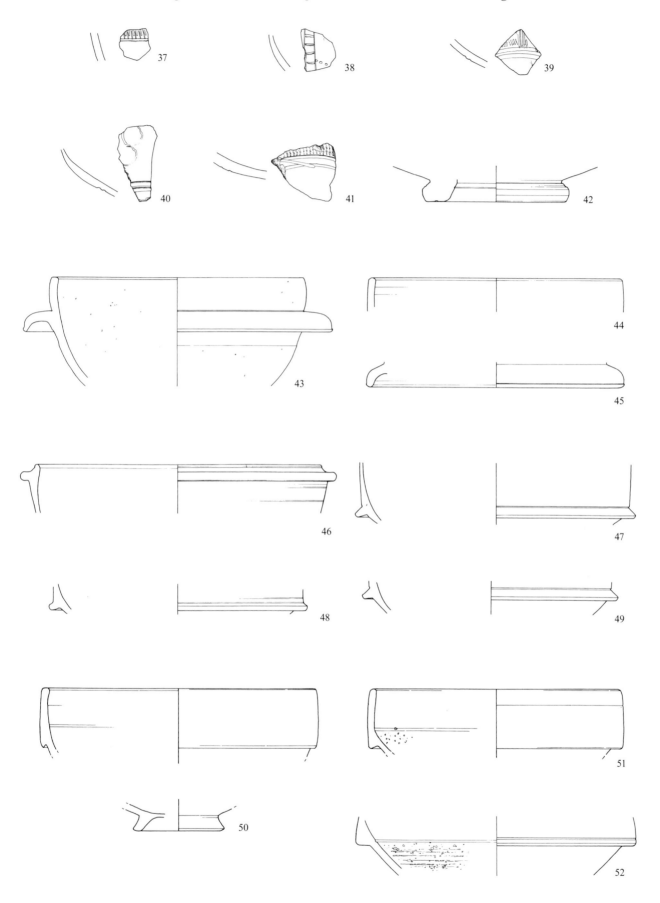

Abb 12.11: Kaiseraugst-Auf der Wacht. Terra-Sigillata-ähnliche Ware, verschiedene Schüsselformen. M 1:3 (Zeichnungen Denise Grossenbacher)

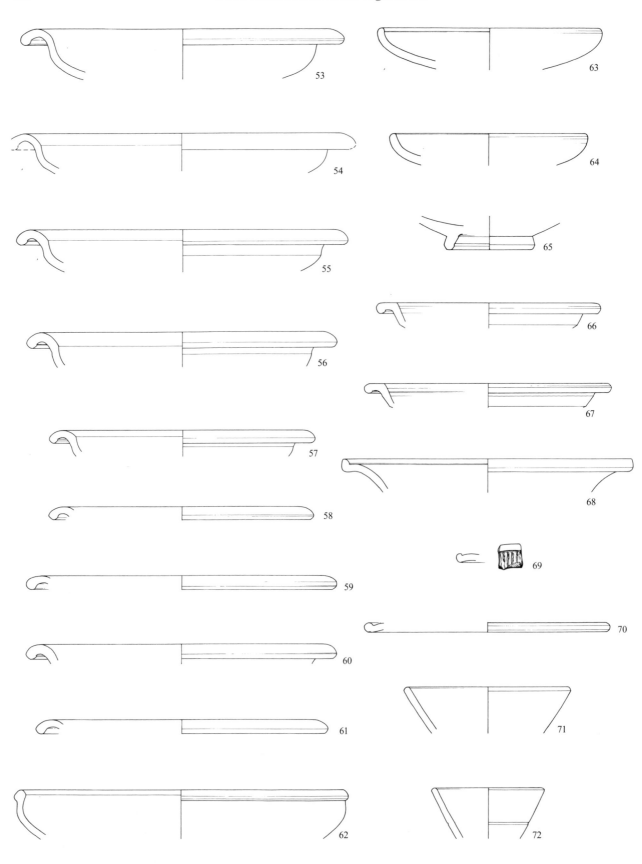

Abb 12.12: Kaiseraugst-Auf der Wacht. Terra-Sigillata-ähnliche Ware, Schalen, Teller und Schälchen. M 1:3 (Zeichnungen Denise Grossenbacher)

Wulst

Handgeformt, sehr grob, verschiedene, teilweise sehr unförmige Objekte, viele stangenförmige Exemplare. Viele Fingerabdrücke, viele halbrunde oder runde Abdrücke von Tonröhren. Meist oranger, mehliger Ton, selten orangeroter oder grauer Ton (Abb 12.6, unten links und unten rechts).

Interpretation: Spontan geformte Abstandhalter und/oder Brennständer beim Beschicken des Ofens. Mit Hilfe dieser Tonwülste wurde beim Einsetzen eines Gefässes individuell aus weichem Ton der gerade benötigte Abstandhalter oder die benötigte Standhilfe geknetet und eingesetzt. Zudem dienten solche Wülste als Verbindungsstück zwischen zwei Tonröhren.

Vergleiche: Argonnen: Chenet 1941, pl 3 (Verbindungsstück zwischen zwei Tonröhren); Baden: Drack 1949, Abb 3; Schwabegg: Sölch 1993, Abb 6; Heiligenberg: Forrer 1911, Taf 12; Heiligenberg/Ittenweiler: Forrer 1911, Taf 9,12–15; Pfaffenhofen: Kellner 1968, Abb 2,2; Westerndorf: Kellner 1968, Abb 13,11; 14.

Keramik

Form Drag 37 (Abbildung 12.10, 19–11, 42)

19 RS, wohl Drag 37, Ton rotbraun, Überzug braunrot mit Glättstreifen, aussen kaum erhalten, Inv. 1981.3771.

20 RS, wohl Drag 37, Ton orange, Überzug braunrot, schlecht erhalten, Inv. 1981.3295.

21 RS, Ton rotbraun, Überzug braunrot, schlecht erhalten, Inv. 1981.3267.

22 2 RS, 2 WS, Ton orange, Überzug braunorange mit Glättstreifen, Ansatz von Ratterblechzone, Inv. 1981.3765.5243.5248.5251.

23 4 RS verbrannt, Ton braun, Oberfläche beigebraun bis grau, kein Überzug erhalten, wohl Ansatz von Dekorzone, Inv. 1981.2787a.b.5280a.b.

24 3 RS, WS, Ton orange, Überzug rotbraun, nur aussen erhalten, Ansatz von Ratterblechzone, Inv. 1981.278 1.2782.2971.5678.

25 2 RS, WS, Ton orange, kein Überzug erhalten, Ansatz von Ratterblechzone, Inv. 1981.2780a.b.5246.

26 RS, 2 WS, Ton orange bis rotbraun, Überzug braunrot, Ansatz von Ratterblechzone. Inv. 1981.3766b.d.e.

27 7 RS, WS verbrannt, Ton orange, Überzug nur noch stellenweise erhalten, orangebraun bis grau, Ansatz von Ratterblechzone, Inv. 1981.3463a.b.3769a.b.5677a–d (vgl Abb 12.8, unten rechts).

28 5 RS, 10 WS, Ton orange, Überzug orange, glänzend, gut erhalten, Ratterblechzone, unterhalb davon Ansatz von Dekorzone mit Ritzlinien und Kammstichreihen, Inv. 1981.2779a–g.4219.4407.5242a.b.5247a. b.5679.6191 (vgl Abb 12.8, unten links).

29 2 WS, Ton orange, Überzug orange, glänzend, gut erhalten. Unterer Teil der Dekorzone im Metopenstil mit 2 Rillen als Abschluss: eingetieftes, kreisrundes Medaillon mit zentraler Vertiefung vom Einstich eines Zirkels, gefüllt mit stilisiertem Blattmotiv und beidseitig gerahmt von geritzten Bogenlinien, Metopentrennung durch Reihen von Kammeinstichen,

Inv. 1981.2968.5688 (zum Dekor vgl auch die innerhalb des späteren Kastells Kaiseraugst gefundene, in grossen Teilen erhaltene Schüssel Abb 12.7).

30 WS, Ton orange, Überzug braunrot, Ratterblechzone und Ansatz von Kammeinstichreihe und eingeritzten Bogenlinien, Inv. 1981.5683.

31 WS, Ton orange, Überzug braunrot, Ratterblechzone und Ansatz von eingestempeltem Kreis. Inv. 1981.5252.

32 WS, Ton orange, Überzug braunorange, unterer Abschluss der Ratterblechzone und eingestempelter Kreis, Inv. 1981.4221.

33 WS, Ton orange, Überzug orange, nur als kleiner Rest auf der Innenseite erhalten. Ähnliches Dekor wie Nr 29, aber Kammeinstichreihen anstelle des eingeritzten Blattmotivs. Inv. 1981.6286, (vgl Abb 12.8, Mitte rechts).

34 WS, Ton orange, Überzug braunrot, schlecht erhalten. Ratterblechzone und Ansatz der Dekorzone. evtl. mit Medaillon. Inv. 1981.3464.

35 2 WS, Ton orange, Überzug braunrot, nur aussen erhalten. Unterer Teil der Dekorzone im Metopenstil mit 2 Rillen als Abschluss: Andreaskreuze und eingestempelte Kreise im Wechsel, getrennt durch Kammeinstichreihen, Inv. 1981.2969.5253.

36 WS, Ton orange, Überzug nur in Spuren erhalten, ähnliches Dekor wie Nr 35, Inv. 1981.2784.

37 WS, Ton orange, Überzug braunrot, Ansatz von Ratterblechzone, Inv. 1981.5682.

38 WS orange, kein Überzug erhalten, Dekorzone mit eingeritztem Leitermuster und Kammeinstichreihe, Inv. 1981.3033.

39 WS, leicht verbrannt, Ton orange bis graubraun, Überzug braunorange, unterer Teil der Dekorzone mit 2 Rillen als Abschluss. Wahrscheinlich Metopentrennung durch Kammstrichbündel, dazwischen Ratterblechzonen, Inv. 1981.4147.

40 WS, Ton orange, Überzug braunrot, schlecht erhalten, unterer Teil der Dekorzone mit 2 eingestempelten, etwas deformierten Kreisen und 2 Rillen als Abschluss, Inv. 1981.5680.

41 WS, Ton rotbraun, Überzug braunrot, unterer Teil der Dekorzone mit Ratterblechband und 2 Rillen als Abschluss, Inv. 1981.5684.

42 WS, 2 BS. Ton rotbraun, Überzug rotbraun, Inv. 1981.3482.5256a.b.

– 15 RS, 16 WS, 1 BS von mindestens 10 weiteren Exemplaren.

Form Drag 38 (Abbildung 12. 11, 43–45)

43 2 RS, 1 WS mit Kragen, Ton orange, Überzug orange bis hellbraun, auf der Gefässinnenseite nirgendwo erhalten, Inv. 1981.5673a.b, 1982.580F.

44 3 RS, Ton rotbraun, Überzug innen und aussen braunorange, Inv.1981.6184.5699a.b.

45 Kragenfragment, Ton rotbraun, Überzug braunrot, glänzend, gut anhaftend, Inv.1982.628.

– RS von einer weiteren Schüssel.

Form Niederbieber 19 (Abbildung 12.11, 46–49)

46　RS, Ton orange, Überzug braunrot, glänzend, gut anhaftend, Inv. 1981.5671.

47　WS, Qualität wie Nr 46, Inv. 1981.6296.

48　WS, Qualität wie Nr 46 und 47, aber Überzug weniger gut erhalten, Inv. 1981.3773.

49　WS, Qualität wie Nr 46–48, aber Innenseite schwarz verbrannt, Inv.1981. 3762.

–　WS von einem weiteren Exemplar.

Form Drag 45/Niederbieber 22 (Abbildung 12.11, 50–52)

50　6 RS, 2 WS, 2 BS, Ton orange, Überzug braunorange, nur in Spuren vorhanden, Inv. 1981.3890a–k.

51　RS, Ton orange, Überzug braunrot, nur unter dem Rand erhalten, Körnung nicht erhalten, Inv. 1981.3456.

52　2 WS, Ton orange, Überzug braunorange, Inv. 1981.2922.5255.

–　3 WS, 3 BS von mindestens 3 weiteren Reibschüsseln.

Form Drag 36/Niederbieber 4b (Abbildung 12.12, 53–61)

53　RS, WS, Ton orange, Überzug braunorange, z. T. braun verbrannt, Polierstreifen, Inv. 1981.3035.3772.

54　2 RS, Ton rotbraun, Überzug braunrot, glänzend, gut anhaftend, Polierstreifen, Inv. 1981.3764.4218.

55　RS, 2 WS, Qualität wie Nr 54, Inv. 1981.3763a–c.

56　RS, Qualität wie Nr 54–55, Inv. 1981.2992.

57　RS, Qualität wie Nr 54–56, Inv. 1981.5669 (vgl. Abb 12.8, oben links).

58　RS, Qualität wie Nr 54–57, z. T. etwas verbrannt, Inv. 1981.5670.

59　RS, Qualität wie Nr 58, Inv. 1981.3037.

60　RS, Ton orange, Überzug braunorange, glänzend, Polierstreifen, Inv. 1981.3036.

61　RS, Qualität wie Nr 60, Inv. 1981.4217.

–　2 RS, 7 WS, z.T. verbrannt, von mindesten 2 weiteren Exemplaren.

Form Niederbieber 5b (Abbildung 12.12, 62)

62　RS, Qualität wie Nr 54–58, Inv. 1981.1724.

Form Drag 32 (Abbildung 12.12, 63–65)

63　3 RS, WS, Ton orange, Überzug braunorange, Glättstreifen, Inv. 1981.4239a–d.

64　RS, Qualität wie Nr 63, Inv. 1981.6243.

65　WS, 2 BS, Ton rotbraun, sehr mehlig, Überzug braunrot, Inv. 1981.3470a.b.5687.

–　5 RS, 1 WS von mindestens 3 weiteren Exemplaren (Mehrzahl der vorhandenen Wandscherben nicht zuweisbar, da sie auch von anderen Schalen- oder Tellerformen stammen können).

Form Ludowici Tb/Niederbieber 3 (Abbildung 12.12, 66–67)

66　RS, Ton orange, Überzug braunorange, Polierstreifen, Inv. 1982.580D.

67　RS, Ton orange, Überzug orangebraun, glänzend, gut anhaftend, Polierstreifen, Inv. 1981.6295 (vgl Abb 12.8, oben rechts).

–　2 RS, 1 WS von mindestens einem weiteren Exemplar.

Form Curle 15/Niederbieber 2 (Abbildung 12.12,68–70)

68　2 RS, Ton gelbbraun, Überzug braun, Inv. 1981.3761a. b. (vgl Abb 12.8, Mitte links).

69　RS, Ton orange, Überzug braunrot, Ratterblechdekor auf dem Rand, Inv. 1981.6298. Keine genaue Parallele unter den TS-Formen, gehört wohl in den Umkreis von Curle 15, Drag 46 und evtl. Niederbieber 8b.

70　RS, Ton orange, Überzug braunrot, Inv. 1982.697. Keine genaue Parallele unter den TS-Formen, gehört wohl in den Umkreis von Curle 15/Drag 46.

Form Drag 33 (Abbildung 12.12, 71–72)

71　RS, WS, Ton rotbraun, Überzug braunrot, Inv. 1981.3083.3084.

72　2 RS, Ton orange, Überzug braunorange, Inv. 1981.2970a.b.

–　5 RS, 2 WS von mindestens 4 weiteren Exemplaren.

Literatur

Alexander, W C, 1975. *A pottery of the middle Roman Imperial period in Augst (Venusstrasse-Ost 1968/69)*, Forsch Augst 2, Basel, Augst, Liestal

Bacher, R und Suter, P J, 1999. Aegerten 1982–1985. Römische Töpfereiabfälle, *Archäologie im Kanton Bern* 4B, 45–132

Berger, L, mit einem Beitrag von Hufschmid, Th, 1998. *Führer durch Augusta Raurica*, Augst

Bet, P, und Delage, R, 1993. Inscriptions gravées et graffites sur céramique à Lezoux (Puy-de-Dôme) durant la période romaine, *Société Française d'Etude de la Céramique Antique en Gaule: Actes du Congrès de Versailles*, 305–27, Marseille

Castella, D und Meylan Krause, M-F, 1999. Témoins de l'activité des potiers à Aventicum (Avenches, Suisse), capitale des Helvètes, du I^er au III^e siècles après J.–C, *Société Française d'Etude de la Céramique Antique en Gaule: Actes du Congrès de Fribourg*, 71–88, Marseille

Chenet, G, 1941. *La céramique gallo-romaine d'Argonne du IVe siècle et la terre sigillée décorée à la molette*, Mâcon

Czysz, W, 1988. Das römische Töpferdorf Rapis und die Terrasigillata-Manufaktur bei Schwabegg, *Arch Jahr Bayern 1987*, 123–32, Stuttgart

Desbat, A, 1993. Observations sur les fours à tubulures des 1^er et II^e siècles à Lezoux, *Société Française d'Etude de la Céramique Antique en Gaule: Actes du Congrès de Versailles*, 361–70, Marseille

Drack, W, 1949. *Die römischen Töpfereifunde von Baden–Aquae Helveticae*, Schr Inst Ur- und Frühgesch Schweiz 6, Basel

Fischer, A, 2009. *Vorsicht Glas! Die römischen Glasmanufakturen von Kaiseraugst*, Forsch Augst 37, Augst

Forrer, R, 1911. *Die römischen Terrasigillata – Töpfereien von Heiligenberg – Dinsheim und Ittenweiler im Elsass. Ihre Brennöfen, Form- und Brenngeräte, ihre Künstler, Fabrikanten und Fabrikate*, Stuttgart

Furger, A R, 1991. Die Töpfereibetriebe von Augusta Rauricorum, *Jahresber Augst und Kaiseraugst* 12, 259–79 (= A R Furger,

Les ateliers de poterie de la ville d'Augusta Rauricorum [Augst et Kaiseraugst, Suisse], *Société Française d'Etude de la Céramique Antique en Gaule:* Actes du Congrès de Mandeure-Mathay, 97–124, Marseille. [Zitiert nach der deutschen Fassung]

Hedinger, B, Hoek, F, und Jauch, V, 1999. Les ateliers de potiers du site d'Oberwinterthur *(VITVDVRVM)* et leur production. Rapport préliminaire, *Société Française d'Etude de la Céramique Antique en Gaule:* Actes du Congrès de Fribourg, 11–18, Marseille

Joly, M, 1994. L'atelier de potiers gallo-romain de Domecy-sur-Cure (Yonne), *Société Française d'Etude de la Céramique Antique en Gaule: Actes du Congrès de Millau,* 213–24, Marseille

Kellner, H-J, 1968. *Beiträge zum Typenschatz und zur Datierung der Sigillata von Westerndorf und Pfaffenhofen,* Rosenheim

Luginbühl, T, 2001. *Imitations de sigillée et potiers du Haut-empire en suisse occidentale. Archéologie et historie d'un phénomène artisanal antique,* Cahiers Arch Romande 83, Lausanne

Martin, T, 1996. *Céramiques sigillées et potiers gallo-romains de Montans,* Montauban

Martin-Kilcher, S, 1987. *Die römischen Amphoren aus Augst und Kaiseraugst 1: Die südspanischen Ölamphoren (Gruppe 1),* Forsch Augst 7(1), Augst

Mauné, S, Bourgaut, R, Lescure, J, Carrato, C, und Santran, C, 2006. Nouvelles données sur les productions céramiques de l'atelier de Dourbie à Aspiran (Hérault) (première moitié du Ier siècle apr. J.–C.), *Société Française d'Etude de la Céramique Antique en Gaule: Actes du Congrès de Pézenas,* 157–88, Marseille

Müller, U, 1989. Ausgrabungen in Kaiseraugst im Jahre 1987, *Jahresber Augst und Kaiseraugst* 10, 177–211, bes. 181–9

Oelmann, F, 1914. *Die Keramik des Kastells Niederbieber,* Materialien Röm Germ Keramik 1, Frankfurt

Pauli-Gabi, T, mit Beiträgen von Berger, D, Schucany, C und Trumm, J, 2006 (2007). Ausgrabungen in Vindonissa im Jahr 2006. *Gesellschaft Pro Vindonissa. Jahresbericht 2006,* 83–101, bes. 90–92, Abb 12 Tonröhre, Abb 13 gelochte Tonscheibe.

Rau, H G, 1977. Die römische Töpferei in Rheinzabern, *Mitteilungen des historischen Vereins der Pfalz* 75, 47–73

Sandoz, Y, 1987. *Kaiseraugst AG, Parzelle 231, Auf der Wacht II, 3. Teil. Die Grabung 1981,* Unpubl Lizentiatsarbeit Basel

Schatzmann, R, mit einem Beitrag von Schmid, D, 2003. *Das Südwestquartier von Augusta Raurica. Untersuchungen zu einer städtischen Randzone,* Forsch Augst 33, Augst

Schmid, D, 2003. Die Töpferei des Fronto, in Schatzmann 2003, 92–109

Schmid, D, 2008. *Die ältere Töpferei an der Venusstrasse-Ost in Augusta Raurica. Untersuchungen zur lokal hergestellten Gebrauchskeramik und zum regionalen Keramikhandel,* Forsch Augst 41, Augst

Schucany, C, Martin-Kilcher, S, Berger, L, und Paunier, D (Hrsg), 1999. *Römische Keramik in der Schweiz,* Antiqua 31, Basel

Sölch, R, 1993. Untersuchungen zur Terra Sigillata-Töpferei von Schwabegg bei Schwabmünchen, Ldkr. Augsburg, in *Forschungen zur Geschichte der Keramik in Schwaben* (Hrsg W Endres, W Czysz und G Sorge), Arbeitsheft 58 Bayerisches Landesamt für Denkmalpflege, 91–8, München

Tomasevic Buck, T, 1988. Ausgrabungen in Augst und Kaiseraugst im Jahre 1981, *Jahresber Augst und Kaiseraugst* 8, 17–27

Vernhet, A, 1981. Un four de la Graufesenque (Aveyron): la cuisson des vases sigillés, *Gallia* 39, 26–43

Vogel Müller, V, und Schmid, D, 1999. Les productions céramiques d'Augusta Raurica (Augst et Kaiseraugst): chronologie, formes, fonctions, *Société Française d'Etude de la Céramique Antique en Gaule: Actes du Congrès de Fribourg,* 45–61, Marseille

13 Reproducing samian pottery: ideas and practical experience

Gilbert Burroughes

Introduction

My interest in Roman pottery started in late 1952/early 1953 as a teenager, when I found fragments of grey coarse ware on my father's farm and took it to a friend's father, F J Watson. He was an amateur archaeologist and director of the pottery business Henry Watson Pottery at Wattisfield, Suffolk, where some 20 or so Roman kilns had previously been found by Basil Brown of Sutton Hoo fame. It was meeting Basil and experiencing his enthusiastic approach to archaeology that encouraged me to take an interest in the subject. F J Watson was also very interested in experimental archaeology and during the years 1952 to 1956 he and Basil Brown fired reproduction Roman kilns built like the ones found in the area (Watson 1958, and unpublished kiln notes).This created interest in the specialist field of research into why Roman pottery, or some of it, was grey in colour and not terracotta as is normal with a lot of pottery. We will look at this later.

Researchers from Cambridge and the British Museum took part in some of these experiments and it was also my privilege to help with the stoking of one of the 1956 firings. By this time I was well involved with the farming business and had moved to Chediston, near Halesworth in East Suffolk, but my future wife happened to be the daughter of F J Watson. She was one of the potters throwing and making what was Wattisfield Ware at that time and of course I was interested in what she was doing, so I too learned to throw. This was to stand me in good stead for the future. My introduction to samian came when I found a piece of a Drag form 18 base with part of a potter's name on it, among other Roman pottery on our farm at Chediston (it was sent to Brian Hartley in about 1958/9 and identified as the potter Germanus: Smedley and Owles 1961, 93 no 17). Watson was interested in the method used to create the characteristic surface that is special to samian and tried himself to apply it, but without success. He had however noticed that, after heavy rains, puddling occurred in the clay pits and, upon drying out, left a very fine, almost shiny surface, and so thought it ought to be possible to recreate this surface from local clays. He and

I had many discussions on this subject, and the processes necessary to make the slip so fine that it shines immediately on application.

F J Watson continued with various types of experimental kiln firing but never tried the samian slip process again. When he died suddenly in 1976 I decided to use my spare time in trying to reproduce the surface which is applied to samian and dedicate it to him. Much has been written about samian generally, with various ideas put forward as to its manufacture, including not just the process of the slip, but also the way in which the body clay was shaped in the moulds (see eg Hoffman 1983). It is in this respect I would like to share my own ideas and the techniques I have used in its reproduction.

Clay sources

Working with Geoffrey Dannell and his team at La Graufesenque in the Tarn Valley, the early samian production site, it was not difficult to see where the clay was coming from, as the village is on the flood plain which is an accumulation of material washed down the valley over thousands of years. It is my understanding that the slip for the pottery of La Graufesenque was made from clay some 12km further west on the Muze, a tributary to the Tarn at St Beauzely (M Picon, pers comm; *cf* Picon 1997). Similar clays should be available in the UK. It has been my experience where I live that the wash from the boulder clays has laid down such deposits. They are not derived from limestone such as those in the Tarn Valley, but from the surface of chalky boulder clay and they also include organic material. At present I have not concerned myself with the body clay of my pottery unduly as I have used a ready-made body clay which has a very smooth consistency. However, my main concern has been in producing a slip so fine that when applied to a vessel it shines straight away when applied before firing. I have continued to explore other sources of clay from the UK.

In my travels I have always tried to find a few pounds of clay and it has been interesting how many do produce a

reasonable surface, shiny but not necessarily the red colour of samian when fired. Some of these clays can be found around our coasts where cliffs have fallen. One of my best sources to date is from the Harlow area; this clay is yellow in colour and has a very fine texture, with a very high ferric oxide content. When fired it gives a rich red colour more like samian. I am grateful to Chris Lydamore from Harlow Museum for helping me acquire this clay. As a point of interest, over the past few years I have visited my daughter in New Mexico USA. Studying clay there and areas where wash occurs, it seems there is a good possibility samian could be made there; certainly some of the Indian pottery closely resembles it.

The pottery factory at Colchester must have had a good source of clay, not just for making the many types and forms of coarse wares, but also to produce a reasonable slip to coat the locally-produced samian (*cf* Hull 1963, 32–3). I have not investigated these sources, but perhaps they were made from a similar clay to that of the Harlow type. It is very interesting that, when dried out, most of the raw clays that will make a shiny surface break into a cubed shape. Whether this is significant or not, I am not sure, and it may be just the density.

Slip production

As with a lot of things, observations of what happens in certain circumstances leads to the evolution of ideas. Early potters must have become aware of which clays would produce good slip to decorate their pots, and it was only a matter of time before they could use this slip, not only to paint their vessels as the Greeks did, but also to make them more impervious to liquids. Chemical analysis shows that certain minerals need to be present in the clay for this process to take place, the mineral ilite being one of them. The amount of ferric oxide determines the final rich red colour of the finished samian. It is not my intention to go further into the chemical analysis of this process, which is well covered in previous books (see eg Picon 1973).

The late F J Watson observed the process whereby rain washing the clay pits formed puddles of slip and when these dried out the surface was quite shiny. He took this material back home and fired it in an oxidizing kiln to around 1,000° centigrade. The result was quite encouraging, but when he tried to repeat this process with washing clay from the pit, he was unable to reproduce its effect for some reason. In the 1950s he had done experimental work on the processes of firing Roman coarse ware, particularly working on the effects of reduction firing. One of these firings was monitored by specialists from Cambridge and also by Mavis Bimson from the British Museum. She had brought pieces of samian and these were re-fired in one of his kilns. The object of this exercise was to see what happened to these pieces, if anything, when fired in a reducing atmosphere. It would seem they were surprised that one of them emerged as Greek Black, so this did indicate the close relationship between the samian slip surface and its predecessors the Greek Black and Red Figure vases (Bimson 1956, 203).

My work on the preparation of samian slips started later in 1976. At that time I was unaware that others were and had been working on this process so could gain no help from their work. My findings were that the water to dry clay ratio is very important in the separation of the particle to coat a vessel. Initially it is just a case of soaking the clay until it is thoroughly mixed but it is important to keep account of amounts of water used. I find that the total of 12 litres of water to 3kg of dry clay is an ideal amount. This I mix into a large plastic storage box. It is helpful to mark graduations on the box for the water levels. I find it easier to use dry clay so it can be crushed to very small particles and then added to the water while stirring. Having completely mixed and broken down the clay particles to liquid form, this can be allowed to settle. Better still is to transfer the liquid back and forth a few times to another storage box, as this will make sure of a complete washing. The process is helped at this stage by getting the whole liquid mass into flotation, allowing the heavy particles to sink.

Another consideration is whether it is necessary to retain any of the clay for making the body of the pottery as it would be better to allow a longer period of settling before pouring or siphoning off the top liquid from which the final slip will come. This is another advantage of using the storage boxes in order to see the various graduations of settling and so siphon off each section, but still it is necessary to float off the fine particles. There are modern methods of doing this using chemical deflocculants; in the Roman period use was probably made of some sort of soda from wood ash or, it has been suggested, sour wine. I have sometimes in the past been able to achieve enough natural flotation, dependant on the organic make up of the clay, where it comes from, and the use of natural rain water, not from the tap (I find this makes a difference). However for the work I am doing now, I use an agent to float off the slip required. It must be appreciated that at this stage we have a very thin slip which needs dehydrating down to a single cream consistency. This takes some time, leaving only a small quantity of slip to work with. It seems obvious that the Roman potters would have had a production line making this slip to cope with the quantity required.

Throwing and turning techniques for plain wares

The sophistication of the early potters, Greek and Roman, in the making of pottery has to be admired. The shapes and sizes they were making were uniform, so special tools were needed to implement the manufacture of these regular shapes. Throwing Greek pottery was perhaps easier, as most pots were made in sections and then luted together and turned as appropriate to the piece. Greek shapes are more rounded, helping the situation, but throwing Roman samian shapes can present problems due to some of the angular forms. We must remember that the body of the clay has very little stabilizing material mixed with it making it more difficult to throw wide shallow vessels, or the very angular pieces, without some form of support or template being used.

The walls and rims of Drag 27, Ritt 9, Drag 15/17, and Drag 24/5 vessels, or any others which have protruding bead decoration on the outer surface, benefit from the use of a template. Wide shallow platters such as Drag 18 and Walters 79 benefit from being made on a plaster former, so equal drying can be achieved over the whole surface, reducing the possibility of the dish plate splitting apart when drying (see Hayes 1997, 20–1). It is perhaps worth mentioning here that when we were working at Banassac in September 2006, close examination of the large dish forms Drag 18R suggested that the footring had been added as with the Drag 37, which would reinforce the idea that these large vessels were made on a former to overcome the splitting problem which might otherwise occur.

The method I use is to throw my pieces of work on a bat (a circular clay plate which sits on the wheel, and is removed after turning still with its pot on it). This is attached to the wheel so that it can be removed and replaced at will. This allows me to turn the inside surface down to a required thickness or shape and also to smooth the surfaces inside and out ready for receiving the slip, which is done with a piece of wet soft leather or a very smooth turning tool. The pot can then be cut from the bat and inverted to turn the foot ring.

Making moulds for decorated wares

There are quite a number of decorated vessels made in moulds, but I shall deal with the main ones found on sites in Britain, namely Drag 29, Drag 30 and Drag 37, the latter being probably the most prolific form found. Each of these forms is decorated in relief, either with continuous friezes such as scrolls, or with subdivisions such as panels and medallions, which might include figures, animals and birds, and foliage elements, with divisions between made up of zigzag lines or rows of beads. The basic requirements for throwing the moulds is much the same as for making other pots of samian manufacture, including the smooth clay, but the moulds are made thicker, making them more durable to use. Having made the bowls with the shape of the form required on the inside, and smoothed them as much as possible, it is time to lay out the pattern required using the appropriate poinçon stamps and markings. I find it an advantage to be patient and wait until the mould has firmed up a bit as it will be necessary to put support on the outside when pressing the pattern from the inside, but it should not be so dry as to make it impossible to true the mould in the final stages before cutting it from the bat or wheel: it is very important that the mould is as true as possible as we shall see later. I must also point out that a hole was made in the centre of the mould base. I believe this served on two counts, firstly to sit on a peg for accurate centring, and possibly as a vent for the release of air between the clay and the mould when forming the pot in the mould. It may have had a third function of helping to release the finished vessel from the mould, although I have not had a problem with this if the shrinkage has worked evenly.

Throwing or forming vessels in moulds

In the previous section I emphasized the importance of centring the mould on the wheel. This is because the vessel has to be turned on the inside surface when it is in the leather hard state and still in the mould. Throwing techniques and ideas for this operation have been put forward by various writers but I am afraid I cannot entirely agree with them. None of the previous writers has explained what happens to the area of clay beyond the top of the mould. Assuming the mould itself is dry when centered on the wheel, all three of the common decorative forms mentioned above rise at least one inch above the mould rim, so if we throw a vessel into a bone dry mould it will be sucked dry in a very short time leaving us with a soft rim section. We shall be able to turn the inside of the bowl to the rim of the mould but will have to wait until the rim is dry enough before this can be done. I experienced this situation when making a bowl for the *Time Team* in 1997 (programme first broadcast on 10 January 1999), because as is well known they have a deadline for finishing their programme and therefore I had to cut the soft top section off so we could get the bowl out of the mould, invert it and add a foot ring. A Drag 37 without a top ring section! Having never made a bowl beyond the top of a mould before, this was a sharp learning curve for me, and one which forced me to consider how it should be done. I am indebted to the *Time Team* for this experience! Because of the time factor in completing this exercise, I had to use the dry method of making a bowl. My experience and advice in the past was to use a mould which is almost as wet as the clay being used. This equalizes out the whole situation and I think it improves the final decoration and allows the whole bowl to dry evenly throughout, including the rim section. How do we make the bowl in the mould? Again there are ideas and diagrams as to how this was achieved by the Roman potters (eg De La Bédoyère 1988, 18). My own experience has been through using some of these ideas, some of which turned out disasters and others where I was able to complete a bowl but when it was finished, removing it from the mould was far from satisfactory.

Before my *Time Team* experience I attended a weekend course on special techniques with Mark Donaldson, a potter in North Devon, and I am indebted to him also for his tuition. In our discussions about making bowls from moulds, he suggested I try making inverted cones or complete bowls upside down and enclosed. I now use this technique for my bowl-making in moulds. It has other advantages also in that the outer surface of the balloon of clay can be smoothed so that when introducing it to the moist mould it gives a good finished surface image after drying and removal. There is no quick way of doing this complete process. It takes about 24 hours at normal temperatures for the bowl to shrink from the mould, drying evenly throughout and including the rim section. The process is as follows: using callipers, we measure the mould diameter and make the cone balloon on a separate bat, obviously of a size that will fit comfortably into the mould. This is then removed from the wheel and set on

one side. Another bat is placed on the wheel head with a peg to centre the mould and a thin layer of clay is thrown ready to receive the wetted mould. We have a situation here in which either the mould or the cone has to be inverted to attach the two together before the cone part is cut from its bat. This is best done with the mould upright, and the whole can then be transferred to the wheel head. Then comes the process of pressing and turning the soft clay into the mould. I would add that it is not necessary to use any water at this stage, especially as it is important that no water gets between the clay and the mould. It is then a matter of drawing up the residue clay to form the rim extension, and the whole is then left until the vessel is dry enough before attempting to turn the inside. I usually leave it overnight, finding it best to complete this process before removing the bowl from the mould. It will take some time for the bowl to shrink out of the mould and the rim of the bowl will by this time be dry enough to stand the weight of the bowl inverted so the outside turning of foot ring can be applied. Voila!!

Slip application

We have already looked at the preparation of slip and what that entails; we now look at how the potters applied their slip to the pots. There are various ways in which this can be done, depending on the type of vessel being coated. I personally use a different way for plain and decorated wares. Let us look firstly at the material we are using: if this has been prepared correctly we will have slip (or *engobe*) about the consistency of single cream. Now this is no ordinary slip, but an extremely strong slip very dense in its makeup and if made correctly it will shine when dry on the pottery before firing.

So when do we apply this thickish slip to a piece of pot in its green state? Most potters will probably say as soon as it is firm enough to pick up, but the one thing I have learned in this situation is that you risk your pot if you get it wrong, and I am not prepared to risk a pot I have just spent several hours making. I have had too many fall apart in my hands. This is an aspect I am still trying to overcome but until that happens I do it my way. Let me explain. One of the problems is this very strong slip, a term that will be well understood by those of you in the pottery-making world. We have a very fine body clay which the pot is made from, with little or no tempering included so as to make a very smooth surface to receive this very fine strong slip. Weak body plus strong slip not applied at the right time: collapsed pot in hands!

I have worked on three techniques of slip application, apart from dipping. In the first, because of the small amount of slip being made, I used the pouring method, making it possible to catch the excess in a bowl. This was applied with the pot leather hard. The second method used was by brushing or laying the slip on with a very soft brush. This is the method I use for the decorated areas of the pottery, where it gives control over the amount of slip which gathers in the decoration and so reduces the possibility of bridging across the figures in the decoration. This can occur during the firing, if the slip is thicker at the edges or in the hollows of the decoration, when it stretches across and leaves a hollow which then after a while flakes off. It is interesting that the Roman potters also had this problem. The third way of applying the slip which I use is by spraying it on to a bone dry pot, which gives a much better control not only in the application but also in the handling of the pottery at that stage. Obviously the slip is absorbed very quickly and the pot can be handled easily without fingers becoming attached to the pot as with the dipping method. The neatness of samian footrings suggests to me that the potters did not suffer this problem in the same way as I have, or they were using the pouring method! In all of these cases it is my experience that it is necessary to remove any excessively thick areas of slip, which can be done with a soft hair paint brush.

On my visits to La Graufesenque I have had every opportunity to study both the archaeological site and the ceramic waste, and to visit the museum in Millau. The site itself reveals to us some of its secrets, one of which is some tanks used either for the preparation of slip or for actually dipping the pots, or just for storage of slip. I understand this is more likely, as these are or were dug into the ground. In this case presumably the potters were using either large pottery vessels or more likely wooden buckets to transport and use the slip.

Firing techniques

I have to admit that up to the time of writing this article I have not fired a single samian reproduction pot in anything other than an electric kiln. I do, however, have a complete understanding of the process which the potters would have used and it is my intention in the very near future to make and fire a samian kiln. Such a kiln seems to have differed from other Roman kilns in the way it was constructed: like the others it was an updraught kiln but the fire did not go through the pottery to fire it; instead it went through a series of tubes specially made for the purpose. The reason for using this method is simply to prevent the direct fire, and more particularly the smoke from the fire, from getting among the pottery.

Perhaps this needs some explanation: the classic samian pottery is a rich red terracotta colour and this is achieved only in a total oxidising kiln. The problem with samian is the very fine surface we have just applied to the pot. Because this slip is so very fine and dense in its make up, and shiny too, it is very susceptible to smoke and any reduction in the kiln, which has therefore to be avoided at all costs if we want a uniform red colour for all the pots throughout the kiln. The Greek potters used this very cleverly to their advantage by firing their pottery in an ordinary kiln. The areas of the decoration which were painted with a fine slip would turn a shiny black very readily when the kiln was put into reduction, and the other colours which were applied but not with the same make up as the samian-type slip would also turn grey/black. When the kiln was opened

up, however, allowing oxygen through, these other colours would change to the colour required, but the fine slip areas would remain shiny black, as it is quite difficult to return this surface back to red. This explains the use of the tubes in the samian kiln to supply reflective heat rather than risk the production of a reduced colour samian.

I trust this gives the reader some idea of the complexity of the manufacture of samian pottery, but also will aid those who would like to have a go. It is a great shame that there are no contemporary records about this type of pottery making.

Acknowledgements

As an amateur archaeologist living and working mostly in Suffolk, only occasionally did I get to meet the specialists of the archaeological world and therefore I feel honoured to be asked to contribute to this book in recognition of Brenda Dickinson's work in the field of samian pottery studies. Sadly I did not meet Brenda until 2003, although I had heard of her expertise and work on samian together with Brian Hartley. I was invited to join the team who were then going to La Graufesenque each year to record the decoration and stamps on samian, and I soon realised that Brenda is a real artist when it comes to using graphite on cigarette paper and can bring a name stamp to life when it seems an impossibility. Brenda, I have learned, is also a visitor to my own area of Suffolk near the east coast and enjoys this part of the country. I feel privileged to have had tuition from her and from other members of the elite team known as the Black Hand Gang in the recording and study of samian, and I offer her this paper as an expression of my thanks. I am also very grateful to Geoffrey Dannell for assistance with the references.

Bibliography

Bimson, M, 1956. The Technique of Greek black and *terra sigillata* red, *Antiq J* 36, 200–4

De La Bédoyère, G, 1988. *Samian ware*, Princes Risborough

Hoffman, B, 1983. *Die Rolle handwerklicher Verfahren bei der Formgebung reliefverzierter Terra Sigillata,* Berlin

Hayes, J W, 1997. Handbook of Mediterranean Roman Pottery, London/Norman, Oklahoma

Hull, M R, 1963. *The Roman potters' kilns of Colchester*, Rep Res Comm Soc Antiq London 21, Oxford

Picon, M, 1973. *Introduction à l'étude technique des céramiques sigillées de Lezoux*, Lyons

Picon, M, 1997. Les Vernis Rouges des céramiques sigillées de la Graufesenque: Recherches sur les argiles utilisées pour leur préparation, *Annales de Pegasus* 3, 58–68

Smedley, N, and Owles, E, 1961. Archaeology in Suffolk, 1961, *Proc Suffolk Inst Archaeol* 29 (1962), 91–102

Watson, F J, 1958. Romano-British kiln building and firing a replica, *Pottery Quarterly,* 5, 72–5

14 Arena scenes with bulls on South Gaulish samian

Joanna Bird

Introduction

This paper had its origins in the report on the bowl illustrated here as Fig 14.1, 1, which was found outside the eastern entrance of the London amphitheatre at Guildhall Yard. It was one of a cluster of eight South and Central Gaulish pots dating within the period *c* AD 75–125 which carry arena motifs and which probably came originally from the entrance drain, or from dumping carried out during the reconstruction of the amphitheatre *c* AD 125 (Bird 2008a, 135–40, fig 129, RP172; Bateman *et al* 2008, 39). Its scene of bullfighting gained additional significance from the discovery of a bull's skull in one of the arena drains, though subsequent analysis has shown that the skull cannot

definitely be linked with the arena spectacles (Bateman *et al* 2008, 128). Research on the imagery of this unusual bowl produced much more comparable material than was appropriate for inclusion in the site report, the greater part of it unpublished and originating from the work carried out by Geoffrey Dannell and his team at the La Graufesenque kiln-site between 1979 and 2006.

Dating from the decade *c* AD 70–80, considerable changes can be discerned in the decorated samian made in the South Gaulish workshops. These are accompanied by what seem to be changes in the organisation of the industry, with a number of new large-scale producers such as Germanus, M Crestio, Mercator i and L Cosius

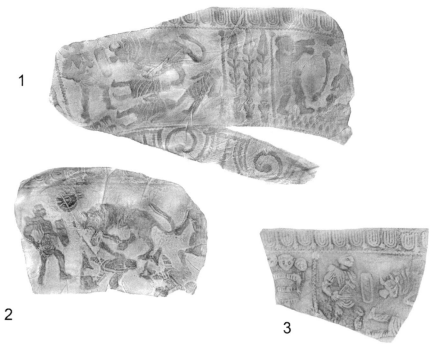

Fig 14.1: 1: Drag 37, London, Guildhall Yard (Bird 2008a, fig 129, RP172); [2005895]; 2: Drag 37, La Graufesenque (Depôt de Fouilles, G91-M79; [2004594]); 3: Drag 37 mould (image reversed), La Graufesenque (Depôt de Fouilles, G69-A62.1; [2003178]). 1:2

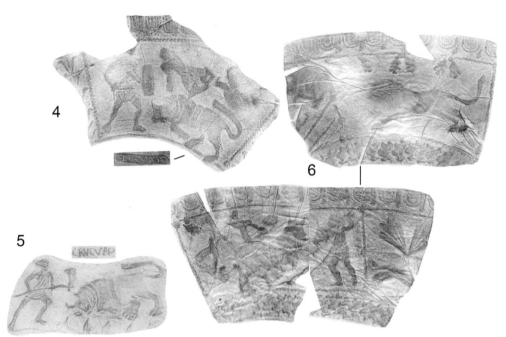

Fig 14.2: 4: Drag 37 with mould-stamp of Amandus iii, Marseille (Aix Laboratoire DO5.3; rubbed by Grace Simpson); 5: Bull and venator figures from Drag 37 with mould-stamp of Crucuro i, Cala Culip (Nieto and Puig 2001, no. 317; Mees 1995, Taf 51, 1); [0004597]; 6: Drag 37, Caerleon, Vine Cottage (National Museum of Wales 36.472505.22; [2001688]. 1:2

becoming prominent; they are identified by mould-stamps, which now appear more frequently among the decoration. The main stylistic change is a much greater use of panel designs, many of them with a 'narrative' element, such as gladiatorial combats. The changes coincide with the replacement of the carinated bowl Drag 29 by the hemispherical Drag 37, but this was clearly not the only reason for them; while form 37 does provide a greater surface area for large panels than form 29, such space was already available on the cylindrical Drag 30. The greater use of arena themes in particular would have received an impetus from the increase in both the building of amphitheatres and the popularity of the games, encouraged by the Flavian emperors and stimulated by the construction of the Colosseum and its inauguration by Titus with lavish and spectacular games in AD 80 (Bateman 1997, 82–3; Köhne and Ewigleben 2000, 24–5).

Among the arena themes that appeared on South Gaulish samian at this date, the scenes involving bulls form a distinct group. The discussion that follows is concerned less with attributing these bowls to specific styles or workshops than with looking at the themes illustrated and with demonstrating that samian ware, small-scale and mass-produced though it is, has the potential to add to the information available on this subject from larger and more thematically coherent media such as mosaic, sculpture and wall-painting. The bowls also provide a number of insights into the sources of decorative schemes and the methods used by the potters to illustrate them. Unless a form is specified, the bowls described are Drag 37; publication references are given where possible, and the numbers in square brackets (eg [2001337]) refer to otherwise

unpublished bowls which can be seen on the website of stamped and decorated South Gaulish ware now made available under the auspices of the Römisch-Germanisches Zentralmuseum at Mainz (RGZM 2009). The numbering of individual potters follows that used in the index of potters' names (Hartley and Dickinson 2008–).

Bullfighting scenes

Bulls were regularly to be seen in the arena in a wide variety of spectacles, many of which came under the rather loose category of the *venatio*, or hunt. One of the most popular of these pitted a lightly-armed *venator* against a large and dangerous animal, and various combinations of bull and *venator* were used by South Gaulish potters. The scenes are usually set in panels, and where there are no other figures involved a low rectangular box is inserted in the corner to raise the bull to a more formidable height. This box might be filled with one of several motifs: a small figure, a pair of birds, one or two animals, a festoon, foliage or imbrication (eg Figs 14.3, 7; 14.7, 16 and 14.11, 25). Landscapes were sometimes specially constructed in the arena as the setting for a *venatio* (Paolucci 2006, 80), and a small number of the fights on samian take place in a landscape of trees and bushes (eg Nieto and Puig 2001, no 317; [2001423], [2004978]). Even within panels, there is often some attempt to indicate the background, with grass or partially impressed leaves along the floor and leaf tendrils or small clusters of buds at the top or sides (eg Figs 14.1, 1; 14.2, 6; 14.3, 7; 14.6, 14; and 14.7, 17).

By far the commonest bull and *venator* pair is that shown on Figs 14.1, 1–3, 14.2, 4; 14.3, 7; 14.9, 20;

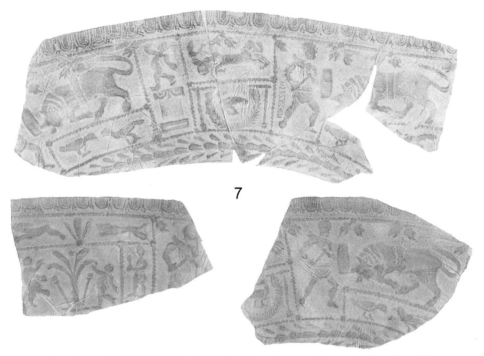

Fig 14.3: 7: Drag 37 with mould-stamp of Masclus ii, La Graufesenque (Depôt de Fouilles, G79-G89; [2002452]). 1:2

14.11, 25. The *venator* wears a short-sleeved kilted tunic, a studded belt and a raised guard, a *galerus*, on his right shoulder to protect his head and neck; the mould fragment, Fig 14.1, 3, also indicates some light protection on his legs. He is armed with a rectangular shield with a plain binding and wields an axe. The bull has its head lowered to attack, and has a band or sash round its body. There are some differences in size and detail between the various images, but only the *venator* on Fig 14.1, 2 and a second bowl from La Graufesenque (site ref G65) is sufficiently different to suggest definite copying.[1] Among the vessels on which this bull and *venator* occur are mould-stamped bowls of Amandus iii (Fig 14.2, 4), Masclus ii (Fig 14.3, 7; Mees 1995, Taf 121, 1; [2002514], [2003171], [2003227], [2004604], [2004608]), Mercator i (Mees 1995, Taf 134, 2 and 8), Patricius i (Mees 2005, Taf 163, 1) and Sulpicius ([2001337]), all of La Graufesenque, and Viir- ii of Montans (Mees 1995, Taf 247, 2). On the Viir- ii bowl, the potter's stamps appear on small rectangles which may also represent shields tossed away by the bull (see below).[2]

A different axe-wielding *venator*, unarmed and wearing only a short tunic fastened on one shoulder, was used with the same bull on mould-stamped bowls of Crucuro i (Fig 14.2, 5). The Crucuro bowls show clearly that the mould-maker used a *venator* who carried only a long shaft and that different heads were added to it for fighting different animals: an axehead for bulls, a spearhead for lions (Nieto and Puig 2001, nos 317 and 557; Mees 1995, Tafn 50, 1; 51, 1 and 2; 53, 3; and 55, 1). While various weapons were used in *venatio* scenes on samian, the axe seems only to have been used in combat with bulls,[3] and there are some parallels for this usage on mosaics, such as the *venatio* from

Vallon in Switzerland (Agustoni and Wolf 2005, 36–9). Sculptured reliefs show that axes were used when bulls were sacrificed (eg Toynbee 1973, pl 57; Ferguson 1970, pls 72–3) and it is possible that this is a reflection of the religious and sacrificial significance that underlay much of the arena spectacle (eg Wiedemann 1996, 12, 96–7, 180). Similarly, the band round the bull's body, which is usually shown with a fringe on more detailed mosaic representations, was worn by sacrificial bulls (Ferguson 1970, pl 36; Toynbee 1973, pl 57), and Delgado Linacero relates it to the *vitta*, a ribbon that adorned sacrificial animals (1996, 388). It would certainly not have helped the arena staff in handling the animals safely. A *venatio* relief from Rome indicates how this was done: a bear, a lion and a lioness all wear a heavy harness with a ring behind the shoulders by which they could be manoeuvred using hooked sticks (Grant 1971, pl 12). The arena mosaic from Zliten shows a bull and a bear chained together, with a naked prisoner approaching them with a hooked stick; both animals wear a harness but the bull also wears a band in a different colour (Köhne and Ewigleben 2000, fig 83; Dunbabin 1978, pl 20, 48). Another African mosaic, from El Djem, shows a medley of fighting bears, bulls and boars, and again only the bulls wear the band (Dunbabin 1978, pl 27, 68), while the *venator* on a mosaic from Bad Kreuznach who has overcome a bull with his spear holds out the fringed band as though it were a trophy (Cüppers 1990, pl 2).

Bulls are also shown in combat with *venatores* wielding swords and spears, and in these scenes too the bulls wear the band round the body. A large standing bull facing to the right confronts a *venator* wearing a short kilted tunic and armed with a small rectangular shield, which on clear

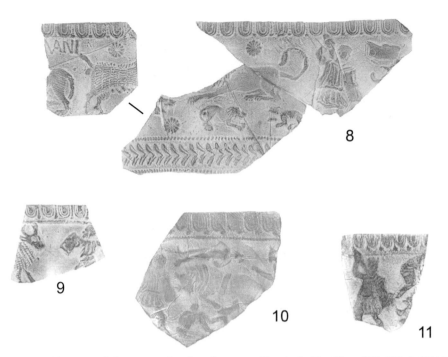

Fig 14.4: 8: Drag 30 with mould-stamp of Germanus, La Graufesenque (Depôt de Fouilles, G75-T33.2, T56C; [1001344]); 9: Drag 30, La Graufesenque (Depôt de Fouilles; [1002211]); 10: Drag 37, La Graufesenque (Depôt de Fouilles, G79-S98.2; [2003725]); 11: Drag 37, La Graufesenque (Musée Fenaille, Rodez, Collection Hermet; [2000021]). 1:2

impressions has a binding and a circular central boss or decoration; his sword is raised behind his head (Fig 14.2, 6).[4] At least two of the bowls with these figures show a shield tossed above the bull's back, perhaps indicating a previous victory ([2004978]; La Graufesenque, site ref G79–H41); a similar device occurs on the Zliten mosaic, where there is a shield below the bull despite the fact that it is currently fighting a bear (Dunbabin 1978, pl 20, 48). The pots recorded with these figures include mould-stamped bowls of Bassus iii (Bird forthcoming, DS 273), Crucuro i (Mees 1995, Taf 53, 5), T Flavius Secundus (Mees 1995, Taf 181, 1) and the anonymous mould-maker of stamp Rosette I (Mees 1995, Taf 210, 1), all of La Graufesenque. The same *venator* occurs with a slightly different bull on a Drag 30 (Fig 14.4, 9) and on a mould fragment by the potter of the Guildhall bowl ([2003176]).

There are also reversed images of this *venator* and bull, with two distinct versions of the *venator*, the second occurring on bowls in late style and probably copied from the first. The first is on a Drag 30 with a mould-stamp of Germanus (Fig 14.4, 8), where the tunic and shield are particularly finely modelled. The Germanus bowl sets the figures among the arena beasts, including bears, lions and boars, and a large shield is tossed above the bull's back. The same figures are on Fig 14.4, 10, on a bowl from Günzburg that is probably by the same potter (Knorr 1919, Taf 96, E), and on Fig 14.4, 11; bowls from La Graufesenque (Hermet 1979, pl 82, 1) and Ovilava (Karnitsch 1959, Taf 17, 1) show the same *venator*, with the bull raised on a small rectangular panel filled with imbrication. The later version of the *venator* is closely similar but more coarsely detailed, with the legs rather oddly placed, and it occurs on

Fig 14.5, 12 and 13, and on bowls from La Graufesenque (site ref G65) and Ovilava (Karnitsch 1959, Taf 17, 3), all probably by the same potter. A closely similar *venator* was used at Banassac (Hofmann 1988, pl 60, 529).

A small number of bowls have been recorded where the *venator* wields a spear. The *venator* who carries a shaft to which different heads could be attached (Fig 14.2, 5) is shown on Fig 14.6, 14 using it with a spearhead to fight a bull facing left. A further fragmentary panel of this bowl has the back hoofs of a second bull facing right, and some of the motifs and figures suggest that this bowl and three of the Cala Culip bowls (Nieto and Puig 2001, nos 318–9 and 639) may be from the same workshop, perhaps that of Frontinus. Another bull and spear-wielding *venator* are shown, unusually, under a winding scroll of palmate leaves on Fig 14.6, 15, probably by a potter of the M Crestio workshop; the indistinct object above the bull is too large to be a shield, as shown with the same figures by Hermet (1979, types 252–3), and may be a gladiator (see below). A closely similar bull and *venator* were used on Banassac bowls, including one with a mould-signature of Lentinus (Mees 1995, Taf 234, 5; Hofmann 1988, pls 20, 153; 31, 239; 32, 471; and 58, 511). A variation of this last pair is on a bowl found at La Graufesenque but with figures and other motifs recorded for Banassac (Fig 14.7, 16); the bull is similar but the *venator* is much taller, and the same tall *venator* appears with a very large bull on a probable Banassac bowl from Narbonne (Fig 14.7, 17).

Scenes of damnatio ad bestias

Some scenes also contain figures that have already been

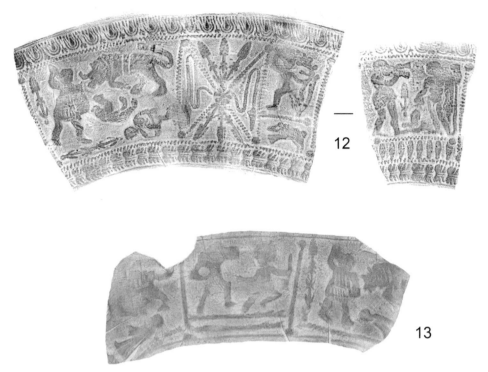

Fig 14.5: 12: Drag 37, Vindolanda (Birley 1994, fig 9, 37; [2004896]); 13 Drag 37, La Graufesenque (Depôt de Fouilles, G79-H41). 1:2

killed or are being tossed by the bull, while other bowls show the bull and victims but omit the *venator*. Bulls, like bears and big cats, were regularly used as state executioners, killing those – *noxii* or *damnati* – who had received the sentence of *damnatio ad bestias*, death among the animals in the arena. In the case of bulls it is likely that the victims were usually tossed and trampled, and Eusebius records the martyrdom at Lyon in AD 177 of Blandina, who was tied in a net and tossed by a bull (*Historia Ecclesiastica* 5.1.56; Paolucci 2006, 100–1). Such scenes appear on African mosaics: one from Silin shows a large white bull with two *damnati* tossed in the air and a third being pushed towards it by an animal handler, a *bestiarius*; the bull wears a narrow fringed band, and the *damnati* wear a distinctive costume of short hooded tunic and trousers (Dunbabin 1999, fig 127). Dunbabin suggests that the costumes either identify the victims as a specific group or allude to some custom or ritual involved in the execution (1999, 123–4), and Coleman notes that prisoners could be forced into an assumed guise as part of their punishment (1990, 66). The fragmentary fourth side of the Zliten mosaic shows the lower half of a bull, again wearing a narrow fringed band, with part of the foot of a victim who is apparently being tossed over its horns (Dunbabin 1978, pl 1; reconstructed on Delgado Linacero 1996, lám 106).

Given the relatively small number of South Gaulish *damnatio* scenes that have been recorded, the majority of them involving bulls, the potters used a surprisingly large range of figure-types to represent the victims. Most were clearly designed as *damnati*: a naked figure with its hands tied behind its knees is on a bowl from Binchester (Fig 14.8, 18: the sherd from which Hermet (1979) took his

types 247–9 may be from the same mould), [2003174], and unpublished bowls from Vindolanda (2001–2) and London (Museum of London A1923); a slightly smaller version of this figure is on a bowl in the style of L Cosius from Caerleon (Fig 14.2, 6). A figure wearing a loincloth, its hands bound behind its back, is on Fig 14.2, 4, by Amandus iii, another possible Amandus bowl ([2000434–5]), Fig 14.4, 10 and the bowl from Günzburg that is probably by the same potter (Knorr 1919, Taf 96, E), and two bowls from Cala Culip (Nieto and Puig 2001, nos 318–9). A third bound victim appears on Fig 14.5, 12, where a small bear has become involved in the action, and [2003173], which is probably by the same potter, and there is another crouched and falling figure on Fig 14.8, 19. A naked upright figure with its hands tied behind its back also appears on Fig 14.4, 10 and the Günzburg bowl, and a further victim is tossed by a bull on Fig 14.4, 11 (*cf* Hermet 1979, types 242–4). However, other figures might be used to represent *damnati*: Cala Culip nos 318–9 and 639 (Nieto and Puig 2001) include a small cloaked figure, and this appears too on the bowl from York (Fig 14.6, 14) which may be by the same potter. The Guildhall bowl (Fig 14.1, 1), a piece of what may be its mould ([2003177]) and another mould by the same potter (Fig 14.1, 3) use a small figure in a short draped garment to act as the victims, while a bowl from London (Fig 14.9, 20) has a dancing satyr. Finally, an anomalously early example of such a scene on the mould for a Tiberian Drag 29 (Fig 14.10, 22) shows a figure in a short hooded tunic (recalling the unusual costume of the *damnati* on the Silin mosaic) falling in front of a bull; the *damnatus* is apparently unrecorded, but the distinctive bull appears among friezes of animals on forms Drag 11 and

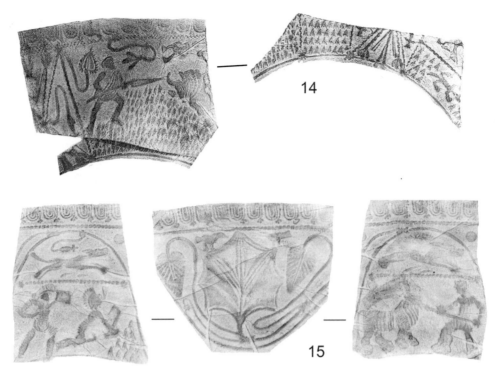

Fig 14.6: 14: Drag 37, ?York (Yorkshire Museum; [2004890]; rubbed by Grace Simpson); 15: Drag 37, Strasbourg (Musée Archéologique 2439; [2003165]; rubbed by Grace Simpson). 1:2

Drag 29 of Tiberian date (eg Joffroy 1962, pl 14; Dannell *et al* 2003, Firmo i, H1–6).

In addition to these victims, there are some who are shown as gladiators or animal handlers, *bestiarii*, and these may represent members of the usual amphitheatre personnel, or perhaps *damnati* condemned to serve in the arena (*cf* Coleman 1990, 56). A gladiator who usually appears as a *secutor* in combat with a trident-wielding *retiarius* (eg Mees 1995, Taf 146, 1, by Mommo) is shown as a corpse on Fig 14.5, 13, [2003169], one of the Ovilava bowls (Karnitsch 1959, Taf 17, 3) and probably Fig 14.6, 15 and [2003464]. The figure on Figs 14.1, 2 and 14.2, 4 for which there is no apparent parallel elsewhere, may also be a gladiator; his garment is similar to that worn by a pair of fighters on the mosaic from Nennig near Trier (Dunbabin 1999, fig 84) and David Bird has suggested (pers comm) that the objects at his feet would be best interpreted as a broken shield and helmet. The bowl stamped by Viir- ii of Montans shows a bull tossing and trampling a pair of torch-bearers (Mees 1995, Taf 247, 2); the same torch-bearer and a *damnatus* are trampled by a bull on [2003173], while the Binchester bowl (Fig 14.8, 18) and the one from which Hermet (1979) took his types 247–9 have the torch-bearer impressed with the tossed *damnati*. Martial records seeing a bull goaded to fury by flares (*De Spectaculis*, 19; Toynbee 1973, 149) and perhaps these images represent torch-bearing *bestiarii* who have got too close to an angry bull.

Fights between bulls and other animals

The last category of scenes involving bulls shows them in combat with other animals, spectacles that also formed part of the *venatio* programme. A mosaic from Kos names three fighting bulls, one of them called Arkodamos, 'Bear-slayer' (Toynbee 1973, 150), and fights between bulls and bears seem to have been particularly popular; the two animals were sometimes tied together, as recorded by Seneca (*De Ira* 3.43.2; Jennison 2005, 71) and shown on a wall-painting from Pompeii (Vismara 2001, 203) and on the Zliten mosaic (Dunabin 1978, pl 20, 48). A fight between a bull and a bear is shown on a mould-stamped bowl of Germanus from Rottweil (Mees 1995, Taf 84, 1), but the South Gaulish potters generally seem to have depicted scenes which pitted a bull against a lion (eg Mees 1995, Tafn 69, 1–2; 70, 1; 71, 2–3; 78, 6; and 83, 5, all with Germanus mould stamps; [2004275], [2004565]). A mould-stamped Knorr 78 of Germanus shows an unusual scene of two fighting bulls (Mees 1995, Taf 80, 11). Like the bullfight and *damnatio* scenes, the animal combats may be set in panels, as on Fig 14.10, 23, or within a landscape, as Figs 14.9, 21 and 14.11, 24. The landscape scenes sometimes include other animals as well (eg Fig 14.9, 21), and the potters, like the African mosaicists (Dunbabin 1978, 65–6), may have taken advantage of the *venatio* theme to illustrate a variety of different species. The Germanus bowl with a bear fighting a bull also shows a hound and a stag, while a bowl in the style of Crucuro i has a bull fighting a lion, a bear fighting a boar, and a lion bringing down a mule (Bird 2005, fig 5, 15). Fig 14.4, 8 shows a bull and *venator* among other animals, and panel designs with animal combats could also include other *venatio* scenes, such as those on a mould-stamped Germanus bowl with a lion and a bull, a boar and a lioness, and a mounted hunter and a lion (Mees 1995, Taf 70, 1).

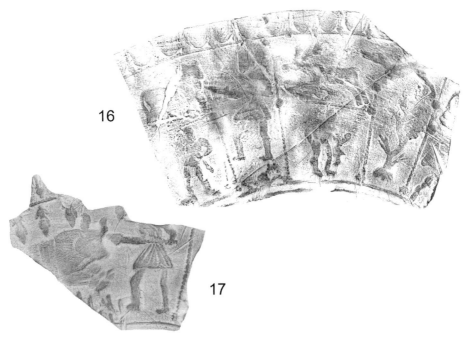

Fig 14.7: 16: Drag 37, La Graufesenque (Depôt de Fouilles; [2000913]); 17: Drag 37, Narbonne (Musée Archéologique, Collection Henri Rouzaud, no. 7231; rubbed by Grace Simpson). 1:2

Accompanying scenes

Where enough of the bowl survives, almost all the pots discussed above include other related themes. Decorated samian ware dating from the Flavian period onwards is usually seen as a random assemblage of unconnected motifs and figures, and in a perceptive paper on decorated samian in Britain Martin Henig noted that 'consistent iconographies are very rare and for the most part limited to subjects of lesser importance such as *venationes*' (Henig 1998, 63). This makes it of particular interest that so many of the bull *venatio* scenes on South Gaulish bowls actually share their space with other images connected with the arena, creating a largely coherent scheme of decoration.

The most obvious companion scenes involve other arena spectacles. Pairs of gladiators are present on Figs 14.2, 6; 14.5, 13; 14.6, 15; and 14.8, 18, and on mould-stamped bowls of Bassus iii (Bird forthcoming, DS273), Germanus (Mees 1995, Taf 69, 1), T Flavius Secundus (Mees 1995, Taf 181, 1) and the Rosette I potter (Mees 1995, Taf 210, 1), all of La Graufesenque, and Lentinus of Banassac (Mees 1995, Taf 234, 5). A *secutor* and *retiarius* appear on one of the Germanus bowls (Mees 1995, Taf 69, 1) and on a bowl from Ovilava which also has the small figure of a lion devouring a victim (Karnitsch 1959, Taf 17, 3). Mould-stamped bowls of Crucuro i show other *venatores*, including combats with lions and boars (Mees 1995, Tafn 50, 1; 51, 1–2; and 53, 5; Nieto and Puig 2001, nos 317 and 557), and a mounted *venator* tackles a lion on a mould-stamped bowl of Germanus (Mees 1995, Taf 70, 1). The *damnatio* scenes on Cala Culip nos 318–9 are separated by trees, among which lions and boars wait to attack the victims (Nieto and Puig 2001). The early Drag 29 mould shown on Fig 14.10, 22 has a huntsman surrounded by

hounds, carrying a pair of hares hanging from a stick over his shoulders; this may be a genuine hunting scene, but paired with the bull and *damnatus* it may represent a bucolic *venatio*. One of the two individual figures on the Rosette I bowl (Mees 1995, Taf 210, 1) has a short topknot of hair, a loincloth and raised fists, and is probably a boxer (*cf* Grant 1971, fig 1; Köhne and Ewigleben 2000, figs 85 and 91); the second figure, apparently armless, is probably another bound captive. One or other of a pair of small two-horse racing chariots is on mould-stamped bowls of Masclus ii (Fig 14.3, 7; [2002514], [2003171]) and on [2002463], [2003182] and [2003568]. The little torchbearer, whose appearance as a victim is noted above, is on mould-stamped bowls of Masclus ii (Fig 14.3, 7; Mees 1995, Taf 121, 1) and on Fig 14.8, 19 as an upright figure, perhaps again as a *bestiarius*, or perhaps representing an attendant at the *pompa*, the ceremonies which preceded the games (eg Köhne and Ewigleben 2000, fig 34).

A number of the bowls include images of deities who have some association with the arena. Diana, as goddess of the hunt, appears in connection with *venationes* on African mosaics, including a leopard *venatio* from Smirat and a scene of unarmed men fighting animals from El Djem (Dunbabin 1978, pls 22, 53, and 23, 56). She is shown on bowls with mould-stamps of Crucuro i (Mees 1995, Taf 50, 1; Nieto and Puig 2001, no 557) and Masclus ii (Mees 1995, Taf 121, 1), and on unmarked bowls from La Graufesenque (eg Hermet 1979, pl 89, 1). On the Masclus ii bowl she is paired with a winged Victory, a personification appropriate to a scene of combat, and a second figure of Victory is on [2002463]. [2002463] also has a throned figure of Jupiter, in whose honour the oldest of the games, the *ludi romani*, were held (Köhne and Ewigleben 2000,

Fig 14.8: 18: Drag 37, Binchester (Wild 2010, fig 63, no. 27; rubbed by Felicity Wild); 19: Drag 37, La Graufesenque (Musée Fenaille, Rodez, Collection Rey; [2003180]). 1:2

10), and it is possible that Jupiter is further represented by the large eagle on a bowl from Colchester (Dannell 1999, fig 2.20, 283).

The most numerous images are those of Bacchus and his followers, and it is in his aspect as a saviour god concerned with death and the afterlife that he would have been associated with the arena. A considerable number of African mosaics attest to this connection, which clearly related to both gladiatorial combats and *venationes* (*cf* Dunbabin 1978, 184–5; Witts 1994, 116), and Delgado Linacero notes that animal combats including bulls featured in the Liberalia games given in Bacchus' honour (1996, 387). Figures of Bacchus, holding a cup and accompanied by a leopard, are on the Guildhall bowl (Fig 14.1, 1), and on Fig 14.5, 12 and a second bowl by the same potter from La Graufesenque (site ref G65). On the two complete panels (Figs 14.1, 1, and 14.5, 12) the god is accompanied by a satyr playing a double flute, a *tibia*, and this satyr is also in the fragmentary scene on [2003177]. Satyrs and fauns, sometimes with one of the satyrs dancing on an altar, appear on bowls stamped by Masclus ii (Fig 14.3, 7; Mees 1995, Taf 121, 1) and on Hermet 1979, pl 89, 1, [2002463], [2003168] and a Drag 30 [1001270]. A bowl by the Guildhall potter has a maenad with a tambourine [2005791], and one of the mould-stamped Crucuro i bowls shows a maenad with a torch, and a leopard beside a grapevine (Mees 1995, Taf 50, 1; Nieto and Puig 2001, no 557); the mould-stamped bowl by Viir- ii of Montans has a satyr carrying grapes (Mees 1995, Taf 247, 2). A second Crucuro i bowl has a grapevine in the landscape (Mees 1995, Taf 51, 1 and 2; Nieto and Puig 2001, no 317). A lizard, a symbol of death and rebirth (*cf* Bird 1996, 123), is on the bowl from York (Fig 14.6, 14), and one is shown dangling from a string

in Bacchus' hand on the mosaic of fighting animals from El Djem (Dunbabin 1978, pl 27, 68).

Hercules, the mythical hunter who destroyed wild beasts and monsters, was also closely connected with the arena (Wiedemann 1996, 178–9), and he too appears on bull-fighting bowls. An image of him killing the dragon Ladon that guarded the golden apples in the Garden of the Hesperides is on Fig 14.5, 12, on a bowl stamped by Masclus ii ([2003227]) and on a bowl from Ovilava (Karnitsch 1959, Taf 17, 2), all with the *venator* and bull of Fig 14.1, 1. A mould fragment from La Graufesenque by the potter of the Guildhall bowl (Fig 14.1, 3) has part of a panel with a triple-headed man, shown as the monster Geryon in combat with Hercules on a bowl by the same potter from Verulamium (Hartley 1972, fig 90, 72). Hercules with his club and lionskin is shown on Fig 14.7, 16, and a standing figure of Hercules with his club is on a sherd from Lyon where only the rear of a left-facing bull survives ([2004268]). A bowl from Agen in the style of Florus of Montans, decorated with deities and scenes of Hercules' Labours, actually uses the bull and *venator* pair of Fig 14.1, 1 to represent Hercules overcoming the Bull of Crete (Jacques and Martin 1997, fig 13, 66).[5] In addition to Hercules, there is a figure who is sometimes shown as Peleus receiving from Vulcan the magical sword which gave victory in both battle and the hunt (Oswald 1936–7, pl 5, types 70 and 883); he would also have been an appropriate hero to be associated with the arena, and appears on [2002098] and on a Drag 30 mould from La Graufesenque (site ref G80-N: ML12).

In addition to human and divine figures, a number of bowls include animals and birds, and these usually appear in smaller panels such as those beneath the bulls. The animals

Fig 14.9: 20: Drag 37, London, between Fenchurch Street and Gracechurch Street (British Museum P&E 1942, 0406.2; rubbed by Grace Simpson); 21: Drag 37, La Graufesenque (Depôt de Fouilles, G77-S8; [2003539]). 1:2

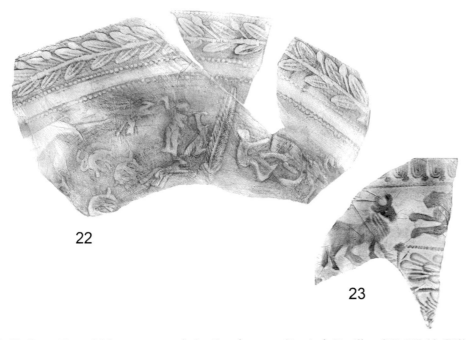

Fig 14.10: 22: Drag 29 mould (image reversed), La Graufesenque (Depôt de Fouilles, G75-T11.12, T42); 23: Drag 37, Ixworth (1946.134; [2005074]). 1:2

again reflect the *venatio* theme; however, while large beasts such as lions and boars do appear (eg Figs 14.2, 6; 14.5, 12; and 14.11, 25), smaller hunting pairs such as hounds and hares seem to be more common, probably because of the space available. Bowls showing hounds and hares or small deer include Fig 14.3, 7, with a mould-stamp of Masclus ii, Figs 14.2, 6; 14.6, 15; 14.7, 16; 14.8, 19; and 14.9, 20, and mould-stamped bowls of Amandus iii (Mees

1995, Taf 7, 7) and Patricius i (Mees 1995, Taf 163, 1) of La Graufesenque, Viir- ii of Montans (Mees 1995, Taf 247, 2) and Lentinus of Banassac (Mees 1995, Taf 234, 5). Birds on samian are usually difficult to identify simply because of their scale, but a number of the birds shown on these bowls appear, from their general outline and rather pronounced beaks, to be crows or ravens. Whether this is an unwelcome reminder of the carrion-eating nature of

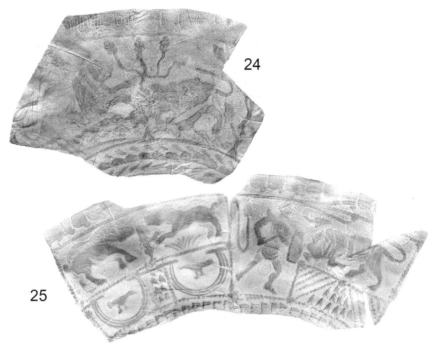

Fig 14.11: 24: Drag 37, La Graufesenque (Depôt de Fouilles, G65-G59); 25: Drag 37 (provenance unknown; ex collection A W G Lowther). 1:2

the crow family, or whether it represents an element of the Gaulish tradition which endowed crows and ravens with chthonic powers, must remain an open question; these birds are on several bowls, including mould-stamped bowls of Masclus ii (Fig 14.3, 7; Mees 1995, Taf 121, 1) and Sulpicius ([2001337]), and Figs 14.8, 19 (in the upper corner of the *damnatio* panel) and 14.11, 25.[6]

It is among the foliage ornament interspersed with the figured panels that perhaps the most surprising element is to be found. The majority of these ornaments comprise the banal saltire arrangements found widely on samian ware of Flavian and Trajanic date, a diagonal cross filled with triple leaves, poppyheads and other simple foliage motifs (eg Figs 14.6, 14 and 14.8, 18). However, the Guildhall bowl and its possible mould (Fig 14.1, 1; [2003177]) have a narrow panel filled with three tall leaves on stalks, and it is probable that they represent the stalks, usually identified as millet, which occur on a number of African mosaics with arena, Bacchic and other themes, and which were clearly believed to have beneficent and apotropaic powers (Dunbabin 1978, 170–2). Such stalks are also found on 3rd-century African red-slipped flasks decorated with applied arena motifs, including bull and *venator* pairs (eg Hayes 1972, 212–3, pl 8). A mosaic from El Djem showing bulls sleeping in the amphitheatre is framed by such stalks, and one of the *venatores* dining in the same scene holds a stalk as his faction symbol (Dunbabin 1978, pl 27, 69); the leopard *venatio* from Smirat shows Diana holding a stalk, with other stalks decorating the leopards and the *venator* Hilarinus (Dunbabin 1978, pl 22, 53; 1999, fig 118); and the bear *venatio* from Khanguet-el-Hadjaj has stalks and spears scattered between the bears and the *venatores* (Dunbabin 1978, pl 26, 65). As Witts has shown,

these stalks can occasionally be found outside Africa (1994, 111–3), and the imagery may well have been recognised in southern Gaul. Another bowl by the Guildhall potter has the tall stalk framing a maenad in the next panel to a bullfight ([2005791]), and a similar tall leaf is shown next to the bull and *venator* of Fig 14.2, 6 on a sherd from Balkerne Heights, Colchester (Jo Mills, pers comm). A tall palm-like leaf separates the scenes on Fig 14.10, 22 and [2003158], and may carry the same symbolism, though palm fronds were common images of victory. Shorter versions of the stalked leaf partially frame the bullfight on Fig 14.5, 12 and 13, appear with Bacchus on Fig 14.5, 12, and separate the boars on Fig 14.11, 25; they are bound into saltires on Figs 14.5, 12 and 14.9, 20.

Discussion and conclusions

Several points emerge from this study of the South Gaulish bull-fighting scenes. Contrary to current perceptions, the potters were clearly capable of producing a coherent scheme of decoration when they wanted to, drawing on a number of sources for their designs, and they sometimes showed considerable ingenuity in adapting figure-types to different uses. The most interesting feature is the African link suggested by the millet stalks, which argues a close familiarity with the arena imagery of the Mediterranean world. This may also be reflected in the rather grisly *damnatio* scenes: the carnage-filled mosaic frieze from Zliten is dated by Dunbabin to the late 1st or very early 2nd century, precisely the date of the pots considered above (1978, 235–7). Further, the bulls depicted, with their short rounded horns, rather humped shoulders and heavy folds of neck muscle, are similar to those on the African mosaics

(eg Dunbabin 1978, pl 27, 69), suggesting that this was the kind of bull usually to be seen in Mediterranean arenas. The scenes on samian in which these bulls feature are all apparently standard images of *venatio* and *damnatio ad bestias*, and this may reflect the normal display at a provincial amphitheatre. There are literary records of a number of more varied and elaborate spectacles involving bulls which have not so far been recorded on samian, including rodeo-like displays originating in Thessaly (Jennison 2005, 59; Köhne and Ewigleben 2000, fig 78; Delgado Linacero 1996, lám 105), acrobatic and bull-leaping turns (Toynbee 1973, 150; Köhne and Ewigleben 2000, fig 79), fights between bulls and more exotic animals such as rhinoceroses and elephants (Jennison 2005, 48, 74), a variety of acts involving trained bulls (Jennison 2005, 71; Toynbee 1973, 150), and *damnatio* scenes in which women were apparently punished in re-enactments of the myths of Dirce and Pasiphaë (Coleman 1990, 63–6). Perhaps these dominate the literature precisely because they were special or rare, and mainly reserved for the audience in Rome.

Also of interest is the apparent understanding of the connections between different deities and mythological characters, and the arena; the use of an image of Peleus seems particularly sophisticated in this context, unless he was simply a convenient figure-punch with a sword. This argues for considerable familiarity with the Roman pantheon and Roman myth among whoever provided the ideas on which the designs were based (on this subject, see the paper in this volume by Janet and Peter Webster). Unfortunately we know nothing of the means by which the potters selected the subjects that they chose to depict, or of how they became aware of new pictorial fashions such as the arena themes. In the latter case, the process must have happened rapidly, since the chronological link between the new styles and the widespread boost to the arena spectacles provided by the construction of the Colosseum is so close: the Cala Culip wreck, for example, probably dates *c* AD 78–82 (Hartley and Dickinson 2001, 32). There would certainly have been regular contacts between the workshop owners and the pottery merchants, the *negotiatores cretariae,* who were trading their products throughout the western Empire, and these may have been the vehicle for new ideas, perhaps via pattern books and examples or drawings of other artefacts.

It is instructive to look for similar scenes among the products of other samian potteries. A bowl from one of the Spanish workshops shows the figure of a *damnatus* tossed over a bull's back (Delgado Linacero 1996, làm 134), but the only other comparable vessel noted from Spain shows a bull and a *venator* with a spear, from the pottery at Andújar (Mayet 1984, pl 39, 192). Both the Spanish bowls have long fern-like leaves among the figures, probably again reflecting the millet-stalk imagery. The Central Gaulish potteries at Les Martres-de-Veyre and Lezoux both produced numerous gladiatorial and *venatio* scenes, but with a single exception there are no recorded images of bull-fighting or of bulls involved in *damnatio* scenes from either site, and bulls are almost absent from

their figure-types (*cf* Oswald 1936–7, types 1870–1891B). The exception is an unpublished Drag 30 mould from Brian Hartley's excavations at the Audouard site at Lezoux; it is in the style of Sacer I/Lentulus, contemporary with much of the South Gaulish material discussed above, and shows a bull (Rogers 1999, type 4097) tossing a naked *damnatus*, while a second *damnatus* is pushed towards it by a *bestiarius* with a whip.

There is a little more comparable material from East Gaul, particularly from Trier. Two Antonine bowls in the style of the anonymous Werkstatt II, Serie A, show small hooded figures in front of or tossed over a bull; the more complete of the two bowls has *bestiarii* with whips urging the *damnati* forward (Huld-Zetsche 1993, Tafn 8, A73, and 18, A134). The 3rd-century potter Dubitatus shows the same bulls and hooded victims, sometimes again with a *bestiarius* armed with a whip (Simon and Köhler 1992, Taf 26, C I 153; Gard 1937, Taf 24, 6, 9 and 11). Separate scenes of bulls confronting *venatores* with spears and *bestiariii* with whips appear on bowls of Werkstatt I, Werkstatt II and the later 2nd-century potter Maiiaaus (Huld-Zetsche 1972, Tafn 2, A11, and 11, B14; 1993, Tafn 35, B97; 56, E31; 76, F137; 79, F156; 80, F161; 81, F163; and 83, F178; Müller 1968, Tafn 47, 1321, and 48, 1348 and 1350). Among the other East Gaulish potteries, a sherd by one of the Antonine Cambo group at Blickweiler shows a bull in the next panel to a *bestiarius* with a whip; another Blickweiler bowl with a bull hanging upside-down from a pole carried by two naked figures may show a genuine hunting scene or an animal being removed from the arena (Knorr and Sprater 1927, Tafn 59, 10, and 69, 4). A bowl of later 2nd- or early 3rd-century date from the kiln-site at Les Allieux in the Argonne shows lions, bulls, a *bestiarius* and a *venator*, including a row of four bulls alternating with four small figures; three more of the figures are impressed below the bulls, one of them upside-down, and it is possible that this is a scene of *damnatio* in the arena (Chenet and Gaudron 1955, fig 60, B). A bowl attributed to Germanus of Lavoye, bowls by Helenius of Rheinzabern, active in the first half of the 3rd century, and a bowl from Westerndorf all have a tall figure in a hooded cloak confronting a bounding bull (Ricken and Thomas 2005, Taf 176, 16 and 18; Oswald 1945, fig 7, 10 and 11).[7] Helenius also shows a bull pursuing a *bestiarius* who is carrying a coiled rope, and a bull facing a *venator* with a rope or net accompanied by other *venatio* scenes, including a bound *damnatus* attacked by a bear (Ricken and Thomas 2005, Tafn 175, 4, and 177, 3). From Britain, a bowl by the Antonine Potter A of Colchester shows two bulls attacking a naked figure whose hands are tied behind his back (Hull 1963, fig 34, 2).

This examination of South Gaulish arena scenes with bulls has, I hope, shown that the potters were capable of producing compositions which, while not perhaps of great elegance, nevertheless demonstrate a degree of thematic coherence. It is also clear that, despite the apparently remote location of their workshops, the potters were in touch with imagery and ideas which, however unattractive to modern sensibilities, were current and fashionable around the

Mediterranean at the turn of the 1st and 2nd centuries. The scarcity of comparable material from the Central and East Gaulish potteries is striking; not only are scenes with bulls rare (and the bulls themselves tend to have larger horns), but the associated millet-stalk imagery seems to be absent, as is the clear link between Bacchus and the arena seen on the South Gaulish bowls and the African mosaics (*cf* Bird 2008a, 140). This would all appear to emphasise a particularly Mediterranean element in the South Gaulish imagery,[8] a feature which is clearly not so marked among the successor potteries despite the 'Roman' nature of so much of their output.

Mention of the location of the La Graufesenque potteries, in the beautiful Causses country just outside Millau, reminds me of how many happy, sunny and well-fed weeks Brenda Dickinson and I have spent working there with Geoffrey Dannell's team. While this may seem a rather gruesome subject with which to celebrate her birthday, I hope that Brenda will appreciate what these scenes can tell us about the potters and how they worked. It is a great pleasure to contribute to her Festschrift, and I am very aware of my good fortune in working so closely with someone who is an awe-inspiringly complete mistress of her subject, an unfailingly helpful colleague, and a very dear friend.

Acknowledgements

I would like to thank Geoffrey Dannell and Robert Hopkins, who have provided scans of rubbings collected by the 'Black Hand Gang'; the collection now includes the late Grace Simpson's South Gaulish rubbings. Those who have generously made pottery available for study include Alain Vernhet and the Société des Lettres, Sciences et Arts de l'Aveyron (La Graufesenque), Xavier Nieto (Cala Culip), Robin Birley (Vindolanda) and the National Museum of Wales (Caerleon). A special debt of gratitude is due to Allard Mees, who has been a prime mover in making so much material available both in publications and on the RGZM (Römisch-Germanisches Zentralmuseum Mainz) website. I would also like to thank David Bird for his comments on a draft of the text, Felicity Wild and Iain Ferris for permission to use the Binchester rubbing, Brenda Dickinson, Martin Henig, Jo Mills, Alex Mullen, Ralph Jackson and Rosemary Wilkinson for further information, and Nick Bateman, Michael Fulford and Peter Rowsome for their kind encouragement.

Notes

1 The factors which may have caused variations in the appearance of the same figure or motif on different bowls, and some of the ways in which individual punches might have been shared or copied between workshops, are discussed in Bird 2005, 77–8. More recently, Geoffrey Dannell has suggested (pers comm) that identical punches may have been turned out from a single matrix and supplied to different mould-makers, rather than being the property of a specific workshop.

2 Brenda Dickinson and Geoffrey Dannell have noted (pers comm) an inscription apparently added to the *venator*'s shield on [2001311]. The *venator* and bull are those shown on Fig 14.1, 1; the writing is not clearly legible, and may represent a potter's mark or perhaps a motto appropriate to the arena.

3 A Drag 11 chalice with a mould-stamp of Rutenos i and a Drag 29 mould, both of Tiberian date, show a hunter attacking a bear with an axe. These are directly copied from an Augustan Arretine chalice, itself closely influenced by late Hellenistic imagery, made more than 70 years before the bowls discussed here, and so are not strictly comparable (Mees 1995, Taf 165, 13; Hoffmann and Vernhet 1992, figs 3–4).

4 A closely similar bull and *venator* appear individually on samian ware plaques from a probable votive deposit of *c* AD 80–120, found some 200m from the source of the Aumède at Creissels, near the La Graufesenque kiln-site (Schaad and Vernhet 2007, fig 32).

5 Four mould-stamped bowls of Crucuro i, one inscribed 'Ac[ta E]rculentis', another inscribed 'Ercule' three times in different panels, show some of the Labours of Hercules. From the details of the combats and from the costume and arms of the Hercules figures, they are likely to represent re-enactments in the arena rather than the original myths (Bird 2008b), and it is possible that the Agen bowl also shows a re-enactment. A mould-stamped bowl of L Cosius is similarly inscribed 'Acta Erculentis' but shows Hercules and several of the Labours in a more traditional way; it includes at least one image of him wrestling with the Cretan Bull ([2002742]).

6 A number of the graffito firing lists found at La Graufesenque have similar crow-like birds incised under the base. A Drag 18 stamped by Castus has a second bird on the exterior, while the one under the base has the word *[c]roax* (perhaps = *corax*, a raven or crow) incised along its back, leaving no doubt as to its identity (Marichal 1988, no 11).

7 It is possible that on its journey into Gaul from the arenas of the Mediterranean the hooded costume of the Silin and La Graufesenque *damnati* became conflated with the heavy hooded cloak of the enigmatic Celtic figure known as the *genius cucullatus*, or 'hooded spirit'. The *cucullatus* seems to have embraced elements of death and rebirth, appropriate to the arena, and tumbling figures in cloaks with tall hoods are shown, for example, on a *venatio* scene in colour-coated ware from Colchester (Hull 1963, fig 53, 8).

8 Martin Henig comments (pers comm) that there is a general absence of bullfighting scenes in glyptics, but that a rare example, a red jasper stone showing a bull attacked by a *venator* with a lance, comes from Béziers in southern France (Guimaud 1988, no. 576); he considers that this was probably of Gaulish manufacture.

Bibliography

Agustoni, C and Wolf, C, 2005. *La mosaïque de la* venatio *à Vallon (Fribourg): 20 ans de découvertes autour des scènes de chasse*, Musée Romain de Vallon 1, Vallon

Bateman, N C W, 1997. The London amphitheatre: excavations 1987–1996, *Britannia* 28, 50–85

Bateman, N, Cowan, C, and Wroe-Brown, R, 2008. *London's Roman amphitheatre: Guildhall Yard, City of London*, Mus London Archaeol Service Monogr 35, London

Bird, J, 1996. Frogs from the Walbrook: a cult pot and its attribution, in *Interpreting Roman London: papers in memory of Hugh Chapman* (eds J Bird, M Hassall and H Sheldon), Oxbow Monogr 58, 119–27, Oxford

Bird, J, 2005. The lion and the mule: from lamps to samian, in *Image, craft and the classical world: essays in honour of Donald Bailey and Catherine Johns* (ed N Crummy), Monogr Instrumentum 29, 69–79, Montagnac

Bird, J, 2008a. The decorated samian, in Bateman et al 2008, 135–42, 184–7 and CD-ROM

Bird, J, 2008b. A samian bowl by Crucuro and the cult of Hercules in London, in *Londinium and beyond: essays on Roman London and its hinterland for Harvey Sheldon* (eds J Clark, J Cotton, J Hall, R Sherris and H Swain), Counc Brit Archaeol Res Rep 156, 134–41, York

Bird, J, forthcoming. The decorated samian, in J Hill and P Rowsome, *Roman London and the Walbrook stream crossing: excavations at 1 Poultry and vicinity 1985–96*, Mus London Archaeol Service Monogr, London

Birley, R, 1994. *Vindolanda vol I, the early wooden forts: the excavations of 1973–76 and 1985–89, with some additional details from the excavations of 1991–3*, Vindolanda Res Rep new ser 1, Hexham

Chenet, G, and Gaudron, G, 1955. *La céramique sigillée d'Argonne des IIe et IIIe siècles*, Gallia Suppl 6, Paris

Coleman, K M, 1990. Fatal charades: Roman executions staged as mythological enactments, *J Roman Stud* 80, 44–73

Cüppers, H, 1990. *Die Römer in Rheinland-Pfalz*, Stuttgart

Dannell, G B, 1999. Decorated South Gaulish samian, in R P Symonds and S Wade, *Roman pottery from excavations in Colchester, 1971–86* (eds P Bidwell and A Croom), Colchester Archaeol Rep 10, 13–74, Colchester

Dannell, G B, Dickinson, B M, Hartley, B R, Mees, A W, Polak, M, Vernhet, A, and Webster, P V, 2003. *Gestempelte südgallische Reliefsigillata (Drag 29) aus den Werkstätten von La Graufesenque, gesammelt von der Association Pegasus Recherches Européennes sur La Graufesenque*, Römisch-Germanisches Zentralmuseum, Kataloge Vor- und Frühgeshichtlicher Altertümer 34 (13 vols), Mainz

Delgado Linacero, C, 1996. *El toro en el Mediterraneo: análisis de su presencia y significado en las grandes culturas del mundo antiguo*, Madrid

Dunbabin, K M D, 1978. *The mosaics of Roman North Africa: studies in iconography and patronage*, Oxford Monogr Classical Archaeol, Oxford

Dunbabin, K M D, 1999. *Mosaics of the Greek and Roman world*, Cambridge

Ferguson, J, 1970. *The religions of the Roman Empire*, London

Gard, L, 1937. *Reliefsigillata des 3 und 4 Jahrhunderts aus den Werkstätten von Trier*, unpub thesis, Univ Tübingen

Grant, M, 1971 (1967). *Gladiators*, revised edn, Harmondsworth

Guimaud, H, 1988 *Intailles et camées de l'époque romaine en Gaule*, Gallia Suppl 48, Paris

Hartley, B R, 1972. The samian ware, in S Frere, *Verulamium excavations vol I*, Rep Res Comm Soc Antiq London 28, 216–62, London

Hartley, B R, and Dickinson, B M, 2001. The evidence for the date of the potters' stamps from Culip IV, in Nieto and Puig 2001, 21–32

Hartley, B R, and Dickinson, B M, 2008 – *Names on* terra sigillata: *an index of makers' stamps and signatures on Gallo-Roman terra sigillata (samian ware)*, Bull Inst Classical Stud Suppl 102, London

Hayes, J W, 1972. *Late Roman pottery*, Brit School Rome, London

Henig, M, 1998. Romano-British art and Gallo-Roman samian, in *Form and fabric: studies in Rome's material past in honour*

of B. R. Hartley (ed J Bird), Oxbow Monogr 80, 59–67, Oxford

Hermet, F, 1979 (1934). *La Graufesenque (*Condatomago*): I vases sigillés, II graffites* (2 vols), repr, Marseille

Hoffmann, B, and Vernhet, A, 1992. Imitations de décors arétins à la Graufesenque, *Rei Cretariae Romanae Fautorum Acta* 31–2, 177–93, Augst

Hofmann, B, 1988. *L'atelier de Banassac*, Revue Archéologique SITES Hors-série 33, Gonfaron

Huld-Zetsche, I, 1972. *Trierer Reliefsigillata Werkstatt I*, Materialen zur römisch-germanischen Keramik 9, Bonn

Huld-Zetsche, I, 1993. *Trierer Reliefsigillata Werkstatt II*, Materialen zur römisch-germanischen Keramik 12, Bonn

Hull, M R, 1963. *The Roman potters' kilns of Colchester*, Rep Res Comm Soc Antiq London 21, London

Jacques, P, and Martin, T, 1997. Céramiques sigillées et vases à parois fines des sites de Lespinasse et du Centre administratif St-Jacques à Agen (Lot-et-Garonne), in *Documents de Céramologie Montanaise 1: Actes du Colloque de Montans 2/3 novembre 1996* (ed T Martin), 41–97, Aussillon

Jennison, G, 2005 (1937). *Animals for show and pleasure in ancient Rome*, repr, Philadelphia

Joffroy, R, 1962. Note sur une coupe à pied (forme 11 Drag) provenant de Vertillum (Vertault, Côte d'Or), *Bulletin de la Société Archéologique et Historique du Châtillonais* 4 ser 3 (1963), 89–90

Karnitsch, P, 1959. *Die Reliefsigillata von Ovilava (Wels, Oberösterreich)*, Schriftenreihe des Institutes für Landeskunde von Oberösterreich 12, Linz

Knorr, R, 1919. *Töpfer und Fabriken verzierter Terra-Sigillata des ersten Jahrhunderts*, Stuttgart

Knorr, R, and Sprater, F, 1927. *Die westpfälzischen Sigillata-Töpfereien von Blickweiler und Eschweiler Hof*, Speier am Rhein

Köhne, E, and Ewigleben, C (eds), 2000. *Gladiators and Caesars: the power of spectacle in ancient Rome* (Engl ed R Jackson), British Museum, London

Marichal, R, 1988. *Les graffites de La Graufesenque*, Gallia Suppl 47, Paris

Mayet, F, 1984. *Les céramiques sigillées hispaniques: contribution à l'histoire économique de la Péninsule Ibérique sous l'Empire Romaine*, Paris

Mees, A W, 1995. *Modelsignierte Dekorationen auf südgallischer Terra Sigillata*, Forschungen und Berichte zur Vor- und Frühgeschichte in Baden-Württemberg 54, Stuttgart

Müller, G, 1968. *Das Lagerdorf des Kastells Butzbach: die reliefverzierte Terra Sigillata,* Limesforschungen 5, Berlin

Nieto, X, and Puig, A M, 2001. *Excavacions arqueològiques subaquàtiques a Cala Culip, 3. Culip IV: la terra sigil. lata decorada de la Graufesenque*, Monografies del Centre d'Arqueologia Subaquàtica de Catalunya 3, Girona

Oswald, F, 1936–7. *Index of figure-types on terra sigillata ('samian ware')*, Univ Liverpool Ann Archaeol Anthropol Suppl 23–4

Oswald, F, 1945. Decorated ware from Lavoye, *J Roman Stud* 35, 49–57

Paolucci, F, 2006. *Gladiatori: i dannati dello spettacolo*, Atlanti del Sapere: Storia, Florence and Milan

RGZM 2009 (Römisch-Germanisches Zentralmuseum Mainz). Samian research (http://www1.rgzm.de/samian/home/frames/htm); consulted January 2009

Ricken, H, and Thomas, M, 2005. *Die Dekorationsserien der Rheinzaberner Reliefsigillata: Textband zum Katalog VI der Ausgrabungen von Wilhelm Ludowici in Rheinzabern*

1901–1914, Materialen zur römisch-germanischen Keramik 14, Bonn

Rogers, G B, 1999. *Poteries sigillées de la Gaule centrale II: les potiers*, Cahier du Centre Archéologique de Lezoux 1/Revue Archéologique SITES, hors série 40 (2 vols), Lezoux and Gonfaron

Schaad, D, and Vernhet, A, 2007. Condatomagos à l'époque romaine, in *La Graufesenque (Millau, Aveyron), vol I: Condatomagus, une agglomeration de confluent en territoire Rutène IIes aC–IIIes pC* (ed D Schaad), Éditions de la Fédération Aquitania, Études d'archéologie urbaine, 48–57, Pessac

Simon, H-G, and Köhler, H-J, 1992. *Ein Geschirrdepot des 3 Jahrhunderts: Grabungen im Lagerdorf des Kastells Langenhain*, Materialen zur römisch-germanischen Keramik 11, Bonn

Toynbee, J M C, 1973. *Animals in Roman life and art*, London

Vismara, C, 2001. La giornata di spettacoli, in *Sangue e arena* (ed A La Regina), 199–221, Rome

Wiedemann, T, 1996 (1992). *Emperors and gladiators*, paperback edn, London

Wild, F C, 2010. The samian ware, in I Ferris, *The beautiful rooms are empty: excavations at Binchester Roman fort, County Durham, 1976–1981 and 1986–1991*, 2 parts, Durham County Council, 219–239

Witts, P, 1994. Interpreting the Brading 'Abraxas' mosaic, *Britannia* 24, 111–7

15 An Elegant Fowl

Vivien Jones

Over the many years that I have known Brenda, I have been in awe of her encyclopaedic knowledge of samian but also full of admiration for her detailed appreciation of many subjects including music, languages and fictional detectives. I have also been touched by her affection for animals (in particular cats) and for owls. This interest in owls was shared by Madame at the Bois du Four and, on Brenda's many visits to this welcoming hostelry while working at La Graufesenque, she would admire Madame's collection of owl souvenirs displayed in the bar. Unfortunately owls are not well represented on decorated samian vessels and those that do appear are poor specimens. Oswald recorded three owl figure types (1936–7, nos 2331, 2332 and 2333). All of these are small, unflattering images which appear almost incidentally among the decoration and do not convey the true character of these magnificent birds.

Owls have been regarded with serious misgivings and have often been associated with bad luck and death. This sinister reputation is likely to have arisen from the fact that they are birds of the night and darkness. An example of the owl's dark reputation can be seen in a mosaic from Rome, where an owl is found next to a representation of the evil eye and both are being mobbed by other creatures within the mosaic (Toynbee 1973, pl 139). In mythology the owl has also been seen as the embodiment of wisdom and is sometimes found accompanying Minerva as, for example, in a shrine of Minerva carved by soldiers of Legio XX in a quarry face near the fortress at Chester (Henig 1984, 91, fig 35) where a small, stiff figure of an owl is seen positioned above the left shoulder of the goddess.

Since the 1970s a small team led by Geoff Dannell (and including Brenda) has spent many happy summers recording the decorated and stamped South Gaulish samian ware from La Graufesenque and the surrounding area. Two sherds recorded by the team fortunately present a different image of an owl (Fig 15.1). The sherds are from a jar (probably Hermet's form 7) (Millau Roc, Four du Roc, sect 1, 1.20, ix.60, 1324) and each has the image of an owl. The same figure type is recorded on a Drag 30 from Wiesbaden where the stamp of Paullus is set into

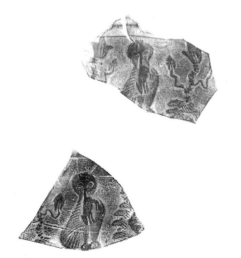

Fig 15.1: Owl on a decorated vessel from La Graufesenque

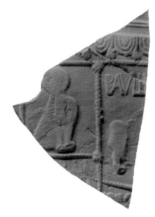

Fig 15.2: Owl on a Drag 30 from Wiesbaden (after Mees 1995, Taf 165, 6)

the decoration alongside the owl (Mees 1995, Taf 165, 6; Fig 15.2). This owl is larger and less stylised than those recorded by Oswald. It is portrayed holding a rodent by the tail from its beak and the shape and plumage of the bird suggest that it may be a barn owl. This is a natural portrait of the owl which I hope that Brenda will appreciate and bring back happy memories of her visits to La Graufesenque and the Bois du Four.

Acknowledgements

I am very grateful to Geoffrey Dannell and Allard Mees for assistance with the illustrations.

Bibliography

Henig, M, 1984. *Religion in Roman Britain*, London

Mees, A. W, 1995. *Modelsignierte Dekorationen auf südgallischer Terra Sigillata*, Forschungen und Berichte zur Vor- und Frühgeschichte in Baden-Württemberg 54, Stuttgart

Oswald, F, 1936–7. *Index of figure-types on terra sigillata ('samian ware')*, Univ Liverpool Ann Archaeol Anthropol Suppl 23–4

Toynbee, J M C, 1973. *Animals in Roman life and art*, London

16 Les estampilles graphomorphes et anépigraphes du Rozier

Ariane Bourgeois et Michel Thuault

Le Rozier (canton de Florac, arrondissement de Meyrueis, Lozère, France) est un petit atelier de céramique sigillée, situé dans le sud du Massif Central, au confluent du Tarn et de la Jonte, au pied du Causse Noir et du Causse Méjean, à une vingtaine de kilomètres au nord du grand centre de production de vaisselle sigillée des Ier et début du IIe siècles de La Graufesenque (Millau, Aveyron). Les deux bourgades artisanales gallo-romaines avaient entre elles des liens très étroits, les mêmes ressources géologiques et les mêmes techniques pour fabriquer des produits si proches les uns des autres qu'on ne les distingue pas. Une de ces similitudes est l'habitude de signer une grande partie des vases fabriqués, lisses et ornés, à l'aide d'un cachet, plus rarement à main levée (Hermet, 1934, 285–288; Thuault et Vernhet, 1986, 110–113: pour les estampilles, voir 112, fig 13, avec les marques incompréhensibles dans la colonne de droite). Beaucoup de ces marques sont des dénominations explicites, dont certaines appartiennent à des potiers de La Graufesenque qui avaient au Rozier une succursale ou y vendaient moules, poinçons et outils divers. Elles indiquent un nom unique, plus rarement des *duo* ou *tria nomina* d'une vingtaine d'artisans. Mais nous souhaitons présenter ici celles qui sont incompréhensibles, réalisées à l'aide de lettres dont l'accumulation ne signifie apparemment rien, de symboles, voire d'un poinçon décoratif détourné de sa finalité, ce que F Hermet appelait 'nébuleuses irréductibles' (Hermet, 1934, 207). On les rencontre aussi bien sur des vases lisses que sur des moules, mais leur usage respectif diffère. En effet, sur les premiers, elles étaient lisibles par l'acheteur, sans doute indifférent à leur lecture et à leur signification, alors que, en réalité, elles étaient destinées à la comptabilité collective des officines, avant la cuisson, mais les secondes, également imprimées avant cuisson, étaient invisibles, car elles figuraient dans le fond interne des moules Drag 30, Drag 37 ou Déch 67, lequel correspond au fond externe des vases ornés. Les dernières finitions les ont alors occultées, notamment l'ajout du pied façonné à part puis rapporté en dernier ressort. Comme les précédentes, elles n'avaient d'utilité que sur le lieu de travail, encore que l'on puisse s'interroger sur leur rôle exact, le décor des moules, ainsi les oves et certains motifs particuliers, suffisant à les faire identifier par le potier décorateur qui utilisait ces matrices après leur cuisson, pour en tirer des répliques à vernis rouge et à décor en relief, et qui n'avait donc nul besoin apparent d'un autre signe distinctif. Ajoutons que des marques en cursive dans le fond interne des moules avaient le même but, mais nous ne les évoquerons pas ici (pour en citer un exemple, voir l'exemple de Senilis dans Bourgeois et Thuault, 2002), et il ne faut pas les confondre avec les rares signatures dans le décor des vases moulés habituellement jamais signés, sauf les Drag 29.

Comme ces estampilles incompréhensibles sont parfois présentes sur plusieurs exemplaires différents, pas nécessairement de même forme, on ne peut les considérer comme résultant d'une mauvaise application de l'outil, donnant par exemple une réplique 'tréflée', pour employer le vocabulaire numismatique, ou incomplète, sauf peut-être le poinçon N° 6. On y voit de pseudo-lettres très diverses, souvent anguleuses, privilégiant ce qui évoque les A, M, N ou V, ou encore des X associés à des hastes verticales (Nos 16–17). Il y a souvent aussi des points disposés au hasard, entre ou dans les caractères (Nos 5, 7, 12, 15, 16), comme on en voit d'ailleurs de temps en temps dans les signatures 'en clair'.

On peut se demander si les 23 timbres différents sur vases lisses sont bien sur de la vaisselle fabriquée au Rozier, et non pas sur des importations de vases depuis l'atelier voisin de La Graufesenque. S'il peut y avoir des doutes pour les témoins uniques (Nos 2, 6, 8), les autres qui, lors de la cuisson, se sont fendus, ont une pâte noircie et un vernis violacé, voire taché, flammé, décoloré ou disparu, indiquant une surcuisson, qui sont troués sur une paroi ou dans le fond, ou bien encore sont affaissés, ou avec diverses autres malfaçons, n'ont évidemment pas fait l'objet d'un transport et d'une vente à des clients. De même les moules à estampille interne, avec huit timbres différents, ont été probablement élaborés au Rozier. En effet ils ont une pâte granuleuse et assez grossière, plus foncée, qui ressemble peu à celle des moules de La Graufesenque,

d'où beaucoup d'autres ont pu être apportés, et le décor conservé est pauvre et maladroit, même s'il s'inspire des productions rutènes.

A) catalogue des 23 estampilles incompréhensibles illisibles, graphomorphes et anépigraphes sur vases lisses

(Figs 16.1–16.2)

1 (1a–b): Les lettres portées par ce cachet oblong, aux angles arrondis, sont en général bien faites et lisibles une par une. Mais l'assemblage des lettres, ES·T·CVOTS ou STOAC·T·SE[], mêlant caractères rétrogrades (les S et C) ou non, éventuellement renversés (les deux T dans la première transcription), reste incompréhensible, d'autant plus qu'on ne sait dans quel sens le lire. Les quatre plats, de forme indéterminable, ainsi marqués du même outil ne permettent pas de corriger la lecture et d'identifier le nom éventuel du potier. L'un d'eux porte la trace de l'arrachement du vase placé au-dessus de lui lors de la cuisson.

2 (2a–b): Il s'agit encore d'une signature dans un cachet oblong, aux angles arrondis, dont les lettres sont apparemment identifiables comme FLEOCIET ou TEICOELF, mêlant caractères rétrogrades (le C et le E), et inversés, le T et le E avec une ligature. Mais leur assemblage semble n'avoir aucun sens, même en supposant des abréviations. Il y a un seul plat de forme indéterminable ainsi marqué.

3 (3a–b): Dix-sept bols, dont treize, voire tous, sont des Drag 27, portent la même marque dans un cartouche ramassé, rectangulaire d'un côté et cranté de l'autre. Les deux lettres M et V (?) ne correspondent à aucun potier Mu() ou M. V() du Rozier et pas davantage Ma() avec un A inversé. Il est encore plus impossible d'envisager le mot *Ma(nu)*, seul et sans précision. Par ailleurs, les deux caractères sont comme barrés, à moins de voir dans la ligne horizontale une vague réminiscence des estampilles en deux lignes de certains centres de production de sigillée italienne, notamment Arezzo. On remarquera la fantaisie qui consiste à superposer plusieurs empreintes sur le même fond de vase, procédé de juxtaposition rencontré aussi pour la marque de deux potiers au nom bien connu au Rozier, Celsus et Felix.

On peut affirmer que ces récipients ont été façonnés et cuits sur place, car ils portent les traces habituelles entraînant la mise au rebut, comme l'engobe violacé ou tressaillé, les fentes qui les rendaient inutilisables, liées à une cuisson mal conduite, ou encore un trou volontairement percé dans le fond, pour concrétiser l'élimination de l'objet. Une autre singularité est la volontaire transformation en coupelle d'un de ces bols Drag 27 par le sciage de la partie du vase située au-dessus de l'étranglement, après cuisson. À part ça, il ne reste aucun vase complet portant cette signature.

4 Six grands plats la portent, dont trois Drag 15/17 et trois de forme inconnue. On ne peut attribuer à aucun potier déjà décrit ces pseudo-lettres, où l'on reconnait seulement un E et un R, à côté de signes incompréhensibles. Il s'agit aussi de ratés de cuisson.

5 Il s'agit peut-être d'une estampille peu reconnaissable d'Avitus, potier actif au Rozier, alors sans doute au nominatif mais sans le S final. Quoi qu'il en soit, ce cachet mal dessiné figure sur deux plats Drag 18/31 et un vase orné Drag 29. Il s'agit encore de rebuts à mauvais engobe.

6 Sur un seul bol Ritt 8 se trouvent ces trois lettres assez lisibles INI, dans un cartouche cranté sur les deux petits côtés. C'est peut-être un poinçon de Linus, potier spécifiquement du Rozier dont on connaît deux timbres différents, au nom complet, au nominatif et au génitif, avec le N dans le bon sens. Ici l'initiale aurait disparu, à cause d'un outil mal appliqué, à moins qu'il ne s'agisse de tout autre chose.

7 Quinze bols Drag 24/25 ont de petites estampilles très proches les unes des autres. Les éventuelles variations dans leur représentation graphique viennent à la fois de la difficulté d'interprétation des signes, points et caractères, et de l'application inégale du cachet dans le fond arrondi de petits bols. Si on interprète les deux lettres apparemment lisibles comme ·NI· (estampille 7e), on a envie de rattacher aussi la marque à Linus, comme l'estampille 6, mais quand on croit voir ·NC· (estampille 7d) ou ·NL· (estampille 7b), l'assimilation avec ce dernier devient impossible. On remarquera la présence constante des points d'encadrement. Pour finir, on est plutôt en présence de pseudo-lettres, dans un petit cartouche d'allure ramassée. La différence de lecture provient sans doute d'un poinçon confus et mal positionné, parfois très profondément enfoncé ou mutilé par des fentes dans le fond. À noter que le cercle interne à l'intérieur duquel est d'ordinaire centrée la signature, cercle destiné à rendre plus précis le geste du potier, est le plus souvent inexistant.

8 Un seul bol Ritt 8 porte ces pseudo-lettres, mais nous ne nous hasarderons pas à les transcrire. Le cartouche est oblong avec des petits côtés arrondis.

9 Sur un bol de forme inconnue, fendu dans le fond, on croit lire IVI ou M ou encore NI, dans un petit cartouche rectangulaire, au côté droit incurvé. Pourtant dans ce dernier cas, il ne faut sans doute pas relier ces deux lettres au nom de l'un des vingt-et-un potiers dont le nom apparaît en clair sur les timbres du Rozier, car plusieurs voient leur dénomination se terminer au génitif par cette désinence. D'ailleurs il faudrait envisager que l'outil pour marquer le nom soit cassé et réduit à deux lettres. D'autre part cette marque diffère de la signature 7.

10 Cette signature est également constituée de pseudo-lettres. Le même cachet figure sur quatre bols, deux Drag 27 et deux de forme indéterminée. Le cartouche est oblong avec des petits côtés arrondis.

11 11a–b): Quatre bols Drag 27 dont un entier, portent

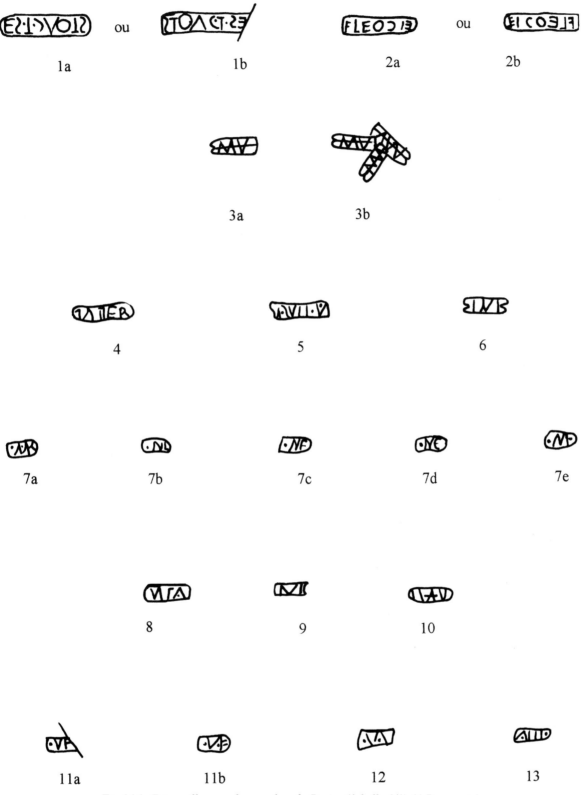

Fig 16.1: Estampilles graphomorphes du Rozier (échelle 1/1) (A Bourgeois)

cette estampille tronquée où l'on peut sans doute deviner ·VF[] ou ·V·F, dans un cartouche court avec des petits côtés arrondis. On remarquera l'absence fréquente du cercle destiné à faciliter le geste du potier lorsqu'il posait le poinçon. Il s'agit encore de rebuts de fabrication, donc fabriqués au Rozier, comme l'indiquent les malfaçons, engobe tressaillé ou trace de l'arrachement du vase supérieur.

12 Dans un cartouche anguleux, les pseudo-caractères ou signes de ce poinçon ne sont pas interprétables. Ils ressemblent un peu au cachet 15 (*infra*). La taille du fragment retrouvé ne permet de proposer une forme.

13 On fera ici la même observation sur la lecture indécise de cette estampille dont les caractères sont en apparence plus lisibles. Elle n'existe que sur un seul bol Drag 27. En fait la juxtaposition de AIII· ou ·IIIV n'évoque rien, sinon des signes reconnaissables seulement par leur auteur.

14 Plusieurs bols Drag 27 portent cette marque indéterminable, avec de pseudo-lettres, qui évoque de loin, par les courtes lignes horizontales superposées situées à droite, les cartouches *in planta pedis* d'Italie. Le petit cercle interne est partout absent. Comme malfaçons, signalons la trace de l'arrachement du vase supérieur, après la fin de la cuisson.

15 Ces deux ou trois signes anguleux mêlés de points ressemblent au poinçon 12, sur trois bols Drag 24/25 et un Drag 27, chaque forme étant représentée par un vase complet. L'un d'eux porte une fente sous le pied, ce qui le rendait invendable.

16 Sur cinq plats de forme inconnue, une suite de signes géométriques graphomorphes entrecoupés de points ne signifie rien de précis: on 'lit' ·IXM·I·X·IM· dans un long cartouche oblong aux petits côtés arrondis. Ils évoquent des estampilles à pseudo-caractères trouvées à La Graufesenque et déjà signalées par Hermet (1934, 207, pl 113), imprimées à partir de timbres différents. Le cercle tout autour du poinçon est très régulier. La plupart des fragments présentent des défauts de l'engobe, preuve qu'ils ont été fabriqués au Rozier.

17 Le commentaire de cette empreinte connue sur un unique plat Drag 18/31 sera semblable au précédent. Mais le cartouche est différent, oblong, cranté du côté gauche, rectangulaire du côté droit. La transcription XAIXCO(?) reste sans aucune signification pour nous. L'engobe est très sombre et il reste la trace du plat posé au-dessus dans le four.

18 Cette estampille anépigraphe n'évoque plus un nom ou un mot intelligible des catalogues de potiers du Rozier ou d'ailleurs, ni même de pseudo-lettres, mais plutôt les poinçons décoratifs. Elle a la forme d'une palme étroite, non inscrite dans un cartouche, que nous n'avons pas rencontrée dans les décors des vases à reliefs du centre de production. On la voit dans le fond de trois bols, dont un grand Ritt 8 entier. Deux sont défectueux par l'engobe, décoloré ou lacunaire. À la différence des autres marques graphomorphes et anépigraphes, présentes seulement sur le lieu de production, celle-ci a également été trouvée sur un site de consommation, lors une fouille d'urgence à Mostuéjouls, à environ 5 km du Rozier, sur le Tarn en aval, preuve que ces vases à signature rare étaient diffusés dans les environs (merci à Jean Pujol de ce renseignement oral).

19 Ce timbre est très simple et n'a même plus la prétention d'imiter des lettres. On ne sait pas ce que le potier a voulu représenter à la place de la signature, dans un cartouche oblong, rectangulaire à gauche, arrondi à droite. En tout cas, c'était un artisan du Rozier, car les deux Drag 27 entiers conservés ont souffert d'une cuisson trop poussée (vase affaissé et noir pour l'un, engobe flammé pour l'autre) et ont été éliminés sur place.

20 Treize bols Drag 24/25, dont un entier, portent cette estampille au schéma sommaire et très reconnaissable – sans doute c'est ce que voulait le potier! Il n'y a pas de cercle de positionnement à l'intérieur. Ce sont aussi des objets de rebut, avec des fentes, souvent un engobe tressaillé ou décoloré.

21 C'est encore un dessin simpliste et irrégulier, ne représentant rien, sans cartouche. Nous l'avons rencontré une seule fois sur le fond d'un petit bol, sans doute un Drag 24/25.

22 Dans ce cas, la signature du potier consiste encore en un symbole, une rouelle dentelée de grande taille. Elle figure sur un fond de vase indéterminable, peut-être un Drag 24/25.

23 Il ne s'agit plus d'une signature ou d'un dessin en tenant lieu: l'habitude de marquer les récipients a poussé un potier anonyme à utiliser seulement un cartouche rectangulaire, sans rien à l'intérieur. Ce procédé existait sur deux fonds de bols de forme indéterminable.

Récapitulation des estampilles 1 à 23 et des différentes formes qui les portent

Les tableaux 16.1 et 16.2 classant les marques graphomorphes et anépigraphes sur les vases indiquent d'abord la prééminence écrasante des bols (68 sur 95 exemplaires, soit 85%), parmi lesquels les formes Drag 24/25 et Drag 27 sont presque à égalité (38% et 36%). Par contraste, les plats sont très peu nombreux (12 exemplaires, soit 15%) et il y a un seul récipient orné Drag 29, avec une 'nébuleuse irréductible' (2,7%).

Par ailleurs on constate que malgré les difficultés de compréhension des estampilles graphomorphes et anépigraphes, deux d'entre elles, les 5 et 15, signent des modèles différents, quand les autres sont réservées à un seul. Les marques 7, 20, 21 sont exclusivement sur des bols Drag 24/25 ; les timbres 3, 11, 13, 14, 19 sur des bols Drag 27; les poinçons 6 et 7 sur des Ritt 8, bien qu'on ne puisse pas se fier à un seul exemplaire. Par ailleurs, comme les plats sont le plus souvent indéterminables, on ne peut rien tirer de l'énumération, et les bols indéterminés qui portent les estampilles 10 et 18 peuvent se rattacher en fait aux Drag 27 dans le premier cas, et Ritt 8 dans le second. On remarquera enfin que les bols Ritt 5 n'ont aucune de ces marques graphomorphes.

B) catalogue des marques incompréhensibles, toutes anépigraphes, sur moules

Comme il s'agit de poinçons décoratifs, il n'y a évidemment pas de cadre ou cartouche pour contenir la marque. Par ailleurs nous avons déjà dit nos doutes sur le rôle de signature des moules par ces procédés. En tout cas il ne faut pas y voir un essai d'empreinte pour le décor du moule car

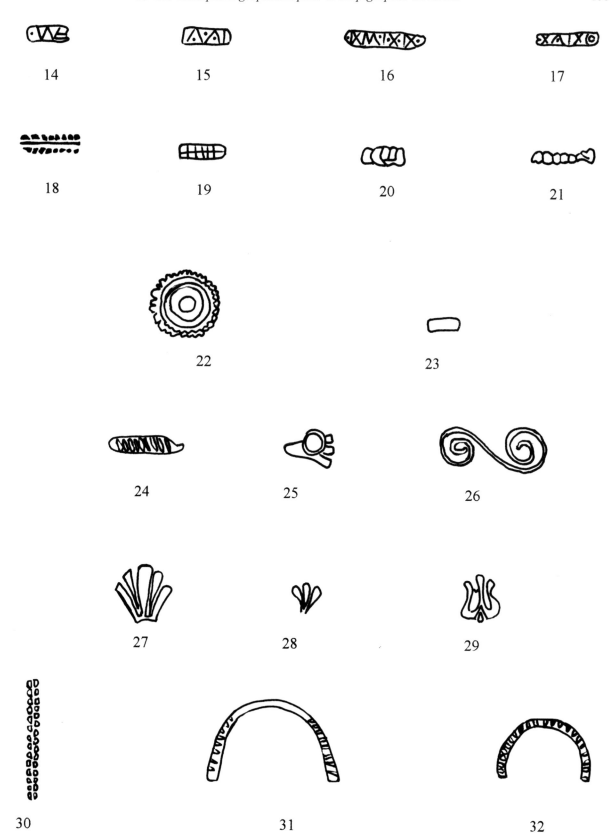

Fig 16.2: Estampilles graphomorphes et anépigraphes du Rozier. Les poinçons 24–32 sont imprimés dans les moules (échelle 1/1) (A Bourgeois)

les estampilles 24 à 32 ne se retrouvent pas dans le décor des moules correspondants, sauf le tortillon 24.

24 Ce motif, en forme de ressort ou de 'tortillon' (selon le vocabulaire d'Hermet, 1934, pl 16, 26–44), figure à deux reprises, sur un moule de Déchelette 67 et sur un Hermet 7 ou 15, c'est-à-dire des vases fermés au

Marque	Drag 29	Drag 24/25	Drag 27	Ritt 8	Bols	Drag 15/17	Drag 18/31	Plats	Indét	Total
1	–	–	–	–	–	–	–	4	–	4
2	–	–	–	–	–	–	–	1	–	1
3	–	–	17	–	–	–	–	–	–	17
4	–	–	–	–	–	3	–	3	–	6
5	1	–	–	–	–	–	2	–	–	3
6	–	–	–	1	–	–	–	–	–	1
7	–	15	–	–	–	–	–	–	–	15
8	–	–	–	1	–	–	–	–	–	1
9	–	–	–	–	1	–	–	–	–	1
10	–	–	2	–	2	–	–	–	–	4
11	–	–	4	–	–	–	–	–	–	4
12	–	–	–	–	–	–	–	–	1	1
13	–	–	1	–	–	–	–	–	–	1
14	–	–	4	–	–	–	–	–	–	4
15	–	3	1	–	–	–	–	–	–	4
16	–	–	–	–	–	–	–	5	–	5
17	–	–	–	–	–	–	1	–	–	1
18	–	–	–	1	2	–	–	–	–	3
19	–	–	2	–	–	–	–	–	–	2
20	–	13	–	–	–	–	–	–	–	13
21	–	1	–	–	–	–	–	–	–	1
22	–	–	–	–	–	–	–	–	1	1
23	–	–	–	–	2	–	–	–	–	2
Total	1	32	31	3	7	3	3	13	2	95

Tableau 16.1: Les marques graphomorphes sur les bols et les plats lisses ou ornés, dans l'ordre du catalogue des estampilles (à l'exclusion des estampilles 24 à 32)

Marque	Drag 29	Drag 24/25	Drag 27	Ritt 8	Bols	Drag 15/17	Drag 18/31	Plats	Indét	Total
G 5	1	–	–	–	–	–	2	–	–	3
G 7	–	15	–	–	–	–	–	–	–	15
G 20	–	13	–	–	–	–	–	–	–	13
G 21	–	1	–	–	–	–	–	–	–	1
G 15	–	3	1	–	–	–	–	–	–	4
G 3	–	–	17	–	–	–	–	–	–	17
G 11	–	–	4	–	–	–	–	–	–	4
G 13	–	–	1	–	–	–	–	–	–	1
G 14	–	–	4	–	–	–	–	–	–	4
G 19	–	–	2	–	–	–	–	–	–	2
G 10	–	–	2	–	–	2	–	–	–	4
G 6	–	–	–	1	–	–	–	–	–	1
G 8	–	–	–	1	–	–	–	–	–	1
G 18	–	–	–	1	2	–	–	–	–	3
G 9	–	–	–	–	1	–	–	–	–	1
G 23	–	–	–	–	2	–	–	–	–	2
G 17	–	–	–	–	–	–	1	–	–	1
G 4	–	–	–	–	–	3	–	3	–	6
G 1	–	–	–	–	–	–	–	4	–	4
G 16	–	–	–	–	–	–	–	5	–	5
G 2	–	–	–	–	–	–	–	1	–	1
G 12	–	–	–	–	–	–	–	–	1	1
G 22	–	–	–	–	–	–	–	–	1	1
Total	1	32	31	3	5	5	3	13	2	95

Tableau 16.2: Les marques graphomorphes regroupées selon les vases lisses et ornés qui les portent (à l'exclusion des estampilles 24 à 32)

décor d'inspiration voisine et très pauvre avec des motifs végétaux peu variés et lourds.

25 Il ressemble à une patte d'oiseau à trois doigts et figure dans le fond interne de trois moules, deux Déchelette 67 et un Drag 30. Sur l'un il a été mutilé par l'implantation postérieure et par en-dessous du trou d'écoulement de l'eau utilisée pour tourner le vase en relief dans le moule, et lui permettre ensuite

d'être évacuée plus aisément lors du séchage, avant le démoulage. Le poinçon des autres est décentré et indépendant des trous en question.

26 Une double spirale se trouve, décentrée, dans le fond interne d'un moule de forme cylindrique Drag 30.

27 Une touffe d'herbe ou une coquille à quatre cannelures longitudinales est associée au motif 26 sur le même fond de moule Drag 30. Les deux motifs sont décentrés.

28 Un autre motif végétal, une fleurette à trois pétales, distingue des autres un moule Drag 30.

29 Un moule Drag 37 portait ce fleuron plus élaboré.

30 Dans le fond d'un moule Drag 30, il s'agit cette fois de la juxtaposition d'au moins trois lignes feuillues, de longueur apparemment inégale mais cela dépend de la manière de poser l'outil.

31 Elle existe dans un moule Drag 30, où elle est décentrée, et elle a la forme d'un arceau strié, motif très banal.

32 Un moule Drag 30 porte un arceau, plus petit que le précédent, ou un demi-cercle strié, centré autour du trou de séchage.

Récapitulation des estampilles 24 à 32 et des différentes formes qui les portent

Sur neuf timbres anonymes recensés, on constate donc que les moules Drag 29 ne sont jamais marqués ainsi, à la différence de ceux des bols cylindriques Drag 30 sur lesquels on voit 7 estampilles différentes. Il y en a une seule sur une matrice Drag 37, deux sur Déchelette 67 et un sur un moule de vase fermé Hermet 7 ou 15. Mais cette énumération n'a rien à voir avec la présence ou l'absence d'estampilles imprimées directement sur les répliques tirées de ces moules. Remarquons que les poinçons 24 et 25 figurent sur deux modèles différents. En revanche, sur le même moule Drag 30 sont juxtaposés les poinçons 26 et 27. Mais en fait tous ces cas sont trop peu nombreux pour qu'on puisse en tirer davantage d'enseignements.

Bibliographie

Bourgeois, A, et Thuault, M, 2002. Les moules de *Senilis* au Rozier, dans *Céramiques de La Graufesenque et autres productions d'époque romaine. Nouvelles recherches. Hommages à Bettina Hoffmann* (dirs M Génin et A Vernhet), Archéologie et Histoire romaine, 7, 273-87, Montagnac

Bourgeois, A, et Thuault, M, 2005. Un potier du Rozier, dans *An archaeological miscellany: papers in honour of K F Hartley* (dirs G B Dannell et P V Irving), *J Roman Pottery Stud* 12, 32–5, Oxford

Hermet, F, 1934. *La Graufesenque (*Condatomago*): I vases sigillés, II graffites* (2 vols), Paris

Thuault, M, et Vernhet, A, 1986. Le Rozier, dans *La terre sigillée gallo-romaine* (dirs C Bémont et J-P Jacob), Documents d'Archéologie Française 6, 110–3, Paris

17 Vases moulés avec marque intradécorative du groupe D d'Espalion (Aveyron, France)

Jean-Louis Tilhard, avec la collaboration de Philippe Sciau et Yoanna Leon

Il y a environ 25 ans que la publication de céramiques sigillées trouvées à Brive (Corrèze, France; Fig 17.1.1, 2) dans les fouilles menées par François Moser (conservateur au musée Labenche, Brive: Moser 1983; 1985) a déclenché une recherche collective qui a abouti à la mise en évidence des productions sigillées d'un atelier situé à ou près d'Espalion (Aveyron: Fig 17.1.1) (Moser *et al* 1985; Moser et Tilhard 1986; Moser et Tilhard 1987; Tilhard *et al* 1991; Tilhard 1991; Tilhard 1993). Une mise au point complète sur les résultats de cette recherche est en préparation (elle est parue depuis la rédaction de cet article: Tilhard 2009), bien que de nombreuses interrogations subsistent encore sur la localisation exacte des installations de production de l'atelier et sur l'éventail complet de ses produits, dont quelques groupes seulement ont été jusqu'à présent reconnus (estampilles sur sigillées lisses et productions à décor moulé). Ce sont les vases à décor moulé avec marque intradécorative (ou *in forma*) du groupe D que j'ai choisi de présenter ici en hommage à Brenda Dickinson, dont l'aide amicale et érudite a accompagné la recherche sur les productions d'Espalion, en particulier lors de rencontres sur le site de La Graufesenque à Millau (Aveyron, France) pendant des cessions estivales de travail de l'équipe britannique et à l'occasion des colloques Pegasus; ces moments constituent d'excellents souvenirs et il m'est particulièrement agréable de fournir cette modeste contribution.

Pour la bonne compréhension du sujet, il est nécessaire de rappeler brièvement les principales étapes de la recherche concernant l'atelier de sigillée d'Espalion et la détermination de ses productions, et parmi elles plus spécialement le groupe D, avant d'étudier la série de vases moulés avec marque intradécorative qui en constitue le noyau.

I. Les grandes lignes de la recherche sur l'atelier d'Espalion et de ses résultats

1. Les données des fouilles de Brive

a) Le 'groupe de Brive' (GB)
Les fouilles de François Moser à Brive ont livré de grandes quantités de céramiques sigillées lisses, estampillées ou non, et à décor moulé de diverses origines (Gaule méridionale: Montans et La Graufesenque; Gaule centrale: Lezoux et autres centres de production proches). Parmi ces sigillées, un groupe comprenait des vases lisses (essentiellement de services flaviens) et moulés attribuables à première vue à La Graufesenque, mais dont certains étaient apparemment surcuits et semblaient des rebuts de cuisson. Les vases moulés de ce groupe (appelé groupe de Brive = GB) dont le style général était apparenté aux productions flaviennes de La Graufesenque, portaient des motifs originaux (oves, quelques personnages et motifs végétaux) connus sur d'autres sigillées moulées de la région (en particulier à Saintes et Périgueux: Tilhard 1977a–b; 1978, attribuées alors à la Graufesenque); leur nombre relativement important, leur diffusion sur une aire régionale, les indices d'une possible fabrication à Brive de sigillées (Moser-Gautrand et Moser 1981, en particulier 56–8), à côté de production bien attestée de figurines moulées, ont conduit à une recherche commune sur ce groupe (GB) et les productions céramiques de Brive à l'échelle régionale (Tilhard *et al* 1991), avec le soutien de la Direction des Antiquités Historiques du Limousin (M Jean-Michel Desbordes), l'aide du Conseil Supérieur de la Recherche Archéologique et le concours des moyens d'analyse du laboratoire de Céramologie CNRS de Lyon (M Picon).

b) Les données du laboratoire de céramologie de Lyon
Une première série d'analyses de 23 échantillons de pâte comprenant des vases lisses (Drag 35–36) et des vases moulés du GB trouvés à Brive, ainsi que des vases moulés considérés comme appartenant au GB de diverses catégories

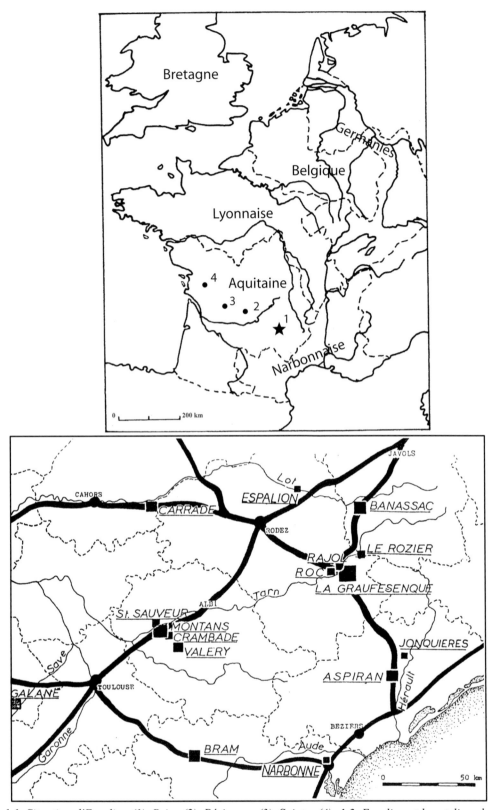

Fig 17.1: 1.1. Situation d'Espalion (1), Brive (2), Périgueux (3), Saintes (4); 1.2. Espalion et les ateliers de sigillée de Gaule méridionale (source: Bémont et al 1987, 81); carrés noirs: ateliers de sigillée; lignes épaisses: voies romaines

stylistiques (certains même sans les motifs caractéristiques évoqués ci-dessus) et de diverses provenances régionales (Moser *et al* 1985; Moser et Tilhard 1987, 38: analyses n[os] 1 à 23, réunies ici avec les suivantes sur la Fig 17.2) a

été réalisée par M Picon par fluorescence X. Ces analyses ont montré l'homogénéité de la composition chimique des pâtes du groupe et mis en évidence qu'elle ne pouvait être rapprochée à celle d'aucun atelier de sigillée connu. Ces

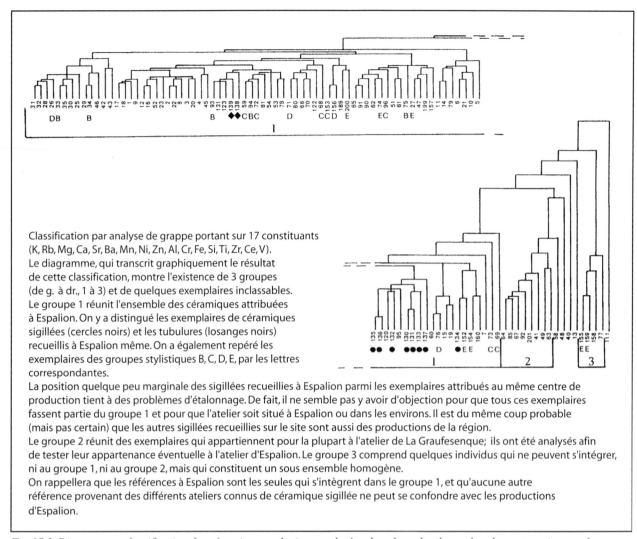

Classification par analyse de grappe portant sur 17 constituants (K, Rb, Mg, Ca, Sr, Ba, Mn, Ni, Zn, Al, Cr, Fe, Si, Ti, Zr, Ce, V). Le diagramme, qui transcrit graphiquement le résultat de cette classification, montre l'existence de 3 groupes (de g. à dr., 1 à 3) et de quelques exemplaires inclassables. Le groupe 1 réunit l'ensemble des céramiques attribuées à Espalion. On y a distingué les exemplaires de céramiques sigillées (cercles noirs) et les tubulures (losanges noirs) recueillis à Espalion même. On a également repéré les exemplaires des groupes stylistiques B, C, D, E, par les lettres correspondantes.

La position quelque peu marginale des sigillées recueillies à Espalion parmi les exemplaires attribués au même centre de production tient à des problèmes d'étalonnage. De fait, il ne semble pas y avoir d'objection pour que tous ces exemplaires fassent partie du groupe 1 et pour que l'atelier soit situé à Espalion ou dans les environs. Il est du même coup probable (mais pas certain) que les autres sigillées recueillies sur le site sont aussi des productions de la région.

Le groupe 2 réunit des exemplaires qui appartiennent pour la plupart à l'atelier de La Graufesenque; ils ont été analysés afin de tester leur appartenance éventuelle à l'atelier d'Espalion. Le groupe 3 comprend quelques individus qui ne peuvent s'intégrer, ni au groupe 1, ni au groupe 2, mais qui constituent un sous ensemble homogène.

On rappellera que les références à Espalion sont les seules qui s'intègrent dans le groupe 1, et qu'aucune autre référence provenant des différents ateliers connus de céramique sigillée ne peut se confondre avec les productions d'Espalion.

Fig 17.2:Diagramme; classification des céramiques calcaires analysées dans le cadre des recherches entreprises sur le groupe d'Espalion (Tilhard et al 1991, 235). Classification par analyse de grappe portant sur 17 constituants (K, Rb, Mg, Ca, Sr, Ba, Mn, Ni, Zn, Al, Cr, Fe, Si, Ti, Zr, Ce, V)

premières analyses ont ainsi confirmé l'existence d'un nouvel atelier, ainsi que la pertinence des critères visuels utilisés pour les distinguer (aspect des tessons et caractères des décors). Mais la présence notable de certains de ces vases à Brive n'impliquait pas automatiquement qu'ils y avaient été fabriqués.

c. Les moules de Brive

La poursuite des fouilles de F Moser à Brive, livrant neuf moules de sigillée, parut dans un premier temps, consolider l'hypothèse d'un atelier local (d'autant qu'un autre fragment de moule avait été trouvé antérieurement à Brive, et qu'un second (plus proche du style du GB) était connu à Saint-Cernin de Larche (Corrèze), non loin de Brive; *cf* Moser et Tilhard 1987, 117, fig 47), bien que leur décor fût totalement différent du GB (Moser et Tilhard 1987, 104–17). C'est ainsi que, sans doute prématurément, la localisation de l'atelier à Brive fut annoncée comme quasi certaine (Moser et Tilhard 1986; Moser 1986a). Mais il est rapidement apparu (*cf* 2b *infra*) que ces moules ne

pouvaient être associés aux sigillées du GB (qui devenait le 'groupe de Brive I' = GBI) et constituaient un nouveau groupe, indépendamment du premier. Ce groupe fut désigné par l'appellation 'groupe de Brive II' (GBII) et la recherche sur ces deux ensembles fut dissociée.

2. Du 'groupe de Brive I' (GBI) au 'groupe A' (gr. A) d'Espalion (ou de Brive à Espalion)

a) Recherche sur le GBI

La première étape de la recherche sur le GBI consista, après avoir établi une liste des motifs ou poinçons considérés alors comme caractéristiques (Moser et Tilhard 1986, 94, fig 1; Moser 1986b, 91, fig 24), à collecter le plus possible de vases du groupe, pour tâcher d'enrichir ainsi la liste des motifs types et des catégories stylistiques, de préciser l'homogénéité stylistique du groupe et ses limites, d'établir aussi un état de sa diffusion suggérant une éventuelle localisation de l'atelier producteur. Il apparut assez vite que ce groupe, composé de divers sous ensembles

décoratifs, présentait une certaine unité et des particularités stylistiques et techniques communes. Outre les poinçons caractéristiques déjà évoqués, l'aspect rouge orangé et le brillant du vernis semblaient un peu différents de ceux des sigillées de La Graufesenque, sans qu'il fût visuellement possible de distinguer nettement les deux productions. Un autre indice était la présence fréquente d'un ou plusieurs sillons sur le bord interne des Drag 37, très rare sur les mêmes formes de La Graufesenque.[1] Toutefois, la parenté stylistique et technique avec certaines productions moulées de La Graufesenque était telle qu'il fallait avoir recours à d'autres arguments pour prouver qu'il s'agissait bien d'une production d'un autre atelier.

b) Deuxième série d'analyse de pâtes
Une nouvelle série d'analyses (de 24 individus) fut effectuée, par M Picon, dans le but de vérifier :

- l'hypothèse de localisation à Brive de l'atelier producteur du GBI (par l'analyse d'un fragment de moule du GBII trouvé à Brive, d'argile locale et de céramiques communes apparemment locales, à pâtes non calcaires et de composition très différentes du GBI: Tilhard *et al* 1991, 230 et 235, diagramme 1; étant donné l'homogénéité de la série de moules, une seule analyse suffisait (n° 44, qui ne figure pas sur le diagramme de la Fig 17.2, vu sa composition très différente des ensembles distingués). Ces analyses Nos 24 à 47 se retrouvent sur la Fig 17.2, sauf celles qui étaient très éloignées des groupes 1 à 3),
- l'attribution de certains vases décorés au GBI,
- si des vases décorés sans rapport stylistique avec le GBI, mais d'aspect comparable, et présentant quelques particularités stylistiques ou techniques semblables, étaient du même atelier que lui (Picon 1987).

Les conclusions amenèrent à douter que l'atelier producteur du GBI fût bien localisé à Brive et confirmèrent que les GBI et GBII n'avaient bien aucun rapport entre eux. Elles montrèrent de plus que cet atelier producteur – de localisation alors inconnue, mais que M. Picon envisageait plutôt dans la région des Causses en raison de la composition des pâtes – avait aussi produit d'autres vases que ceux du GBI, qui n'en constituait qu'un groupe stylistique. Ainsi, les vases apparemment surcuits du GBI trouvés à Brive correspondaient, non à des rebuts de cuisson, mais bien plutôt au dépôt ou au magasin d'un marchand de céramique qui avait subi un violent incendie.

c) Localisation de l'atelier à Espalion
Par l'intermédiaire d'Alain Vernhet furent connus des indices de production de sigillée à Espalion (Aveyron), recueillis en deux points en aval de la ville au cours de prospections en surface dans la vallée du Lot par Lucien et Jérome Cabrolié, habitants du lieu. Il s'agissait de fragments (quatre) de moules et de tubulures de four (Tilhard 1991, 33 et sv, fig 2, 3), de divers tessons de sigillée lisse et moulée (certains surcuits) dont une partie présentait les caractéristiques stylistiques du GBI (Tilhard 1991, figs 4–8; Tilhard *et al*

1991, 232, fig 2, a–d, 1–36). Ceci incitait à situer à Espalion, ou aux environs, l'atelier producteur du GBI. Une première confirmation fut apportée par M Picon: l'analyse des pâtes de huit tessons de sigillée lisse pris au hasard parmi ceux recueillis sur le site, et de deux fragments de tubulures montra qu'ils avaient les mêmes compositions chimiques que celles du groupe original antérieurement défini (*cf* Fig 17.2, groupe 1). Comme les tubulures des fours à sigillée sont généralement constituées des mêmes argiles que les céramiques produites dans l'atelier, on pouvait affirmer qu'il s'agissait bien de l'atelier producteur du GBI.

Deux sondages tentèrent de trouver le site de l'atelier, sans succès. Un premier en aval d'Espalion dans la vallée du Lot (en 1990, au lieu dit Pas del Cary: Tilhard 1991), sur la rive droite de la rivière, où avaient été recueilli le plus grand nombre de tessons, mais sans résultat probant; un deuxième, ultérieurement en 1993, plus près de la ville où des travaux de voirie avaient fourni des indices de four (au bord du chemin de Combefouillouse; résultats inédits), dégagea bien des décombres de four de tuilier antique, mais ne livra aucune trace de production de sigillée.

En l'absence d'autres éléments, on ne connaît pas actuellement l'emplacement précis de l'atelier (peut-être disparu: la construction d'une station d'épuration sur les rives du Lot, effectuée autrefois sans surveillance archéologique, à un endroit où avaient été trouvés des tessons et des fragments de moules, a pu en détruire les vestiges), mais il ne fait aucun doute qu'il se situe à ou près d'Espalion. L'expression 'atelier d'Espalion' est donc à utiliser avec les précautions qui s'imposent dans un tel cas, en attendant une confirmation archéologique sur le terrain et doit être considérée comme un terme commode pour désigner le site de production de ces sigillées (nos collègues britanniques emploient, avec plus de prudence, l'expression plus générale de 'productions de la vallée du Lot' pour les désigner). Toutefois, par leur composition, elles constituent un groupe relativement homogène qui se distingue nettement des productions des autres ateliers méridionaux (Bocquet et Picon 1994).

d) Les productions d'Espalion
Parallèlement à cette recherche du site de l'atelier producteur, s'est posée la question de la définition des productions de l'atelier. Une série d'analyses de pâtes a porté sur des tessons estampillés dont l'aspect pouvait correspondre à des productions d'Espalion; une autre a concerné des groupes stylistiques sans rapport avec le GBI (qu'il convient d'appeler maintenant groupe A d'Espalion (= gr.A)). Ces dernières ont permis de définir de nouveaux groupes décoratifs B à G (selon l'ordre chronologique dans lequel ils ont été identifiés), dont il n'est pas possible de présenter ici les caractéristiques (on trouvera les premiers éléments de caractérisation de ces groupes dans Tilhard *et al* 1991, 235–44: nouveaux groupes de vases moulés, 244–6; estampilles). L'atelier a aussi produit des sigillées lisses mais en l'absence d'un important catalogue d'estampilles attribuables à l'atelier, il est difficile de déterminer l'éventail des formes produites. En effet, le site de l'atelier n'ayant

pas été découvert, nous ne disposons pas de dépotoirs qui donneraient ces indications, et l'aspect des produits espalionnais est, d'autre part, trop proche de celui des sigillées de La Graufesenque pour qu'une attribution à l'un ou l'autre de ces ateliers sur ce seul critère visuel soit pertinente; on peut toutefois postuler que l'atelier a produit les formes bien connues dans les autres centres de production méridionaux et plus ou moins standardisées pendant la même période de production (en gros donc dans la seconde moitié du Ier siècle), et tout particulièrement à La Graufesenque avec laquelle il avait apparemment des liens privilégiés. Des analyses de formes de services flaviens trouvés à Brive (Fig 17.2, Nos 1 à 4; Moser et Tilhard 1987, 102), de tessons lisses recueillis en surface à Espalion (Fig 17.2, cercles noirs; Tilhard *et al* 1991, 231), qui, pour la plupart devraient appartenir à la production de l'atelier, confirment cette production. Le fait qu'une part notable de

ces formes lisses corresponde aux services flaviens, qui sont rarement estampillés, explique en partie le petit nombre de potiers dont le nom soit connu.

II. Les vases du groupe D d'Espalion avec marque intradécorative

1. Détermination du groupe D

a) Point de départ

Il est maintenant nécessaire de préciser rapidement comment ce groupe D a été identifié; la démarche est commune avec celle qui a permis d'identifier les groupes A, B et C (Moser et Tilhard 1987; Tilhard *et al* 1991). En 1986, au cours des recherches sur le gr.A, une première analyse (Fig 17.2, No 26) a été effectuée sur un vase Drag 37 de Périgueux (Fig 17.3, D30) n'appartenant pas au

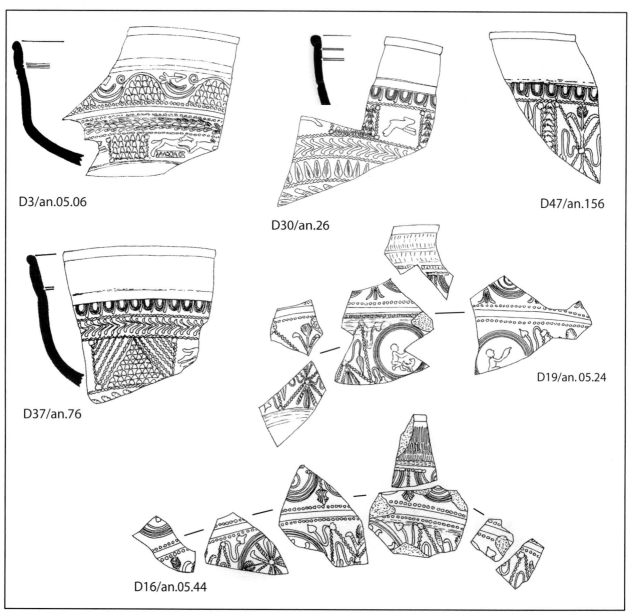

D3/an.05.06

D30/an.26

D47/an.156

D37/an.76

D19/an.05.24

D16/an.05.44

Fig 17.3: Vases du groupe D soumis à analyse (échelle: 1/2)

gr.A par son décor, mais qui avait l'aspect des produits du nouvel atelier. Ce vase portait des oves connus sur quelques autres tessons de Brive, Périgueux et Saintes (d'aspect comparable), apparemment peu courants, au moins dans la région, et était muni de sillons internes, mais son décor s'apparentait à ceux de La Graufesenque (sans particularité notable: décor de zones ornées de motifs courants; la palissade de feuilles lancéolées, en zone 3, est fréquente sur les décors de Carrade). Il fallait vérifier s'il appartenait à la Graufesenque ou au nouvel atelier. L'analyse révéla une même composition de l'argile du vase que celle du GBI/gr.A (Fig 17.2, ensemble 1, numéros notés D) et permit donc d'envisager une origine commune et une production par le même atelier.

Nous avions donc là l'amorce d'un nouveau groupe, de style différent des précédents. Le premier signe distinctif en était le type d'oves (décrit plus bas; *cf* Figs 17.3–4, 6–8) pouvant correspondre à un type utilisé à La Graufesenque et appelé ove 'f' du nouvel atelier (Hermet 1934, pl 35bis, 029; Knorr 1952, Taf 53; Atkinson 1914, nos 73, 74, 75?, pour ne citer que quelques ouvrages de base utilisés alors). A ce premier tesson se sont ajoutés d'autres vases de divers sites, rencontrés au cours de la recherche de la diffusion du gr.A, et qui possédaient les mêmes oves f et avaient des éléments de décor communs; ils constituèrent le noyau du groupe D (abrégé gr.D), qui peu à peu s'enrichit d'autres éléments, dont certains avec marque intradécorative (*in forma*) qui font l'objet de cet article.

b) Premières analyses et extension de la recherche
Pour vérifier qu'il s'agissait bien d'un groupe du nouvel atelier, avant d'avancer davantage dans cette voie, quelques analyses supplémentaires ont été faites, qui ont confirmé l'origine espalionnaise commune des tessons sélectionnés selon des critères d'aspect et de décor.

Des tessons recueillis ultérieurement en surface à Espalion (Tilhard *et al* 1991, 233, fig 3, 54–5; Tilhard 1993, 118, fig 8, 57–8) portent l'ove f ainsi que quelques motifs connus dans le groupe et confirment apparemment cette origine donnée par la première série d'analyses (rappelons à ce propos que les analyses de tessons de sigillée recueillis en surface à Espalion ont toutes conclu à l'appartenance au groupe de pâte d'Espalion: *cf* Fig 17.2).

Un tesson découvert à Troyes (D6, Figs 17.6 et 17.7) fit progresser l'étude du groupe: ce fragment de Drag 37, muni de deux sillons internes, porte l'ove f et possède un décor à zones avec métopes (plus ou moins comparable à celui de D30 (Fig 17.3), en tout cas dans le même esprit) avec une estampille intradécorative lisible DACOM ou plutôt DAGOM rétrograde (avec A sans barre horizontale) dans un cartouche aux petits côtés légèrement concaves. Cette marque de Troyes permit d'en lire trois autres identiques (Fig 17.6: D7 de Rodez, D14 d'Espalion, D1 de Brive) mais non lues alors, car tronquées ou partiellement effacées, et dont une seule (sur D7) était associée à l'ove f.

Un potier dont le nom puisse correspondre à cette marque (Dacom/Dagom, ou Daco M/Dago M) n'est connu à La Graufesenque, ni comme décorateur, ni comme producteur de vases lisses (Bémont et Jacob 1986, 281; Vernhet 1990–1991; Mees 1995). D'autres signatures du même type (plus ou moins bien lisibles) furent rencontrées ensuite, ainsi que des décors qui pouvaient entrer dans le gr.D, et la poursuite des recherches sur les productions d'Espalion amena un nouveau recours au laboratoire pour vérifier l'origine de certains décors ou de certaines estampilles présumés de cet atelier.

N° anal.	N° vase	Forme	s. i.	Décor	Provenance
26	D30	Drag 37	2	Ove f; zones avec métopes	Périgueux ?
71	D39	Drag 37	3	Ove f; zones avec métopes	Périgueux
76	D37	Drag 37	1	Ove f; zones avec métopes	Brive
156	D47	Drag 30		Ove f; métopes avec sautoir	Brive

Tableau 17.1: Première série d'analyses de vases du gr.D (s.i. = sillon(s) interne(s) sur Drag 37; cf Fig 17.2, ensemble 1, n° marqué D, et pour les décors, Fig 17.3–4)

N° anal.	N° vase	Forme	s. i.	Décor	Provenance	Attribution
05.03	D50	Drag 37	3	Ove f; métopes avec sautoirs et médaillons	Périgueux	Espalion
05.06	D3	Drag 29	/	A: rinceau; B: guirlande et métopes, marque (D)AGOM rétrograde *in forma*	Cahors	Espalion
05.21	D51	Drag 37	1	Ove f; métopes avec sautoirs et médaillons	Rodez	Espalion
05.23	/	Drag 37	3	Ove f; métopes avec sautoirs et médaillons	Rodez	La Graufesenque
05.24	D19	Drag 29	/	A: festons; B: métopes	Rodez	Espalion
05.44	D16	Drag 29	/	A: festons; B: métopes	Espalion	Espalion

Tableau 17.2: Deuxième série d'analyses de vases attribuables au gr.D (la mention de s.i. ne concerne que les Drag 37; pour les Drag 29, A et B désignent les registres supérieur et inférieur du décor; la dernière colonne indique l'attribution du vase d'après l'analyse)

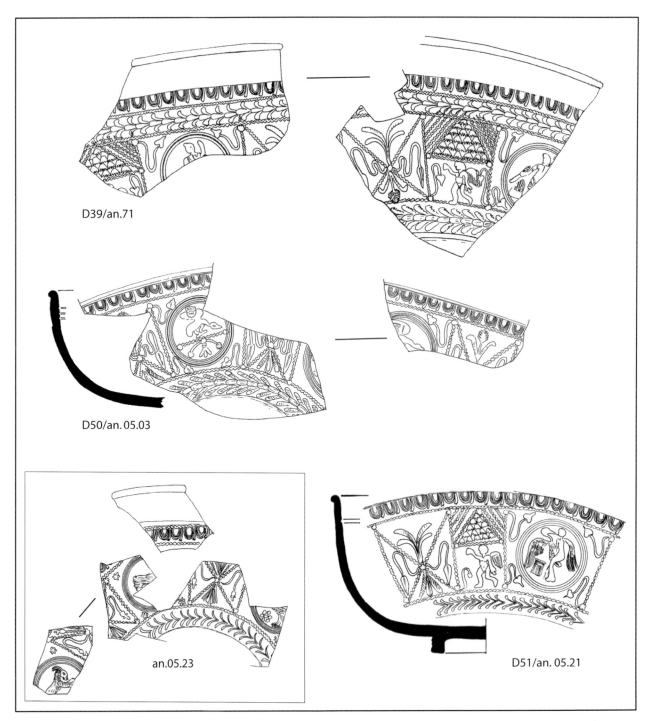

D39/an.71

D50/an.05.03

an.05.23

D51/an. 05.21

Fig 17.4: *Vases soumis à analyse pour déterminer le groupe D d'Espalion; dans l'encadré, vase que l'analyse attribue à La Graufesenque plutôt qu'à Espalion (échelle: 1/2)*

c) Analyses chimiques de nouveaux tessons du groupe D
Les décors des vases du gr.D étant stylistiquement très proches de certaines productions de La Graufesenque portant les mêmes oves, il était indispensable de vérifier que la composition chimique de certains des nouveaux tessons (Tableau 17.2) attribuables à ce groupe était compatible avec celle des productions d'Espalion définies lors des analyses précédentes.

Ces investigations ont été réalisées dans le cadre d'une étude des caractéristiques physico-chimiques des sigillées sud gauloises (Dejoie *et al* 2005; Sciau *et al* 2007) dont les résultats complets concernant Espalion sont exposés dans la publication récemment parue (Tilhard 2009, chap 2). Ces analyses de pâte ne pouvant être effectuées à Lyon par fluorescence X, comme précédemment, nous nous sommes tournés vers le PIXE accessible sur l'accélérateur AGLAE du Centre de Recherche des Musées de France (le Louvre, Paris), qui a l'avantage d'être une technique non destructive et dont nous avons récemment montré la compatibilité avec les analyses de M Picon (Sciau *et al* 2007). La composition

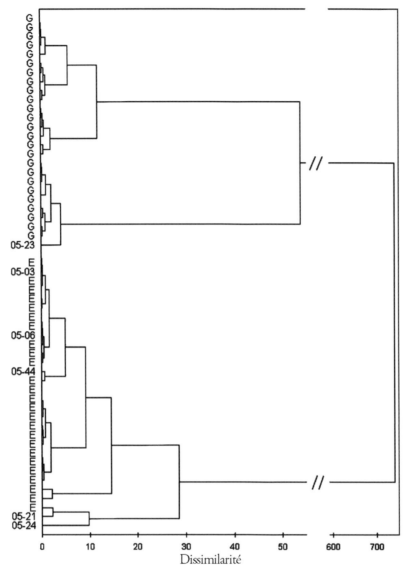

Fig 17.5:Position des 6 tessons attribués au groupe D dans le dendrogramme obtenu à partir des analyses PIXE des pâtes de 25 échantillons de la Graufesenque et de 25 d'Espalion

élémentaire des engobes a également été déterminée par microsonde électronique au Laboratoire des Mécanismes et Transferts en Géologie de l'Université Paul Sabatier (Toulouse).

La nouvelle série d'analyses confirme les différences de composition entre Espalion et La Graufesenque comme le montre le dendrogramme (Fig 17.5), obtenu à partir d'une classification hiérarchique ascendante. Il fait bien apparaître deux groupes distincts: un groupe formé par les échantillons de la Graufesenque (notés G) et un autre par ceux d'Espalion (notés E). Sur les six échantillons du Tableau 17.2, seul 05.23 se retrouve du côté Graufesenque. Les cinq autres fragments (05.03, 05.06, 05.21, 05.24 et 05.44) ont une composition de pâte compatible avec les caractéristiques chimiques du groupe d'Espalion. Les engobes des fragments 05.03, 05.06, 05.21, 05.23 et 05.24 ont également été analysés. Les caractéristiques chimiques des engobes de ces deux centres sont très proches et il existe une zone de recouvrement importante entre les

deux groupes. Toutefois le point associé au 05.23 se situe nettement du côté Graufesenque tandis que les points associés aux 05.03, 05.06, 05.21 et 05.24 apparaissent dans la zone Espalion.

Au vu de ces résultats, seul le Drag 37 05.23 est attribuable à La Graufesenque (bien qu'il possède trois sillons internes: on a vu plus haut que ces sillons internes sont fréquents sur les Drag 37 d'Espalion, et beaucoup plus rares à La Graufesenque (où ils existent néanmoins); par ailleurs, ce vase possède quelques motifs qui n'apparaissent pas sur les autres décors du gr.D actuellement connus). Les autres appartiennent bien au groupe d'Espalion, confirmation particulièrement intéressant pour D3 (Figs 17.3 et 17.6), seul vase analysé du gr.D portant la marque *in forma* DAGOM. Les Drag 37 D50 et D51 (Fig 17.4) ont des décors suffisamment complets pour être restituables; ils possèdent des éléments caractéristiques du gr.D associés à l'ove f, mais également des poinçons nouveaux. Le Drag 29 D16 (Fig 17.3) trouvé en surface à Espalion porte tous les

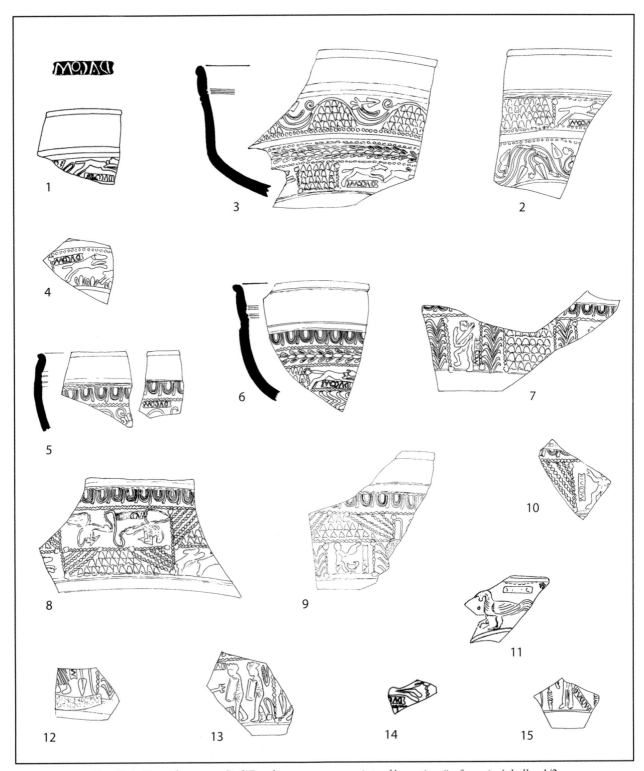

Fig 17.6: Vases du groupe D d'Espalion avec marque intradécorative (in forma); échelle: 1/2

éléments décoratifs connus dans le groupe, et sa fabrication dans l'atelier, fort probable d'après sa provenance, son aspect et son décor, se voit ainsi confirmée; D19 (Fig 17.3) possède des éléments de décor correspondant à de nombreux vases du gr.D, seul le trifol utilisé en pendentif entre les festons de la zone supérieure n'y était pas encore connu.

2. Les vases avec marques in forma du groupe D (gr.D)

a) Les marques (Figs 17.6–7)

Nous disposons donc d'une quinzaine de marques *in forma* apparemment identiques, certaines incomplètes, d'autres empâtées et plus ou moins lisibles; toutes ont été apposées dans le moule avant cuisson, pendant la confection du

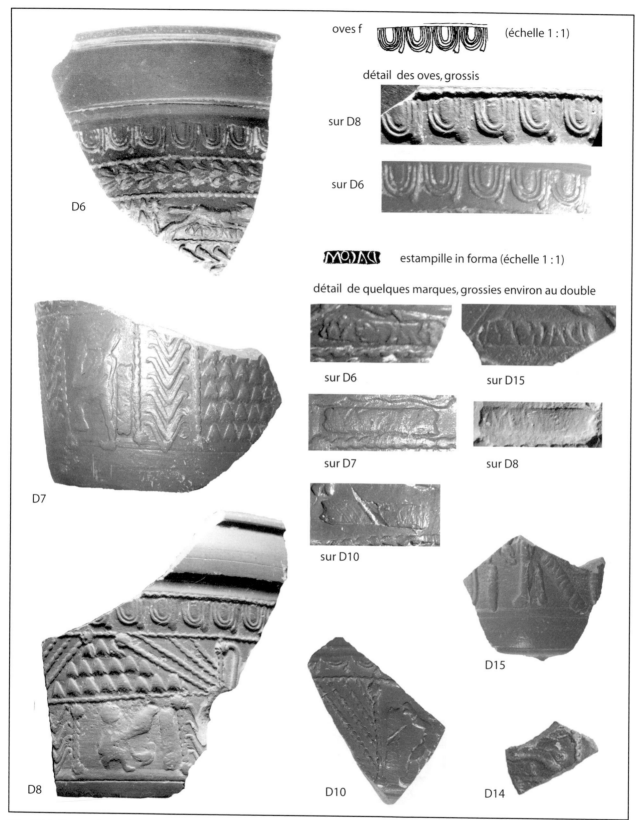

oves f (échelle 1 : 1)

détail des oves, grossis

sur D8

sur D6

estampille in forma (échelle 1 : 1)

détail de quelques marques, grossies environ au double

sur D6

sur D15

sur D7

sur D8

sur D10

D6

D7

D8

D10

D15

D14

Fig 17.7: Photos de quelques vases (échelle: 1/1 environ) avec des détails des oves et des marques (grossissements variables, environ x 1,5 pour les oves, proche du double pour les marques)

décor, avec apparemment le même cachet aux petits côtés concaves (concavité tournée vers l'extérieur). Les lettres apparaissent en creux et ont été imprimées avec un poinçon que l'on peut penser plutôt destiné à l'estampillage sur fond interne des vases lisses ou de Drag 29, où le timbre devait apparaître avec des lettres en relief et en lecture 'normale' (antégrade) de gauche à droite (voir les remarques à ce sujet de Bet et Delage 1991, 195–6 (les petites estampilles)).

N° vase	Forme	Remarque	Particularités du décor	Provenance
D1	Drag 29 [5]	Bord sup. lisse	A: Libre ? (incomplet)	Brive
D2	Drag 29	Bord sup. lisse	A: métopes; B: rinceau	Vichy ?
D3	Drag 29	Bord sup. lisse	A: rinceau; B: guirlande et métopes	Cahors
D4	Drag 29		B: métopes	Périgueux
D5	Drag 37	3 s.i.	Ove f; zones avec rinceau	Périgueux
D6	Drag 37	3 s.i.	Ove f; zones avec métopes	Troyes
D7	Drag 30		Ove f; métopes pleines	Rodez
D8	Drag 30		Ove f; métopes coupées	Puy de Dôme
D9	Drag 30		Ove f; métopes sur 2 zones	Mâlain
D10	Drag 30		Oves f; métopes pleines	Périgueux
D11 [6]	Déch 67		Incomplet, indéterminé	Le Mas-d'Agenais
D12	Drag 30		Métopes	Saintes
D13	Drag 30		Ove f; métopes, sautoir	Rodez
D14	Drag 37?		Métopes	Espalion
D15	Drag 30		Métopes	Rodez

Tableau 17.3: Les vases du gr.D avec marque intradécorative DAGOM(…) rétrograde

Une marque de Périgueux sur fond interne correspond à ce poinçon; une autre, d'un libellé différent, pourrait également appartenir à cette officine et quelques autres sont signalées dans le bassin de la Garonne, sans que l'on puisse être certain qu'il s'agisse bien du même potier espalionnais.[2]

Sauf sur D5, les timbres ont été imprimés dans un panneau, à proximité d'un motif figuré ou animé, le plus souvent horizontalement ou verticalement, une seule fois en oblique; les positions sont variées selon la place offerte: au dessus (D4, D11) ou en dessous (D1, D2, D3, D6, D14), à gauche (D10) ou à droite (D7, D9, D12, D15 en oblique) d'un motif ou entre deux motifs (D8, D13 doublée); sur D5, elle est située au dessus de la courbe d'un rinceau, juste contre la ligne sous les oves. Nous ne connaissons actuellement aucune marque infradécorative en cursive pouvant correspondre à ce timbre imprimé dans le décor.

On a pu hésiter sur la lecture de cette marque souvent empâtée, parfois incomplète, mais les timbres les plus nets ne laissent guère d'autre choix que DACOM ou DAGOM rétrograde: le A sans barre se présente comme un V inversé (en fait, sur quelques timbres la trace d'un point ou d'une petite barre oblique se devine, à peine perceptible); le G est souvent lisible C, mais sur certaines marques, un petit trait vertical apparaît au niveau de la fin du C et rend préférable une lecture G; le O, plus petit que le G et le M, et légèrement décalé vers le haut, touche la première jambe du M. Ainsi DAGOM est certainement l'interprétation qui convient le mieux; elle ne peut guère correspondre qu'au nom Dagomarus, attesté à Lezoux et aux Martres-de-Veyre,[3] dont un homonyme est possible à Montans, mais n'y est pas signalé (il ne figure pas dans la liste de Martin 1996, 60). Aucun autre nom connu ne convient apparemment à ces cinq lettres, et nous pouvons admettre qu'il s'agit bien de Dagomarus, anthroponyme

composé de deux racines gauloises bien connues, *dago-maros* associant les deux significations flatteuses de bon et de grand (Lambert 1994, 32–33).

On pourrait par ailleurs envisager aussi une lecture DAGO M(anu), un nom suivi de M sans point de séparation, comme cela est connu sur bien des estampilles, dont il n'est pas nécessaire ici de donner la longue liste. *Dago* pourrait correspondre au début d'un nom de potier autre que Dagomarus; pour ne prendre que cet exemple, Oswald (1964a, 101) nous donne Dagobitus et Dagodubnus, mais ces noms ne figurent pas dans la liste de Bémont et Jacob (1986); d'autres noms que ceux de potiers connus peuvent aussi être envisagés. Aussi, en attendant qu'un timbre au développement plus complet nous apporte une information supplémentaire, il sera prudent de ne désigner notre potier que par Dagom(…).

Sur cinq vases (D7, D8, D9, D10, D11, Figs 17.6–7), la marque, peu nette, est difficilement lisible, au point qu'on pourrait douter de cette lecture, mais la taille et la forme du timbre, quelques traces de lettres et les éléments de décor présents vont dans le sens de cette interprétation. Quelques timbres tronqués par la cassure (D13 avec marque doublée entre les gladiateurs de part et d'autre du trident,[4] D14), mais nettement lisibles, ne permettent guère d'autre attribution. D12 est moins sûr, car un M final peut correspondre à bien des libellés; toutefois le petit côté du cartouche, le pilastre de bifols et la feuille lancéolée, qui apparaissent sur d'autres vases de la série, autorisent une attribution très probable à notre Dagom(…).

Les formes portant ces marques correspondent aux quatre types les plus courants à l'époque flavienne; on remarquera seulement la particularité des Drag 29 à bord lisse et lèvre arrondie, qui s'écartent de la norme (*cf* note 5) et qui sont connus dans d'autres groupes d'Espalion.

Cette quinzaine de signatures recensées amène une

première remarque sur l'importance relative de l'officine de Dagom(…); c'est un chiffre comparable à celui des marques connues de Memor, mais nettement inférieur à celles de Momo, pour prendre deux potiers de La Graufesenque dont les rapports stylistiques avec lui sont étroits (Memor: Mees 1995, 85; 162, Tafn 124–7: 19 marques recensées; Momo: ibid, 86; 166–7, Tafn 144–7: 32 marques, plusieurs autres non illustrées; total: 39). Difficile d'en tirer des conclusions sur une appréciation ou une estimation de la production de Dagom(…), sinon d'estimer qu'elle n'est pas négligeable; mais nous ne connaissons pas la fréquence moyenne du marquage des moules, qui n'était probablement pas normalisée, et les raisons de la présence de ces marques dans les moules sont d'ailleurs toujours un sujet de discussion qui dépasse notre sujet du moment (voir par exemple Mees 1995, 30–8; Bet et Delage 1991, 195–6).

L'importance du gr.D est par ailleurs délicate à estimer; il est en effet difficile d'en dresser un inventaire précis en raison des rapports stylistiques étroits que l'on constate avec des décors comparables de La Graufesenque. Sont actuellement recensés environ 70 éléments susceptibles de lui appartenir; c'est nettement moins que le groupe A (décorateur: Primus) qui compte près de 500 individus, moins également que le groupe E (décorateur: Albus), avec environ 120. Ces marques associées à des décors sont pour nous particulièrement précieuses, puisqu'elles nous permettent de percevoir ce que nous pourrions appeler le style de Dagom(…) (et du gr.D), qui se caractérise par l'utilisation d'un attirail de poinçons dans des structures particulières (sur la notion de style décoratif, voir les remarques de Bet et Delage 1991, 199). Il est fort probable que d'autres marques de notre décorateur seront identifiées (et c'est un des buts de cet article de le permettre), car beaucoup de celles que nous avons vues sont difficilement lisibles, et peuvent être facilement attribuées à Momo, par exemple (cela avait été les cas pour D5: Sarradet et Lantonnat 1991, 73).

b) Poinçons attestés avec la signature de Dagom(…)
(Fig 17.8)
Pour ce catalogue des poinçons, j'ai limité les références, que l'on pourrait multiplier indéfiniment, à quelques ouvrages courants ou aux autres groupes d'Espalion.; référence aux poinçons du groupe A d'Espalion: Moser et Tilhard 1987, 44 et sv, figs 5 à 11: référence à Hermet 1934 (préféré pour notre sujet à Oswald 1964b): Herm. suivi d'un seul numéro renvoie aux pls 18–24, où les motifs figurés sont en numérotation continue de 1 à 300; pour les autres motifs, la mention de la planche est indiquée en premier, suivie d'une barre oblique et du n° du motif (par exemple: Herm. 25/15).

Ove f: Il a été évoqué à propos de D30; le corps de l'ove est formé d'un cœur bordé de deux arceaux; le bâtonnet, à droite, est incurvé vers la gauche à son extrémité, qui porte un pendentif, le plus souvent empâté et prenant l'aspect d'un renflement indéterminé, mais que quelques exemplaires permettent de distinguer comme trifide (selon l'empâtement, on peut d'ailleurs avoir l'impression d'oves différents: *cf* Fig 17.7, D6 et D8). C'est un type bien attesté

à La Graufesenque où il est courant, associé aux signatures *in forma* de plusieurs potiers (Memor, Momo, Secundinus I, Tetlo[7]); il existe aussi au Rozier, sur moule, avec signature d'un décorateur identifié comme Senilis (Bourgeois et Thuault 2002, 275, fig 3, moule 2; 276, fig 5, Ob; 278; différent apparemment du Senilis de La Graufesenque: Mees 1995, Tafn 182–4).

Personnages
D/1 Porteur d'amphore (?) (Herm.78, considéré comme un Hercule; Dzwiza 2004, M1.14): sur D7.
D/2 Putto à gauche (incomplet, les ailes manquent) (Herm. 34, ailé; *cf* A/161 ou 180): sur D10.
D/3 Gladiateur à gauche, avec bouclier rectangulaire (dérivé de Herm. 152; *cf* A/255): sur D13.
D/4 Gladiateur à droite (incomplet et indéterminé; non dessiné sur la Fig 8); il n'en reste qu'un trident, correspondant probablement à un rétiaire, affronté au gladiateur précédent (Herm. 140, 151; *cf* A/254): sur D13.
D/5 Oiseleur (Herm. 368): sur D9.
D/6 Femme drapée à droite (incomplète et indéterminée, non dessinée sur la Fig 8); il ne subsiste que les pieds et la base du vêtement (parallèles à chercher dans Herm. 123 à 128): sur D12.
D/7 Personnage incomplet et indéterminé (non dessinée sur la Fig 8), apparemment debout de face, le bras droit retombant le long du corps (Herm. 50 ne correspond guère): sur D15.

Animaux
D/8 Petit chien courant à droite (sans équivalent dans Hermet; *cf* A/346; Nieto et Puig 2001, fig 92, Bd20; Dzwiza 2004, T2.7): sur D1, D2, D3, D4, D6, D8?
D/9 Grand chien à droite, incomplet (peut–être Herm. 26/18): sur D8 ?, D14.
D/10 Lapin courant à droite (sans équivalent dans Herm. Pl. 26; correspond au motif sur moule trouvé à Espalion (Tilhard *et al* 1991, 232, fig 2d); Dzwiza 2004, T1.4): sur D3, D4, D8 (entier sur D30).
D/11 Oiseau à droite, ailes éployées (Herm. 28/29): sur D8.
D/12 Oiseau à gauche, ailes éployées (Herm. 28/30): sur D8.
D/13 Coq à gauche (proche de Herm. 28/28; correspond à un poinçon de Carrade: Pauc 1973, pl XXIII, 5–6, sur Drag 37): sur D11.

Végétaux
D/14 Feuille lancéolée (proche de Herm. 13/A2, 126/15): sur D2, D12.
D/15 Feuille lancéolée, plus étroite et un peu plus longue que la précédente (proche de Herm. 13/A2; motif très présent sur les décors de Carrade: Pauc 1973, pls XV, 7, XVIII; attesté aussi sur moule au Rozier: Bourgeois et Thuault 2002, fig 283, 10, c), pas toujours facile à distinguer d'elle: sur D13.
D/16 Elément bifolié (bifol) en V, l'extrémité des côtés

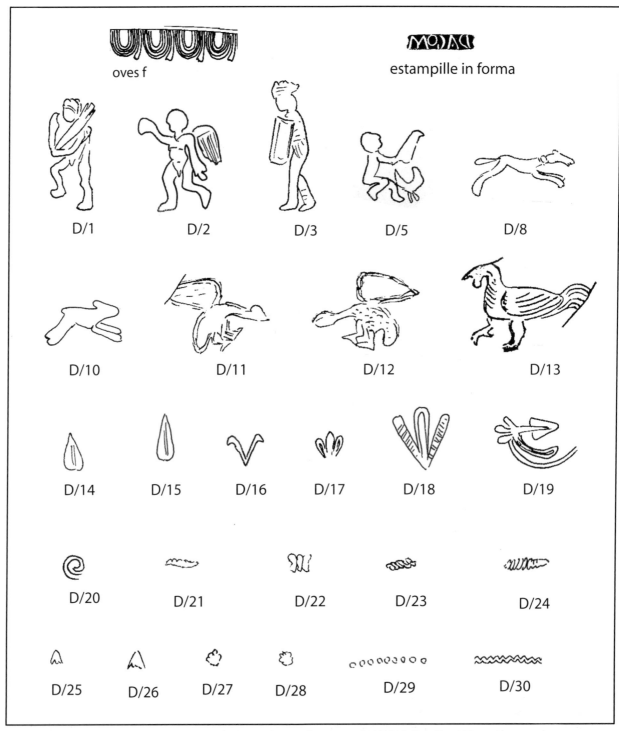

oves f

estampille in forma

Fig 17.8: Poinçons attestés avec la marque DAGOM (échelle: 1/1)

est pointue et saillante (Herm. 13/B51 est différent; il est difficile de trouver un équivalent exact parmi le grand nombre des bifols plus ou moins proches existant sur les sigillées décorées méridionales, d'autant plus que l'écartement des côtés semble parfois différent, comme entre D7 et D9, et qu'il pourrait exister deux motifs distincts; un bifol courant sur les décors de Carrade correspond bien: Pauc 1973, pls XV, 1, XVII, XVIII, XIX, 1–2, XXVI, 6, sur moule): sur D6, D7, D9, D12.

D/17 Petit élément trifolié (trifol) composé d'une languette centrale unie et de deux côtés avec division médiane (sans parallèle exact, mais le motif existe à La Graufesenque, où j'ai pu l'observer; proche de Nieto et Puig 2001, fig 129, Eb.23 ou Eb.23a): sur D3, D4, D6.

D/18 Trifol (incomplet et peu net) avec languette centrale et côtés striés (probablement comme A/441; Knorr 1919, Tafn 82, C3; 83, E8 (Vitalis); Dzwiza 2004, F12.5): sur D1 (également D30, entier sur D51).

D/19 Mystica (sans équivalent dans Herm. 11): sur D3.

Eléments décoratifs divers (pour ces motifs, je n'ai pas cherché à trouver des équivalents précis, tâche quasiment impossible vu la grande parenté de ces éléments très nombreux sur les sigillées méridionales):

D/20 Petite volute de rinceau à gauche: sur D3, D5.

D/21 Gaine de rinceau; le motif est empâté et peu net; il semble formé de plusieurs nodules placés côte à côte: sur D2, D3 (peut-être s'agit-il de deux motifs différents).

D/22 Gaine de rinceau, constituée d'une division centrale entre deux petits éléments trifides: sur D5.

D/23 Petit tortillon: sur D13.

D/24 Tortillon; un peu plus grand que le précédent: sur D15.

D/25 Pointe de flèche: sur D2, D3.

D/26 Pointe de flèche; ce motif paraît un peu plus grand que le précédent; tous deux sont généralement très empâtés et peu nets: sur D6, D7, D8, D9.

D/27 et D/28 Rosettes; il est difficile de distinguer le nombre de poinçons différents; apparemment, il en existe au moins deux types, de taille différente.

D/29 et D/30 Cordons; il en existe deux types: une ligne perlée utilisée sur les Drag 29 (D/29) et une ligne tremblée (D/30).

D/31 Ligne unie, faite probablement à main levée dans le moule pour tracer l'axe des rinceaux (à moins qu'il ne s'agisse d'un poinçon au motif d'arc), des tiges sinueuses portant des éléments divers dans les coins des panneaux ou les secteurs latéraux des sautoirs, ou d'autres éléments sinusoïdes.

Nous disposons donc d'un nombre relativement réduit de poinçons pour connaître et reconnaître les produits décorés de Dagom(…); cela tient en grande partie à la petite taille des fragments retrouvés. Je n'ai pas voulu, par principe méthodologique, ajouter à ce catalogue les motifs présents sur les autres vases du gr.D sans signature (dont tous ne sont pas avec certitude attribuables à Espalion), ni même ceux des vases dont l'analyse confirme l'origine espalionnaise (on les trouvera sur les vases des Figs 17.3–4), qui feraient plus que doubler notre série. Il est donc bien possible que la découverte de nouveaux vases signés de notre décorateur permette d'allonger cette liste des motifs attestés.

Sur cette trentaine d'éléments utilisés pour la décoration des moules signés, aucun n'apparaît comme vraiment exclusif à Dagom(…); tous, ou des motifs proches, sont présents sur des décors de La Graufesenque (particulièrement chez les décorateurs utilisant le même type d'oves); toutefois, dans la mesure où leur association avec la signature peut être indicative, ils ont servi de fil directeur pour repérer les décors attribuables au gr.D, en liaison aussi avec les motifs présents sur les vases analysés du gr.D, mais sans signature.

c) Dagom(…) décorateur du groupe D d'Espalion
La quinzaine de vases signés au décor incomplet dont

nous disposons ne donne donc qu'un aperçu très modeste d'un style attribuable à Dagom(…): quelques rinceaux, des décors à zones et à métopes qui ne se distinguent guère des schémas existant sur bien des vases de La Graufesenque, et tout particulièrement ceux portant l'ove f. Chez Memor et Momo en particulier, on peut trouver des éléments très proches (*cf* Mees 1995, Tafn 124–7 et 144–7). Quelques éléments décoratifs sont toutefois à remarquer: la frise/ guirlande avec le petit trifol D/17 assez peu fréquent à La Graufesenque, la frise/guirlande ou le pilastre avec le bifol D/16 (mais celui-ci est très couramment employé ailleurs par d'autres décorateurs, et également à Carrade); l'utilisation fréquentes de pointes de flèche pour remplir la boucle inférieure de rinceau, des panneaux entiers (relativement larges) ou des triangles (larges eux aussi), est aussi très fréquente dans les décors de La Graufesenque. La feuille lancéolée (D/15), présente ici sur quelques tessons, revient fréquemment dans les vases du gr.D (voir D30, en palissade; D19 et D16 en sautoir/croix de saint André comme sur D13), alors qu'elle n'apparaît ni chez Memor, ni chez Momo; elle est en revanche courante dans les décors de Carrade (Pauc 1973, pl XV, 7, Pauc 1986, 88, fig 22, 18; 89, fig 23, 22, 27, 33, 38; mais l'ove 'f' y est inconnu).

Les vases sans signature que l'analyse a permis d'attribuer à Espalion (Figs 17.3–4) et qui portent l'ove f (ainsi que le Drag 29 D16) ont été présentés ici, sans commentaire particulier, en complément de ce dossier. Ils possèdent tous des éléments décoratifs qui les mettent en relation directe avec ce que nous connaissons de Dagom(…) par notre série de vases signés, et peuvent lui être attribués, puisqu'il est actuellement le seul décorateur connu dans le gr.D. Mais, comme il existe une étroite parenté avec des décors de La Graufesenque ayant le même type d'ove, la grande question est de distinguer parmi les vases sans signature et non analysés, attribués au gr.D, ceux qui sont d'Espalion et ceux qui sont de La Graufesenque ou du Rozier (et qui appartiennent probablement à l'importante production largement diffusée en Occident de Momo, Memor et/ou d'autres). L'attribution d'un décor sans marque de Dagom(…) au gr.D d'Espalion plutôt qu'à La Graufesenque ou au Rozier relève parfois plus de l'intuition que d'une déduction logique (c'est d'ailleurs pour cette raison que des analyses ont été effectuées). Il n'est donc guère possible actuellement de saisir la limite entre ces productions apparentées d'ateliers différents, ni de définir plus précisément les rapports que *Dagom*(...) a pu avoir avec les décorateurs de La Graufesenque et du Rozier étroitement proches de son style; il a, pour le moins, puisé aux mêmes sources que ses collègues et peut-être concurrents, apparemment contemporains (Memor, Momo, Secundinus I, Tetlo de La Graufesenque, et Senilis du Rozier). Une chose est sure, Dagom(...) a produit des moules (peut-être à Espalion, puisque son nom est inconnu à La Graufesenque) avec des éléments décoratifs courants à La Graufesenque, et ces moules ont servi à fabriquer des vases à Espalion.

Les liens entre ces ateliers dépassent d'ailleurs le cadre du seul gr.D et concernent aussi la plupart des groupes

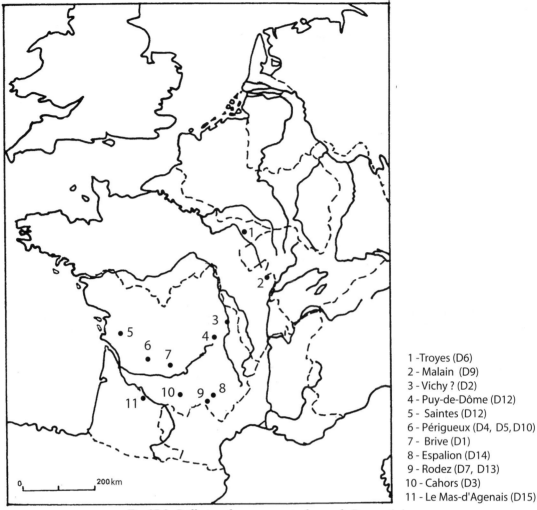

1 -Troyes (D6)
2 - Malain (D9)
3 - Vichy ? (D2)
4 - Puy-de-Dôme (D12)
5 - Saintes (D12)
6 - Périgueux (D4, D5, D10)
7 - Brive (D1)
8 - Espalion (D14)
9 - Rodez (D7, D13)
10 - Cahors (D3)
11 - Le Mas-d'Agenais (D15)

Fig 17.9: Diffusion des marques in forma de Dagom(...)

stylistiques d'Espalion; l'atelier, dont l'importance ne peut évidemment pas se comparer à celle de La Graufesenque, apparaît plutôt comme une dépendance ou un satellite du grand centre de production rutène, et nous avons peut-être avec ce dossier Dagom(...) un exemple d'organisation concertée de la production entre des officines apparentées (dont la nature précise des liens nous échappe), en fonction de la commercialisation vers des zones différentes ou complémentaires.

d) Datation et diffusion
La datation de ces vases avec signature ne peut guère provenir du contexte archéologique, inconnu pour les découvertes anciennes, ou trop peu précis (mais D1, de Brive, est flavien: voir Moser et Tilhard 1987, 97–8). Elle peut se déduire surtout des formes et des décors associés à ces marques. Les formes Drag 37 et Déch 67 apparaissent vers la fin du règne de Néron (voir en dernier lieu Mees 1995, 57–8: le Déch 67 apparaît avant les Flaviens, et le Drag 37 vers la fin des années 60), et sont courantes à la période flavienne; le Drag 29 disparait du répertoire des formes des ateliers méridionaux autour de 85/90 ap. J.-C (Pferdehirt 1986, 250; Mees 1995, 29–30). Parmi les vases

analysés, D37 (Fig 17.3) est très probablement issu du même moule qu'un vase de Rottweil, qui fournit donc un élément de datation de l'époque flavienne (Planck 1975, II, 100/6: Drag 37 au décor plus complètement conservé et possédant un sillon interne sur le bord (renseignement aimablement fourni par Allard Mees)). Mais ce sont surtout les parallèles décoratifs avec Memor et Mom(m)o qui donnent des repères chronologiques assez solides: la période de production de ces potiers se situe sous les Flaviens entre 75 et 95 environ (Vespasien-Domitien: Mees 1995, 85–6, Nr 44; 87–8, Nr 47; leurs vases sont présents à Pompéi: Dzwiza 2004), et les parallèles sont nombreux avec les potiers d'époque flavienne, ce qui conduit à dater la période de production de Dagom(...) dans la même fourchette chronologique.

Quant à la diffusion de ces marques (Fig 17.9), elle correspond bien à ce que nous connaissons de la commercialisation des sigillées d'Espalion (avec toute le prudence avec laquelle on doit considérer ce genre de cartographie; un premier état, d'après les sigillées moulées du groupe A, est donné dans Moser et Tilhard 1987, 100–1, actualisé dans Tilhard 2005, 39, fig 9, sans modification notable). On peut noter une forte concentration sur un

axe privilégié Espalion, Rodez, Brive, Périgueux, Saintes, peut-être par Cahors d'où ces produits, par la vallée du Lot, ont pu atteindre aussi la moyenne Garonne (dans notre cas, ceci concerne 11 marques sur 15, soit près de 75%). Un autre courant, apparemment moins important, se dessine vers la Gaule centrale (Puy-de-Dôme et Vichy ?) et se prolonge vers le nord/nord-est par Mâlain et Troyes. Les régions rhénanes et la Bretagne, atteintes par d'autres sigillées d'Espalion (gr.A), sont absentes ici (mais des productions non signées du gr.D – ou attribuables au gr.D – y sont présentes).

On soulignera ici cette forte densité des sigillées d'Espalion de la région productrice vers le nord-ouest du Bassin aquitain, qui se situe entre une zone nettement dominée par les productions de Montans (bassin de la Garonne et côtes atlantiques jusque dans le sud de l'Armorique) et, au nord, des régions où dominent les productions de La Graufesenque (cette question de la commercialisation des sigillées en Aquitaine a été suffisamment examinée récemment pour qu'il ne soit pas nécessaire d'en faire ici un nouveau commentaire: *cf* Marsh 1981; Martin et Triste 1997, 112; Martin 1999; Carponsin-Martin et Tilhard 2001–2002, 250–5; Tilhard 2004, 118 et sv; Martin et Tilhard 2004; Martin 2005). Les trois marques de Périgueux sont d'ailleurs emblématiques de la situation particulière de cette ville dans la commercialisation des sigillées dans la seconde moitié du Ier siècle ; les produits de Montans y sont minoritaire, alors que les sigillées d'Espalion (dont on ne connaît sans doute actuellement qu'une partie indéterminée), avec celles de La Graufesenque, constituent une part importante de la consommation des habitants en céramiques fines (*cf* Tilhard 2005).

Conclusion

Cette série de vases avec marque *in forma* de Dagom(…), décorateur du groupe D d'Espalion, forme un ensemble homogène qui nous permet d'avoir un aperçu de son style et de celui du groupe D, jusqu'alors peu connu. Ce style ne se distingue pas nettement de celui de potiers de La Graufesenque et du Rozier qui ont utilisé le même type d'ove et des poinçons semblables dans des structures du même genre; c'est pourquoi pour la détermination du groupe D, comme pour l'ensemble de la recherche sur Espalion, le recours aux moyens d'investigation de laboratoire d'archéométrie a été indispensable. Cette production particulière d'Espalion est vraisemblablement de la période flavienne (vers 75–95) et la diffusion des vases s'inscrit dans ce que nous connaissons de celle des autres productions de ce centre.

La question de la nature des rapports qui existaient entre l'officine espalionnaise de Dagom(…) et celles de La Graufesenque (ou du Rozier) apparentées, reste posée. Cette question s'inscrit dans le cadre plus général de la définition des relations qui ont existé entre l'atelier d'Espalion et le centre de production de La Graufesenque.

Notes

1 Indication de Alain Vernhet avec qui j'ai pu examiner à diverses reprises des quantités importantes de tessons-bords de Drag 37 de La Graufesenque sur lesquels les sillons internes sont rarissimes (de l'ordre de quelques unités pour cent, mais je n'ai pas effectué de comptage systématique); les Drag 37 de Cala Culip, originaires de La Graufesenque, confirment cette donnée: sur une série significative de 305 individus avec bord supérieur conservé dessinés dans Nieto et Puig 2001, 313–494, 12 seulement sont munis d'un sillon interne, soit 3.9% (il s'agit de productions flaviennes, approximativement contemporaine des groupes A et D d'Espalion). Un comptage récent fait sur les vases du groupe A d'Espalion ayant conservé leur bord supérieur (environ 150, ce qui constitue également un échantillon significatif) donne une proportion de plus de 90% possédant un ou plusieurs sillons internes, ce qui est l'inverse.

2 Périgueux: Barrière 1995, 86: …AGOMI (sans illustration) (musée du Périgord, inv VB 3935/92 8 317); j'ai pu l'examiner au musée du Périgord: elle se trouve sur fond de Drag 29, sans décor conservé, dont l'aspect concorde avec les sigillées d'Espalion; la lacune du début (cassure) permet cependant de reconnaître la partie inférieure droite du A, et les autres lettres correspondent parfaitement à nos marques, légèrement plus grandes ici, en relief, et lisibles de gauche à droite; le petit côté du cartouche, concave, est également reconnaissable. Tout porte à penser qu'il s'agit d'une estampille imprimée avec le même poinçon que les marques de nos moules, légèrement plus petites puisqu'il y a eu un retrait supplémentaire.

Tilhard 1977b, 18, pl I n° 50, 28, n° 50, DAGO avec point dans le O, sur fragment de fond de Drag 33 (?), peut-être aussi d'un service flavien, attribuée aux Martres-de-Veyre. L'aspect du support, revu récemment, peut correspondre à une sigillée d'Espalion; par ailleurs, le libellé DAGO n'est pas attestée aux Martres-de-Veyre (Terrisse 1968, Romeuf 2001).

Autres: Oswald 1964a, 102, recense 2 estampilles DAGOM à Montans et Agens [sic]; celle de Montans ne m'est pas connue; le support de celle d'Agen a plutôt l'aspect des produits de Montans (Tilhard 1985, 190, fig 10, et 196); les découvertes d'estampilles DACO à Saint-Genès (Tarn-et-Garonne; Labrousse 1963, fig 2, E40, attribué au Centre-Gaule) et DAGO.F dans le Gers, à Preignan (Ferry *et al* 1980, n° 9) vont plutôt dans le sens d'une origine montanaise qu'il faudrait confirmer par une découverte sur l'atelier. Il faut en ajouter une sur fond interne de Drag 29 trouvé à Villeneuve-sur-Lot (site de Cantegrel, daté de 68/69: *cf* présentation succincte de Chabrié *et al* 2006, 407) aimablement communiquée par Thierry Martin; il s'agit certainement du même poinçon que celui qui a servi à imprimer cette marque dans nos moules: DAGO[…] avec petit côté échancré, mais le décor, incomplet (il s'agit d'un rinceau ondulé), n'a rien de commun avec notre série (aucun des poinçons associés à la marque Dagom… ou relevés sur les vases attribués au gr.D n'y figure); toutefois, Thierry Martin considère, d'après l'aspect du tesson, qu'il s'agit bien d'un produit d'Espalion; inédite, elle est actuellement en cours d'étude avec le lot de sigillées du site, et il conviendra de la verser au dossier, qui ne s'en trouvera pas simplifié…

3 Oswald 1964a, 102; Terrisse 1968, 81, 83; Bémont et Jacob 1986, 281; Bet 1988, n° 336; Romeuf 2001, 44: les graphies connues sont différentes. Il semble n'y avoir qu'une homonymie, et on peut certainement exclure un déplacement du potier d'Espalion vers les Martres-de-Veyre, car outre la différence des poinçons sur vases lisses, les décors du gr.D

d'Espalion et ceux de Dagomarus des Martres-de-Veyre n'ont apparemment pas de rapport; il y a de plus un hiatus chronologique entre leurs périodes de production.

4 C'est une pratique de certains décorateurs; on peut citer le parallèle de Momo, qui a avec les décors du groupe D une parenté certaine: Mees 1995, Taf 146, 1, Drag 30, position comparable de deux timbres identiques OFMO dans un panneau avec ces gladiateurs affrontés, celui de droite doublé, comme ici.

5 Dans Tilhard *et al* 1991, 241, fig 9, 19–D19, ce fragment (Tableau 17.3, D1) est présenté par erreur comme un Knorr 78; il s'agit en fait d'un Drag 29 particulier, à bord supérieur lisse et plan et à lèvre extérieure arrondie débordante, dont la partie supérieure est comparable à un bord de Drag 37; D2 correspond à la même forme Drag 29 à bord lisse et lèvre arrondie débordante; d'autres exemples existent dans les productions espalionnaises (Tilhard *et al* 1991, 244, fig 11, 7, vase analysé; d'autres sont inédits). D3 possède un bord lisse mais légèrement bombé, un peu plus proche des Drag 29 classiques.

6 Je ne connais ce vase (Tableau 17.3, D11) que par la publication de P Cadenat (1982, 69, fig 58, F1–3; 73, fig 62, 6), dont le dessin est repris ici; la photo de la publication est plus nette et autorise la lecture DAGOM. P Cadenat n'a pas proposé de lecture pour cette marque qu'il considérait comme indéchiffrable, mais Brian Hartley m'a confirmé la validité de cette interprétation; quant à la forme, elle est indéterminée: plutôt qu'un Drag 37 comme indiqué dans la publication, ou qu'une zone inférieure de Drag 29 qu'évoque la trace de ligne perlée du dessin (en fait il s'agit simplement du passage irrégulier de la zone décorée à la zone lisse au-dessus du décor), il me paraît s'agir plutôt ici de la zone décorée assez étroite d'un Déch 67 (un autre vase attribuable au groupe D, trouvé à Brive et inédit, présente le même poincon sur Déch 67).

7 Grâce à l'obligeance de Alain Vernhet, j'ai pu examiner sur place un grand nombre de vases et des moules pourvus de ce type d'ove; il y est attesté sur moules de Drag 37 avec signature *in forma* de Secundinus et de Tetlo (inédits) (et je l'ai aussi rencontré sur un Drag 37 de Vichy avec même type de signature de Secundinus (inédit, fouilles J Corrocher, CRAV Vichy, n° inv: MOS 376); un certain nombre de ces vases de La Graufesenque présentent un aspect très proche des produits d'Espalion (argile, vernis) au point qu'il est difficile de les en distinguer (mais les Drag 37 que j'ai eus entre les mains n'étaient pas munis de sillon(s) interne(s), cas également de celui de Vichy)): Mees 1995, Tafn 124–7 Memor, Taf 144, 1 Momo; Dannell *et al* 1998, 80, fig 2, SE; 83; 84; Dannell 2005, 81–83, fig 2, a–f (mais donne comme référence pour e, Primus IV, du groupe de la vallée du Lot, faisant probablement un confusion entre le gr.D et le gr.A, où cet ove n'apparaît pas); il est répertorié dans le site internet online 'RGZM samian' sous les n°^os 10, 11, 11'(avec un grand nombre de vases). Le type paraît proche d'oves employés par M. Crestio, plus nets et légèrement plus grands: Mees 1995, Tafn 36, 1, 4–7; 38, 1. Ces oves apparaissent aussi sur de nombreux vases moulés de sites divers dont il n'est guère utile de donner ici une longue liste nécessairement incomplète; on se contentera de quelques exemples significatifs: il s'agit probablement du type Da.10 de Nieto et Puig 2001, 121, fig 115, présent sur plusieurs Drag 37 de Cala Culip; Dzwiza 2004, 92, E2a et E2b sur vases de Pompéi avec signatures de Memor et Momo et d'autres sans signature; ils sont également nombreux sur les sites britanniques: par exemple, à Colchester, Dannell 1999,

60, nos 416, 418, 419; 61, nos 421, 424, 425, 427, 428; 29, attribués à Memor.

Remerciements

Il convient ici de remercier les musées de Brive (musée Labenche), Cahors, Périgueux (musée du Périgord, Vesunna, musée gallo-romain), Rodez (musée Fenaille), Saintes, le Service Régional de l'Archéologie de Midi-Pyrénées (Toulouse), ainsi que MM Bénévent (Savignac, Aveyron), Cabrolié (Espalion, Aveyron), Loustaud (Limoges, Haute-Vienne) d'avoir permis d'effectuer des prélèvements pour analyse au cours de ces recherches.

Les analyses de pâte ne pouvant être effectuées à Lyon par fluorescence X, comme précédemment, nous nous sommes tournés vers le PIXE accessible sur l'accélérateur AGLAE du Centre de Recherche des Musées de France (le Louvre, Paris), qui a l'avantage d'être une technique non destructive et dont nous avons récemment montré la compatibilité avec les analyses de M Picon (Sciau *et al* 2007). Les analyses ont été réalisées grâce au soutien technique de Joseph Salomon et d'Anne Bouquillon (C2RMF-Louvre). La composition élémentaire des engobes a également été déterminée par microsonde électronique au Laboratoire des Mécanismes et Transferts en Géologie de l'Université Paul Sabatier (Toulouse). Ces investigations ont été effectuées en collaboration avec Philippe de Parseval (LMTG-toulouse).

Annexe: Catalogue des vases du groupe D avec marques DAGOM (Fig 17.6)

Avertissement pour la lecture du catalogue: à la suite du numéro de chaque vase, on trouvera, l'indication de la forme avec les abréviations suivantes (Déch: Déchelette, Drag: Dragendorff, K: Knorr); pour les Drag 37, la mention de la présence éventuelle de sillons(s) interne(s) (si) sur ou sous la lèvre précédée de leur nombre (?si: présence inconnue, par manque de la partie supérieure du vase; 0 si: pas de sillon interne; les dimensions du vase sont indiquées de la manière suivante: 'd' pour diamètre, suivi d'un chiffre en mm, éventuellement accompagné de '±' pour des dimensions approximatives sur vase incomplet, ou seulement de '?' si on ne peut les estimer (fragment trop petit, absence du bord du vase). Après cette première série d'indications vient la description du décor, du haut vers le bas et de gauche à droite: type d'ove, CI: courbe inférieure de rinceau; CS: courbe supérieure de rinceau; F: feston; M: métope ou panneau; (dans le cas de métope coupée ou recoupée, les subdivisions de haut en bas correspondent à Ma, Mb, Mc); M1: première métope; M2: deuxième métope, etc; P: pendentif de feston; S: sautoir, appelé aussi croix de saint André (Sa: secteur supérieur; Sb: secteur inférieur; Sc: secteurs latéraux, toujours identiques; Z: décor à zones; Z1: première zone, sous les oves; Z2: deuxième zone, ZI: zone inférieure. Pour les Drag 29, le registre supérieur ('frise' d'après Hermet) est désignée par ZA et le registre inférieur (ou 'panse') par ZB, la moulure médiane séparant les deux registres par mm. En fin de description, (inc) signifie que le décor, incomplet, n'est pas

restituable; on trouvera ensuite la mention éventuelle d'une analyse par 'an' suivi du numéro qui renvoie aux divers tableaux où elles sont présentée avec leur problématique. Dans la description du décor, les chiffres entre parenthèses renvoient au catalogue des poinçons ci-dessus (II2b).

Sous la description du décor est mentionnée la provenance (éventuellement suivie de ? si elle est incertaine) suivie de l'endroit ou elle est conservée (ville et musée ou autre, avec n° d'inventaire éventuel, c. pour collection, f. pour fouille, p. pour prospection.

En dessous est indiquée la (ou les) publication(s) où figure l'objet; en l'absence de publication, on trouvera la mention inédit.

D1: Drag 29 (bord lisse à lèvre arrondie débordante), d±160. ZA: trifol en buisson (18), chien (8), timbre *in forma*: DAGOM rétrograde (inc).
Brive (19), musée Labenche (86.1.135, f. F Moser).
Tilhard *et al* 1991, 241, fig 9, 19–D19; Tilhard 1990–1991, 46, fig 4, D17 (décrit comme K.78); Mees 1995, Taf 253, 5.

D2: Drag 29 (bord lisse à lèvre arrondie débordante), d±150. ZA: semis de pointes de flèche (25), chien (8), timbre *in forma*: [DA]GOM rétrograde; mm entre deux lignes de points; ZB, rinceau ondulé, CI = CS: gaine/astragale (21), feuille lancéolée (14), rosette (27) (inc).
Vichy? (03), musée des Antiquités Nationales (Saint-Germain-en Laye 95) (c. Aymé Rambert, sans n° inv).
Inédit.

D3: Drag 29, d±160. ZA: rinceau avec gaine empâtée sur l'axe, CS: volute (20) , mystica (19), CI: semis de pointe de flèche (25); mm entre deux lignes de points; ZB; Z1: guirlande de trifol (45), Z2: répétition de deux panneaux: semis de pointe de flèche (25); chien (8) et lapin (10), sous le chien, timbre DAGOM rétrograde *in forma* (inc). Esp.05.06.
Cahors (46), musée Henri Martin (Société des Etudes de Lot.
Inédit.

D4: Drag 29, d?. ZB, métope: petit trifol (17), chien (8), lapin (10), timbre *in forma*: DAGOM rétrograde (inc).
Périgueux (24), Vesunna, musée gallo-romain (92.8.309/3092).
Tilhard 1995, 93 (représenté par erreur face au n°48), 97, n° 73); Tilhard 2005, 35, fig 7, n° 6.

D5: Drag 37, 3 si, d?. Z1, rinceau avec gaine (22) et volute (20), timbre *in forma*: DAGOM rétrograde (inc).
Périgueux (24), Vesunna, musée gallo-romain (NDS, 92.9.81).
Sarradet et Lantonnat 1991, 74, fig 13, NDS.15; Mees 1995, Taf 253, 6; Tilhard 2005, 35, fig 7,n° 3.

D6: Drag 37, 3 si, d±180. Z1, guirlande de trifol (17), Z2, panneaux: semis de pointes de flèche (26), chien (8), timbre *in forma*: DAGOM rétrograde, Z3: guirlande de bifol (16) (inc).

Troyes (10), musée archéologique (rue H. Huez).
Tilhard *et al* 1991, 240, fig 8, 6–D15; Tilhard 1990–1991, 46, fig 4, D15; Mees 1995, Taf 253, 4.

D7: Drag 30 (petit), d?. Panneaux, M1: pilastre de bifol (16), M2: porteur d'amphore (1), timbre *in forma*: DAGOM rétrograde, panneau comme M1, M3, M1, M2?: semis de pointes de flèche (26?) (probablement répétition de M1-2-1-3 sur la circonférence).
Rodez (12), dépôt départemental du SRA (123, f. L. Dausse).
Tilhard *et al* 1991, 240, fig 8, 8–D16; Tilhard 1990–1991, 46, fig 4, D16; Mees 1995, Taf 253, 3.

D8: Drag 30, d?. Panneaux, M1a: triangle avec pointes de flèche (26), M1b: grand chien à dr (incomplet, peut-être 9), M2a: oiseaux affrontés (11–12) avec un ruban en S inversé, timbre *in forma*: DAGOM rétrograde (peu nette), M2b: triangle avec pointes de flèche (26); M3a: triangle avec pointes de flèche (26); M3b: lapins (26) (inc).
Puy de Dôme (63), Temple de Mercure, Musée Bargoin, Clermont-Ferrand (fonds ancien, Puy de Dôme).
Inédit.

D9: Drag 30 (petit), d?. M1a: triangle avec pointes de flèche (26), M1b: pilastres de bifol (16) encadrant un porteur d'oiseau (5), timbre empâté *in forma*: (DAG)OM rétrograde, M2a: ? (inc).
Mâlain (21), musée archéologique de Dijon (Mâlain 410).
Dolle 1969, pl 65, 410 (communiqué par A Mees).

D10: Drag 30 (petit), d?. M1: triangle avec pointes de flèche (?), M2: timbre empâté *in forma*: (DAG)OM rétrograde, putto (2) (inc).
Périgueux (24), Vesunna, musée gallo-romain (sans n° inv).
Tilhard 1978, 108, pl x, 157; Tilhard 2005, 35, fig 7, 2.

D11: Déch 67, d?. M: coq à g (13), au-dessus cartouche tronqué avec marque difficilement lisible DAGOM rétrograde (inc).
Le Mas d'Agenais (47), musée de Sainte-Bazeille? (47).
Cadenat 1982, 69, fig 58, F1–3; 73, fig 62, 6.

D12: Drag 30, d?. M1: femme drapée à g (6), feuille lancéolée (14), timbre *in forma*: (DAGO)M rétrograde; M2: pilastre de bifol (16) (inc).
Saintes (17), musée archéologique de Saintes (ROU P2.652).
Inédit.

D13: Drag 30 (petit), d?. M1: gladiateurs (3) opposés à un rétiaire (4), tiges sinueuses avec tortillon (23) et rosette (27), deux timbres incomplets *in forma*: DA(GOM) et D(AGOM) rétrogrades, M2, sautoir, b: trifol (?), c: tige sinueuse et feuille lancéolée (15) (inc).
Rodez (12), musée Fenaille (c. SLSAA, rue Peyrot, 13bis).
Inédit.

D14: Drag 37, si ?, d?. M1: chien (9?), timbre *in forma*:

DAG(OM) rétrograde (inc).

Espalion (12), p. et c. Cabrolié (Epalion).

Tilhard *et al* 1991, 241, fig 9, 18–D14; Tilhard 1991, 42, fig 6, 70; 45, fig 8, 70; Tilhard 1990–1991, 46, fig 4, D14.

D15: Drag 30, d?. Structure du décor inconnue (peut-être panneaux), tortillon (24) sur tige curviligne, personnage drapé indéterminé à g (7) , timbre *in forma:* (DAGO)M rétrograde.

Rodez (12), musée Fenaille (R96', f. L. Dausse). Inédit.

Bibliographie

Atkinson, D, 1914. A hoard of samian ware from Pompeii, *J Roman Stud* 4, 26–80

Barrière, C, 1995. 'Domus Pompeia'. Rue des Bouquets à Périgueux. Inventaire du mobilier archéologique I, *Documents d'Archéologie et d'Histoire Périgourdines* 10, 39–104

Bémont, C, et Jacob, J P (dirs) 1986. *La terre sigillée gallo-romaine. Lieux de production du Haut Empire: implantations, produits, relations*, Documents d'Archéologie Française 6, Paris

Bémont, C, Vernhet, A, et Beck, F, 1987. *La Graufesenque, village de potiers gallo-romains*, Dieppe

Bet, P, 1988. *Groupes de productions et potiers à Lezoux (Puy-de-Dôme) durant la période gallo-romaine*, Thèse de l'Ecole Pratique des Hautes Etudes (IVe section), 9 vols, Paris.

Bet, P, et Delage, R, 1991. Introduction à l'étude des marques sur sigillée moulée de Lezoux, *Société Française d'Etude de la Céramique Antique en Gaule: Actes du Congrès de Cognac*, 193–227

Bocquet, A, et Picon, M, 1994. La Graufesenque et les autres ateliers de la Gaule du sud: problèmes d'analyses et de techniques, *Société Française d'Etude de la Céramique Antique en Gaule: Actes du congrès de Millau*, 75–82

Bourgeois, A, et Thuault, M, 2002. Les moules de *Senilis* au Rozier, dans *Céramiques de la Graufesenque et autres productions d'époque romaine. Nouvelles recherches. Hommages à Bettina Hoffmann* (dirs M Genin et A Vernhet), 273–87, Montagnac

Cadenat, P, 1982. *Nouvelles recherches dans la nécropole gallo-romaine d'Ussubium (commune du Mas-d'Agenais) 1975*, Société Académique d'Agen

Carponsin-Martin, C, et Tilhard, J-L, 2001–2002. Les céramiques sigillées trouvées à Perigueux: apport des fouilles récentes, *Aquitania* 18, 193–259

Chabrié, C, Daynès, M, et Garnier, J F, 2006. Villeneuve-sur-Lot/Eysses *Excisum*, dans *Les fortifications militaires* (dirs M Reddé, R Brulet, W Fellmann, J K Haalebos, et S von Schnurbein), Documents d'Archéologie Française 100, 407.

Dannell, G B, 1999. Decorated South Gaulish samian, dans *Roman pottery from excavations in Colchester 1971–86* (dirs R P Symonds et S Wade), Colchester Archaeol Rep 10, 13–119, Colchester

Dannell, G B, 2005. Recording the loads at La Graufesenque, dans *Craft and the classical world. Essays in honour of Donald Bailey and Catherine Johns* (dir N Crummy), Monogr Instrumentum 29, 81–4, Montagnac

Dannell, G B, Dickinson, B, et Vernhet, A, 1998. Ovolos on Dragendorff form 30 from the collection of Frédéric Hermet and Dieudonné Rey, dans *Form and Fabric, Studies in Rome's material past in honour of B. R. Hartley* (dir J Bird), Oxbow Monogr 80, 69–109, Oxford

Dejoie, C, Relaix, S, et Sciau, Ph, 2005. Les sigillées des ateliers de La Graufesenque et de Montans. Etude comparative des pâtes et engobes, dans Nieto *et al* 2005, 9–18

Dolle, R, 1969. Mâlain-Mediolanum. La sigillée 3. *Cahiers du Mesmontois* 3, Dijon

Dzwiza, K, 2004. Ein Depotfund reliefverzierter südgallischer Terra Sigillata-Schüsseln aus Pompeji, *Jahrbuch des Römisch-Germanischen Zentralmuseums Mainz* 51 (2), 381–587

Ferry, D, Lebot, E, et Mousseigne, R, 1980. Marques sur poteries communes et céramiques sigillées découvertes à Preignan (Gers), *Augusta-Auscorum, Fouilles et Recherches archéologiqes à Auch* 1, dactylographié, non paginé

Hermet, F, 1934. *La Graufesenque (Condatomago): I vases sigillés, II graffites* (2 vols), Paris

Knorr, R, 1919. *Töpfer und Fabriken verzierter Terra Sigillata des ersten Jahrhunderts*, Stuttgart

Knorr, R, 1952. *Terra Sigillata Gefässe des ersten Jahrhunderts mit Töpfernamen*, Stuttgart.

Labrousse, M, 1963. Marques de potiers gallo-romains trouvées à Saint-Genès, commune de Castelferrus (T.-et-G.), *Actes du XIXe Congrès d'Etudes Régionales tenu à Moissac, les 5 et 6 mai 1963*, 199–256

Lambert, P Y, 1994. *La langue gauloise*, Paris

Marsh, G, 1981. London's samian supply and its relationship to the development of the Gallic samian industry, dans *Roman pottery research in Great Britain and north west Europe* (dirs A C Anderson and A S Anderson), Brit Archaeol Rep Int Ser 123, 173–238, Oxford

Martin, T, 1986. Groupe de Montans, dans Bémont et Jacob 1986, 57–84

Martin, T, 1996. *Céramiques sigillées et potiers gallo-romains de Montans*, Montauban

Martin, T, 1999. Le port de Bordeaux et la diffusion atlantique des sigillées montanaises, Mélanges Claude Domergue 2, *Pallas* 50, 47–61

Martin, T, 2005. Périple aquitain, commerce transpyrénéen et diffusion atlantique des céramiques sigillées de Montans en direction des marchés du nord et du nord-ouest de la péninsule ibérique, dans Nieto *et al* 2005, 21–62

Martin, T, et Tilhard, J-L, 2004. Le commerce des céramiques sigillées en Aquitaine sous les Julio-Claudiens, *IVᵉ Colloque Aquitania*, 473–502, Saintes

Martin, T, et Triste, A, 1997. Le commerce des céramiques sigillées de Montans sur les côtes du Morbihan: l'exemple de Vannes. I – Les estampilles (fouilles 1981–1991), *Documents de Céramologie Montanaise* 1, 111–136

Mees, A W, 1995. *Modelsignierte Dekorationen auf südgallischer Terra Sigillata*, Forschungen und Berichte zur Vor- und Frühgeschichte in Baden-Württtenberg 54, Stuttgart

Moser, F, 1983. La céramique sigillée découverte à Brive (1979–1984), *Travaux d'Archéologie Limousine* 4, 53–84

Moser, F, 1985. La céramique sigillée lisse découverte à Brive (1979–1984), *Travaux d'Archéologie Limousine* 6, 39–54

Moser, F, 1986a. Les ateliers gallo-romains de Brive (Corrèze), *Travaux d'Archéologie Limousine* 7, 77–89

Moser, F, 1986b. Brive, dans Bémont et Jacob 1986, 90–3

Moser-Gautrand, C, et Moser, F, 1981. Les figurines gallo-romaines en terre cuite de Brive dans leur contexte stratigraphique et chronologique, *Travaux d'Archéologie Limousine* 2, 17–58

Moser, F, et Tilhard, J-L, 1986. Un nouveau centre de production de céramique sigilllée: Brive (Corrèze), *Société Française d'Etude de la Céramique Antique en Gaule: Actes du Congrès de Toulouse*, 93-104

Moser, F, et Tilhard, J-L, 1987. Un nouvel atelier de sigillée en Aquitaine, *Aquitania* 5, 35–121

Moser, F, Picon, M, et Tilhard, J-L, 1985. Etude préliminaire en laboratoire d'un nouveau groupe de céramiques sigillées gauloises, *Travaux d'Archéologie Limousine* 6, 55–6

Nieto, X, et Puig, A, 2001. *Excavacions arqueològiques subaquàtiques a Cala Culip, 3. Culip IV: la terra sigil. lata decorada de la Graufesenque*, Monografies del Centre d'Arqueologia Subaquàtica de Catalunya 3, Girona

Nieto, X, Roca Roumens, M, Vernhet, A, et Sciau Ph (dirs), 2005. *La difusió de la terra sigil.lata sudgàl.lica al nord d'Hispania*, Monografies del Centre d'Arqueologia Subaquàtica de Catalunya 6, Barcelona

Oswald, F, 1964a (1931). *Index of potters' stamps on terra sigillata ('samian ware')*, repr, London

Oswald, F, 1964b (1936–7). *Index of figure types on terra sigillata ('samian ware')*, Univ Liverpool, Annals of Archaeol and Anth Suppl, repr, London

Pauc, R, 1973. *Les céramiques sigillées rouges de Carrade*, extrait du *Bulletin de la Société des Etudes du Lot* 93 (1972)

Pauc, R, 1986. Carrade, dans Bémont et Jacob 1986, 84–9

Pferdehirt, B, 1986. Die römische Okkupation Germaniens und Rätiens von der Zeit des Tiberius bis zum Tode Trajans. Untersuchungen zur Chronologie südgallischer Relief-sigillata, *Jahrbuch des Römisch-Germanischen Zentralmuseums* 33, 221–320

Picon, M, 1973. *Introduction à l'étude technique des céramiques de Lezoux*, Dijon

Picon, M, 1987. Etude en laboratoire des céramiques sigillées dites du groupe I de Brive; note complémentaire, dans Moser et Tilhard 1987, 118–120

Picon, M, 1997. Les tubulures et les supports d'étagères du grand four à sigillées de La Graufesenque, et les céramiques calcaires de l'Antiquité, *Annales de Pegasus* 3, 69–72

Picon, M, 2002. Les modes de cuisson, les pâtes et les vernis de la Graufesenque: une mise au point, dans *Céramiques de la Graufesenque et autres productions d'époque romaine. Nouvelles recherches. Hommages à Bettina Hoffmann* (dirs M Genin et A Vernhet), Archéologie et Histoire Romaine 7, 139–164, Montagnac

Planck, D, 1975. *Arae Flaviae, Neue Untersuchungen zur Geschichte des römischen Rottweil*, Forschungen und Berichte zu Vor- und Frühgeschichte in Baden-Württemberg 6, 2 vols

RGZM samian = (Römisch-Germanisches Zentralmuseum Mainz). Samian research (http://www1.rgzm.de/samian/home/frames/htm)

Romeuf, A M, 2001. *Le quartier artisanal gallo-romain des Martres-de-Veyre (Puy-de-Dôme)*, Cahiers du Centre Archéologique de Lezoux 2/Revue Archéologique SITES, hors-série 41, Lezoux

Sarradet, M, et Lantonnat, M, 1991. Découvertes archéologiques aux Cébrades en août 1971, *Documents d'Archéologie Périgourdine* 6, 63-82

Sciau, Ph, Bouquillon, A, et Chabanne, D, 2007. Analyses des fragments de bustes, dans *La Graufesenque (Millau, Aveyron), vol I: Condatomagus, une agglomération de confluent en territoire Rutène II^es aC-III^es pC* (dir D Schaad), Éditions de la Fédération Aquitania, Études d'archéologie urbaine, 246–52, Pessac

Sciau, Ph, Dejoie, C, Relaix, S, et De Parseval, Ph, 2007. Les engobes d'un point de vue physico-chimique dans M Genin, *La Graufesenque (Millau, Aveyron). Volume II: Sigillées lisses et autres productions*, Editions de la Fédération Aquitania, Études d'archéologie urbaine, 20–33, Pessac

Terrisse, J R, 1968. *Les céramiques sigillées gallo-romaines des Martres-de-Veyre (Puy de Dôme)*, Gallia Suppl 19, Paris

Tilhard, J-L, 1977a. *Musée Archéologique de Saintes. La céramique sigillée. II. Les vases à décor moulé*, Saintes

Tilhard, J-L, 1977b. La céramique sigillée du Musée du Périgord; catalogue des marques de potiers, *Bull Soc Historique et Archéologique du Périgord* 104, 16–65

Tilhard, J-L, 1978. La céramique sigillée du Musée du Périgord; catalogue des vases moulés, *Bull Soc Historique et Archéologique du Périgord* 105, 88–164

Tilhard, J-L, 1985. Les estampilles sur céramique sigillée du Musée d'Agen, *Revue de l'Agenais* 112 (2), 189–213

Tilhard, J-L, 1990–1991. L'atelier de sigillée d'Espalion et ses rapports avec La Graufesenque, *Annales de Pégasus* 1, 38–48

Tilhard, J-L, 1991. Indices de localisation à Espalion d'un atelier de céramique sigillée, *Revue du Rouergue* 25, 25–50

Tilhard, J-L, 1993. Bilan des recherches sur les sigillées d'Espalion, *Vivre en Rouergue, Cahiers d'Archéologie Aveyronnaise* 7, 108–23

Tilhard, J-L, 1995. La céramique sigillée, dans *Architecture et vie privée. La domus des Bouquets, futur musée gallo-romain*, Catalogue d'exposition (Musée du Périgord– Périgueux, 1er juillet–9 octobre 1995), 91–9

Tilhard, J-L, 1996. Un nouvel atelier de sigillée: Espalion, *Dossiers d'Archéologie* 215, 20–3

Tilhard, J-L, 2004. *Les céramiques sigillées du Haut-Empire à Poitiers d'après les estampilles et les décors moulés*, Société Française d'Etude de la Céramique Antique en Gaule Suppl 2, Saint-Paul-Trois-Châteaux

Tilhard, J-L, 2005. Périgueux et Espalion: commercialisation et consommation des sigillées de l'atelier d'Espalion (Aveyron-France) à Périgueux. Bilan provisoire, *Documents d'Archéologie et d'Histoire Périgourdines*, 20, 25–44

Tilhard, J-L, Moser, F, et Picon, M, 1991. De Brive à Espalion; bilan des recherches sur un nouvel atelier de sigillée et sur les productions céramiques de Brive (Corrèze), *Société Française d'Etude de la Céramique Antique en Gaule: Actes du congrès de Cognac*, 229–258.

Tilhard, J-L, avec la collaboration de Bouquillon, A, Ciszak, R, Dejoie, C, Delage, R, Leon, Y, de Parseval, P, Martin, T, Moser, F, et Sciau, P, 2009. *Les céramiques sigillées d'Espalion (Aveyron, France), Localisation de l'atelier, productions, diffusion*, Documents d'Archéologie et d'Histoire Périgourdines Suppl 4/Aquitania Suppl 16

Vernhet, A, 1981. Un four de La Graufesenque (Aveyron): la cuisson des vases sigillés, *Gallia* 39, 25–43

Vernhet, A, 1990–1991. Signatures de décorateurs découvertes à La Graufesenque, *Annales de Pegasus* 1, 12–14

18 The influences on the designs of the potters at Lezoux

Robert A Pitts

I was honoured to be asked to contribute to Brenda's Festschrift. In the few years that I have known Brenda she has been a source of knowledge and encouragement to me and a good friend. She has always found time to point a 'new boy' in the right direction and give him sound advice, even when she has been very busy. I look forward to our friendship lasting many more years.

Production of samian pottery in Gaul was preceded by samian manufacture in Arezzo and other Italian centres, notably Pisa. A list of these centres can be found in the *Conspectus* (Ettlinger *et al* 1990). Production probably then moved to Lyon and La Graufesenque, Southern Gaul. According to Bet and Vertet (1986, 139), production commenced in Lezoux, Central Gaul, in the Augustan-Tiberian period. It is therefore interesting to compare the designs on decorated samian ware and potters' stamps from different production sites to try to establish the movement of ideas or even of the potters themselves, or their moulds or poinçons, from one area to another. In looking at the influences on the potters of Lezoux, this article includes examples from recent and as yet largely unpublished studies of rubbings of first century Lezoux ware which show great similarity to those of vessels from other areas.

Wells states that it is not clear why Arezzo became the main production site of samian in Italy, or why it ended up giving its name to it. Stamps such as ARR, ARRETI, ARRE/VERV were not the names of the potters but either the name of the city Arretium or the adjective Arretinum (Wells 2002, 24). The use of these stamps is especially evident in the potteries of Pozzuoli which seem to have used them in their exports. This was probably to try to link themselves with the red gloss pottery produced at Arezzo. Wells suggests that Arezzo exported not only pottery but potters as well. The one important centre outside Italy that was producing Italian-style samian at this period was situated at the La Muette site beside the river Saône at Lyon (Desbat 1997). It can be deduced that the potters who worked there came from Italy as the names appear to be similar, as do the stamps used, and they were producing genuine samian (Wells 2002, 25). Another kiln site was

at Loyasse, also at Lyon, but on the hill at Fourvières. The quality of the samian at Loyasse appears to be quite inferior to that from La Muette. We do not know any of the names of the potters from Loyasse, so we are left with the possibility that they were either less technically competent potters from Italy, or locals who were trying to imitate what they had seen and who were not very competent.

The next stage of development of Gaulish samian appears to have been at La Graufesenque, near Millau in Aveyron. Here they began by imitating Arretine forms prior to evolving the standard samian forms that eventually came to dominate the market. At La Graufesenque we find the introduction of potters with Celtic names as well as the Latin and Greek slave and family names found at Arezzo and La Muette. It is probable that these potters switched from making pottery in the local Gaulish tradition to imitating and making samian (Wells 2002, 25).

Although samian production started at Lezoux at much the same time as it did at La Graufesenque, this production was mainly for local consumption and only small quantities appear to have been exported. It is therefore not very surprising that we can see considerable links between the designs in use in the middle of the 1st century in Lezoux and those from La Graufesenque.

Catalogue

Let us now look at some examples of the evidence for the influences on the potters at Lezoux. In Figs 18.1–3 which follow, each pair of rubbings shows a Lezoux example to the left and its putative prototype to the right. The rubbings from the Hartley Lezoux excavations are from the Hartley Archive held at Cardiff University.

1) Drag 29 Hartley Lezoux excavations LAS 67 E.7 waster.
2) Drag 29 upper zone, stamped FIRMO FEC Tiberian kiln waster. Fosse Cirratus G80 H53, La Graufesenque (Dannell *et al* 2003, Firmo i, Taf G27, 3293).

The designs on these two rubbings from Lezoux and La

Fig 18.1: Catalogue Nos 1–8

Graufesenque, show certain similarities. It would appear that the star-shaped design between the two leaves in No. 1 has been influenced by the similar design in No. 2. Both are thought to be of Tiberian date.

3) Lezoux excavations unmarked sherd. Probably Sacer i.

4) Sherd in the style of Germanus of La Graufesenque. Lyon Musée Gallo Romaine.

The design that is of interest here is that of the dolphins, which is very similar in both cases and would therefore imply that the dolphin used by Germanus iii of La Graufesenque influenced the one produced by the Lezoux potter who was probably Sacer i. No. 3 is probably an Early Lezoux piece. There is an almost identical Drag 30, attributed by Rogers to Sacer i, in the Musée de Roanne (Rogers 1999, pl. 99.3)

5) Drag 29 upper zone, stamped by Atepomarus.

6) Drag 29 upper zone, Tiberian kiln waster. Fosse Cirratus G80 H53, La Graufesenque.

If No. 5 is compared with No. 6 it can be seen that the potter has incorporated elements of the same design. The rosette within the swirl is very similar to the rosette in Rogers identified as C173 (Rogers 1974).

7) Drag 29 upper zone Hartley Lezoux excavations LAS 67 N.2.

7.8) Drag 29 upper zone Hartley Lezoux excavations LAS 67 N.2.

8) Drag 29 upper zone, Tiberian kiln waster. Fosse Cirratus G80 H53, La Graufesenque.

A comparison of the leaves in the upper zone of No. 7 and the leaves from the upper zone of No. 8 shows a remarkable similarity between the two. A close-up of the leaf from a different Drag 29 is given in No. 7.8; it shows the same pair of leaves as in No. 8, and the star-shaped motif noted in Nos 1 and 2 above.

9) Drag 29 Upper zone. Hartley Lezoux excavations LAS 67 N.1.

10) Drag 29 upper zone, Tiberian kiln waster. Fosse Cirratus G80 H53, La Graufesenque.

The four-armed rosette between the trailing vegetation in the upper zone of No. 9 is very similar to the motif in the upper zone of No. 10, a Drag 29 kiln waster from La Graufesenque which has been dated to the Tiberian period.

11) La Graufesenque copy of an Arretine figure type. It has been recorded on an early Lezoux mould from Coulanges (Bet and Montinéri 1989).

The 'Medusa' head in No. 11 is a copy of an Arretine figure type that was used by the potters at La Graufesenque. It is similar to, but not the same as, a head used by the Arretine potters (Dragendorff and Watzinger 1948, Taf 17, 260). It has also been seen on an early Lezoux mould from Coulanges according to Philippe Bet (Bet and Montinéri 1989, fig 16.7).

12) Drag 29 lower zone, stamped MASCLOS.F. Lezoux Museum.

13) Drag 29 lower zone, stamped FIRMO FEC. Tiberian kiln waster. Fosse Cirratus G80 H53, La Graufesenque (Dannell et al 2003, Firmo i, Taf A6, 3268).

The design in the lower zone of No. 12 from Lezoux is very similar to that shown in No.13 which is from La Graufesenque. The latter has been dated to the Tiberian period.

14) Rubbing of leaf from a Drag 37 from the Lezoux excavations attributed by Brian Hartley to Sacer i I. (JH64 J (4)).

15) Detail Ca 110 from the Cala Culip cargo of La Graufesenque samian dated *c* AD 82 (Nieto and Puig 2001).

These leaf designs appear to be almost identical clearly demonstrating the influence of the La Graufesenque potters on their counterparts at Lezoux.

16) Leaf detail from an unmarked Drag 37. Hartley Lezoux excavations (No. 18 below; *cf* Hopkins no. 17 this volume).

17) Detail Ca 62 from the Cala Culip cargo of La Graufesenque samian (Nieto and Puig 2001).

Again, the leaf designs are almost identical.

18) Unmarked Drag 37. Hartley Lezoux excavations.

19) La Graufesenque, 'Cluzel 15' deposit *c* AD 60 (Depôt de Fouilles, ACL276).

The leaves and trailing design on the Drag 37 from Lezoux are similar to those on the La Graufesenque vessel.

20) Drag 29 upper zone. Stamped SACROM[. Neronian. Augst. (Early Lezoux files at Leeds pers comm B Dickinson).

21) Drag 29 stamped VIRTHVS (T and H ligatured). Cala Culip cargo of La Graufesenque samian *c* AD 82 (Nieto and Puig 2001, no. 160).

The hunting scene shown on No. 20 from Lezoux, stamped SACROM[is very similar to that shown as No. 21, stamped VIRTHVS from La Graufesenque.

22) Mask used as an ovolo frieze. Drag 11 Arretine crater, Pitt-Rivers Collection, Salisbury and South Wilts Museum. (Hopkins 2005,123, fig 3,10).

23) Oswald 1291A used as an ovolo frieze. Drag 37 Hooper St London.

The last comparison that we shall make is between that used as an ovolo frieze on an Arretine Drag 11 crater and that which was used as an ovolo frieze on a Lezoux Drag 37. Again the similarity between the two is apparent.

Conclusions

George Rogers appears to have seen the potters of the late 1st century and early 2nd century at Lezoux as the source

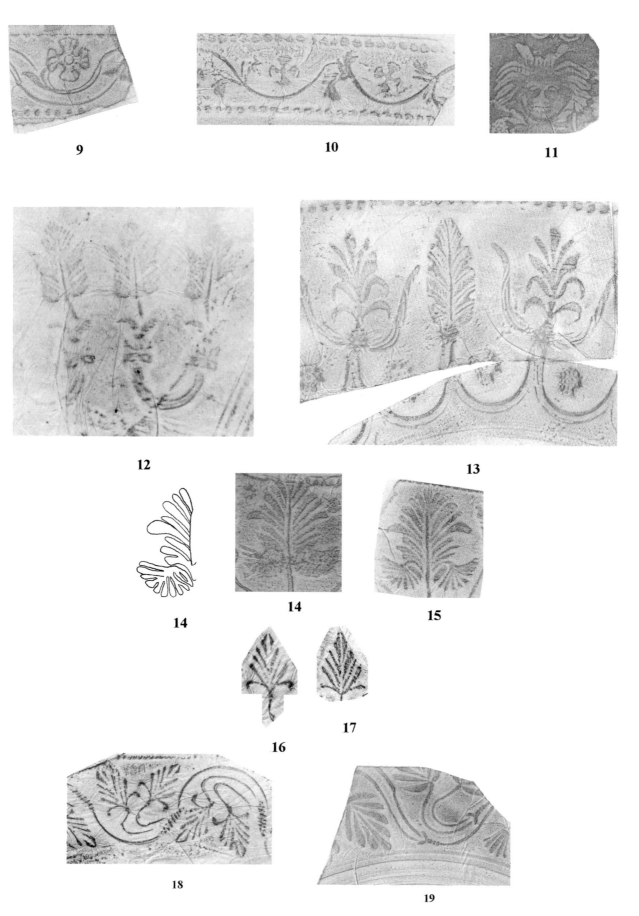

Fig 18.2: Catalogue Nos 9–19

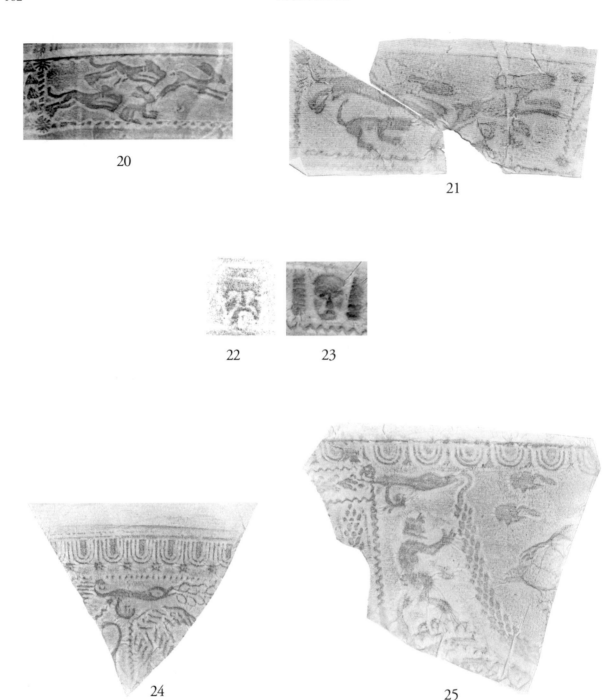

Fig 18.3: Catalogue Nos 20–25

of the designs which predominate at the beginning of the main export period *c* AD 120. As a result of this, he starts his major publications on Central Gaul (Rogers 1974; 1999) at around AD 90. Certainly this would appear to be a moment of change and we may suggest this is at least partly due to the influence of the prolific South Gaulish potter Germanus on the Central Gaulish potters Sacer I and the one designated X-0 by Rogers (Rogers 1974; 1999). This is aptly demonstrated by reference to the rubbings of a design on two Drag 37s by Germanus and X-0 in the museum at Lyon (Fig 18.3, Nos 24 and 25)

The influence of the potter X-0 on the potter X-1 can

be seen in the work of the Trajanic potters at Les Martres-de-Veyre. X-1 was either a contemporary working towards the end of the time of X-0 or was his immediate successor. Among these potters at Les Martres-de-Veyre are the potters X-2, X-3, the Potter of the Rosette, X-8, X-9, X-11, X-12, and X-13. Where some of these potters' stamps are found, they are thought to be name stamps and not necessarily the makers of the mould. An example of why this should be so can be seen on a vessel that is stamped MEDETVS but is in the style of X-2 (Terrisse 1968, pl 43, 1210).This influence is assumed to have been the cause behind one of the main lines of development at Lezoux which can

be seen in the work of the Sacer ii-Attianus partnership, followed in turn by Cinnamus.

The examples illustrated above suggest that the potters of 1st and early 2nd century Lezoux were at least as accomplished as their counterparts at La Graufesenque and Les Martres-de-Veyre in the production of poinçons and moulds. It is not surprising that they drew inspiration for their designs from the larger production centres. Being situated on river systems with direct access to the north, they were better placed than the potteries of South Gaul to exploit the North Gaulish, German and British markets. What is perhaps most surprising is that it took the merchants, who, it is generally assumed, controlled the all important marketing side of samian production, so long to realise the full potential of Lezoux as a manufacturing centre.

Acknowledgements

I am indebted to Robert Hopkins for providing me with the details of the designs above. Also to Dr Peter Webster, Geoff Dannell, Brenda Dickinson (for the Augst rubbing) and Elizabeth Hartley for permission to use their rubbings, and to Joanna Bird for help and advice. I am particularly indebted to Brenda Dickinson for her friendship, guidance and support.

Bibliography

Bet, P, and Montinéri, D, 1989. La céramique sigillée moulée tibéro-claudienne du site de la Z.A.C. de l'enclos à Lezoux, *Société Française d'Etude de la Céramique Antique en Gaule: Actes du Congrès de Lezoux 1989*, 55–69

Bet, P, and Vertet, H, 1986. Centre de production de Lezoux, in *La terre sigillee gallo-romaine. Lieux de production du Haut Empire: implantations, produits, relations* (eds C Bémont and J-P Jacob), Documents d'Archéologie Française 6, 138–44, Paris

Bird, J, 2005. The lion and the mule: from lamps to samian, in *Image, craft and the classical world: essays in honour of Donald Bailey and Catherine Johns* (ed N Crummy), Monogr Instrumentum 29, 69–79, Montagnac

Boon, G C, 1967. Micaceous sigillata from Lezoux at Silchester, Caerleon, and other sites, *Antiq J* 47, 27–42

Dannell, G B, Dickinson, B M, Hartley, B R, Mees, A W, Polak, M, Vernhet, A, and Webster, P V, 2003. *Gestempelte südgallische Reliefsigillata (Drag 29) aus den Werkstätten von La Graufesenque, gesammelt von der Association Pegasus Recherches Européennes sur La Graufesenque*, Römisch-Germanisches Zentralmuseum, Kataloge Vor- und Frühgeshichtlicher Altertümer 34 (13 vols), Mainz

Déchelette, J, 1904. *Les vases céramiques ornés de la Gaule Romaine*, 2 vols, Paris

Desbat, A, 1997. Les productions des ateliers de potiers antiques de Lyon. 2: Les ateliers du Iᵉ s. après J.-C, *Gallia* 54, 1–119

Dragendorff, H, and Watzinger, C (ed), 1948. *Arretinische Reliefkeramik mit Beschreibung der Sammlung in Tübingen*, Reutlingen

Ettlinger, E, Hedinger, B, Hoffmann, B, Kenrick, P M, Pucci, G, Roth-Rubi, K, Schneider, G, von Schnurbein, S, Wells, C M, and Zabehlicky-Scheffenegger, S, 2002. *Conspectus formarum terrae sigillatae italico modo confectae*, Materialen zur römisch-germanischen Keramik 10, Bonn

Hopkins, R, 2005. The Pitt-Rivers collection of samian ware in the Salisbury and South Wiltshire Museum, in *An archaeological miscellany: papers in honour of K F Hartley* (eds G B Dannell and P V Irving), *J Roman Pottery Stud* 12, 117–25, Oxford

Martin, J, 1942. L'évolution des vases sigillés ornés de Lezoux, au premier siècle de notre ère, *Bull Hist et Scient de l'Auvergne* 62, 181–209

Mees, A W, 1995. *Modelsignierte Dekorationen auf südgallischer Terra Sigillata*, Forschungen und Berichte zur Vor- und Frühgeschichte in Baden-Württemburg, 54, Stuttgart

Nieto, X, and Puig, A M, 2001. *Excavacions arqueològiques subaquàtiques a Cala Culip, 3. Culip IV: la terra sigil. lata decorada de la Graufesenque*, Monografies del Centre d'Arqueologia Subaquàtica de Catalunya 3, Girona

Oswald, F, 1937, Carinated bowls (form 29) from Lezoux, *J Roman Stud* 27, 210–4

Piboule, A, Senechal, R, and Vertet, H, 1981. *Les potiers de Lezoux du premier siècle: Titos*, Revue Archéologique SITES, hors-série 8, Avignon

Rogers, G B, 1974. *Poteries sigillées de la Gaule centrale I: les motifs non figurés*, Gallia Suppl 28, Paris

Rogers, G B, 1999. *Poteries sigillées de la Gaule centrale II: les potiers*, Cahier du Centre Archéologique de Lezoux 1/Revue Archéologique SITES, hors-série 40 (2 vols), Lezoux and Gonfaron

Stanfield, J A, and Simpson, G, 1958. *Central Gaulish potters*, London

Stanfield, J A, and Simpson, G, 1990. *Les potiers de la Gaule centrale*, Revue Archéologiques SITES, hors-série 37, Gonfaron

Terrisse, J, 1968. *Les céramiques sigillées gallo-romaines des Martres-de-Veyre*, Gallia Suppl 19, Paris

Wells, C M, 2002. 'Imitations' and the spread of sigillata manufacture, in E Ettlinger *et al* 2002, 24–5

19 New Central Gaulish poinçons

Robert Hopkins

My wife and I became acquainted with Brenda Dickinson in the early 1990s, when we attended Peter Webster's samian day schools in Cardiff. A few years later, we met Brenda again when we were invited to participate in Geoff Dannell's annual samian recording sessions at La Graufesenque. Brenda has many passions, one being the many facets of the English language, especially keeping up with 'street slang'; it never ceases to amaze us how she can come up with answers to the most cryptic of crosswords. Both Wendy and I value Brenda's friendship and sense of humour, and long may it continue

The study of decorated Central Gaulish samian ware relies heavily on the poinçon catalogues compiled by Felix Oswald, George Rogers, and to a lesser extent, Joseph Déchelette. Although there are criticisms to be made of each work, it is to each author's credit that relatively few 'new' Central Gaulish poinçons can be added to the repertoire.

The figures and motifs presented below are a selection of new poinçons that have been identified during the course of research on Central Gaulish samian. Most are taken from unpublished rubbings, although some have been published as part of the decorative scheme on sherds in various site reports. Several examples are already well known, having previously been catalogued in the standard reference works, but they are reproduced here as rubbings because they add to or clarify what has previously been published. Others demonstrate that a number of similar poinçons are represented in the literature by just one existing catalogue entry. There are numerous papers and books written on individual potters which contain poinçon catalogues, and those dies have not been duplicated here.

We are very fortunate to have access to sherds, moulds, rubbings and casts from the excavations at Lezoux undertaken by B R Hartley, Professor S S Frere and Hugues Vertet in the 1960s. These are currently being studied by Dr Peter Webster's samian students at the Department of Lifelong Learning, Cardiff University, for eventual publication on the internet. Research into Central Gaulish samian has only just started, and more will undoubtedly appear.

Catalogue

Note: all mould impressions have been reversed to give the impression seen on a bowl. Some rubbings have been taken from Plaster of Paris casts of moulds, and consequently the exact size of the original impression cannot be guaranteed. There is, however, no obvious shrinkage where we have both an original mould and its plaster cast. Several examples of the same poinçon have been reproduced if it adds to or clarifies the image. Dating of the poinçons is based on stylistic grounds, on other dated examples, or on the currency of the forms. Abbreviations: O = Oswald (1936–7); R = Rogers' motifs and figures (1974 and 1999). Sherds recorded in museum collections are cited with the accession numbers – if known – at the time of recording. The Lezoux references relate to site codes and contexts from Brian Hartley's excavations at Audouard-Gagnadre (AUD), Jardin de l'Hôpital (JH) and Chantier Lasteyras at Lezoux (LAS), although not all were initialled with a site reference.

1) Ovolo, double-bordered, tongue to the left, ending in a rosette, which, because of the amount of wear, looks like a 'blob'. This is not a worn version of R.B18, as the central core is more ovoid. Drag 37, attributed by B Hartley to the potter Austrus. Lezoux 1964 AUD A.I.5. *c* AD 125–145.

2) Ovolo, double-bordered, with a narrow central core; tongue appears to be attached to the right, indistinct terminal. Drag 37, possibly by the anonymous potter, Rogers' P-8 (1999). Castleford vicus Trench 10, context 254 (Dickinson and Hartley 2000, fig 36, 1019). *c* AD 125–145.

3) Ovolo, single-bordered, tongue to the left, ending in a 'chisel' tip turning very slightly towards the egg. Drag 37, attributed to Tetturo. Castleford vicus Trench 10, context 342 (Dickinson and Hartley 2000, fig 37, 1025). *c* AD 130–160.

4) Ovolo, double-bordered, tongue to the left, and appears to be beaded. The egg is unusually flat-bottomed giving a squarish appearance. Drag 37, unattributed. Caerwent, Newport Museum CWT 123. ?Antonine.

Fig 19.1: Catalogue Nos 1–41

5) Ovolo, single-bordered, tongue to the left, with a solid ovoid terminal. The egg is slightly asymmetric. Drag 11, stamped within the decoration with the rectangular, two-line stamp of Nonnus(?), die 1a. Lezoux LAS 1967 T3. Tiberian.

6) Ovolo, double-bordered, no central core, no tongue. Drag 37, unattributed. Lezoux 64 JH V (6). Flavian–Trajanic.

7) Ovolo, double-bordered, with a broken core and beaded tongue ending in a trifid tassel. This corrects

R.B144: the bottom segment of the tongue actually ends in a trifid tassel rather than a bead as previously thought. Drag 37, Cinnamus style. Private collection. *c* AD 135–150+.

8) Ovolo, double-bordered, with a broken core and beaded tongue ending in a bifid or trifid tassel. Appears to be a reduced version of R.B144; could this be R.B182? Drag 37, Cinnamus style. Bavay Museum 772 4672. Antonine.

9) Oval 'cat's eye' ovolo; *cf* R.B213 (Libertus etc) for a smaller version. The tongue, to the right, is divided into small square beads, and ends in a large square terminal. Drag 37 mould, unattributed. Lezoux 1964 AUD E III (7). Flavian–Trajanic.

10) Ovolo, double-bordered, slightly asymmetric, no tongue; used as the base of a nautilus gadroon. Drag 29, unattributed. Lezoux LAS 67 G.7. Tiberian.

11) Ovolo, double-bordered and 'heart-shaped'; used as the base of a nautilus gadroon. Drag 29, unattributed. Lezoux LAS 67 N.2. Tiberian.

12) Column, made up of two separate elements; the base and stem appear to be a single poinçon, the spray leaf is a separate punch, *cf* No. 92 for a second example. Drag 37 mould, rubbing of a plaster cast; attributed by B Hartley to the potter 'A-6' = Rogers' potter(s) P-6 group (1999). Lezoux B.IX.2. Flavian – Trajanic.

13) Vine scroll, an improvement on R.M5. Form not noted; attributed by B Hartley to Austrus. Lezoux 1964 AUD A.I.5. *c* AD 125–145.

14) Leaf. Drag 29, stamped MASCLOS·F. Lezoux Museum 986.2.7. Tiberian.

15) Leaf; *cf* R.J38 for similar. Drag 29, unattributed. Lezoux LAS 67 G.5. Tiberio–Claudian.

16) Leaf. Drag 37, signed in the mould D]RUSUSF retrograde. Castleford vicus Trench 10, context 472 (Dickinson and Hartley 2000, fig 38, 1030). The same leaf appears on a Drag 37 from Alcester, attributed to the potter Attianus, or someone associated with him (Hartley *et al* 1994, fig 48, 201). *c* AD 125–145.

17) Leaf, *cf* R.J114 for similar, very nearly identical to a leaf on several La Graufesenque vessels from the Cala Culip IV shipwreck (Nieto and Puig 2001, Ca. 62). Form not noted; unattributed. Lezoux excavations, unmarked. Flavian – Trajanic.

18) Leaf. Drag 37, attributed to Cettus of Les Martres-de-Veyre. Castleford vicus Trench 10, context 908 (Dickinson and Hartley 2000, fig 40, 1040). *c* AD 135–160.

19) Leaf. Drag 29, unattributed. Lezoux 63 B.XIV.1. Neronian – Flavian.

20) Leaf. Drag 29, unattributed. Lezoux (?)LAS 67 R.3. Tiberian.

21) Leaf. Drag 29, stamped MASCLOS·F. Lezoux Museum 986.2.7. Tiberian.

22) Leaf. Drag 29, upper zone, unattributed. Musée Gallo-Romain, Lyon. Neronian.

23) Leaf. Drag 29, unattributed. Lezoux LAS 67 L.3. Neronian–Flavian.

24) Leaf. Drag 29, unattributed. Lezoux LAS 67 N.1. Tiberio–Claudian.

25) (?)Wheat ear. Drag 29, unattributed. Lezoux LAS 67 N.2. Tiberian.

26) Leaf. Drag 29, unattributed. Lezoux LAS 67 O.1. Tiberio–Claudian.

27) (?)Oak leaf. Drag 29, unattributed. Lezoux LAS 67 N.1. Tiberio–Claudian.

28) Serrated leaf. Drag 29, unattributed. Lezoux LAS 67 O.3. Tiberian.

29) Serrated leaf. Drag 37, unattributed. Lezoux 64 JH V (4). Trajanic.

30) Leaf. Drag 29, unattributed. Lezoux 63 B.XIV.1. Claudio–Neronian

31) Bifid leaf. Presumably left and right hand sections of same poinçon. Drag 37 attributed by B Hartley to the potter Austrus. Lezoux 1964 AUD A.I.2. *c* AD 125–145.

32) Bifid leaf, here used as a wreath. Drag 37, attributed by B Hartley to the potter Austrus or an associate. Lezoux 1965 LAS VIII.4. *c* AD 125–145.

33) Bifid leaf. Drag 37, attributed by B Hartley to Austrus or an associate. Lezoux 1965 LAS VIII.4. *c* AD 125–145.

34) Bifid leaf. Drag 29, unattributed. Lezoux LAS 67 O.3. Tiberio–Claudian.

35) Bifid leaf. Drag 29, unattributed. Lezoux LAS 67 H.+. Tiberian.

36) Maltese cross. Drag 29, unattributed. Lezoux LAS 67 N.1. Tiberio–Claudian.

37) Leaf cruciform, an improvement of R.U9. Drag 29, unattributed. Lezoux LAS 67 O.2. Tiberian–Hadrianic.

38) Leaf cruciform. Drag 29, unattributed. Lezoux LAS 67 H. 7a. Tiberian.

39) Pointed circle, similar to, but different from R.U21. Drag 29, unattributed. Lezoux LAS 67 H. 7a. Tiberian.

40) Cruciform. Drag 37, Les Martres-de-Veyre fabric, attributed to X-4/Igocatus; the motif also occurs on an X-4/Igocatus sherd from Les Martres-de-Veyre (Romeuf 2001, pl 48, 5). Orléans Museum. *c* AD 100–120.

41) 'Cushion'. Drag 37, attributed to Cinnamus. Alcester pit DII 29A (Hartley *et al* 1994, fig 51, 280). It also appears on a Cinnamus sherd from Mumrills (Hartley 1961a, fig 8, 1). *c* AD 150–180, although the Alcester pit group is dated *c* AD 150–160.

42) Striated column, lain horizontally to represent grass tufts. Drag 37, stamped S CROTICI retrograde (Sacroticus). Castleford vicus Trench 10 context 058 (Dickinson and Hartley 2000, fig 33, 1006). *c* AD 130–155.

43) Curved leaf, used as a wreath. Drag 29, unattributed. Lezoux LAS 67 N.1. Tiberio–Claudian.

44) Curved leaf, used as a basal wreath. Drag 29, unattributed. Lezoux LAS 67 N.1. Tiberio–Claudian.

45) Trifid leaf, used in the upper zone scroll. Drag 29, unattributed. Lezoux LAS 67 O.3. Tiberio–Claudian.

46) Trifid leaf, used in the upper zone scroll. Drag 29, unattributed. Lezoux LAS 67 O.3. Tiberio–Claudian.

47) Leaf cruciform, used in the upper zone scroll of two different Drag 29s, unattributed. Lezoux LAS 67 O.1 (47a) and Lezoux LAS 67 N.2 (47b). Tiberio–Claudian.

48) (?)Leaf, used as a scroll 'in-fill'. Drag 29, unattributed. Lezoux LAS 67 W.53. Tiberio–Claudian.

49) Bifid leaf, used in an upper zone scroll. Drag 29 with a stamp within the decoration: NICF. Lezoux (unmarked). Tiberio–Claudian.

50) Bifid leaf, used in an upper zone scroll. Drag 29, unattributed. Lezoux LAS 67 N.1. Tiberio–Claudian.

51) 'Tulip' leaf, similar to a leaf on a Drag 29 from Sea Mills (Boon 1967, fig 1, 9b); however the central stem of our example ends in a bifid leaf, rather than a single bud as at Sea Mills. Drag 29, unattributed. Lezoux LAS 67 H.+. Tiberio–Claudian.

52) Small 'tulip' leaf, used as a horizontal wreath in an upper zone. The central stem ends in a four-tipped leaf spray. Drag 29, unattributed. Lezoux LAS 67 H. 7a. Tiberian.

53) Nautilus terminal ending in a 'feather'. Drag 29, unattributed. Lezoux LAS 67 N.1. Tiberio–Claudian.

54) Nautilus terminal ending in an 'oval'. Drag 29, unattributed. Lezoux LAS 67 E.7. Tiberio–Claudian.

55) Palisade motif topped with a hollow circle. The body appears to be decorated with cross-hatching. Drag 29, unattributed. Musée Gallo-Romain, Lyon. Mid-1st Century.

56) Striated motif. A second example suggests that the base looks part of it rather than added. Drag 30, unattributed. Lezoux 64 JH V (11). Flavian–Trajanic.

57) Striated motif. Drag 29, unattributed. Lezoux LAS 67 N.2. Tiberian.

58) Straight gadroon. Drag 37, attributed by B Hartley to the potter Austrus. Lezoux 1965 AUD VIII.4. *c* AD 125–145.

59) Straight gadroon. Form not noted (?Drag 37), attributed by B Hartley to the potter Austrus. Lezoux 1964 AUD A.I.5. *c* AD 125–145.

60) 'S' motif, used as a wreath. Drag 37, unattributed. Watling House, London. Flavian–Trajanic.

61) Spiral, used as a suspended motif between festoons. Form not noted; attributed by B Hartley to the potter Austrus. Lezoux 1964 AUD. *c* AD 125–145.

62) Festoon, or, more probably a medallion, made up of small double-bordered circles; note the parallel guide lines, *cf* R.E24 and R.F75 for similar. Drag 29, Lezoux LAS 67 above PSH 4. Flavian–Trajanic.

63) Chevron wreath. Drag 37, attributed to Cinnamus. Alcester pit DII 29A (Hartley *et al* 1994, fig 51, 280). It also appears on a Cinnamus sherd from Mumrills (Hartley 1961a, fig 8, 1). *c* AD 150–180, although the Alcester pit group is dated *c* AD 150–160.

64) Trifid leaf, used as a wreath. Drag 37, unattributed. Lezoux (?)JH I 4. Flavian–Trajanic.

65) 'Y' motif, used as a scroll or festoon. Drag 29, unattributed. Lezoux LAS 67 E.7. Claudio–Neronian.

66) Rosette, used as fillers in upper zone scrolls. Drag 29, unattributed. Lezoux LAS 67 N.1. Tiberio–Claudian.

67) (?)Trophy/cup. *cf* R.U107 for similar. Used as part of a horizontal, composite 'Y' motif in an upper zone. Drag 29, unattributed. Lezoux LAS 67 N.2. Tiberian.

68) (?)Trophy/cup. *cf* R.U107 for similar. Drag 29, unattributed. Lezoux LAS 67 G+. Tiberian.

69) Acorn, used as a terminal. Drag 29, unattributed. Lezoux LAS 67 H.+. Tiberian.

70) Tiered cup. An improvement on R.T37, it also appears on stamped bowls of Austrus from Lezoux. Form not noted. Lezoux 1964 AUD A.I.5. *c* AD 125–145.

71) 'Arrowheads'; appear to be a panel filler of an upper zone. Drag 29, unattributed. Lezoux 63 B.VI.20 Neronian–Flavian.

72) Mask, female, facing forward. Drag 37, attributed to Geminus. Castleford vicus Trench 10, context 299 (Dickinson and Hartley 2000, fig 36, 1022). *c* AD 125–145.

73) Mask, bearded man facing forward. Drag 29, unattributed. Lezoux LAS 67 O.2. Tiberian.

74) Head, male facing right, wearing a helmet or peaked cap. Drag 29, unattributed. Lezoux LAS 67 S+. Tiberian.

75) Head, facing front with a circular 'medallion' in the centre of the forehead, a crown/ tiara/ diadem or priestly head-dress. Drag 29, unattributed. Lezoux LAS 67 N.2. Tiberian.

76) Small (?)male figure. Drag 37, by a member of the Quintilianus group. Castleford vicus Trench 10, context 097 (Dickinson and Hartley 2000, fig 33, 1011). *c* AD 125–150.

77) Figure, legs only. (?)Drag 37, attributed by B Hartley to the potter Austrus. Lezoux 1964 AUD A.I.6. *c* AD 125–145.

78) Venus, smaller than O.286, but larger than O.286A. Drag 30, attributed to Cinnamus' early style. Castleford 'pottery shop', Level 3 Site 1(74); 3 (Dickinson and Hartley 2000, fig 19, 290). *c* AD 125–150.

79) Seated (?)female. Drag 37, stamped ALBVCI. Castleford vicus Trench 10, context 910 (Dickinson and Hartley 2000, fig 40, 1043). *c* AD 150–180.

80) Seated figure. Drag 37, unattributed, but associated with Illixo and Rogers' P–16 (1999). Castleford vicus Trench 10, context 951 (Dickinson and Hartley 2000, fig 40, 1044). *c* AD 130–150.

81) Abundance/Ops with cornucopia, an improvement on O.357A. Drag 37, unattributed. Cambria Archaeology education collection. Site unknown, but marked A76 1797. Pre-export Lezoux *c* AD 100–120.

82) Scarf dancer; the nearest parallel for size is O.361A which has been restored by Oswald. Drag 37, loosely

Fig 19.2: Catalogue Nos 42–71

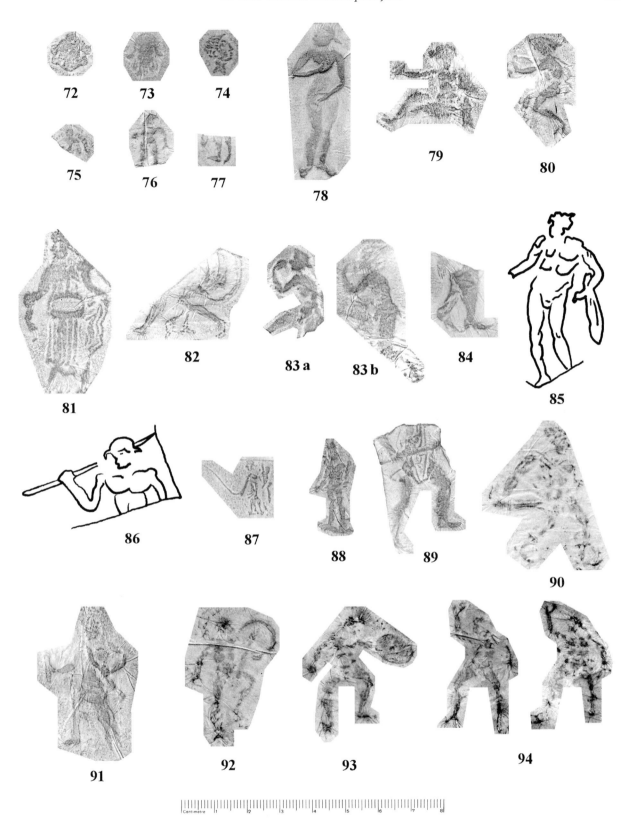

Fig 19.3: Catalogue Nos 72–94

attributed to Paternus III (Leeds Potters' Index Paternus iv). Castleford vicus Trench 10, context 239 (Dickinson and Hartley 2000, fig 36, 1018). *c* AD 135–165.

83) Feeding figure or boxer, an improvement on R.3071.

(83a) Drag 37, attributed to (?)Albucius. Caerwent, Newport Museum D2/4/211. Antonine. A second example from Caerwent, is attributed to potter X-13, Newport Museum 97.85. (83b) Drag 37, attributed

to Paternus III (Leeds Potters' Index Paternus iv). Priory Street, Carmarthen, context 6912 (Webster 2003, fig 7.8, no. 130a). A fourth example comes from the Steene-Pitgam area, near Dunkirk, attributed to Birrantus (Bird *et al* 1999, no. 22). *c* AD 100–155.

84) Figure walking to the right, wearing pointed shoes or boots. Drag 37, unattributed. Castleford vicus Trench 10, context 078 (Dickinson and Hartley 2000, fig 33, 1007). Hadrianic–Antonine.

85) Mercury, with missing right hand. The nearest Oswald equivalent is O.535, with a stick/staff in the right hand, although it is larger than our example. Drag 37, attributed to Paternus II (after Hartley 1961b, fig 8, 36). *c* AD 150–180. Two further examples are known, a Drag 37 stamped ANVNIM retrograde (Anunus II) from Exeter (Dannell 1991, fig 18, 119), *c* AD 150–180; the other a Drag 37 in the Pitt-Rivers/ Cranborne Chase Gallery in Salisbury and South Wiltshire Museum, in the style of the Cinnamus group (personal observation), *c* AD 140–180.

86) (?)Satyr, resting a stick over his right shoulder, *cf* O.604. Drag 37, attributed to the potter X-2. Les Martres-de-Veyre, Inv. 82.24a4 (after Romeuf 2001, pl 43, 5). *c* AD 100–120.

87) Abundance/Ops with cornucopia and (?)wand. Drag 29 upper zone, unattributed. Lezoux LAS 67 O.5. Tiberian.

88) Small figure, possibly carrying a staff. Drag 37, unattributed. Castleford vicus Trench 10, context 332 (Dickinson and Hartley 2000, fig 36, 1024). *c* AD 130–150.

89) (?)Bestiarius with lance. Drag 29, unattributed. Lezoux LAS 67 O.1 Flavian–Trajanic

90) Warrior advancing to the right with a sword; similar to, but not O.188; a second example of the warrior from Vindolanda (1992 VY 10, 15, 16 and 26). O.188 is a 'real' figure, *cf* a stamped Cinnamus bowl from Alcester (Hartley *et al* 1994, fig 53, 290). Drag 37 mould, rubbing of a plaster cast; unattributed. Lezoux excavations, unmarked. Pre-export Lezoux *c* AD 100–120.

91) (?)Archer. Drag 37, stamped S CROTICI retrograde (Sacroticus). Castleford vicus Trench 10 context 058 (Dickinson and Hartley 2000, fig 33, 1006). *c* AD 130–155.

92) Warrior with shield. Drag 37 mould, rubbing of a plaster cast; attributed by B Hartley to the potter 'A-6' (Rogers' potter(s) P-6 group (1999)). Lezoux B.IX. *c* AD 100–120.

93) Warrior with shield. Drag 37 mould, rubbing of a plaster cast; attributed by B Hartley to the potter 'A-6' (Rogers' potter(s) P-6 group (1999)). Lezoux B.IX.2. *c* AD 100–120.

94) Man, right arm raised and legs akimbo. Drag 37 mould, rubbing of a plaster cast; attributed by B Hartley to the potter 'A-6' (Rogers' potter(s) P-6 group (1999)). Lezoux B.IX.2. *c* AD 100–120.

95) Warriors with shields and swords. The warrior on the left appears to be a complete example of R.3105; the detail of the right hand figure suggests that it is R.3144; the two figures appear to be identical, and we can tentatively suggest that R.3105 = R.3144. Drag 37 waster; attributed by B Hartley to the potter 'A-6' (Rogers' potter(s) P-6 group (1999)). Lezoux 1964 AUD Pit E B.IV.9. *c* AD 100–120.

96) Perseus. Superficially identical to O. 234 (*cf* Rogers P-6A (1999) for an example of the mis-identification), but our example's baton is much longer; he has no drapery on the left arm; there is also a slight difference in the torso modelling, and the angle of the right arm is different. Drag 37 mould, rubbing of a plaster cast; attributed by B Hartley to the potter 'A-6' (Rogers' potter(s) P-6 group (Rogers 1999 Pl.122,4)). Lezoux 1964 AUD Pit E B.III.4. *c* AD 100–120.

97) Standing male, facing front. Drag 30, unattributed. Silchester, unmarked. Tiberian.

98a) Seated Apollo, O.83 with broken chair leg, replaced by a dolphin motif. Drag 37, stamped ANVNIM retrograde, Rogers' Anunus II (after Rogers 1999, pl 4, 3). Musée des Antiquités Nationales. *c* AD 140–160.

98b) Seated Apollo, O.83 with broken chair leg, replaced by a dolphin motif. Drag 30, attributed to Anunus II (after Rogers 1999, pl 4, 10). Newstead *c* AD 140–160.

98c) Seated Apollo, O.83 with broken chair leg, replaced by a diamond motif. Drag 37, attributed to Anunus II by Rogers (after Rogers 1999, pl 4, 5), and attributed to the Paullus group by Hartley (1961b, fig 8, 24). Littlechester (LP f 2). *c* AD 140–175.

98d) Seated Apollo, O.83 with broken chair leg, replaced by a diamond motif, R.U46. Drag 37, attributed to Aventinus (*cf* Stanfield and Simpson 1958, pl 156, 6). Caerwent, Newport Museum D2/3/69. *c* AD 120–140.

It is probable that we are dealing with a single broken poinçon, and that the mould-maker(s) are replacing the missing leg with the most suitable poinçon to hand. There is a difference in size: No. 98b appears larger than the others, but this is probably an error by Rogers. Other examples of the diamond replacement have been noted on bowls in the style of Cinnamus – Cerialis at the Castleford Pottery Shop (Dickinson and Hartley 2000, nos. 295–337). A connection to the Cinnamus workshop for the origin of the broken poinçon is evident from a Drag 37 stamped by Cinnamus from Carlisle (die 5a; CAR 81 CST B513 1140).

99) Hoofed animal, probably a horse, partially obscured by a nude Venus. Drag 37, unattributed. Lezoux 64 JH V (4). Flavian–Trajanic.

100) Large stag running to the left. Drag 37, stamped S CROTICI retrograde (Sacroticus). Castleford vicus Trench 10 context 058 (Dickinson and Hartley 2000, fig 33, 1006). *c* AD 130–55.

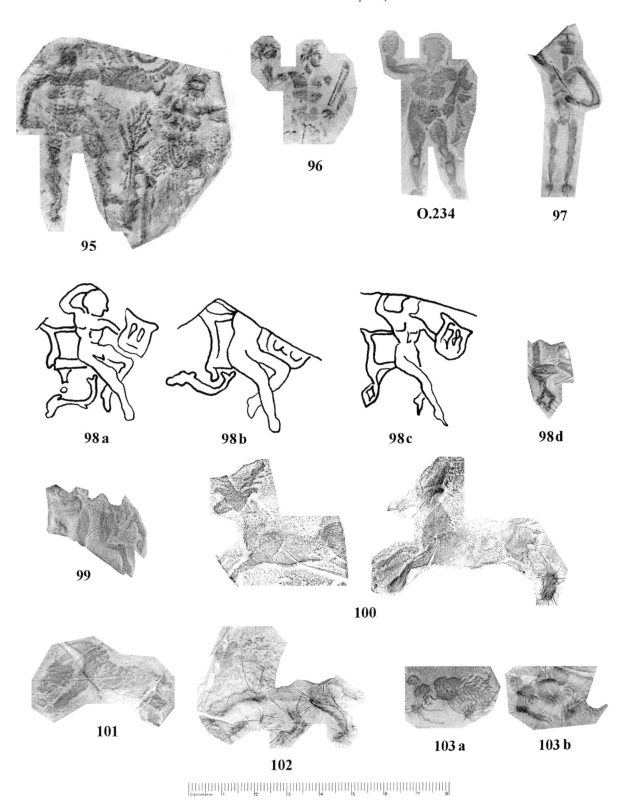

Fig 19.4: Catalogue Nos 95–103

101) Boar to the left. Drag 37, potter known, but anonymous. Castleford vicus Trench 10 context 448 (Dickinson and Hartley 2000, fig 37, 1028). *c* AD 125–40.

102) Lion to the left, used in a freestyle scheme. Drag 37 stamped SENILA.F (Senila). Castleford vicus Trench 10 context 127 (Dickinson and Hartley 2000, fig 34, 1012). *c* AD 125–50.

Fig 19.5: Catalogue Nos 104–116

103a) Lion's head and front legs, to the left, within a festoon. Drag 37, attributed by B Hartley to the potter Austrus. Lezoux 1964 AUD A.I.5. *c* AD 125–45.

103b) Lion's head and front legs, to the left, within a festoon. Drag 37, attributed by B Hartley to the potter Austrus. Lezoux 1964 AUD A.I.3. *c* AD 125–45.

104) (?)Dog running to the left. Drag 29 mould, unattributed. Lezoux LAS 67 B +. Tiberio – Claudian.

105) Crouching (?)dog. Drag 29, unattributed. Lezoux LAS 67 G 5. Tiberio–Claudian.

106) Dog running to the left. Drag 37 stamped SENILA. F (Senila). Castleford vicus Trench 10 context 127 (Dickinson and Hartley 2000, fig 34, 1012). *c* AD 125–50.

107) Dog running to the left. Drag 11, stamped within the decoration with a rectangular, two-line stamp of Nonnus(?), die 1a. Lezoux LAS 1967 T3. Tiberian.

108) Dog running to the right (the decorative scheme shows it chasing hares). Drag 29, unattributed. Lezoux 63 B.V.8. Neronian–Flavian.

109) Dog running to the right. Drag 37, attributed to Cerialis (Cinnamus). Alcester D II 28 (Hartley et al 1994, no. 160). *c* AD 135–70.

110) (?)Goat to the left. Drag 37, attributed by B Hartley to potter 'A9'. Lezoux excavations BVI.24 Pit B. Flavian–Trajanic.

111) Duck to the left. Drag 29, unattributed. Lezoux 63 B.VI.12. (?)Claudio–Neronian.

112) Feeding bird to the left. Drag 29, unattributed. Musée Gallo-Romain, Lyon. Mid-1st Century.

113) Hare to the left. Drag 37, stamped S CROTICI retrograde (Sacroticus). Castleford vicus Trench 10 context 058 (Dickinson and Hartley 2000, fig 33, 1006). *c* AD 130–155.

114) Hare running to the right, similar to No. 106 (above). Drag 37, attributed to Pugnus' early style. Castleford vicus Trench 10 context 448 (Dickinson and Hartley 2000, fig 37, 1027). *c* AD 125–150.

115) Hare running to the right. Drag 29, stamped NIC[…] within the decoration. Lezoux (unmarked). Tiberio–Claudian.

116) Small dolphin. Drag 29, unattributed. Lezoux LAS 67 N.2. Tiberian.

Towards a new central Gaulish poinçon catalogue

Until now, the study of Central Gaulish samian has been straightforward. We have comprehensive catalogues of motifs (Rogers 1974; 1999, annexe A), figures (Déchelette 1904; Oswald 1936–7; Rogers 1999, annexe B) and a list of who used them (Oswald 1936–7, updated by Hopkins 2000), together with the repertoire of each potter (Rogers 1999). However, criticism of the above reference works, especially the quality of the drawings, together with the advancement of our knowledge, indicates the need for a complete revision. Using graphite rubbings, catalogues can be constructed in parallel with Geoff Dannell's catalogues

for La Graufesenque, such as the South Gaulish ovolo catalogue currently on the internet (http://www1.rgzm. de/samian/home/frames.htm)

We also need to take a new approach to the output of Central Gaul. Not only are the number of production sites increasing, but we need to take into account that a 'potter' may have had a main workshop, as well as outlying 'franchises'. It is also possible that the potters themselves may have travelled from one kiln site to another: for example the 'potter' Casurius appears to have had workshops at Lubié, Lezoux and Les Martres-de-Veyre. We may also note the potter Austrus, who is known to have worked at Blickweiler and Lezoux (Pferdehirt 1987). The distribution of Austrus' output in the Blickweiler hinterland is greater compared to that around Lezoux. This suggests that the primary workshop was not at Lezoux as was previously thought, and that Lezoux was producing vessels mainly for export (pers comm G Dannell). This idea of 'travelling' is further complicated by moulds and dies moving to other kiln sites; for example, analysis of a poinçon of a pygmy from Rheinzabern demonstrates that it was manufactured in Lezoux (Hoffmann and Juranek 1982, 81). At Caister-on-Sea, two Central Gaulish vessels, one by Servus iv and the other by Caletus, are both in a Rheinzabern fabric, leading to the suggestion that as neither potter worked at Rheinzabern, the moulds travelled eastwards from Central Gaul (Dickinson 1993, 157, 159, nos 16, 22). We are also now questioning whether the potters at Les Martres-de-Veyre were making moulds or were importing them from Lezoux. Thus a Drag 37 mould in Dijon Museum in the unmistakeable style of X-10 is clearly in a micaceous fabric, suggesting an origin at Lezoux. We also need to take into account the possibility of a number of mould-makers working for an enterprise, either contemporaneously or successively, and the probability that artisans moved between workshops. This would account for styles common to two or more potters, for example the freestyle scenes of Attianus, Birrantus and Criciro. Some stylistic commonality may also be due to apprentices learning from one master.

Some poincons appear to have a long lifespan. Take for example O.177, first used by X-2 at Les Martres-de-Veyre (*c* AD 100–120) and continuing through to later potters such as Doeccus *c* AD 170–200 (Stanfield and Simpson 1990, 118, pl 4, 42 and 291, pl 147, 6 respectively). If this were the case, there should be a demonstrable amount of wear on the later examples of its use, or, if copied by surmoulage, a reduction in size due to shrinkage of the clay. At the Castleford 'Pottery Shop' deposit *c* AD 140, it was noted that Cinnamus was using large and reduced versions of some of his poinçons contemporaneously, for example no. 289 (Dickinson and Hartley 2000, 36). In our catalogue, we may note that there are clearly two sizes of Cinnamus' ovolo R.B144, Nos. 7 and 8, and the Venus No. 78 is a size mid-way between the two examples drawn by Oswald (O.286 and O.286A). A reduced Cinnamus stamp seemingly created by surmoulage has been found on a Drag 31 from Dover (Bird 1989, 70). Is this indicative

of an internal workshop practice, a way of creating cheap poinçons and dies, or possibly sending copied, and therefore reduced, poinçons to his satellite workshops? To compound the problem, there were some figure-types which were used by many contemporaneous potters; multiple copies must have been made from one poinçon.

The similarity between the decoration of some Banassac and Central Gaulish bowls has been known for some time; George Rogers has drawn attention to the use of copied, that is reduced, Cinnamus (style) poinçons at Banassac (Rogers 1969–70). Is this a member of the Cinnamus group moving south, or just straightforward 'plagiarism' by the Banassac potters, having lost 'inspiration' due to the cessation of exports by their counterparts at La Graufesenque? What too of the relatively 'new' samian group known as 'Centre-Ouest', many of whose elements – but not style – are reminiscent of Trajanic and Hadrianic period Lezoux and Les Martres-de-Veyre poinçons?

We need to move away from the idea of 'one poinçon fits all'. Just because several potters 'share' a particular Oswald or Rogers (numbered) poinçon, it does not necessarily follow that it is the same die that has been shared, traded, handed down or copied. In our catalogue, No. 96 could be – and has been – classified as O.234 (*cf* Rogers' repertoire for P-6A (1999)), but there are subtle differences which demonstrate that it is a poinçon that is similar to, but different from the 'standard' O.234; the discrepancies would normally be put down to interpretation by Oswald's illustrator, Miss Wheatley. We need to be thinking more along the lines of each potter having individually modelled poinçons which were unique to him, until it can be demonstrated otherwise. Why there should be this general similarity is not clear, but is an interesting area of study, although beyond the scope of this paper.

It is questionable whether we can trust the authenticity of poinçons in museum collections; Hugues Vertet published two dies of Apollo with Lyre O.77 (and/or O.77a) from the museums at Geneva, stamped OFFI.LIBERTI retrograde, and Dijon, signed GRANIVS (Vertet 1963, 166, fig 49 and 170, fig 50). George Rogers has suggested that there was a Victorian antiquities dealer selling forged dies, particularly ones stamped by Libertus (pers comm G Rogers; Bailey and Bowman 1981). An analysis of over 40 poinçons in various French museums demonstrated that approximately half were 'modern' forgeries (Symonds 1989), and unless we can authenticate a die as being genuine, either because it comes from an excavation or by scientific analysis, then it cannot be relied upon.

Can we identify the use of broken poinçons, before and after breakages? Once broken, each one should be considered as 'new'. Nos. 82 and 95 are examples of broken dies, both used by Anunus II. His tab stamps appear on bowls in the style of Cinnamus; did he leave the Cinnamus workshop, taking the broken poinçons with him?

George Rogers has brought to our attention a number of new potters, mainly for the period *c* AD 100–120/5; most of these did not apparently export to Britain. However, a number of anonymous potters are known, which are

not identified by Rogers (1999), and these need bringing together and publishing. We also need to tease out the individuals amongst the anonymous Les Martres-de-Veyre group of potters, and try to follow them into the export period at Lezoux; for example some of the output of X-9 looks very similar to X-5. Sadly, very little kiln material from Les Martres-de-Veyre is available for study (pers comm P Bet), although we have been able to identify rubbings of sherds excavated by J R Terrisse amongst the Hartley Collection.

A complete revision of Central Gaulish poinçons is long overdue. Work has started on cataloguing stamped and/or signed sherds from the literature, and collections of graphite rubbings held by samian specialists. From these, we can begin to assemble repertoires for each potter and update the lists published by Rogers (1999), and at the same time, we can revise the motif and figure type catalogues to parallel the updated South Gaulish catalogues. Moreover, it is important to gain access to record kiln collections in Central France to complement the Hartley Collection (Lezoux), and the Oswald-Plicque Collection (mainly Lezoux) at the Universities of Nottingham and Durham. Using the kiln collections, we can begin to identify which poinçons were used where, by whom, and when. At one time, we thought that we knew all there was to know about Central Gaulish samian, but clearly we have only started.

Acknowledgements

I would like to thank the following for access to rubbings and collections: Mr G Dannell; Mrs E Hartley; Mr R Jones, Cambria Archaeology; Mr X Nieto, Centre d'Arqueologia Subaquàtica de Catalunya, Girona; Dr P Webster; Mr C Vernou, Musée Archéologique, Dijon; and of course Brenda Dickinson herself. I would also like to thank the following for their assistance in writing this paper: Wendy Hopkins, Joanna Bird and Margaret Ward.

Bibliography

Bailey, D M, and Bowman, G E, 1981. Thermoluminescence examination of five samian poinçons of Central Gaulish type, *Antiq J* 61, 352–6

Bird, J, 1989. The samian ware, in B Philp, *The Roman house with Bacchic murals at Dover*, Kent Monogr Ser 5, 67–74, Dover

Bird, J, De Clercq, W, Deschieter, J, and Dickinson, B, 1999. Terra sigillata, in W De Clercq and J Deschieter, Prospections à Steene-Pittgam: analyse d'un ensemble de terre sigillée, *Revue du Nord – Archéologie de la Picardie et du Nord de la France* 81, 86–104

Boon, G C, 1967. Micaceous sigillata from Lezoux at Silchester, Caerleon and other sites, *Antiq J* 47, 27–42

Caerwent Samian. http://www.cardiff.ac.uk/learn/archaeol/ caerwent/Master_Index.html

Dannell, G B, 1991. Decorated samian, in N Holbrook and P T Bidwell, *Roman Finds from Exeter*, Exeter Archaeol Rep 4, Exeter City Council and The University of Exeter, 55–71, Exeter

Déchelette, J, 1904. *Les vases céramiques ornés de la Gaule Romaine*, Paris

Dickinson, B M, 1993. Decorated samian, in M J Darling and D Gurney, *Caister-on-Sea: excavations by Charles Green 1951–1955*, East Anglian Archaeol Rep 60, 157–159

Dickinson, B, and Hartley, B, 2000. The samian, in *Roman Castleford: Volume III, The Pottery* (eds C Philo and S Wrathmell), West Yorkshire Archaeol Service (Leeds), 5–88

Hartley, B R, 1961a. The samian ware, in K A Steer, Excavations at Mumrills Roman fort 1958–60, *Proc Soc Antiq Scot* 94, 100–110

Hartley, B R, 1961b. Samian pottery, in G Webster, An excavation on the Roman site at Little Chester, Derby, *Derbyshire Archaeol J* 81, 85–110

Hartley, B R, Pengelly, H, and Dickinson, B, 1994. Samian ware, in *Roman Alcester: southern extramural area: 1964–1966 excavations* (eds S Cracknell and C Mahany), Roman Alcester Series Vol 1 Pt 2, Counc Brit Archaeol Res Rep 97, 93–119, York

Hoffmann, B, and Juranek, H, 1981. Bestätigung der Zusammenhänge von La Graufesenque und Lezoux durch chemische und töpferische/technische. Analyse des Abdruckes eines Bildstempels, *Rei Cretariae Romanae Fautorum Acta* 21–22, Augst, 79–89

Hopkins, R, 2000. *Central Gaul figure types index*, http://www. cardiff.ac.uk/learn/archaeol/ gaulish/Main.html

Nieto, X, and Puig, A M, 2001. *Excavacions arqueològiques subaquàtiques a Cala Culip, 3. Culip IV: la terra sigil. lata decorada de la Graufesenque*, Monografies del Centre d'Arqueologia Subaquàtica de Catalunya 3, Girona

Oswald, F, 1936–7. *Index of figure-types on terra sigillata ('samian ware')*, Univ Liverpool Ann Archaeol Anthropol Suppl 23–4

Pferdehirt, B, 1987. Austrus: un potier de vases décorés a Blickweiler? *Revue Archéologique de L'est et du Centre-Est* 38, Fasc 1–2, 57–66

Rogers, G B, 1969–70. Banassac and Cinnamus, *Rei Cretariae Fautorum Acta* 11/12, 98–106

Rogers, G B, 1974. *Poteries sigillées de la Gaule centrale. I. Les motifs non figurés*. Gallia, Suppl 28 (Paris)

Rogers, G B, 1999. *Poteries sigillées de la Gaule centrale II: les potiers*, Cahier du Centre Archéologique de Lezoux 1/Revue Archéologique SITES, hors-série 40 (2 vols), Lezoux and Gonfaron

Romeuf, A-M, 2001. *Le quartier artisanal gallo-romain des Martres-de-Veyre (Puy-de-Dôme)*, Cahiers du Centre Archéologique de Lezoux 2/Revue Archéologique SITES, hors-série 41, Lezoux

Stanfield, J A, and Simpson, G, 1990. *Les potiers de la Gaule centrale. Recherches sur les ateliers de potiers de la Gaule centrale*. Revue Archéologique SITES, hors-série 37, Marseille

Symonds, R P, 1989. Summary review of Bémont C and Gautier J, Manipulations ou forgeries? A propos de quelques poinçons-matrices, *Recherches Gallo-Romaines I*, Laboratoire de Recherche des Musées de France, Editions de la Réunion des Musées Nationaux 1985, 183–218. Entry 373 in Roman pottery bibliography, *J Roman Pottery Stud* 2, 106–30

Vertet, H, 1963. Poinçons-matrices pour moules de vases représentant Apollon appuyé sur sa lyre. *Revue Archéologique de L'Est et du Centre-Est* 14 Fasc 1-2-3, 165–174

Webster, P, 2003. The samian ware, in H James, *Roman Carmarthen. Excavations 1978–1993*, Britannia Monogr 20, 204–41

20 'Is your figure less than Greek?' Some thoughts on the decoration of Gaulish samian ware

Janet and Peter Webster

Introduction

For most samian specialists the attraction of decorated samian lies not in the decoration itself but in the detective work necessary to discover who was responsible for the design, a 'whodunnit' rather than an exercise in art criticism. As a result, questions about the reason for an artist (or a purchaser) choosing one design rather than another are rarely raised. We do not place ourselves in the position of the mould-maker faced with a totally blank surface and ask why he chose one design rather than another.

Such a choice was presumably not entirely a personal one. The taste of the customer must have played some part. Even if the mould maker is unlikely to have had any direct contact with the customer in say Germany or Britain, he (or she) will have been influenced by those who controlled the marketing of the pottery and who, presumably, had some sense of public taste in their chosen markets. Equally, there will also have been some influence from styles popular in other media (such as silverware). There were some technical considerations: the small motifs to be found on Claudian and Neronian vessels, for instance, are likely to have been dictated by the narrow surface zones available on the most common decorated bowl of the time, Drag 29. The advent of larger motifs was certainly facilitated by the advent of the more continuous decorative surface of the hemispherical bowl, Drag 37, which emerged in the 60s AD.

Leaving technical considerations apart, some broad stylistic trends have long been recognised (*cf* Oswald and Pryce 1920, pls 2–4, 7–8, 9–13 for instance). Early schemes tend to be dominated by stylised plant motifs arranged garland-like around the vessels. By the mid 1st century, overall designs begin to be broken up into panels and small figures to appear. Figures increase in number across the Flavian period and, especially with the advent of Drag form 37, larger panels become common as the possibilities of the more continuous decorative surface were realised and, presumably, as older smaller poinçons were replaced.

Hermet branded the late 1st century and early 2nd century at La Graufesenque as the period of 'decadence' (1934,

pls 84–8) and anyone familiar with the vessels from that source, which flooded the British market in the late Flavian and earlier Trajanic period, will know why. Standards of production had declined, possibly under pressure from outside to produce a greater number of vessels. Artistically, this is hardly a high point either, with rather randomly placed panels being the most common method of filling space. Artistic decline is not, however, always accompanied by economic collapse and we should, perhaps, look to other factors to explain the cessation of large-scale export from South Gaul and the migration of the samian-producing centres northwards to central and eastern Gaul.

The early 2nd century production of central Gaul is characterised by some of the most detailed and pleasing of the figured poinçons. In the Trajanic and Hadrianic period, however, these are used in designs crowded with small decorative motifs as if the designers abhorred empty space. We shall look at some of them in more detail later, but the general style is common to both Les Martres-de-Veyre and Lezoux in this period. Only gradually does the more open style, which became characteristic of the Antonine period, develop. It may not be mere accident that this change is paralleled by an increase in production, perhaps leading to the recognition that it is more economical to use fewer larger poinçons in larger, less crowded designs. This trend was not lost on the East Gaulish manufacturers who, from the later 2nd century to the mid 3rd, often appear to be attempting to use as small a number of poinçons as possible in many of their designs.

The figures chosen for portrayal

Such a broad survey of design trends across two centuries can only discuss the main outlines of designs and must largely ignore the content of those schemes. Later we will look in detail at just a few producers, but first it is worth asking just what figures the Gaulish potters considered attractive to their customers. The answer is in many ways surprising. Gaulish samian was marketed largely in Gaul itself, the Germanies and Britain, all areas with extensive

	Total	**%**
Classical deities	377	9.91
Named classical & mythological figures	237	6.23
Unnamed classical figures	574	15.09
Amphitheatre & circus figures	181	4.76
Other figures	829	21.80
Animals	1171	30.79
Birds	349	9.18
Sea creatures	70	1.84
Total	3803	100.00

Table 20.1: Classification of figure types in Oswald 1936–7

native populations, who, one would expect, had tastes which were not wholly classical. This is not, however, the impression which one gains from looking at the figures on samian. Classical figures predominate and there is little which is outside classical culture.

We can verify this general impression if we look at the numbers of figures appearing in Oswald's index of figure types (Oswald 1936–7). Oswald does not, of course, give a clear indication of how often each type is used. However, it seems reasonable to suppose that popularity is reflected in the number of different representations of any given type of figure produced. Thus the production of 181 types of lion but only 4 lizard types indicates that lions were a good deal more popular than lizards. Appendix 1 offers a more detailed breakdown, but the overall pattern can be summarised as shown in Table 20.1.

To achieve this classification, those Oswald types which are drawings of classical prototypes, and intended for comparative purposes only, have been excluded. In a very few instances, we have not agreed with his identifications. There seems no good reason, for instance, to regard O.923 as Eumachia, rather than a generalised priestess, despite Oswald's illustration of the Eumachia from Pompeii (Mau 1899, fig 245 for a photograph). Types which occur in more than one production centre are counted separately rather than as a single occurrence. It is recognised that the Oswald series probably includes some figures which have been conflated and there are certainly some figures which appear in more variants than Oswald noted, but the collection seems adequate for this type of overview.

Using this rough guide to popularity, it is thus of interest that, of the Classical deities, the most popular was Venus (102 types out of the 377 classical deity types) with Mercury (52), Apollo (51) and Bacchus (50) the next most popular. Other deities in descending order of popularity are: Diana (32), Mars (28), Minerva (23), Jupiter (13), Vulcan (11), Neptune (11) Juno (2), and Ceres and Proserpina, Oswald's Demeter and Core (2). Among the 237 named classical and mythological figures only a few stand out as being truly popular. Hercules (74, of which 19 show the labours and 16 show him as a drinker) and Pan (50) are the only figures which appear in more than 15 types and most are represented by one or just a few types. The 'horned' figure of our list is R.3041 described by Rogers

as Silvanus, but possibly an incomplete Hercules with lion-skin cape. The 573 other classical figures are dominated by cupids (239 with a further 21 figures which are cupid-like but without wings). The varied nature of the remainder of this category is best illustrated by simply listing the eleven with more than 10 types: Sileni, Satyrs and Fauns (62), Griffins (30), Victory (28), Pygmies (26) Caryatids (26), Centaurs (20), Sea monsters (18), Sea Horses (17), Sphinx (11), Tritons (25) and Abundance (11).

To this strictly classical collection can be added 829 types which we have termed 'other 'human' figures'. Many of these are what in art works would be termed 'genre figures'. They include warriors (152 types with a further 33 mounted warriors)), erotic groups (47), scarf dancers (32), boxers and wrestlers (24) and hunters (20) as well as large collections of masks and busts (205), some of which are clearly theatrical masks, and naked males (100). In the main they are strongly classical in content but generalised rather than specific in their identity. An interesting exception to this general rule are five animal-headed figures, most if not all from East Gaul (O.549–551A), one of which appears to be a follower of Mithras of the Lion grade and all of which may be Mithraic in content. To this motley collection can be added 208 types specifically related to the amphitheatre or circus (39 bestiarii, 15 charioteers, 98 gladiators and 29 prisoners or victims).

Among the many (1171) animal types, there appears to be a division between the exotic, such as would only be seen in western Europe in the arena (181 lions and 96 panthers/leopards) and those associated with hunting (232 deer, 141 hares, 114 boars and 90 bears). To these we may perhaps add the 177 dogs as these often appear in what are clearly hunting scenes. The remainder are largely domestic (46 goats, 23 horses, 26 sheep).

The birds are totally dominated by geese (186 types) with only eagles (52), storks and cranes (48), cockerels (36) and peacocks (22) mustering more than a few examples apiece. Sea creatures are largely dolphins (43) and fish (18) if one excludes the more mythical occupants of the sea (sea horses, tritons and the like) which have been placed with the classical figures. We may note that the cranes sometimes occur in combination with pygmies (*cf* Pliny, *Natural History*, 10.30), one of the few areas of overlap with Nilotic designs (*cf* Toynbee 1973, 244).

Discussion

The choice of theme

In considering the choice of decorative motifs employed in the manufacture of samian vessels a wide variety of factors needs to be taken into account. The influence of the traditional themes of earlier tableware, both ceramic and of precious metal, has been referred to above and the more or less elaborate leaf and plant decoration of some early forms of samian is surely derived, albeit at several removes, from the foliage ornament of late Republican silver ware, as exemplified in the Casa del Menandro cup

(Painter 2001, 58–60, M7–8, pls 7–8) and those from Alesia and Herculaneum discussed by Strong (1966, 135–6, pl 33, A and B).

Appeal in the market place was essential, not only for the vendor of samian pottery but also for the manufacturer. At present, however, it is uncertain how far its ornamentation dictated the customer's choice of vessel; form, practicality of function and characteristic glossy red colour may have been over-riding considerations. Indeed, it can be argued that much of the detail of decoration, though not the strong colour, must have been lost in the relatively ill-lit context of Roman dining room or barracks. A survey of decorative motifs classified according to military, urban or rural find spots might clarify how far the customer's taste influenced his purchase and how far this impacted on the decorator. Such a magnum opus is, however, beyond the scope of this small paper.

As mass-produced table ware, samian distributed imagery, drawn almost exclusively from classical mythology, life and literature, across virtually all social groups within the widespread and culturally divergent populace of the western European provinces. But it would surely be dangerous to assume that the many users had more than a limited comprehension of the significance of much of the imagery and some allusions to epic stories must have been lost on the majority. In the medium of mosaic, the splendid image of Europa and the Bull from the Lullingstone villa (Meates 1979, frontispiece) might have been taken to imply a considerable degree of familiarity, on the part of the owner, with the classical sources, even without the accompanying 'elegiac couplet that scans correctly and is of quite respectable Latinity' which 'would have been meaningless to anyone who did not know his Virgil' (Toynbee 1964, 263–4). But it seems less certain that the significance of the figure group identified by Oswald as depicting Neoptolemus and Polyxena, for example (O.238 and 1936–7, 30), was appreciated by the owners of the vessels on which it occurs (including one from London), nor can they necessarily be assumed to have been familiar with the sources of the story, ultimately derived from the lost 'Little Iliad', or of 'Hecuba' the tragedy by Euripides in which the story of Polyxena's death is told, or even of the Latin versions of the story in the works of Seneca (*Troades*) and Hygenus (*Fabulae*).

Indeed, it is not unreasonable to question whether the potters themselves were aware of the significance of the motifs they used. The theme of O.238 could be said to be traditional, the death of Polyxena at the hand of Neoptolemus having been depicted by the potter Timiades on a Black figure Tyrrhenian amphora of the second quarter of the 6th century BC (Boardman 1974, 37, fig 57 [image printed in reverse] and 231). But the samian image depicting Polyxena, not stabbed in the throat as she lies on a bier, but, as, in death, she sinks to the ground above Achilles' tomb, follows more closely sculptural prototypes of the mid 5th century BC (*cf* the Niobid from the Gardens of Sallust, now in the Terme Museum: Aurigemma 1958, 102–3 and pl 45; Paribeni 1932, 169–170, no. 454).

The classical deities

The repertoire of deities depicted on decorated samian is surprisingly limited, being confined almost wholly to the twelve main deities of the Pantheon (according to Ennius: Apollo, Ceres, Diana, Juno, Jupiter, Mars, Mercury, Minerva, Neptune, Venus, Vesta and Vulcan), but including Bacchus and omitting Vesta, unless, of course, she has not been recognised as such.

As with bronze statuettes, samian images of deities are commonly derived, however remotely, from large scale (often marble) sculpture. Oswald cited, for a number of his figures, prototypes drawn mainly from large-scale marble sculpture, but including also some large-scale bronze sculpture and a few wall paintings (he also includes some prototypes from coins and signet rings which are not considered here). The choice of which figures to parallel in this way was his and it is not universal but, of some 68 or so prototypes of gods in 'human' form, 33 are of 8 major deities (Venus, 11 prototypes; Bacchus, 5; Apollo, 5; Jupiter, Mercury, and Minerva, 3 each; Vulcan, 2; Mars, 1), confirming that relatively standardised 'types' were in use in the samian industry, particularly in the depiction of gods and goddesses.

Their reproduction in ceramic form is often crude and that not merely because of the difficulty of achieving crisp definition in pottery. The prototype which Oswald suggests for his type 2 (a La Graufesenque type), a marble statue from the Louvre illustrated by Reinach (1897, 158, pl 311, no. 681) and the bronze Jupiter from Bree in Belgium thought to be Hadrianic (Faider-Feytmans 1979, 49–50, no.1, pls 1–4) are both versions, albeit of vastly differing quality, of a Jupiter in majesty type which may have been established as early as the 5th century BC (see Boucher 1976, 84–6; Mitten and Doeringer 1968, 264–5, no. 255, pl 6).

That the repertoire of deities depicted is almost wholly confined to those of 'official' religion is, perhaps, of particular significance. It is noteworthy that none of the eastern cults, which were rising in popularity in the Roman world from the Late Republic onwards, those of Cybele and Isis, for instance, are represented here, although there is small evidence of limited use of Mithraic imagery in Eastern Gaul (O.550–551A). Nor do the Gaulish potters appear to have exploited the rich iconography of their own Celtic pantheon. Without an accompanying inscription, many Celtic deities can be identified only by their associated symbols (*cf* Green 1995, 475–84). But the images of Epona, the Mother Goddesses, triple-horned bulls and ram-headed serpents, for example, would all surely have been recognisable had they been used. But it is perhaps in the absence of any portrayal of the Lares and Penates that the greatest significance lies. Like the deities of the Celtic Pantheon for the potters themselves, these essential gods of the household, whose importance took on a reinforced significance under Augustus, belonged to a different genre from those of the classic Roman Pantheon, suggesting that here, at least, the latter were regarded primarily as decorative elements, not as subjects of veneration.

Mythological tableaux

It is perhaps easier to understand why certain figures from mythology were included in the repertoire of decorative motifs for samian vessels. In the tables listed above, the figure of Hercules is represented by the greatest number of stamps within this category. His appeal to the army and those who admired deeds of 'derring-do' is obvious, but he found favour, too, among philosophers, the Stoics in particular, for his fortitude. The decorators themselves seem to have had a considerable familiarity with their subject, depicting him variously as bearded or beardless, totally naked, or equipped with lion-skin cloak and with or without club. As with the portrayal of other mythological figures, however, some of the images of Hercules tell a complete story. The legend of the Labours of Hercules lends itself to illustration of individual labours each through a single motif. Oswald illustrates three stamps, for example, (O.787, 787A, 788) which each depict Hercules slaying the many-headed Hydra. Other Labours represented on single stamps include Hercules picking the Golden Apples of the Hesperides (O.784–6), capturing the Erymanthian Boar (O.789–790), tethering Cerberus (O.792) and, of course, slaying the Nemean Lion (O.795[?], 796–7, 799). The Legend of Hercules and Iole (O.766B and C) for the loving of whom Hercules was to pay with his life (Ovid, *Metamorphoses*, 9, lines 104, 278, 394) is, if correctly identified, less immediate in its presentation as if the stamp maker was less familiar with the story than with the image. Similarly, in the portrayal of Hercules killing the snakes (O.783), he is shown as a grown, indeed bearded, man not as the baby whom Hera had intended to kill in his cradle (*cf* the wall painting from the House of the Vettii at Pompeii: Ling 1991, 128 and pl 7A for a possible prototype for the painting). This again may imply an imperfect understanding of the legend on the part of the potter, although it is noteworthy that Jocelyn Toynbee identified as unusual the rendering, on a bronze jug from Welshpool, of Hercules, as a boy, clutching the two snakes he has just killed rather than as a baby in the act of strangling them (Toynbee 1962, 175, no.117, pl 133), which may, rather, suggest that there were alternative versions of this legend.

The use of a single image to tell a whole mythological story in a nutshell can be paralleled in other media. The story of Europa and the Bull, for example, on the Lullingstone mosaic referred to above, encapsulates the legend in a single image very similar to the Oswald figure, O.62 in particular (other Europa and the bull stamps include O.63 and perhaps O.64). The metamorphosis of Actaeon into a stag and the attack upon him of his hounds is similarly depicted in both media, the image in a roundel in the Seasons Mosaic at Cirencester (Witts 2005, 133–4, pl 24) and O.125 being particularly alike. Oswald identifies three other stamps of the same subject (O.122–4), although O.123 seems to portray a very docile dog and an Actaeon with none of the stag elements (perhaps indicating a lack of understanding of the theme by the *poinçon* maker, or perhaps this is simply a huntsman) and O.124 is a single image which lacks the essential element of the dogs. Whereas even the humblest

purchaser of decorated samian may be expected to have had a familiarity with images of the vine harvest (O.473–496), of fishermen (O.951–956) and of the trade of butchery (O.959), for example, the use of these storytelling images must imply a considerable, although scarcely universal and not always perfect, acquaintance with the mythology from which they are drawn, among users and decorators alike. The image of Leda and the Swan (O.60–1), for example, would have been particularly startling to someone to whom the story of the need for metamorphosis in Zeus' amorous adventures with mortal women was unknown.

One image from the samian repertoire emphasises the need for caution in attempting to evaluate, from a 21st century standpoint, the extent of the dispersion of classical culture throughout the western Empire. Among the large number of figure types of Bacchus listed by Oswald is a group of five (O.557–561) of which two (O.559–60) bear a very close resemblance to the marble group from the Walbrook Mithraeum discussed by Jocelyn Toynbee (1962, 128–30, no.12, pl 34; 1986, 39–42, no.15, pls 12 and 21). In the marble group, a drunken Bacchus, clutching a snake emerging from the branch of a tree above his head, is accompanied (to his right) by a Silenus seated on an ass and, to his left, by a naked satyr, who supports him, and a maenad; the figure of Pan sat in the tree above Silenus but is lost through damage. On O.559–560, Bacchus is accompanied by two figures: what may be a maenad on his left and a naked horned deity, probably Pan, on his right, both supporting him. To the side of the Pan figure and above Bacchus' head is what can only be seen as a misunderstood interpretation of the tree with the serpent onto which Bacchus hangs in the marble version. Toynbee noted that the head of the marble Bacchus was somewhat overlarge and the torso too broad and thickset. The same is true of the samian version. These figure types and the marble sculpture from the Wallbrook Mithraeum are so similar, despite the vastly differing quality of the artistry, as to confirm that they are derived from the same prototype. The three associated figure types depict the same scene but the tree element is lacking. Jocelyn Toynbee had considerable difficulty finding sculptural parallels for the marble piece. Yet, the presence of five versions of the same scene in samian pottery suggests that it was not an unpopular, certainly not a rare theme among potters and their customers.

How did the images reach the potter?

Sources for images and design motifs on samian have been discussed briefly above and, once the industry had established itself, the decorative repertoire of an individual potter may be expected to have grown through interchange of ideas, simple copying and through the exchange or purchase of *poinçons*. But the people who actually made the pottery, as opposed to those who distributed and marketed it, are believed to have been artisans of humble status, the majority of whom are unlikely to have moved far from their working environment. They were, therefore,

	Selected LMdV		All Gaulish	
	Total	%	Total	%
Classical deities	58	12.69	377	9.91
Named classical & mythological figures	76	16.63	237	6.23
Unnamed classical figures	60	13.13	574	15.09
Amphitheatre and circus figures	20	4.38	181	4.76
Other figures	104	22.76	829	21.80
Animals	107	23.41	1171	30.79
Birds	23	5.03	349	9.18
Sea creatures	9	1.97	70	1.84
Total	457	100.00	3803	100.00

Table 20.2: Classification of Les Martres Figures compared to the total Gaulish repertoire

unlikely to have had the opportunity to see the large scale prototypes, or copies thereof, from which much of their repertoire was derived. Equally they are unlikely to have frequented the sumptuous villas which feature the mosaic images that parallel some of their mythological themes. Given their circumstances and the fact that many of the images in use recur across a variety of media, it seems reasonable to conclude that copy-books in some form or other were being employed extensively in the samian industry (see Toynbee's discussion of this aspect of Roman art: 1964, 10–11).

But what of the purchaser, where did he make his acquaintance with the imagery in use on the vessels he bought, insofar as he needed, or, indeed, wanted, to know their significance? Many users of samian, higher ranking army officers, for example, will have been familiar, from birth-place or through travel, with large-scale Roman sculpture, and with its religious and mythological background, through their education and personal reading. Many, ambitious to improve their social and economic status, will have sought to enhance their own process of Romanisation, not only through possession of the trappings of Roman culture but also through an understanding of their significance. Others may have been content merely to own a 'genuine Roman pot', one characterised by its glossy red colour and, to them, largely incomprehensible iconography.

A further possibility presents itself. One of the great unanswered, and, indeed, unasked questions about stone theatres, which, in the Imperial period, proliferate throughout the western provinces, concerns the use to which they were put, given that the era of the great Latin playwrights was over. Theatrical masks occur in some numbers among the figure types assembled by Oswald and it seems possible, given the established tradition of story-telling in both the classical and Celtic worlds, that theatres may have been used for plays, recitals or even live tableaux based on mythological themes.

The case of the Les Martres potters

Overall there can be little doubt from the lists that the overwhelming character of the figures used on samian is classical in derivation. The assemblage owes virtually nothing to non-classical sources and we are clearly in the realm of *romanitas*, not of the Celtic fringe. So much is clear, from a general survey of figures from all manufacturing centres and across the period of Gaulish export of samian and of our more detailed look at the deities depicted. There will, however, be variations in emphasis across time and from centre to centre and from potter to potter. To elucidate such variations for all centres would clearly be beyond a study such as this, but to test the potential for such a study we have taken a particular look at some of the principal Trajanic potters of Les Martres-de-Veyre. Those we have chosen are the Trajanic 'X-potters', X-1, X-2, Drusus I (X-3), Igocatus (X-4), X-8, X-9, X-10, X-11, X-12 and X-13.

To assemble the artistic repertoire of the Trajanic Les Martres potters, we have used the list of figure types assembled by Stanfield and Simpson (1958, 59–69, omitted in the 1990 version) as modified by George Rogers (1999 *passim*). The full list of figure types used, divided by category, will be found in Appendix 2 in a chart which clearly owes a good deal to the Stanfield/Simpson original. This allows us to produce a direct comparison between our summary of the Gaulish repertoire as a whole and that of Les Martres (Table 20.2).

Overall the Les Martres output appears to have used more classical deities and figures (almost 42.5% as opposed to 29.25% for all Gaulish factories) while their interest in the animal kingdom was slightly less than the norm (almost 30.5% as opposed to just over 42.5%). There are, however, considerable differences between potters, not only in the number of types used but also in their range. We have set this out in Appendix 2. Here we would like to comment briefly on the designs of each potter.

Potter X-1. The most striking designs by this potter are those with winged figures (O.705–6) within architectural niches and holding curtain-like drapery to hide their lower bodies (S&S, pl 1, 1–4, 6–7). These figures are usually coupled with a distinctive herm playing pan pipes and a caryatid-like female figure (R.3000–1). The herm is also used on other pots, including one occurrence almost as a

panel divider (*cf* S&S, pl 2, 15). The architectural niches bear comparison with those appearing on many wall paintings but the figures do not seem to find parallel in that medium and appear to be a contrivance of the one potter (who may have taken them with him, if, indeed, he migrated to Chémery; *cf* S&S, 4).

Potter X-2. This potter was one of the most prolific users of figures. His range far exceeds that of other Les Martres potters and the high quality of many of his *poinçons* and designs is noted by Stanfield and Simpson. The tendency of many of the larger figures to overlap either basal or ovolo borders (or both) would suggest that the carver of the *poinçons* was not the maker of the moulds. Almost a third (31 out of 98) of the vessels illustrated by Stanfield and Simpson show this characteristic (*cf* S&S, pl 7, 79–83, 85–6, 88, 90–92, 96, for instance). They refer to a 'careful attention to subject matter' (S&S 1958, 6) but themes appear to be fairly generalised. A number of vessels show friezes of deities (eg Mars, Minerva and ?Venus on S&S, pl 5, 55). There are a number of possible representations of the Bacchic 'rout' (*cf* S&S, pl 8, 107–8). The juxtaposition of the semi-recumbent figure and drinker on S&S, pl 8, 103 might just be a reference to the drinking context between Hercules and Bacchus, a theme which appears much later on the famous silver Mildenhall dish. There are also a number of designs which might be termed 'animals in a wood' (*cf* S&S, pl 3, 30; pl 9 *passim*). We may also note the pigmy and crane theme of S&S, pl 4, 36. More often, however, one detects a desire to produce a pleasing and balanced design rather than to tell an overall story.

Drusus I (Potter X-3). Stanfield and Simpson, in their discussion of Drusus, emphasise the limited number of figure types and the numerous decorative details. Looked at as a whole we can see a number of elements in the 'style' of this potter. There is a willingness to innovate, seen particularly in the use of ovolo substitutes (eg S&S, pl 10, 121; pl 11, 133). There is also a willingness to produce some highly repetitive designs such as the zoned S&S, pl 11, 133 or the vine-covered pl 11, 134. In other cases, the use of a limited range of figures can produce vessels which are more closely themed than most Les Martres products. This is the case with many of the vessels showing gladiators (eg S&S, pl 13, 155–162, Terrisse 1968, pls 3–4) where the gladiators themselves are joined by related symbols such as the shield, Rogers 1974, U209. One would be unwise, however, to over-emphasise the thematic approach. If we examine S&S, pl 10, for instance we find a vessel from Birdoswald (no.127) with panels of gladiators and a lion arranged so that the gladiators are alternately over and beneath the lion. Dividing these panels is a narrow panel with a figure on a tripod. This is clearly a composite design as the figure used is different on each of the narrow panels shown. One of these figures is in full armour and can clearly be related to the gladiators. One is a standing warrior and the other a scarf dancer. The latter seems to have as little to do with the arena as does the tripod on which all three figures stand. The reason may be discernible in the other vessels shown on the Stanfield and Simpson plate. Clearly

the potter found the alternation of wide double panels with a single narrow one, a stylistically satisfactory device. The slightly tapering tripod fits conveniently into the lower part of the narrow panels. The space above will take a small figure. In the case of S&S, pl 10, 121 with its larger panels containing a series of deities, these are an appropriate seated Jupiter and a less appropriate gladiator. One suspects that the overall effect was more important than the detail.

Igocatus (Potter X-4). This is a potter limited in both style and content. He uses a small number of figures repeatedly, but, perhaps more importantly, uses them in much the same way throughout. The leaf cross, Rogers 1974, L1, is used often (although rarely as the only major element of the design as in S&S, pl 17, 215). More typical is its use in fairly narrow vertical panels along with single figures as in S&S, pl 18, 224. The latter also shows a naked male with a cloak (?Mercury), Perseus and Venus, a combination which it is hard to unite within a single theme. Elsewhere Perseus is coupled with a prisoner (S&S, pl 19, 238), a philosopher (*ibid* 242) and an apparent bodice-ripping female (*ibid* 244, actually the Medea, O.844). Just as with the arcades supported rather improbably on cup stacks (Rogers 1974, Q50, *cf* S&S, pl 18, 227–8) one suspects that the overall effect was the most important element of the design decisions.

Potter of the Rosette. Figures dominate on only a few of this potter's bowls. Among them is the fine, freestyle hunting scene, S&S, pl 26, 319 with its woodland setting represented by leaves only. More typical are the bowls seen on S&S, pls 20–21 where abstract designs and apparently randomly-chosen small details sit within often multiple borders which include bead and reel, and columns along with the normal wavy lines. The result is surprisingly pleasing and must have taken a long time to produce because of the large number of individual small poinçon impressions involved, but the designs appear to be aiming at an overall pattern rather than any form of visual story.

Potter X-8. Stanfield and Simpson note the close connection between potters X-8 and X-9. These links are largely in the decorative details and it may be that we have here products of the same workshop or even the same potter. X-8 uses comparatively few figure stamps and even some of the small figures which he does use (such as the ass, R.4016 in S&S, pl 27, 325 and the cupid in the vine design, S&S, pl 27, 328) seem subsidiary to plant designs. The larger figures in designs such as S&S, pl 28, 332–3 seem to be placed so as to give a pleasing effect rather than for the significance of the figure itself.

Potter X-9 uses more figures in less crowded designs. The figures in arcades (S&S, pl 29, 344–5; pl 30, 355–7) seem reminiscent, in their placing, of those of Igocatus, although the figures themselves are different. However, just as with the former, it is difficult to see any link between the figures used. Typical is S&S, pl 31, 368 where O.238, the Neoptolemus and Polyxena figures discussed above, appear with Pan and Minerva.

Potter X-10 uses a style which is utterly distinctive and almost wholly abstract. The style itself is unique but

whether the mould-maker worked only in this style is more open to question.

Potter X-11 was originally classified under the name of Ioenalis, the name of one of the purchasers of the work of this mould-maker. Stanfield and Simpson commented 'figures are not very important in the work of [this potter]'. This is true in many cases, for example S&S, pl 35, 412; pl 37, 432, where the figures are almost incidental in an otherwise abstract pattern. Other designs make greater use of figures, but their placing and juxtaposition seems random with no clear themes apparent.

Potter X-12. Although some of the figure work by this potter seems randomly placed there are other examples where a clear theme is visible. S&S, pl 40, 468 appears to alternate major deities with some of the labours of Hercules, while S&S, pl 40, 470 features pygmies hunting a crane. It may also be noted that the griffins facing a cantharus of S&S, pl 41, 485 (also Terrisse 1968, pl 41, 263) is reminiscent of a design used on a frieze from the Forum of Trajan in Rome (Packer 2001, 76, figs 69–70).

Potter X-13. The themes adopted by this potter seem to be, in the main, generalised, but, particularly where he used large figures, there is an emphasis on balance. For instance, in S&S, pl 42, 487, large medallions within large panels alternate with panels of comparable size but containing a carefully constructed zonal design. Equally, the spandrels of the medallion panels match in design top and bottom. The winding scroll design on S&S, pl 44, 512 shows a similar balance between large leaves in the upward opening lobe and a zonal design in the downward opening one. The choice of figures does not, however, suggest any desire to tell a story but rather to have a dominant general style. Thus, S&S, pl 42, 487 is dominated by its warriors, pl 45, 527 by its facing lion and panther. The design on pl 46, 545 with its satyrs and vines is one of the few with an overall emphasis on one theme. One might expect the large panels on pl 47, 549 to revolve around a scene which may represent the drinking contest between Hercules and Bacchus (Panel A) but the other panels are unrelated: hunting (a lion chasing a stag, and a pigmy and cranes), a lion confronting a panther. Also one of the large panel designs which one would expect to be a repeat of the Hercules and Bacchus has the Hercules but with a seated female (R.3046). We may also note O.783, the Hercules and snakes discussed above, on S&S, pl 46, 534.

General remarks on the Trajanic potters of Les Martres

The Trajanic potters obviously had a lot in common and worked within the same artistic climate. However, they each had their own particular preferences both for the sort of figures they used and for their placing. Some themes are apparent (gladiators in Drusus, Hercules in X-12) but often the choice of figure is more random and one suspects that the choice has been dictated more by a desire to have a certain shape of figure (a tall standing figure or a triangular seated one) or to achieve a match for some opposing figure

(eg the frequent juxtaposition of Neptune and Vulcan) than to pursue a specific theme.

Superficially one might suspect a fairly random process, but this is to ignore the initial choice of poinçons. A glance at Appendix 2 will show that the choices made by each potter are very different. Drusus, for instance, uses a large number of gladiators, while Igocatus uses none and even X-2 (the most prolific user of figures among all the potters) does not use many. Figures from the entourage of Bacchus are more popular with Potters X-2 and X-3 than with Potters X-11, X-12 and X-13 (who appear to be connected in some way) while the latter make greater use of Hercules. One may suggest, therefore, that the potters were reasonably specific in their choice of the types which they would use, but that, once chosen, other design considerations were possibly more important than a closely unified theme to their designs.

Conclusion

The choice of what to portray on samian cannot be random. The figures used come from a restricted repertoire and are almost wholly classical in content. Individual potters clearly favour specific parts of this repertoire and make an even more limited choice when selecting poinçons. Some of these are clearly selected so as to conjure up well-known stories within the genre of classical mythology. In this case, there seems to be a preference for the single poinçon encapsulating the story within a single scene. Occasionally, a suite of poinçons are assembled which together allude to a story. More often the potter is content to choose a more random batch of poinçons from his limited stock. In this case the potter may be deemed to have made his choice of theme when he made or commissioned his poinçons. The varying preferences of the potters in our case study of Trajanic potters suggests that their choice could be idiosyncratic but nevertheless wholly classical.

Whether seeking to tell stories from classical mythology, portray everyday life or, as with the many gladiators, to conjure up scenes from popular entertainment, there is always a desire to convey a general impression of *romanitas*. It is hard to escape the view that samian was a means of conveying selected images from the classical world and the classical world alone, into areas where classical civilisation was in places thinly spread. The ubiquitous nature of samian throughout north-west Europe suggests that buying into this classical world was a desirable and popular activity.

Acknowledgements

Posthumous thanks go to Lorenz Hart for providing an anthem for those struggling with the artistic endeavours of Oswald, Rogers and the potters whom they were copying.

This paper is offered to Brenda not only in acknowledgement of the many times when she has willingly shared her knowledge of samian, but also as a small 'thank-you'

for meals shared in the sun of southern France or the rain of Cardiff, for friendship across the years, and for her constant cheerfulness whatever the circumstances.

Appendix 1

A classification of figure types

In this appendix, we have divided figure types according to their general type and then listed them in alphabetical order. The ascriptions as to type are largely those suggested by Oswald, although occasionally we have disagreed or felt that the ascription was too narrow. The Oswald types alone have been counted to provide the numbers in the 'All Gaul' columns. A few of the Oswald types are, in fact, drawings of sculptural prototypes and these have not been counted. Where, however, Oswald shows an apparently identical type in use in two different manufacturing centres, this has been counted twice. The columns for the selected Trajanic Les Martres potters (LMdV) have been achieved using the charts in Appendix 2, itself a compilation from Stanfield and Simpson (1958) and Rogers (1999).

General Type	Figure	All Gaul	% of Class	Selected LMdV	% of Class
Classical deities	Apollo	51	13.53	5	12.20
	Bacchus	50	13.26	9	21.95
	Demeter & Core	2	0.53	0	0.00
	Diana	32	8.49	4	9.76
	Juno	2	0.53	0	0.00
	Jupiter	13	3.45	4	9.76
	Mars	28	7.43	1	2.44
	Mercury	52	13.79	3	7.32
	Minerva	23	6.10	3	7.32
	Neptune	11	2.92	1	2.44
	Venus	102	27.06	8	19.51
	Vulcan	11	2.92	2	4.88
	Total Classical deities	377	100.00	41	100.00

General Type	Figure	All Gaul	% of Class	Selected LMdV	% of Class
Named classical & mythological figures	Actaeon	7	2.95	0	0.00
	Aesculapius	5	2.11	1	2.78
	?Ajax	1	0.42	0	0.00
	Amazons	6	2.53	4	11.11
	Ariadne & Silenus	5	2.11	0	0.00
	Bellerophon & Pegasus	2	0.84	0	0.00
	Dioscuri	11	4.64	0	0.00
	Eros & Pyche	4	1.69	0	0.00
	Europa & Bull	4	1.69	0	0.00
	Greeks at Troy	9	3.80	0	0.00
	Hercules	38	16.03	4	11.11
	drinking	16	6.75	4	11.11
	labours	19	8.02	2	5.56
	& snakes	1	0.42	2	5.56
	'Horned' figure	0	0.00	1	2.78
	Hygeia	6	2.53	1	2.78
	Iphigenia cycle (?)	9	3.80	0	0.00
	Leda & swan	2	0.84	0	0.00
	Marsyas	1	0.42	0	0.00
	Medea	4	1.69	1	2.78
	Neoptolemus & Polyxena	1	0.42	0	0.00
	Niobid	1	0.42	0	0.00
	Oedipus & Sphinx	2	0.84	0	0.00
	Orpheus	3	1.27	0	0.00

General Type	Figure	All Gaul	% of Class	Selected LMdV	% of Class
	Pan	50	21.10	11	30.56
	Paris	10	4.22	2	5.56
	Peleus	1	0.42	0	0.00
	Perseus	11	4.64	3	8.33
	Prometheus	2	0.84	0	0.00
	Ulyses & Polyphemus	1	0.42	0	0.00
	Wolf & twins	5	2.11	0	0.00
	Total named figures	237	100.00	36	100.00

General Type	Figure	All Gaul	% of Class	Selected LMdV	% of Class
Unnamed classical figures	Abundance	11	1.92	2	3.08
	Caryatids	26	4.54	1	1.54
	Centaurs	20	3.49	0	0.00
	Cupids	199	34.73	22	33.85
	& curtain	2	0.35	2	3.08
	& dolphin	3	0.52	0	0.00
	as vintner	32	5.58	0	0.00
	& sea monster	3	0.52	0	0.00
	unwinged cupids	21	3.66	0	0.00
	Figure & cornucopia	4	0.70	0	0.00
	Griffins	30	5.24	3	4.62
	Maenads	9	1.57	0	0.00
	Nymphs	5	0.87	0	0.00
	Pygmies	26	4.54	9	13.85
	Sileni, satyrs & fauns	62	10.82	12	18.46
	Sea bulls	3	0.52	1	1.54
	sea centaurs	9	1.57	0	0.00
	Sea horses	17	2.97	2	3.08
	Sea monsters	18	3.14	0	0.00
	Sirens & harpies	5	0.87	1	1.54
	Sphinx	11	1.92	4	6.15
	Tritons	25	4.36	2	3.08
	Victory	28	4.89	4	6.15
	Winged genii	4	0.70	0	0.00
	Total unnamed classical	573	100.00	65	100.00

General Type	Figure	All Gaul	% of Class	Selected LMdV	% of Class
Historical figures	Soldier & 'Dacian'	1		0	
	Tyrannicides	14		0	
Amphitheatre & Circus	Bestiarii	39	21.55	2	11.76
	Charioteers	15	8.29	1	5.88
	Gladiators	98	54.14	10	58.82
	Prisoners/victims	29	16.02	4	23.53
	Total amph & circus	181	100.00	17	100.00

General Type	Figure	All Gaul	% of Class	Selected LMdV	% of Class
Other 'human' figures	Athletes	5	0.60	1	0.99
	Archers	10	1.21	1	0.99
	Boxers/wrestlers	24	2.90	1	0.99
	Butchers	6	0.72	0	0.00
	Draughts players	1	0.12	0	0.00
	Entertainers	1	0.12	0	0.00
	Erotic groups	47	5.67	1	0.99
	Figure group	3	0.36	0	0.00
	Figure: & altar	0	0.00	1	0.99
	Figure: & birds	3	0.36	0	0.00
	& lamp	1	0.12	0	0.00
	& mask	5	0.60	0	0.00
	praying	3	0.36	0	0.00
	seated	13	1.57	0	0.00
	in ship	3	0.36	0	0.00
	& staff	27	3.26	0	0.00
	Fishermen	5	0.60	0	0.00
	Hunters	20	2.41	3	2.97
	Jugglers & tumblers	2	0.24	0	0.00
	Mithraists	5	0.60	0	0.00
	Male: & amphora	1	0.12	0	0.00
	draped	30	3.62	2	1.98
	miscellaneous	3	0.36	0	0.00
	naked	100	12.06	22	21.78
	& pipes	20	2.41	0	0.00
	& staff	4	0.48	0	0.00
	& whip	1	0.12	0	0.00
	& wine	8	0.97	1	0.99
	Masks & busts	205	24.73	9	8.91
	Man digging	1	0.12	0	0.00
	Orator ('Aristides')	1	0.12	0	0.00
	?Priestess	9	1.09	0	0.00
	Sacrificers	4	0.48	1	0.99
	Scarf dancers	32	3.86	11	10.89
	Smith	1	0.12	0	0.00
	Warriors	152	18.34	42	41.58
	Warrior on horseback	33	3.98	0	0.00
	Women: draped	40	4.83	4	3.96
	naked	0	0.00	1	0.99
	Total other figures	829	100.00	101	100.00

General Type	Figure	All Gaul	% of Class	Selected LMdV	% of Class
Animals	Apes	5	0.43	0	0.00
	Bears	90	7.69	6	7.32
	Boars	114	9.74	7	8.54
	Bulls/oxen	28	2.39	0	0.00
	Deer: hinds	70	5.98	5	6.10
	stags	162	13.83	7	8.54
	Dogs	177	15.12	7	8.54
	Dog & deer	0	0.00	1	1.22
	Goats	46	3.93	2	2.44

General Type	Figure	All Gaul	% of Class	Selected LMdV	% of Class
	Frog (?)	1	0.09	0	0.00
	Hares	141	12.04	8	9.76
	Horses	23	1.96	2	2.44
	Lions	181	15.46	14	17.07
	Lizard	4	0.34	0	0.00
	Panthers/leopards	96	8.20	21	25.61
	Sheep/rams	26	2.22	1	1.22
	Snakes	3	0.26	1	1.22
	Snake & rock	1	0.09	0	0.00
	Squirrel	2	0.17	0	0.00
	Tortoise (?)	1	0.09	0	0.00
	Total animals	1171	100.00	82	100.00

General Type	Figure	All Gaul	% of Class	Selected LMdV	% of Class
Birds	Cockerels	36	10.32	0	0.00
	Eagles	52	14.90	2	14.29
	Geese etc.	186	53.30	10	71.43
	Parrot (?)	1	0.29	0	0.00
	Peacocks	22	6.30	0	0.00
	Owls	4	1.15	0	0.00
	Storks	48	13.75	2	14.29
	Total birds	349	100.00	14	100.00

General Type	Figure	All Gaul	% of Class	Selected LMdV	% of Class
Sea creatures	Dolphins	43	61.43	5	
	Fish	18	25.71	1	
	Lobsters/crabs etc.	6	8.57	0	
	Shells	2	2.86	0	
	Squid (?)	1	1.43	0	
	Total sea creatures	70	100.00	6	

Appendix 2

Selected Les Martres Potters and their figures

In their 1958 edition, Stanfield and Simpson published a chart showing the figure types used by their Trajanic potters (S&S 1958, 59–69). The chart was not repeated in their later French edition (S&S 1990), probably because the (only part-published) work of George Rogers had resulted in a number of alterations. Here, we have adapted the Stanfield-Simpson chart to show a smaller range of Trajanic potters (essentially those working at Les Martres-de-Veyre), incorporating material from the 1999 Rogers volume and arranging the figure types in the same classified sequence as those in Appendix 1.

Classical deities

Figure	O.no.etc.	X-1	X-2	Drusus I (X-3)	Igotacus (X-4)	Potter of Rosette	X-8	X-9	X-10	X-11	X-12	X-13
Apollo	73	x	x									
	83											x
	92		x			x						
	96		x		x							
Bacchus	562		x									
	563		x									
	566			x				x			x	x
	567			(x)								
	569		x									
	570											x
	571			x							x	x
	579		x									
	588					x						
Diana	103c					x						
	103d	x										
	106							x		x		x
	109		x					x				x
	111			x								
Jupiter	3			x								
	R3091			x								
	R3110		x									
	R3111		x									
Mars	143		x									
Mercury	522	x										
	532		x							x		x
	541	x										
Minerva	126		x									
	126a							x				
	129	x										
Neptune	13			x								
Venus	277		x									
	278					x						
	281		x					x				
	322		x									
	324	x	x									
	325		x									
	331				x							
	341											x
Vulcan	66			x							x	x
	69a	x										

Named Classical & Mythological Figures

Figure	O.no.etc.	X-1	X-2	Drusus I (X-3)	Igotacus (X-4)	Potter of Rosette	X-8	X-9	X-10	X-11	X-12	X-13
Aesculapius	905				x							
Amazons	207a			x								
	241		x	x								
	243		x									
	244		x									
Hercules	748		x									
	748b	x										
	753							x				
	757			x								x
& cup	772											x
	773											x
	774		x									
	776			x								
& snakes	783											x
& Hydra	785							x		x	x	
& snake ?	796										x	
	R3054											x
Horned' figure	R3041										x	
Hygeia	908a	x										
Maenad	368									x		
Medea	844				x							
Pan	707		x									
	710											x
	712		x	x								
	717							x			x	
	718a		x									
	719		x	x								
	720		(x)	(x)								
	721		x									
	723	x				x						
	729				x							
	730				x							
Paris	842					x						
	843				x							
Perseus	233						x	x				
	234				x							
	238							x				

Unnamed classical figures

Figure	O.no.etc.	X-1	X-2	Drusus I (X-3)	Igotacus (X-4)	Potter of Rosette	X-8	X-9	X-10	X-11	X-12	X-13
Abundance	801											x
	R3046											x
Caryatids	1198a		x									
Cupids	376a		x									
	381		x									
	382		x									
	383		x									
	384		x	x								
	385			x								
	388		x	x								
	389		x	x								
	395		x									
	400		x									
	403											x
	404											x
	405											x
	407			x								
	408											x
	419											x
	420		x				x					
	424											x
	425		x									
	501					x						
& curtain	705	x										
	706	x										
& wine	508		x									
	R3013		x									
Griffin	864										x	x
	871a		x								x	
	878					x						
Pigmies	691									x	x	
	692											x
	692a			x	x							
	696a		x									
	698											x
	699									x		x
	699a		x									
	703		x									
	R3023										x	

Historical Figures

Figure	O.no.etc.	X-1	X-2	Drusus I (X-3)	Igotacus (X-4)	Potter of Rosette	X-8	X-9	X-10	X-11	X-12	X-13
Tyrannicides	188						x					

Amphitheatre & theatre

Bestiarii	1073			x								
	R3086	x										
Charioteers	1160			x								
Gladiators	1003			x								
	1004			x								
	1025			x								
	1027		x	x								
	1047			x								x
	1063			x								
	1064		x									
	1065		x									
	R3029			x								
	R3030			x								
Victims	1141		(x)									
	1142		x									
	1143				x							
	1146				x							

Generic figures

Figure	O.no.etc.	X-1	X-2	Drusus I (X-3)	Igotacus (X-4)	Potter of Rosette	X-8	X-9	X-10	X-11	X-12	X-13	
Athlete?	1192											x	
Archers	269			x									
Boxer/s	1186		x										
Erotic	O.K											x	
	247										x		
	251											x	
Figure:													
& altar	R3021		x										
Males:													
draped	364		x										
	365		x										
nude	632									x			
	659										x	x	
	660									x	x		
	667a		x										
	668				x								
	679									x			
	682a												
	684a											x	
	688									x	x		
	R3004		x										
	R3006		x										
	R3008		x										
	R3009		x										
	R3010		x										
	R3015		x										
	R3024		x										
	R3031		x										
	R3058					x							
	R3088		x										
	R3089											x	
	R3090					x							
other	R3003	x											
Masks/busts	1262					x							
	1270a											x	
	1275				x								
	1276			x									
	1286	x											
	1287		x										
	1292			x									
	1293				x								
	R3094			x									
Reveller	R3092					x							
Sacrificer	980		x										

Generic figures cont.

Figure	O.no.etc.	X-1	X-2	Drusus I (X-3)	Igotacus (X-4)	Potter of Rosette	X-8	X-9	X-10	X-11	X-12	X-13
Scarf Dancers	345		x									
	347		x	x								
	353										x	
	354						x	x				
	355		x									
	356		x	x								
	361											x
	362									x		
	R3014		x									
	R3047											x
	R3087		x									
Warriors	155				x							
	157		x	x			x					
	158									x		
	163			x								
	166		x									
	167									x		x
	171		x									
	172		x									
	174		x									
	175									x		
	177		x									
	177a		x									
	197									x		x
	198									x	x	
	202									x		
	204											x
	208											x
	210									x		x
	211			x								
	211a		x									
	213			x								
	217		x									
	218		x	x								
	220									x		
	R3011		x									
	R3016		x									
	R3017		x									
	R3018		x									
	R3019		x									
	R3020		x									
	R3025		x									
	R2026		x									
	R3027		x									
	R3028		x									
	R3032		x									
	R3033		x									

Generic figures cont.

Figure	O.no.etc.	X-1	X-2	Drusus I (X-3)	Igotacus (X-4)	Potter of Rosette	X-8	X-9	X-10	X-11	X-12	X-13
	R3034									x		
	R3035		x									
	R3036			x								
	R3042											x
	R3070											x
	R4043			x								
Women												
draped	363									x		
	923				x							
	939				x							
naked	R3012		x									
seated	949				x							

Animals

Figure	O.no.etc.	X-1	X-2	Drusus I (X-3)	Igotacus (X-4)	Potter of Rosette	X-8	X-9	X-10	X-11	X-12	X-13
Bears	1574											x
	1580		x									
	1588				x							
	1595							x				x
	1607					x		x			x	
	1610					x						
Boars	1641		x									
	1666		x									x
	1677					x						
	1678					x						
	1696p				x							
	R4003		x									
	R4004		x									
Deer:												
hinds	D.863											x
	1763							x		x		
	1806											x
	1815					x						
	1819					x						x
stags	1704											x
	1723											x
	1770			x								
	1791					x						
	1822p					x						
	R4013									x		
	R4047					x						
Dogs	1928						x	x				
	1944									x		
	1979					x				x		
	1984					x						
	R4007			x								
	R4017									x		
	R4053					x						
Dog & deer	R4057					x						
Goats	1836						x	x	x			x
	1852		x									
Hares	2057											x
	2057a					x						x
	2063a							x				
	2084							x		x		
	2115					x		x		x		
	2116											x
	2124					x				x		
	R4011							x				

Animals cont.

Figure	O.no.etc.	X-1	X-2	Drusus I (X-3)	Igotacus (X-4)	Potter of Rosette	X-8	X-9	X-10	X-11	X-12	X-13
Horses	R4009		x									
	R4016							x				x
Lions	1375			x								
	1384									x		
	1404										x	x
	1422									x		x
	1437	X-1										
	1448			x								
	1450										x	x
	1457							x				
	R4001		x									
	R4006		x									
	R4021											x
	R4022											x
	R4052					x						
	R4058					x						
Panthers/	1499					x						
leopards etc.	1507			x								
	1513		x									
	1518							x				x
	1519									x		
	1520			x								
	1521			(x)								
	1537				x							
	1542										x	x
	1559					x						
	1562		x									
	1564									x		
	1566					x						x
	1569					x						x
	1570							x				x
	R4000		x									
	R4002		x									
	R4008			x								
	R4018		x									
	R4019									x		
	R4023					x						
Sheep/rams	1857a										x	
Snake	2155											x

Birds

Figure	O.no.etc.	X-1	X-2	Drusus I (X-3)	Igotacus (X-4)	Potter of Rosette	X-8	X-9	X-10	X-11	X-12	X-13
Cranes etc.	2196						x	x			x	x
	2197		x									
Eagles	2162					x						
	R4033							x				
Geese etc.	2279											x
	2286a					x						
	2292					x						
	2298	x					x	x	x	x		
	2314					x						
	2315a											x
	2348					x						x
	2350		x									x
	2361					x						x
	R4033							x				

Sea Creatures

Figure	O.no.etc.	X-1	X-2	Drusus I (X-3)	Igotacus (X-4)	Potter of Rosette	X-8	X-9	X-10	X-11	X-12	X-13
Dolphins	2382					x						x
	2392											x
	2393						x			x	x	
	R4014						x					
	R4015						x				x	
Fish	2407a			x								

Bibliography

Aurigemma, S, 1958. *The Baths of Diocletian and the Museo Nazionale Romano*, 4 ed, Rome

Boardman, J, 1974. *Athenian black figure vases*, London

Boucher, S, 1976. *Recherches sur les bronzes figurés de la Gaule pré-romaine et romaine*, Bibliothèque des Écoles Françaises d'Athénes et de Rome 228, Rome

Faider-Feytmans, G, 1979. *Les bronzes romaines de Belgique*, 2 vols, Mainz

Green M J, 1995. The Gods and the supernatural, in *The Celtic world* (ed M Green), 465–88, London

Hermet, F, 1934. *La Graufesenque (Condatomago)*, Paris

Ling, R, 1991. *Roman painting*, Cambridge

Mau, A, 1899. *Pompeii, its life and art*, (trans F W Kelsey), New York

Meates, G W, 1979. *The Roman villa at Lullingstone, Kent*, Kent Archaeol Soc Monogr Ser 1, Maidstone

Mitten, D G, and Doeringer, S. 1968. *Master bronzes from the classical world*, Greenwich, Connecticut

O. = Figure type in Oswald 1936–7.

Oswald, F, 1936–7. *Index of figure types on terra sigillata ('samian ware')*, Univ Liverpool Ann Archaeol Anthropol Suppl 23–4

Oswald, F, and Pryce, T D, 1920. *An introduction to the study of terra sigillata*, London

Packer, J E, 2001. *The Forum of Trajan in Rome*, Berkeley, Los Angeles and London

Painter, K S, 2001. *The Insula of the Menander at Pompeii. Vol. IV: The silver treasure*, Oxford

Paribeni, R, 1932. *Le Terme di Diocleziano e il Museo Nazionale Romano*, 2 ed, Rome

Picard, C, 1939. *Manuel d'archéologie Grecque. II. La sculpture: periode classique*, Paris

R. = Figure type in Rogers 1999, 481–499

Reinach, S, 1897. *Répertoire de la statuaire Grecque et Romaine* 1, Paris

Rogers, G B, 1974. *Poteries sigillées de la Gaule Centrale. I. Les motifs non figurés*, Gallia Suppl 28, Paris

Rogers, G B, 1999. *Poteries sigillées de la Gaule centrale II: les potiers*, Cahier du Centre Archéologique de Lezoux 1/Revue Archéologique SITES, hors-série 40 (2 vols), Lezoux and Gonfaron

S&S = Stanfield and Simpson 1958 and 1990. The specific edition is only cited where there is variance between the two.

Stanfield, J A and Simpson, G, 1958. *Central Gaulish potters*, London

Stanfield, J A and Simpson, G, 1990. *Les potiers de la Gaule Centrale*, Revue Archéologiques SITES, hors-série 37, Gonfaron

Strong, D E, 1966. *Greek and Roman gold and silver plate*, London

Terrisse, J, 1968. *Les céramiques sigillées gallo-romaine des Martres-de-Veyre*, Gallia Suppl 19, Paris

Toynbee, J M C, 1962. *Art in Roman Britain*, London

Toynbee, J M C, 1964. *Art in Britain under the Romans*, Oxford

Toynbee, J M C, 1973. *Animals in Roman life and art*, London

Toynbee, J M C, 1986. *The Roman art treasures from the Temple of Mithras*, London Middx Archaeol Soc Special Paper 7

Witts, P, 2005. *Mosaics in Roman Britain*, Stroud

21 Some samian potters' signatures from the North of Britain

Felicity C Wild

When I first met Brenda, she was not collecting material for the revised Leeds Index of Potters' Stamps; I was! After a highly instructive year, during which I received the thorough grounding in samian ware only possible through handling it every day under the expert guidance of Brian Hartley, I handed over to her the job originally destined for her. Over forty years later, with commensurate knowledge and experience – and admirable stamina – she is still there. The Index nears completion (Hartley and Dickinson 2008 –). Our thanks and good wishes go out to her and to her helpers for the final publication of this seminal lifetime's work.

For over forty years, we have all sent to Brian and Brenda our stamps and signatures, our queries and pieces of particular interest. There must be little, if anything, excavated during that time that she has not at some point seen or written up. I must apologise, therefore, for presenting her here with some pieces, which, with one exception, she has already seen. In one case, she has even written notes on the potter's name, which I quote (No. 4 below). They are, however, pieces of importance, which should be in the public domain, and I hope that it will give her pleasure to see them in print.

The bowls published here all have the potter's signature inscribed by hand (as opposed to stamped) into the mould, within or beneath the decoration. Assuming that the signatures were written into the damp clay of the mould before firing (*ante cocturam*), as is likely to have been the case with all the examples here, they provide proof of the mould-maker, his style and the types that he used. All the signatures here appear in reverse upon the bowl and were therefore written from left to right into the mould. They are all upside down. The potter clearly supported the mould in his hand, tipped towards him, and wrote his name into or below the decoration on the side nearest to him. In this way it would have been most clearly visible to anyone looking at or using the mould. Signatures were also occasionally scratched into the mould after firing (*post cocturam*), which presumably denote the owner (and user) of the mould rather than its maker (though the latter is not

excluded). Obviously the difference between signatures inscribed *ante* and *post cocturam* is easier to distinguish from the mould itself rather than from the bowl made in it, which may be poorly moulded, abraded in use or after deposition, or, indeed, all three. Signatures inscribed beneath the decoration were also likely to be damaged, or completely wiped off, during the addition of the footring and the finishing of the bowl. In all, the finding of mould signatures on decorated sherds is a comparatively rare occurrence.

The bowls discussed and illustrated here have been collected over a number of years but, with one exception, had not been published at the time of writing. Four, all from the North-West, are by Lezoux potters of Hadrianic–early Antonine date; the fifth, from Binchester, is South Gaulish and Flavian. Two are by Drusus ii, a potter whose work is common on northern sites. The other three are by potters comparatively little known, to whose corpora these bowls will provide additional information.

The origins of these pieces are varied. No. 1, of Drusus ii, came to light unexpectedly in a basement store in the University of Manchester in a small box marked 'BBS1, Vicus Area', and is from the excavations by the late Professor G D B Jones at Burgh-by-Sands (Wild 2009, 64, fig 29). Its companion piece, No. 2, also by Drusus, from Watercrook, has already been published (Potter 1979, fig 120, 72), but this seemed a good opportunity to republish it in more detail, with the original rubbing, in the light of Rogers' important work on the Central Gaulish potters (1974; 1999), unavailable when the original report was written. The other three bowls are from excavations as yet unpublished. No. 3, by Eppillus, is from excavations at Papcastle in 2004 by Frank Giecco of North Pennines Archaeology Ltd and No. 4, by Tetturo, from excavations at Walton-le-Dale in 1996 by Gifford and Partners and Lancaster University Archaeological Unit (now Oxford Archaeology North). No. 5 is from excavations by Drs R F J Jones and I M Ferris at Binchester in the late 1970s (Wild 2010, 222, fig 60, 8). It was only after the report had been written and its accompanying drawings completed

that the rubbings were scanned by Geoffrey Dannell. On magnification, faint traces of a signature of Tetlo became visible, previously unnoticed.

For abbreviations used in the descriptions below (O. etc) see bibliography.

Drusus ii

1. Burgh-by-Sands (BBS1, Vicus area). Drag 37, Central Gaulish. Fourteen sherds in all of a small bowl, badly abraded and fragmented, with part of the cursive signature of Drusus (retrograde), upside down in the mould beneath the decoration (Fig 21.1). The ovolo (Rogers B15) with wavy-line horizontal border occurs on a small bowl with his signature from Heronbridge (S&S, pl 89, 12). Panels show his branched motif (Rogers Q40) over a crossed motif probably consisting of two chevrons (*cf* Rogers G284) placed back to back; Abundance (O.801); repeat of Q40 over chevrons; satyr (O.591) with small figure (R.3075). The satyr and Q40 occur together on a signed bowl from Chester (S&S, pl 88, 3) with the same beaded vertical borders ending in a six-dot rosette (Rogers C278). The diagonal beaded bar is also a characteristic feature of his style. The Abundance (O.801) is not among the types attested for Drusus, but was used by Attianus ii,

with whose work that of Drusus shows links. Likewise not attested for Drusus is the small figure (R.3075), used at Lezoux by the Large S Potter (S&S, pl 76, 32), and a favourite of the slightly later Small S Potter, Cettus, of Les Martres-de-Veyre (S&S, pl 144, 53, 57, 62 etc.). There do not appear to be direct parallels on Drusus' work for the chevron motif.

2. Watercrook (Potter 1979, fig 120, 72). Drag 37, Central Gaulish. Two joining fragments of bowl, also with panel decoration and cursive signature DRVSVSF (retrograde), upside down in the mould beneath the decoration (Fig 21.2). The ovolo is damaged, but is probably his larger ovolo (Rogers B36), which occurs on his larger bowls (S&S, pl 88, 1). Fine-beaded borders are used both horizontally and vertically, ending in a blob rather than a dot rosette (*cf* S&S, pl 89, 14). Panels show the warrior (O.167) over his large rosette (Rogers C55); an arcade, composed of the pediment (Rogers U269) supported on cross-gartered columns, containing the dancer (O.353); a larger branching ornament (Rogers Q42) over his characteristic 'lantern' (Rogers Q65); festoon (Rogers F4) with horse (O.1903) over a panther (O.1520). Of the types and details, only the rosette, lantern, festoon and panther are attested by Rogers for Drusus ii. The pediment (Rogers U269) and horse once again show links to the Sacer i-Attianus ii group. The

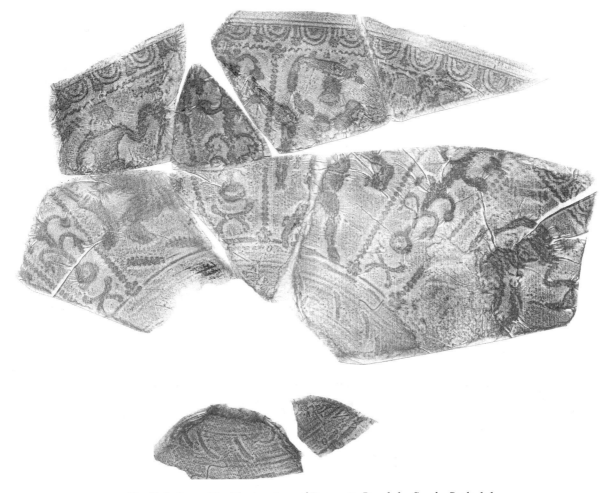

Fig 21.1: Drag 37 with signature of Drusus ii. Burgh-by-Sands. Scale 1:1

column that supports the pediment appears, incomplete, on a bowl signed by Drusus (Rogers 1999, pl 42, 1). Rogers describes it as P85, though the columns here, and probably also on his pl 42, 1, are considerably taller than this. The warrior (O.167) was used by X-11 and X-13, earlier potters who share features with Drusus, though it does not seem to have been noted for Drusus himself or the other members of the Sacer-Attianus group.

The motif Q42 occurs on work in the style of Geminus iv (Rogers 1999, pl 44, 16), another potter with whom Drusus had links, as does the dancer (O.353). A sherd in the distinctive style of Geminus iv, but with the cursive signature DRVS[below the decoration, was found at Gloucester (Wild 1985, with note by B R Hartley and B M Dickinson). Rogers publishes a small bowl from the Musée des Antiquités Nationales (MAN 32376, Rogers 1999, fig 27) with the signature DRVSVSVSF beneath the decoration and GIIMI beneath the base. This bowl, in Geminus' typical style, shows a very similar arcade to that on the Watercrook bowl, with the pediment Rogers U267 (apparently identical, but slightly smaller than U269) supported on columns (Rogers P85). The complete arcade on this bowl appears as a scaled-down version of that on the Watercrook bowl, as befits a smaller bowl.

In their note on the Gloucester bowl, Hartley and Dickinson (Wild 1985) raise the question of whether the various signatures of Drusus all belong to the same man, and his relationship, if any, to Drusus i of Les Martres-de-Veyre. The question of identity arises again with the variant spelling of the signature on MAN 32376, which Rogers includes as a separate potter, Drususus. The signature on the Gloucester bowl in similar style, of which only the beginning survives, could well have had the same reading. Is this indeed a different potter, or merely careless spelling? On the whole, it seems more likely that this is a case of diplography. The sharing of types by Drusus and Geminus and the similarity of the arcade on MAN 32376 suggest a definite connection. Maybe, as tentatively suggested by Hartley and Dickinson, Drusus was a mould-maker who worked first for Geminus before moving on to work with Sacer and Attianus in conventional 'Drusus ii' style. Both the bowls discussed here, large and small, with their links to Sacer and Attianus, are likely to belong to the period to which Drusus' work is conventionally dated, *c* AD 125–145.

Eppillus

3. Papcastle (NPA04 PAP-B 137). Drag 37, Central Gaulish, in an orangey fabric with a matt, highly micaceous orange slip, not dissimilar to the fabric produced at Lezoux in the 1st and early 2nd centuries AD before large-scale export began, and the result of firing at a lower temperature than that normally achieved during the period after *c* AD 120 (Fig 21.3). The style is close to that of the Quintilianus i group, who used the ovolo (Rogers B206), here so close

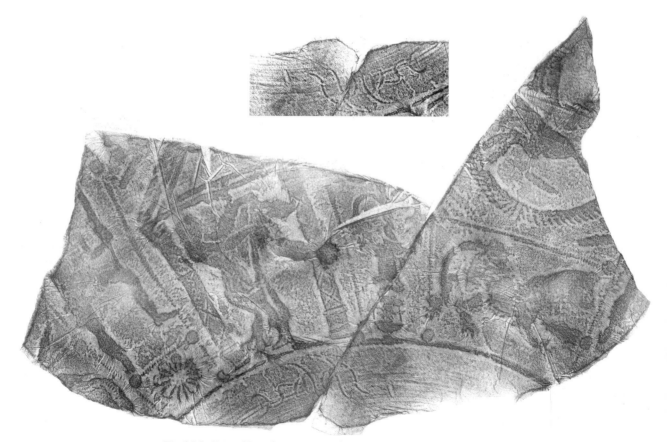

Fig 21.2: Drag 37 with signature of Drusus ii. Watercrook. Scale 1:1

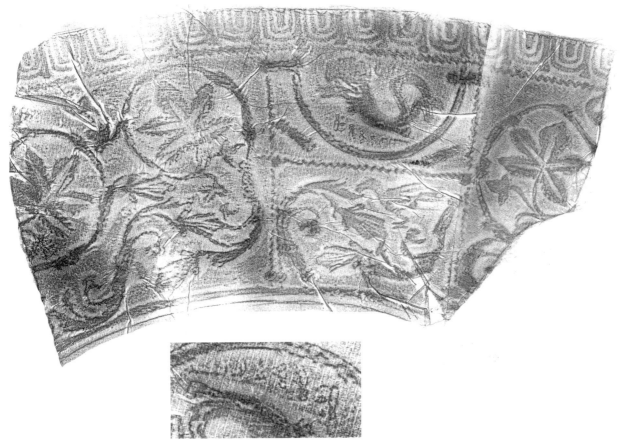

Fig 21.3: Drag 37 with signature of Eppillus. Papcastle. Scale 1:1; detail of signature: 2:1

together that the impressions are overlapping, and wavy-line borders. Panels show a complex design involving the vine scrolls (Rogers M4, M5), leaf spray (Rogers H117) and bud (Rogers G208) with a small bird (O.2299), all used by the Quintilianus group, and a wide festoon containing the dolphin (O.2394) with the signature EPPILLI (retrograde, upside-down, with lambda Ls) beneath it, over a motif involving Rogers H117 and G208 with a larger bird (O.2270A). The dolphin and larger bird do not appear to be attested on the work of the Quintilianus group.

Little is known for certain about Eppillus. Stanfield and Simpson publish two pieces under different headings: a mould with the cursive signature EPPILVS (S&S, pl 96, 1) and a small sherd with the mould stamp EPPILL[(retrograde) (S&S, pl 96, 2). Rogers (1999, fig 28) illustrates five pieces, three signed, two stamped, commenting on their diversity of styles. One of these (*ibid* fig 28, 4), showing motifs composed of Rogers H117 and G208 almost identical to those on the present bowl, has the cursive signature EPPILLI (retrograde) below the decoration, which he describes as 'apparently cut after firing on a mould of the Quintilianus group'. If the signature were indeed cut after firing, it might suggest that Eppillus was a potter who bought moulds for his own use from a variety of sources, which would account for the diversity of styles. The present signature, however, in, rather than beneath, the decoration, seems more likely to have been

inscribed before firing, during the making of the mould. Perhaps Eppillus worked with the Quintilianus group at some point in his career?

At another point, perhaps later, assuming that this is indeed the same man, Eppillus had links, as Rogers points out, with Illixo and the potter he calls Paullus I (Rogers 1999, Eppillus, fig 28, 2 (presumably cast from the mould illustrated S&S, pl 96, 1), also perhaps fig 28, 3; Illixo, pl 47, 1; Paullus I, pl 81, 1. Note that the sherds of Paullus I and Paullus II have been placed under the wrong headings on pl 81). It may be worth noting that the signatures of the two bowls of Eppillus in this style (*ibid*, fig 28, 2 and 3) both appear to read EPPILVS with one 'L', whereas the two in Quintilianus style (fig 28, 4 and the present piece) read EPPILLI with two. Here, again, are we dealing with one man's variation in the spelling of his own name, or with two different people? A better case could perhaps be made for two people here, where the styles are so different, than for DRVSVS/DRVSVSVS. The question of the Eppillus who used a mould stamp (*ibid*, fig 28, 1 and 5), in a different style still, is beyond the scope of this article.

There appears to be little close dating evidence for Eppillus. Rogers, following Stanfield and Simpson, tentatively suggests *c* AD 140. Clearly the present bowl must date to within the conventional bracket for the Quintilianus group, *c* AD 125–145. The site dating evidence from Papcastle cannot help to refine the date further.

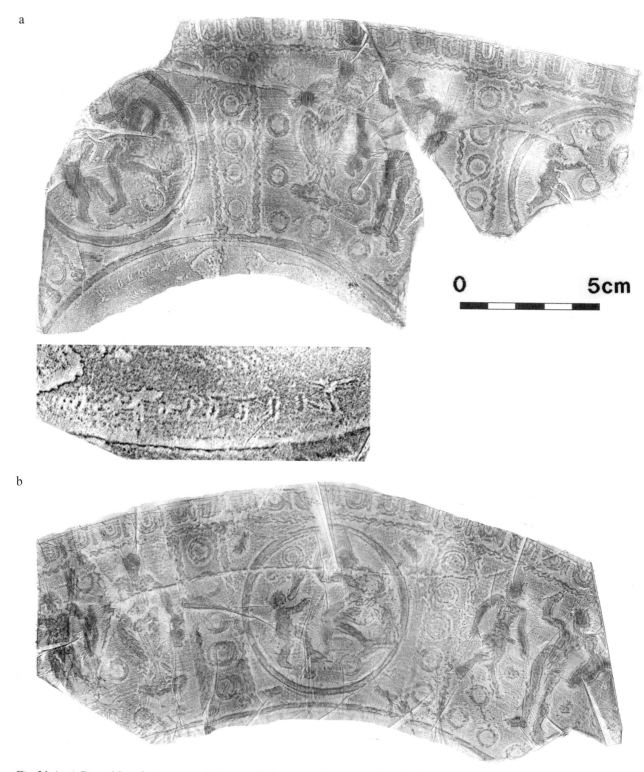

Fig 21.4: a) Drag 37 with signature of Tetturo. Walton-le-Dale. The left-hand edge of the rubbing joins Fig 21.4b below. b) continuation from Fig 21.4a; detail of signature: 1:1

Tetturo/Tetturus

4. Walton-le-Dale (WD96 180/5412, 177/5413). Drag 37, Central Gaulish. Many fragments of a bowl with the signature TETTVRI (retrograde) upside down below the decoration, inscribed in the mould before firing (Fig 21.4). The rim shows rivet holes, where the bowl has been

mended in antiquity. Panels, with wavy-line borders ending in a rosette (Rogers C120), show a medallion containing Cupid (O.394) and Jupiter (O.3) alternating with a panel containing two of the following types: Pan (O.717A), Hygieia (O.908) and a figure holding a club or caduceus (?)(R.3057). The choice and arrangement of the two types

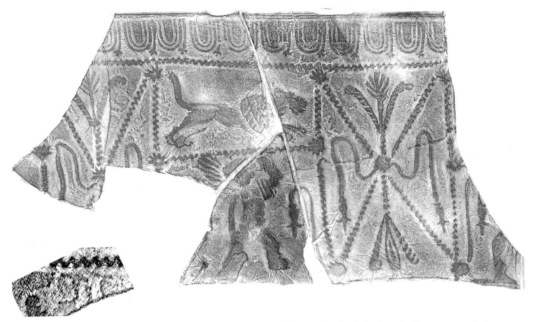

Fig 21.5: Drag 30 with signature of Tetlo. Binchester. Scale 1:1; detail of signature: 2:1

in the panels between the medallions varies. Between each panel is a vertical row of circles. Rogers (1974, 45) suggests that Tetturo's ovolo was perhaps B143 or B144. Although generally similar, the ovolo here appears slightly smaller, with a thinner tongue and without obvious damage to the core. It appears, perhaps, closer to Rogers B162, attributed to Sissus ii.

The bowl appears to be from the same mould as a signed sherd from Corbridge (S&S, pl 131, 3), though it shows, effectively, the complete scheme of decoration.

On the signature, Brenda writes:

'.... a signature of Tetturo/Tetturus of Central Gaul. Moulds of this potter were certainly used at Toulon-sur-Allier, but the fabric of this bowl suggests that it was made at Lezoux, and it seems likely that Tetturo/Tetturus worked there, in view of the frequency of his wares in Britain. Other signatures known for him read Tetturof, Tetturo and Tetturu, and one of his plainware stamps reads Tetturi. Despite these variants, there is no doubt that the same man is involved. Decorated ware in his style occurs in a pottery shop at Castleford destroyed by fire in the 140s and in Antonine Scotland. His plain ware includes several examples of Drag form 27, but only one of Walters form 80. *c* AD 130–160.'

Tetlo/Tetlonis

5. Binchester (BIN 79.2 A2312, A2294, A2221). Drag 30, South Gaulish. Four joining sherds showing panel decoration with saltire, and lion (O.1398) over Cupid (O.379) (Fig 21.5). Faint traces of a signature are visible in the upper panel of the left-hand saltire, across the break between sherds. The writing appears identical to that of

another signature, read as TIITLON[(retrograde), upside down below the decoration on a bowl of Drag form 37 from La Graufesenque (G72 35.1) with the same ovolo (Dannell *et al* 1998, SE). An unsigned form 30 from La Graufesenque with the same ovolo, which was also used by Memor, shows a saltire with the same bud at the top and the same panel with Cupid and corner tendril as appear on the Binchester bowl (G Dannell, pers comm).

The potter here is presumably the same as one who produced a Drag form 29 in the Hildyard Collection, probably from London, acquired by the Department of Archaeology at Durham University, with the internal stamp TETLONISF (retrograde, with lambda L) (Birley 1963; Dannell *et al* 2003, Tetlo, Taf E1, 2574. In the latter, the decoration is illustrated, but not the stamp). Birley notes another example of what is clearly the same stamp, on form 29 (no decoration surviving) from Donald Atkinson's excavations at Wroxeter, misread as LELIONISI (S reversed) (Oswald 1931, 395).

The form of the name is problematic. In conjunction with '*fecit*', it should be Tetlonis, in the nominative, and Birley clearly accepted it as such. Brian Hartley (Hartley and Dickinson 2008) lists the potter as Tetlo, also noting for him three examples of a stamp on Drag form 27g, probably to be read as TETLOF. Stamps with the name in the genitive followed by 'F' or 'FI', although rare, are not unknown in South Gaul (Polak 2000, 40). In such cases, the abbreviation must stand for a term such as '*figuli*' or '*figlina*'. The ethnic origin of the name is also a problem. Birley (1963) notes that Professor Kenneth Jackson did not consider it to be Celtic. John Peter Wild comments:

'the root TETLON[] does not appear to be attested in any of the literature on Gaulish and Germanic personal

names, in onomastica of the Greek-speaking world or in prosopographies of the Roman Empire. Brian Hartley constructs the nominative as Tetlo: Tetlonis is less likely, although the nominative suffix in –onis is found in Greek personal names'.

As noted above, the signature on the present bowl was only noticed under magnification. The very faintness of his signatures, as they appear upon the bowl, serves to underline the need to scrutinise very carefully not just the area beneath the decoration, but also within the decoration itself, in the search for mould signatures. The general associations of the decoration and the fact that he made both Drag forms 29 and 37 suggest a date *c* AD 65–85.

Conclusion

By signing his name in the mould, the mould-maker clearly was not advertising himself to the customers who acquired the bowls made inside it, as his signature would rarely survive the production process. Where it did, it was in reverse, upside-down and, as in the case of Tetlo, barely legible. Where an individual was part of a group of potters working together, as in the case of the Quintilianus i group, the signatures may have been added as a sign of accountability and to indicate who was responsible for the individual moulds in use within the workshop. If the mould-maker or his employer sold on the moulds to other workshops, they would act as advertisement for their place of origin. Whatever their purpose, they are undoubtedly worth looking for specifically, as evidence not just of an individual potter's style, but as an indicator of the possible production stages within the industry.

Acknowledgments

I am most grateful to the excavators who gave permission to publish; also to Geoffrey Dannell for his help in scanning the rubbings and to Brenda herself for permission to make use of an entry from the forthcoming Index of potters' stamps. Last but not least, I must thank John Peter Wild for reading and commenting on the text and for his energetic, if somewhat negative, pursuit of Tetlo.

Bibliography

Birley, E, 1963. A newly identified South Gaulish potter, *Antiq J* 43, 287–8

Dannell, G B, Dickinson, B, and Vernhet, A, 1998. Ovolos on Dragendorff form 30 from the collections of Frédéric Hermet and Dieudonné Rey, in *Form and Fabric: Studies in Rome's material past in honour of B.R. Hartley* (ed J Bird), Oxbow Monogr 80, 69–109, Oxford

Dannell, G B, Dickinson, B M, Hartley, B R, Mees, A W, Polak, M, Vernhet, A, and Webster, P V, 2003. *Gestempelte Südgallische Reliefsigillata (Drag. 29) aus den Werkstätten von La Graufesenque*, Verlag des Römisch-Germanischen Zentralmuseums, Mainz

Hartley, B R, and Dickinson, B M, 2008 – *Names on* terra sigillata*: an index of makers' stamps and signatures on Gallo-Roman* terra sigillata *(samian ware)*, Bull Inst Classical Stud Supplement 102, London

O. = Figure type in Oswald 1936–7.

Oswald, F, 1931. *Index of potters' stamps on terra sigillata 'samian ware'*, East Bridgford

Oswald, F, 1936–7. *Index of figure-types on terra sigillata ('samian ware')*, Univ Liverpool Ann Archaeol Anthropol Suppl 23–4

Polak, M, 2000. *South Gaulish terra sigillata with potters' stamps from Vechten*, Rei Cretariae Romanae Fautorum Acta Suppl 9, Nijmegen

Potter, T W, 1979. *Romans in North-West England*, Cumberland Westmorland Antiquarian Archaeol Soc Res Ser 1, Kendal

R. = Figure type in Rogers 1999, 481–499

Rogers = Central Gaulish decorative motifs from Rogers 1974

Rogers, G B, 1974. *Poteries sigillées de la Gaule Centrale I: les motifs non figurés*, Gallia Suppl 28, Paris

Rogers, G B, 1999. *Poteries sigillées de la Gaule centrale II: les potiers*, Cahier du Centre Archéologique de Lezoux 1/Revue Archéologique Sites, hors série 40 (2 vols), Lezoux and Gonfaron

S&S = Stanfield and Simpson 1958

Stanfield, J A, and Simpson, G, 1958. *Central Gaulish potters*, London.

Wild, F, 1985. The samian ware, in A G Hunter, Building-excavations in Southgate Street and Quay Street, Gloucester, 1960, *Trans Bristol Gloucestershire Archaeol Soc* 103, 62–65

Wild, F C, 2009. The samian pottery, in D J Breeze and D J Woolliscroft, *Excavation and survey at Roman Burgh-by-Sands*, Cumbria Archaeol Res Rep 1, 64

Wild, F C, 2010. The samian ware, in I Ferris, *The beautiful rooms are empty: Excavations at Binchester Roman fort, County Durham, 1976–1981 and 1986–1991*, 2 parts, Durham County Council, 219–239

22 Senex, samian and saffron – solution in sight?

Ralph Jackson

Introduction

We cannot hope to make sense of every surviving fragment of past material evidence, but some puzzles are more vexing than others. Such is the case with several fragmentary samian vessels impressed with a stamp bearing the name Lucius Iulius Senex. George Boon incorporated a review of the examples known to him in the early 1980s in a wide-ranging paper (Boon 1983, 1–3) that took as its starting point his recognition of a new Senex find amongst the kiln waste from the 'grand four' then recently excavated at La Graufesenque (Boon 1983, 1; Vernhet 1981, 34–5, fig 8, no. 32).

The impression of the stamp is far from enigmatic and may be expanded and read:

Luci Iuli Senis crocodes ad aspritudines
'Lucius Iulius Senex's saffron salve for granulation (of the eye-lids)'.

It is an abbreviated text of standard and distinctive form of the type encountered on the dies of the small stone stamps popularly called 'oculists' stamps' but more correctly termed 'collyrium-stamps', for it is evident that the stamps were used by a far wider medical personnel than those who called themselves oculists or those who we might characterise as practitioners who treated only eye diseases. In fact, the collyrium-stamps themselves are by no means fully understood – their idiosyncratic distribution and precise role in ancient healing still await an unequivocal explanation (Nutton 1972; Boon 1983; Künzl 1985; RIB 2.4, pages 43–4; Jackson 1996a, 2241–2; 1996b, 177–8).

The Senex stamp was first recognised in1854, when Charles Roach Smith published a cup base found at an unrecorded site in the City of London (Fig 22.1; Table 22.1, no. 8). Smith realised the significance of the stamp which he translated *'The Crocodes of L. Julius Senis for granulations of the eyelids.'* (Roach Smith 1854, 47). We should not be surprised at his recognition of the stamp and interest in it, not least because he was a chemist by trade, but also because there was by then already an extensive literature

on 'oculists' stamps'. These objects fascinated antiquaries and collectors alike, both for their attractive appearance – small tablets of stone in various colours – and for the intrinsic interest of their dies – abbreviated, and usually finely-engraved, retrograde Latin (or occasionally Greek) inscriptions which record an extensive range of *collyria* advocated by a seemingly infinite number of salve-blenders for the treatment of an assortment of eye diseases. By 1854 over 100 collyrium-stamps were known, including twelve from Britain (Voinot 1999, nos.15, 31, 37, 39, 43, 49, 68, 73, 92, 94, 95, 97), one of which (from Kenchester) Roach Smith himself had published (Roach Smith 1849).

The collyrium-stamp dies generally comprise one or more of three components: a personal name, a medication and an indication for use, the latter invariably related to the eye and/or its margins. In combining all three of those components the Senex samian stamp precisely parallels the most explicit and comprehensive type of collyrium-stamp die. To add a further complexity to the situation the Senex stamp has been encountered as two distinct dies.

The dies (Fig 22.2)

Die 1: (Table 22.1, nos. 1–2 (*cf* L. Iulius Senex die 1a: Hartley and Dickinson 2009, 356)

 L.IVL.SENIS.CRO/CODAD.ASPRITV
 L(uci) Iul(i) Senis cro/cod(es) ad aspritu(dines)
 'Lucius Iulius Senex's saffron salve for granulation (of the eye-lids)'.

Die 2: (Table 22.1, nos. 3–10 (*cf* L. Iulius Senex die 2a: Hartley and Dickinson 2009, 356))

 L.IVL.SENISCR/OCOD.ADASPR
 L(uci) Iul(i) Senis cr/ocod(es) ad aspr(itudines)
 'Lucius Iulius Senex's saffron salve for granulation (of the eye-lids)'.

As can be seen, the expanded text is the same for both dies but there are several differences between them – in the organisation of the lettering, in the use of interpunct, in the line-break, and in the degree of contraction of the word *aspritudines*. As Boon noted (1983, 1) Vernhet's

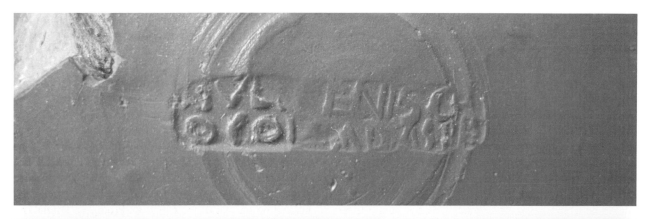

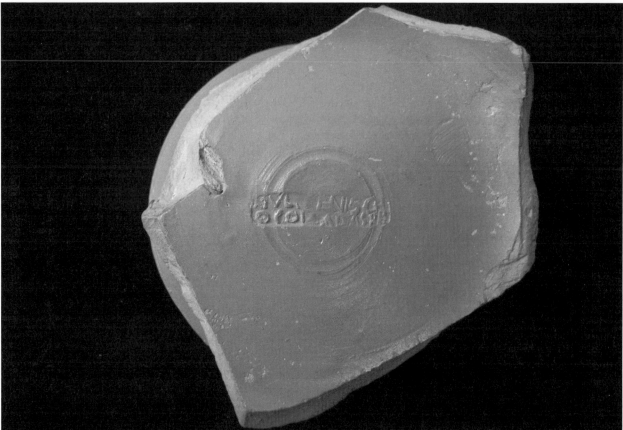

Fig 22.1: Base of a Drag 33 cup from London, with Die 2 stamp of L. Iulius Senex (British Museum, 1856,0701.595. Images: Ralph Jackson)

reading (1981, 34–5, fig 8, no. 32) of a stop after *cr* at the end of the first line of the La Graufesenque 'grand four' Die 1 impression (Fig 22.2, no. 1) is incorrect: a stop would not be expected within the word *crocodes* and Espérandieu (1904, 174, no. 233 and fig 68, no. 233) recorded a diminutive *o* in that position on the Mainz Die 1 impression (Fig 22.2, no.2).

The Senex dies are notable not only for the overtly medical nature of their text but also for their format: as two-line stamps they are exceptional among samian potters' stamps, which almost invariably comprise just a single line, but they are the norm for collyrium-stamps, which sometimes comprise single-line dies and occasionally three-line dies but overwhelmingly take the form of two-line dies. Thus, in textual content and in format the dies are, at first sight, indistinguishable from those of collyrium-stamps.

How they differ from the collyrium-stamps is in the size of their impressions: the Die 1 stamp on the dish from La Graufesenque (Fig 22.2, no. 1) – a slightly distorted impression with elliptical borders – measures *c* 25 × 5mm; the Die 2 stamp on the cup from London (Fig 22.2 no. 8) – a more even impression with near parallel borders – measures 22.3 × 5.1mm. Both die impressions are, therefore, smaller than the majority of dies on collyrium-stamps. Nevertheless, they may be paralleled by a good number of examples. Collyrium-stamp die faces with a height as much as 18mm are recorded, though they are most frequently between 8 and 10mm high, and many measure as little as 3–7mm high. The length of the collyrium-stamp die faces reaches a maximum of 96mm, but mostly they fall within the range 30–50mm and quite a few are a diminutive 20–30mm in length. Thus, it is just conceivable that the samian impressions were made directly with a very small collyrium-stamp and there is not necessarily a need to invoke quite the degree of 'shrinking processes' through multiple surmoulages that some have done in the past (RIB 2.4, no. 2446.25 endnote). However, while the direct use of a collyrium-stamp is not ruled out in terms of size of impression there are other reasons for doubting that the Senex samian stamp was a collyrium-stamp.

The name

The name L. Iulius Senex is not further attested either among samian potters' stamps or among collyrium-stamps. Of the more than three hundred names recorded on the collyrium-stamp dies there are just three instances of Sen-prefixed names (and only one of those as a *cognomen*) – Senni(us) Virilis on the four dies of an unprovenanced stamp (Voinot 1999, no. 6); Sen(nius) Matidianus on a re-cut die of a stamp from Compiègne (Voinot 1999, no. 122); and Seni(or) on the two dies of a stamp from Staines (Voinot 1999, no. 305; Jackson 1996b, 178–84). Senior is found again, as a graffito cut twice on the planar faces of a stamp of T. Vindacius Ariovistus from Kenchester (Voinot 1999, no. 94; Jackson 1996b, 183–4).

However, as has been observed (Künzl 1985, 471–4, figs 16–17), there are very few instances of the same name appearing on more than one collyrium-stamp and even fewer cases with the name in *tria nomina* form. It is therefore not difficult to postulate a unique stamp of L. Iulius Senex. Were that the case, though, the stamp would have to have had two dies, both advertising the same salve of Senex for the same eye disease. Of more than 300 collyrium-stamps only four (Voinot 1999, nos. 58, 77, 163, 179) fall into this category and two of those (58, 179) are examples of collyrium-stamps with die faces tailored to stamping *collyrium* sticks of two different sizes. Of the remaining two examples one (Voinot 1999, no. 163, from Mainz) is a four-die stamp with exactly the same inscription on two of the dies – Q. P(ompei). DIODOTI. DIA/SMYRNES. The other (Voinot 1999, no. 77, from Nuits-Saint-Georges) is a columnar four-die stamp with two versions of the same inscription on two of the dies – C DEDEMONIS MELINVM/ AD CLARITATEM ET CALIGI(nes) and C DEDEMONIS MELINV/M AD CLARITATEM ET KA(ligines). The latter is the sole true parallel to a supposed original collyrium-stamp of Lucius Iulius Senex with two slightly varying forms of the same prescription.

A further small, but perhaps telling, difference between the Senex dies and those of collyrium-stamps relates to the contracted form of the word *crocodes* and its position at the line break: a range of contractions between the extremes of *crocodes* and *cr* is found within the 61 occurrences on collyrium-stamp dies, including 14 in the form *crocod*, but of those only two (Voinot 1999, nos. 22 and 299) are divided by the line break and neither exactly parallels the break point of the Senex dies.

In view of the absence of exact comparanda we might question whether the L. Iulius Senex impressions were made with a former collyrium-stamp. More logically, perhaps, we should envisage at least two stamps of L. Iulius Senex purpose-made for marking samian vessels. Furthermore, since two different contractions were used for *aspritudines* it would seem reasonable to assume that the maker of the samian stamps was conversant with the abbreviated medical terminology of collyrium-stamps and, perhaps, with the prescriptions of the contemporary pharmacopoeias.

The salve

Although some one hundred salves are recorded on the collyrium-stamps more than a third of them are mentioned once only, while just six salves – *crocodes, dialepidos, diamisus, diasmyrnes, opobalsamatum* and *stactum* – account for over 40% of the occurrences (Jackson 1996a, 2240; Voinot 1999). *Crocodes* registers some 7% of the total, a figure exceeded only by *diasmyrnes* (a salve made from myrrh) at 9%. *Crocus – krokos –* was a frequent ingredient of the recipes for *collyria* in the ancient medical literature, alongside the two 'Arabian spices' myrrh and frankincense (also encountered on the collyrium-stamps as *dialibanum*, though at little more than one per cent of occurrences). These were very costly substances. According

Die 1

Die 2

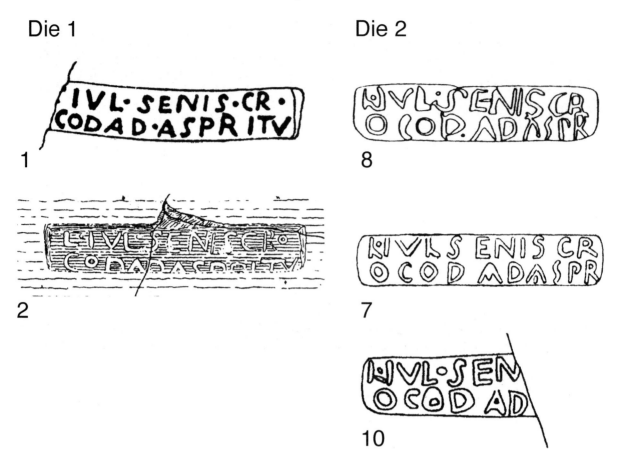

Fig 22.2: Drawings of the impressions of the two dies of L. Iulius Senex. The numbers refer to Table 22.1. (1 after Vernhet; 2 after Espérandieu; 7 after J Roman Stud 19, 217, fig 14; 8 after Hartley and Dickinson; 10 after Boon, courtesy National Museum of Wales)

to Pliny the Elder (*Nat Hist* 12.65 and 70) a Roman pound of best quality frankincense cost six denarii and of Arabian myrrh sixteen-and-a-half denarii. *Crocus* – saffron, made from the styles of the flowers of *Crocus sativus*, required 100,000 flowers to make one kilogram (Scarborough 1996, 50), so it is hardly surprising to find that in Diocletian's Price Edict the price of a pound of saffron was set at 2000 denarii.

Whether it was the colour or scent of saffron that gave its name to *crocodes* we do not know, nor the proportion or quantity (if any) of saffron that was incorporated in the *collyrium*. However, the results of scientific analysis of a find from Lyon – perhaps the clearest and best-recorded archaeological evidence to date for a healer specialising in eye medicine – encourage caution and certainly discourage any acceptance at face value of the nature of the *collyria* marked with collyrium-stamps. A cremation grave of the late 2nd–early 3rd century AD in the cemetery of La Favorite, to the west of Lyon, yielded a rectangular drug box containing twenty sticks of dried *collyrium*, a tubular case with three probes, of the type used to mix and apply medicaments, and a worn stone palette upon which the *collyria* had evidently been prepared (Boyer 1990). Eleven of the sticks bore stamped impressions, which included four *collyria* of Zmaragdus – *stratioticum, dialibanum, dielaeum* and *crocodes*. Samples were subjected to chemical analysis,

pollen analysis and Raman spectrometry in an attempt to characterise and quantify both inorganic and organic ingredients of the named *collyria* and compare them with the corresponding recipes in the ancient pharmacopoeias. There were points of contact, but no precise correspondence, between the pharmacopoeias and the analytical results for *stratioticum* and *dialibanum*, while for *crocodes* the analyses demonstrated a complete absence of saffron (Boyer 1990, 239–40). Thus, Zmaragdus' *crocodes* may have been saffron-coloured and it may have been beneficial, with its ingredients of iron, silica, copper, zinc, potassium etc., together with an indeterminate organic compound, but saffron it was not. The discordance is not attributable solely to the limitations of analysis and it was concluded (Boyer 1990, 246) that pharmaceutical terminology may have varied both in time and in cultural zone, an intriguing supposition that may lend credence to a fiscal explanation for the collyrium-stamps (Künzl 1985, 474–5. Jackson 1996a, 2242–3). For, if the *collyria* of the north-western provinces differed in their composition from those in other parts of the empire their export could have resulted in confusion and perhaps even in danger to eye patients and this may have led to the requirement for the north-west *collyria* to be identified by stamped inscriptions. However, for the potentially infinite variation of *collyrium* ingredients in the early 1st century AD we need look no further than

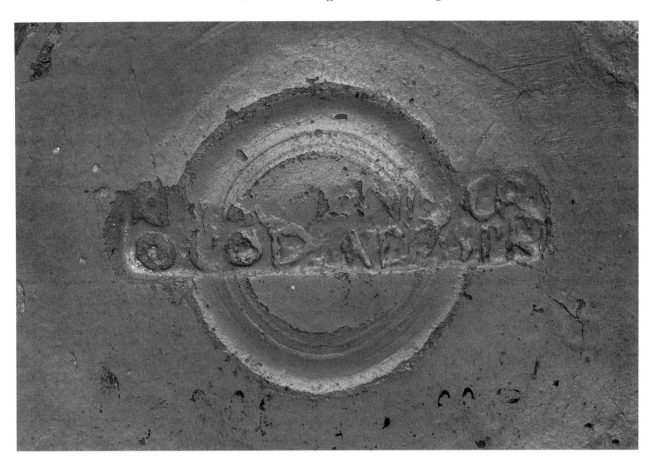

Fig 22.3: Base of a Drag 27 cup from Moorgate Street, London, with Die 2 stamp of L. Iulius Senex (Museum of London 12,108. Images: Museum of London)

the pages of Celsus' *De medicina* (6.6.2), where it is noted that 'there are many salves devised by many inventors, and these can be blended even now in novel mixtures, for mild medicaments and moderate repressants may be readily and variously mingled'.

The eye disease

Aspritudo together with *lippitudo* was foremost among eye diseases in the Roman world. Celsus used *aspritudo* for the Greek *trachoma* and *ophthalmia* but he also included *ophthalmia* under *lippitudo*, a condition with the symptoms of inflamed and running eyes with sticky secretions, sometimes chronic, and consequent on, or contributing

to, *trachoma*. Between them, *aspritudo* and *lippitudo* also correspond to our conjunctivitis and to other eye diseases displaying the symptoms of inflamed and running, sticky eyes (Celsus *De medicina* prooemium 30; 1.5.1; 6.6.1; 6.6.27; Neilsen 1974, 90–1). As a consequence a very large proportion of the *collyrium* recipes and collyrium-stamp dies are dedicated to the treatment of these eye diseases, in the case of the collyrium-stamps 25% for *lippitudo* and 20% for *aspritudo* (Jackson 1990, 276–7). The roughness and granulation of the eyelids and corners of the eyes caused by *aspritudo* was unpleasant enough, but if not treated promptly and effectively it might easily trigger further disease, including trichiasis – abnormal inturned eyelashes which irritate the cornea and conjunctiva causing

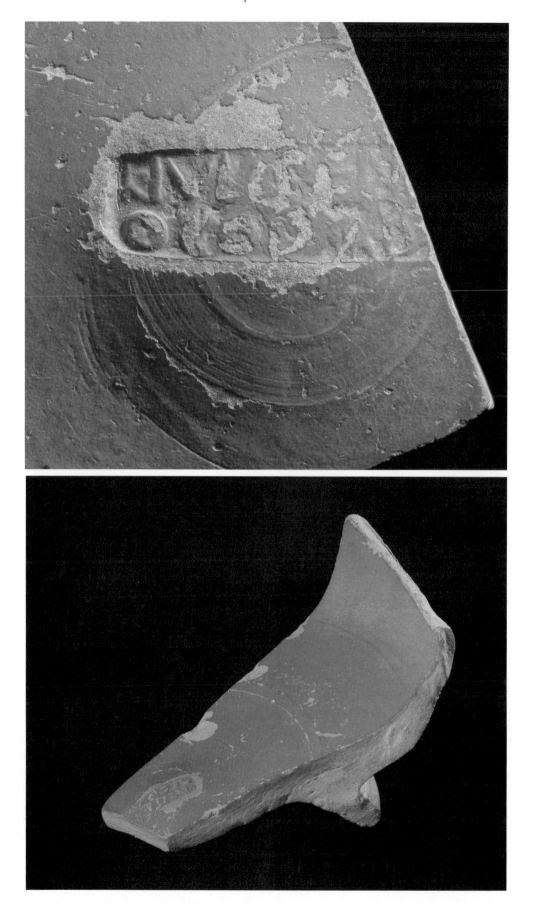

Fig 22.4: Base of a Drag 18 dish from Caerleon, with Die 2 stamp of L. Iulius Senex (National Museum of Wales 56.214B. Images: National Museum of Wales)

No.	Provenance	Site	Vessel	Context date	Die
1	La Graufensenque (Vernet 1981, fig 8, no. 32)	Kiln-site waste	Drag 18R or 18/31R	*c* AD 120	1
2	Mainz (Espérandieu 1904, fig 68, 233)		Drag 18/31		1
3	La Graufesenque (Musée Fenaille, Rodez, Coll Hermet '9'	Kiln-site	Drag 27		2
4	Mainz		Drag 27		2
5	Butzbach (A1956.1889.40)	Fort vicus	Drag 27	Fort estab *c* AD 90	2
6	Butzbach (2427.1141)	Fort vicus	Drag 27	Fort estab *c* AD 90	2
7	London (Museum of London 12, 108; RIB 2.4, 2446.25 (ii))	Moorgate St ?artisan quarter	Drag 27	Prob 2nd century AD	2
8	London (British Museum 1856.0701.595; M2028; CIL 13, 10021.231; RIB 2.4, 2446.25(i))	City of London	Drag 33		2
9	Strasbourg (7354)		Drag 18		2
10	Caerleon (National Museum of Wales 56.214B; RIB 2.4, 2446.25 (iii))	Legionary parade-ground levelling, near Building VIII	Drag 18	Before *c* AD 140	2

Table 22.1: Samian vessels marked with the stamp of Lucius Iulius Senex (adapted from Hartley and Dickinson 2009, 356)

secondary infection – which might ultimately lead to blindness. Amongst the many *collyria* employed to combat *aspritudo* Celsus recommended *basilicon*:

'Nothing is better than that named by Euelpides basilicon. It contains: poppy-tears, cerussa and Assos stone, 8 grms. each; gum 12 grms.; white pepper 16 grms.; saffron 24 grms.; psoricum 42 grms.' (*De medicina* 6.6.31, trans W G Spencer).

Like most of Celsus' *collyria*, basilicon comprised active and aromatic ingredients blended with an agglutinant – gum. Saffron – *croci* – was the principal aromatic of basilicon, but the metal oxide and acetate ingredients of *psoricum*, together with the analgesic effect of the poppy-tears (opium) and the additional properties of the other ingredients, provided a cocktail of anodyne, antiseptic, astringent, bactericidal and desiccant substances. These may have alleviated and cleared the symptoms not only of *aspritudo* but also of other eye complaints, for Celsus adds: 'It is generally agreed that the salve *basilicon* is suitable for all affections of the eyes [*ad omnes affectus oculorum*]'. A little further on he advocates use of two more saffron-based *collyria* for ophthalmia, 'the salve called Asclepios. ... which is composed of saffron dregs (*croci magmate*)' and 'a special preparation for this purpose called *dia crocu*' (ie containing saffron – that from Cilicia was specified) (*De medicina* 6.6.32–3, trans W G Spencer).

Whatever may have been the actual ingredients of the *collyrium* marked with the salve name *crocodes* on the

collyrium-stamps, its intended principal use appears to have been in the treatment of *aspritudo*. For, of the twenty-three dies specifying an application for *crocodes* eighteen are *ad aspritudines* while the remaining five comprise singletons for corneal scarring, ectropion (a gaping lower eyelid), dim sight, clear vision and 'affections'. Thus, in the case of a further twenty-two occurrences of *crocodes* in which no application is specified it seems probable that *ad aspritudines* would have been the obvious, and therefore unwritten, usage. Certainly, the L. Iulius Senex dies record one of the most troublesome of Roman eye diseases – *aspritudo* – and the principal salve used to treat it – *crocodes*.

The stamped vessels

The fact that the two dies of L. Iulius Senex are both represented on vessels from La Graufesenque and from Mainz has resulted in some confusion over the number of stamped vessels. Thus, Boon listed a total of eight – two of one die, six of the other – which includes only single examples from Mainz and La Graufesenque (Boon 1983, 1–2, details subsequently followed by Künzl 1985, 475 and RIB 2.4, no. 2446.25 endnote). However, according to the Leeds Index of potters' stamps (Hartley and Dickinson 2009, 356) ten examples are known, two and eight according to die type, and these are listed in Table 22.1 above. Hartley, working from a rubbing and a record supplied by D Atkinson, attributed the Mainz Drag

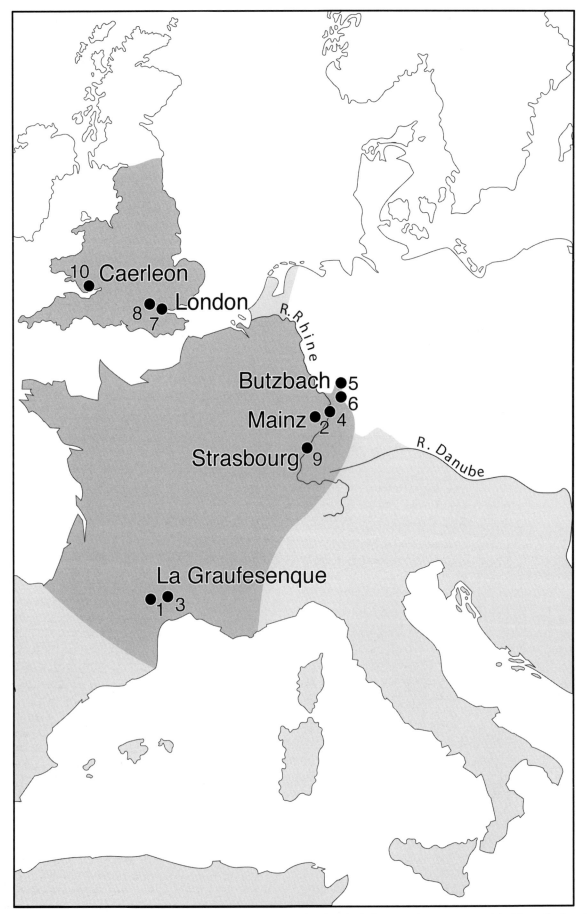

Fig 22.5: Map to show the distribution of the L. Iulius Senex vessels. The shaded area is the tax region of the Four Gauls, which coincides with the principal distribution of collyrium-stamps (Craig Williams, copyright The British Museum)

18 dish to his die 2a, the larger group, while the Mainz vessel which shares the La Graufesenque 'grand four' die stamp he recorded as a Drag 27 cup. Boon, on the other hand, described the Mainz vessel which he linked to the La Graufesenque 'grand four' die type, as a Drag 18 plate, 'lost in the war'. Confirmation of Boon's identification comes from Espérandieu (1904, 174, no. 233 and fig 68, no. 233) who illustrates a Drag 18/31 dish with a stamp clearly identifiable as that of the 'grand four' die type (ie Hartley's 1a). In Table 22.1, therefore, I have accepted Hartley's totals but have followed Boon/ Espérandieu regarding the identification of the Mainz dish, on the assumption that the Hartley listing transposed the Mainz vessel types.

There has also been a longstanding uncertainty over the form of both London vessels which are represented only by their base. A resolution has now been reached: one is a Drag 33 (British Museum; Fig 22.1), an early version of the form dating to before or around the end of the 1st century AD, the other (Museum of London; Fig 22.3) a Drag 27 which, with the groove on its footring, is likely to date before the end of the 1st century AD (Joanna Bird, in litt)

It is hoped that the present simplified Table will help to clarify things.

Dating

'The date [AD 75–110] is clear from the site record, the Butzbach pieces being particularly useful.' (Hartley and Dickinson 2009, 356).

Distribution, context and function

Why, then, were these dies used to mark samian vessels? The question has vexed and the answer eluded all those who have examined the impressions since Roach Smith who, with only a single example to explain, ventured that 'it was probably applied by the potter accidentally, or as a substitute' (Roach Smith 1854, 47). Boon (1983, 2–3) reviewed and rejected that and the few further explanations that had been offered (by Caylus, Sichel, Grotefend and Oxé: references in Boon 1983, fn 3–13), before tentatively advancing his own inimitable solution 'which would see in this bizarre use merely a cumbersome jest of a kind immemorially dear to country-potters, who might in another age and clime model a toad at the bottom of a mug'.

This theory of a 'potter's jest' certainly has its attraction: a fuddled diner drains his cup and focuses his blurred gaze on an inscription recommending an ointment for eye disease! However, although such wry humour might be thought to resonate with the Roman enjoyment of verbal and visual punning (Petronius *Satyricon* 56; Jackson 2002) it falls short of providing a thoroughly convincing explanation of the stamps.

Similarly unsatisfactory is the most mundane explan-ation, that a collyrium-stamp was pressed into service, metaphorically and literally, by an illiterate potter. For, as already discussed, this would fail to explain the existence of two dies. It would also be a more convincing

explanation were the context late Roman, when it is more likely that an increased proportion of the large number of collyrium-stamps in circulation was no longer being used for their original intended purpose. Rather, the period of manufacture of the L. Iulius Senex vessels in the late 1st to early 2nd century AD coincides with the rise in usage of collyrium-stamps – only a small proportion of collyrium-stamps has a firm intrinsic or contextual date and very few of those precede the turn of the 1st/ 2nd century AD (Künzl 1985, 472–3). Thus, samian production at La Graufesenque is situated in time early in the period of usage of collyrium-stamps and in space at the southern edge of their principal distribution.

As it happens, one of the best contexts for the activity of a medical practitioner who included eye medicine in his realm of healing, a 3rd century cremation group (Künzl 1983, 57–8; Jackson 1996a, 2234–5), comes from a grave at St Privat d'Allier, only some 100 km north-east of La Graufesenque, while a more recent find from Campagnac, just 30 km away, was also reported to have included a collyrium-stamp and medical instruments (Voinot 1999, no. 273). To the east, further finds of collyrium-stamps include those from Arles (3), Nimes (3) and Orange (Voinot 1999, nos. 131, 154, 185, 24, 28, 44, 78, 148, 192). It is probable, then, that collyrium-stamps, whatever their precise role, were in use, in some numbers, together with other medical equipment, in the vicinity of La Graufesenque at the time when the L. Iulius Senex stamp was being used. Furthermore, drugs and *materia medica* in various forms are likely to have been included in the range of traded commodities passing (in all directions) through the Rhone valley, the Mediterranean littoral and the port of Marseilles.

If the general medical setting for La Graufesenque is tolerably clear, so, too, is the distribution of the wares of L. Iulius Senex, albeit they are small in number: while La Graufesenque samian was traded widely Senex's vessels have not been found outside the area of principal distribution of collyrium-stamps (within the tax region of the Four Gauls). Furthermore, excepting those from the kiln site all of the vessels are certainly or probably from military sites on the Rhine frontier and in Britain (Fig 22.5). At just this time we find graphic evidence from Britain's northern frontier of the prevalence and problem of contagious eye disease. On May 18 of a year somewhere around AD 95 Vindolanda's garrison was suffering not only from wounds and sickness but from a bout of *lippitudo*: on an interim strength report ten soldiers described as *lippientes* were listed separately from the sick (*aegri*) and injured (*volnerati*), fifteen and six soldiers respectively (Tab Vindol 2, 154). The importance of good vision for serving soldiers was keenly appreciated – hence the inclusion of an eye test in the medical examination for new recruits (Jackson 1988, 130) – but so, too, were the potentially catastrophic consequences of contagious eye infections – hence the separate category (and thus presumed segregation) of the *lippientes* at Vindolanda and the presence of eye doctors in the British Fleet (Galen 12.786K).

While the idea has rightly been dismissed that the collyrium-stamp system was specifically related to healing in the Roman army (Boon 1983, 4–5 *contra* Neilsen 1974, 97–102), it is evident that the concentration of large numbers of soldiers in forts and fortresses would have led to the requirement of regular and large quantities of medical supplies, as a further document from Vindolanda implies (Tab Vindol 3, 591). Could the L. Iulius Senex vessels have formed a part of such supplies? Although the sample is not particularly great – a total of just ten vessels – it forms a relatively coherent group comprising six cups and four dishes. It has been said that the vessels, being dishes and wide-mouthed cups, are of a shape unsuitable to contain medicaments (Boon 1983, 3; RIB 2.4, no. 2446.25 endnote), but such an assertion seems questionable. All are of modest capacity and might have accommodated semi-solid preparations, while their beaded lip would have facilitated use of a tied cover. Certainly, cups and dishes of just these sizes, variously in ceramic (including a Hofheim 22 cup and a Drag 31 dish), bronze or silver, are commonly found in graves with medical and pharmaceutical equipment from the 1st to the 3rd century AD (Künzl 1983, 45–9, fig 13, 1; 61–4, fig 30, 4–6; 70, fig 44, 4; 88–9, fig 64, 1 and 3; 91–3, fig 70, 12). It is also instructive to read the near-contemporary (mid-1st century AD) advice of Dioscorides on the optimum storage of drugs:

> ' ... for moist drugs, any container made from silver, glass or horn will be suitable. An earthenware vessel is well adapted provided that it is not too thin ...' (*De materia medica* Preface, 9).

If not containers for transporting and storing the Senex *collyrium* it is alternatively conceivable that the vessels were intended for the preparation of that and other *collyria* and drugs. That suggestion has also been made by Künzl (2002, 86), who interprets the vessels as trade gifts from Senex, a pharmacist, to those who purchased his medical supplies and in which they could prepare their medications. That might well apply to the only other known pottery vessel impressed with a collyrium-stamp – a 1st century AD mortarium from *Glanum* stamped twice on its rim with the die C DVRON CLETI/CHELIDO AD CAL (CIL 13, no. 10021.230; Boon 1983, 2–3). The salve-blender's name is unusual, the salve and application less so: *chelido(nium)*, a celebrated drug formed from the plant-juice of *Chelidonium majus* (Neilsen 1974, 37–8), was a favoured eye-salve that was especially recommended for the treatment of *caligo* – dimness of vision – (Pliny *Nat Hist* 25.50) which is the fifth commonest ailment recorded on collyrium-stamp dies. A mortarium might be considered a most appropriate vessel for the preparation of *collyria*, whether from fresh ingredients or the crumbling of a stick of dried *collyrium* for rubbing down and mixing with water, wine, vinegar, milk or egg albumen.

What seems inescapable is 1) the purposeful nature of the Senex stamps, which were carefully made for a particular task, and 2) the clear indication of a connection with the practice of medicine, specifically the treatment of eye disease. We might even go so far as to conjecture that the Senex vessels were made as containers for a blender of eye-salves (perhaps for L. Iulius Senex himself and perhaps commissioned by him), resident in the vicinity of La Graufesenque, who had a contract to supply medication to units of the Roman army in the north-western provinces in the late 1st – early 2nd century AD. But while we may apply such a solution *ad claritatem*, full 'clarity of vision' remains elusive.

Acknowledgements

It is a very great pleasure to contribute to this volume in honour of Brenda Dickinson, a most kind and generous colleague. For information in advance of the publication of the Leeds Index of potters' stamps I am indebted to Joanna Bird and Brenda herself; and for information, images, ideas and stimulating discussion I am most grateful to Joanna Bird, Jenny Hall, Beth Richardson, Evan Chapman, Richard Brewer, Martin Dearne, Richard Hobbs, Ernst Künzl and Craig Williams (Figs 22.2 and 22.5). Over the years I have benefited beyond measure from discussions on collyrium-stamps with the late George Boon, Ernst Künzl, the late Paul Janssens, Jacques Voinot and many others.

Bibliography

Boon, G C, 1983. Potters, oculists and eye-troubles, *Britannia* 14, 1–12

Boyer, R, 1990. Découverte de la tombe d'un oculiste à Lyon (fin du II siècle après J.-C.). Instruments et coffret avec collyres, *Gallia* 47, 215–49

CIL 13 = Espérandieu, E, 1901, *Inscriptiones trium Galliarum et Germaniarum Latinae. Instrumentum domesticum II, signacula medicorum oculariorum*, Corpus Inscriptionum Latinarum 13 (3.2), 558 – 610, Berlin

Espérandieu, E, 1904. *Signacula medicorum oculariorum*, Paris

Feugère, M, Künzl, E, and Weisser, U, 1985. Les aiguilles à cataracte de Montbellet (Saône-et-Loire). Contribution à l'étude de l'ophtalmologie antique et islamique/ Die Starnadeln von Montbellet (Saône-et-Loire). Ein Beitrag zur antiken und islamischen Augenheilkunde, *Jahrbuch des römisch-germanischen Zentralmuseums* 32, 436–508

Hartley, B R, and Dickinson, B M, 2009. *Names on* terra sigillata: *an index of makers' stamps and signatures on Gallo-Roman* terra sigillata *(samian ware), vol 4 (F to Klumi)*, Bull Inst Classical Stud Supplement 102 (4), London

Jackson, R P J, 1988. *Doctors and diseases in the Roman empire*, London

Jackson, R P J, 1990. A new collyrium stamp from Cambridge and a corrected reading of the stamp from Caistor-by-Norwich, *Britannia* 21, 275–83

Jackson, R P J, 1996a. Eye medicine in the Roman empire, in *Aufstieg und Niedergang der römischen Welt (ANRW)* II, 37.3 (eds W Haase and H Temporini), 2228–51, Berlin/New York

Jackson, R P J, 1996b. A new collyrium-stamp from Staines and some thoughts on eye medicine in Roman London and Britannia, in *Interpreting Roman London: papers in memory of Hugh Chapman* (eds J Bird, M Hassall and H Sheldon), Oxbow Monogr 58, 177–87

Jackson, R P J, 2002. 'Venus' and the ox: a Roman visual pun, in *Artefacts and archaeology. Aspects of the Celtic and Roman world* (eds M Aldhouse-Green and P Webster), 152–61, Cardiff

Künzl, E, 1983. *Medizinische Instrumente aus Sepulkralfunden der römischen Kaiserzeit*, Cologne/ Bonn

Künzl, E, 1985. Epigraphische Zeugnisse römischer Augenärzte: Inschriften und Okulistenstempel, in Feugère *et al* 1985, 468–77

Künzl, E, 2002. *Medizin in der Antike. Aus einer Welt ohne Narkose und Aspirin*, Stuttgart

Neilsen, H, 1974. *Ancient ophthalmological agents*, Odense

Nutton, V, 1972. Roman oculists, *Epigraphica* 34, 16–29

RIB 2.4 = Collingwood, R G, and Wright, R P, 1992. *The Roman inscriptions of Britain* 2, Instrumentum domesticum *(personal belongings and the like)*, Fasc 4, (eds S S Frere and R S O Tomlin), Stroud

Roach Smith, C, 1849. On Roman medicine stamps, etc, found at Kenchester, *J Brit Archaeol Assoc* 4, 280 –86

Roach Smith, C 1854. *Catalogue of the museum of London antiquities*, London

Scarborough, J, 1996. Drugs and medicines in the Roman world, *Expedition* 38(2), 38–51

Spencer, W G, 1938. *Celsus, De Medicina*, vol 2, Loeb Class Lib, London/Cambridge, Mass

Tab Vindol 2 = Bowman, A K, and Thomas, J D, 1994. *The Vindolanda writing-tablets (Tabulae Vindolandenses II)*, London

Tab Vindol 3 = Bowman, A K, and Thomas, J D, 2003, *The Vindolanda writing-tablets (Tabulae Vindolandenses III)*, London

Vernhet, A, 1981. Un four de La Graufesenque (Aveyron): la caisson des vases sigillés, *Gallia* 39, 25–43

Voinot, J, 1999. *Les cachets à collyres dans le monde romain*, Monographies Instrumentum 7, Montagnac

23 Coarseware mortaria found at La Graufesenque and nearby Millau

Kay Hartley

Brenda Dickinson has been a friend and colleague for many years and I am delighted to have this opportunity to show some appreciation of the unstinting friendship and support she has always offered. I would like to offer all my good wishes for her future work, health and happiness.

This paper refers to coarseware mortaria found within the area generally referred to as *Condatomagos*, ie at La Graufesenque and nearby Millau (Fig 23.1). In total the sample consists of 23 mortaria made elsewhere and up to 20 unused mortaria, apparently waste pottery, from a late 3rd-century production site at Le Roc in Millau. A sad contrast to the thousands of samian vessels present, but not without some interest.

Catalogue

Notes on the catalogue:
- 'Cluzel' refers to a hectare of land at the La Graufesenque site, which is situated outside the gate and immediately to the west when looking down the drive away from the house. It was owned by M Cluzel until 1973 when it was purchased by the state.
- 'Miquel' refers to land owned by the Miquel family on the plain of La Graufesenque, near the River Dourbie, where excavations took place 1950–54.
- Le Roc and Rajol are old *quartiers* of Millau.
- Most of the mortaria were found in excavations undertaken by M Louis Balsan and M Alain Vernhet, but the coarseware mortaria were rarely, if ever, published in the excavation reports. Details for the precise location of these sites and of the respective publications can be found in Schaad and Vernhet 2007.

Found at La Graufesenque (Fig. 23.2)

1 *G 1952 B-1, 90* (Vernhet 1971, 65, 6, a, and pl IX, no. 1). Diameter 340mm. A thin-walled, bowl-like mortarium with a footring, which never had any trituration grit. There is a small circular hole in the

body. Fabric: softish, fine-textured cream. Inclusions: fairly frequent, tiny white quartz and red-brown rock, with occasional, medium to large red-brown sandstone and white quartz.

Vernhet notes the presence of mortaria of the same type as Nos 1 and 4, at La Graufesenque, Javols and Saint-Bonnet de Chirac. He considers that they are in identical fabric to that of amphorae known to be imported from Italy. It is worth noting that in the 1st century AD when the practice of stamping mortaria had begun, some potters in Italy, like Herme(s) and Saturninus were still making both amphorae and mortaria, but not, of course, of this type.

2 *Code G-51* (Vernhet 1971, 65, 6, b, and pl IX, no. 2). Diameter 300mm. Five joining sherds from a mortarium with two finger-like depressions on the flange, the break occurring in the middle of the second one; these could be part of a handle. The use of 'cordons' of this kind goes back to earlier Greek practices (Pallechi 2002, 39–40 and fig 4). A mortarium, found at Toulouse, which has similar depressions was dated to the Augustan period and attributed to Italy (Fouet 1964, fig 19 and pl I, 12). Fabric: dull black, hard, but brittle in texture with sooty type surface. Inclusions: frequent, very ill-sorted, crystalline calcite with hackly fracture.

3 *Code G-51* (Vernhet 1971, 65, 6, b, and pl IX, no. 3). Diameter c 270mm. Fabric: similar to No. 2, but oxidised to a hard, dark red-brown colour. Inclusions: frequent, ill-sorted, white quartz with hackly fracture and rare black material. Vernhet described the fabric of Nos 2–3 as the common Gaulish coarse ware of La Tène III. He illustrates the large projecting spout of this type of mortarium by a sherd from the oppidum of Saint-Bonnet-de-Chirac in the same fabric (pl.IX, no. 5).

In Vernhet 1971, No. 2 was drawn with trituration grit, but, in fact, neither No. 2 nor No. 3 have any trituration grit; it is the exposed inclusions which have been drawn. The unusual combination of sooty black

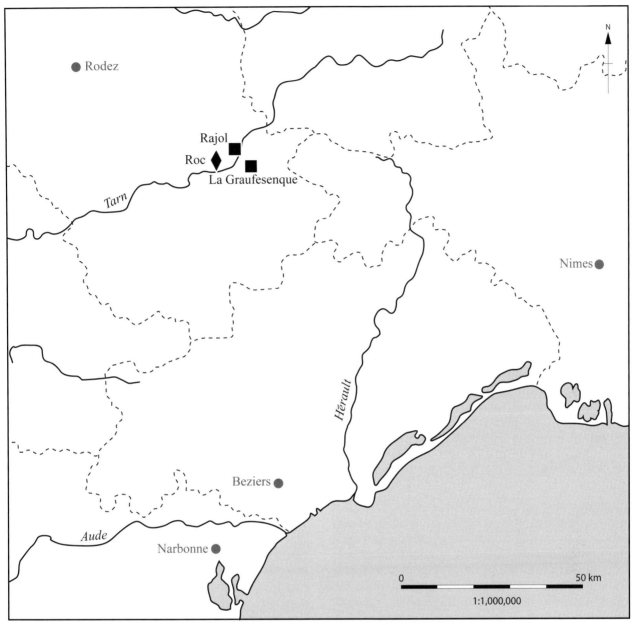

Fig 23.1: Location map (drawn by Adam Parsons)

fabric and excessive inclusions indicates that they were fired in a bonfire or clamp (pers comm V Rigby). The colour from such firings could vary and No. 3 is just such a variant.

4 *No code recorded* (Vernhet 1971, 65, 6, a, and pl IX, no. 4). Diameter *c* 340mm. A mortarium sherd with a circular hole in the flange. Fabric: fairly fine-textured and soft, slightly greenish cream. Inclusions: tiny quartz and rare brown rock. No trituration grit on the sherd. The fabric approximates to that of No. 1 and is presumed to be from the same source.

Nos 1–4 and No. 14 are dated to the 1st century BC by Vernhet. Saison-Guichon (2001, 465) notes the rarity of mortaria in Lyon before the creation of the *colonia* in 43 BC; they could perhaps have been somewhat commoner nearer to the Mediterranean in

contexts dating before the 1st century AD. Up to now, no mortarium earlier than our era has been recorded in Britain.

5 *1952, Criciro Ceindre V*. Diameter *c* 340mm. Four joining sherds. Fabric: fairly fine-textured, cream. Inclusions: fairly frequent, tiny quartz with some black rock, together with occasional large quartz and black rock (sometimes containing quartz grains). Trituration grit: small-sized, quartz and black rock. Condition: slightly burnt and with three circular holes either for rivets or for hanging. In form this mortarium is very close to No. 4 above and may be from the same source and of the same date. The fabrics are close, but not identical.

6 *Canal côté est G97 L100*. Diameter 260mm. A mortarium with distinctive rim-profile and with faintly

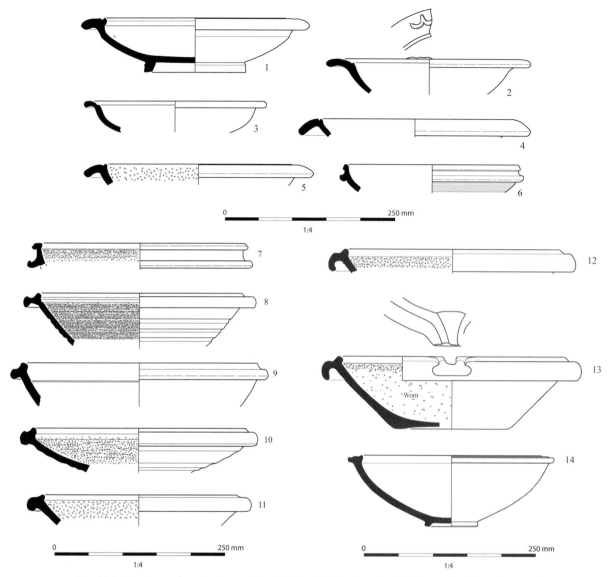

Fig 23.2: Unstamped mortaria made in Gaul and Italy (Nos 1–14) (drawn by Adam Parsons)

incised parallel grooves on the outside of the body. Fabric: brown-buff, either self-coloured or with self-coloured slip; the surface has been made very slightly abrasive by the inclusions. Inclusions: frequent, tiny and small, quartz, opaque black and red-brown with transparent and gold mica. This mortarium may never have had any trituration grit. Found in a Tiberian context (pers comm A Vernhet).

(*Not illustrated*). A second mortarium of exactly similar type and fabric to No. 7 below was recovered from the same context in 2004.

These mortaria are perhaps to be attributed to Saison-Guichon Type 5 (2001, fig 5, no. 1). The Lyon example was found in a context dated 30–10 BC (*ibid*, 469). This form is rare in Lyon and Saison-Guichon suggests that an *atelier* south-west of Nîmes is a possible source; she also notes that the form is more common at sites in the lower Rhône at the turn of the

millennium. Judging from Desbat (below) and Nos 6–7, the terminal date of production was within the period of the late 1st century BC to the early 1st century AD; the La Graufesenque examples could be residual or the form may have continued in production into the Tiberian period. The form is, however, unknown in Britain, where there are many mortaria dated to the Claudian period and at least some likely to have been imported before AD 43 (eg Skeleton Green: Partridge 1981, 196–9, fig 79, nos 1, 3, 4, 6).

7 *No code, but at La Graufesenque*. Diameter *c* 320mm. A wall-sided mortarium with the lower end of the wall projecting like a flange. Fabric: micaceous, fired to cream at the surface, but brownish-pink elsewhere. Inclusions: frequent, tiny quartz, red-brown and black rock and with some larger, quartz with hackly fracture. Trituration grit: mostly quartz, rare red-brown and very rare black rock. This rim-profile is close to

Saison-Guichon Type 5 (2001, fig 5, no. 1) and is perhaps the same date as No. 6 to which it bears some resemblance.

Mortaria of the same basic type as Nos 6–7 are recorded from Gergovia (Labrousse 1948, fig 31, 2432) and Lyon (Desbat et al 1979, pl 11, nos 7–8; Desbat states that he had found none of this type in any of the contexts dating later than 10 BC). See also Barberan et al 2009, 298, fig 16, nos 1–5, for an Augustan group.

8 *G52 N-130*. Diameter 340mm. Fabric: exactly as No. 7. Inclusions: frequent, mostly tiny quartz with few larger quartz and rare, dark red-brown rock. Trituration grit: mostly tiny quartz and rare, dark red-brown rock. The fabric is similar enough to that of No. 7 to suggest manufacture in the same workshop.

(*Not illustrated*) La Graufesenque (no code). A second mortarium similar in rim-profile to No. 8. Diameter *c* 340mm. Fabric: slightly micaceous, cream at the surface, but pale orange-brown elsewhere with pale grey core. Inclusions: sporadic and moderate, tiny to smallish quartz, black rock, one large light grey fragment and some soft white material, rare orange-brown, and black organic material appearing in streaks. Trituration grit: sparse quartz on the sherd.

Three other mortaria, similar in fabric to the above two mortaria and probably from the same source, have been noted from Rodez (Le Musée Fenaille: Dausse 1991, pl 6, no. 1). The type is believed to be Claudian, but it does not occur in Britain and it is possible that it could be residual by that period.

9 *Miquel, La Graufesenque GR.T.52 A89*. Diameter *c* 350mm. Fabric: self-coloured; softish, fine-textured, brownish-cream. Inclusions: few, ill-sorted, white and transparent quartz, red-brown material and flakes of gold mica. Trituration grit: none on sherd and may never have had any.

10 *GR.T.52 D12*. Diameter *c* 320mm. Fabric: fine-textured, surface skin (1mm thick) orange-brown, area within is dark grey. Inclusions: none readily visible, but at x20 magnification, few quartz and rare red-brown barely visible. Trituration grit: white quartz, few transparent combined with some rough scoring.

11 *Cluzel, La Graufesenque*. Diameter 330mm. Two fragments and a body sherd making up one-third of the rim. Fabric: slightly brownish-cream with at least one pale brown horizontal stripe, 10mm in width, around the outside of the body. Inclusions: frequent, large to medium-sized quartz with hackly fracture, few smallish red-brown and black material; with frequent tiny grits in the matrix consisting of all three materials. Trituration grit: very little added grit and all of that which survives is quartz; there is no concentric scoring. Condition: worn.

Nos 9–11 were found in pre-Flavian contexts (AD 40–60) (pers comm A Vernhet). Nos 7–11 could well be from a source or sources in southern France.

12 *1952*. Diameter 360mm. Fabric: soft, fine-textured; cream surface skin (*c*1mm), with thick pink core. Inclusions: very moderate, random, ill-sorted quartz, (some pink) with hackly fracture, rare opaque black and flakes of mica. Trituration grit: probably all quartz combined with concentric scoring. This mortarium is virtually identical to Saison-Guichon 2001, fig 6, no.1, which is her type 4A.

13 *Cluzel, G.85 S.12 and G65 S.12*. Diameter 340mm. Two joining sherds. Fabric: self-coloured, fine-textured, pink fabric, nearer to cream at the surface. Inclusions: very moderate, ill-sorted, quartz with hackly fracture, rare black, flakes of mica and ?feldspar. Trituration grit: primarily quartz combined with concentric scoring. Condition: heavily worn. Saison-Guichon 2001, fig 6, no.1, which is her type 4A. Examples of this type are recorded from Lyon (Desbat et al 1979, pl ix, no. 5, from a context dating from AD 60; and pl xi, no. 7, in a context dating AD 150–200). This is either a very long-lived form or, perhaps more likely, some in later contexts are residual.

(*Not illustrated*) three other mortaria approximating to Saison-Guichon type 4A:

- Cluzel, G.74 U66-α in similar fabric, with rim-profile distorted through proximity to the spout; same general type and date as Nos 12–13. The spout is identical to that of No. 13.
- G91.M33.1 and M.67.1 Car Park, La Graufesenque. Found in 2003. Several sherds from one mortarium. Fabric: cream, somewhat powdery in texture. Inclusions: rare quartz.
- La Graufesenque 1988. Diameter 330mm.

The five mortaria under Nos. 12–13 are identical to mortaria in Britain, imported from the potteries at Lyon. They always have a smooth rim, but the trituration grit on the inside surface is invariably combined with concentric scoring. The spout is also typical for this type. Saison-Guichon dates her Type 4A from the middle of the 1st century to the middle of the 2nd-century AD (2001, 471), but these mortaria are common in Britain only within the period *c* AD 50–80/85 (see Hartley 1991, 195, types TC8-18 and figs 78–80 for examples). Production at Lyon probably continued after the import to Britain ceased, but it is possible that some of those found in 2nd-century contexts at Lyon could be residual. Two generally similar mortaria which can be attributed to the same source, and which have been found at l'Hospitalet-du-Larzac, Habitat de la Vaissière, are from a context dated 1st to 2nd century AD (pers comm A Vernhet).

14 *La Graufesenque, in excavations of L Balsan 1950–54*. Diameter *c* 320/330mm. Base diameter 100mm. Base sherds from at least three different mortaria, but only one rim sherd survives from a mortarium of unusual form with a very small reeded rim and a small footring. Fabric: dark grey. Inclusions: quartz and crystalline calcite. There is no trituration grit, but a slurry finish covers the inclusions and any wear exposes them to view. Associated with finds dated to the 1st century

BC. Probably Gaulish. [Extra information concerning No 14 became available at a late stage; it should rather be No 1 or No 6 in this catalogue but has been retained as No 14 to avoid changes in the text.]

Mortaria made at a kiln-site at Le Roc (Fig 23.3)

In 1965 M Balsan discovered a circular Gallo-Roman kiln, 1.30m in diameter, with a vented floor. It was dated *c* AD 275 by two coins, an *antoninianus* of Tetricus and a *minimus* of the same period. The kiln was associated with a late type of decorated samian, together with fragments of moulds (Labrousse 1966, 412–3 and figs 1–2).

More than 60 sherds from at least 20 mortaria of types A–G were found together '*devant le four*', perhaps in the stokehole; none were published. None show any sign of wear. This group of vessels shows clear homogeneity in rim-form, fabric and details of technique. There are clear similarities in the rim-profiles, the surviving spouts are all of the same, large, wide type, made by breaking the bead and trailing it over the flange. All have fine concentric scoring combined with tiny to small trituration grit extending throughout the inside from immediately below the bead (except in one instance, Type G, where it starts at the change in angle below the bead). The fabric is said to resemble that of the samian moulds present and it would be especially useful to compare analysis of these with analysis of the mortaria, but it has not been possible to do that on this occasion.

This homogeneity together with the lack of use, the relatively large number of vessels and their discovery on a kiln-site leaves no doubt that they were made at Le Roc and fired either in the kiln excavated by M Balsan or in a kiln in the vicinity.

Profile types

The Le Roc mortaria have been divided into seven types A–G, but all show a fundamental similarity. None of the sections survive in full, but some base sherds survive, and one, in the variant fabric, Fabric 2, probably belongs to No. 15 and has been used to restore it. The base sherds surviving show at least four different treatments of the profile (No. 21, and No.15).

Fabrics

Two fabrics are discernible, but Fabric 2 appears to be just a coarser version of Fabric 1. Both fabrics may be self-coloured or could have a slightly darker, matt slip. The sherds can be powdery, but this is probably due to being from wasters.

Fabric 1: The common fabric, regarded at the time of examination as similar to the fabric of the samian moulds. Fabric: fine-textured, orange-brown, approximating to Munsell 5YR 6/6 ('reddish-yellow'). Inclusions: these include quartz and red-brown material, but are too small for macroscopic examination. Trituration grit: mostly white and translucent quartz with hackly fracture, some feldspar(?); red-brown and rare black rock, and rare flakes of gold mica..

Fabric 2: Only one mortarium in this group (No. 15) is in this variant of the fabric, but it is clearly similar to the rest in every other way, and the fabric differs only in having much larger inclusions. Fabric: hard, fine-textured, orange-brown, approximating to Munsell 5YR 6/6 ('reddish-yellow'), slightly redder at the surface. Inclusions: moderate, large- to medium-sized, ill-sorted, milky and transparent quartz with hackly fracture; also some small red-brown and rare black rock. Trituration grit: as Fabric 1.

(Nos 15–20 are all from 'le four, Le Roc, Ville Millau').

15 *Type A*. About one-third of the rim survives in nine sherds including one basal fragment; only two sherds join, and one other sherd is darker than the rest. Diameter 520mm. Base diameter uncertain. This is the only example in Fabric 2.
 Four other mortaria of Type A:

- Diameter *c* 500mm. Fabric 1.
- Diameter *c* 500mm. Fabric 1.
- A much smaller mortarium, diameter 340mms. Fabric 1, with thick blue-grey core.
- Another small mortarium in Fabric 1 with a slight distal bead.

Type B (not illustrated): similar to type A, but with a high, inward pointing bead. Fabric 1. Diameter *c* 520mm.
 A second mortarium of Type B has a smaller flange.

16 *Type C*. Two joining sherds. Diameter *c* 540mm. Fabric 1. There are sherds from up to seven other mortaria of Type C including three spouts.
 There is enough evidence from surviving spout fragments from Types A–C to indicate that the spouts of at least the large mortaria were of the type drawn on No.15.

17 *Type D*. Two fragments, not joining. Diameter *c* 340mm. Fabric 1.

18 *Type E*. Two sherds, not joining. Diameter *c* 340mm. Fabric 1. A second mortarium, diameter *c* 340mm. Fabric 1.

19 *Type F*. Diameter *c* 340/370mm. Fabric 1.

20 *Type G* has a distinct change of angle just below the flange. Diameter *c* 320mm. Fabric 1 with some faint greyness in the core.

21 *Three variant basal forms present among the mortarium fragments from Le Roc*. Although it was clear that all the surviving base fragments belonged to mortaria made there, only the base of No. 15 (in fabric 2), which is a fourth variant, could be linked with any particular rim.

Two stamped mortaria imported from Italy (Fig 23.4)

22 *La Graufesenque 1973.78 (Cluzel)*. Diameter 420mm. Fabric: pale, pink-brown fabric (Munsell 5YR 8/4, 'pink'). Inclusions: fairly frequent, ill-sorted, mixed,

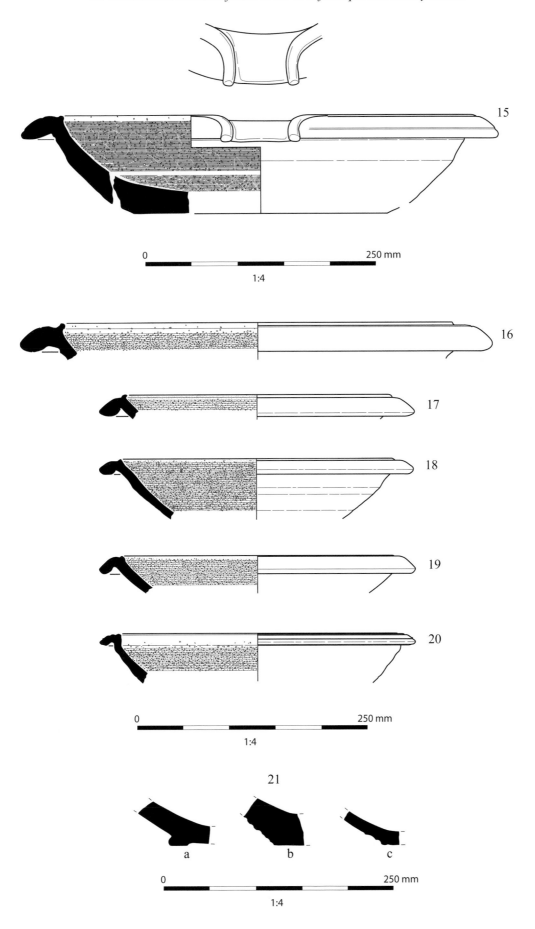

Fig 23.3: Mortaria made at Le Roc, Millau (Nos 15–21) (drawn by Adam Parsons)

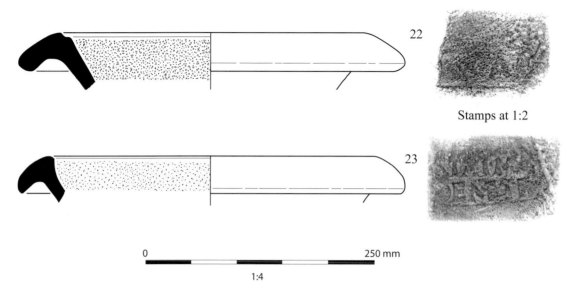

Stamps at 1:2

0 250 mm

1:4

Fig 23.4: Stamped mortaria made in Italy (Nos 22–23) (drawn by Adam Parsons)

transparent quartz, red-brown and shiny black rock and rare gold mica. Trituration grit: small-sized, quartz, black and red-brown rock, and rare gold mica. Inside surface in poor condition.

A broken stamp survives, but in such poor condition that only one letter, A, is completely certain, possibly preceded by C; they could be on the lower line of a two-line stamp though even that is uncertain. The mortarium is clearly an Italian product of the type associated with the Italian brickyards in the Tiber valley in the 1st and 2nd centuries AD. Judging from the mortaria in the *Condatomagos* area, imports from Italy are more likely to be 1st century than later.

23 *Rajol, Millau 74.* Diameter *c* 420mm. Fabric: very pale, brownish-pink (Munsell 5YR 8/3, 'pink'). Inclusions: fairly frequent, ill-sorted, mixed, transparent quartz, orange-brown and black rock and gold mica. Trituration grit: not recorded.

An incompletely impressed, two-line stamp survives, reading STAT·MA[..] | DEMETR[..], with ME ligatured. This is a stamp of Statius Marcius Demetrius who was one of the Statii Marcii, several *officinatores* whose overall activity stretched from before AD 40 to the 3rd century and whose *figlinae* can be attributed to the Tiber valley. His stamps are recorded on bricks, clay sarcophagi, and mortaria: Rome (7 brickstamps (CIL 15, no. 1273); 1 clay sarcophagus (*ibid*, 2460); and 1 mortarium (Pallechi 2002, 202, no. 274); Pozzuoli, Naples (1 mortarium or dolium (*ibid*, no. 275)); near Badalona in Spain (1 mortarium (*ibid*, no. 276). He is believed to be the same Demetrius recorded on a stamp at Pompeii as the slave of Statius Marcius Helenus and it is this stamp (Steinby 1987, 82) which links the initial date of his *tria nomina* stamps to the period after AD 79. Demetrius is not recorded on 2nd-century brick stamps so his production can be dated to the late 1st century

(Helen 1975, 127; for further details of this man and of the Statii Marcii in general see ibid, 125–7 and Pallechi 2002, 197–221).

Comments

One or two of the mortarium fragments in this sample were found amongst pottery thrown away during old excavations and one must assume that others were also despatched in the past as has happened on many sites. Despite the fact that some mortaria were probably thrown away, the small number of 23 (excluding kiln waste) in this sample is still probably a reasonable reflection of a general paucity of coarseware mortaria, considering the extensive excavation in the area. Nevertheless the mortaria probably provide a fair representation of the forms, sources and fabrics present in *Condatomagos* in the Roman period. Coarseware mortaria or stone mortars would have been present in larger than usual quantities if they had been used for any kind of preparation in the samian industry; it is clear that they were not so used at La Graufesenque; nor is there any evidence to indicate that samian mortaria were used in this way. There is also little reason to suppose that the numbers are any more affected here by the presence of samian mortaria than on other sites in Gaul. It is not at all uncommon for coarseware mortaria to be relatively rare in parts of Gaul and in other parts of the Roman Empire (Hartley 1998).

Despite the shortcomings of the sample, one can draw some deductions and conclusions from it, some more reliable than others. The complete absence of the Augustan to Claudian wall-sided mortarium, which is so ubiquitous on Claudian and earlier sites in Britain and Germany, is particularly striking (Hawkes and Hull 1947, Type 191; Saison-Guichon 2001, Type 1). These were made in quantity at Lyon.

Nos 12–13 (representing five mortaria), which are later

in date, can be confidently attributed to Lyon and the inference is that *Condatomagos* did not obtain mortaria from Lyon until the mid-1st century when the flanged mortaria of Saison-Guichon, Form 4A were being made. It is likely that before the mid-1st century AD all of their mortaria came from sources in the south, perhaps in the Nîmes area and from Italy.

Although there is excellent clay available, Nos 15–21 (up to 20 mortaria) provide the only evidence for manufacture of any coarseware mortaria at Millau.

To sum up, of the 43 mortaria present, up to 20 are waste pottery from a local kiln, dating to *c* AD 275, five can be attributed to potteries at Lyon, three (Nos 2, 3 and 14) are early Gaulish current in the 1st century BC, two (Nos 22–23) are from Italy and 13 are from sources in the south of France or Italy. Out of the 43 only two, Nos 22–23, from Italy, were ever stamped (Fig 4). Oddly, there are no mortaria in this sample from any source outside Millau which post-date the mortaria of Saison-Guichon type 4a; equally, there are none made in the Millau area except for those dated *c* AD 275 on the production site at Le Roc.

Acknowledgements

François Leyge, Directeur du Musée de Millau has kindly given permission for the publication of these mortaria. They were examined at intervals during the visits made by Geoffrey Dannell and his équipe over many years for the purpose of recording and studying the products of the samian potteries at La Graufesenque. Mr Dannell kindly allowed me to have time off from working on samian ware to record the coarseware mortaria. I am especially grateful to Alain Vernhet for locating the sherds and for patiently bearing with my inadequate French; without his help there would have been no question of my being able to write this paper. I am all too aware that I failed to record all the information which was so generously given to me over the years. Unfortunately, circumstances never permitted the evaluation of all the sherds at any one time nor was there any expectation of being able to publish them until this happy opportunity arose. I have, therefore, been chary of being too precipitate in suggesting sources or dates except where completely confident of specific evidence. I am also grateful to M Lucien Dausse for permission to study the mortaria in Le Musée Fenaille at Rodez. Valery Rigby has provided much fruitful discussion especially concerning the early mortaria.

Bibliography

Barberan, S, Malignas, A, Martínez Ferreras, V, Renaud, A, Silvéréano, S, and Vincent, G, 2009. Un ensemble augustéen mis au jour au pied du monument corinthien de l'aglomération du *Castellas* (Murviel-lès-Montpellier, Hérault), *Société Française d'Étude de la Céramique Antique en Gaule: Actes du Congrès de Colmar 21–24 Mai 2009*, 289–317

CIL 15 = H Dressel, 1891. *Inscriptiones urbis Romae Latinae. Instrumentum domesticum,* Corpus Inscriptionum Latinarum 15 (1), Berlin

Dausse, L, 1991. Un exemple d'aménagement de pente gallo-romain, in *Vivre en Rouergue. Cahiers d'Archéologie Aveyronnaise* 5, 92–108

Desbat, A, Larouche, C, and Mérigoux, E, 1979. Notes préliminaries sur la céramique commune de la rue des Farges à Lyon, *Figlina* 4, 1–17

Fouet, G, 1964. Un nouveau puit funéraire gaulois, rue St Roch à Toulouse, *Mémoires de la Société Archéologique du Midi de la France* 30, 309–58

Hartley, K F, 1991. Mortaria, in N Holbrook and P Bidwell, *Roman finds from Exeter*, Exeter Archaeol Rep 4, 189–215, Exeter

Hartley, K, 1998. The incidence of stamped mortaria in the Roman Empire with special reference to imports to Britain, in *Form and fabric: studies in Rome's material past in honour of B. R. Hartley* (ed J Bird), Oxbow Monogr 80, 199–217, Oxford

Hawkes, C F C, and Hull, M R, 1947. *Camulodunum: first report on the excavations at Colchester 1930–1939*, Rep Res Comm Soc Antiq London 14, Oxford

Helen, T, 1975. *Organization of Roman brick production in the first and second centuries AD*, Annales Academiae Scientiarum Fennicae: Dissertationes Humanarum Litterarum 5, Helsinki

Labrousse, M, 1948. Les fouilles de Gergovie, *Gallia* 6, 31–95

Labrousse, M M, 1966. Circonscription de Midi-Pyrénées, *Gallia* 24, 411–48

Pallechi, S, 2002. *I mortaria di produzione centro-italica: corpus dei bolli*. Instrumentum 1, Rome

Partridge, C, 1981. *Skeleton Green: a Late Iron Age and Romano-British site*, Britannia Monogr Ser 2, Gloucester

Saison-Guichon, A, 2001. Les mortiers de cuisine en céramique commune claire à Lyon, *Société Française d'Étude de la Céramique Antique en Gaule: Actes du Congrès de Lille-Bavay 24–27 Mai 2001*, 465–478

Schaad, D, and Vernhet, A, 2007. Les données archéologiques, in *La Graufesenque (Millau, Aveyron). Volume 1: Condatomagos. Une agglomération de confluent en territoire Rutène IIᵉs a.C–IIIᵉs p.C* (ed D Schaad), Editions de la Fédération Aquitania. Études d'archéologie urbaine, 61–215, Pessac

Steinby, E M, 1987. *Indici complementari ai bolli doliari urbani (CIL XV, 1)*, Acta Instituti Romani Finlandiae 11, Rome

Vernhet, A, 1971. *Céramiques gauloises et céramiques d'importation dans les départements de l'Aveyron et de la Lozère, du IIᵉ siècle avant J.-C. jusqu'à l'époque augustéenne*, unpub Mémoire de Maîtrise, Université Paul Valéry, Montpellier III

24 A roller-stamped unguentarium from the City of London

Fiona Seeley

This article discusses the fabric, dating and source of three unguentaria found in an early medieval pit during excavations in 1974 by the Department of Urban Archaeology on the site of St Paul's Cathedral Choir School, New Change, City of London (site code: SPS74; Muir nd). They are of particular interest as one of the vessels has roller-stamped decoration. The significance of their discovery and the possible circumstances of their deposition are also examined in the light of other excavations in the area.

The St Paul's Cathedral Choir School unguentaria

All three vessels are in the fabric range allowable for the fine variant of London oxidised ware (LOXIF) (Seeley and Drummond-Murray 2005, 115). This fabric is made from the micaceous iron-rich London clay. The unguentaria all have a pedestal base which is flattened allowing them to stand independently. The two vessels with surviving profiles have collared rims (Nos 1 and 3) and it is most likely that vessel No. 2 also had this rim form. They are

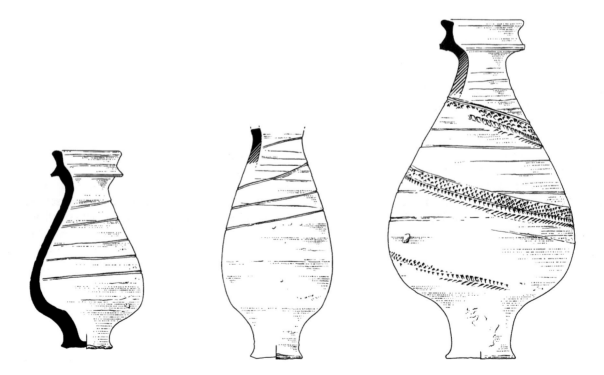

Fig 24.1: Three unguentaria from St Paul's Cathedral Choir School. Vessels Nos 1–3 (drawn by Chris Green)

all decorated with a continuous spiral groove. This form is also referred to as an amphora stopper although their suitability for this function has been debated (see Peacock and Williams 1986, 51) and their flat bases would suggest that they were required to stand alone.

Catalogue

Vessel No. 1. 108mm in height. Complete profile. Missing section on part of lower body.

Vessel No. 2. Surviving height 122mm. Complete apart from part of neck and rim.

Vessel No. 3. 177mm in height. Complete profile. Part of rim and neck missing. Unlike Nos 1 and 2, the vessel has several flints (up to 7mm long) embedded in its surfaces. This is not unusual for this fabric but it is more common in the coarse variant of London oxidised ware (LOXI) rather than the fine variant. It has roller-stamped decoration going in the opposite direction to the spiral groove. The upper part of the stamp consists of hatching enclosed above by a notched groove; below the hatching is a herringbone pattern. The width of the stamp is 11mm. This vessel has patches of burning which could be the result of the original firing being uneven or the vessel coming into contact with heat later through use.

One other example of an unguentarium with roller-stamped decoration from London was found at 116–126 Borough High Street, Southwark (site code: BGG01), in the upper fill of a timber-lined well (context [340]). Other dating information from the well suggests a late 2nd/3rd-century date (Richardson, in prep). This example is in the same fabric as those from St Paul's Cathedral Choir School, the fine variant of London oxidised ware (LOXIF). The neck and rim are missing but the vessel is otherwise complete. The surviving height is 77mm and the widest point of the girth is 56mm. It is similar in dimensions to the smallest of the three St Paul's examples. The design of the roller-stamp used on the Southwark vessel is the same as that used on the largest of the St Paul's unguentaria and it is likely that the same die was used for both the vessels. Roller-stamped decoration on coarse wares in Britain is not common and is thought to be restricted to the later Roman period (Symonds and Wade 1989, 85) Apart from the St Paul's and Borough High Street unguentaria, only one other example has been published from London and is from the site of the Cripplegate Fort. Its decoration consists of a lattice pattern bordered by two grooves on each side (Seeley 2004, 45, fig 44, no. P6). The fabric is not local but north Kent shell-tempered ware (NKSH) and the sherd is thought to be from a large storage jar. It was found in a medieval pit.

Dating and source

The dating of these unguentaria is not well defined. The only known kiln site for the production of London oxidised ware is at 20–28 Moorgate where pottery was being made from c AD 110 to AD 170 (Seeley and Drummond-Murray 2005). This kiln site is linked to other production sites situated alongside Watling Street between Brockley Hill and Verulamium which form part of the Verulamium region pottery industry. Pedestalled unguentaria with collared rims were made at Moorgate both in this fabric and others such as Verulamium region white ware (VRW) and Verulamium coarse white-slipped ware (VCWS). All are decorated with a continuous spiral groove but none from the kiln site were found with roller-stamped decoration. However, LOXI is found in consumer assemblages prior to AD 110 and also in 3rd-century AD assemblages. It is possibly residual in later contexts but its presence in earlier features suggests that this fabric was produced at other sites in the London region prior to the 2nd century AD. To ascertain if the St Paul's and Southwark vessels could be products of the Moorgate kilns, all four unguentaria were subject to chemical compositional analysis using Inductively-Coupled Plasma Spectroscopy and the data from this analysis was compared to existing data sets for London oxidised wares from the Moorgate kilns and other reduced and oxidised pottery fabrics made from the London clay (Vince 2007). The report concludes that the unguentaria are likely to be products of the upper Walbrook valley but that the clay is not typical of that used at the Moorgate kilns. This suggests that there are further kilns producing this fabric in the London area. An alternative source of production in London for these vessels could be the kilns discovered during the rebuilding of St Paul's Cathedral in 1672. Pottery was also found on the site and the illustrated forms include unguentaria, but from the contemporary records it is not possible to be definite that these vessels (now lost) were associated with the kilns and therefore possibly kiln products, or were from other features in the vicinity unrelated to pottery production (Schofield in prep). Recent excavations at 1 New Change have produced a further pottery kiln. The pottery associated with this kiln has not been fully analysed but preliminary work suggests that the material dates to the 1st century AD and is composed of reduced wares.

Although the use of roller-stamps is unusual on London ceramic vessels, their use on tiles is well documented (eg Betts *et al* 1994). However, the dies used on tiles are significantly larger than the ones used on the London unguentaria as they range in size from 52mm to 570mm plus (*ibid*, 5). But it is interesting to note that the same technology is being applied to ceramic vessels, especially as there are links between the pottery industry that produced the unguentaria (the Verulamium region industry) and the regional tile industry in regard to the use of the same dies to stamp mortaria and tiles (Hartley 1996).

Deposition

While the vessels were found in a medieval pit and have either been re-deposited or come from an earlier feature that has been truncated by later activity, their completeness and their number is unusual and suggests that they were originally deposited together and probably not far from

the context in which they were finally discovered. One explanation could be that they are waste products of the St Paul's kilns. However, apart from the burning on vessel No. 3 which may be the result of an uneven firing, the vessels do not show any obvious signs of being wasters or seconds. An alternative explanation is that the vessels could have come from a ritual deposit or a burial. Unguentaria are not uncommonly found in association with ritual or religious contexts; for example this type is present at the 'triangular' temple at Verulamium (Wheeler and Wheeler 1936, 190–3, figs 32–3, pl LIX) and ceramic unguentaria are also found associated with burials in London (Hall 1996, 82, appendix 1). The site of St Paul's has also long been associated with a Temple of Diana. However, John Clark has demonstrated that the only evidence of an archaeological nature that has been used to support this theory is a large amount of ox heads dug up in the early 14th century, that we cannot be sure of what period these come from and that there are examples of ritual deposits of animal heads from the prehistoric to Saxon periods (Clark 1996, 7–8). The site of St Paul's is located within the Roman walls, outside of which to the west was the western cemetery. But there are earlier burials/cremations within the walls near to St Paul's such as those found at Warwick Square and Paternoster Square (Watson 2003, 8, fig 6; Shepherd 1988, 11) and it is not inconceivable that these unguentaria were originally accessory vessels associated with an inhumation or cremation. Indeed one explanation for the complete vessels illustrated from the rebuilding of St Paul's is that these too are accessory vessels from burials.

Conclusions

The discovery of roller-stamped decoration on a locally-made vessel has added to our knowledge of pottery production in London. The results of the chemical analysis of the unguentaria has provided further evidence to support the suggestion of other pottery production sites within the London area aside from those at Moorgate. Their completeness and number suggests that these vessels were deliberately deposited, possibly as accessory vessels associated with a burial.

Acknowledgements

I would like to thank and acknowledge the London Archaeological Archive and Research Centre of the Museum of London for helping to fund this research and allowing the reproduction of the illustration by Chris Green. I would also like to thank Chris Green for his illustration and the late Dr Alan Vince for his report on the compositional analysis of the unguentaria, a full version of which can be consulted at the LAARC.

Bibliography

Betts, I M, Black, E W, and Gower, J L, 1994 (1997). *A corpus of relief-patterned tiles in Roman Britain,* J Roman Pottery Stud 7, Oxford

Bird, J, Hassall, M, and Sheldon, H (eds) 1996, *Interpreting Roman London: Papers in memory of Hugh Chapman,* Oxbow Monogr 58, Oxford

Clark, J, 1996. The Temple of Diana, in Bird *et al* 1996, 1–9

Hall, J, 1996. The cemeteries of Roman London: a review, in Bird *et al* 1996, 57–84

Hartley, K F, 1996. Procuratorial mortarium stamps, in Bird *et al* 1996, 147–51

Muir, P J, nd. *Watching brief at St Paul's Cathedral Choir School, New Change, City of London, EC1 (SPS74),* unpub site summary, Dept Urban Archaeol, Museum of London

Peacock, D P S, and Williams, D F, 1986. *Amphorae and the Roman economy: an introductory guide,* London

Richardson, B, in prep. The Roman pottery, in D Saxby, in prep, *The excavations at 116–126 Borough High Street, Southwark*

Seeley, F, 2004. The Roman pottery, in E Howe and D Lakin, *Roman and medieval Cripplegate, City of London: archaeological excavations 1992–8,* Mus London Archaeol Service Monogr 21, London

Seeley, F, and Drummond-Murray, J, 2005. *Roman pottery production in the Walbrook Valley: excavations at 20–28 Moorgate, City of London, 1998–2000,* Mus London Archaeol Service Monogr 25, London

Schofield J, in prep. *The archaeology of St Paul's Cathedral: vol 1, survey and excavation up to 2004*

Shepherd, J D, 1988. The Roman occupation in the area of Paternoster Square, City of London, *Trans London Middlesex Archaeol Soc* 39, 1–30

Symonds, R P, and Wade, S M, 1989. A remarkable jar found inside an amphora cremation chamber at Colchester, *J Roman Pottery Stud* 2, 85–7

Vince, A, 2007. *Compositional analysis of some Roman unguentaria from the City of London,* unpub archive report

Watson, S, 2003. *An excavation in the western cemetery of Roman London, Atlantic House, City of London,* Mus London Archaeol Service Archaeol Stud Ser 7

Wheeler, R E M, and Wheeler, T V, 1936. *Verulamium: A Belgic and two Roman cities,* Rep Res Comm Soc Antiq London 11, 181–202

25 Makers' marks – on textiles?

John Peter Wild

'Brenda will crown me!' That was my initial thought when the title for the topic I have chosen to examine in her honour first occurred to me. Having spent the best part of her career among the samian potters of Gaul – she must know some of them better than their spouses did – how would she react to what promises at first glance to be more of the same? I would plead in mitigation that maker's marks on textiles are an extremely rare breed and giving them an airing here might prompt a search for more.

Samian ware carries the widest spectrum of makers' marks on any class of Roman artefact, from the autograph of the mould-maker scratched into the 'green' mould through names stamped into the bases of plain vessels or incorporated into the decoration of mould-made forms to the bowl finisher's stamp on the rim (Webster 1996, 7–9, fig 5). However, a range of other types of Roman artefact, mostly portable, also carry an occasional explicit reference to their origin and manufacture.

Stamps on mortaria (Hartley *et al* 2006, 16–17) and amphorae (Peacock and Williams 1991; Manacorda and Panella 1993) have made a major contribution to our understanding of the economic geography of these vessel types. Gallo-Belgic wares (Rigby 1973; Rigby 1998; http://gallobelgic.thehumanjourney.net), fine-walled ACO-beakers (Vegas 1969–70), terracotta lamps (Schneider 1993; Flügel *et al* 2000) and pipeclay figurines (Wright and Hassall 1971, 297–8) regularly name those responsible for their production. The majority of building and roof tiles in the provinces are unstamped – yet military production units often, and private tilers occasionally, identify their wares (Darvill and McWhirr 1983). The situation in Italian tileries was far more complex: estate or factory owners, managers and operatives all sought to make themselves known (Steinby 1993; Helen 1975).

Manufacturers of goods at the upper end of the market were particularly eager to claim credit for their work. Superior glassware (Sternini 1993; Harden 1987, 153, 164, no. 86, 166, no. 87, 167, no. 88) may bear a signature; copper-alloy cooking vessels (Petrovszky 1994), strigils (Giovannini and Maggi 1994), fibulae (Bayley and Butcher 2004, 66–9) and even specialist moulding-tools (Gostenčnik 2002) may boast a name. Contractors who supplied the Roman army with equipment, particularly swords, also stamped their wares (MacMullen 1960; Lønstrup 1986, 747; Bishop and Coulston 2006, 43–47, 238).

Ingots of metal with a strategic value are regularly stamped, not least to discourage pilfering. Silver (Kent and Painter 1977, 26; Wamser 2000, 353), lead (RIB 2.1, no. 2404; Todd 2007, 83–85) and pewter ingots (RIB 2.1, no. 2406) come most readily to mind. Silver bowls (Kent and Painter 1977, 20–22, 41) and even lead salt-pans (Penney and Shotter 2002) can be added to the list. Coopers frequently marked barrel-staves, not just with numerals to help assembly, but with their own brands (Renard 1961; Ulbert 1959). Some shoemakers, too, felt moved to identify their handiwork (Van Driel-Murray 1993, 68–72).

It has to be admitted that it is often impossible to be sure that a name on an artefact is indeed the name of the craftsman or woman whose hands made it. A few examples, however, inspire particular confidence. The famous *tubulus* from Leicester inscribed (*ante cocturam*) PRIMUS FECIT LX was probably one of the batch turned out by Primus in person (RIB 2.5, no. 2491.3). Sennianus who declared in brown slip on a mortarium rim from Water Newton that he had fired it 'at Durobrivae' is probably to be believed (Wright 1940, 190 fig 21). Monnus who signed an outstanding 3rd-century mosaic in Trier would at least have supervised the work *in situ*, even if he laid few of the *tesserae* himself (Donderer 1989, 99–100, Kat Nr A74). Sculptors, too, might label their commissions (Roueché 1989): classical Greek sculptors after all were celebrities.

The title of this tribute to Brenda implies that makers' marks on textiles exist. The importance of the textile industry to the Roman economy and the examples of makers' marks on the other materials quoted above might lead one to expect to find them. The presumption, however, might prove over-optimistic, and for that reason, in compiling the catalogue below, the net has been cast wide.

In reviewing the textiles caught in the net it is important to note how any putative identifying mark was generated. There are three, possibly four, relevant techniques:

a. Tapestry weaving
As the garment is being woven on the loom, coloured weft, substituted for the ground weft, is inserted freehand over and under the warp threads to build up the shape of the lettering or motif required. It is the textile equivalent of constructing a mosaic from coloured *tesserae*.

b. Brocading
A supplementary yarn in a contrasting colour is introduced alongside the ground weft as the cloth is being woven, to create a simple linear figure or motif.

c. Embroidery
Lettering, a figure or a motif is added to the woven cloth with a needle and thread.

d. Dipinti in ink or paint
The existence of inked laundry marks at the edges of some dynastic Egyptian linens (Hall 1986, 53–54) and an inked 'motto' on a late Roman tapestry (Trilling 1982, 41, no.19) suggest another – but less durable – way of marking fabrics. None appears to be relevant to the present review.

Tapestry and brocading are an integral part of the original web and so contemporary with its manufacture. Embroidery, however, and *dipinti* could be much later additions. This is a fundamental distinction.

Catalogue

It should be noted that since the catalogue is based primarily on examples drawn from published literature, the degree of technical information available about the entries is variable.

1 Epigraphic examples of possible makers' marks

1.1 F]LORENTIA OF on silk in Trier, Germany (Fig 25.1(a))

A fragment of yellow damask silk from Trier, closely associated with the reburial of Paulinus, former bishop of Trier, in AD 395, bears the embroidered inscription F]LORENTIA OF within an ansate panel (Schneider 1884; Braun 1910a, Sp.279–284, Abb Sp.282; Braun 1910b, Sp.348–350). The silk (De Jonghe and Tavernier 1977–78, 157, Abb 7, 158, Abb 8), possibly from a tunic torn into strips, was apparently used with other textiles both to wrap the cadaver of Paulinus and the cedarwood coffin in which his remains were translated from his place of exile and death in Phrygia for re-interment in Trier (Reusch 1965, 71–72, Abb.53). Few traces remain of the stitches (said to be of hide when first noted), but the letters can be read from the lines of stitch-holes. The panel was just over 14cm long. The inscription was first discussed in print in 1910 (Braun 1910a, 1910b), then

disappeared, only to be rediscovered recently in a paper archive in Trier. After fresh scientific examination it will be republished by B Dreyspring and S Schrenk, through whose kindness I can list it here (Dreyspring and Schrenk 2007). The resolution and implications of the inscription will be discussed below.

1.2 PRI on stocking from Les Martres-de-Veyre, Puy-de-Dôme, France

Among the items furnishing the 2nd-century(?) grave of a young girl buried fully clothed at Les Martes-de-Veyre was a pair of knee-length wool stockings woven in 2/2 plain twill, dark brown and felted (Audollent 1922, 13, 44–45, no. 48, pl 8, 2, tombe D). On the right stocking, using the vertical rear seam as a guide and base line, the letters PRI have been embroidered in pale (once white) wool yarn in the angle between the seam and the fringed stocking top. Charles Pagès who prepared the technical report for Auguste Audollent, did not mention or describe it. (I am grateful to Hero Granger-Taylor for comparing notes with me on this item.) PRI might be the initials of *tria nomina*, but are more likely to be resolved as PRI(MA) or a similar name. It is probably the owner's rather than the maker's mark.

2 Non-epigraphic examples of possible makers' marks

The entries below have been grouped by technique – tapestry weaving, brocading and embroidery.

2.1 Triple-Z motif on tunic from Dura-Europos, Syria (Fig 25.1(b))

Into the fabric of both sleeves of a wool tunic from Dura-Europos (*terminus ante quem* AD 257) the weaver has introduced in triplicate the letter Z (or less plausibly N), woven in blue wool in weft direction between an outer pair of narrow blue pin stripes and the two wider, shorter, sleeve bands (Pfister and Bellinger 1945, 17, no. 1, pl 5, 14, fig 7). The letters are about 14mm high.

2.2. 'Crank' symbol on tunic from Cave of Letters, Palestine (Fig 25.1(c))

A wool tunic (no. 22) from the so called 'Cave of Letters' near the Dead Sea (*terminus ante quem* AD 132/5) was woven in two sheets but on the same warp, leaving a narrow strip of bare warp between them. On each side of the bare strip, but offset in relation to one another, the weaver included two small 'crank' symbols in 'purple' weft: measuring 17 by 8mm overall they were set 28 and 23mm back from the edge of the weft (Yadin 1963, 219, figs 72, 73, pl 65, 86). When the tunic was worn, the marks would have been on the wearer's flank and virtually invisible.

2.3 Arrow motif on cloak from At-Tar near Kerbala, Mesopotamia (Fig 25.1(d))

A tabby wool cloak from an early Roman-period burial in one of the caves at At-Tar near Kerbala (IV-OH-368-5,

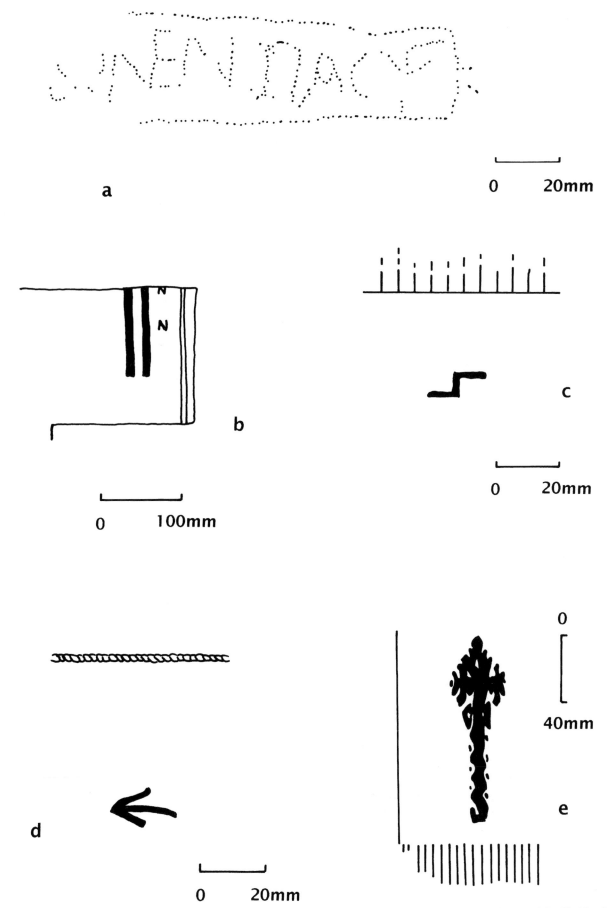

Fig 25.1: Makers' marks on textiles (warp shown vertically): (a) catalogue No.1.1; (b) No. 2.1; (c) No. 2.2; (d) No. 2.3; (e) No. 2.7 (drawn by J P Wild)

textile 12) bears, in addition to the familiar tapestry-woven gamma motifs in the four corners, a small red tapestry-woven arrow (*c* 20mm long), inserted 50mm from (and parallel to) a corded transverse border (Fujii *et al* 1989, 137, pl 29b).

2.4 Tip of arrow motif on cloak from At-Tar
Just the tip remains of an arrow motif similar to No. 2.3 on a wool cloak in half-basket weave from At-Tar (V-77-2, textile 9). It is set about 38mm from the corded edge (Fujii *et al* 1993, 120, 130, 135, pl 2d). The cloak once had swastika motifs in each corner and a selvedge panel.

2.5 Purple band on tunic, 'from Egypt'
A short narrow band of plain purple wool weft on a linen tunic said to be from Egypt (1st to 3rd century AD ?), now in the Victoria and Albert Museum (T.530 to B-1974). The band was woven parallel to the *clavi*, but placed in isolation in the lower corner of the garment as worn (King 1996, 2, fig 1, top left).

2.6 Purple-and-gold band on a tunic from Panopolis/ Achmîm, Egypt
On a late 3rd or early 4th-century woman's linen dalmatic (supposedly from Panopolis) is a narrow tapestry-woven band (*c* 200mm long) asymmetrically placed on the skirt of the garment close to the transverse border and, as in No. 2.5, parallel to the *clavi* (Victoria and Albert Museum, T.361-1887). It is said to be woven in 'tabby and twill' using Z-spun purple wool: down its centre runs a still narrower stripe in gold thread, made from gold ribbon Z-twisted round a Z-spun yarn core (King 1996, 4, fig 3; Walker and Bierbrier 1997, 178–179, no. 227).

2.7 Stylised 'tree' motif on tunic from Egypt (Fig 25.1(e))
A thick wool tunic from Egypt, now in the Pennsylvania University Museum of Archaeology and Anthropology, Philadelphia, displays in one corner, standing in an angle between selvedge and fringed border, a 'purple' tapestry-woven insert (*c* 112mm long) consisting of a stem of stylised vegetation expanding into a diamond-shaped ?leaf-cluster (details kindly supplied by Hero Granger-Taylor). It may be late Roman.

2.8 'Sprays of flowers' on wool textiles from sites in Lower Nubia (Fig. 25.2(a))
In publishing the textiles recovered from a series of cemeteries on the right bank of the Nile in Sudanese Nubia, Ingrid Bergman drew attention to a small recurring tapestry-woven feature which she described as 'sprays of conventionalised flowers' (her type B1A) (Bergman 1975, 48–49, fig 52). The sprays consist of circular flower heads atop bunched stems in a contrasting colour which 'sprout' inwards from the reinforced selvedges: they measure no more than 15 × 15mm overall. From the opposite selvedge, where it survives, sprouts or sprouted a similar spray; in one case a third spray is attested on the same textile (Bergman 1975, 71, pl 64, 3). The sprays have from three

to five stems and flower heads: red contrasts with yellow by turns. While some of the textiles may have been cloaks, at least two are narrower items and may have been shawls. The dating of the material is not precise, but some of the examples fall within the span AD 350–650, while others are probably later.

2.9 Short bands projecting from selvedges in Lower Nubia
There are three examples of Bergman's type B2A and B2B, single tapestry-woven bands in yellow wool (tomb 25/209) and in blue wool (tomb 333/47, 350/VIII) (Bergman 1975, 70, 80–81, 82, pl 66, 1). Item 350/VIII appears on a cloak which is decorated in each corner with the familiar H-shaped tapestry-woven motif. Types B2A and B2B could be devolved forms of B1A.
The one example of type B2C (tomb 63/4) consists of a pair of fragmented narrow red bands 'standing' on the reinforced selvedge of a dark brown wool ?cloak (Bergman 1975, 75, pl 66, 2).

2.10 Quincunx symbols on linen textile from Palmyra, Syria (Fig 25.2(b))
A large fringed textile (measuring 287 × 167cm) found in the tower-tomb of Iamblichus at Palmyra once carried in each corner a 'quincunx' motif in wool tapestry. The motif is built of 5 juxtaposed rectangles, 4 in dark purple wool, the central rectangle in red; it measures 130mm weft-ways, 90mm warp-ways (Schmidt-Colinet *et al* 2000, 151, Kat Nr 271, Taf 49c, Farbtaf 4a; Pfister 1940, 17, fig 7, pl 3d). The main site occupation has a *terminus ante quem* of AD 272/3, but regular burial in the tower-tombs may have ended earlier.

2.11 'Augmented quincunx' on a wool cloak from Dura-Europos, Syria
A slightly more elaborate form of quincunx (measuring overall 118 × 12.5mm) in light purple wool tapestry adorns a fragment of 2/2 diamond twill, probably a military cloak, at Dura-Europos. It pre-dates the fall of the city in AD 257 (Pfister and Bellinger 1945, 22 no.36, pl 13).

2.12 Quincunces in silhouette on cloak no.24 from the Cave of Letters, Palestine (Fig 25.2(c))
A quincunx framed and silhouetted in 'purple' wool (measuring *c* 20 × 12mm overall) was woven into the web at two points close to indents in the purple selvedge panel on a wool cloak recovered from the Cave of Letters (AD 132–135) (Yadin 1963, 224, fig 76, 233, pl 69, bottom left). It should be noted that a more plausible 'weaver's mark' appears elsewhere on this textile (*cf* No. 2.14 below).

2.13 Quincunx in silhouette on a cloak (no. 28) from Cave of Letters
Another purple-framed quincunx (20 × 15mm overall) closely similar in form and position to No. 2.12 (Yadin 1963, 224, fig 76, 234, pl 69, bottom right).

Fig 25.2: Makers' marks on textiles (warp shown vertically): (a) catalogue No. 2.8; (b) No. 2.10; (c) No. 2.12; (d) No. 2.14; (e) No. 2.15; (f) No. 2.18; (g) No. 2.21; (h) No. 2.22 (drawn by J P Wild)

2.14 Grid-check motif on cloak no. 24 from the Cave of Letters (Fig 25.2(d))

A single grid-check motif (10mm square) was tapestry-woven in 'purple' wool *c* 19mm from the cloak's corded transverse border. Too little survives to reveal its position on the cloak (Yadin 1963, 224, fig 76, 233, pl 69, top right).

2.15 H-shaped framed motif on cloak no. 27 from the Cave of Letters (Fig 25.2(e))

Again about 20mm from a corded transverse edge, an H-shaped tapestry-woven 'purple' motif within a frame (*c* 16 × 18mm) has been recorded on a fragmentary cloak (Yadin 1963, 224, fig 76, 234, pl 69, top left).

2.16 Framed cross motif on cloak no. 32 from the Cave of Letters

During the weaving of a wool cloak a simple framed cross (once *c* 22 × 12mm) was introduced by the weaver in 'purple' wool. In addition the cloak once bore H-shaped tapestry-woven decorative motifs in each corner (Yadin 1963, 224, fig 76, 235, pl 85, bottom).

2.17 A framed rectilinear dotted motif on a cloak from At-Tar near Kerbala, Mesopotamia

A vestigial motif of dotted lines within a frame (*c*.17 × 17mm) tapestry-woven in dark red wool appears on a large wool cloak from a burial in Cave 16 (V-77-2) at At-Tar (2nd or 3rd century AD) (Fujii *et al* 1980, 273 specimen 185 (102)). The cloak itself seems to have had H-shaped motifs in each corner.

2.18 Standing-bow-over-star symbol on a cloak from El-Lahun, Fayum, Egypt (Fig 25.2(f))

The Whitworth Art Gallery, Manchester, possesses a large semi-circular wool cloak in tabby weave from a cemetery at El-Lahun in the Fayum: it dates probably to the 6th century (Pritchard 2006, 120, fig 5.4(a), 5.4(b); Granger-Taylor 2007). A narrow crescentic band of white wool close to the curved lower edge of the cloak carries as a centrally-placed motif a 'standing bow' in tapestry weave over an eight-point brocaded star in Z-spun purple wool. It measures *c* 35mm left to right.

2.19 Chevron motif on tunic from Qustul, Lower Nubia

Brocaded next to pin stripes adjacent to the starting and finishing borders on a light brown sleeveless tunic (*colobium*) from an infant burial (Q150) at Qustul on the Nile in Lower Nubia are two small 'feathered-arrow' motifs (*c* 80mm long) in purple wool. When the (adult-sized) tunic was worn, an arrow would descend on each shoulder next to the armholes; but in fact they would hardly be noticeable (Mayer Thurman and Williams 1979, 69, no. Q150.3, pl 29). The burial may date to before AD 350.

2.20 Double chevron motif on textile fragment, 'from Egypt'

Close to the starting border on a wool textile fragment of uncertain function, bought in Egypt, appears a back-to-back feathered-arrow motif, 165mm long, which at the mid point of its central shaft reverses the direction of the chevron strokes. The shaft is tapestry-woven, while the oblique strokes are in a freehand brocading technique. One half of the design is all in red, the other half in purple (seen through the kindness of Hero Granger Taylor). It is presumably of Roman date.

2.21 Chevron motif on cotton cloth from Egypt (Fig 25.2(g))

The British Museum's Egyptian Department (Greville Chester Collection) houses a piece of cotton cloth, possibly of Roman date and supposedly from 'Achmîm', on which a 'feathered-arrow' motif (*c* 80mm long) has been brocaded in 'purple' wool (kind information from Hero Granger Taylor).

2.22 Chevron motifs on a child's tunic from Egypt (Fig 25.2(h))

A child's wool tunic bought in Cairo and now in the Röhsska Museum, Göteborg (RKM 157-35) is adorned with at least 24 feathered arrows in red and green wool. The stem is tapestry woven, the oblique strokes brocaded over and under two warp threads (Erikson 1997, 84–89, cat. no. 2). It may be of late Roman or early Islamic date.

2.23 Embroidered crosses on a tunic from Egypt

A sleeveless wool tunic in damask weave acquired from Egypt by the Abegg Stiftung, Bern, is marked in one corner by a line (35mm long) of five small crosses roughly embroidered in a pale green S-spun yarn. The tunic has been radiocarbon dated (94.8% confidence) to AD 50–232; but the date of the embroidery is uncertain (Wild 1994, 36, 33, fig 36; Schrenk 2004, 158–162). If ancient, it might be a laundry mark.

Discussion

1 Epigraphic makers' marks

Late antique and early Islamic textiles from Egypt frequently carry written messages in Greek, Coptic or Arabic. They include goodwill messages, pious sentiments, names of donors and dates of donation – but rarely any reference to the weaver (Fluck and Helmecke 2006). Zacharias, for example, whose name appears in Greek lettering on some well-known early 7th-century silks, may have been the weaver, but that is far from agreed (Fluck and Helmecke 2006, 160–161).

The most satisfactory epigraphic maker's mark from the Roman Empire is the embroidered inscription F]LORENTIA OF on a silk damask from Trier (No. 2.1 above). The circumstances of its discovery at the (re)opening of Paulinus' coffin in 1883 make it unlikely that it was added to the relics at a date later than AD 395, the traditional date of the reburial (Schneider 1884; Heinen 1985, 335–337). The angled bar on the letter A, a feature ultimately borrowed from Greek, becomes increasingly

popular in the 4th century (Gordon and Gordon 1965, pl 148, no. 316, pl 152, no. 321, pl 163, no. 339), though Lawrence Keppie has pointed out to me that it is to be seen on three distance-slabs from the Antonine Wall (Robertson 1990, 13, fig. 11, nos. 4, 5, 6). The ansate panel, like those framing tile stamps and even makers' names on glassware (Harden 1987, 164, fig page 165), has formal overtones.

How is the abbreviated inscription to be resolved? The name stem *Florent-* is one of the commonest recorded on inscriptions from late Roman Trier (Gose 1958, 122), reflecting its wider currency (Weisgerber 1968, 265–266). To judge by its incidence on tiles, pottery and metalwork OF may be resolved as OFFICINA or a congener. There are several possibilities:

- *F]lorentia of(ficina)*, 'the Florentian workshop'. *Florentia* would be adjectival on this hypothesis, but parallels are hard to find in the corpus of *officina*-stamps in any artefact category.
- *F]lorentia* or *F]lorenti(n)a of(ficinatrix)*, 'Florenti(n)a the manageress', was J Braun's suggestion in 1910 (Braun 1910a). Silk garment production, however, was a male preserve, as Diocletian's Edict and the Theodosian Code reveal: but there were a few female overseers (*officinatrices*) in the tile industry (Helen 1975, 112).
- *F]lorentia(nus) of(ficinator)* is a possibility, given the stamp OF(FICINATOR) PRIMUS on a silver ingot issued by the Trier mint (Wamser 2000, 353, Kat Nr 74c2, Abb S.353). There is other evidence, too, for the post of *officinator* in a mint (CIL 6, no. 298,). Florentianus seems to be the only name developed from the *Florent-* root which fits; but there is a problem in that it is not attested in official prosopography until the 6th century AD (Martindale 1980, 476).
- *F]lorentia(ni) of(ficina)* would probably be the first suggestion of a student of samian ware stamps, and on balance it is the best option. (One might also recall *ex off(icina) Curmissi* on a silver ingot from Kent (Kent and Painter 1977, 26)). But the uncertainty over the form of the proper name remains.

Whatever the correct resolution, the significance of the inscription is not in doubt: a workshop under the management of Florentia(nus) was responsible for the silk. The workshop must have been in the Latin-speaking western empire, and there are arguments for locating it in Trier, for much of the fourth century an imperial seat. Stamped precious-metal ingots, the stuff of donatives, were issued by the Trier mint bearing the names of specific functionaries (Wamser 2000, 353); coins minted there are attributed to lettered or numbered internal *officinae* (Grierson and Mays 1992, 68–69). Trier was also the home to two *gynaecea*, weavers' workshop complexes, one a state concern, the other private to the Emperor (Wild 1976, 54). Their principal output was wool clothing for the army and the court respectively. In AD 369, however, Valentinian decreed that long-sleeved shirts (*paragaudae*) of silk with gold-thread tapestry decoration should only be made 'in

our *gynaecea*' (*Codex Theodosianus* 10.21.1). It is very tempting to propose that Florentia(nus)' workshop was a department of the Emperor's private *gynaeceum* at Trier and the source of the silk garment ultimately recycled for the reburial of Paulinus. The workshop probably did not weave the silk (Wild 1987, 470–1), but may have obtained it through the Syrian community in Trier (Gauthier 1975, 131–3, Cat no. 1, 10; 172–4 Cat no. 1, 32; 270–3, Cat no. 1, 93; 310–11, Cat no. 1, 112; 422–33, Cat no. 1, 68: kind information from Hiltrud Merten, Trier). The workshop may have completed the garment's tailoring (as Sabine Schrenk has suggested), and authorised its issue in compliance with Valentinian's edict.

2 Non-epigraphic makers' marks

The non-epigraphic examples of potential makers' marks present particular challenges: do they identify a producer or have they another meaning altogether? I have tended to prefer a functionalist approach; but the research of Eiluned Edwards (pers comm) among the textile producers of Kachchh in north-west India has demonstrated that what may seem to be a functional constructional feature may have in the mind of the maker an explanation deeply rooted in traditional beliefs.

The linear Z-shaped symbols woven close to the transverse borders on tunics from Dura-Europos (No. 2.1) and the Cave of Letters (No. 2.2) are not easy to see and hence are unlikely to have had a formal decorative role; but they do not resemble the symmetrically-placed lines on some late Roman textiles from Egypt presumed to be weavers' marking-out guides (eg Pritchard 2006, 74, 77, fig 4.25(a)). Two instances of small arrows woven near the borders of cloak fragments from At-Tar (Nos. 2.3, 2.4) may be classed with Nos. 2.1 and 2.2, and all four regarded as weavers' marks.

Two late Roman tunics from Egypt in the Victoria and Albert Museum have a short narrow tapestry-woven band placed to one side on the skirt, not part of the clavate decoration (Nos. 2.5, 2.6). A third late Roman tunic from Egypt shows a more elaborate tree motif in a similar position (No. 2.7). They could reasonably be assumed to identify a workshop or a weaver.

The 'sprays of flowers' noted on textiles from Lower Nubia (Nos. 2.8, 2.9) are precursors of a local tradition that continues to at least the 8th century (Adams 1999, 68, figs 9, 10). Their symmetrical positioning, however, on opposing edges of a fabric – at least three sprays were recorded on one textile – suggests an ornamental role; their sheer variety, however, might simultaneously reflect the work of specific hands.

A quincunx motif and devolved versions of it have been recorded on a number of cloaks from 2nd- or 3rd-century site contexts in Syria (Nos. 2.10, 2.11), Palestine (Nos. 2.12–2.16) and Mesopotamia (No. 2.17). In some cases (Nos. 2.10 and possibly 2.11) the motif has been repeated in each corner of the cloak, replacing the commoner gamma or H-devices; these must be decoration, not makers' marks. In

two more cases (Nos. 2.12, 2.13) the quincunx is probably also ornamental. However, a series of very small openwork motifs, seemingly simplified echoes of the quincunx, appear on other cloaks: in one case (No. 2.14) the mark features on a cloak which also bears quincunx decoration in each corner (No. 2.12). Identification of producer rather than decoration seems to be the purpose here.

The 'feathered arrow' motifs covering a child's tunic from Egypt (No. 2.22) are surely decorative – or apotropaic? The pair on tunic No. 2.19 might also have symbolic meaning, but too little survives of the textiles on which Nos. 2.20 and 2.21 appear to venture an opinion. The unique symmetrically-placed 'standing-bow-over-star' device on the half-moon cloak from El-Lahun (No. 2.18) may also have some deeper meaning.

Most of the marks catalogued above thus fall into one of five groups. Linear Z- and arrow-shaped motifs occur in Syria, Palestine and Mesopotamia in the 2nd or 3rd century AD on tunics and cloaks. Asymmetrically placed tapestry bands are found on some late Roman tunics from Egypt. The 'sprays of flowers' are confined to Lower Nubia in late antiquity and the early medieval period. The devolved quincunx mark appears on 2nd- and 3rd-century cloaks in Syria and Palestine. Brocaded 'feathered arrow' motifs in the Nile Valley identify a maker, but perhaps only incidentally. They have very little in common!

Tryphon of Oxyrhynchus, the papyrologist's favourite Roman weaver, was functionally illiterate (Parsons 2007, 214). It should be no surprise therefore to find that weavers preferred a trade mark to a signature or a monogram (Tomlin and Hassall 2002, 367, fig 17; Sternini 1993, 87; Cüppers 1969, 154–7). What look like trademarks were stamped into many items of footwear found at Vindolanda: indeed L Aeb(utius) Thales stamped a lady's sandal with a vine leaf and cornucopiae as well as his own name (Van Driel-Murray 1993, 69). Bases of square glass bottles sometimes carry moulded motifs which may not be solely ornamental (Charlesworth 1959, 53, fig 9; Price and Cottam 1998, 194–8); the relief patterns on flue tiles in southern Britain may also represent deliberately personalised designs (Betts *et al* 1994, 52). Mortarium potters sometimes stamp what looks more like a trademark than a name (Hartley *et al* 2006, 16).

3 Why did makers mark?

It has emerged from the review above that textile operatives seldom felt urged to identify their handiwork. They must have been aware, however, that many other craft workers had no such inhibitions. That might have something to do with what was perhaps the primary function of a mark or stamp: to establish accountability.

Florentia(nus)' name on the Trier silk, I have suggested, was a guarantee that the textile had been duly 'passed' by a workshop in the imperial *gynaeceum*. It may also have been an indication of quality; for we know that the Roman army in an earlier age demanded the best: cloth checking scenes were a stock theme in Gallic funerary art and the

specifications for clothing and blankets ordered by the army in Egypt were stringent (Wild 2001, 87). The inconspicuous trade marks on some items of clothing may reflect a local or internal referencing system.

ACO-beakers, FORTIS-lamps and AUCISSA-brooches, given their ubiquity, could be regarded as branded goods – a 'must-have' name on a recognisable product. Certainly when a fenland potter at Stanground near Peterborough tried to turn out copies of some East Gaulish samian vessels, he felt obliged to add his illiterate stamp INDIXIVIXI (Dannell 1973).

Brenda of course has seen it all before. 'Accountability' is expressed in the fleeting cursive signatures of samian mould-makers, and her friend Cinnamus raised his 'brand-profile' with some very prominent stamps on his decorated bowls. All one can claim for textiles is that makers' marks existed: their full meaning and message are still to be discovered.

Bibliography

Adams, N K, 1999. The grave goods, in W Y Adams, N K Adams, D Van Gerven and D Greene, *Kulubnarti III: the cemeteries*, Brit Archaeol Rep Int Ser S814, 51–71, Oxford

Audollent, A, 1922. *Les tombes gallo-romaines à inhumation des Martres-de-Veyre, Puy-de-Dôme*, Mémoires présentés à l'Academie des Sciences et Belles Lettres 13, Paris

Bayley, J, and Butcher, S, 2004. *Roman brooches in Britain: a technological and typological study based on the Richborough collection*, Rep Res Comm Soc Antiq London 68, London

Bergman, I, 1975. *Late Nubian textiles*, Stockholm

Betts, I, Black, E W, and Gower, J, 1994. A corpus of relief-patterned tiles in Roman Britain, *J Roman Pottery Stud* 7, 1–167

Betts, I, 1995. Procuratorial tile stamps from London, *Britannia* 26, 207–29

Bishop, M C, and Coulston, J C N, 2006. *Roman military equipment: from the Punic wars to the fall of Rome*, 2 ed, Oxford

Braun, J, 1910a. Die spätrömischen Stoffe aus dem Sarkophag des hl.Paulins zu Trier, *Zeitschrift für christliche Kunst* 23 (9), Sp.279–84

Braun, J, 1910b. Nochmals das Gewebe aus dem Sarkophag des hl.Paulinus, *Zeitschrift für christliche Kunst* 23 (11), Sp.348–50

Charlesworth, D, 1959. Roman glass in northern Britain, *Archaeol Aeliana*, 4 ser 37, 33–58

CIL 6 = Bormann, E, and Henzen, G, 1876. *Inscriptiones urbis Romae Latinae. Inscriptiones sacrae. Augustorum, magistratum, sacerdotum. Latercula et tituli militum*, Corpus Inscriptionum Latinarum 6 (1), Berlin

Cüppers, H, 1969. *Die Trierer Römerbrücken*, Mainz

Dannell, G B, 1973. The potter Indixivixus, in *Current research in Romano-British coarse pottery* (ed A P Detsicas), Counc Brit Archaeol Res Rep 10, 139–42, London

Darvill, T, and McWhirr, A D, 1983. Brick and tile production in Roman Britain: models of economic organisation, *World Archaeology* 15 (3), 239–61

De Jonghe, D, and Tavernier, M, 1977–78. Die spätantiken Köper 4-Damaste aus dem Sarg des Bischofs Paulinus in der Krypta der St.-Paulinus-Kirche zu Trier, *Trierer Zeitschrift* 40–41, 145–174

Donderer, M, 1989. *Die Mosaizisten der Antike und ihre wirtschaftliche und soziale Stellung: eine Quellenstudie*, Erlangen

Dreyspring, B, and Schrenk, S, 2007. Die spätantiken Seidengewebe in Trier, in A Demandt and J Engemann, *Konstantin der Grosse*, 416–7, Mainz

Erikson, M, 1997. *Textiles in Egypt 200–1500 AD in Swedish Museum Collections*, Göteborg

Fluck, C, and Helmecke, G (eds), 2006. *Textile messages: inscribed fabrics from Roman to Abbasid Egypt*, Leiden

Flügel, C, Schneider, G, and Wagner, U, 2000. Archäologie und Naturwissenschaften, in Wamser 2000, 304–8

Fujii, H, 1980. A special edition on the studies on textiles and leather objects from At-Tar caves, Iraq, *Al-Rāfidān* 1, 1–329

Fujii, H, Sakamoto, K, and Ichihashi, M, 1989. Textiles from At-Tar caves, part I: cave 12, hill C, *Al-Rāfidān* 10, 109–66

Fujii, H, Sakamoto, K and Ichihashi, M, 1993. Textiles from At-Tar caves – part II-(3): cave 16, hill C, *Al-Rāfidān* 14, 109–40

Gauthier, N, 1975. *Receuil des inscriptions chrètiennes de la Gaule I: première Belgique*, Paris

Giovannini, A, and Maggi, P, 1994. Marchi di fabbrica su strigili ad Aquileia, in *Epigrafia della produzione e della distribuzione. Actes de la VIIᵉ rencontre franco-italienne sur l'épigraphie du monde romain* (eds S Nicolet and S Panciere), Collection de l'École française de Rome 193, 609–43, Rome

Gordon, A E, and Gordon, J S, 1965. *Album of dated Latin inscriptions, Rome and the neighborhood 3 (AD 200–525)*, Berkeley

Gose, E, 1958. *Katalog der frühchristlichen Inschriften in Trier*, Berlin

Gostenčnik, K, 2002. Agathangelus the bronzesmith: the British finds in their continental context, *Britannia* 33, 227–56

Granger-Taylor, H, 2007. 'Weaving clothes to shape in the ancient world' 25 years on: corrections and further details with particular reference to the cloaks from Lahun, *Archaeol Textiles Newsletter* 45, 26–35

Grierson, P, and Mays, M, 1992. *Catalogue of the later Roman coins in the Dumbarton Oaks Collection and in the Whittemore Collection*, Washington DC

Hall, R, 1986. *Egyptian textiles*, Aylesbury

Harden, D B, 1987. *Glass of the Caesars*, London

Harris, W V (ed), 1993. *The inscribed economy: production and distribution in the Roman Empire in the light of* instrumentum domesticum. *Proceedings of a conference held at the American Academy in Rome on 10–11 January 1992*, J Roman Archaeol Suppl 6, Ann Arbor

Hartley, K F, Tomber, R, and Webster, P V, 2006. A mortarium bibliography for Roman Britain, *J Roman Pottery Stud* 13, 1–139

Heinen, H, 1985. *Trier und das Trevererland in römischer Zeit I*, Trier

Helen, T, 1975 *Organization of Roman brick production in the first and second centuries AD*, Helsinki

Kent, J P C, and Painter, K S, 1977. *Wealth of the Roman world AD 300–700*, London

King, D, 1996. Roman and Byzantine dress in Egypt, *Costume* 30, 1–15

Lønstrup, J, 1983. Das zweischneidige Schwert aus der jüngeren römischen Kaiserzeit im freien Germanien und im römischen Imperium, in *Studien zu den Militärgrenzen Roms III: 13. internationaler Limeskongress, Aalen 1983, Vorträge* (ed C Unz), 747–9, Stuttgart

MacMullen, R, 1960. Inscriptions on armor and the supply of arms in the Roman empire, *American J Archaeol* 64, 23–40

Manacorda, D, and Panella, C, 1993. Anfore, in Harris 1993, 55–64

Martindale, J R, 1980. *The prosopography of the Later Roman empire II: AD 395–527*, Cambridge

Mayer Thurman, C C, and Williams, B, 1979. *Ancient textiles from Nubia*, Chicago

Parsons, P, 2007. *City of the sharp-nosed fish: Greek lives in Roman Egypt*, London

Peacock, D P S, and Williams, D F, 1991. *Amphorae and the Roman economy; an introductory guide*, London

Penney, S H, and Shotter, D C A, 2002. Further inscribed salt-pans from Shavington, Cheshire, *J Chester Archaeol Soc* 76, 53–61

Petrovszky, R, 1994. *Studien zu römischen Bronzegefäßen mit Meisterstempeln*, Kölner Studien zur Archäologie der römischen Provinzen 1, Köln

Pfister, R, 1940. *Textiles de Palmyre III*, Paris

Pfister, R, and Bellinger, L, 1945. The Textiles, in M I Rostovtzeff, A R Bellinger, F E Brown, N P Toll, and C B Welles, *The excavations at Dura-Europos conducted by Yale University and the French Academy of Inscriptions and Letters, final report IV, part II*, New Haven

Price, J, and Cottam, S, 1998. *Romano-British glass vessels: a handbook*, York

Pritchard, F, 2006. *Clothing culture: dress in Egypt in the first millennium AD*, Manchester

Renard, M, 1961. Note épigraphique sur les sigles et graffiti du tonneau romain de Harelbeke, *Latomus* 20, 785–99

Reusch, W, 1965. *Frühchristliche Zeugnisse im Einzugsgebiet von Rhein und Mosel*, Trier

RIB 2.1 = Collingwood, R G, and Wright, R P, 1990. *The Roman inscriptions of Britain* 2, Instrumentum Domesticum *(personal belongings and the like)*, Fasc 1, *The military diplomata; metal ingots; tesserae; dies; labels; lead sealings* (eds S S Frere and R S O Tomlin), Stroud

RIB 2.5 = Collingwood, R G, and Wright, R P, 1993. *The Roman inscriptions of Britain* 2, Instrumentum Domesticum *(personal belongings and the like)*, Fasc 5, *Tile stamps of the* Classis Britannica*; imperial, procuratorial and civic tile stamps; stamps of private tilers; inscriptions on relief-patterned tiles and graffiti on tiles* (eds S S Frere and R S O Tomlin), Stroud

Rigby, V, 1973. Potters' stamps on terra nigra, in *Current research in Romano-British coarse pottery* (ed A P Detsicas), Counc Brit Archaeol Res Rep 10, 7–24, London

Rigby, V, 1998. Where did Cen, Reditas and Sace produce pots? A summary of the range and distribution of Romano-British stamped wares, in *Form and fabric: studies in Rome's material past in honour of B. R. Hartley* (ed J Bird), 191–7, Oxford

Robertson, A S, 1990. *The Antonine wall* (rev ed L Keppie), Glasgow

Roueché, C, 1989. *Aphrodisias in late antiquity*, London

Schmidt-Colinet, A, Stauffer, A, and Al-As'ad, K, 2000. *Die Textilien aus Palmyra*, Mainz

Schneider, F, 1884. Die Krypta von St Paulin zu Trier, *Jahrbücher des Vereins von Alterthumsfreunden im Rheinlande* 78, 167–98

Schneider, G, 1993. X-ray fluorescence analysis and the production and distribution of *terra sigillata* and *Firmalampen*, in Harris 1993, 129–37

Schrenk, S, 2004. *Textilien des Mittelmeeres aus spätantiker bis frühislamischer Zeit*, Bern

Steinby, M, 1993. L'organizzazione produttiva dei laterzi: un modello interpretivo per l'instrumentum in genere?, in Harris 1993, 139–43

Sternini, M, 1993. I vetri, in Harris 1993, 81–94

Todd, M, 2007. *Roman mining in Somerset: excavations at Charterhouse on Mendip 1993–1995*, Exeter

Tomlin, R S O and Hassall, M W C, 2002. Roman Britain in 2001 II: inscriptions, *Britannia* 33, 355–71

Trilling, J, 1982. The Roman heritage: textiles from Egypt and the eastern Mediterranean 300–600 AD, *Textile Museum J* 21, 1–112

Ulbert, G, 1959. Römische Holzgefäße aus Regensburg, *Bayerische Vorgeschichtsblätter* 24, 6–29

Van Driel-Murray, C, 1993. The leatherwork, in *Vindolanda Research Reports, new series III: the early wooden forts* (ed R E Birley), 1–75, Bardon Mill

Vegas, M, 1969–70. Aco Becher, *Rei Cretariae Romanae Fautorum Acta* 11–12, 107–24

Walker, S, and Bierbrier, M, 1997. *Ancient faces: mummy portraits from Roman Egypt*, London

Wamser, L (ed), 2000. *Die Römer zwischen Alpen und Nordmeer*, Mainz

Webster, P V, 1996. *Roman samian pottery in Britain*, London

Weisgerber, J L, 1968. *Die Namen der Ubier*, Köln

Wild, J P, 1976. The *gynaecea*, in *Aspects of the* Notitia Dignitatum (eds R Goodburn and P Bartholomew), Brit Archaeol Rep Int Ser S15, 51–8, Oxford

Wild, J P, 1987. The Roman horizontal loom, *American J Archaeol* 91, 459–71

Wild, J P, 1994. Tunic no. 4219: an archaeological and historical perspective, *Riggisberger Berichte* 2, 9–36

Wild, J P, 2001. Textiles et activités relatives au textile sur le monument d'Igel, *Annales de l'Est* 51 (2), 83–92

Wright, R P, 1940. Roman Britain in 1939 II: inscriptions, *J Roman Stud* 30, 182–90

Wright, R P and Hassall, M W C, 1971. Roman Britain in 1970 II: inscriptions, *Britannia* 2, 289–304

Yadin, Y, 1963. *The finds from the Bar Kokhba period in the Cave of Letters*, Jerusalem

26 The occurrence and use of samian ware in rural settlements in the Upper Thames Valley

Paul Booth

Introduction

This contribution aims to provide an impression of the level at which, and perhaps some of the ways in which, samian ware was used in a region of Roman Britain dominated not by major towns and military establishments, but by lesser nucleated sites and rural establishments, mostly of low status. The intention is to use quantified data from as many sites as possible to test a number of (at regional level) frequently asserted but rarely conclusively demonstrated assumptions about the character of samian ware assemblages from such sites, placing them in the context both of the wider pottery collections of which they form part and of the sites from which they derive. The approach relates to the work of Willis (1998; 2005), although not directly based upon it and with some differences of emphasis (see further below). The paper is offered to Brenda with deep gratitude for many years of ready assistance with samian ware, tinged only with a personal regret that her more pressing commitments made it impossible to draw on her expertise as much as could have been wished.

The data used have been gathered from a variety of published and unpublished reports of varying date. Some (but by no means all) of these have been produced using a unified recording system developed by Oxford Archaeology from the early 1990s (eg Booth *et al* 1993, 135–6, 153) with the intention of providing datasets suitable for inter-site comparison across the Oxford region and, if possible, beyond. From the initiation of this system it was intended that samian ware should be recorded like any other category of pottery, so that its role in the recorded assemblages could be assessed easily. Approaches to quantification remain an issue in pottery studies (eg Symonds and Haynes 2007) and in no area more so than in relation to samian ware (eg Willis 1998, 89, 94). From the viewpoint of a non-specialist what is most significant is understanding the role of samian within an integrated picture of total pottery assemblages, rather than the very detailed picture that may be obtained for one small part of these assemblages, however important some of the fine detail may be.

Where possible, therefore, data have been drawn from assemblages in which sherd count, weight, EVEs (strictly REs – rim equivalents) and a count of vessels based on rim sherds have all been recorded. For present purposes analysis has been based principally on sherd count and REs, but in some cases vessel counts have had to be used. Some of the sherd count data have been presented before in a different context (Booth 2004a) and in a few cases there are minor differences between the quantities and percentages quoted there and in the present paper, mainly because some of the earlier figures were based on provisional data. There are also a few differences between figures given here and in some of the published sources from which they have been derived, as a result of reworking. While the survey is based on published data where possible, archive data sets have been re-examined in some cases in order to extract the desired information, although this was not always recorded.

Emphasis has been placed on broad aspects of quantification and the breakdown of assemblages in terms of vessel classes. Aspects of detailed chronology have been given less systematic attention. This is, regrettably, in part because of the dearth of practicing samian specialists, which has perforce required pottery workers in some cases to make their own identifications. While this is usually unproblematic in respect of vessel forms, this contributor has less confidence in the consistency of non-specialist attribution (including his own) of sherds to source, so this aspect, with its potential to inform (*inter alia*) understanding of the chronological development of samian assemblages, has not been stressed here. The principal reason for not following the detailed chronological and typological framework set out by Willis (1998, 94–7), however, relates to the small size of many of the samian ware assemblages considered – subdivision at these levels would in almost all cases produce meaningless figures.

The assemblages

The basic data are laid out in Table 26.1, in which the sites are roughly grouped in related geographical areas

Site	Type	Date	No sherds	% site total	REs	% site total	% sherds decorated	Comment	Reference
1. Alchester (A421)	Nucleated extramural	m 1C-4C	1142	2.4	17.13	3.0	11.6	Phased pottery only	Dickinson 2001
2. Bicester, Oxford Road	Rural	e/m 1C–e 2C	13	1.2	0.18	1.2	(7.7)	All SG	Booth 1996
3. Middleton Stoney	Roadside	1C-m/1 3C	c 120	0.9	?	?	?		Brown and Leggatt 1984; Simpson 1984
4. Wilcote	Nucleated	m 1C-3C	345	2.8	?	?	?	CAT excavation only	Mills 2004
5. Asthall	Nucleated	m 1C-4C	704	6.2	9.83	6.6	5.4		Mills 1997
6. Birdlip	Roadside	m/1 2C-4C	397	2.5	3.51	3.4	?21.5	Dec only 3 'vessels' (all 37), but no. sherds unclear	Dickinson 1999; Timby 1999b
7. Middle Duntisbourne	Rural	m 1C	3	0.3	?	?	-	Includes 1 Arretine sherd	Timby 1999a, 329-332
8. Duntisbourne Grove	Rural	m 1C	4	0.2	-	-	(25.0)	27?; 29	Timby 1999a 332-335
9. Weavers Bridge	Rural	12C-4C	6	0.8	-	-	-		Timby 1999a, 337-339
10. Somerford Keynes, Neigh Bridge	Rural	1C-12C	153	1.5	3.74	4.0	15.0		Brown 2007a
11. Somerford Keynes Cotswold Community	Rural	1C-4C	229	1.1	3.98	1.9	10.0		Unpublished
12. Latton Lands	Rural	1C-3C	32	0.9	0.62	1.6	6.3		Stansbie 2009
13. Whelford Bowmore	Rural	2C-e/m 3C	331	9.3	5.44	18.3	5.4		Brown 2007b
14. Fairford, Thornhill Farm	Rural	e/m 1C-e 2C	20	0.2	0.33	0.4	5.0		Timby 2004
15. Fairford, Claydon Pike	Rural	1C-4C	1482	4.2	21.43	5.2	9.6		Webster 2007
16. Horcott	Rural	1C-3C	205	2.7	2.48	4.2	?	Figures based on fabrics defined as 'later prehistoric-early Roman' and 'Roman'	Timby and Harrison 2004
17. Kempsford Quarry	Rural	11C-3C	6	1.4	0.03	2.2	-	Drag 31	Biddulph 2007
18. Kempsford Stubbs Farm	Rural	1C-2C	15	1.7	0.12	1.4	-		Booth 2007
19. Lechlade, Roughground Farm 1990	Villa	2C-4C	75	3.5	2.06	6.4	12.0		Green & Booth 1993
20. Lechlade, Roughground Farm East	Rural, villa related	2C-4C	250	4.5	?	?	?		Green and Booth 1993
21. Old Shifford	Rural	1C	-	-	-	-	-	893 sherds, no samian	Timby 1995

Site	Type	Date	Sherds					Notes	Reference
22. Old Shifford B	Rural	mainly 4C	16	0.6	?	?	?	27, 18/31, 18/31R, 37 ?no. rims etc	Timby 1995
23. Hardwick, Smiths Field	Rural	e/m 1C–e/m 2C	4	0.1	-	-	-		Unpublished
24. Hardwick, Watkins Farm	Rural	m/l 1C–2C	35	1.1	?8*	3.7*	8.6	2 sherds dec + 1 rim from Knorr 78	Raven 1990
25. Stanton Harcourt, Gravelly Guy	Rural	e/m 1C-e 2C	10	0.1	0.07	0.1	-	?15/17R; 27 (the only rim)	Green et al 2004
26. Northmoor	Rural	2C-4C	22	3.8	0.55	4.5	4.5	30/37; 33; 31 x5, 36	Unpublished
27. Yarnton	Rural	e/m 1C-4C	63	0.8	1.43	1.0	4.8		Booth forthcoming
28. Watchfield Triangle	Rural	e/m 1C-l 3C?	17	0.9	0.38	2.9	(11.8)		Biddulph 2004
29. Faringdon Coxwell Road	Rural	1C-4C	21	0.7	?	?	(9.5)		Bryan and Brown 2004
30. Hatford	Rural	e/m 1C-e/m 2C	-	-	-	-	-	2130 sherds, no samian	Booth 2000b; 2004b
31. Wantage, Mill Street	?Nucleated	l1C-4C	108	3.5	2.04	4.1	10.2 (?+)	27, 33, 18/31, 31, 35/36, 9 dec vessels (29, 30, 37 x7)	Timby 1996
32. Oxford Mansfield College etc	Rural	l1C-4C	21	1.0	0.50	1.6	(14.3)	Immediately adjacent sites	Booth 2000a; Biddulph 2005
33. Abingdon, Barton Court Farm	Villa	e/m 1C-e 2C; l3C-4C	2.24 kg	0.7	?	?	?	Figures from Miles et al 1986	Bird et al 1986
34. Abingdon Old Station	?Nucleated	?l1C-e 4C	13	1.8	0.17	1.7	-		Unpublished
35. Abingdon Cinema	?Nucleated	1C-e 4C	51	3.1	1.64	6.8	7.8		Unpublished
36. Drayton	Rural	m 1C-2C	8	0.9	2*	2.8*	-	2 rims ?dish	Booth 2003
37. Harwell	Rural	e/m 1C-4C	8	0.5	-	-	(12.5)	Dec sherd is the only SG	Unpublished
38. Appleford	Rural	m 1C-e/m 2C	48	1.7	1.33	3.2	14.6	Mostly SG	Booth 2009
39. Berinsfield, Wally Corner	Rural	m/l 2C-4C	35	1.5	9*	3.2*	11.4		Booth 1995
40. Berinsfield, Mount Farm	Rural	e/m 1C-e 3C	10	0.4	1*?	0.2*?	-?	18/31	Unpublished
41. Dorchester (CD92)	Rural	l2C-4C	20	1.9	?	?	10.0		Unpublished surface collection
42. Benson	Rural	e/m 1C-?e 2C	1	0.1	0.10	1.7	-		Timby 2005

Decorated sherds figures include rims of decorated forms where confidently identified
*Data based on vessel rim count, not on REs

Table 26.1: Outline quantification of Upper Thames Valley samian ware assemblages

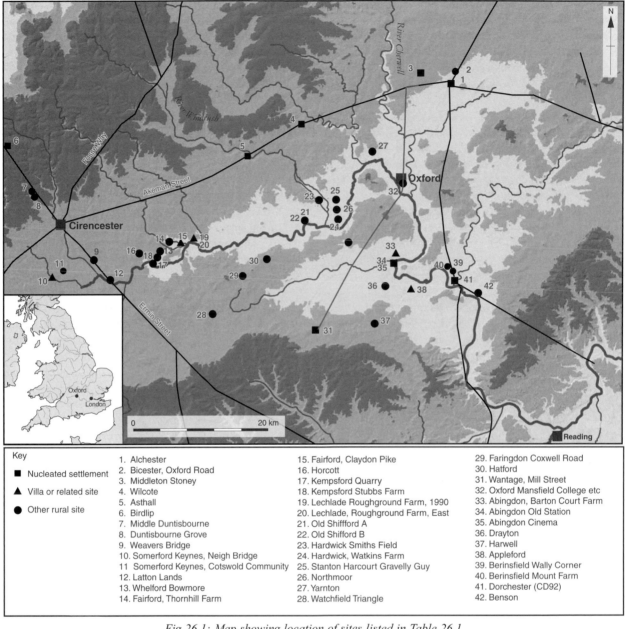

Key

■ Nucleated settlement

▲ Villa or related site

● Other rural site

1. Alchester	15. Fairford, Claydon Pike	29. Faringdon Coxwell Road
2. Bicester, Oxford Road	16. Horcott	30. Hatford
3. Middleton Stoney	17. Kempsford Quarry	31. Wantage, Mill Street
4. Wilcote	18. Kempsford Stubbs Farm	32. Oxford Mansfield College etc
5. Asthall	19. Lechlade Roughground Farm, 1990	33. Abingdon, Barton Court Farm
6. Birdlip	20. Lechlade, Roughground Farm, East	34. Abingdon Old Station
7. Middle Duntisbourne	21. Old Shiffford A	35. Abingdon Cinema
8. Duntisbourne Grove	22. Old Shifford B	36. Drayton
9. Weavers Bridge	23. Hardwick Smiths Field	37. Harwell
10. Somerford Keynes, Neigh Bridge	24. Hardwick, Watkins Farm	38. Appleford
11. Somerford Keynes, Cotswold Community	25. Stanton Harcourt Gravelly Guy	39. Berinsfield Wally Corner
12. Latton Lands	26. Northmoor	40. Berinsfield Mount Farm
13. Whelford Bowmore	27. Yarnton	41. Dorchester (CD92)
14. Fairford, Thornhill Farm	28. Watchfield Triangle	42. Benson

Fig 26.1: Map showing location of sites listed in Table 26.1

(see also Fig 26.1). First is a group of sites lying north of the Thames Valley in Oxfordshire, consisting mainly of nucleated settlements on and close to Akeman Street, the major road linking Verulamium and Cirencester. Second is a group lying both north and south of Cirencester and consisting mainly of sites excavated as part of the A417/419 (Swindon to Gloucester) project (Mudd *et al* 1999). The most southerly of the A417/419 sites, Weavers Bridge, lies in the Thames Valley and provides a link with a whole series of valley sites extending downstream from the Cotswold Water Park to just west of Oxford, but with a gap in the area between Lechlade and Bampton, where less archaeological work has been carried out (this is not an area of current gravel extraction). The next group of sites lies south of the Thames on the Corallian Ridge and in the Vale of White Horse, and the final group is again Thames Valley based,

running downstream from Oxford itself as far as Benson, south-east of Dorchester on Thames.

As many assemblages as possible have been considered. Some sites have had to be excluded from this study, however, either because their assemblages are too small to produce any meaningful data, or because the samian ware has not been quantified in any useable way (or, in some cases, at all). It is unfortunate that a number of assemblages from key higher status sites, such as the small town of Dorchester (with material principally from 1960s and '70s excavations), have had to be set aside for the latter reason (the fieldwalking collection CD92 is from a site on the Chalgrove to Didcot pipeline close to but not in Dorchester). The nucleated settlement of Wilcote and the neighbouring villa at Shakenoak, and the villa at Barton Court Farm, are similarly problematic. In addition

a few sites have been excluded for chronological reasons – mainly because they were largely or entirely of late Roman (later 3rd–4th century) date, such as Uffington (Brown 2003). The site assemblages for which data are available or have been recovered vary considerably in size, but only that at Kempsford Quarry has a total of less than 500 sherds and most have many more. The quantities of samian ware likewise range considerably, from a tiny handful of sherds up to 'one of the largest collections from a small town in Roman Britain' (Dickinson 2001, 277), from the northern extramural settlement area of Alchester, and the exceptionally large assemblage from the rural settlement and later villa complex at Claydon Pike (Fairford, Glos). It is important to indicate reliable negative evidence and note that in two cases (Old Shifford A and Hatford) no samian ware was recorded at all. The first of these sites, distinguished from Old Shifford Site B both spatially and chronologically, produced a pottery assemblage that was relatively small but more significantly, in terms of explaining the absence of samian ware, entirely of 1st century date. The two adjacent areas at Hatford, however, were part of a site occupied at least into the early 2nd century; the absence of samian ware from those assemblages (together totaling more than 2000 sherds) is remarkable and, indeed, most unusual for the region, where samian is generally considered to be ubiquitous, even if sometimes only found in small quantities.

Samian ware quantities

Where present, the representation of samian ware generally ranges from 0.1% to *c* 4.5% of sherds. Only two sites have higher percentages, Asthall with 6.2% of sherds and Whelford Bowmore, remarkably, with 9.3% (see further below). In both these cases the assemblages are large enough for there to be little doubt that the figures are reliable. At Asthall the sherd count figure is supported by that derived from REs, despite the fact that unusually high rates of fragmentation in part of the site might have resulted in an inflated representation of samian sherds. At Whelford Bowmore, however, the representation of samian is twice as common by REs as by sherd count. Equal or higher representation by REs is in fact seen in a majority of cases (22 out of 24 sites for which relevant data are available), but even by this measure relatively few assemblages contain more than 5% samian ware (Asthall, Whelford Bowmore, Claydon Pike, Roughground Farm 1990 and Abingdon Cinema) and the Whelford Bowmore figure of 18.3% is quite exceptional. Typically, and unsurprisingly, data based on weight, not presented here, tend to give consistently slightly lower percentages of samian ware compared to other measures.

These figures can be considered in a number of different ways – geographically, chronologically, and in relation to perceived site type. It can be said at once that there is no suggestion of meaningful variations in samian ware supply between the different geographical groupings of sites in the region. So, for example, the presence of a major market centre at Cirencester does not seem to have resulted in higher levels of samian ware representation across the board in the sites closest to it. The principal factors affecting variation in samian ware supply are therefore chronological and status related, and most probably combine aspects of both. In addition a locational (as opposed to a geographical) factor is relevant; nucleated settlements on the major road network will generally have higher proportions of samian ware, but here issues that relate exclusively to location are inextricably intertwined with those that define site type, and it is the latter characteristic that is considered (perhaps arbitrarily) the more important one here.

Assemblages from the lower status rural settlements almost invariably have less than 2% samian ware, and well over half of these have less than 1% (not counting the two sites mentioned above with no samian ware at all). A chronological aspect needs to be borne in mind, as a number of these sites ceased to be occupied after the early 2nd century – a pattern widely observed in the Upper Thames Valley (Henig and Booth 2000, 106–8). This will have had a bearing on their potential to acquire samian ware, since South Gaulish material is always less common than Central Gaulish in this region (at sites occupied in both the 1st and 2nd centuries), and the latest phases of these sites broadly coincide with the downturn in supply to Britain prior to the expansion of export from Lezoux. Very occasional examples of higher representation at apparently low status rural settlements, as for example the 3.8% at Northmoor, are associated with sites where occupation only commenced after the early 2nd century settlement hiatus, and it is possible that in this case the samian level in the small assemblage (only 579 sherds) has been exaggerated. As already mentioned, the remarkable representation of samian ware (9.3% of sherds) at Whelford Bowmore cannot be explained in this way. A possible interpretation of this anomalous assemblage will be discussed below.

Not all pottery assemblages with less than 2% of samian ware necessarily derived from lower status rural sites, but this is an almost invariable rule. The most obvious exception is the small roadside settlement at Middleton Stoney, with only *c* 1% of samian ware (the exact figure, which it must be said seems implausibly low, is not presented clearly in the published report; *cf* Brown and Leggatt 1984, 76; Simpson 1984). The only figure available for the villa at Barton Court Farm is also less than 1%, but this is based on weight and the (unknown) value for sherd count is likely to have been rather higher (see above). All the other villa-associated assemblages (Claydon Pike and two from contrasting elements of the Rough Ground Farm complex) have at least 3% of samian ware and the possible 'proto-villa' at Appleford, quite close to Barton Court Farm, which never developed beyond the early 2nd century, had 1.7%. Nucleated settlements apart from Middleton Stoney also produce samian ware quantities fairly consistently above those of the lower status rural sites, but not distinguishable from those at the villas. The sites in question are Alchester, Wilcote (one slightly problematic group only), Asthall, Birdlip and Wantage. The

	C Jar	E Beaker	F Cup	H Bowl	J Dish	K Mortarium	Z Uncertain	Types etc
Asthall		1.0	22.2	25.1	51.2	0.5		Wide range
Alchester A421	0.6		42.4	17.3	37.7	1.9		Wide range. Total 22.72 REs including unphased contexts
Bicester, Oxford Road			(16.7)		(83.3)			24/5; 18(2), J, (Drag 29 body sherd)
Birdlip			18.2	4.3	77.5			33; 35; 37; 31, 32, 36
Middle Duntisbourne			(100)					Haltern 8, 27 (also 24/5 not rim)
Latton Lands			6.5	6.5	87.0			33, 37, 18/31(5)
SKNB			33.7	15.2	50.3		0.8	27, 33; 30, 37, 44, Curle 11, Ritt 12; 15/17, 18/31, 18/31R, 31, 36
SKCC			22.6	9.5	64.6	1.8	1.5	27, 33; 37, Curle 11; 18, 18/31, 31, 31R, 36; 45, Curle 21
Whelford Bowmore		4.6	44.5	12.1	38.8			72; 27, 33; 30, 37, 38, 44; 15/31, 18/31, 31, 36, 79R
Thornhill Farm		(15.2)	(60.6)	(6.1)	(18.2)			E; 27, 35; 30, 36
Claydon Pike		0.5	41.6	11.9	42.3	3.4	0.3	Wide range; J
Kempsford Stubbs Farm					(100)			
Roughground Farm 1990			19.9	25.2	54.9			All cups; 7 dec sh + 2 rims poss Dr 37. 27, 33(3); 37(2), 44; 18(2), 18/31(3), 31(8), Curle 15, 79, J
Watkins Farm								33; 37; 18, 18/31; Knorr 78. The latter is a rim, number of rims and basis of quantification of others is unknown
Gravelly Guy			(100)					27 (the only samian rim and the only cup in the entire assemblage)
Northmoor			10.9	5.5	83.6			33; 30/37; 31(5), 36.
Yarnton			21.7	17.5	60.8			33(3); 38, H(2); 31(9), 36
Watchfield Triangle				(92.1)	(7.9)			33; 37(2); 31
Mansfield College etc			(60.0)	(20.0)	(20.0)			All cups are S (33 x 3); 37(1) 3 dec sherds from this vessels are only ones on site, 38(1); ?18/31etc, 31, 36
Abingdon Old Station				(64.7)	(35.3)			H; J
Abingdon Cinema			39.6	11.6	48.8			Ritt 8, 27, 33; Curle 11, (29 & 30/37); Curle 15, 15/17, 18/31, 31, 36, 18/31 or 31
Appleford			35.3	18.8	45.9			27, 35; 30, 37; 15/17, 18, 36
Wally Corner			(44.4)*	(11.2)*	(44.4)*			33(4) all the cups from the site; 38?; 18, 31(3)
Dorchester			(20.0)*	(20.0)*	(40.0)*		(20.0)*	33; 37; 23, 31; 35/6
CD92 Benson					(100)			18/31?

*Data based on vessel rim count

Table 26.2: Percentage of major vessel classes in samian ware assemblages (REs)

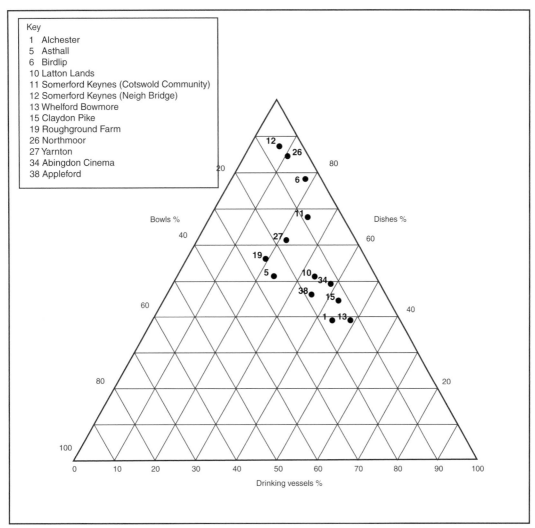

Key
1 Alchester
5 Asthall
6 Birdlip
10 Latton Lands
11 Somerford Keynes (Cotswold Community)
12 Somerford Keynes (Neigh Bridge)
13 Whelford Bowmore
15 Claydon Pike
19 Roughground Farm
26 Northmoor
27 Yarnton
34 Abingdon Cinema
38 Appleford

Fig 26.2: Relative proportions of three principal vessel classes based on RE quantities

status of Abingdon (represented here by two separate, small assemblages) is less clear, but it is likely to have been some sort of nucleated settlement in the early Roman period, although there may have been a change of site character, possibly to rural estate centre, later.

The broad implications of varying chronological ranges for our sites have already been mentioned. The anticipated pattern is that those sites only occupied up to the early 2nd century will produce less samian ware than the rest, the most widespread distribution of samian ware in this region being seen in the Antonine period. This pattern is generally supported by the present data; of some ten rural settlements producing between 1% and 2% of samian ware – ie the higher figures for sites in this group – most were occupied well past the early 2nd century settlement hiatus. The only exceptions are Bicester (Oxford Road) and Appleford, the latter potentially a high status early settlement, as has already been mentioned. Even in sites with longer occupation sequences, however, the overall incidence of samian ware could remain low. This is particularly the case at Yarnton, for example, and also at Watchfield and Faringdon, although the later (mid 2nd–3rd century) occupation at these two sites may have been less

intensive than in earlier periods. Nevertheless, the majority of sites with less than 1% of samian ware were those not occupied after the early 2nd century.

Decorated samian ware

Another aspect of samian ware assemblages which may be used as a basis for assessment of their character is the proportion which consists of decorated sherds (it should be noted that the percentages quoted here include undecorated rim sherds demonstrably from decorated forms). Meaningful data on this are only available for a relatively few sites, partly because the size of many of the samian ware assemblages is such that percentages of decorated material can be greatly inflated by the presence of one or two sherds. The figures considered least likely to be reliable have been placed in brackets in the relevant column of Table 26.1, but it is accepted that some of the other figures in this column may also be open to question.

This last factor may help to account for some of the considerable variation in the percentages of decorated sherds in the 'reliable' assemblages, from *c* 1.5% to 15% (some of the smallest groups have no decorated sherds at

all, but while this may be significant the samples cannot be considered statistically meaningful). The former figure is that for the minor roadside settlement at Birdlip, Glos. It is not precisely certain, since the report refers only to a minimum of four decorated vessels without specifying the number of sherds. By implication, however, the number of decorated pieces was considered to be unusually low (Dickinson 1999, 342), as indeed it is. Elsewhere the lowest representation of decorated sherds is around 5%, values of this order being seen in low status rural contexts at Thornhill Farm, Northmoor and Yarnton, but also at the small town of Asthall. At the other nucleated settlements of Alchester and Wantage rather higher levels of decorated sherds are recorded, 11.6% and *c* 10.2% respectively, while the only figure for Abingdon is 7.8% from the Cinema site. As with the overall quantities of samian ware, the percentages of decorated sherds at villa sites (Claydon Pike, 9.6% and Rough Ground Farm 1990, 12%) are quite closely similar to those from nucleated settlements. Percentages of decorated sherds at the majority of rural settlements lie in the 5–10% range, but the figures seem to show a less clear-cut separation of lower status rural and other site types than is apparent simply in relation to overall quantities of samian ware.

Two possible anomalies emerge amongst the rural settlements. At Somerford Keynes (Neigh Bridge), decorated pieces comprised 15% of all samian sherds, while at Appleford the figure was 14.6%, albeit of a relatively low total. Appleford, already mentioned, originated around the time of the Conquest (the pottery dating evidence is not sufficiently precise to determine if this was shortly before or shortly after AD 43) and was one of the many Upper Thames Valley sites where occupation ceased in the first half of the 2nd century. The samian ware, almost entirely South Gaulish, included sherds from at least four bowls (Drag forms 29, 30 (2) and 37), a striking collection for a small rural site of this period in the region, and contributes (along with other pottery and small finds, but also morphological and limited structural evidence) to the case for interpreting this settlement as being of relatively high status (see also Booth 2004a, 45, based on a much smaller sample, and Henig and Booth 2000, 84–5). The situation at Somerford Keynes is in some respects comparable to that at Appleford. Occupied from the late Iron Age, Somerford Keynes was distinguished in the early 2nd century by the construction of a substantial timber aisled building (Miles *et al* 2007, 236–239), setting it rather apart from contemporary run-of-the-mill settlement. A similar development occurred at the same time at Claydon Pike, which eventually developed into a modest villa, but here a substantial 'native' settlement component was maintained alongside the enclosed aisled building complex, and it is likely that the ceramic component of that part of the site masked any particular characteristics of the assemblage from the enclosed area.

Vessel classes

Here the data are most problematic because of a range of approaches to quantification of vessel types – in those cases where it is used at all. It is still a matter of concern that even a few recent reports make no attempt to present quantification of vessel types or classes at the most basic level (for assemblages overall, not just the samian ware component).

In Table 26.2 as many as possible of the assemblages listed in Table 26.1 are presented in terms of the breakdown of major vessel classes. As mentioned at the outset, these are categories that apply across complete site assemblages, not just to the samian ware. The intention is to provide general characterisation of samian assemblages, rather than lists of individual forms. Given the huge variety in assemblage sizes comparisons based on the latter are unlikely to be helpful here. The preferred method of quantification is by REs, to provide data which can be set directly alongside not only those for other categories of pottery but also items such as glass vessels (see Cool 2006, 191 for a favourable comment on the quantification of the Claydon Pike samian in this way). Usually the percentages presented in Table 26.2 are of the RE totals shown in Table 26.1, although for Alchester the larger RE total in Table 26.2 includes vessels from unphased contexts. Percentages of vessel count (based on rims), used where RE data are not available, are marked with an asterisk. As in Table 26.1, values considered to be statistically unreliable are given in brackets. The vessel class headings used are mostly self explanatory. The separation of bowls and dishes is based around a cut-off point of the rim diameter:height ratio of 3:1 (see eg Webster 1976, 17–19). This may not be ideal in relation to samian ware, but it seems to work tolerably well and again it is comparability with other elements of the assemblages that is important. In some cases the exact diameter:height ratio cannot be determined and slightly arbitrary decisions may have been made. Generally speaking, however, the cut-off point between bowls and dishes/platters (the latter not distinguished here, see Willis 1998, 112–3) is clear.

The figures (even excluding the 'unreliable' samples) show substantial variation from site to site. The three main classes represented are cups, bowls and dishes. Representation of cups ranges from 10.9% at Northmoor to 44.5% at Whelford Bowmore, that of bowls from 5.5% (again at Northmoor) to 25.2% at Roughground Farm 1990, and that of dishes from 37.7% at Alchester to 87% at Latton Lands. The relative proportions of the three principal vessel class groups, drinking vessels (combining cups and beakers), bowls and dishes, are quite variable, and have been plotted in an attempt to identify possible patterns of use in relation to the different sites concerned (Fig 26.2; note that for the purposes of this diagram the proportions of the three main vessel classes have been recalculated disregarding the figures for minor vessel classes, where present). Relatively few sites, however, have data which can be used for this purpose (13 out of the 40 with samian ware listed in Table 26.1).

Some of the variation may be explained in chronological

terms. The clearest aspect of this may be in relation to the representation of dishes, which is arguably particularly high in those sites with a later emphasis (i.e. where the occupation sequence started in the 2nd century), such as Northmoor and Birdlip, assemblages dominated by examples of Drag form 31, but the significance of Latton, with a slightly broader date range, is less clear, although the small size of the group may be a factor. Generally, however, chronology does not appear to be a marked factor in the definition of differences in assemblage composition, as the cluster of sites towards the right of the plot shows – this includes sites with both early, middle and later Roman emphases. Broadly speaking, three groups of assemblages seem to emerge from the plot. The first of these, already mentioned, is heavily dominated by dishes, which typically comprise 80% or more of samian vessels. Bowls are consistently poorly represented (well under 10%) while the proportion of drinking vessels is more variable. Birdlip, Northmoor and Latton fall clearly into this group.

The second group consists of sites still with a high representation of dishes (typically from 55–70%) and a consistent occurrence of drinking vessels in a range from 20–25%. The representation of bowls is more variable, from just under 10% to about 25%; two sites with the latter value, Rough Ground Farm 1990 and Asthall, have the highest numbers of bowls of any of the assemblages under consideration. It may be that these two assemblages should be considered separately from the others in this group, Cotswold Community and Yarnton, both relatively typical rural settlements, as opposed to the villa and small town. The third group consists of six sites, relatively tightly clustered. These assemblages have moderate quantities of bowls (11.6–18.8%) and reduced amounts of dishes in comparison with the other sites (from 38.8–50.3%). What appears to be their most distinctive characteristic is a relatively high percentage of drinking vessels (usually cups but including some beakers at Asthall, Claydon Pike and particularly at Whelford Bowmore). Together such vessels comprise 33.7–49.1% of these assemblages, with Whelford Bowmore the site with the highest drinking vessel representation of all, and correspondingly the lowest proportion of dishes. The sites in question form a rather disparate group, of varying character and chronological profile. All but one, however, rank on morphological criteria above the lower status rural settlements (represented in Fig 26.2 by sites such as Latton Lands, Northmoor and Yarnton). They include one certain and one possible small town/nucleated settlement assemblage (Alchester and Abingdon respectively), the probable early 'proto-villa' at Appleford, the estate centre/villa complex at Claydon Pike and the site at Neigh Bridge, Somerford Keynes, originating in the late Iron Age/early Roman period but distinguished by a significant reorganisation in the early 2nd century.

The apparent exception is Whelford Bowmore. Here a series of irregular small enclosures was established *de novo* in the early 2nd century. Stone spreads of mid–late 2nd century date probably formed a building platform, and midden deposits were another feature of the site before it

fell out of use, probably by the middle of the 3d century (an unusual chronological range for a rural site in this region, although small numbers of brooches and coins suggest limited activity beyond both ends of this chronological range). The relatively restricted date range of this site might be invoked to explain why samian ware, essentially Central Gaulish material, is common, but this will not do. Birdlip, for example, while occupied for longer, had a very similar floruit to Whelford Bowmore; not only did it have much less samian ware, but the composition of the group was radically different and has been characterised (above) as broadly rural in nature with a very heavy emphasis on dishes. While the composition of the samian assemblage at Whelford Bowmore is comparable with that from some other sites it has, as already indicated, an extreme pattern in the ratio of drinking vessels to other forms, in addition to the fact that the absolute proportion of samian ware in the total assemblage is quite exceptional. In combination these factors suggest that this site had an unusual aspect to its use which is not otherwise indicated in the stratigraphic or artefactual records. The marked emphasis on samian ware drinking vessels provides a pointer, supporting the suggestion that the site, probably associated principally with stock rearing in a relatively marginal (wet) environment, may have been occupied on a seasonal basis, activity which involved periodic feasting (Smith 2007, 294).

None of the sites in the group just discussed was necessarily of exceptionally high status. In relation to Whelford Bowmore it can be suggested that this was a site where status was expressed in terms of commodities like samian ware, rather than in the glass and metal vessels that might have been used in feasting in a higher status context (for example a wealthy villa). Such a suggestion might help to explain the position of Roughground Farm on Fig 26.2 – samian ware drinking vessels may have been less important here because their place at the table was taken at times by vessels in other materials. Nevertheless, the importance of samian ware for drinking vessels is apparent in a number of assemblages across the region, including several of those which are too small to have featured in the analysis based on Fig 26.2. In the Middle Duntisbourne assemblage, for example – a group which contains a number of exotica suggesting a potentially high status (and short-lived) site – all the identifiable samian ware forms were cups. This type of vessel appears exclusively in samian ware at a number of sites, including Middle Duntisbourne, Roughground Farm 1990, Gravelly Guy, Mansfield College, Appleford and Wally Corner. In no other case was such a close correlation between fabric and vessel class observed – all the other classes in which samian ware vessels occurred were extensively represented by other vessels in a variety of fine and coarse wares. Even if samian drinking vessels were consistently supplemented with glass and metal vessels the association of this functional type with samian ware appears significant and noteworthy.

While assemblages with a heavy emphasis on drinking vessels (usually cups) are typically of middling or higher status (in local terms, at least), such an association is

not automatic. The example of the Roughground Farm villa has already been mentioned. The total number of sites in some type categories is really too small to allow confident generalisation, but the situation with regard to nucleated/roadside settlements does seem to be genuinely and particularly variable, with examples in each of the three 'functional' groupings identified. The explanation of this is not certain, but the Birdlip assemblage appears to be purely rural and essentially low status in character, while the assemblages from Asthall and Alchester differ considerably in their ratio of dishes to drinking vessels. If the line of argument used in relation to Roughground Farm (above) is followed here it may be the case that the Asthall assemblage (with the highest proportion of bowls of any of the analysed examples) was of higher status than the Alchester one, the latter deriving from a site at the margin of the small town and having a number of rural characteristics.

Summary and conclusions

Consideration of a significant number of assemblages from a relatively restricted region has enabled some general conclusions to be drawn about the incidence of samian ware here. This has only been possible, however, through use of more or less consistently quantified data, although the absence of systematic quantification of vessel types at some sites is problematic. Samian ware was almost universally available across the region – failing to appear at only two early Roman sites, perhaps reflecting their relative poverty but possibly indicating a deliberate choice on the part of the inhabitants. Elsewhere the occupants of lower status rural settlements acquired modest amounts of samian ware, typically amounting to no more than 1% of the total sherds from the site, particularly in those numerous sites where occupation ceased in the first half of the 2nd century. Even when occupied later, samian ware at lower status rural settlements almost never exceeded 2% of sherds.

Decorated vessels formed a variable proportion of these assemblages, though they were perhaps proportionally less common at lower status sites, and certainly when these were only occupied up to the early 2nd century. Here the lack of data from early phases of the larger nucleated settlements makes comparison difficult.

Considerable variation is evident in the overall proportions of three principal vessel classes, drinking vessels (principally cups), bowls and dishes. Chronological factors seem to have been less significant here, but while status-related factors can be invoked in explaining this variation there will have been settlement types in which samian ware may not have been regarded as a 'top of range' commodity and it was therefore less important than other material types. This may have been the case particularly in relation to drinking vessels. Nevertheless, the occurrence of high proportions of samian ware cups does seem to correlate with sites of a particular character, not usually including those of the lowest perceived status.

All of these conclusions are broadly consistent with

patterns of samian ware use suggested by wider studies such as those of Willis (1998; 2005). It is hoped, however, that examination of a relatively restricted region in some detail will not only allow future assemblages to be measured more precisely against established bodies of data but will also give support to generalised assertions about settlement character based on their pottery assemblages. In addition to these broad conclusions, this survey has thrown up one anomalous group, from Whelford Bowmore, which stands out from the other assemblages in terms of the high percentage of samian ware which it contains. The potential significance of this characteristic was identified at the time of publication (Brown 2007b, 286; Smith 2007, 294) but its importance is now underlined by more extensive comparative study. While its interpretation cannot be absolutely certain, the possibility that it reflects an unusual emphasis on dining-related activity at this otherwise unremarkable site is an indicator of the potential of detailed, quantified finds analysis to shed unexpected light on site functions.

Acknowledgements

I am very grateful to the organizers of the Festschrift for inviting me to contribute to this volume. Thanks are also owed to all those who have collected data upon which I have drawn, and particularly to my colleagues Dan Stansbie and especially Edward Biddulph for making available unpublished data from current Oxford Archaeology projects and discussing some of the points made here. Responsibility for errors and omissions remains mine alone.

Bibliography

Barber, A, McSloy, E, and Holbrook, N, 2004. Excavations in 2000 on the line of the Thames Water North-West Oxfordshire Supply Improvement pipeline, in Hands and Cotswold Archaeology 2004, 260–340

Biddulph, E, 2004. The Iron Age and Roman pottery, in R Heawood, Iron Age and Roman activity at Watchfield Triangle, *Oxoniensia* 69, 298–309

Biddulph, E, 2005. Roman pottery, in P Bradley, B Charles, A Hardy and D Poore, Prehistoric and Roman activity and a Civil War ditch: excavations at the Chemistry Research Laboratory, 2–4 South Parks Road, Oxford, *Oxoniensia* 70, 155–67

Biddulph, E, 2007. Pottery, in P Booth and D Stansbie, *A Roman rural landscape at Kempsford Quarry, Gloucestershire*, Oxford Archaeol Occas Paper 15, 25–31, Oxford

Bird, J, Dickinson, B, and Hartley, B, 1986. Samian and samian stamps, in Miles *et al* 1986, fiche 7:B9–B13

Booth, P, 1995. Roman pottery, in A Boyle, A Dodd, D Miles and A Mudd, *Two Oxfordshire Anglo-Saxon cemeteries: Berinsfield and Didcot*, Oxford Archaeol Unit Thames Valley Landscapes Monogr 8, 16–26

Booth, P, 1996. Pottery and other ceramic finds, in C Mould, An archaeological excavation at Oxford Road, Bicester, Oxfordshire, *Oxoniensia* 61, 75–89

Booth, P, 2000a. Roman pottery, in P Booth and C Hayden, A Roman settlement at Mansfield College, Oxford, *Oxoniensia* 65, 307–17

Booth, P, 2000b. The Iron Age and Roman pottery, in R Bourn,

Manorhouse Farm, Hatford, Oxfordshire, in *Three Iron Age and Romano-British Rural Settlements on English Gravels* (ed R J Zeepvat), Brit Archaeol Rep Brit Ser 312, 25–45, Oxford

Booth, P, 2003. Roman pottery, in A Barclay, G Lambrick, J Moore and M Robinson, *Lines in the landscape. Cursus monuments in the Upper Thames Valley: excavations at the Drayton and Lechlade cursuses*, Oxford Archaeol, Thames Valley Landscapes Monogr 15, 149–53, Oxford

Booth, P, 2004a. Quantifying status: some pottery data from the Upper Thames Valley, *J Roman Pottery Stud* 11, 39–52

Booth, P, 2004b. The pottery, in P Booth and A Simmonds, An Iron Age and early Romano-British site at Hatford Quarry, Sandy Lane, Hatford, *Oxoniensia* 69, 335–44

Booth, P, 2007. Pottery, in A M Cromarty, M R Roberts and A Smith, Archaeological investigations at Stubbs Farm, Kempsford, Gloucestershire, 1991–1995, in Miles *et al* 2007, 301–4

Booth, P, 2009. Late Iron Age and Roman pottery, in Booth and Simmonds 64–85

Booth, P, forthcoming. Iron Age and Roman pottery, in G Hey and J Timby, *Yarnton: Iron Age and Romano-British settlement and landscape: results of excavations 1990–8*, Oxford Archaeol Thames Valley Landscapes Monogr, Oxford

Booth, P, Boyle, A, and Keevill, G D, 1993. A Romano-British kiln site at Lower Farm, Nuneham Courtenay, and other sites on the Didcot to Oxford and Wootton to Abingdon water mains, Oxfordshire, *Oxoniensia* 58, 87–217

Booth, P, and Simmonds, A, 2009. *Appleford's first farmers; archaeological work at Appleford Sidings 1993–2000*, Oxford Archaeol Occas Paper 17, Oxford

Brown, K, 2003. Roman pottery, in D Miles, S Palmer, G Lock, C Gosden and A M Cromarty, *Uffington White Horse and its landscape: investigations at White Horse Hill, Uffington, 1989–95, and Tower Hill, Ashbury, 1993–4*, Oxford Archaeol Thames Valley Landscapes Monogr 18, 175–8, Oxford

Brown, K, 2007a. Pottery, in A Smith, excavation at Neigh Bridge, Somerford Keynes, in Miles *et al* 2007, 243–7

Brown, K, 2007b. Pottery, in A Marshall, S Palmer and A Smith, Archaeological investigations at Whelford Bowmore, Gloucestershire, 1983, 1985 and 1988, in Miles *et al* 2007, 284–8

Brown, L, and Leggatt, E, 1984. The Roman pottery, in S Rahtz and T Rowley, *Middleton Stoney, excavation and survey in a North Oxfordshire parish 1970–1982*, Oxford Univ Dept Continuing Education, 76–90, Oxford

Bryan, E, and Brown, K, 2004. Roman pottery (ceramic phase 3), in J Cook, E B A Guttman and A Mudd, Excavations of an Iron Age site at Coxwell Road, Faringdon, *Oxoniensia* 69, 229–39

Cool, H E M, 2006. *Eating and drinking in Roman Britain*, Cambridge

Dickinson, B, 1999. Samian, in Timby 1999b, 340–2

Dickinson, B, 2001. Samian ware, in P Booth, J Evans and J Hiller, *Excavations in the extramural settlement of Roman Alchester, Oxfordshire, 1991*, Oxford Archaeol Monogr 1, 277–85, Oxford

Green, S, and Booth, P, 1993. The Roman pottery, in T G Allen, T C Darvill, L S Green and M U Jones, *Roughground Farm, Lechlade, Glos.: a prehistoric and Roman landscape*, Oxford Univ Comm Archaeol Thames Valley Landscapes: The Cotswold Water Park 1, 113–42, Oxford

Green, S, Booth, P, and Allen, T, 2004. Late Iron Age and Roman pottery, in G Lambrick and T Allen, *Gravelly Guy,*

Stanton Harcourt: the development of a prehistoric and Romano-British community*, Oxford Archaeol Thames Valley Landscapes Monogr 21, 303–34, Oxford

Hands, A R, and Cotswold Archaeology, 2004. *The Romano-British roadside settlement at Wilcote, Oxfordshire III. Excavations 1997–2000*, Brit Archaeol Rep Brit Ser 370, Oxford.

Henig, M, and Booth, P, 2000. *Roman Oxfordshire*, Alan Sutton, Stroud

Miles, D, Hofdahl, D, and Moore, J, 1986. The pottery, in *Archaeology at Barton Court Farm, Abingdon, Oxon: an investigation of late Neolithic, Iron Age, Romano-British and Saxon settlements* (ed D Miles), Counc Brit Archaeol Res Rep 50, fiche 7:A1-7:G6, London

Miles, D, Palmer, S, Smith, A, and Jones, G P, 2007. *Iron Age and Roman settlement in the Upper Thames Valley: Excavations at Claydon Pike and other sites within the Cotswold Water Park*, Oxford Archaeol Thames Valley Landscapes Monogr 26, Oxford

Mills, J M, 1997. Samian ware, in P M Booth, *Asthall, Oxfordshire, excavations in a Roman 'small town', 1992*, Oxford Archaeol Unit Thames Valley Landscapes Monogr 9, 106–13, Oxford

Mills, J M, 2004. The samian, in Barber *et al* 2004, 299–300, 311–3

Mudd, A, Williams, R J, and Lupton, A, 1999. *Excavations alongside Roman Ermin Street, Gloucestershire and Wiltshire: The archaeology of the A419/A417 Swindon to Gloucester Road Scheme*, Vols 1 and 2, Oxford

Raven, S, 1990. The Romano-British pottery, in T G Allen, *An Iron Age and Romano-British enclosed settlement at Watkins Farm, Northmoor, Oxon*, Oxford Univ Comm Archaeol Thames Valley Landscapes, The Windrush Valley, Vol 1, 46–51, Oxford

Simpson, G, 1984. Samian, in S Rahtz and T Rowley, *Middleton Stoney, excavation and survey in a North Oxfordshire parish 1970–1982*, Oxford Univ Dept Continuing Education, 91, Oxford

Smith, A, 2007. Discussion, in A Marshall, S Palmer and A Smith, Archaeological investigations at Whelford Bowmore, Gloucestershire, 1983, 1985 and 1988, in Miles *et al* 2007, 293–4

Stansbie, D, 2009. The Late Iron Age and Roman Pottery, in K Powell, G Laws and L Brown, A Late Neolithic/Early Bronze Age enclosure and Iron Age and Romano-British settlement at Latton Lands, Wiltshire, *Wiltshire Archaeol Nat Hist Mag* 102, 69–75

Symonds, R P, and Haynes, I, 2007. Developing methodology for inter-provincial comparison of pottery assemblages, in *Roman finds: context and theory* (eds R Hingley and S Willis), Oxbow, 67–76, Oxford

Timby, J R, 1995. Pottery, in G Hey, Iron Age and Roman settlement at Old Shifford Farm, Standlake, *Oxoniensia* 60, 124–36

Timby, J, 1996. The pottery, in N Holbrook and A Thomas, The Roman and early Anglo-Saxon settlement at Wantage, Oxfordshire, Excavations at Mill Street, 1993–4, *Oxoniensia* 61, 131–47

Timby, J, 1999a. Late prehistoric and Roman pottery, in Mudd *et al* 1999, 320–39

Timby, J, 1999b. Roman pottery from Birdlip Quarry, Cowley, in Mudd *et al* 1999, 339–65

Timby, J, 2004. The pottery, in D Jennings, J Muir, S Palmer and A Smith, *Thornhill Farm, Fairford, Gloucestershire.*

An Iron Age and Roman pastoral site in the Upper Thames Valley, Oxford Archaeol Thames Valley Landscapes Monogr 23, 90–107, Oxford

Timby, J, 2005. Pottery, in J Pine, Early Roman occupation at Jubilee Villa, 21 The Moorlands, Benson, Oxfordshire, *Oxoniensia* 70, 122–5

Timby, J, and Harrison, E, 2004. Pottery, in J Pine and S Preston, *Iron Age and Roman settlement and landscape at Totterdown Lane, Horcott near Fairford, Gloucestershire*, Thames Valley Archaeol Services Monogr 6, 55–67, Reading

Webster, G (ed), 1976. *Romano-British coarse pottery: a student's guide*, Counc Brit Archaeol Res Rep 6, London

Webster, P V, 2007. Samian ware, in S Green and P Booth, Claydon Pike Roman pottery, in Miles et al 2007, CD Section 3.2

Willis, S, 1998. Samian pottery in Britain: exploring its distribution and archaeological potential, *Archaeol J* 155, 82–133.

Willis, S, 2005. *Samian pottery, a resource for the study of Roman Britain and beyond: the results of the English Heritage funded samian project. An e-monograph*, Internet Archaeol 17 (http://intarch.ac.uk/journal/issue17/willis_toc.html)

27 Alphen aan den Rijn-Albaniana and the dating of the Roman forts in the Rhine delta

Marinus Polak, Ryan Niemeijer and Ester van der Linden

When work on the Leeds Index of Potters' Stamps had only just started, Brenda Dickinson visited the major archaeological collections in the Netherlands to rub thousands of sigillata stamps from rich and well-known sites such as Arentsburg, Nijmegen and Vechten. Many more Dutch stamps were added in later years, received by post or through personal visits from fellow researchers. The first author had the privilege to spend two weeks in Leeds around 1990, to explore the index for his PhD thesis on the South Gaulish potters' stamps from Vechten. His work profited immensely from the data gathered there, from Brenda's phenomenal memory and, later, from her scrupulous corrections of the jargon in the English version of his work (Polak 2000). It is a great pleasure to be able to honour Brenda with some reflections on the foundation of the Roman forts in the western Netherlands, based on her work and on new evidence. The first author concentrated on the stamped vessels, the second and third on the decorated ware.

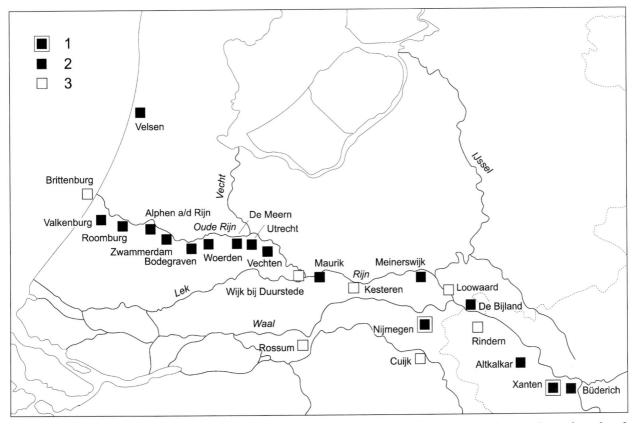

Fig 27.1: Roman fortifications in the Lower Rhine area during the first century AD. 1: legionary fortress. 2: auxiliary fort. 3: presumed auxiliary fort

The Roman fort of Alphen aan den Rijn (*Albaniana*)

In 2001–2002 most of the remaining features of the Roman auxiliary fort of *Albaniana*, today Alphen aan den Rijn in the western Netherlands, were excavated by Radboud University Nijmegen (Polak *et al* 2004). *Albaniana* is part of a chain of small forts on the southern levee of the Rhine between Vechten (*Fectio*) and Valkenburg (*Praetorium Agrippinae*) (Fig 27.1). Whereas Vechten is assumed to have been built in the first decade of the 1st century AD, and the foundation of Valkenburg is assigned to the reign of Caligula, the intermediate forts were until recently considered as a sequel to Cn. Domitius Corbulo's withdrawal from German territory in AD 47 at the order of the emperor Claudius.

The site of the auxiliary fort at Alphen was considerably damaged by clay extraction and building activities from the 17th century onwards. Most of the remains of the Flavian and later building phases were severely eroded, but part of the pre-Flavian fort was relatively well preserved (Fig 27.2). Only the latter building phase will be discussed here.

The first fort was established at a distance of only a few metres from the Roman-period course of the Rhine. It was probably slightly less than 1 ha in area and shaped as a parallelogram. As usual in the Rhine delta, the fort had no *retentura*. The *porta praetoria* was situated in one of the long sides and orientated towards the Rhine, which has a S-N course here. Of the internal buildings three barracks were unearthed in the right *praetentura*, and what is presumed to be a *fabrica* to the right of the supposed *principia* and a *horreum* to its left. Three more barracks may be expected in the left *praetentura*, while the commander's quarters may have been situated in the left or right half of the *latera praetorii*.

The defensive works consisted of an earth-and-timber wall strengthened with corner towers; the long sides may have had interval towers, but they have not been confirmed by excavation. Of the gates only the *porta principalis dextra* could be investigated; it is uncertain whether the fort had a *porta decumana* in this phase. The river bank in front of the fort was lined with timber revetments, which were repeatedly eroded by the river and rebuilt.

The excavations have produced over 700 Roman coins. No less than 324 of them were issued by Caligula, the majority in AD 37–38. As two thirds of them lacked the countermarks typical of Caligulan coins circulating after his death, Alphen might be considered as a Caligulan fort (*cf* Kemmers 2004). This conclusion was later confirmed by the dendrochronological analysis of no less than 129 timber samples. The timbers used for the wall, the southern gate and one of the corner towers yielded felling dates of autumn/winter AD 40/41 and spring/summer AD 41, while

0 5 m

Fig 27.2: Remains of the porta principalis dextra of the successive Roman auxiliary forts at Alphen aan den Rijn. The pre-Flavian gate (period 1a) consists of two towers, each resting on six heavy timber posts. On either side of the gate the horizontal timbers of the foundation of the earthen wall were still present. The closely spaced 'dots' cutting the timber gate and the ditches in front of it represent the foundation posts of the stone gate towers and wall (period 3). Not to scale

those used for the barracks and the *via principalis* were felled in AD 42. It seems likely that construction started late in Caligula's reign and was continued after his death. The first fort (period 1a) was twice repaired or rebuilt before it was destroyed during the Batavian revolt of AD 69/70 (periods 1b–c).

From the later building phases of Alphen little more remains than the ditches and the timber posts on which the stone defensive wall and the gates were founded. Period 2 is dated to AD 70–160, period 3 to AD 160–270/5.

The terra sigillata from Alphen aan den Rijn (Albaniana)

The pottery recovered during the excavation was as abundant as were the coins. It was studied by Ester van der Linden and Ryan Niemeijer, and the main results were published in 2004 (Polak *et al* 2004). Amongst the 27,008 sherds of Roman pottery were 2902 fragments of terra sigillata. Of those, 163 were stamped internally and 587 showed remains of a moulded decoration. Vessel types, stamps and most of the decorated ware from South Gaul will be presented and discussed here.

Types

The range of types of the South Gaulish ware is shown in Table 27.1. Rouletted dishes are hardly represented, with a mere 2% of the 2121 South Gaulish sherds. Dishes and cups are available in comparable quantities, with 37 and 32% respectively. Decorated vessels are relatively common, with 20%.

For a Caligulan foundation, early types are rare. Drag 17 and Ritt 5 are absent, which is perhaps not astonishing for a site of this date (*cf* Polak 2000, 74–137 for a discussion of the evolution of stamped South Gaulish forms). But the slightly later dishes Ritt 1 and Drag 16 and cups Ritt 8 and 9, which were produced throughout the pre-Flavian period, are represented by only a few fragments each.

Another indication of the chronological distribution of the South Gaulish ware may be gained from the ratios between Drag 15/17 and 18 and between Drag 24/25 and 27g. Drag 15/17 and 24/25 disappeared or became much rarer in the Flavian period, whereas the other two were produced until the distant markets were taken over by Central and East Gaulish potteries (Polak 2000, 71–2). At Alphen the ratios between the types mentioned were almost identical: 27:73% for the dishes and 26:74% for the cups. Averages in this range were reached by AD 60–65 at Vechten (Polak 2000, figs 6.8 and 6.11).

In 1986 Pferdehirt argued that the ratio between Drag 29 and 37 can be used to assess the foundation date of a military settlement (Pferdehirt 1986). Although her views were not unchallenged (Eschbaumer and Faber 1988, Haalebos *et al* 1991), it is interesting to note that the proportion of Drag 29 at Alphen, with its ratio between Drag 29 and Drag 37 of 60:40%, is only slightly lower than at the Caligulan fort of Valkenburg and well above that at the presumed Claudian forts of Utrecht, Woerden and Zwammerdam (Pferdehirt 1986, 245, table 3: 62.4, 46.9, 52.1 and 48.0 % of form Drag 29 respectively).

Stamps

The 121 South Gaulish potters' stamps excavated in 2001–2002 are listed in Appendix 27.2. A further 42 stamps are of Central and East Gaulish provenance (Van der Linden 2004a, 135); as usual on the Lower Rhine, most of them are from Chémery-Faulquemont and La Madeleine, the main suppliers of this area in the first half of the 2nd century. The chronological distribution of the stamps is illustrated in Fig 27.3. A stamp dated to *c* AD 50–70 was counted as 0.25 in each of the five-year periods covered by this date range, etc. To a certain degree the histogram is in accordance with the information derived from the distribution of the types: the maximum is reached under Nero. However, pre-Flavian stamps are perhaps more numerous than the types distribution suggests.

15/17R	10		Ritt. 8	5		
18R	21		Ritt. 9	4		
unidentified	19		24/25	152		
plates	*50*	2.4%	27	433		
			33	15		
Ritt. 1	17		35	6		
16	2		unidentified	69		
15/17	148		*cups*	*684*	32.2%	
18	395					
36	21					
42	4		29	200		
Curle 15	1		30	74		
unidentified	186		37	136		
dishes	*774*	36.5%	Déch. 67	21		
			decorated	*431*	20.3%	
Ritt. 12	52					
Curle 11	7		Ritt. 13	1		
unidentified	29		unidentified	93		
bowls	*88*	4.1%	*other*	*94*	4.4%	

Table 27.1: Overview of the types of South Gaulish terra sigillata from Alphen aan den Rijn, with the numbers of fragments (totals of rims, walls and bases). The quantities are summed up per category, with their relative frequencies expressed as percentages of the total assemblage

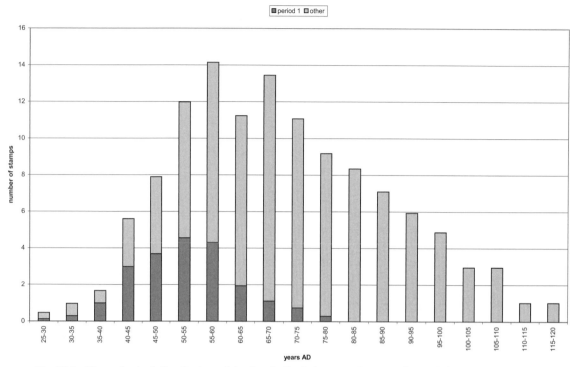

Fig 27.3: Chronological distribution of the South Gaulish potters' stamps from Alphen aan den Rijn

Markedly early stamps are rare, however. Only three stamps from Maccarus (S35–37), two from Salvetus (S66–67) and one from Scottius (S71) have initial dates before AD 40. The latter three have final dates of AD 55, the former of AD 60. Other productive early potters such as Acutus, Bilicatus, Cantus and Vapuso are absent, although a complete vessel from Vapuso was found in 1985, below the floor of the centurion's quarters of one of the barracks (Bogaers and Haalebos 1987, 47).

The 21 stamps recovered from period 1 contexts are distributed normally over the pre-Flavian period, with a peak in AD 50–55. Only four of these have dates extending into the Flavian era (S11, 24, 98 and 101). One wonders whether this means that the camp was evacuated in a controlled way during the Batavian revolt – with most of the sigillata taken elsewhere by the soldiers – or just illustrates our reluctance to extend the dates of stamps known from pre-70 contexts. The former possibility may not be ruled out, since less than 2% of the pottery from Alphen shows traces of burning, including no more than three stamped sigillata vessels (S2, 40 and 94).

The diagram also illustrates that a considerable amount of pottery dateable in period 1 was dug up in later occupation phases. Of the sixteen stamps from period 2 contexts (AD 70–160), eight are pre-Flavian and only four entirely Flavian or later. By far the most stamps dateable in period 2 were found in rubbish layers in the Rhine. This underlines the severe erosion of the remains of the later forts.

A final peculiarity that requires explanation is the slight 'dip' in AD 60–65. This results from a relatively large number of stamps dated until AD 60 (17 examples)

and from AD 65 onwards (15 examples). Since almost all the stamp dates were adopted from the catalogue of the Vechten stamps, a similar dip might be expected for the stamps from that site. At Vechten, however, there is a steady increase in numbers, until a peak is reached in AD 65–70 (Polak 2000, 57, fig 5.2). The temporary scarcity at Alphen might therefore indicate a local event such as a reduction of the garrison.

Decorated vessels

During the 2001–2002 excavations 587 fragments of decorated samian were found. Over 73% (431 fragments) are of South Gaulish provenance; the remaining 156 fragments are Central or East Gaulish. Although the latter were not studied in detail, it is clear that the majority were made in East Gaulish potteries, especially La Madeleine, and can be dated in the first half of the 2nd century (Van der Linden 2004a, 134). The catalogue of the South Gaulish decorated ware (Appendix 27.1) comprises 143 fragments from 90 vessels with sufficient detail to make some comment.

The chronological distribution of the vessels studied is illustrated in Fig 27.4. The numbers per five year period were calculated in the same way as for the stamps. The maximum is reached in the early-Flavian period, more than a decade later than for the types and the stamps. This difference is difficult to explain. Perhaps Alphen received much less decorated than plain ware in period 1. The discrepancy is not unique for Alphen, however. The same has been attested at Woerden (see below), Colchester, Exeter and Wroxeter

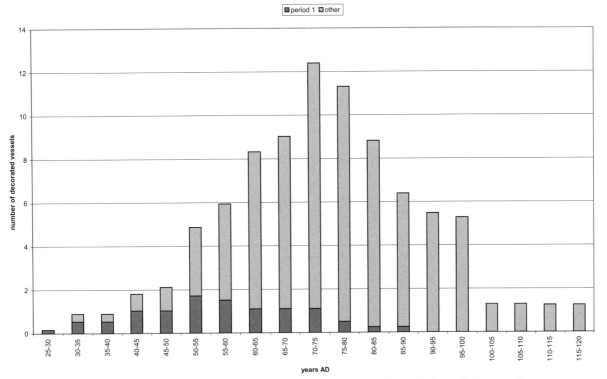

Fig 27.4: Chronological distribution of the South Gaulish decorated vessels from Alphen aan den Rijn

(pers comm Geoffrey Dannell). At present it cannot be excluded that such differences are (partly) due to different dating methods, with attributions on stylistic grounds still playing a part in the dating of decorated vessels, although dated sites are gaining ground in this field.

As with the stamps, markedly early decorated vessels are quite rare. Five bowls, three from period 1, one from period 2 or later and one from the rubbish layers in the Rhine bed, have initial dates before AD 40 (D1–5). Only one of these has a rouletted central cordon (D3). In 1985 another bowl with rouletted cordon was found, in the centurion's quarters of barrack E from period 1 (Bogaers and Haalebos 1987, 49). Only one of the five early bowls has a final date extending into the Flavian period, but that is based on a parallel published by Knorr, which has probably been dated too late (cf the comments on D4).

Fig 27.4 also shows that the eleven decorated bowls recovered from period 1 contexts are distributed normally over the pre-Flavian period, with a peak in AD 50–55. This corresponds with the evidence of the stamps. Four of these have dates extending into the Flavian era; one is even entirely Flavian. However, the attribution of this fragment to period 1 is not certain (D20). Only one fragment, from the destruction level of the barracks, was burnt (D6). It was found together with a hoard of seven coins struck in AD 65 (Kemmers 2004, 37–38). Much of the decorated ware dateable in period 1 was found in the rubbish layers in the Roman Rhine. Of the bowls recovered from the castellum, almost half were found in period 1 contexts.

The slight dip around AD 60–65 which is visible in the distribution of the stamps cannot be found in the decorated ware. The fact that the latter reaches its peak more than a decade later than the stamps possibly plays a part in this. If the difference in dating is not caused by our method of dating – as mentioned above – perhaps the import of decorated ware had only just started to increase when the plain ware reached its first maximum just before 60–65.

Other auxiliary forts in the Rhine delta

As noted above, the establishment of most forts in the Rhine delta was until recently dated in or after AD 47. It may be interesting to compare the evidence of the other forts with that of Alphen, to judge whether this still holds for all of them. The relevant data will be briefly discussed below.

At **Utrecht**-*Traiectum* there is no recent information available on the excavated terra sigillata. None of the 73 published stamps (Ozinga *et al* 1989, 139–42) is from the early potters previously mentioned. Most pre-Flavian stamps are dateable from AD 50 onwards. The earliest decorated vessels have been dated as late Claudian (Ozinga *et al* 1989, 137 with further references in note 10).

For the fort at **De Meern** the situation is even less favourable. Slightly over 20 South Gaulish stamps and 30 decorated vessels have been published (Jongkees and Isings 1963; Kalee and Isings 1980). None of them hints at a construction date before AD 47, but recent studies of coins from the fort area and its immediate surroundings show a strong similarity to the coin assemblages of Alphen and Valkenburg (Kemmers 2006, esp fig 2; additional unpublished information kindly provided by Fleur Kemmers).

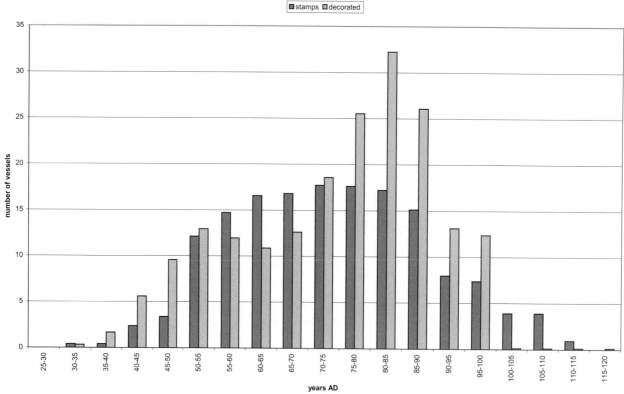

Fig 27.5: Chronological distribution of the South Gaulish potters' stamps and decorated vessels from excavations at Woerden in 1975–1984, mainly in the eastern military vicus

The terra sigillata from the excavations at **Woerden-Laurium** in 1975–1984 has not been published. Unfinished studies left by Jan Kees Haalebos include lists of 297 terra sigillata stamps and 200 decorated fragments from La Graufesenque. Most of them are from the military vicus to the east of the successive forts, which were located only in 1999. The dating of the stamps and the South Gaulish decorated ware was available in Haalebos's manuscripts, that of the stamps based on information provided by Brian Hartley and Brenda Dickinson.

There is a striking discrepancy between the dates of the stamps and those of the decorated vessels (Fig 27.5). Although in dating the decorated ware Haalebos seems to have had a strong preference for the date range of AD 80–100 (assigned to 49 vessels) and a reluctance to date South Gaulish vessels later than AD 100 for the decorated ware (just one vessel), it may not be simply a matter of personal habit. Geoffrey Dannell has attested comparable anomalies at several British sites (pers comm).

Only two stamped vessels have initial dates before AD 40, both with the same stamp of Daribitus. One of them is a Drag 29, and its decoration is dated to AD 40–55 by Haalebos. The early potters Bilicatus and Maccarus are represented, but with stamps dated from AD 40 onwards. Seven decorated vessels were given dates starting with AD 30 or 35, but from the description of their decoration none of them seems decisively early. Only one Drag 29 has a rouletted central moulding.

The results of the excavations carried out at Woerden

since 2002 have only just become available (Van der Linden 2008). Whereas the earlier research mainly concerned the vicus to the east of the forts, the recent work concentrated on the south-western perimeter of the forts and the area immediately outside it. A type distribution is only available for a small sample of 276 sherds. The absence of Drag 17 and Ritt 5 is not unexpected, while that of Ritt 1 and Drag 16 may be due to small numbers rather than chronologically significant. Ritt 8 and 9 are rare, with a mere six fragments in all. The chronological distribution of the 133 stamps (Fig 27.6) shows an interesting difference between fort and vicus. The material from the fort starts some 15 years earlier and reaches its peak a decade earlier. There is only one stamp with an initial date before AD 40, of Maccarus.

In the range of South Gaulish types at **Zwammerdam-Nigrum Pullum** (Haalebos 1977, appendix II) Drag 17 and Ritt 5 are missing. The dishes Ritt 1 and Drag 16 and the cups Ritt 8 and 9 are even slightly rarer than at Alphen. The chronological distribution of the 177 South Gaulish potters' stamps (Haalebos 1977, 92–93 with fig 12) shows a peak in AD 60–65, somewhat later than at Alphen (Fig 27.7). Haalebos pointed out the almost complete absence of stamps from early potters. Only Maccarus is represented, with no more than a single stamp. The number of stamps is large enough not to consider this rarity as a statistical coincidence.

At **Bodegraven** the gate of a small fort was found in 1995; it has a dendrochronological construction date of AD 61. The recent pottery finds have not been published,

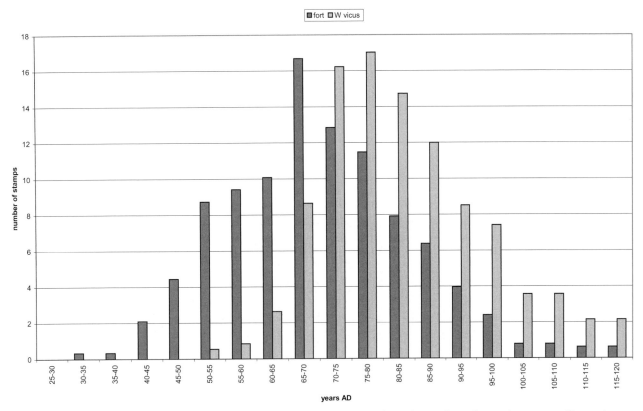

Fig 27.6: Chronological distribution of the South Gaulish potters' stamps from the auxiliary fort and western military vicus at Woerden (excavations 2002–2004)

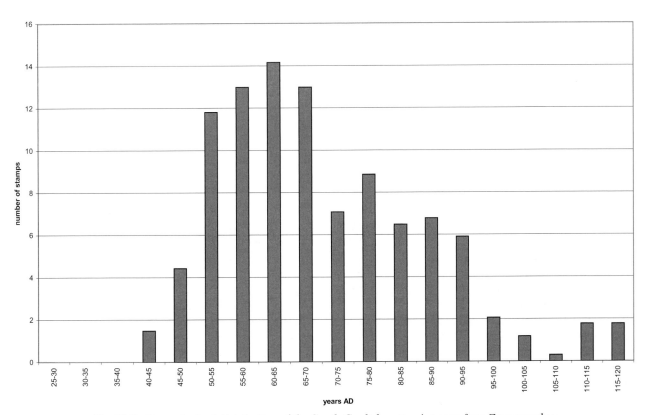

Fig 27.7: Chronological distribution of the South Gaulish potters' stamps from Zwammerdam

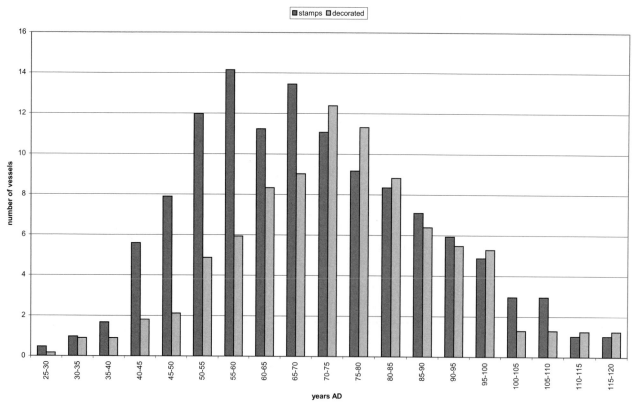

Fig 27.8: Chronological distribution of the South Gaulish potters' stamps and decorated vessels from Alphen aan den Rijn

but a small series of decorated ware studied by Haalebos indicates that the troops may have arrived a decade before (Haalebos 1980).

Although the location of the Roman auxiliary fort *Matilo* at Leiden-**Roomburg** is well known, there have been hardly any excavations up to date. Finds from the adjacent military vicus have produced only a little pre-Flavian pottery; hardly anything has been published. The best argument for a building date in the 40s of the 1st century AD is the situation of the fort at the joining of the Rhine and the channel to the Meuse estuary which Corbulo dug in AD 47 according to Tacitus (*Annals* 11.20).

At **Valkenburg** large quantities of sigillata have been unearthed, but only a very modest part of it has been published (Glasbergen 1940–1944a and b, 1948–1953, 1967). Among the over 400 published stamps there are twenty from early potters: Bilicatus (2), Maccarus (5), Salvetus (5), Scottius (2) and Vapuso (6). A few others may also have initial dates before AD 40, such as the same stamp of Daribitus as recorded at Woerden. The earliest decorated vessels which have been published present only few typical Tiberian or early-Claudian characteristics. One of the exceptions is a Drag 29 with a large straight wreath in the lower zone (Glasbergen 1940–1944a, fig 55, 7 = Dannell 2005, fig 4, 14). At least five vessels Drag 29 have rouletted central mouldings (Glasbergen 1940–1944a, fig 55, 1–4 and 8; *cf* Dannell 2005, fig 4, 16–17).

Velsen has produced the earliest terra sigillata to the west of Vechten. The previously separated forts 1 and 2

are considered as one complex nowadays. On the basis of the coin assemblage and of the Italian sigillata unearthed, Velsen is likely to have been built for the campaigns of Germanicus in AD 14–16. A horizontal timber from one of the gates of Velsen 2 has produced a felling date of AD 42/43, and provides a *terminus post quem* for the evacuation of the fort. The sigillata was listed extensively – without illustrating stamps and decorations – by Bosman (1997, 150–183), but it is difficult to obtain a numerical overview. As may be expected, early potters are well represented: Acutus (17), Bilicatus (6), Cantus (9), Maccarus (7), Salvetus (7), Scottius (27) and Vapuso (21) alone are responsible for almost a third of the stamped South Gaulish vessels (*ibid*, 182–3).

As far as the types assemblage is concerned (calculations based on Bosman 1997, 174), the ratio between the dishes Drag 15/17 and 18 is exactly the opposite of Alphen, with 73:27%. For the cups, however, the Velsen figures contrast less sharply with those from Alphen, with a ratio of 38:62% for Drag 24/25 and 27. Although other early dish types (Haltern 1, Ritt 1, Drag 16 and 17) are less numerous than other early cups (Ritt 5, 8 and 9) at Velsen, including their numbers has only a limited effect. The ratio of all other dishes versus Drag 18 is 80:20%; that of all early cups to Drag 27 is 57:43%. A better representation of Drag 27 in the first half of the 1st century has also been observed at Vechten (Polak 2000, figs 6.8 and 6.11 show values around 10% for Drag 18 and 30% for Drag 27 by AD 30).

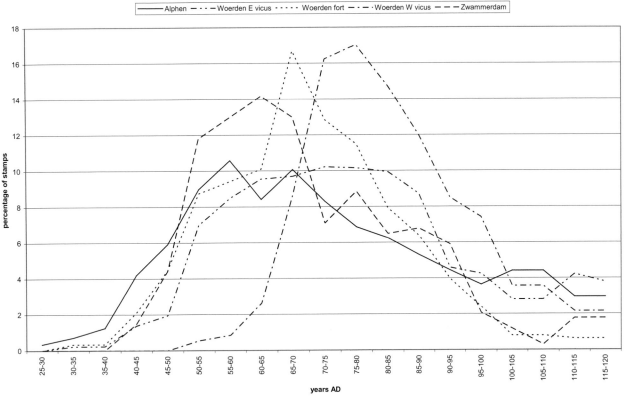

Fig 27.9: Chronological distribution of the South Gaulish potters' stamps from various military contexts in the Western Netherlands. The quantities are expressed as percentages

Conclusions

The analysis of the South Gaulish terra sigillata from the Roman fort at Alphen aan den Rijn has demonstrated that there are surprisingly few vessels which corroborate its building date of AD 40/41. If this scarcity is not due to systematic dating errors, perhaps resulting from the near absence of firmly dated Tiberian contexts, it might mean that the provisioning of terra sigillata was problematic at first. Various possible causes present themselves. If the camp was set up as a very short term measure, more or less luxury goods may only have been provided when it was turned into a longer term base. Another possibility is that its position far downstream from the nearest legionary base at Xanten was not favourable from a logistical viewpoint. A more provoking hypothesis is that the establishment of the fort was directly connected with the invasion of Britain, and that the provisioning of the forces overseas gained priority over that of the continental armies.

Quite unexpectedly, the chronological distributions of the decorated vessels and the potters' stamps differed considerably, with an earlier start and maximum for the stamps (Fig 27.8). Again this may simply result from our inadequate dating methods, for it is not unique for Alphen. Otherwise, the influx of decorated and stamped vessels may have varied, for as yet unknown reasons.

A comparison of the pattern of the South Gaulish potters' stamps from Alphen with those from nearby forts (Fig 27.9) shows a slightly larger portion of early stamps here. On this evidence the forts at Woerden and Zwammerdam may

have been built a few years later. Whereas at Alphen the erosion of the Flavian and later levels might explain the drop in the number of stamps from AD 70 onwards, this proves once more to be a general phenomenon, as G Marsh had already signalled in 1981. A satisfactory explanation remains outstanding.

At Woerden the area to the west of the forts (vicus excavations from 2002 onwards) was probably not occupied before the reign of Nero at the earliest, unlike the eastern vicus (1975–1984 excavations). It is difficult to ascertain whether this late start is entirely responsible for the relatively large number of Flavian stamps – being expressed as percentages an early low inevitably produces a late high – or whether it mirrors considerable differences in development within the Roman settlement as a whole.

This short survey reveals that there is still a lot of work to be done. Evidence from relatively novel techniques such as dendrochronology offer new chronological insights which force us to reconsider our datings and dating methods. Although tens of thousands of stamped and decorated vessels have been published already, the extensive presentation of terra sigillata, especially from dated contexts, is still highly desirable. The forthcoming Leeds Index of Potters' Stamps will be an enormous stimulus to new analyses, and Brenda Dickinson deserves our full support. The authors of the present paper humbly apologize for any delay that the presentation of this new material from Alphen aan den Rijn may cause to the appearance of the Index.

Bibliography

Bogaers, J E, and Haalebos, J K, 1987. Opgravingen te Alphen aan den Rijn in 1985 en 1986, *Westerheem* 36, 40–52

Bosman, A V A J, 1997. *Het culturele vondstmateriaal van de vroeg-Romeinse versterking Velsen 1*, Amsterdam

Dannell, G B, 2005. A study in scarlet: samian pottery and the Claudian invasion, in *An archaeological miscellany: papers in honour of K F Hartley* (eds G B Dannell and P V Irving), *J Roman Pottery Stud* 12, 64–82, Oxford

Dannell, G B, Dickinson, B M, and Vernhet, A, 1998. Ovolos on Dragendorff form 30 from the collections of Frédéric Hermet and Dieudonné Rey, in *Form and fabric: studies in Rome's material past in honour of B.R. Hartley* (ed J Bird), Oxbow Monogr 80, 69–109, Oxford

Dannell, G B, Dickinson, B M, Hartley, B R, Mees, A W, Polak, M, Vernhet, A, and Webster, P V, 2003. *Gestempelte südgallische Reliefsigillata (Drag. 29) aus den Werkstätten von La Graufesenque, gesammelt von der Association Pegasus – Recherches Européennes sur La Graufesenque*, Römisch-Germanisches Zentralmuseum Kataloge Vor- und Frühgeschichtlicher Altertümer 34, Mainz

Eschbaumer, P, and Faber, A, 1988. Die südgallische Relief-sigillata: Kritische Bemerkungen zur Chronologie und zu Untersuchungsmethoden: Eine Stellungnahme zu dem Aufsatz von B. Pferdehirt im Jahrbuch RGZM 33, 1986, *Fundberichte aus Baden-Württemberg* 13, 223–47

Glasbergen, W, 1940–1944a. Versierde Claudisch-Neronische terra sigillata van Valkenburg Z.H., in A E Van Giffen, De Romeinsche castella in den dorpsheuvel te Valkenburg aan den Rijn (Z.H.) (Praetorium Agrippinae), I: De opgravingen in 1941, *Jaarverslag van de Vereeniging voor Terpenonderzoek* 25–28, 206–17

Glasbergen, W, 1940–1944b. Pottenbakkersstempels op terra sigillata van Valkenburg Z.H, in: A E Van Giffen, De Romeinsche castella in den dorpsheuvel te Valkenburg aan den Rijn (Z.H.) (Praetorium Agrippinae), I: De opgravingen in 1941, *Jaarverslag van de Vereeniging voor Terpenonderzoek* 25–28, 218–36

Glasbergen, W, 1948–1953. Pottenbakkersstempels op terra sigillata van Valkenburg Z.H. (1942), in A E Van Giffen, De Romeinse castella in de dorpsheuvel te Valkenburg aan de Rijn (Z.H.) (Praetorium Agrippinae), II: De opgravingen in 1942–'43 en 1946–1950, *Jaarverslag van de Vereeniging voor Terpenonderzoek* 33–37, 127–148

Glasbergen, W, 1967. *De Romeinse castella te Valkenburg Z.H.: De opgravingen in de dorpsheuvel in 1962*, Cingula 1, Groningen

Haalebos, J K, 1977. *Zwammerdam – Nigrum Pullum: Ein Auxiliarkastell am Niedergermanischen Limes*, Cingula 3, Amsterdam

Haalebos, J K, 1980. Versierde terra sigillata uit Bodegraven, *Westerheem* 29, 36–45

Haalebos, J K, Mees, A W, and Polak, M, 1991. Über Töpfer und Fabriken verzierter Terra-sigillata des ersten Jahrhunderts, *Archäologisches Korrespondenzblatt* 21, 79–91

Hermet, F, 1934. *La Graufesenque (Condatomago)*, Paris

Jongkees, J H, and Isings, C, 1963. *Opgravingen op de Hoge Woerd bij De Meern (1957, 1960)*, Archaeologia Traiectina 5, Groningen

Kalee, C, and Isings, C, 1980. Beknopt verslag van een opgraving in De Meern, *Jaarboek Oud-Utrecht*, 5(25)

Kemmers, F, 2004. Caligula on the Lower Rhine: coin finds from the Roman fort of Albaniana (the Netherlands), *Revue Belge de Numismatique et de Sigillographie* 150, 15–49

Kemmers, F, 2006. Coins, countermarks and Caligula: the connection between the auxiliary forts in the Lower Rhine delta and the invasion of Britain, *Hadrianic Society Bulletin* 1, 5–11

Knorr, R, 1912. *Südgallische Terrasigillata-Gefässe von Rottweil*, Stuttgart

Knorr, R, 1919. *Töpfer und Fabriken verzierter Terra-Sigillata des ersten Jahrhunderts*, Stuttgart

Knorr, R, 1942. Frühe und spate Sigillata des Calus, *Germania* 26, 184–91

Knorr, R, 1952. *Terra-sigillata-Gefässe des ersten Jahrhunderts mit Töpfernamen*, Stuttgart

Linden, E van der, 2004a. Terra sigillata, in Polak *et al* 2004, 130–8

Linden, E van der, 2004b. Bijlage 2: pottenbakkersstempels op terra sigillata, in Polak *et al* 2004, 282–97

Linden, E van der, 2008. Aardewerk, in *Woerden-Hoochwoert: De opgravingen 2002–2004 in het Romeinse castellum Laurium, de vicus en van het schip de 'Woerden 7'* (eds E Blom and W K Vos), ADC Rapport 910, 143–88, Amersfoort

Marsh, G, 1981. London's samian supply and its relationship to the development of the Gallic samian industry, in *Roman pottery research in Britain and North-West Europe* (eds A C Anderson and A S Anderson), Brit Archaeol Rep Int Ser 123, 173–238, Oxford

Mees, A W, 1995. *Modelsignierte Dekorationen auf südgallischer Terra Sigillata*, Forschungen und Berichte zur Vor- und Frühgeschichte in Baden-Württemberg 54, Stuttgart

Nieto, X, and Puig, A M, 2001. *Excavacions arqueològiques subaquàtiques a Cala Culip, 3. Culip IV: la terra sigil. lata decorada de la Graufesenque*, Monografies del Centre d'Arqueologia Subaquàtica de Catalunya 3, Girona

Oswald, F, 1936–1937. *Index of figure-types on terra sigillata 'samian ware')*, Univ Liverpool Ann Archaeol Anthropol Suppl 23–4

Ozinga, L R P, Hoekstra, T J, Weerd, M D de, and Wynia, S L (eds), 1989. *Het Romeinse castellum te Utrecht: De opgravingen in 1936, 1938, 1943/44 en 1949 uitgevoerd onder leiding van A.E. van Giffen met medewerking van H. Brunsting, aangevuld met latere waarnemingen*, Studies in Prae- en Protohistorie 3, Utrecht

Pferdehirt, B, 1986. Die römische Okkupation Germaniens und Rätiens von der Zeit des Tiberius bis zum Tode Trajans: Untersuchungen zur Chronologie südgallischer Reliefsigillata, *Jahrbuch des Römisch-Germanischen Zentralmuseums Mainz* 33, 221–320

Polak, M, 2000. *South Gaulish terra sigillata with potters' stamps from Vechten*, Rei Cretariae Romanae Fautorum Acta Supplementum 9, Nijmegen

Polak, M, Kloosterman, R P J, and Niemeijer, R A J, 2004. *Alphen aan den Rijn – Albaniana 2001–2002: Opgravingen tussen de Castellumstraat, het Omloopkanaal en de Oude Rijn*, Libelli Noviomagenses 7, Nijmegen

Appendix 27.1: Decorated South Gaulish vessels from Alphen aan den Rijn

The catalogue includes 143 fragments of 90 decorated South Gaulish vessels, arranged in chronological order. Small fragments without identifiable decoration are not listed. Rubbings are illustrated in Figs 27.10–14, at a 1:2 scale.

D1. Drag 29, four fragments (three illustrated).
Lower frieze is Knorr 1952, pl 72 G, probably by Volus.
La Graufesenque, *c* AD 20–50.
ALP01.042.2438. Probably period 1.

D2. Drag 29.
Similar upper zones with 'rams-horn' wreaths are Knorr 1919, pl 1, A (Albinus), pl 77, J and K (Senicio), and Dannell 2005, fig 6, 32–33, from Richborough, dated early Claudian there.
The latter three have central moulding without rouletting, like the Alphen bowl (published before: Van der Linden 2004a, 134, fig 64, 2).
La Graufesenque, *c* AD 30–50.
ALP01.042.2245. Probably period 2 or later.

D3. Drag 29, nine fragments (six illustrated).
Upper zone *cf* Knorr 1919, pl 20 D (stamped CARVS.FE), pl 30 C (stamped DARIBITVS) and Knorr 1952, pl 2 A (stamped OF.ARDACI). Leaf in lower zone is Knorr 1919, fig 8 (FIRMO. FEC). Infilled scroll with leaf tips *cf* Knorr 1919, pl 30 C (DARIBITVS).
La Graufesenque, *c* AD 30–55.
ALP01.028.1292, period 1a. ALP01.042.2345+ 2421, probably period 1. ALP01.042.2440, via principalis, probably period 1.

D4. Drag 29, seven fragments (four illustrated).
Upper zone scroll with stirrup leaves and rosettes (published before: Van der Linden 2004a, 134, fig 64, 1). Lower zone scroll filled with different sorts of leaves and eagles. From the same mould as Knorr 1919, pl 31 E, stamped DARIBITVS. The bowl from Alphen has a rouletted central moulding, however.
La Graufesenque, *c* AD 30–60.
ALP01.033.1661+1662, period 1, occupation level fabrica.

D5. Drag 29.
Upper zone wreath as Knorr 1952, 38, A (stamped OFMATV). The parallel from Mainz is dated to *c* AD 55–75; the bowl from Alphen may be dated earlier, from *c* AD 30 (published before: Van der Linden 2004a, 134, fig 64, 3). The same wreath is found on a bowl from the 'Fosse de Cirratus', stamped by Salvetus (Dannell 2005, fig 3, 11).
La Graufesenque, *c* AD 30–75.
ALP01.027.0460. Rhine bed, rubbish layers.

D6. Drag 30 (burnt).
Ovolo is Dannell *et al* 1998, BB (Sabinus?), *cf* Hermet 1934, pl 77, 16. Festoons filled with striated rods, *cf* Hermet 1934, pl 59, 22.
La Graufesenque, *c* AD 40–60.
ALP01.028.1047. Period 1, destruction level barracks, with hoard of 7 coins struck in AD 65.

D7. Drag 30.
Motif is Knorr 1919, pl 32, 4 (stamped DARRA FE).
La Graufesenque, *c* AD 40–60.
ALP01.032.1574. Probably period 1.

D8. Drag 29.
Lower zone with volute and acorn as Knorr 1919, pl 1, A (stamped ALBINI), Mees 1995, pl 173, 2 (Sabinus I) and 199, 3 (Volus), Hermet 1934, pl 60, 30 and 117, 5.
La Graufesenque, *c* AD 40–60.
ALP01.027.0460. Rhine bed, rubbish layers.

D9. Drag 29.
Upper zone scroll with leaves, probably identical with Knorr 1952, pl 2, A (stamped OF.ARDACI).
La Graufesenque, *c* AD 40–70.
ALP01.027.0465. Rhine bed, rubbish layers.

D10. Drag 29.
Upper zone with scroll and lower zone with gadroons *cf* Knorr 1952, pl 39, F (stamped OFMODESTI) and 47, A (stamped OFNIGRI).
La Graufesenque, *c* AD 45–75.
ALP01.027.0460. Rhine bed, rubbish layers.

D11. Drag 30.
Similar arrangement with scroll and vegetal ornament *cf* Knorr 1952, pl 42, C (style of Modestus). Long leaf *cf* Mees 1995, pl 83, 1 (Germanus III). Germanus II and III regularly use festoons.
La Graufesenque, *c* AD 45–80.
ALP01.032.1592. Unstratified.

D12. Drag 30.
Female figure to the left between columns, *cf* Mees 1995, cover illustration and pl 170, 1, both by Sabinus i.
La Graufesenque, *c* AD 50–70.
ALP01.032.1583. Probably period 1.

D13. Drag 29.
Leaf is Knorr 1952, pl 70, E, *cf ibid* pl 72, A, both dated pre-Flavian. Similar leaves were used by Passienus and Senicio, for example.
La Graufesenque, *c* AD 50–70.
ALP01.042.2244. Via principalis, probably period 2.

D14. Drag 30.
Signature M as Mees 1995, pl 108, 2 and pl 109, 1: Masclus. Scroll and bird are also found on other bowls signed by Masclus, *cf* Mees 1995, pl 108, 2 and 4, pl 109, 1.
La Graufesenque, *c* AD 50–70.
ALP01.032.1555. Period 2 or later.

D15. Drag 30.
Ovolo probably Dannell *et al* 1998, KK, attributed to the 'potter of the large rosette', said to be Cal(v)us i. Saltire and vertical wreath as Hermet 1934, pl 76, 12; the dog is Oswald 1936–1937, 1963, *cf* Mees 1995, pl 168, 1, by Sabinus i.
La Graufesenque, *c* AD 50–70.
ALP01.023.0342. Period 2 or 3.

D16. Drag 30, five fragments.
Ovolo is Dannell *et al* 1998, DB. Identical large leaves and scroll with identical small leaves at the end are on Knorr 1919, pl 76, D (SENICIOFE); the ovolo is missing there. Similar arrangements on Hermet 1934, pl 69, 2 and Mees 1995, pl 105, 10 (Masclus).
La Graufesenque, *c* AD 50–70.
ALP01.023.0335. Period 3, robber trench stone gate.

Marinus Polak, Ryan Niemeijer and Ester van der Linden

Fig 27.10: Alphen aan den Rijn. Decorated South Gaulish vessels

D 21 D 22 D 23 D 24 D 25 D 26 D 27 D 28 D 29 D 30 D 31 D 32 D 33 D 34 D 35 D 36 D 37 D 39 D 39 D 40 D 41 D 42 D 43 D 44 D 45

Fig 27.11: Alphen aan den Rijn. Decorated South Gaulish vessels

Fig 27.12: Alphen aan den Rijn. Decorated South Gaulish vessels

Fig 27.13: Alphen aan den Rijn. Decorated South Gaulish vessels

Fig 27.14: Alphen aan den Rijn. Decorated South Gaulish vessels

D17. Drag 30.
Leaf probably identical with Hermet 1934, pl 8, 39–40. *Cf* Mees 1995, pl 106, 1–2, pl 107, 1 and pl 108, 1–4 (Masclus).
La Graufesenque, *c* AD 50–70.
ALP01.027.0464. Rhine bed, rubbish layers.

D18. Drag 29.
Signature (retrograde) [SENI]CIO below the decoration (published before: Van der Linden 2004b, 297, fig 109, 3). Similar arrangement with the same small leaves but a different wreath on Mees 1995, pl 182, 4.
La Graufesenque, *c* AD 50–70.
ALP01.023.0310. Unstratified.

D19. Drag 30.
Ovolo is Dannell *et al* 1998, NN, with a relatively restricted range of poinçoins, one of which can be connected with Marinus. Bottle bud, ovolo and festoon are on Hermet 1934, pl 78, 13. The contents of the festoon seems to be different, however.
La Graufesenque, *c* AD 50–70.
ALP01.025.0420. Unstratified.

D20. Drag 30.
Ovolo is possibly identical with Dannell *et al* 1998, BA, by Bassus-Coelus, Coelus and Seno.
La Graufesenque, *c* AD 50–75.
ALP01.028.1289. Period 1a, occupation level barrack D.

D21. Drag 29.
Gadroons, *cf* D22.
La Graufesenque, *c* AD 50–75.
ALP01.033.1661. Period 1, occupation level fabrica.

D22. Drag 29.
Gadroons are very common in the Neronian period. *Cf* D21.
La Graufesenque, *c* AD 50–75.
ALP01.042.2430. Probably period 1.

D23. Drag 29, three fragments.
Lower zone with wreath and festoon as Knorr 1919, pl 13, C (stamped BASSICO).
La Graufesenque, *c* AD 50–75.
ALP01.027.0481. Rhine bed, rubbish layers.

D24. Drag 29.
Upper zone inhabited scroll with rosettes and medallion with rabbit, *cf* Knorr 1952, pl 43, L (stamped OFMODESTI) and Knorr 1919, pl 66, B (stamped PRIMIM). Lower zone with gadroon, *cf* Mees 1995, pl 5, 1 (Albinus) and pl 149, 1 (Murranus).
La Graufesenque, *c* AD 50–75.
ALP01.027.0482. Rhine bed, rubbish layers.

D25. Drag 30.
Ovolo identical with Dannell *et al* 1998, AA. Decorative details as Mees 1995, pl 104, 8 (Masclinus), pl 111, 3 (Masclus), pl 99 (Lupus).
La Graufesenque, *c* AD 50–80.
ALP01.027.0481. Rhine bed, rubbish layers.

D26. Drag 29.
Upper zone festoon with rabbits as Hermet 1934, pl 43, 25. *Cf* Knorr 1952, pl 77, D (stamped OFMO) and Knorr 1919, pl 87, B.
La Graufesenque, *c* AD 55–75.
ALP01.032.1577. Period 2 or later.

D27. Drag 29.
Lower zone with rows of repeated motifs, *cf* Knorr 1919, pl 85 ('OF.CABAL.APT?' i.e. C. Salarius Aptus). Rosette in medallion as Hermet 1934, pl 64, 4 (stamped OFLABIONIS).
La Graufesenque, *c* AD 55–75.
ALP01.027.0475. Rhine bed, rubbish layers.

D28. Drag 30.
Ovolo is Dannell *et al* 1998, FD a/b, by Martialis and Masclus. Scroll containing a festoon with an eagle in the lower lobe, and two large leaves in the upper one. The large lobed leaf is Knorr 1919, pl 56 A, stamped by Melus.
La Graufesenque, *c* AD 55–80.
ALP01.022.0241. Period 2, filling inner ditch.

D29. Drag 29.
Upper zone with festoon *cf* Knorr 1919, pl 55, B (MEDDILLVS), pl 63, C–D (OFPASSENI), pl 67, K (OFPRIMI), pl 82, C (VITAL). Lower zone with wreath of cordate leaves as Knorr 1919, pl 82, C (VITAL).
La Graufesenque, AD *c* 55–80.
ALP01.040.1899. Rhine bed, rubbish layers after AD 150.

D30. Drag 29.
Cigar-shaped ornaments in the lower zone can be found in the work of Murranus, *cf* Mees 1995, pl 148. A similar lower zone is Hermet 1934, pl 62, 7. Similar upper zone is Hermet 1934, pl 42, 1–2, dated by Hermet in the transition period, and attributed to Germanus.
La Graufesenque, *c* AD 55–80.
ALP01.023.0341. Unstratified.

D31. Drag 29.
Upper zone with scroll. Rosette as Nieto and Puig 2001, Cb. 41 (stamped OFPRIMI).
La Graufesenque, *c* AD 55–85.
ALP01.040.1985. Rhine bed, rubbish layers after AD 150.

D32. Drag 29.
Upper zone panels with wavy lines. Lower zone frieze of trifids, upper parts of festoons are visible. For the frieze and festoons *cf* Knorr 1919, pl 87, A. Frieze and panels with wavy lines *cf* Knorr 1919, pl 87, C.
La Graufesenque, *c* AD 60–80.
ALP01.028.1125. Period 1.

D33. Drag 30.
Woman with amphora Oswald 1936–1937, 927A, probably accompanied by Minerva, *cf* Hermet 1934, pl 75, 4 and 8.
La Graufesenque, *c* AD 60–80.
ALP01.028.1035. Period 2 or 3.

D34. Drag 29 (slightly burnt).
Probably from the same bowl as D35. Lower zone panel decoration below gadroons, *cf* Knorr 1952, pl 50, A (stamped OFPONTI).
La Graufesenque, *c* AD 60–80.
ALP01.028.1067. Period 2 or later.

D35. Drag 29 (slightly burnt).
Probably from the same bowl as D34.
La Graufesenque, *c* AD 60–80.
ALP01.028.1044. Unstratified.

D36. Drag 29.
Upper zone medallion with bird and wavy lines, as Knorr 1919, pl 54, A (MEDDILLV); pl 48 (MACRI.M); *cf* Knorr 1952, pl 4, E (stamped OFAQVITAN) and pl 50, A (stamped OFPONTI).
La Graufesenque, *c* AD 60–80.
ALP01.028.1075. Probably period 2 or later.

D37. Drag 30.
Hercules identical with Oswald 1936–1937, 766B. Decorative scheme as Hermet 1934, pl 75, 1, 5 and pl 79, 7, 12. Motifs occur on bowls attributed to Masclus, *cf* Mees 1995, pl 110.
La Graufesenque, *c* AD 60–80.
ALP01.027.0475. Rhine bed, rubbish layers.

D38. Drag 29, two fragments.
Upper zone scroll with stirrup leaf, bird and rosette and lower zone with gadroons *cf* Mees 1995, pl 148, 3 (Murranus) and Knorr 1919, pl 53 (stamped OFMATV). Bird identical with Oswald 1936–1937, 2263.
La Graufesenque, *c* AD 60–80.
ALP01.027.0481. Rhine bed, rubbish layers.

D39. Drag 29.
Upper zone with dolphins in festoons as Mees 1995, pl 126, 4 (Memor) and 157, 1 (Passienus). Lower zone with gadroons as Hermet 1934, pl 60, 9.
La Graufesenque, *c* AD 60–80.
ALP01.027.0460. Rhine bed, rubbish layers.

D40. Drag 29.
Upper zone panel decoration with horizontal leaf tips and animal, *cf* Knorr 1952, pl 40, B (Meddillus).
La Graufesenque, *c* AD 60–80.
ALP01.040.1981. Rhine bed, rubbish layers after AD 150.

D41. Drag 30.
Ovolo identical with Dannell *et al* 1998, KK, attributed to the 'potter of the large rosette', said to be Cal(v)us i. Hare identical with Oswald 1936–1937, 2100. *Cf* Dannell *et al* 2003, Calvus i, pl D1, 3041.
La Graufesenque, *c* AD 60–85.
ALP01.021.0187. Rhine bed, rubbish layers.

D42. Drag 30.
Ovolo identical with Dannell *et al* 1998, KK, attributed to the 'potter of the large rosette', said to be Cal(v)us i.
La Graufesenque, *c* AD 60–85.
ALP01.021.0187. Rhine bed, rubbish layers.

D43. Drag 30.
Ovolo identical with Dannell *et al* 1998, KK, attributed to the 'potter of the large rosette', said to be Cal(v)us i.
La Graufesenque, *c* AD 60–85.
ALP01.027.0481. Rhine bed, rubbish layers.

D44. Déch 67.
Infilled scroll as Hermet 1934, pl 91, 4–5, Nieto and Puig 2001, no 683.
La Graufesenque, *c* AD 60–90.
ALP01.040.1899. Rhine bed, rubbish layers after AD 150.

D45. Déch 67.
Scroll with twist, rosette and tendrils as Nieto and Puig 2001, no 682.
La Graufesenque, *c* AD 60–90.
ALP01.040.1991. Rhine bed, rubbish layers after AD 150.

D46. Drag 30, four fragments.
Ovolo identical with Dannell *et al* 1998, KK, attributed to the 'potter of the large rosette', said to be Cal(v)us i. Bacchus identical with Knorr 1919, pl 69, 2 (stamped OFSABIN). Silenus identical with Knorr 1919, pl 34, 7 (stamped OFGERMANI). *Cf* Knorr 1942, fig 3D: 'Art des Calus'.
La Graufesenque, *c* AD 60–100.
ALP01.027.0479. Rhine bed, rubbish layers.

D47. Drag 29, two fragments.
Upper zone with panels. Cupid possibly identical with Knorr 1919, pl 17, 29 (Calvus). Panel with wavy lines and leaf tips as Knorr 1952, pl 40, B (stamped MEDDILLVS) and pl 77, E (stamped OPASSEN).
La Graufesenque, *c* AD 65–85.
ALP01. 027.0481. Rhine bed, rubbish layers.

D48. Drag 29.
Upper decoration zones with similar arrangements Nieto and Puig 2001, no 82 (SEX.IVL.IVCVND) or nos 90–91 (VIRTHV), and Knorr 1952, pl 8, 3 (OFCENS) and pl 49, F (OFPASSENI). Trifid is possibly Knorr 1952, pl 8, 2 (OFCOELI) and pl 47, A (OF NIGRI).
La Graufesenque, *c* AD 65–85.
ALP01.029.1133. Unstratified.

D49. Drag 29.
Lower zone infilled scroll comparable with Polak 2000, pl 38, h (stamped OFCELADI) and Knorr 1919, pl 74, B (stamped OFSECVND).
La Graufesenque, *c* AD 65–90.
ALP01.027.0467. Rhine bed, rubbish layers.

D50. Drag 29, stamped <O>FIC.PRIM<I> (*cf* S57 below).
Inhabited scroll with Amor on a stage, *cf* Knorr 1919, pl 68, A (Rufinus) and pl 22, A (Censor) (published before: Van der Linden 2004b, 291, fig 106, 4).
La Graufesenque, *c* AD 70–80.
ALP01.027.0475. Rhine bed, rubbish layers.

D51. Drag 29, nine fragments.
Upper zone with panels. Lower zone with wreath and panels. Alternating saltire and medallion decoration rare on Drag 29, typical for the Flavian period, *cf* Mees 1995, pl 96, 12 (Iustus), pl 204, 1, 3, pl 205, 2 and pl 206, 3 (Anepigraphiker).
La Graufesenque, *c* AD 70–85.
ALP01.027.0481. Rhine bed, rubbish layers.

D52. Drag 37.
Basal frieze consisting of short twists. No parallels were found on Drag 37. On Drag 29 bowls the motif is rare, *cf* Knorr 1919, pl 9, K (Aquitanus), Mees 1995, pl 148, 3 (Murranus). On these vessels the twists are longer than on the bowl from Alphen.
La Graufesenque, *c* AD 70–85.
ALP01.040.1991. Rhine bed, rubbish layers after AD 150.

D53. Drag 30.
Leaf is the same as on D54, *cf* Knorr 1912, pl XVI, 1. The dating of the fragment is based on this parallel.
La Graufesenque, *c* AD 70–90.
ALP01.032.1589. Probably period 1.

D54. Drag 30, eight fragments.
Ovolo is Dannell *et al* 1998, KK, attributed to the 'potter of the large rosette', said to be Cal(v)us i. Two zones with scrolls are very rare. Leaf is the same as on D53, *cf* Knorr 1912, pl XVI, 1.
La Graufesenque, *c* AD 70–90.
ALP01.032.1577. Period 2 or later.

D55. Drag 29.
Upper zone scroll with stirrup leaf. *Cf* Nieto and Puig 2001, nos 79, 127, 216 (stamped SEX.IVL.IVCVND).
La Graufesenque, *c* AD 70–90.
ALP01.027.0475. Rhine bed, rubbish layers.

D56. Drag 29.
Festoon with birds, divided by wavy lines, *cf* Hermet 1934, pl 43, 22.
La Graufesenque, *c* AD 70–90.
ALP01.027.0456. Rhine bed, rubbish layers.

D57. Drag 29.
Lion identical with Nieto and Puig 2001, Ba. 6. There are links with bowls stamped by Primus and Virthus.
La Graufesenque, *c* AD 70–90.
ALP01.021.0113. Rhine bed, rubbish layers.

D58. Drag 29.
Upper zone scroll with leaf and rosette probably identical with Knorr 1919, pl 18, D (stamped OFCVLVI, Calvus).
La Graufesenque, *c* AD 70–90.
ALP01.040.1991. Rhine bed, rubbish layers after AD 150.

D59. Drag 37.
Panels with animals and rosettes. Dog as Mees 1995, pl 126, 4 (Memor), Knorr 1919, pl 54, A (MEDDILLV), Knorr 1919, pl 73, 26 (stamped OFSECVND). Identical dog on D70. Boar *cf* Knorr 1919, pl 73, 28 (stamped OFSECVND). Basal wreath as Knorr 1919, pl 13, F (stamped OFBASSICO) and pl 85, C (stamped OFC[…]), Mees 1995, pl 66, 1 (Frontinus I).
La Graufesenque, *c* AD 70–90.
ALP01.040.1991. Rhine bed, rubbish layers after AD 150.

D60. Drag 37.
Basal wreath as on D59, *cf* Knorr 1919, pl 13, F (stamped OFBASSICO) and pl 85, C (stamped OFC[…]), Mees 1995, pl 66, 1 (Frontinus I). Hare or dog.
La Graufesenque, *c* AD 70–90?
ALP01.021.0185. Rhine bed, rubbish layers after AD 150.

D61. Drag 29.
The dog is Knorr 1919, pl 84, J (by Vitalis ii). Decoration scheme as in Hermet 1934, pl 54, 12–14, pl 80, 1 and pl 92, 8. See also Nieto and Puig 2001, nos 447–448. A similar arrangement on D75.
La Graufesenque, *c* AD 70–90.
ALP01.023.0310. Unstratified.

D62. Drag 37, two fragments.
Identical wreath Knorr 1919, pl 63, B (OFPAS[---]), on a bowl Drag 29. Identical wreath Nieto and Puig 2001, Ec.8a, appearing on many bowls Drag 37.
La Graufesenque, *c* AD 70–90.
ALP01.025.0419+0430. Unstratified.

D63. Drag 30.
Diana with hare identical with Oswald 1936–1937, 103A; man with goat identical with Oswald 1936–1937, 548. *Cf* Hermet 1934, pl 79, 7.
La Graufesenque, *c* AD 70–95.
ALP01.021.0103. Rhine bed, rubbish layers.

D64. Drag 37.
Diana with hare identical with Oswald 1936–1937, 104B. *Cf* Knorr 1919, pl 68 (stamped OFPVDENT); Mees 1995, pl 132, 11 and Knorr 1919, pl 57, 1 (Mercator).
La Graufesenque, *c* AD 70–100.
ALP01.027.0468. Rhine bed, rubbish layers.

D65. Drag 37, three fragments.
Upper zone with boar and bush made of three trifids Nieto and Puig 2001, Ec.8. Lower zone with festoon, stirrup leaf and fan *cf* Nieto and Puig 2001, no 479, Mees 1995, pl 190, 2–3 (Severus II).
La Graufesenque, *c* AD 70–100.
ALP01.027.0450+0460. Rhine bed, rubbish layers.
ALP01.040.1895, Rhine bed, rubbish layers after AD 150.

D66. Drag 37.
Saltire *cf* Mees 1995, pl 62, 2 and 63, 1 (Frontinus I), pl 208, 3–4 (Zahlenstempel).
La Graufesenque, *c* AD 70–100.
ALP01.040.1899. Rhine bed, rubbish layers after AD 150.

D67. Drag 37.
Panels with gladiator identical with Mees 1995, pl 195, 1 (L. Cosius Virilis). The animal on the latter bowl may be identical with the one from Alphen.
La Graufesenque, *c* AD 70–100.
ALP01.040.1904. Rhine bed, rubbish layers after AD 150.

D68. Drag 37, two fragments.
Ovolo with tongue ending in a trident, identical with D69–73. Similar ovolos are used by Albanus, Memor and Medillus. Panel with animal (dog or hare?) to the right.
La Graufesenque, *c* AD 70–100.
ALP01.040.1900. Rhine bed, rubbish layers after AD 150.

D69. Drag 37.
Ovolo with tongue ending in a trident, identical with D68 and D70–73. Panels with dog on a stage consisting of wavy lines, *cf* Knorr 1919, pl 23, B (stamped OFCOELI), pl 68 (stamped OFPVDENT), pl 78 (stamped C.SILVIP), pl 74, E (stamped OFSECVND). Dog identical with Dannell *et al* 2003, Secundus ii, pl E1, 2475.
La Graufesenque, *c* AD 70–100.
ALP01.040.1985. Rhine bed, rubbish layers after AD 150.

D70. Drag 37.
Ovolo with tongue ending in a trident, identical with D68–69 and D71–73. Dog as Mees 1995, pl 126, 4 (Memor), Knorr 1919, pl 54, A (Meddillus), Knorr 1919, pl 73, 26 (stamped OFSECVND). Identical dog on D56.
La Graufesenque, *c* AD 70–100.
ALP01.040.1985. Rhine bed, rubbish layers after AD 150.

D71. Drag 37.
Ovolo with tongue ending in a trident, identical with D68–70 and 72–73. Bush *cf* Mees 1995, pl 136, 2 and pl 137, 2 (Mercator).
La Graufesenque, *c* AD 70–100.
ALP01.040.1991. Rhine bed, rubbish layers after AD 150.

D72. Drag 37.
Ovolo with tongue ending in a trident, identical with D68–71 and D73. Panel decoration.
La Graufesenque, *c* AD 70–100.
ALP01.040.1991. Rhine bed, rubbish layers after AD 150.

D73. Drag 37.
Ovolo is identical with D68–72. Dating is based on the dating of the previous sherds.
La Graufesenque, *c* AD 70–100.
ALP01.000.5000. Unstratified.

D74. Drag 30.
Style of M.Crestio, *cf* Mees 1995, pl 38–41. Apollo is Knorr 1919, pl 28, 10 and Mees 1995, pl 41, 1 (M.Crestio).
La Graufesenque, *c* AD 70–110.
ALP01.027.0479. Rhine bed, rubbish layers.

D75. Drag 29.
Lower zone infilled scroll with leaf tips and animal as Knorr 1919, pl 74, E (stamped OFSECVND), Hermet 1934, pl 80, 1 and 92, 8, Nieto and Puig 2001, nos 336, 337, 384. Basal wreath as D59–60 above.
La Graufesenque, *c* AD 75–85.
ALP01.040.1991. Rhine bed, rubbish layers after AD 150.

D76. Drag 37.
Ovolo and scroll with big leaves and twists as Mees 1995, pl 78, 4, 5, and 7 (Germanus III).
La Graufesenque, *c* AD 75–100.
ALP01.040.1991. Rhine bed, rubbish layers after AD 150.

D77. Déch 67.
Identical with Hermet 1934, pl 90, 9, erroneously dated Claudio-Neronian by Hermet. It should probably be dated from the Flavian period onwards. See also Mees 1995, pl 56, 7 and 9 (Crucuro II).
La Graufesenque, *c* AD 80–100.
ALP01.023.0327. Period 2, upper filling inner ditch.

D78. Drag 37, two fragments.
Ovolo is Mees 1995, pl 128, 1 (Mercator), with a similar arrangement with scroll containing birds and leaves. Identical large leaf Mees 1995, pl 132, 3–4 (Mercator). Ovolo and vegetal motif are on Mees 1995, pl 163, 2 (Patricius I).
La Graufesenque, *c* AD 80–100.
ALP01.028.1111. Probably period 2.

D79. Drag 37, two fragments, probably from the same bowl. Attributed to M.Crestio. Gladiators and bull *cf* Mees 1995, pl 129, 1 and pl 134, 2.
La Graufesenque, *c* AD 80–110.
ALP01.040.1985. Rhine bed, rubbish layers after AD 150.

D80. Drag 37.
Bestiarius identical with Mees 1995, pl 12, 2 and Knorr 1919, pl 16, 3 (Biragillus), *cf* Knorr 1919, pl 67, 3 and pl 68 (stamped OFPVDENT).
La Graufesenque, *c* AD 80–120.
ALP01.027.0462. Rhine bed, rubbish layers.

D81. Drag 37, two fragments.
Upper zone with boar and bush as Knorr 1912, pl XXIII, 2. Lower zone with festoon and stirrup leaf *cf* Knorr 1952, 5 (Quintio), Mees 1995, pl 54, 3 (Crucuro II).
La Graufesenque, *c* AD 80–120.
ALP01.027.0483. Rhine bed, rubbish layers. ALP01.040.1991. Rhine bed, rubbish layers after AD 150.

D82. Drag 37.
Panels with animals and twists. The fish is identical with Oswald 1936–1937, 2390, Nieto and Puig 2001, Bk. 19; *cf* Mees 1995, pl 126, 4 (Memor); the bear is probably identical with Oswald 1936–1937, 1596. Both are found on bowls dating from the Flavian period. Style of Masculus and Senilis, *cf* Mees 1995, pl 120, 2, pl 121, 1 and pl 182, 7.
La Graufesenque, *c* AD 80–120.
ALP01.040.1904. Rhine bed, rubbish layers after AD 150.

D83. Drag 37, two fragments.
Narrow panels with people and trifids as Mees 1995, pl 121, 1 (Masculus), pl 47, 3 (M.Crestio), pl 180, 6 (T. Flavius Secundus). The figure on the right is probably Victoria.
La Graufesenque, *c* AD 80–120.
ALP01.040.1985. Rhine bed, rubbish layers after AD 150.

D84. Drag 37, two fragments.
Ovolo, wreath, festoon with birds and frieze with S-shaped gadroons. All motifs occur on bowls by Mercator, *cf* Mees 1995, pl 129, 1, pl 130, 1 and pl 135, 1.
La Graufesenque, *c* AD 90–100.
ALP01.029.1134. Period 2 or later.

D85. Drag 37, two fragments.
Stag and tree identical with Mees 1995, pl 133, 5: Mercator.
La Graufesenque, *c* AD 90–100.
ALP01.032.1559. Unstratified. ALP01.049.2561. period 2 or later.

D86. Drag 37.
Ovolo and leaf identical with Mees 1995, pl 133, 1, 3, 5 (Mercator).
La Graufesenque, *c* AD 90–100.
ALP01. 021.0083. Rhine bed, rubbish layers.

D87. Drag 37.
Ovolo, panel decoration with erotic scene. Similar ovolos are used by Amandus (Mees 1995, pl 6, 2), Albanus (Mees 1995, pl 1, 8) or Rosette I (Mees 1995, pl 209, 2). Amandus also depicted erotic scenes in panels, *cf* Mees 1995, pl 6, 1–2. The scene is identical with Knorr 1912, pl XXVII, 1.
La Graufesenque, *c* AD 90–120.
ALP01.033.1640. Period 2 or later.

D88. Drag 30.
Ovolo is Dannell *et al* 1998, TT (Crucuro II, M.Crestio). Bird as Mees 1995, pl 57, 1 (Crucuro II).
La Graufesenque, *c* AD 90–120.
ALP01.040.1901. Rhine bed, rubbish layers after AD 150.

D89. Drag 37.
Basal wreath with wavy line and rosette as Mees 1995, pl 10, 4 (Bass-/Bassinus). Similar wreaths are used by Mercator (*cf* Mees 1995, pl 128–137).
La Graufesenque, *c* AD 90–120.
ALP01.040.1991. Rhine bed, rubbish layers after AD 150.

D90. Drag 37.
Panels with amor, gladiators, and grass as Mees 1995, pl 186, 2, 6, 10, pl 187, 5; basal wreath as Mees 1995, pl 188, 5 (C.Cingius Senovir).
La Graufesenque, *c* AD 110–130.
ALP01.040.1991. Rhine bed, rubbish layers after AD 150.

Appendix 27.2: South Gaulish potters' stamps from Alphen aan den Rijn

The catalogue includes 121 South Gaulish stamps. They were published together with the Central and East Gaulish stamps in 2004, but without illustrations and context evidence (Van der Linden in Polak *et al* 2004, 282–9). Some stamps were identified since then, and the numbering here does not correspond with the earlier one.

But for a few exceptions the Alphen stamps are identical to examples known from Vechten. The evidence for their dating is listed elsewhere (Polak 2000, 155–395) and not repeated here. The dates of unidentified fragments and illiterate stamps rest on typological characteristics (*cf* Polak 2000, 74–131). Ligatures in the stamp texts are indicated by underlining. The stamps are illustrated in Figs 27.15–17, at a 1:1 scale.

S1. **OF.ALBIN**, Drag 33a.
Polak 2000, A31. Albinus i, La Graufesenque, *c* AD 50–75.
ALP01.050.2627. Fabrica, undateable context.

S2. **[OFAQ]VITAN<I>**, dish (slightly burnt).
Polak 2000, A56*. Aquitanus, La Graufesenque, *c* AD 55–75.
ALP01.021.0075. Rhine bed, rubbish layers.

S3. **[OFAQVIT]ANI**, Drag 18.
Polak 2000, A57. Aquitanus, La Graufesenque, *c* AD 45–65.
ALP01.041.1977. Unstratified.

S4. **AQVITANI**, Ritt 1.
Polak 2000, A67. Aquitanus, La Graufesenque, *c* AD 40–60.
ALP01.029.1247. Period 1b, occupation level barrack F.

S5. **AQVITA[NI]**, dish.
Identical with previous stamp. Aquitanus, La Graufesenque, *c* AD 40–60.
ALP01.050.2802. Fabrica, undateable context (together with S7).

S6. **AQVIT[ANI]**, Drag 15/17.
Identical with previous stamps. Aquitanus, La Graufesenque, *c* AD 40–60.
ALP01.050.2662+2823. Period 1, fabrica.

S7. **AQVIT**, Drag 27g.
Polak 2000, A73. Aquitanus, La Graufesenque, *c* AD 45–65.
ALP01.050.2802. Fabrica, undateable context (together with S5).

S8. **AVE**, Drag 27.
Possibly Polak 2000, A105. Avetus, La Graufesenque, *c* AD 40–60.
ALP01.028.1214. Period 2, foundation trench barracks?

S9. **OFBA[SSI]**, dish.
Polak 2000, B10. Bassus i, La Graufesenque, *c* AD 50–75.
ALP01.041.2006. Period 2, filling inner ditch.

S10. **OFBASS[I]**, Drag 27.
Polak 2000, B15. Bassus i, La Graufesenque, *c* AD 50–70.
ALP01.056.2476. Period 2, filling inner ditch.

S11. **BASSI**, Drag 27g.
Polak 2000, B30. Bassus i, La Graufesenque, *c* AD 50–70.
ALP01.033.1659. Period 2 or later.

S12. **BASSI**, dish.
Polak 2000, B32. Bassus i, La Graufesenque, *c* AD 55–75.
ALP01.051.3844. Via principalis, probably period 1.

S13. **BASSIC**, Drag 24/25.
Polak 2000, B51. Bassus i – Coelus, La Graufesenque, *c* AD 50–70.
ALP01.045.2064. Unstratified.

S14. **[OF.CA]LVI**, Drag 27g.
Polak 2000, C17? Calvus i, La Graufesenque, *c* AD 65–95.
ALP01.021.0069. Rhine bed, rubbish layers after AD 150.

S15. **OFCALVI**, Drag 18.
Polak 2000, C25. Calvus i, La Graufesenque, *c* AD 65–85.
ALP01.027.0473. Rhine bed, rubbish layers.

S16. **CARANT[IM]**, Drag 18.
Polak 2000, C64. Carantus i, La Graufesenque, *c* AD 70–100.
ALP01.044.3613. Rhine bed, rubbish layers after AD 150.

S17. **CA[RBONISMA]**, dish.
Polak 2000, C66. Carbo, La Graufesenque, *c* AD 65–95.
ALP01.040.1896. Rhine bed, rubbish layers.

S18. **[CAS]STVS.CANTI**, rouletted dish.
Cf Polak 2000, 199, sv Castus. Castus – Cantus, La Graufesenque, *c* AD 45–60.
ALP01.027.0468. Rhine bed, rubbish layers.

S19. **CELADVSF**, Drag 24/25.
Polak 2000, C87. Celadus, La Graufesenque/Le Rozier, *c* AD 55–70.
ALP01.027.0465. Rhine bed, rubbish layers.

S20. **[CELA]DVSF**, Drag 24/25.
Identical with previous stamp. Celadus, La Graufesenque/Le Rozier, *c* AD 55–70.
ALP01.040.1904. Rhine bed, rubbish layers after AD 150.

S21. **OFC.N.CELSI**, Drag 18.
Polak 2000, C112. C. N- Celsus, La Graufesenque, *c* AD 80–110.
ALP01.040.1904. Rhine bed, rubbish layers after AD 150.

S22. **OFC.N.CELSI**, Drag 18.
Identical with previous stamp. C. N- Celsus, La Graufesenque, *c* AD 80–110.
ALP01.040.1985. Rhine bed, rubbish layers after AD 150.

S23. **OFC.ENS**, Drag 18.
Polak 2000, C121. Censor i, La Graufesenque, *c* AD 80–120.
ALP01.042.1518. Via principalis, unstratified.

S24. **[OFCRE]STIO**, Drag 29.
Polak 2000, C158. Crestio, La Graufesenque, *c* AD 50–75.
ALP01.042.2243. Via principalis, probably period 1.

S25. **OFCRES**, Drag 18.
Polak 2000, C166. Crestio, La Graufesenque, *c* AD 70–110.
ALP01.025.0448. Rhine bed, unstratified.

Fig 27.15: Alphen aan den Rijn. Samian stamps

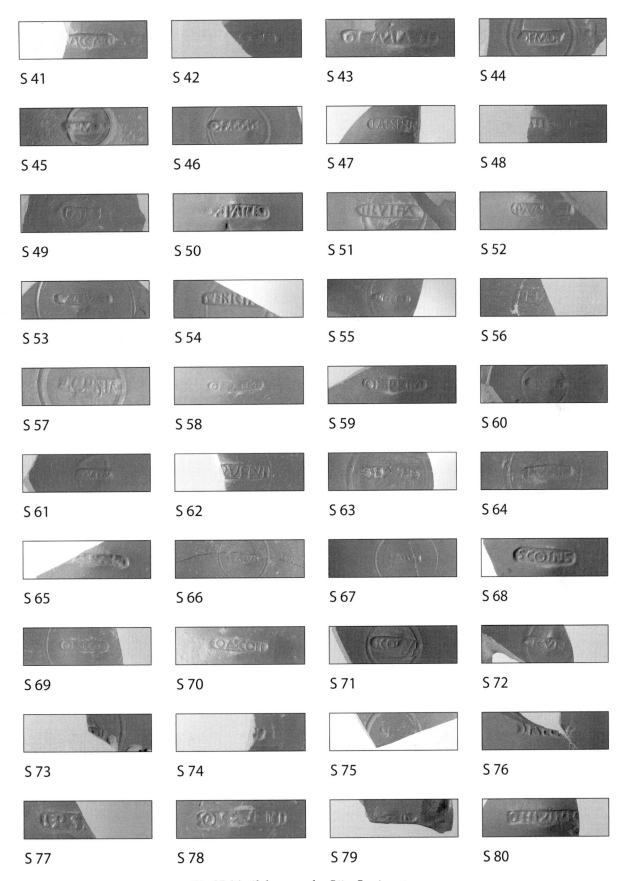

Fig 27.16: Alphen aan den Rijn. Samian stamps

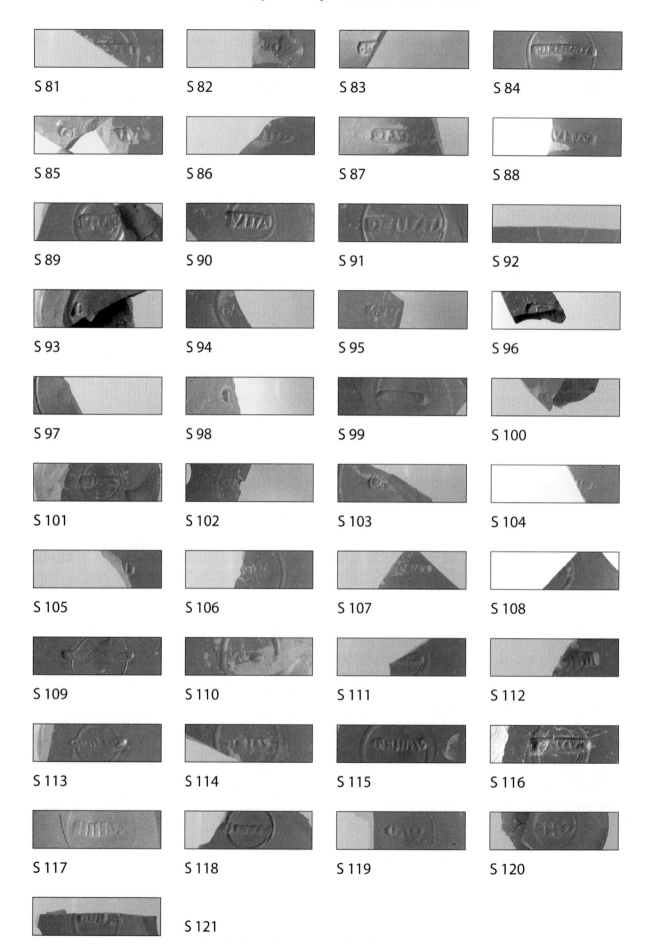

Fig 27.17: Alphen aan den Rijn. Samian stamps

S26. **CRESTI**, Drag 24/25.
Polak 2000, C171. Crestio, La Graufesenque, *c* AD 55–70.
ALP01.029.0560. Period 2, foundation trench of barracks?

S27. **FELI.TE**, Drag 27g.
Polak 2000, F5. Feli(cem) te, La Graufesenque, *c* AD 60–80.
ALP01.000.5000. Unstratified.

S28. **FLORVS**, Drag 24/25.
Polak 2000, F38. Florus ii, La Graufesenque, *c* AD 50–70.
ALP01.050.2648. Fabrica, undateable context.

S29. **OF.FVSC**, Drag 18R.
Polak 2000, F58. Fuscus ii, La Graufesenque, *c* AD 80–100.
ALP01.040.1988. Rhine bed, rubbish layers after AD 150.

S30. **[OF]IVCVND[I]**, dish.
Polak 2000, I10. Iucundus ii, La Graufesenque, *c* AD 65–85.
ALP01.044.3506. Rhine bed, unstratified.

S31. **[L]CNI<u>ANA</u>[O]**, Drag 24/25.
Polak 2000, L19. Licinus, La Graufesenque, *c* AD 50–70.
ALP01.027.0468. Rhine bed, rubbish layers.

S32. **LICINVS**, Drag 27g.
Polak 2000, L20. Licinus, La Graufesenque, *c* AD 45–70.
ALP01.051.3880. Probably period 1.

S33. **[<L>OG]IRN** (retrograde), Drag 27g.
Polak 2000, L26. Logirnus, La Graufesenque/Montans, *c* AD 75–95.
ALP01.021.0102. Unstratified.

S34. **LVPVS**, Drag 24/25.
Polak 2000, L38. Lupus ii, La Graufesenque, *c* AD 50–75.
ALP01.031.1520. Period 3, ditch.

S35. **OFICMACCAR[I]**, Drag 18.
Polak 2000, M1. Maccarus, La Graufesenque, *c* AD 30–60.
ALP01.053.2933. Post-Roman context.

S36. **OFICMACCAR[I]**, dish.
Identical with previous stamp. Maccarus, La Graufesenque, *c* AD 30–60.
ALP01.046.3657. Probably fabrica, period 1 (together with S38).

S37. **[OFICMA]CCAR[I]**, Drag 15/17.
Identical with previous stamps. Maccarus, La Graufesenque, *c* AD 30–60.
ALP01.032.1590. Unstratified.

S38. **OFI.MACCA**, Drag 24/25.
Polak 2000, M2. Maccarus, La Graufesenque, *c* AD 40–60.
ALP01.046.3656+3657. Probably fabrica, period 1 (together with S36).

S39. **[O]F.<u>MA</u>CCAR**, Drag 24/25.
Polak 2000, M3. Maccarus, La Graufesenque, *c* AD 40–60.
ALP01.028.1033. Post-Roman context.

S40. **<O>F.MACCA<R>**, dish (slightly burnt).
Polak 2000, M4*. Maccarus, La Graufesenque, *c* AD 60–70.
ALP01.043.2056. Neronian well.

S41. **[M]ACCARI**, Drag 18.
Polak 2000, M8. Maccarus, La Graufesenque, *c* AD 35–60.
ALP01.042.2509. Via principalis, period 1.

S42. **[<u>MA</u>]SCL**, dish.
Polak 2000, M50. Masculus ii, La Graufesenque, *c* A.D. 80–110.
ALP01.040.1904. Rhine bed, rubbish layers after AD 150.

S43. **OFMATE**, Drag 18.
Polak 2000, M55. Maternus ii, La Graufesenque, *c* AD 80–110.
ALP01.040.1990. Rhine bed, rubbish layers after AD 150.

S44. **OFMO<D>**, Drag 27g.
Polak 2000, M85*. Modestus i, La Graufesenque, *c* AD 65–80.
ALP01.030.1176. Unstratified.
S45. **OFMO<D>**, Drag 27g.
Identical with previous stamp. Modestus i, La Graufesenque, *c* AD 65–80.
ALP01.027.0481. Rhine bed, rubbish layers.

S46. **OFM[<u>VR ANI</u>]?** Drag 27g.
Possibly Murranus, La Graufesenque, *c* AD 60–90.
ALP01.022.0258. Period 3, ditch.

S47. **PASSE<u>NI MA</u>**, dish.
Polak 2000, P14. Passienus, La Graufesenque, *c* AD 50–70.
ALP01.032.1563. Period 2 or later.

S48. **[PA]SSENI**, dish.
Polak 2000, P16. Passienus, La Graufesenque, *c* AD 55–75.
ALP01.044.3509. Rhine bed, unstratified.

S49. **PATER**, Drag 27g.
Pater i, La Graufesenque, *c* AD 80–110.
ALP01.042.2331. Via principalis, period 2 or later.

S50. **OFPA<u>TRI</u>CI**, Drag 18.
Polak 2000, P25. Patricius i, La Graufesenque, *c* AD 65–85.
ALP01.027.0475. Rhine bed.
S51. **SILVIPA**, Drag 27g.
Polak 2000, P40. C. Silvius Patricius, La Graufesenque, *c* AD 65–85.
ALP01.044.3506. Rhine bed, unstratified.

S52. **P<u>A</u>VLLVS.F**, Drag 18.
Polak 2000, P47. Paullus i, La Graufesenque, *c* AD 40–60.
ALP01.046.3693. Via principalis, probably period 1.

S53. **P<u>A</u>VLLVS.F**, Ritt 8 or 9.
Identical with previous stamp. Paullus i, La Graufesenque, *c* AD 40–60.
ALP01.049.2699. Period 3, lower filling of ditch.

S54. **PERRIM[AN]**, Drag 27g.
Polak 2000, P61. Perrus i, La Graufesenque, *c* AD 55–75.
ALP01.027.0451. Rhine bed, rubbish layers.

S55. **PONTI**, Drag 27g.
Polak 2000, P76. Pont(i)us, La Graufesenque, *c* AD 70–95.
ALP01.027.0481. Rhine bed, rubbish layers.

S56. **PRIM[VLI]**, Drag 24/25.
Polak 2000, P85. Primulus i, La Graufesenque, *c* AD 70–90.
ALP01.043.3634. Unstratified.

S57. **<O>FIC.PRIM<I>**, Drag 29 (*cf* D50).
Polak 2000, P91*. Primus iii, La Graufesenque/Le Rozier,
c AD 70–80.
ALP01.027.0475. Rhine bed, rubbish layers.

S58. **OFPRIMI**, Drag 18.
Polak 2000, P110. Primus iii, La Graufesenque/Le Rozier,
c AD 45–65.
ALP01.029.1293. Period 1b, occupation level barrack F.

S59. **OF.PRIM**, Drag 18.
Polak 2000, P111. Primus iii, La Graufesenque/Le Rozier,
c AD 55–75.
ALP01.027.0481. Rhine bed, rubbish layers.

S60. **QVIN**, Drag 27g.
Polak 2000, Q11. Quin-, La Graufesenque, *c* AD 45–65.
ALP01.032.1632. Period 1, occupation level fabrica.

S61. **QVIN**, Drag 27g.
Quin-, La Graufesenque, *c* AD 40–70.
ALP01.033.1662. Period 1, occupation level fabrica.

S62. **[OF]RVFNI**, dish.
Polak 2000, R16. Rufinus ii, La Graufesenque, *c* AD 65–90.
ALP01.044.3509. Rhine bed, unstratified.

S63. **OFRVFIN**, Drag 27.
Polak 2000, R18. Rufinus ii, La Graufesenque, *c* AD 65–75.
ALP01.021.0188. Rhine bed, rubbish layers.

S64. **RVSTIC**, Drag 24/25.
Rusticus, La Graufesenque, *c* AD 25–65.
ALP01.051.3883. Probably period 1.

S65. **OFSABI**, dish.
Sabinus iii, La Graufesenque, *c* AD 45–100.
ALP01.027.0483. Rhine bed, rubbish layers.

S66. **SALVE**, Drag 24.
Polak 2000, S33. Salvetus i, La Graufesenque, *c* AD 35–55.
ALP01.051.3878. Probably period 1.

S67. **SALVE**, Drag 24/25.
Identical with previous stamp. Salvetus i, La Graufesenque,
c AD 35–55.
ALP01.029.0654. Period 1a, occupation level barrack E.

S68. **SCOTNS.**, Drag 18.
Polak 2000, S37. Scotnus, La Graufesenque, *c* AD 40–65.
ALP01.027.0481. Rhine bed, rubbish layers.

S69. **OFSCOTI**, Drag 24/25.
Polak 2000, S41. Scottius i, La Graufesenque, *c* AD 40–60.
ALP01.042.2440. Via principalis, probably period 1.

S70. **OFSCOTI**, Drag 15/17.
Identical with previous stamp. Scottius i, La Graufesenque,
c AD 40–60.
ALP01.051.3830. Via principalis, probably period 1.

S71. **SCOTIVS** (impressed twice), Drag 24/25.
Polak 2000, S54. Scottius i, La Graufesenque, *c* AD 25–55.
ALP01.027.0460. Rhine bed, rubbish layers.

S72. **SECVND[I]**, Drag 24/25.
Polak 2000, S81. Secundus ii, La Graufesenque, *c* AD 45–70.
ALP01.032.1579. Period 2 or later.

S73. **[SECVN]DI**, Drag 24/25.
Identical with previous stamp. Secundus ii, La Graufesenque,
c AD 45–70.
ALP01.027.0464. Rhine bed, rubbish layers.

S74. **[SECVN]DI**, Drag 18.
Possibly identical with previous stamps. Secundus ii, La
Graufesenque, *c* AD 45–70.
ALP01.029.0612. Period 2, foundation trench of barracks?

S75. **SECVN**, Drag 24/25.
Secundus ii, La Graufesenque, *c* AD 50–70.
ALP01.042.2344. Via principalis, period 2 or 3.

S76. **OFSECV**, Drag 18.
Polak 2000, S94. Secundus iii, La Graufesenque, *c* AD 65–90.
ALP01.027.0481. Rhine bed, rubbish layers.

S77. **LTER.SE[CVN]**, dish.
Polak 2000, S106. L. Tertius Secundus, La Graufesenque, *c* AD
80–110.
ALP01.040.1991. Rhine bed, rubbish layers after AD 150.

S78. **OFSEVERI**, rouletted dish.
Polak 2000, S134. Severus ii, La Graufesenque, *c* AD 70–95.
ALP01.040.1991. Rhine bed, rubbish layers after AD 150.

S79. **[O]FSILV**, Drag 27.
Polak 2000, S172. Silvius i, La Graufesenque, *c* AD 55–70.
ALP01.027.0452. Rhine bed, rubbish layers.

S80. **OFISVLPIC**, dish.
Polak 2000, S179. Sulpicius, La Graufesenque, *c* AD 80–110.
ALP01.027.0462. Rhine bed, rubbish layers.

S81. **[OF.VIR]ILI**, Drag 27.
Polak 2000, V26. Virilis, La Graufesenque, *c* AD 80–110.
ALP01.040.1991. Rhine bed, rubbish layers after AD 150.

S82. **[OFLCVI]RILI**, Drag 27.
Polak 2000, V36. L. Cosius Virilis, La Graufesenque, *c* AD
75–110.
ALP01.040.1991. Rhine bed, rubbish layers after AD 150.

S83 **.L.C[OS.VIRIL]**, Drag 18.
Polak 2000, V40. L. Cosius Virilis, La Graufesenque, *c* AD
80–110.
ALP01.044.3625. Rhine bed, unstratified.

S84. **VIRTHVSFE**, Drag 24/25.
Polak 2000, V48. Virthus, La Graufesenque, *c* AD 45–70.
ALP01.025.0409. Rhine bed, undateable context.

S85. **OF[VITA]L**, Drag 18.
Polak 2000, V67. Vitalis ii, La Graufesenque, *c* AD 65–80.
ALP01.040.3504. Rhine bed, unstratified.

S86. **[OF.V]ITA<.>**, dish.
Polak 2000, V69*. Vitalis ii, La Graufesenque, *c* AD 65–80.
ALP01.043.3799. Post–Roman context.

S87. **OF.VITA.**, Drag 18.
Polak 2000, V71. Vitalis ii, La Graufesenque, *c* AD 75–100.
ALP01.046.3511. Unstratified.

S88. **[OF.]VITA.**, Drag 18
Identical with previous stamp. Vitalis ii, La Graufesenque, *c* AD 75–100.
ALP01.040.1990. Rhine bed, rubbish layers after AD 150.

S89. **VITAL[I]**, Drag 27.
Polak 2000, V83. Vitalis ii, La Graufesenque, *c* AD 70–100.
ALP01.044.3623. Rhine bed, rubbish layers after AD 150.

S90. **VITA**, Drag 27.
Possibly Polak 2000, V89. Vitalis ii, La Graufesenque, *c* AD 65–95.
ALP01.040.1896. Rhine bed, rubbish layers after AD 150.

Unidentified and illiterate stamps
S91. **illiterate**, Drag 27.
La Graufesenque, *c* AD 70–110.
ALP01.040.1988. Rhine bed, rubbish layers after AD 150.

S92. **AVE?**, Drag 24/25.
Cf Polak 2000, A104–105. Avetus?
La Graufesenque, *c* AD 40–60.
ALP01.027.0479. Rhine bed, rubbish layers.

S93. **B[---]**, Drag 27g.
La Graufesenque, after *c* AD 65.
ALP01.027.0475. Rhine bed, rubbish layers.

S94. **BA[---]**, Drag 27g (burnt).
Possibly Bassus i , La Graufesenque, *c* AD 55–75.
ALP01.028.1065. Post-Roman context.

S95. **C.L.[---]**, service E?
La Graufesenque, *c* AD 70–120.
ALP01.040.1985. Rhine bed, rubbish layers after AD 150.

S96. **F[---]**, dish.
Perhaps Fuscus ii, La Graufesenque, before AD 120.
ALP01.025.0415. Post-Roman context.

S97. **G[---]**, rouletted dish.
Perhaps Germanus i, La Graufesenque, *c* AD 60–100.
ALP01.027.0481. Rhine bed, rubbish layers.

S98. **L[---]**, Drag 24/25.
La Graufesenque, *c* AD 40–80.
ALP01.029.0675. Period 1a, occupation level barrack E.

S99. **M[---]?**, Drag 27g.
La Graufesenque, *c* AD 60–100.
ALP01.041.1973. Unstratified.

S100. **R[OGAT<V>?]**, cup.
Probably Polak 2000, R8*. Rogatus, La Graufesenque, *c* AD 40–65.
ALP01.063.3907. Period 1a, post-hole porta principalis dextra.

S101. **V[---]**, Drag 27g.
La Graufesenque, *c* AD 50–80.
ALP01.030.1169. Period 1(c?), barrack F.

S102. **V[---]**, Drag 27.
La Graufesenque, *c* AD 60–100.
ALP01.028.1056. Post-Roman context.

S103. **OF[---]**, Drag 29.
Small fragment of saltire decoration in lower zone. Very brilliant glaze.
La Graufesenque, *c* AD 50–70.
ALP01.027.0480. Rhine bed, rubbish layers.

S104. **[---]VI**, Drag 18.
La Graufesenque, *c* AD 40–90.
ALP01.040.1991. Rhine bed, rubbish layers after AD 150.

S105. **[---]I**, Drag 18.
La Graufesenque, before AD 120.
ALP01.040.3504. Rhine bed, unstratified.

S106. **[---]VIN** (impressed twice), Drag 24/25.
La Graufesenque, *c* AD 50–80.
ALP01.050.2192. Post-Roman context.

S107. **[---]CCIO**, dish.
La Graufesenque, *c* AD 50–100.
ALP01.045.2059. Unstratified.

S108. **[---]S**, Drag 24/25.
La Graufesenque, *c* 40–80.
ALP01.022.0261. Period 2, upper filling inner ditch.

S109. **[---]**, Drag 27g.
La Graufesenque, *c* AD50–80.
ALP01.027.0451. Rhine bed, rubbish layers.

S110. **[---]**, Drag 24/25.
La Graufesenque, *c* AD 50–80.
ALP01.044.3578. Rhine bed, unstratified.

S111. **[---]VIR?** Drag 27.
La Graufesenque, *c* AD 60–120.
ALP01.040.1899. Rhine bed, rubbish layers after AD 150.

S112. **[---]**, Drag 27.
La Graufesenque, *c* AD 80–120.
ALP01.032.1592. Unstratified.

S113. **illiterate**, Drag 27.
Polak 2000, Y99. La Graufesenque, *c* AD 70–120.
ALP01.040.3504. Rhine bed, unstratified.

S114. **OCIIS**, Drag 27.
Polak 2000, Y124. La Graufesenque, *c* AD 70–100.
ALP01.040.1991. Rhine bed, rubbish layers after AD 150.

S115. **illiterate**, Drag 27.
La Graufesenque, *c* AD 70–120.
ALP01.040.1895. Rhine bed, rubbish layers after AD 150.

S116. **AICV?** Drag 27.
La Graufesenque, *c* AD 80–120.
ALP01.029.0484. Unstratified.

S117. **IIIIIV**, Drag 27.
La Graufesenque, *c* AD 70–120.
ALP01.040.1991, Rhine bed, rubbish layers after AD 150.

S118. **?NNI**, Drag 27g.
La Graufesenque, *c* AD 40–80.
ALP01.032.1577. Period 2 or later.

S119. **IAI.**, Drag 27g.
La Graufesenque, *c* AD 50–100.
ALP01.046.3523. Unstratified.

S120. **?FO**, Drag 27g.
La Graufesenque, *c* AD 60–90.
ALP01.042.2247. Via principalis, probably period 2.

S121. ..**I.I**, Drag 24/25.
La Graufesenque, *c* AD 50–80.
ALP01.050.2622. Fabrica, undateable context.

28 Costing the (figured) earth: using samian to estimate funerary expenditure

Edward Biddulph

Establishing a price list

Destruction deposits from urban centres like Colchester and Wroxeter raise the possibility that an inhabitant of such towns wishing to purchase a samian vessel or two could do so at a shop or stall (Willis 2005, 6.1). If so, then how much would that inhabitant expect to pay? The limited information we have on prices suggests that, during the late 2nd century, a decorated Drag 37 bowl cost 20 *asses* (*cf* Martin 1996, 52). Given the rate of 16 *asses* to one *denarius* (Reece 2002, 108), this is a little over a day's pay for the vineyard workers of the eponymous parable (Matthew 20:2), and a little under a day's pay for the legionaries of Septimius Severus; under earlier, 1st-century, emperors, the cost of the bowl approached one-and-a-half days' pay (Lewis and Reinhold 1990, 469; Hartley 2005, 116). In comparison, a graffito also reveals that a plain Ludowici Ta' plate cost 12 *asses* (*cf* Willis 2005, 1.3), or three-quarters of a day's pay for a legionary. The figures should be treated with caution; they do not cover the same period of time, nor account for regional differences. Nevertheless, they provide a useful starting place to order samian forms by value, confirming what we might have thought intuitively: that a decorated bowl cost more than a plain dish.

Extending the sequence, we might expect a plain bowl (eg Drag 38), being deeper, to be more expensive than a plain dish, and a cup (eg Drag 33) to be cheaper. Mortaria and mortarium-like forms (eg Drag 45 and Curle 21), being large and robust and incorporating technically-challenging elements like spouted collars and trituration grits, may have been priced closer to decorated bowls. Rather pleasingly, this sequence finds some agreement with price lists for modern reproduction samian. That accompanying Gilbert Burroughes' replicas (see also Burroughes, this volume) follows a similar order, cups being the cheapest and decorated bowls being the most expensive, with plain dishes somewhere in between. And if we are reasonably satisfied about the order of forms and relative values given on this modern price list, then it provides a model with which to examine samian expenditure in Roman Britain.

Grave groups are ideal for such a study, representing closed single-event assemblages with all the samian being deposited at the same time. Viewed in terms of the price list, a grave group comprising two dishes represented a greater financial outlay than one consisting of a cup only. On this basis, we can order samian-yielding graves according to expenditure, allowing us to compare the status of graves within cemeteries, as well as the status of cemeteries as a whole across different site-types, and with this information contribute to questions related to the supply of funerary pottery.

To gain a systematic picture of samian expenditure, I collected data from almost 40 cemeteries and single high-status graves from across south-east England, mainly Kent and Essex, but also including some from Sussex, Hertfordshire and Buckinghamshire. (Graves labelled as high-status have been identified not on the basis of their samian, but other aspects that set them apart from the normal range of graves seen in settlement cemeteries. These include the presence of glass or metal vessels such as bottles and patera, the use of lead coffins and stone sarcophagi, or the construction of barrows and perimeter walls.) This gave me a database of over 300 samian-yielding graves containing 446 samian vessels (Tables 28.1 and 28.2). In order to calculate samian expenditure for each grave, I devised a list of prices for samian forms based on the price list provided by Gilbert Burroughes (Table 28.3). My prices largely reflect modern market values, though I made some amendments. I standardised values across vessel classes, so that, for example, all cups are valued at £15 (or, if preferred, 15 'samian purchasing units'), while all plain dishes are £25. Drag 36, a dish with barbotine rim-decoration, is valued with plain bowls at £30. In addition, the decorated bowl Drag 29 is priced at £60, a little lower than its current market value. Not only does this give all mould-decorated bowls an identical value, but it also describes a relationship between decorated bowls and plain dishes that is closer to that suggested by the graffiti on the Drag 37 and Ludowici Ta'.

Site	County	Status	Number of graves with samian	Mean samian expenditure per grave	Reference
Allington-Maidstone	Kent	High-status	1	£65	VCH Kent, vol 3 (1932), 144
Bartlow Hills-Ashdon	Essex	High-status	3	£85	VCH Essex, vol 3 (1963), 39–43
Beverley Road-Colchester	Essex	Urban centre	20	£34.75	May 1930
Boxfield Farm-Stevenage	Herts	Rural settlement	12	£30	Hunn and Going 1999, 29–33
Butt Road-Colchester	Essex	Urban centre	2	£22.50	Crummy and Crossan 1993, 4–163
Chequers Lane-Great Dunmow	Essex	Small town	8	£29.38	Wickenden 1988
Churchyard-Great Wakering	Essex	Small town	1	£55	Dale and Vaughan, in prep
Cranmer House-Canterbury	Kent	Urban centre	8	£21.88	Frere et al 1987
Darenth	Kent	Villa	1	£25	VCH Kent, vol 3 (1932), 151
Duckend Car Park-Stansted	Essex	High-status	2	£140	Havis and Brooks 2004
Duckend Car Park-Stansted	Essex	Rural settlement	3	£30	Havis and Brooks 2004
Dunmow High School-Great Dunmow	Essex	Small town	3	£25	O'Brien 2003
Each End-Ash	Kent	?Rural settlement	10	£29.50	Savage 1998, 133–148
Elms farm-Heybridge	Essex	Small town	4	£26.25	Biddulph et al forthcoming; Atkinson and Preston 1998
Haslers Lane-Great Dunmow	Essex	Small town	14	£28.57	Hickling 2003
Hassocks	Sussex	?Small town	6	£31.67	Lyne 1994
Kelvedon	Essex	Small town	4	£31	Rodwell 1988
Leafy Grove-Keston	Kent	Villa	1	£40	Philp 1973, 94–98
Little Oakley	Essex	?Villa	1	£15	Barfield 2002, 62–63
Langley-Maidstone	Kent	High-status	1	£25	VCH Kent, vol 3 (1932), 158–60
Luton-Chatham	Kent	High-status	1	£115	VCH Kent, vol 3 (1932), 160
Ospringe	Kent	Small town	63	£23.81	Whiting 1921, 1923, 1925, 1926; Whiting et al 1931
Pepper Hill-Southfleet	Kent	Small town	35	£26.14	Biddulph 2006a
Plaxtol-Maidstone	Kent	Villa	1	£65	VCH Kent, vol 3 (1932), 163
Pleshey	Essex	High-status	2	£100	VCH Essex, vol 3 (1963), 166
Radnage	Bucks	High-status	1	£225	Skilbeck 1923, 242–3
Skeleton Green	Herts	Small town	30	£27.17	Partridge 1981, 258–65
Southfleet	Kent	High-status	1	£50	Rashleigh 1808, 221–3
St John's Abbey-Colchester	Essex	Urban centre	1	£25	Crummy 1993, 203–235
St Pancras-Chichester	Sussex	Urban centre	33	£35.78	Down 1971
St Stephen's-Verulamium	Herts	Urban centre	14	£32.50	Davey 1935, 243–275
Strood Hall-Little Canfield	Essex	Rural settlement	8	£28.13	Timby et al 2007, table 3.2
Sutton Valence-Maidstone	Kent	High-status	1	£115	VCH Kent, vol 3 (1932), 170–1
Takeley	Essex	High-status	2	£75	VCH Essex, vol 3 (1963), 185
Toppesfield	Essex	High-status	1	£45	VCH Essex, vol 3 (1963), 192–3
Westhawk Farm-Ashford	Kent	Small town	5	£52	Booth et al forthcoming
Weston Turville	Bucks	High-status	1	£65	Waugh 1962

Table 28.1: The dataset

Vessel class	Towns and rural settlements		High-status/villas	
	Vessel count	%	Vessel count	%
Cups	122	33%	26	37%
Dishes/plates	213	57%	40	56%
Bowls	32	9%	-	-
Decorated bowls	1	<1%	4	6%
Other forms	7	2%	1	2%
TOTAL	375		71	

Table 28.2: Distribution of vessel class among low- and high-status sites

Vessel class	Form (present in dataset)	Value
Cup	Drag. 13, 24/25, 27, 33, 35, 40, 42, 46	£15
Beaker/jar	Drag. 54, 67, 72	£15
Plate	Drag. 15/31, 18	£25
Dish	Drag. 18/31, 18/31R, 22, 31, 32, 42, 79, Curle 15	£25
Decorated dish	Drag. 36	£30
Flagon	Stanfield 1929, 67	£30
Bowl	Drag. 38, Curle 11	£30
Decorated bowl	Drag. 29, 30, 37	£60
Mortarium	Drag. 45	£60

Table 28.3: List of prices for samian forms

Site	Status	Mean	Standard deviation (sd)	Coeffecient of variation (sd/mean)
Colchester	Urban centre	34.74	34.77	1
Ash	Rural settlement	29.5	13.83	0.5
Stevenage	Rural settlement	30	14.62	0.5
Chichester	Urban centre	35.76	15	0.4
Strood Hall	Rural settlement	28.13	11.93	0.4
Pepper Hill	Small town	26.1	9.24	0.4
Verulamium	Urban centre	32.5	13.41	0.4
Ospringe	Small town	23.8	7.9	0.3
Hassocks	Small town	31.67	10.8	0.3
Gt Dunmow	Small town	25	6.79	0.3

Table 28.4: Comparison of selected cemeteries using standard deviation as a measure of dispersion

Calculating value

Using this pricing scheme we can calculate the value of the samian in each grave. For example, early to mid 2nd-century grave 1287 from Strood Hall, a rural settlement in north-west Essex (Timby *et al* 2007, table 3.2), contained a South Gaulish Drag 18 plate costing £25 and a Central Gaulish Drag 27 cup costing £15, giving a total cost of £40. Moving to north Kent, late 2nd-century grave 451 from Pepper Hill, one of the cemeteries surrounding Springhead or *Vagniacis* (Biddulph 2006a), contained a Drag 46 cup at £15 and a Curle 11 bowl at £30, the group totalling £45. At the higher end of the range, grave 26 from Stansted, possibly associated with a villa (Havis and Brooks 2004, fig 155, 85), contained two Drag 35 cups costing £15 each, one Drag 27 cup costing another £15, a Drag 18/31R dish costing £25,

and a Drag 37 decorated bowl costing £60, together totalling £130. If we calculate the mean expenditure per grave for these cemeteries, we reach a figure of £28.13 for Strood Hall, based on eight samian-yielding graves, £26.14 for Pepper Hill, based on 35 graves, and the somewhat higher £140 at Stansted, the average of two high-status graves. Table 28.1 provides the averages for a further 37 sites, where we can see a generally uniform value across settlements of different types – rural settlements, some villas, small towns, and urban centres – but noticeably higher values for high-status graves. The overall mean expenditure per grave for rural settlements is £33.53. This compares with £30.46 for small towns and £28.81 for urban centres.

At first glance, these means are similar enough to suggest that there was little difference in the levels of expenditure, and

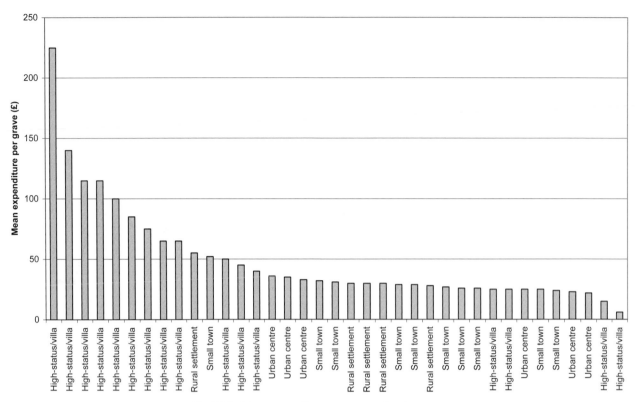

Fig 28.1: Mean expenditure per grave by site status

therefore wealth, across these settlement types. The burial of a deceased resident of the rural settlement at Boxfield Farm, Stevenage, would not differ greatly in scale and range of goods deposited than that of a Colchester resident, at least among those for whom samian was available. There is a slight drop in mean with increased size of settlement, but this does not appear to be significant. Of greater interest, though, is a comparison of the dispersion of values among sites (Table 28.4). Beginning with Beverley Road-Colchester, an urban centre, its mean of £34.75 is matched by a standard deviation of £34.77, which is the product of a wide range of values, from £15-worth of samian in one grave, to £170 in another. By comparison, Chequers Lane-Great Dunmow, a small town, has a standard deviation of £6.79, against a mean of £25, with values ranging from £15 to £45. The standard deviation of Pepper Hill cemetery, belonging to another small town, seems just as modest at £9.24, while that of St Pancras-Chichester (a major town) is somewhat higher at £15. The differences point to a generally wider range of values with increased settlement size, although we should note that rural settlements like Strood Hall-Little Canfield and Each End-Ash enjoyed relatively high standard deviations of £11.93 and £13.83 respectively. Such differences in the levels of expenditure are perhaps what we would expect. Burials in a settlement like Colchester are likely to reflect a socially- or economically-diverse population, encompassing, for example, town officials, veterans, businessmen, artisans, traders, slaves, and the destitute, though the effects of wealth differences might be mitigated to some extent by burial clubs and the activities of guilds (Biddulph 2006b, 356). A settlement with a smaller

population such as a small town might see fewer extremes of wealth and therefore show less differentiated expenditure. Rural settlements do not easily fit this model, though they might better correspond with villas and have a population comprising a relatively wealthy leading family and poorer estate workers. But we should be careful when interpreting these figures. Using the coefficient of variation to standardise the measure of dispersion and reduce the effects of sample size (Table 28.4; Shennan 1997, 44), differences between sites are not so marked, though the sites are broadly in the expected order. Colchester is exceptional, retaining a strong sense of highly variable samian expenditure and thus a diverse population.

The overall mean for high-status graves, including those associated with villas, was £81.75. This reflects a higher average number of samian vessels per grave compared with that for lower-status sites and the greater incidence of the more expensive decorated forms, such as Drag 29 and 37. Expenditure ranged from £15 at Little Oakley villa to £225 at Radnage. The standard deviation (£54.20) and the coefficient of variation (0.7) further indicate wide-ranging expenditure. But while there was a degree of overlap between these sites and lower-status cemeteries (Fig 28.1), the majority of high-status graves contained samian worth more than the values at the higher end of the spectrum observed among other cemeteries. Some 60% of lower-status graves contained samian worth between £20 and £30. Twenty per cent of graves contained samian worth over £30. In contrast, just 5% of high-status graves graves had samian worth less than £30. Clearly high-status graves are characterised by high

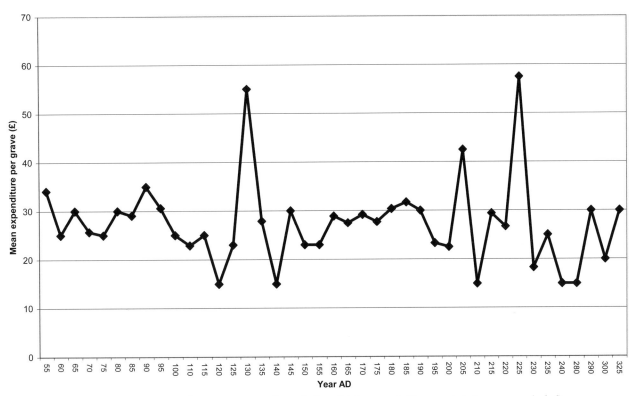

Fig 28.2: Mean expenditure per grave through time (high-status/villa-associated graves excluded)

samian expenditure, and this level of expenditure appears to be significantly different to that of lower-status graves; samian assemblages of the sort normally seen in high-status graves are rare occurrences in graves belonging to settlement cemeteries. Indeed, Fig 28.3 highlights how uniform average expenditure is across lower-status sites, showing a relatively flat profile that reflects the narrow range (£15–£30) into which the majority of graves were placed; high-status graves in contrast display much broader limits on expenditure. This may reflect differences in the ways that pottery was acquired for burial, with high-status graves benefiting from better access to samian, although the broadly similar proportions of vessel classes recorded at high and lower-status assemblages (Table 28.2) suggest that mourners from both ends of the social spectrum acquired pottery from the same supply stream. The expenditure in high-status graves may therefore be attributable simply to greater wealth. In any case, the pattern of expenditure emphasises the preferential selection of samian for high-status graves, and supports the assertion that samian had a value that other pottery lacked (Biddulph 2005, 34). If any pottery was to be selected for burial in high-status graves, it usually had to be samian.

It is worth recalling, though, that some settlement cemeteries included some very rich graves. Grave 8 from Beverley Road-Colchester contained eleven samian vessels totalling £170. The samian from grave 220 from Westhawk Farm-Ashford totalled £155, while samian worth £90 was recovered from Skeleton Green's grave 49. Given that the occasional very high samian expenditure seen at settlement cemeteries matches the range of values more commonly recorded from high-status graves, it seems reasonable to suggest that the individuals buried in those graves shared social or economic status. If the high-status graves marked the burial of local aristocracy, civil or religious officials, or other members of the local elite, then high-ranking individuals were also to be found in otherwise ordinary cemeteries.

A fluctuating market

The close dating of stamped samian and, to a lesser extent, decorated vessels allows graves that contain samian to be dated to within a margin of decades or a few years, and even plain samian without name stamps offers relatively good dating. Given this strong chronological framework, we can use the price list to suggest how samian expenditure changed over time. To this end, I gave each grave in the dataset a single date to the nearest five years based on the mid-point of that grave's date range; essentially I averaged its earliest and latest date, so that a grave dated to AD 120–170, say, was given a mean date of AD 145. I then calculated the average expenditure for each 5-year period. The results, excluding high-status graves, are shown on Fig 28.2. The 1st century was a period of fluctuating expenditure. The average expenditure per grave in AD 55 was £34.10, declining to £25 in AD 75. Expenditure increased over the next fifteen years, reaching £35 in AD 90. Values dropped again, falling to £15 in AD 120. Expenditure was somewhat erratic during the next 20 years, but after AD 140, there was a slow, though steady, rise in values, reaching £31.70 in AD 185. Another decline followed – average expenditure in AD 200 was £22.50 – and thereafter expenditure returned to a more erratic pattern, never again becoming stable.

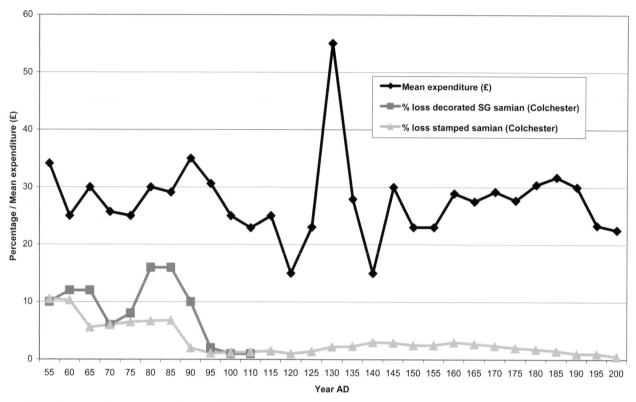

Fig 28.3: Pattern of samian supply to Colchester using stamps and decorated samian compared with mean expenditure per grave (high-status/villa-associated graves excluded)

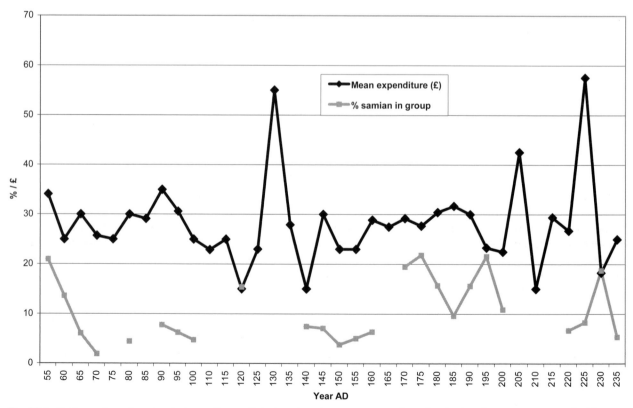

Fig 28.4: Pattern of samian supply to south-east Britain using the percentage of samian in dated groups compared with mean expenditure per grave (high-status/villa-associated graves excluded)

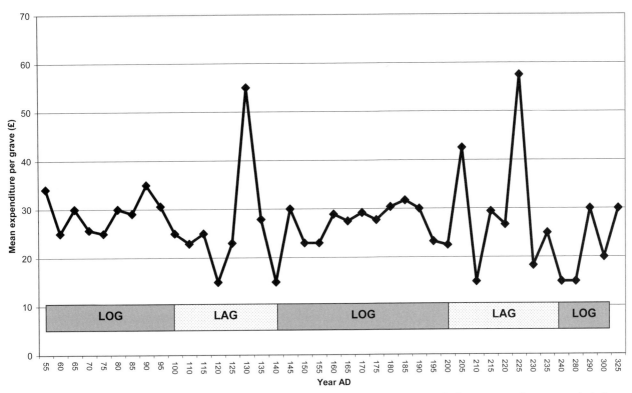

Fig 28.5: Economic cycles compared with mean expenditure per grave (high-status/villa-associated graves excluded)

Of course, an examination of expenditure on a chronological basis must consider factors like inflation and the presence of residual samian. Both are complicating, inflation perhaps more so than residuality, despite the use of coinage and documents. Residual samian is scarcely a more approachable topic, depending largely on stratigraphic associations, which sometimes remain unrecorded in the case of older cemetery reports, or are in any case absent where no intercutting is observed. This study takes the line of least resistance and largely avoids these issues, assuming a good degree of concordance between the dating of graves and the samian.

That is not to say that the picture of fluctuating expenditure presented in Fig 28.2 cannot be calibrated, as a range of ceramic data can be used to test the pattern and place it in context. The most obvious starting place is to compare samian expenditure with samian supply patterns, some of which are shown in Fig 28.3. Looking first at the average percentage loss of decorated South Gaulish samian at Colchester (Dannell 1999, fig 2, 1), we can see a good match with mean expenditure. The percentage of loss – or the volume of supply – falls between AD 55 and 70 and corresponds with a drop in mean expenditure. A subsequent increase in samian-discard, and therefore supply, up to about AD 80 is matched with increased expenditure. The fall in the volume of discarded samian that follows, which runs to the end of South Gaulish samian supply to Britain in about AD 110, is paralleled with a fall in samian expenditure. The pattern is clear: a high volume of samian supply is accompanied by high samian expenditure for graves, and when supply falls, so too does expenditure. And while the correspondence is not exact – expenditure appears

to be slightly out of step with supply to Colchester by about 5 years – the peaks and troughs of expenditure generally follow those of South Gaulish supply to Britain, which is characterised by a strong period of growth beginning in *c* AD 60 and continuing until 90, and thereafter a decline in volume as supply fell back first to military markets in Germany, then retreated to local consumers by 120 (information from a demonstration of a samian database (www1.rgzm.de/samian/home/frames.htm) by A Mees in Cardiff, July 2007).

Colchester's stamped samian shows a slightly different pattern (Dickinson 1999, fig 2, 64). For much of the 1st century, there is a reasonably good correlation between the percentage loss of stamped samian and mean expenditure – both rise and fall broadly at the same time (Fig 28.3). But after a somewhat flat early 2nd century, the trends start to diverge, with the rise and subsequent fall in the proportion of stamped samian occurring perhaps twenty years before we see similar changes in the mean-expenditure pattern. There are of course pitfalls in constructing a pattern of samian supply from samian stamps. Typically the proportion of legible and datable stamped pottery in any assemblage is pitifully small, and the record is biased towards forms more usually stamped, and against East Gaulish factories where stamping was relatively uncommon (Willis 2005, 5.3.1). The data perhaps reveal as much about stamping as supply, and other data are required to support the picture gained from stamps. One source of information is the proportion of samian present in dated groups. Willis (2005, table 27) presents samian data from a number of such assemblages, and taking those from sites in south-eastern Britain, averaging group date-ranges to produce a single year to the nearest five

years, we can plot the information against mean expenditure (Fig 28.4). The trends do not match exactly, and the number of dated groups does not allow a complete sequence, but the changing proportions of samian nevertheless follow the pattern of Colchester's decorated samian reasonably closely, so that when the proportion increases, expenditure rises, and when the proportion decreases, expenditure drops. One area of concern is the period AD 175–185, when the proportion of samian decreases sharply against a period of increasing expenditure. However, this may in part be due to the number of dated groups in the dataset, and many more groups than the handful offered by Willis may be needed to correct the average.

There is one further point of interest. In his remarkable paper on Roman-period ceramic chronology in Britain, C J Going (1992) identified a series of economic cycles marking the peaks and troughs of pottery production. He described 'log' periods, when industries expanded and were innovative, and 'lag' periods, when production declined and development stagnated. He suggested that the pattern was related to the fortunes of continental pottery production, most notably samian, detecting there the beginnings of economic waves that were ultimately felt in Britain (Going 1992, 108). Plotting these periods against mean samian expenditure (Fig 28.5), we find that the 'lag' periods of recession coincide with periods when expenditure became very erratic, while 'log' periods of industry growth correspond with smoother, more structured and relatively quieter changes in expenditure. Interestingly, the erratic expenditure profile continued into the log period dated after AD 240, a time when the samian industries had collapsed and samian importation had virtually ceased. We may be able to identify in 'lag' periods, and the period after 240, erratic samian supply which caused the market (whether dependent on new samian or second-hand vessels) to rise and crash in short succession. Perhaps as a result, samian prices became volatile and the effects of inflation were felt. The absence of new samian meant that the samian market – and prices – was subject solely to internal forces. This may have relevance to the deposition of residual samian. We may notice, for example, that most of the residual or 'antique' samian identified by Colin Wallace (2006) is present in Going's 'lag' periods. If there was an organised secondary market in older samian, then this seems to have been triggered when new supply was scarce. However, the suggestion requires testing with more data on residual samian.

Towards a new model

Picking out the main trends of this analysis, we can see that high-status burials on the one hand and towns and rural settlements on the other are separated by the amounts spent on samian – high-status burials generally show much higher levels of expenditure. We can also suggest that samian expenditure was closely tied to samian supply: increased volume of supply led to a rise in expenditure on funerary samian. In truth, these patterns can also be seen using other measures, such as the average number of samian vessels per grave, site, or year. There are advantages, however, with using relative vessel values. Based on our albeit limited knowledge of vessel prices, the measure is a more realistic one, allowing us to compare the social or economic status of grave-groups not only in terms of vessel count, but also vessel type. Also, the scheme offers a larger scale with which to view grave-groups and cemeteries, resulting in a more nuanced picture; any variations are bigger and more visible compared with, say, the number of vessels, with which differences tend to be measured in fractions of a single pot.

That said, the relative price scheme does not match reality in one respect. It is based in part on Gilbert Burroughes' price list, which necessarily reflects modern manufacturing costs. The basis on which the market value of ancient samian was calculated – that is, the factors that determined the prices that the inhabitants encountered on the streets of Roman Britain – is by no means certain, but it is very unlikely to have been linked directly with manufacturing costs. Instead, the market value was a product of transportation costs, insured risk, and in-built profit-margins (Dannell 2002, 234–6, and pers comm). Samian producers on the whole did not benefit greatly from an empire-wide trade zone; theirs was essentially a local market, and the products of most manufactories did not travel beyond it. A few centres, mainly La Graufensenque, Lezoux, and a number of East Gaulish sites, prospered, and their pots reached Britain. However, even in these manufactories, production did not reflect demand in those distant markets, and the fortunes of the production centres remained tied to the consumers on their doorsteps (Woolf 2000, 197–201). To move it beyond local markets, samian was taken up by pottery traders – *negiotiatores cretarii* – who identified maturing markets and established relatively stable and profitable trading relationships. This was no simple process itself, involving stages en route where the pottery changed hands and consignments were denuded, swapped, or added to. A dump of South Gaulish Drag 37s in a tank in Lodève (Dannell 2002, 234), or the wreck-assemblage of undecorated bowls and dishes from Pudding Pan Rock off the Kentish coast, both biased assemblages, reveal that traders did not necessarily carry representative selections of products from the workshops. The general character of samian assemblages from British sites, being of mixed source and potter, also suggests that the pottery arriving in Britain had long broken its connection with its potters and had been altered by complex trade networks (Willis 2005, 6.4.6).

Once in Britain, the samian was destined for the traders' primary consumers, chiefly the army and major centres like London; there the pottery was used or redistributed, and consequently subject to new, local, trading systems. These centres undoubtedly enjoyed reasonably regular supplies (*cf* Willis 2005, 6.3), but the close correlation between supply and funerary expenditure demonstrated above (Figs 28.3 and 28.4) suggests that the 'funerary market' also benefited from accessible samian. That the ware was over-represented in funerary assemblages compared with associated domestic

assemblages is well-appreciated. At Strood Hall-Little Canfield, for example, samian accounted for approximately 15% of the early Roman cemetery assemblage, but was virtually non-existent in contemporaneous domestic groups (Biddulph *et al* 2007). The occasional presence in graves of worn vessels suggests that some vessels saw domestic use before being deposited in graves, but pristine, seemingly unused vessels are just as common, if not more so. And if the samian in graves typically came from the home, then we might expect to see repaired samian on a regular basis, since the accidental breakage of a samian vessel (a relatively scarce commodity at lower-status settlements) opportunistically released it from household service. However, repaired samian vessels are extremely rare in funerary assemblages. A Drag 36 dish in grave 1593 at Strood Hall had been repaired with lead rivets before deposition (Timby *et al* 2007, fig 3, 36), but this appears to be exceptional. None was recovered, for example, from Pepper Hill cemetery, in contrast to the samian from its associated settlement at Springhead, which included many repaired vessels (Mills, forthcoming). In this respect, funerary assemblages resemble high-status settlement sites and military sites. These received good, regular, supplies of new samian, and their assemblages typically exhibit low frequencies of repaired vessels, in contrast to the higher numbers recorded at small towns and rural settlements (Willis 2005, 11.5; table 73). We may also recall the evidence of graffiti on funerary vessels, which suggests that grave-goods were acquired specifically for burial and given by mourners as gifts, single vessels sometimes representing group donations (Biddulph 2006b). All these factors go a considerable way to indicating that the samian in graves by-passed domestic use and was supplied more-or-less new directly from redistribution centres or by more local, but dedicated, traders. In other words, there was a funerary market distinct from the trade that supplied settlements. Indeed, samian must have been regarded by some inhabitants of Roman Britain as primarily a funerary ware, so strong was the connection between the pottery and burials. If the pottery was stockpiled or reserved for gradual release to the funerary market, for example by burial societies, then this may help to explain the apparent five-year gap between the samian arriving in Britain and its deposition in graves (Fig 28.3).

With this in mind, the necessity for mourners to acquire pots on the death of a family member is entirely feasible. What pots they got depended on the contributions the deceased had made to a burial club, or the purchasing power of the goods or coin the mourners carried with them to the supplier. Many graves were never equipped with samian, and perhaps those that did contain it accompanied the relatively well-off or financially-prudent. While the complicating factors of transportation and marketing mean that it is impossible to assess the validity of the prices offered in Table 28.3, the information on the different pricing of decorated bowls and plain dishes (Martin 1996, 52; Willis 2005, 1.3) suggests that vessels were placed in a relative scheme of values based on form. The order of cups, dishes, bowls, mortaria and decorated bowls is of course debatable;

simply using the criterion of quantity, we could make the case that cups were priced higher than dishes, since dishes were the more common in cemetery assemblages (the other classes generally following my suggested order). Adding a little support to this are graffiti from Pompeii that value a plate, presumably made in a local coarseware, at one *as*, and a drinking vessel at two *asses* (Martin 1996, 52). Countering this view, however, are again the grave-goods with graffiti. Of the funerary samian listed in volume 2 of Roman Inscriptions of Britain (Collingwood and Wright 1995), six of the 23 or so vessels had two or more personal names or ownership marks, and all these vessels were dishes (Drag 18, 18/31, 31, Walters 79, and Curle 23). If vessels with multiple graffiti represented group gifts, mourners having 'clubbed together' to acquire them (Biddulph 2006b), then this suggests that dishes were less affordable than cups to the individual mourner. The test of higher cup prices is to see how the revised prices match samian supply patterns, and unfortunately the result is rather incoherent. Increasing the cost of cups to, say, £40 and keeping dishes at £25 gives a pattern that provides little correlation, either positive or negative, with samian supply. That said, it is worth noting that cups appear to have had a special status in their own right, at least in Essex, being more strongly associated with high-status burials and having connotations of wine-drinking and Roman food production (Biddulph 2005, 36; Willis 2005, 8.3). Their appearance in ordinary graves may have been fairly restricted, though not necessarily on the ground of expense.

Acknowledgements

This paper is based on a presentation given at the annual conference of the Study Group for Roman Pottery at Cardiff in 2007. I am grateful to the delegates who commented and made helpful suggestions. I also would like to record my thanks to Gilbert Burroughes and Geoffrey Dannell for their advice and support; I am especially thankful to Geoffrey for pointing me in the right direction with regard to the marketing of samian. I, like all students of samian, owe an enormous debt to Brenda Dickinson, whose breadth of knowledge and meticulous research have laid the strongest foundation for researchers like me newly entering the complex world of samian. I am privileged to contribute this paper to her Festschrift, and my thanks go to the organisers for allowing it to be included. But, of course, any errors in the paper are my responsibility alone.

Bibliography

Atkinson, M, and Preston, S J, 1998. The late Iron Age and Roman settlement at Elms Farm, Heybridge, Essex, 1993–5: an interim report, *Britannia* 29, 85–110

Barfield, P M, 2002. *Excavations at Little Oakley, Essex, 1951–78: Roman villa and Saxon settlement*, East Anglian Archaeol Rep 98, Chelmsford

Biddulph, E, 2005. Last orders: choosing pottery for funerals in Roman Essex, *Oxford J Archaeol* 24(1), 23–45

Biddulph, E, 2006a. The Roman Cemetery at Pepper Hill, Southfleet, Kent, *CTRL Integrated Site Report Series*, Archaeology Data

Service http://archaeologydataservice.ac.uk/archives/view/ctrl/phlisr/?CFID=45&CFTOKEN=454ECBCD-4089-404A-BD2E40E91FF417B6

Biddulph, E, 2006b. What's in a name? Graffiti on funerary pottery, *Britannia* 37, 355–8

Biddulph, E, Compton, J, and Martin, T S, forthcoming. The late Iron Age and Roman pottery, in M Atkinson and S J Preston, *Heybridge: a late Iron Age and Roman settlement, excavations at Elms Farm*, East Anglian Archaeol Rep, Chelmsford

Biddulph, E, Jones, G P, and Stansbie, D, 2007. Late Iron Age and Roman pottery, in Timby *et al* 2007, CD Rom Chapter 4

Booth, P, Bingham, A, and Lawrence, L, 2008. *The Roman roadside settlement at Westhawk Farm, Ashford, Kent: excavations 1998–9*, Oxford Archaeol Monogr 2, Oxford

Collingwood, R G, and Wright, R P, 1995. *The Roman inscriptions of Britain* 2, Instrumentum Domesticum *(personal belongings and the like)*, Fasc 7, *Graffiti on samian ware (*terra sigillata*)*, *(RIB* 2501.1–880) (eds SS Frere and R S O Tomlin), Stroud

Crummy, N, and Crossan, C, 1993. Excavation at Butt Road Roman cemetery, 1976–9, 1986 and 1989, in Crummy *et al* 1993, 4–163

Crummy, N, Crummy, P, and Crossan, C, 1993. *Excavations of Roman and later cemeteries, churches and monastic sites in Colchester, 1971–88*, Colchester Archaeol Rep 9, Colchester

Crummy, P, 1993. Excavation and observations in the grounds of St John's Abbey, 1971–85, in Crummy *et al* 1993, 203–35

Dale, R, and Vaughn, T, in prep. *St Nicholas' Church cemetery extension, New Road, Great Wakering: excavation 2000*, Essex County Council/English Heritage

Dannell, G B, 1999. Decorated South Gaulish samian, in Symonds and Wade 1999, 13–74

Dannell, G B, 2002. Law and practice: further thoughts on the organization of the potteries at la Graufesenque, in *Céramique de la Graufesenque et autre productions d'époque romaine. Nouvelles recherches. Hommages à Bettina Hoffmann* (eds M Genin and A Vernhet), Archéologie et histoire romaine 7, Montagnac, 211–42

Davey, N, 1935. The Romano-British cemetery at St Stephen's, St Albans, *Trans St Albans Hertfordshire Archit Archaeol Soc*, 243–75

Dickinson, B, 1999. Samian stamps, in Symonds and Wade 1999, 120–36

Down, A, 1971. The Roman cemetery at St Pancras, in A Down and M Rule, *Chichester excavations I*, 53–127, Chichester

Frere, S S, Bennett, P, Rady, J, and Stow, S, 1987. *Canterbury excavations: intra- and extra-mural sites, 1949–55 and 1980–84*, The Archaeol of Canterbury 8, Maidstone

Going, C J, 1992. Economic 'long-waves' in the Roman period? A reconnaissance of the Romano-British ceramic evidence, *Oxford J Archaeol* 11(1), 93–115

Hartley, B R, 2005. Pots for tables; tables awaiting pots: an exercise in archaeoeconomy, in *An archaeological miscellany: papers in honour of K F Hartley* (eds G B Dannell and P V Irving), *J Roman Pottery Stud* 12, 112–16, Oxford

Havis, R, and Brooks, H, 2004. *Excavations at Stansted Airport 1985–91*, East Anglian Archaeol Rep 107, Chelmsford

Hickling, S, 2003. Excavations at Haslers Lane, Great Dunmow, *Counc Brit Archaeol Mid-Anglia Group newsletter, summer 2003*

Hicks, A J, 1998. Excavations at Each End, Ash, 1992, *Archaeol Cantiana* 118, 91–172

Hunn, J R, and Going C J, 1999. *Excavations at Boxfield Farm, Chells, Stevenage, Hertfordshire*, Hertfordshire Archaeol Trust Rep 2, Hertford

Lewis, N, and Reinhold, M, 1990. *Roman Civilization Volume II: Selected readings*, Columbia University Press, New York

Lyne, M, 1994. The Hassocks cemetery, *Sussex Archaeol Collect* 132, 53–85

Martin, T, 1996. *Céramiques sigillées et potiers gallo-romains de Montans*, Montauban

May, T, 1930. *Catalogue of the Roman pottery in the Colchester and Essex Museum*, Cambridge

Mills, J, forthcoming. The samian ware, in *Settling the Ebbsfleet Valley: CTRL excavations at Springhead and Northfleet, Kent – the late Iron Age, Roman, Anglo-Saxon and medieval landscape* (P Andrews, E Biddulph, A Hardy, and A Smith), Oxford Wessex Monogr

O'Brien, L, 2003. A Roman cremation cemetery at Dunmow Junior School, High Stile, Great Dunmow, Essex, *Counc Brit Archaeol Mid-Anglia Group newsletter summer 2003*

Partridge, C, 1981. *Skeleton Green: a late Iron Age and Romano-British site*, Britannia Monogr 2, London

Philp, B, 1973. *Excavations in West Kent 1960–1970, the discovery and excavation of prehistoric, Roman, Saxon and medieval sites, mainly in the Bromley area and in the Darent valley*, Kent Archaeol Res Rep 2, Dover

Rashleigh, P, 1808. An account of antiquities discovered at Southfleet in Kent, *Archaeologia* 14, 37–9, 221–3

Reece, R, 2002. *The coinage of Roman Britain*, Stroud

Rodwell, K A, 1988. *The prehistoric and Roman settlement at Kelvedon, Essex*, Counc Brit Archaeol Res Rep 63, London

Savage, A, 1998. The Roman pottery, in Hicks 1998, 132–50

Shennan, S, 1997. *Quantifying archaeology*, Iowa City

Skilbeck, C F, 1923. Roman remains at Radnage, *Records of Buckinghamshire* 11(5), 242–3

Symonds, R P, and Wade, S, 1999. *Roman pottery from excavations in Colchester, 1971–86*, Colchester Archaeol Rep 10, Colchester

Timby, J, Brown, R, Biddulph, E, Hardy, A, and Powell, A, 2007. *A slice of rural Essex: archaeological discoveries from the A120 between Stansted and Braintree*, Oxford Wessex Monogr 1, Oxford and Salisbury

VCH Kent 3 = W Page (ed), 1932. *The Victoria History of the county of Kent 3*, London

VCH Essex 3 = W R Powell (ed), 1963. *The Victoria History of the county of Essex 3*, London

Wallace, C, 2006. Long-lived samian?, *Britannia* 37, 259–72

Waugh, H, 1962. The Romano-British burial at Weston Turville, *Records of Buckinghamshire* 17(2), 107–14

Whiting, W, 1921. A Roman cemetery discovered at Ospringe, *Archaeol Cantiana* 35, 1–16

Whiting, W, 1923. A Roman cemetery discovered at Ospringe, *Archaeol Cantiana* 36, 65–80

Whiting, W, 1925. Roman cemeteries at Ospringe, *Archaeol Cantiana* 37, 83–96

Whiting, W, 1926. The Roman cemeteries at Ospringe. Description of finds concluded, *Archaeol Cantiana* 38, 123–51

Whiting, W, Hawley, W, and May, T, 1931. *Report on the excavation of the Roman cemetery at Ospringe, Kent*, Rep Res Comm Soc Antiq London 8, Oxford

Wickenden, N P, 1988. *Excavations at Great Dunmow, Essex: a Romano-British small town in the Trinovantian civitas*, East Anglian Archaeol 41, Chelmsford

Willis, S, 2005. *Samian pottery, a resource for the study of Roman Britain and beyond: the results of the English Heritage funded samian project. An e-monograph*, Internet Archaeol 17 (http://intarch.ac.uk/journal/issue17/willis_toc.html)

Woolf, G, 2000. *Becoming Roman: the origins of provincial civilization in Gaul*, Cambridge

29 Aspects of the use of samian pottery in Romano-British funerary practices

H E M Cool and R S Leary

Introduction

We take as our starting point a comment made by Brenda and her colleagues in their discussion of the samian from Brougham: 'As far as we know, no specific study has been made of the samian ware from cemeteries in Britain' (Dickinson *et al* 2004, 346). This aside caught the eye of one reviewer, who mused that 'surely there is a thesis topic there for some bright student' (Ottaway 2004, 249). Since then, a survey of the samian from 30 cemetery sites has appeared (Willis 2005, Section 9) and the role of samian in vessel assemblages in graves has also been considered (Biddulph 2005). Both of these were limited in geographic scope, concentrating on the south-east. They were also limited in another aspect as they concentrated on vessels deliberately placed in the grave as grave goods. Material culture was used in various aspects of a funeral, not just when the deceased was placed in the grave. In this paper we seek to explore the wider role of samian pottery within Romano-British funerals. To do full justice to the topic would indeed be the work of a bright student labouring for three years for their doctorate, and so we have had to be selective about the data used and questions asked. We hope though, that we will have highlighted avenues where further research would be useful.

The paper concentrates on cemeteries where burial was by cremation, the rite dominant during the period when samian was being produced. It is now understood that cremating an individual can produce a variety of different archaeological features. These are summarised here but a more extended discussion can be found in McKinley 2000. There will be *pyre sites* which may, occasionally, become the final resting place of the deceased (*bustum* burials). The cremated bones and other debris from the pyre may be placed in formal burials which are either *urned* or *unurned*. In the latter case the bones may be loose or have been in an organic container which has not survived. As well as being left on the pyre or placed in the formal burial, the pyre debris may also be placed in cut features or in spreads (*redeposited pyre debris*). In addition, a recurring type of feature is a pit in which pottery vessels have been

deposited but which contains no traces of human bone. These have been variously termed *cenotaphs*, *memorials* or *special pot deposits*. In cremation burials objects may be deposited with the deceased both on the pyre (*pyre goods*) and in the formal burial (*grave goods*). Fragments of pyre goods can be found in any type of context which contains pyre debris.

The realisation of the complexity of the types of deposits present in a cremation cemetery came relatively recently to Romano-British studies (see Cool 2011 for discussion). For a long time the only elements regularly observed and reported on were the formal burials, though some reports did note the presence of material that had been burnt on the pyre. The regular and systematic reporting of pyre goods is a relatively recent phenomenon and is the result of changes in excavation practice. Although some pyre goods can be picked out by eye during excavation, full recovery will only be achieved by the wet sieving of whole earth samples and this has only become standard within the past two decades. This has governed the data sets available for this paper. Some sites can only be used to explore the formal burials and their grave goods, as evidence for the activity that took place on and around the pyre is lacking in the published reports. Other excavations have recovered the full range of evidence and these can be used to explore the pyre activity as well. Several of these were unpublished at the time of writing and we are very grateful to the individuals and organisations mentioned in the acknowledgements for making the data available.

Our aim has been to produce a data set that includes sites from throughout Roman Britain, that were associated with a variety of communities and that were of different dates. We stress again that the data set is far from exhaustive but is sufficient to illustrate various aspects of the use of samian in burials. The principal sites used are summarised in Table 29.1. In this table the column 'total deposits' includes all cremation-related deposits excavated. In the column 'total formal burials' we have attempted to isolate the deposits that it is reasonable to consider as urned and unurned cremation burials and *busta*. Deposits that excavators may

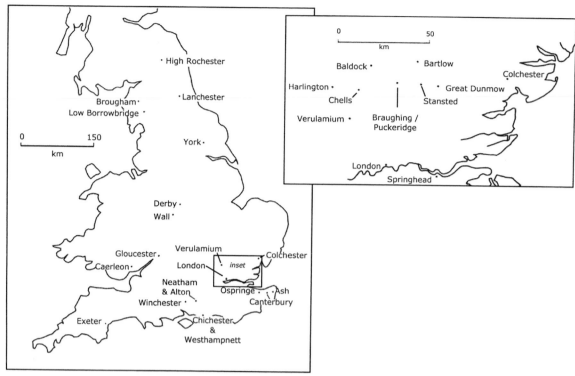

Fig 29.1: Locations of the main sites mentioned in the text

have considered to be 'cremation burials' have thus been excluded if there is no evidence of cremated remains or if the description suggests they are more likely to have been pyre debris deposits. The final column indicates whether information about the pyre goods is available. The location of the sites is given in Fig 29.1.

Apart from specialist contributions cited several times, the convention of citing 'specialist name' in 'main author name' has been used in the text with only the main author present in the bibliography.

The use of samian as a pyre good

A picture is starting to emerge of the type of goods generally considered appropriate to place on the pyre. Table 29.2 summarises the incidence of some of the more common of these and also itemises the quantity of burnt samian at the same cemeteries. As can be seen animal bone was regularly placed on the pyres of at least some of the deceased. Shoes, as evidenced by the hobnails, were regularly present. Melted glass from vessels is also not uncommon. Burnt samian, by contrast, is rare. It is noticeable that in this table those few sites which do have burnt samian have military connections (Caerleon, Wall, Brougham). The evidence from the Derby Racecourse cemetery would support this. Though it cannot be quantified in the same way, it was noted that most of the samian recovered was burnt, and samian is recorded in 26% of the features (this includes the fills of the inhumations). At recent (2006) excavations in the cemetery of the military site at Beckfoot 76% of the samian assemblage of 32 sherds was burnt.

Data from Brougham always have to be used with

some caution as many strands of evidence suggest the community was ethnically distinct and practised rites that were not shared by contemporary military communities. Even allowing for this, it would appear that samian was more likely to be used in pyre ceremonies amongst military communities than amongst other ones. The case should not be overstated, however; as can be seen from Table 29.2 the number of deposits where this occurs is always very small and at some military sites such as Low Borrowbridge, Petty Knowes and Lanchester, samian in any form is absent.

Elsewhere burnt samian at cemetery sites is sometimes noted though it is not always possible to quantify it in the same way as has been done in Table 29.2. Important groups have come from York. At the Trentholme Drive cemetery a large deposit of pyre debris belonging to the late 2nd to 3rd century was recognised which contained both burnt samian and melted vessel glass (Wenham 1968, 25). An urned cremation burial accompanied by a large group of burnt samian dated to the Hadrianic to early Antonine period was also recovered from the Mount cemetery (Dickinson and Wenham 1957, 287–8, dating derived from Monaghan 1997, 1135).

The possibility that samian was placed on the pyres at the East London cemetery cannot be entirely discounted. Unfortunately the presentation of the pottery in that report is problematic as it is impossible to ascertain how much, if any, was burnt. Samian is noted as being present in three of the 15 pyre debris deposits, but the excavators observe that the 'link between samian and pyre ritual is unproven' (Barber and Bowsher 2000, 124). The implication of this would be that the samian was unburnt though, if that is correct, its incorporation within the deposits is curious.

Site	Reference	Site type	Date (centuries)	Total deposits	Total formal burials	Nature of evidence
Alton	Millett 1986	Rural	1st	9	9	Formal burials only
Ash	Hicks 1998	Rural	Mid-late 2nd	15	12	Pyre, formal burial, can be quantified
Baldock, sites D-E	Stead and Rigby 1986	Small town	D – 1st E – 2nd	8 15	8 7	Both Formal burials only
Baldock 1925-30	Westell 1931	Small town	Later 1st – end 2nd+	215	215	Formal burials only
Bartlow	Gage, 1834 - 1842.	Rural	2nd	6	6	Formal burials only
Brougham	Cool 2004	Military	3rd	213[1]	132	Pyre, formal burial, can be quantified
Caerleon, Abbeyfield	Evans and Maynard 1997	Military		121	57	
Chells	Going and Hunn 1999	Rural	Later 1st – 2nd	24	21	Ploughed out, formal burial only.
Chichester, St Pancras	Down and Rule 1971	Major town	Later 1st – late 2nd	314	210	Formal burial numbers are the minimum; pyre goods occasionally commented upon.
Derby, Racecourse	Wheeler 1985	Military	Late 1st to 3rd	52[2]	Unknown	Pyre, formal burial, pyre goods cannot be quantified accurately.
Gloucester, London Rd	Simmonds et al 2008; King and Ellis forthcoming	Fortress / Colonia	Mid 1st to 2nd	28	28	Pyre, formal burial, can be quantified
Great Dunmow	Wickenden 1988	Small town	2nd	19(?)	15	Formal burials only
Harlington	Dawson 2001	Rural	1st – 2nd	11	13	Pyre, formal burial, can be quantified
Lanchester	Turner 1990	Military	3rd	57	Unknown	Goods other than animal bone recorded but degree of burning, if any, not noted.
London, Atlantic House	Watson 2003	Major Town	2nd – 3rd	29	27	Pyre, formal burial, can be quantified
London, East cemetery	Barber and Bowsher 2000	Major town	Mid 1st to 4th	176	161	Pyre, formal burial, pyre goods other than pottery can be quantified accurately.
London, West Tenter St.	Whytehead 1986	Major town	Early 2nd – early 3rd	Unknown	14	Formal burials only
Low Borrowbridge	Lambert 1996, 87-125	Military	3rd	71	26	No differentiation was made between formal burials and deposits of pyre debris. Formal numbers are the urned burials.
Neatham	Millett and Graham 1986	Small town	Late 1st to mid 2nd	7	7	Formal burial only
Ospringe	Whiting 1921-26; Whiting et al 1931	Small town	1st – 3rd	183	165	Formal burial only
Pepperhill, Springhead	Anon 2000 Biddulph forthcoming	Small town	Mid 1st to 4th	175[2]	150	Pyre, formal burial, can be quantified
Petty Knowes	Charlton and Mitcheson 1984	Military	Late 1st to mid 2nd	16	Uncertain	Pyre goods recorded and can be approximately quantified
Puckeridge / Braughing	Partridge 1977, 1981	Small town	Late 1st to 3rd	160	141	Formal burials only
Stansted	Havis and Brooks 2004	Rural	1st BC to later 2nd AD	43	37	Pyre, formal burial, not all categories of pyre goods can be quantified accurately.
Strood Hall	Timby et al 2007	Rural		26	25	Pyre, formal burial, can be quantified
Verulamium, Folly Lane	Niblett 1999	Major town	Mid 1st to mid 2nd	22	21	Pyre, formal burial, can be quantified
Wall	McKinley 2008	Military	Late 1st – mid 2nd	63	41	Pyre, formal burial, can be quantified
Westhampnett	Fitzpatrick 1997	Rural	Late 1st -3rd	37	28	Pyre, formal burial, can be quantified

Table 29. 1: Summary of the cemetery data used

Notes

(1) Brougham – this excludes the deposits described as unknown (see Cool 2004, table 4.1).

(2) Derby and Pepperhill were mixed inhumation and cremation cemeteries. The deposits included in this column exclude the cremated material found in the fills of the inhumation burials.

(3) For the purposes of Fig 29.3, where the number of formal burials are noted as unknown here, it has been assumed that half of the total deposits were formal ones

Site	Burnt samian		Hobnail		Glass		Animal bone		Total
	No.	%	No.	%	No.	%	No.	%	
Caerleon	1	1	25	20	0	0	11	9	121
Wall	2	3	14	22	4	6	44	70	63
Brougham	7	3	42	20	15	7	55	26	213
Petty Knowes	0	0	8	50	0	0	1	6	16
Low Borrowbridge	0	0	25	35	0	0	2	3	71
Gloucester	0	0	3	11	8	29	?	?	28
Folly Lane, Verulamium	0	0	2	10	2	10	9	43	21
East London	?	?	35	21	13	8	61	36	169
Ash	0	0	1	7	0	0	4	27	15
Pepperhill	0	0	13	7	0	0	43	25	175
Strood Hall	0	0	2	8	3	12	13	50	26
Westhampnett	0	0	0	0	1	3	2	5	37

Table 29.2: The incidence of selected pyre goods in cremation-related deposits

Note. For the East London cemetery only the pyre goods associated with the formal burials (excluding the bustum) can be quantified

Site	Date (centuries)	Cup	Platter /shallow dish	Plain deep bowl	Dec. bowl	Jar /beaker	Reference
Colchester, Handford House	Mid 1st	3[1]	-	-	-	-	Unpublished, find nos. 21, 91, 1004
Woodlands, Dorset	AD 70 - 85	1[2]	5	-	-	-	Fowler 1965
Caerleon	Late 1st	1	-	-	-	-	Evans and Maynard 1997, 196 burial 60.
Wall	Late 1st to mid 2nd	1	2	-	-	-	McKinley 2008 deposits 122784 & 122975
The Mount, York	Early-mid 2nd	8	2	-	-	-	Dickinson and Wenham 1957, 287-9.
Chichester	2nd	1	-	-	-	-	Down and Rule 1981, 97 no. 59E
Derby	Late 1st - 3rd	Present	Present	1	3	-	Dickinson in Wheeler 1985
Trentholme Drive, York	Mid 2nd – 3rd	2[3]	1	-	9	-	Simpson and Birley in Wenham 1968, 54.
Beckfoot	Mid 2nd – 3rd	4	-	2	3	3	Unpublished
Brougham (deposits)	3rd	-	-	2	4	1	Cool 2004
Brougham (unstratified EVE)	3rd	-	16	52	Present	-	Cool 2004

Table 29.3: Burnt samian by form. The quantification is by minimum numbers of vessels per deposit apart from the unstratified deposits from Brougham
Notes
(1) Handford House – one cup from topsoil.
(2) Decorated form (Knorr 78).
(3) Trentholme Drive. This includes one which might be either a Drag 35 or 36 (ie the fragment could be either a cup or a shallow dish).

These spreads were large, clearly derived from multiple acts of cremation given the numbers of individuals represented, and contained other artefacts which were definitely pyre goods (see Barber and Bowsher 2000, figs 55 and 58).

Table 29.3 summarises the burnt samian at various sites according to broad forms. Cups are taken as small vessels whatever their rim form (Drag 27, 33, 35, 46), the dish category includes such forms as Drag 15/17, 18/31, 36, Curle 15 and Walters 79. Bowls include Drag 31, 31R, 38 and Curle 11. The one burnt mortarium (Drag 45 from Beckfoot) is tabulated as a bowl. Even though this is only a very small data set an intriguing pattern starts to emerge. In the 1st to mid 2nd century cups and shallow dishes are favoured but from the mid 2nd century, whilst those are still present, deeper bowls become far more numerous and almost for the first time decorated samian is thought appropriate to be used regularly. Earlier decorated material is very rare and conspicuously occurs in burials that have good claims to be those of elite individuals, as one example was from the barrow at Woodlands (AD 70–85) and the other from a roadside mausoleum at Derby (late 1st to early 2nd century). It is useful to compare the burnt samian with the proportions occurring in non-sepulchral sites. Table 29.4 quantifies the very large samian assemblage from Piercebridge which has the advantage of showing a strong samian presence well into the 3rd century. Within the plain vessel totals the shift from shallow dishes to deep bowls seen in the burnt material can be explained by general changes of fashion seen in the domestic assemblages. The

growth in the popularity of the decorated deep bowls cannot be explained in the same way and must be reflecting a deliberate choice and possibly change in funerary ritual.

One aspect that would repay careful examination in the future is the degree of burning observed. When this is reported on in any detail it is clear that the burning is not uniform. It ranges from heavy burning that turned the fabric grey, as on a Drag 18 at Wall (deposit 122784) and a Drag 18/31 in the barrow at Woodlands (Simpson in Fowler 1965, 35 no. 9), to cases where the vessels has only been partially burnt. At Derby 22 sherds from a decorated samian bowl (Drag 37) came from Mausoleum 1. Many of the sherds joined and some, but not all, were burnt (Wheeler 1985, 224, 259 fig. 11). The burial on the Mount at York also had vessels which showed differential burning. Some fragments are described as showing 'considerable signs of burning' whilst others 'showed few signs' (Dickinson and Wenham 1957, 287–8). In this case it is not possible to be certain that the differential burning was visible on fragments from the same vessel, but the implication of the wording is that it was.

Vessels burnt grey can plausibly be interpreted as having been on the pyre and subject to a high level of heat for a considerable length of time. They are good candidates for having been placed there at the same time as the body. The role of the vessels described as slightly burnt or differentially burnt is more complex. In an ideal world the degree of burning on a vessel would be compared to the degree of burning the corpse underwent as demonstrated

Date (centuries)	Cup		Shallow dish		Deep bowl plain		Decorated bowl		Total
	No.	%	No.	%	No.	%	No.	%	
Late 1st/mid 2nd	23	19	72	60	2	2	24	20	121
Second half 2nd/3rd	82	15	54	10	378	68	44	8	558[1]

Table 29.4: *Proportions of different samian types at Piercebridge quantified by rim numbers. The dates are based on the production period (source Ward 2008)*
Note
(1) One beaker and three flagons excluded from total

Types	Formal burial	Re-deposited pyre debris	Unstratified	Total
Decorated deep bowls (Drag 30, 37)	6	53	73	132
Plain deep bowl (Drag 31, 31R	-	52	105	157
Plain shallow dishes (Drag 36, Lud Tb)	-	-	33	33
Cut glass jar (Lud VSb)	95	-	-	95
Total	101	105	211	417

Table 29.5: *The burnt samian from Brougham according to deposit type and form (weights in grams)*

by the bone. It is clear that not all cremations in Roman Britain resulted in fully oxidised (white) bone (McKinley 2000, 39), so some of the 'slightly' burnt vessels might just reflect a pyre which did not reach the highest temperature and where the human bone will contain a high proportion of blue and black fragments. It is not always possible to make this comparison at present but it should become easier in the future.

In the case of the differentially burnt bowl from the mausoleum at Derby the bone is well oxidised (Harman in Wheeler 1985, 332), and so it is unlikely that the vessel will have been on the pyre from the outset. It might perhaps have been placed beside the pyre as has been suggested for many of the cremation urns at Brougham which had been burnt on one side only (Evans 2004, 358). Equally though, such vessels might have been placed on the pyre at a late stage of the proceedings. Here the glass vessels may provide a model as their degrees of burning can be very informative. In some cases the glass has become completely molten and has run over the bones, and the lumps of solidified glass can contain fragments of calcined bone and charcoal. Sometimes the molten glass has formed smooth spheres or ovoids. These would result if the molten glass was cooled suddenly by liquids, as could have happened if libations of wine were poured over the pyre. In other cases the glass is a recognisable but deformed vessel or a body fragment whose broken edges have been rendered glossy and slightly rounded as the heat has caused the piece to start to soften. Sometimes both completely melted and merely deformed vessels occur in the same grave suggesting that glass vessels and their contents had a role to play at two different points in the process. Where recognisable the glass vessels are normally some form of unguent flask for perfumed oils and it might be suspected that the completely melted vessels were also containers as the glass is generally blue/green. It could be hypothesised that the completely melted vessels had contained perfumes to anoint the body or the pyre contents at the beginning of the process. The deformed vessels could have been placed

on sometime later. Experimental work has shown that a pyre can maintain temperatures of over 1000°C for up to three hours (McKinley 1997, 134). This would be a high enough temperature, and a long enough time, to completely melt vessels placed on a pyre at the outset, and if others were added towards the end of the period, the pyre would still be hot enough to deform them, though there would not be the time to melt them in their entirety.

If this two-stage model is correct, then different degrees of burning on the samian might provide information of where in the funerary ritual the vessels were used. Establishing what particular vessel types were normally used for is far from straightforward, but there is clear evidence from some mottos that decorated samian bowls may have been associated with drinking rather than eating (Dannell 2006, 158). Drag form 37s are known with strap handles and pouring spouts suitable for wine mixed in the Roman way, and Dannell suggests that some samian cups may have also been used for both mixing and serving mixed wine whereas others may have been for sauces. Biddulph (forthcoming) points out that the cup Drag form 27 may have been used as a ladle for serving wine and references a silver version of the form attached to a tall ivy-wreathed handle (Strong 1966, pl 39A). Given that the practice of using wine to put out the flames of the pyre is attested in Roman literature (Toynbee 1996, 50) and hinted at by some of the melted glass, it would be interesting to compare the degrees of burning on the different forms. It could be hypothesised that forms associated with solid food offerings might be put on the pyre with the body whilst those associated with drinking might be placed there later after libations had been poured. The shallow dishes from Wall and Woodlands burned grey and the differentially burnt decorated bowl from Derby would fit this model, as would some of the melted glass from the Trentholme Drive pyre debris as it can be identified as coming from a colourless cylindrical cup (Harden in Wenham 1968, 93 no. 14). These were the commonest glass drinking vessels at the time of the cremations that generated the debris, and the fact that this example is still

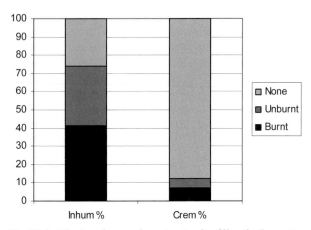

Fig 29.2: The incidence of samian in the fills of inhumation and cremation burials at the Racecourse cemetery, Derby

Burial type	With samian		Without samian		Total
	No.	%	No.	%	
Inhumation burial	58	12	411	88	469
Cremation burial	5	3	156	97	161
Total	65	-	567	-	630

Table 29.6: The incidence of samian in the fills of inhumation and cremation burials in the East London cemetery (data derived from Barber and Bowsher 2000, table 6)

recognisable would argue for the fact that it had not been on the pyre for the full duration of the burning.

Elsewhere it has been possible to explore the degree to which samian burnt on the pyre was incorporated into the formal burials (Polfer 2000, 34–5). In Britain there is currently insufficient data on which to explore this in any depth. At the two cemeteries where it can be examined (Brougham and Wall), there appears to be, if anything, an active shunning of incorporating such material. A comparison with the melted glass at both sites shows that this cannot merely have been because its colour made it clear that it was not part of the body of the deceased. At Wall all of the melted glass occurs in formal burials, and at Brougham it is divided equally between formal burials and redeposited pyre debris. At Wall both deposits that contain burnt samian are pyre debris deposits, and the degree to which the incorporation of burnt samian into formal burials at Brougham is avoided can be seen in Table 29.5. This has included the unstratified material as the nature of the rescue excavations there meant that only deposits that were deemed to be burials were recorded in any detail; everything else was regarded as unstratified. The jar (Cool 2004, 206 no. 253.11) is substantially complete and appears to be a special case which will be considered further below. If it is excluded, then less than 2% by weight was incorporated into the formal burials.

A similar avoidance of burnt samian in the fills of the cremation-related features is also noticeable at Derby (again ignoring the substantially complete Drag 37 from Mausoleum 1 to be considered below). By contrast some 40% of the inhumation grave fills had burnt samian sherds (see Fig 29.2). Several of the inhumation graves with burnt samian had scattered pyre debris within their fill or inserted into them, and the excavator noted that the enclosed cemetery area had a great deal of burnt material scattered within it. The conditions within the enclosure were obviously such that it would not have been difficult to incorporate samian into the fills of the cremation burials but this seems to have been avoided.

One might suspect that something similar was going on

at the East London cemetery. Some of the problems with the reporting of the pottery have already been alluded to. Another is that, other than the deliberately placed vessels in the formal burials, the pottery was without exception considered residual (Barber and Bowsher 2000, 76–7). If that was correct then there should be no association between the amount of samian in the fill and the type of burial. In Table 29.6 the presence of samian in the fills of the two types of burials is compared. As can be seen there is a distinct difference. A Chi-square test allows this to be formally investigated. It returns a p-value of 0.0012 equivalent to a significance level of 0.1%, that is, there is very strong evidence against the assumption that the rite does not influence whether the samian is included in the fill. As published it is not possible to explore the role of samian at the cemetery in more detail, but the evidence suggests that pottery use in the cemetery might have been more complex than allowed for in the report. (For the statistical methodology see Cool and Baxter 2005; here Pearson's Chi-squared test with Yates' continuity correction calculated in R was used).

Against this background of the avoidance of burnt samian in the formal burial, it can be seen that those cases where substantial parts of burnt samian vessels are included are frequently exceptional burials when the broader context is considered. The differentially burnt Drag 37 at Derby came from the burial of an adult in a stone mausoleum. It is noticeable that all the individuals associated with the stone mausolea are distinguished by large weights of cremated bone compared to the formal burials in the walled cemetery there. The weights of bone thought appropriate to collect and deposit varied greatly in Roman Britain (McKinley 2000, 40) but there are some hints that in military cemeteries the elite members of society tended to be represented by high weights. At Brougham the three individuals burned with horses generally had rich pyre goods and unusual grave goods pointing to them being important individuals. Of these two were undisturbed (102, 303) and both had considerably more than 1kg of cremated human bone whereas the average weight from an undisturbed urned cremation burial there was just under 400g (McKinley in Cool 2004, 297). The weight of the bone in the mausoleum alone would be sufficient to mark out this individual as exceptional, but in addition there were also ten pottery lamps and burnt pig, sheep and bird bones. Only one other individual in the cemetery had been cremated with as many animal offerings. The inclusion of large parts of the decorated bowl thus takes its place

amongst the other unusual aspects of the burial of someone who may have been a senior officer in the unit.

The cut-glass beaker from Brougham, by contrast, was deposited with an infant aged between three and four. This child, most likely a little girl to judge by the numerous melted beads that accompanied her, had a richly furnished pyre with silver amongst the pyre goods. At Brougham the whole funerary ritual was very closely structured according to the age and the sex of the deceased. Young children were often afforded special treatment both in their grave goods and the position of the burials. That this unusual vessel, the only one from the cemetery, should accompany the child from the pyre to the grave is not surprising against that background.

The burnt samian from Woodlands was also part of the burial of an exceptional individual given that they were buried under a barrow and cremated with steatite objects (very rare within a Roman context), bronze vessels and possibly enamelled harness equipment in addition to the samian and at least one glass flask.

To sum up: the picture of samian use as a pyre good that emerges is that it was rarely used in this way by any community, but the military may have favoured it more than others. Decorated samian does not generally become acceptable until the later 2nd century. Where samian was burnt on the pyre, it tended not to be collected for deposition in the formal burial other than in the case of exceptional individuals.

Unburnt samian used in pre-burial rites

In addition to samian vessels being offered on the pyre and possibly used to douse the flames, there is also evidence for its use in pre-burial feasts. One of the earliest and most spectacular examples of this can be seen at Folly Lane outside Verulamium (Niblett 1999). There a complex burial shaft and chamber was constructed for the obsequies of an adult in about AD 55. This individual was clearly of very high status given the effort expended on the construction of this burial site, the goods burnt on the pyre which included chain mail and ivory objects, and the fact that the site became 'the key element to the design of the new town of Verulamium' (Creighton 2006, 125). There is no evidence of samian having been burnt on the pyre but it clearly played an important role in the ceremonies surrounding the burial. The infill of the funerary shaft contained much smashed pottery relating to eating and drinking. It is clear that not all of the pottery was placed in the shaft and it is unclear precisely how many vessels are represented, but judged by minimum numbers there appear to be almost as many samian platters and cups as native examples (Niblett 1999, 185–93). Visually the samian would have been very distinct from the native pottery fired to a range of finishes ranging from glossy black to variegated red/brown, and it is tempting to suggest that here the samian was symbolising an aspect of the deceased's relationship with the Roman state given that they could have been in a client king relationship (Creighton 2006, 125).

The distinction between formal burial and deposits relating to funeral-related feasting has not always been made as often as it should be. That it is sometimes possible to distinguish between vessels placed in graves as grave goods and debris from funeral feasts is demonstrated at the rural cemetery at Alton where three graves (nos. 5, 7 and 8) had a two-stage infill with the upper one being described as a mass of broken pots. It may be suspected that one of the problems about identifying funeral feasting deposits is that there is still a tendency to identify all pits with pottery in cemeteries as 'burials'. A good example of this is a feature (VS 362) dated to the Neronian or early Flavian period and located to the south-east of the legionary fortress at Exeter in an area that was being used to deposit urned cremation burials (see VS356) (Salvatore 2001). The pit in question had been cut centrally and it was argued that this could have removed an urned cremation. In what remained pottery and glass vessels were found and were considered to have been deliberately broken before deposition. The pottery included parts of nine samian vessels, three flagons, two cooking pots, a bead rim jar, a bowl in Lyon ware and a mortarium. The samian consisted of three shallow dishes (Drag 15/17, 18) four cups (Drag 27s, Ritt 8 and 9) and two decorated bowls (Drag 29 and 30). The only explicitly cremation-related find was a burnt figurine of Victory. Whilst the flagons, dishes and cups would not be out of place as grave goods, the inclusion of decorated samian bowls would be unusual and the inclusion of a mortarium exceptional. Equally military cemeteries of the 1st century rarely have samian vessels as grave goods. On balance the mixture of tablewares and cooking wares would be much more appropriate for a feasting deposit than for a formal burial, and it might be suspected that a second pit with samian and other pottery and charcoal would best be interpreted in the same way (VS 368). It had olive oil amphora fragments, cooking wares and fragments of two decorated samian bowls (Drag 29) as well as three dishes (Drag 15/17, 18) and one cup (Drag 27).

There is, of course, a problem in deciding whether such feasts took place at the same time as the burial, or were later ones held *in memoriam*. Where, as at Exeter, the deposits include material that could plausibly have come from the pyre, it can be suspected that the feast was contemporaneous. Something similar might be suspected at Ospringe, demonstrated by the well known samian bowl inscribed 'Lucius, Lucianus, Iulius, Diantus, Victor, Victoricus, Victorina, (their) common dish' (Whiting *et al* 1931, 67–8; RIB 2.7, no. 2501.307). It is suggested that the dish was that used at a funerary feast. The excavator describes the bowl as having been found dispersed over an area of 6ft from the centre of the grave but one of the sherds had been placed over a beaker. This implies that the breakage was ancient rather than post burial and parts were deliberately selected to protect the contents of a beaker.

Samian used as grave goods

The most remarkable observation about samian grave goods

Site	Date (centuries)	With Samian %	No	Cup	Dish	Plain bowl	Decorated bowl	Mortarium	Beaker /jar
Rural									
Ash	Mid-late 2nd	67	9	2	4	4	-	-	-
Bartlow	2nd	50	3	7	3	-	-	-	-
Harlington	1st – 2nd	33	3	1	3	-	-	-	-
Chells	Later 1st – 2nd	33	7	3	7	1	-	-	-
Alton	1st	22	2	-	3	-	-	-	-
Westhampnett	Late 1st – 3rd	21	6	4	4	-	-	-	1
Stansted	1st BC – late 2nd	19	7	7	10	8	1	-	-
Sub total			37	24	34	13	1		1
Small town									
Great Dunmow	2nd	53	8	2	5	3	-	-	-
Baldock Site D	1st	50	4	5	9	-	1	-	-
Baldock 1925-30	Late 1st – end 2nd	47	102	23	83	62	1	1	-
Puckeridge	Late 1st- 3rd	45	64	14	34	23	-	-	-
Neatham	Late 1st – mid 2nd	43	3	2	8	2	-	1	-
Ospringe	1st – 3rd	38	63	25	5	29	-	-	-
Pepperhill	Mid 1st – 3rd	16	24	6	8	4	-	-	-
Baldock Site E	2nd	13	1	1	-	-	-	-	-
Sub total			269	78	152	123	2	2	-
Major town									
Chichester	Late 1st – late 2nd	17	36	26	25	5	-	-	1
Canterbury	Mid 2nd – 3rd	15	8	2	4	2	-	-	-
London (Atlantic House)	2nd – 3rd	4	1	-	-	1	-	-	-
Sub total			45	28	29	8	-	-	1
Military									
Brougham	3rd	35	46	4	4	35	6	5	2
Wall	Late 1st – mid 2nd	5	2	-	2	-	-	-	-
Caerleon	Late 1st – early 2nd	4	3	2	-	1	-	-	-
Derby	Late 1st – 3rd	4[1]	1	-	-	-	-	1	-
Sub total			52	6	6	36	7	5	2

Table 29.7: Types of samian vessels found in the formal deposits of the cemeteries listed in Table 29.1. The sites have been arranged according to settlement type and ranked within each category by the proportion of formal deposits with samian vessels
Notes
(1) The number of formal burials is an estimate here. See note (3) to Table 29.1.

is that the deposition patterns are the opposite of what might be expected from the use patterns in the corresponding settlements. This is brought out very clearly in Table 29.7 where it can be seen that decorated samian is extremely rare, and that samian was more popular as a grave good in cemeteries associated with rural and small settlements than it was at major towns and forts.

To show quite how much at variance with normal life these patterns are, they may be compared to the consumption patterns established by Willis's (2005) survey. In that, the average proportions of decorated vessels in samian assemblages were 30% on military sites, 26% at major towns, 17% at minor settlements and 20% on rural sites (Willis 2005, section 7.3). The proportion of graves with samian, both plain and decorated, as compared with site norm in the total pottery assemblage (Willis 2005, Table 33), is shown in Fig 29.3 which clearly shows that there is an inverse relationship between the two. The rural population, or at least that in the south-east, have a disproportionate amount of graves with samian considering the small numbers apparently in circulation, as do the inhabitants of the small towns. By contrast the graves associated with military installations seem poverty stricken in every case except Brougham. At the major towns, evidence is somewhat patchy but there is certainly little evidence that the urban populations consistently used samian grave goods. Another aspect of samian use which is the reverse of what might be expected is the incidence of graffiti. It is more commonly observed on the samian in

the small town cemeteries than in those attached to other types of settlements. Evans' (1987) work has shown that generally the highest level of graffiti occurs in military sites and major towns.

These odd patterns have been commented on before. The rarity of decorated samian was noted by Brenda Dickinson and her colleagues in their study of the material from Brougham (Dickinson *et al* 2004, 347), and Willis observed similar patterns in his south-eastern survey (Willis 2005, section 9). Clearly explanations need to be sought for them. It is likely that the precise impetus for deposition differed from community to community and varied with time, but some more general trends do start to emerge.

With regard to the deposition of decorated samian it is possible to show that those individuals with such vessels may well have been regarded as exceptional or unusual within their communities. At Brougham the decorated bowls were reserved for the graves of older men and women whose other grave and pyre goods often indicated they were amongst the elite of their community and regarded as esteemed elders (Cool 2004, 451). The case of the bowl at Derby has already been considered above. This was placed in the grave of an adult who was clearly marked out for special treatment by other aspects of the burial. The bowl at Stansted (Cremation 26) was in one of the more richly furnished graves and the cremated bone indicated the presence of both an adult and a juvenile. This appears to be the only example amongst the burials excavated there to have possibly been that of two individuals. The individual

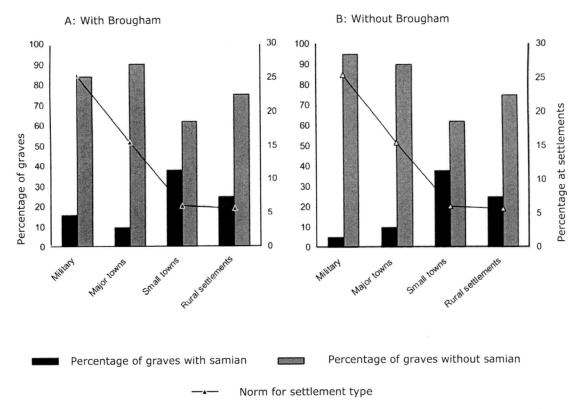

Fig 29.3: The proportion of graves with samian grave goods compared to the site norm for the settlement types (the cemeteries are those summarised in Table 29.1: the settlement norm data is taken from Willis 2005, table 33). The military figures are calculated both with and without the data from Brougham

in Burial 6 at Baldock (Stead and Rigby 1986) was an adult in a richly furnished burial. The level of furnishings was not unusual in the group of burials of which it was a part, but what was unusual was that the leg of a red deer had been placed on the pyre. Game tends to be extremely rare on Romano-British sites (Cool 2006, 112–4) and does not form a common element of the animal bones found as pyre goods.

No age or sex details of the other person at Baldock (Westell 1931: Burial Group 89) are known but most unusually the cremated bone was placed in the bowl together with a necklace of gold-in-glass beads. Within the context of both Baldock and Britain generally this burial group stands out as very unusual. The necklace is of particular interest as nowhere else has one just composed of gold-in-glass beads been observed. This is an alien bead form very likely arriving with military units transferred from the Danubian lands in the late 2nd century (Boon 1977; Cool 2004, 387). The grave must date to the later 2nd century at the earliest as the bowl is stamped SACRILLIM and DOECCVS. The latter is the potter associated with many of the decorated bowls placed in the Brougham graves (Dickinson *et al* 2004, 349–50) where the date of manufacture is given as *c* AD 165–200. Necklace wearing in the native communities of Britain in the later 2nd or earlier 3rd centuries is rare and so there is the distinct possibility that the individual buried in this grave may have been an immigrant. The fact

that she had a decorated bowl may have been a function of this. She, like the community at Brougham, could well have come from the trans-Danubian lands where the ratio of decorated to plain samian vessels in graves (Gabler and Vaday 1992, 96) appears to have been noticeably higher than it was in Britain.

Even for exceptional individuals, decorated samian does not appear generally to have been regarded as appropriate until well into the 2nd century. Of the two earliest bowls, only that from Baldock burial 6 was likely to have been deposited broadly contemporaneously with its date of manufacture (*c* AD 50–65). The bowl in the Stansted grave was made not later than AD 75 but not deposited until the second quarter of the 2nd century. The bowl at Derby appears to have been deposited at the end of the 1st or in the early 2nd century. That from Baldock group 89 dates to the later 2nd century at the earliest as does one at Beckfoot where a decorated cylindrical bowl (Drag 30) was used to contain the cremated bone (Bellhouse and Moffat 1959, 59*)*. The bowls at Brougham were made in the later 2nd century but not deposited until well into the 3rd century. This chronological trend is also one that has already been traced in the pyre goods. For whatever reason, it does seem to indicate that a change in attitude towards the role of decorated samian in the funerary process was taking place at this time.

It is possible to take a very functional view of why

the samian pottery was placed in the grave. In some of the larger graves such as at Grange Road, Winchester (Biddle 1967) what amounts to a dinner service is set out as if for a meal for the deceased and guests and there is evidence of foodstuffs in the form of animal bones, shells, etc. Something similar can often be observed within more modest burial groups. At Westhampnett several graves (nos. 20803, 20739, 20392, 20791, 20727, 20538) had pottery vessels, including a samian vessel or vessels, set out around the urn. Elsewhere it is not unusual to find bones placed on dishes, (see for example Bennett *et al* 1982, 34, fig 7). A straightforward view would be to interpret the remains as equipment for the meal the deceased might want in the afterworld. Yet, as has been demonstrated, there is an inverse relationship between what the living were using in the various types of settlements and what was being provided in the grave. Equally, in the rural and small settlement cemeteries, the animal bones indicate the provision of meat (pork and chicken) that was rarely eaten in them (Cool 2006, 83, 101). Why was the provisioning of the dead so different to the provisioning of the living?

Here a consideration of the other goods in the larger graves such as at Bartlow, Stansted and Grange Road may help. These may be summarised as regularly containing one or more sets of artefacts that relate to bathing (strigils etc), offering sacrifice in the correct way (*trullum* and jug), writing (seal box, stylus, pen knife) and administering justice (magistrate's chair) (see Cool 2006, 193–9 for details). What these graves appear to be expressing is a way of being 'Roman' in the new world order. Set alongside this, the samian vessels take their place as being the correct tablewares as do the meats themselves, as these occur regularly within high quality dining debris from forts. Interestingly the unusually high level of deposition seen at Brougham would fit into this model as well. It seems very likely that the dead here belonged to a *numerus* raised amongst tribal people in the trans-Danubian area. They too were reacting to 'being Roman' in a way they had not been prior to their recruitment.

Whilst it seems reasonable to interpret the use of samian dinner services within the elite native graves as an overt statement in this way, such an explanation seems less convincing when looking at the more modest graves that might have only a single samian cup or dish in them. Given that the main focus of samian deposition in graves in rural and small settlement settings is in the south-east, it may just be that samian vessel are replacing the *terra nigra*, etc, imports from north Gaul that had been used by their parents and grandparents (see for example the King Harry Lane cemetery at Verulamium: Stead and Rigby 1989). What made the mourners think that these alien pottery types were important in the same way that the provision of animals that were not much eaten in everyday life was?

A clue may be provided by the fact that sometimes the bones relate to parts of the animal which do not yield prime meat. In two burials at Stansted only the right side of the skulls of young pigs were deposited. In one of these (cremation no. 17) only the right side of a chicken was also present (Hutton in Havis and Brooks 2004, 247). This burial was probably that of a female. The pig skull also came from a female and it might be suspected that more than the simple provision of food for the woman was taking place. Animals could have symbolic meanings and special relationships with the gods. Cocks were one of the attributes of Mercury, one of whose duties was to accompany the soul after death, whilst according to some ancient sources the sacrifice of pigs at the grave was also viewed as being an essential part of the ritual (Lindsay 1998, 72). It is possible that the animal bones in graves were sacrifices and food for the gods and not the dead.

In the light of that, it is useful to consider whether the samian may have also been thought more appropriate for the gods than everyday pottery was. In burial LIX at Skeleton Green a cup (Drag 33) had part of the footring missing and a graffito – ORKIVOT – cut into the inner wall of the remaining part (Hassall in Partridge 1981, 273 no. 3; RIB 2.7, no. 2501.20). This has been cautiously read as *Orki vot(um),* translating as 'A vow for [literally, 'of'] Orcus', with Orcus being a Latin synonym for Pluto or Hades. This would seem to make explicit that the vessel was not for the deceased but for a deity. The fact that part of the foot ring was missing may also be significant. It is not recorded whether this was a deliberate modification, but it is interesting to note how often the samian in a grave is described as modified in some way. In the same cremation at Stansted that had only the right-hand sides of animals, a samian cup (Drag 27) had been cut down so that only the bottom curve of the side remained. The cemetery at Great Dunmow provides many good examples where deliberate notches were sawn in the rims of dishes and cups (Going in Wickenden 1988, 22–3, fig 20). Halving and quartering of samian dishes were also noted by Willis at the shrine at Orton's Pasture, Rocester, Staffordshire (Ferris *et al* 2000, 44, from F603 and F609). Here a form 15/17 divided into one half and two quarters was associated with a concentration of graffiti on samian vessels as well as an unusual and selective ceramic assemblage. Finds at Orton's Pasture included artefacts with Bacchic associations, and a consideration of the nature and distribution of the artefacts and ecofacts suggested worship involved the offering of foodstuff and artefacts, including these modified samian sherds, at different times. The grave goods treated in similar manner may likewise be offerings to deities. In some cases the 'killing' went as far as quartering or halving. A Drag 27 cup from Strood Hall grave 1287 had been neatly halved while the accompanying vessel, a Drag 18 dish, had had a section of rim removed. In some cases graves could contain vessels which had been both killed and repaired by lead rivets. In cremation 10 at Great Dunmow a dish (Drag 18/31R) had two lead repairs whilst the cup (Drag 33) is described as possibly killed. The Drag 30 used as an urn at Beckfoot was both riveted and missing part of the rim. Sometimes the degree of riveting seems very excessive. The dish (Drag 18/31R) from cremation 1 at Harlington is described as 'riveted in five places with a hole for a sixth rivet' (Dickinson in Dawson 2001, 29).

Phase	Not riveted; No elite goods	Not riveted; Elite goods	Riveted; Elite goods	Total
1 – 200/20 - 240	1	1[1]	-	2
2 – 240 - 270	8	1	2[1]	11
3/3b – 270 – 300/310	4	3	1	8
Total	13	5	3	21

Table 29.8: The incidence of Drag 31 and 31R as grave goods at Brougham showing their relationship with elite pyre and grave goods (see text for definitions)

Notes

(1) More than one elite good present.

Whilst the deliberate cutting down, holing or notching of a vessel is normally accepted as a ritual act, the repair of vessels is normally interpreted as a thrifty response to scarcity. Again, however, there does appear to be a mismatch between the domestic pattern and the sepulchral one. From Willis's study of riveting (Willis 2005, appendix 11.1) it is possible to extract the number of riveted items compared to the total samian assemblage at 18 sites. A rate of 1.5% can be established for the riveted material (152 riveted out of a total of 10087). By contrast the riveting rates for the samian vessels in Table 29.7 is 3% if the material from Bartlow and Ospringe, where it is unknown if riveting was present or not, is excluded. It is possible that mean-spirited mourners felt repaired material was 'good enough' for the dead, but this parsimony is often not seen in the other grave and pyre goods in the same burials.

The repaired bowls at Brougham provide a good case study. The data there are large enough for the incidence of repair on one particular type (Drag 31 and 31R) to be put in context. At this site this form of bowl was considered appropriate for adults, and elite graves tended to have at least one of the following: gold, silver or ivory pyre goods, glass vessels and joints of meat as grave goods. Riveting generally was noted to be fairly low for a Highland zone site (Evans 2004, 360). Table 8 shows the incidence of the bowls through time and with their associations. If riveting was a thrifty response to scarcity or poverty then the riveted bowls ought to occur in the graves without elite goods and late in the sequence when they were less easy to acquire. As can be seen, quite the reverse is true.

The association of riveted bowls with otherwise richly furnished graves does not just occur at Brougham. At Neatham the burial 5 complex includes two riveted Drag 31Rs in the main pit. Intriguingly one of these is also described as heavily burnt and the catalogue entry says 'repaired with rivets' (Millett and Graham 1986, 59). Joanna Bird has kindly looked at her records of these vessels and notes that there are some errors in this description as published in the grave catalogue. Both of these vessels are in fact Drag 18/31Rs. That stamped by Lollius had eight repairs and the one with an unidentified stamp had five repairs. The other Drag 18/31R correctly recorded from the group and stamped by Cucalus had five repairs. All of these repairs were carried out using lead wire threaded through drilled holes which seems to be largely intact though oxidised. She also notes that her slide of the illegibly stamped vessel indicates that a better description would be 'scorched'.

This vessel would thus be a good candidate for a vessel placed alongside the pyre as had it been on the pyre the lead would most likely have started to melt. Here too the degree of riveting seen on three vessels seems excessive. It is useful to bear in mind that lead alloys, which many of the repairs were made of, were seen as an attribute of ill health and death and thus an appropriate medium for curse tablets (Tomlin 1988, 81). It was thought of as dark and heavy and thus would have been an appropriate material for the chthonic deities. Riveting too might have made the vessel appropriate for a god. In this respect Biddulph's (2002) observation that the positions of the vessels in the grave (upside down as a lid or on their sides, ie not in the way originally intended) may have been to make them more accessible to the dead is relevant, as it might have made them more accessible to the gods.

Whilst many aspects of the samian in the native graves shows that it was being regarded in a very special way, in many contemporary cemeteries attached to military sites and major towns it was ignored. There are no samian grave goods at sites such as London Road, Gloucester or Handford House, Colchester and very few at London. The first two of these are especially informative as the populations being buried would either have been legionaries or colonists and their dependents. These are the burial places of an incomer community. The people being buried at London were probably also of a more cosmopolitan origin than the community being buried at Chichester, and this might account for the differing levels of use of samian noted between the two. One might suspect that the high level of samian use in some native communities was part of a complex response to being part of a new world order. Alien artefacts appear to be taking on quite a different meaning to the one they had amongst their makers. That the samian forms were seen as very important in these communities can be shown by the deposition of imitation ones. At Chichester, Alton and Neatham imitation samian dishes and cups were common (Millett 1986, 80) and in the second burial at Grange Road, Winchester (Biddle 1967), the mourners ensured that, as far as possible, an appearance of the correct pottery was deposited in the grave, even to the extent of ensuring the imitation cups had faked name stamps.

Samian within post-burial ritual

The dead were not ignored after burial. There are many

references in the ancient literature to the commemoration ceremonies that took place at the tomb in later years (Toynbee 1996, 61–4), and one might suspect that some of the deposits of pottery in cremation cemeteries that have no human bone associated might relate to these. Some of them appear to have been a single deposit, but others suggest such activities might have continued over time. A group of broken but near complete vessels found in a pit within the cemetery at the Royal Hotel, York may be such a deposit, as pottery ranged from a samian bowl dating AD 160–200 to a 4th century flagon (pers comm A Vince and B Precious). The pottery found on a cemetery site in the fills of graves or unstratified can also be used to explore these rituals. At Brougham, where there is no occupation other than the cemetery, this could be seen especially clearly as the unstratified material had quite a different composition to that associated with the burials, reflecting the food preparation and consumption that went on in the cemetery (Evans 2004, 364). At West Tenter Street London, although samian vessels were not used as grave goods, Pierpoint (in Whytehead 1986, 81) found evidence for their use in ritual feasting during the 2nd century with an emphasis on flagons, beakers, samian bowls and amphorae contrasting with the characteristics of the ceramic grave goods which are predominantly jars and small jar/beakers. At Wall fragments of Drag 37s were found in four features including two of the small ditched enclosures which may have served as funerary gardens. These enclosures were associated with tableware and vessels associated with food preparation, suggesting feasting as well as drinking, and contrast with the flagons and beakers associated with the pyre related deposits and cremation burials at this site. A more detailed exploration of the pottery fragments, including the samian, found in such contexts might well enable us to explore the attitudes to samian further. There are hints that though decorated samian was not appropriate for the dead at these sites, it might have been appropriate for the living mourners. Currently, however, there are too few data to explore this.

The future

In this paper we have not considered the inclusion of 'old' samian in graves nor the implications of the graffiti on the samian vessels as both have been the subject of recent studies (Wallace 2006; Biddulph 2006). Nor have we looked at the subject matter of the images on the decorated samian that is present in the cemeteries, the iconography of which is surely a rich source of information (see now Bird forthcoming). Equally we have not addressed the interesting question of why the rural populations of much of the country outside of the south-east saw no reason to incorporate samian vessels into their funerary rituals. Correlations between samian vessel types and the age or gender of the deceased have been noted at some sites and this too would repay more detailed analysis. What we hope we have done is show that potentially the study of these vessels, both presence and absence, in association with all the other classes of material found within a cemetery, has the potential to be very informative about how samian was actually viewed by the people who used it. Material indeed for the bright student alluded to in the introduction.

Finally we would like to say that it has given us great pleasure to write this paper for Brenda and we hope she enjoys it. It could not have been written without her scholarship as she is a contributing specialist to many of the reports cited here. One of us (HEMC) has benefited from her help since the 80s when we were both based in Leeds and would occasionally escape from the worlds of samian and glass to discuss the matches we had seen at Headingly and Trent Bridge. The other (RSL) would like to mark with gratitude the many reports received from her, often written at short notice and of small rural assemblages with maybe only one or two memorable pieces, when larger and more important reports were pressing. These were always done with patience and cheerfulness. Lunch breaks with her and Kay Hartley at Leeds were always a treat mid-way through a mortarium and samian consultation day.

Acknowledgements

The unpublished information in this paper, and that unpublished at the time of writing, has been made available courtesy of the following individuals and units.

Beckfoot: Mark Brennand, Margaret Ward and Oxford Archaeology North
Colchester, Handford House: Kate Orr and Colchester Archaeological Trust
Gloucester, London Road: Diana Mayer and Foundations Archaeology; Alex Smith and Oxford Archaeology.
Pepper Hill: Edward Biddulph, Stuart Foreman and Oxford Archaeology.
Wall: Jackie McKinley, Paul Booth, Wessex Archaeology and Oxford archaeology

Joanna Bird very kindly not only made unpublished material available but also checked her records of the Neatham material published long ago. Nina Crummy, Barbara Precious, Margaret Ward and Alan Vince also made unpublished material available. Edward Biddulph, Margaret Ward, Gwladys Monteil, Geoff Dannell and Jackie McKinley have all helped in the formation of ideas by patiently responding to various enquiries and by offering suggestions during discussions. To all we express our grateful thanks for so courteously and promptly responding to all of our queries.

Bibliography

Anon, 2000. Springhead Roman cemetery, *Current Archaeol* 14 (12) (issue no. 168), 458–9
Barber, B, and Bowsher, D, 2000. *The Eastern cemetery of Roman London: excavations 1983–1990*, Mus London Archaeol Service Monogr 4, London
Bellhouse, R L, and Moffat, I, 1959. Further Roman finds in the Beckfoot cemetery area, *Trans Cumberland Westmorland Antiq Archaeol Soc* new ser 58, 57–62

Bennett, P, Frere, S S, and Stow, S, 1982. *Excavation at Canterbury Castle*, The Archaeology of Canterbury 1, Canterbury

Biddle, M, 1967. Two Flavian burials from Grange Road, Winchester, *Antiq J* 47, 224–50

Biddulph, E, 2002. One for the road? Providing food and drink for the final journey. *Archaeol Cantiana* 122, 101–11

Biddulph, E, 2005. Last orders: choosing pottery for funerals in Roman Essex, *Oxford J Archaeol* 24, 23–45

Biddulph, E, 2006. What's in a name? Graffiti on funerary pottery, *Britannia* 37, 355–8

Biddulph, E, forthcoming. The Roman cemetery at Pepper Hill, Southfleet, Kent, *CTRL Integrated Site Report Series*, Archaeology Data Service

Bird, J, forthcoming. Samian in religious and funerary contexts: a question of choice, in *Seeing red: new social and economic perspectives on the production and consumption of Gallo-Roman sigillata* (ed M Fulford), Bull Inst Class Stud Suppl, London

Boon, G C, 1977. Gold-in-glass beads from the ancient world, *Britannia* 8, 193–207

Charlton, B, and Mitcheson, M, 1984. The Roman cemetery at Petty Knowes, Rochester, Northumberland, *Archaeol Aeliana* ser 5, 12, 1–31

Cool, H E M, 2004. *The Roman cemetery at Brougham Cumbria: excavations 1966–67*, Britannia Monogr 21, London

Cool, H E M, 2006. *Eating and drinking in Roman Britain*, Cambridge

Cool, H E M, 2011. Finds from funerary contexts, in *Artefacts in Roman Britain: their purpose and use* (ed L Allason-Jones) 293–312, Cambridge

Cool, H E M, and Baxter, M J, 2005. Cemeteries and significance tests, *J Roman Archaeol* 18, 397–404

Creighton, J, 2006. *Britannia: the creation of a Roman province*, London

Dannell, G B, 2006. Samian cups and their uses, in *Romanitas: essays on Roman archaeology in honour of Sheppard Frere on the occasion of his ninetieth birthday* (ed R J A Wilson), 147–76, Oxford

Dawson, M, 2001. Harlington Roman cemetery, *Bedfordshire Archaeol* 24, 20–39

Dickinson, B, Hartley, B R, and Pengelly, H W, 2004. Fabric supply: Class S, samian wares, in Cool 2004, 345–50

Dickinson, C, and Wenham, L P, 1957. Discoveries in the Roman cemetery on The Mount, York, *Yorkshire Archaeol J* 39, 283–323

Down, A, and Rule, M, 1971. *Chichester excavations 1*, Chichester

Evans, E, and Maynard, D J, 1997. Carleon Lodge Hill cemetery: the Abbeyfield site 1992, *Britannia* 28, 169–243

Evans, J, 1987. Graffiti and the evidence of literacy and pottery use in Roman Britain, *Archaeol J* 144, 191–204

Evans, J, 2004. The pottery vessels, in Cool 2004, 333–64

Ferris, I M, Bevan, L, and Cuttler, R, 2000. *The excavation of a Romano-British shrine at Orton's Pasture, Rocester, Staffordshire*, Brit Archaeol Rep Brit ser 314, Oxford

Fitzpatrick, A P, 1997. *Archaeological excavations on the route of the A27 Westhampnett Bypass, West Sussex. Volume 2: the Late Iron Age, Romano-British, and Anglo-Saxon cemeteries*, Wessex Archaeol Rep 12, Salisbury

Fowler, P J, 1965. A Roman barrow at Knob's Crook, Woodlands, Dorset, *Antiq J* 45, 22–52

Gabler, D, and Vaday, A H, 1992. Terra Sigillata im Barbaricum zwischen Pannonien und Dazien, *Acta Archaeologica Academiae Scientarum Hungaricae* 44, 83–160

Gage, J, 1834. A plan of barrows called the Bartlow Hills, in the parish of Ashdon, in Essex, with an account of Roman sepulchral relics recently discovered in the lesser barrows, *Archaeologia* 25, 1–23

Gage, J, 1836. The recent discovery of Roman sepulchral relics in one of the greater barrows at Bartlow, in the parish of Ashdon, in Essex, *Archaeologia* 26, 300–17

Gage, J, 1840. An account of further discoveries of Roman sepulchral relics in one of the Bartlow Hills, *Archaeologia* 28, 1–6

Gage Rokewode, J, 1842. An account of the final excavations made at the Bartlow Hills, *Archaeologia* 29, 1–4

Going, C J, and Hunn, J R, 1999. *Excavations at Boxfield Farm, Chells, Stevenage, Hertfordshire*, Hertfordshire Archaeol Trust Rep 2, Hertford

Havis, R, and Brooks, H, 2004. *Excavations at Stansted Airport, 1986–91. Volume 1: Prehistoric and Romano-British*, East Anglian Archaeol 107, Chelmsford

Hicks, A J, 1998. Excavations at Each End, Ash, *Archaeol Cantiana* 118, 91–171

King, R, and Ellis, P, forthcoming. The Wotton cemetery, Gloucester. Excavations at 124–30 London Road, 2002, *Trans Bristol and Gloucestershire Archaeol Soc*

Lambert, J, 1996. *Transect through time. The archaeological landscape of the Shell North-Western Ethylene Pipeline*, Lancaster Imprints 1, Lancaster

Lindsay, H, 1998. Eating with the dead: the Roman funerary banquet, in *Meals in a social context* (eds I Nielsen and H S Neilsen), Aarhus Studies in Mediterranean Archaeology

McKinley, J I, 1997. Bronze Age 'barrows' and the funerary rites and rituals of cremation, *Proc Prehist Soc* 63, 129–145

McKinley, J I, 2000. Phoenix rising: aspects of cremation in Roman Britain, in Pearce *et al* 2000, 38–44

McKinley, J I, 2008. Ryknield Street, Wall (Site 12), in A B Powell, P Booth, A P Fitzpatrick and A D Crockett, *The Archaeology of the M6 Toll 2002–2003*, Oxford Wessex Archaeol Monogr 2, 87–190, Salisbury

Millet, M, 1986. An early Roman cemetery at Alton, Hampshire, *Proc Hants Field Club Archaeol Soc* 42, 43–87

Millett, M, and Graham, D, 1986. *Excavations on the Romano-British small town at Neatham, Hampshire 1969–1979*, Hants Field Club Monogr 3, Gloucester

Monaghan, J, 1997. *Roman pottery from York*, The Archaeology of York 16 (8), York

Niblett, R, 1999. *The excavation of a ceremonial site at Folly Lane, Verulamium*, Britannia Monogr 14, London

Ottaway, P, 2004 (2005). Review of H E M Cool, *The Roman cemetery at Brougham Cumbria: excavations 1966–67*, *Archaeol J* 161), 248–9

Partridge, C, 1977. Excavation and fieldwork at Braughing 1968–73, *Hertfordshire Archaeol* 5, 22–108

Partridge, C, 1981. *Skeleton Green*, Britannia Monogr 2, London

Pearce, J, Millett, M, and Struck, M (eds), 2000. *Burial, society and context in the Roman world*, Oxford

Polfer, M, 2000. Reconstructing funerary rituals: the evidence of *ustrina* and related archaeological structures, in Pearce *et al* 2000, 30–37

RIB 2 = Collingwood, R G, and Wright, R P, 1995. *The Roman inscriptions of Britain* 2, Instrumentum Domesticum *(personal belongings and the like)*, Fasc 7, *Graffiti on samian ware (*terra sigillata*)*, (*RIB* 2501.1-880) (eds S S Frere and R S O Tomlin), Stroud

Salvatore, J P, 2001. Three Roman military cremation burials

from Hollaway Street, Exeter, *Proc Devon Archaeol Soc* 59, 125–39

Simmonds, A, Márquez-Grant, N, and Loe, L, 2008. *Life and death in a Roman city*, Oxford Archaeol Monogr 6, Oxford

Stead, I M, and Rigby, V, 1986. *Baldock. The excavation of a Roman and pre-Roman settlement, 1968–72*, Britannia Monogr 7, London

Stead, I M, and Rigby, V, 1989. *Verulamium: the King Harry Lane site*, English HeritageArchaeol Rep 12, London

Strong, D E, 1966. *Greek and Roman gold and silver plate*, London

Timby, J, Brown, R, Biddulph, E, Hardy, A, and Powell, A, 2007. *A slice of rural Essex: archaeological discoveries from the A120 between Stansted and Braintree*, Oxford Wessex Monogr 1, Oxford and Salisbury

Tomlin, R S O, 1988. The curse tablets, in *The Temple of Sulis Minerva at Bath, Vol 2. The Finds from the Sacred Spring* (ed B Cunliffe), Oxford Univ Comm Archaeol Monogr 16, 59–277

Toynbee, J M C, 1996 (1971). *Death and burial in the Roman world*, repr, Baltimore and London

Turner, R, 1990. A Romano-British cemetery at Lanchester, Durham, *Archaeol Aeliana* ser 5, 18, 63–77

Wallace, C, 2006. Long-lived samian?, *Britannia* 37, 259–72

Ward, M, 2008. The samian pottery, in *Roman Piercebridge: excavations by D W Harding and Peter Scott 1969 – 1981* (eds H E M Cool and D J P Mason), Archit Archaeol Soc Durham Northumberland Rep 7, 169–96, Durham

Watson, S, 2003. *An excavation in the western cemetery of Roman London*, Mus London Archaeol Service Archaeol Stud Ser 7, London

Wenham, L P, 1968. *The Romano-British cemetery at Trentholme Drive, York*, London

Westell, W P, 1931. A Romano-British cemetery at Baldock, Herts, *Archaeol J* 88, 247–301

Wheeler, H, 1985. The Racecourse cemetery, in J Dool and H Wheeler, *et al, Roman Derby: excavations 1968–1983*, *Derbyshire Archaeol J* 105, 222–80

Whiting, W, 1921. A Roman cemetery discovered at Ospringe in 1920, *Archaeol Cantiana* 35, 65–80

Whiting, W, 1923. A Roman cemetery discovered at Ospringe in 1920, *Archaeol Cantiana* 36, 1–16

Whiting, W, 1925. The Roman cemeteries at Ospringe. Description of the finds continued, *Archaeol Cantiana* 37, 83–96

Whiting, W, 1926. The Roman cemeteries at Ospringe. Description of the finds concluded, *Archaeol Cantiana* 38, 123–51

Whiting, W, Hawley, W and May, T, 1931. *Report on the excavation of the Roman cemetery at Ospringe, Kent*, Rep Res Comm Soc Antiq London 8, Oxford

Whytehead, R, 1986. The excavation of an area within a Roman cemetery at West Tenter Street, London, *Trans London Middlesex Archaeol Soc* 37, 23–124

Wickenden, N P, 1988. *Excavations at Great Dunmow, Essex*, East Anglian Archaeol 41, Chelmsford

Willis, S, 2005. Samian pottery, a resource for the study of Roman Britain and beyond: the results of the English Heritage funded samian project. An e-monograph, *Internet Archaeol* 17 (http://intarch.ac.uk/journal/issue17/willis_toc.html)

30 Lamplighters and plate-spinners: the final phase of use for some samian vessels from Kent?

J M Mills

It is generally accepted that samian was used as fine table ware, but the exact use of each of the standard forms may never be known. Were the vessels we call 'cups' actually used for drinking, or for other liquids – or were they intended to hold nuts, jellies, sauces or a host of other edibles? We will probably never know. Nor will we know how samian was used at the table – how this related to other samian vessels and a range of other ceramics, glass and metal as well as wooden and shale vessels in well-to-do-households. One imagines that the red of samian would contrast particularly well with the black of a shale tray – but did they ever appear together? We do know that samian was ubiquitous, although occurring more frequently in towns and forts than in more rural settings, and that it is to some extent a measure of relative wealth and status.

Being amongst the hardest-fired ceramics available during the 1st and 2nd century AD it may well have been longer-lived than other types of pottery. As an expensive commodity the purchase of samian ware was no light undertaking. The most commonly quoted evidence for the price of samian vessels comes from two second century graffiti and suggests that a decorated bowl would have cost 20 *asses*, whilst a Ludowici platter cost 12 *asses* (Darling 1998, 169; Hartley 2005, 116). According to Hartley this equates to one-and-a-half days' pay for a legionary of the time for the decorated bowl, and a little over half a day's pay for the plain ware some decades later. Given the initial expense, it would not be at all surprising to find carefully curated vessels lasting for decades, and indeed becoming heirlooms as has been suggested by several writers. Samian was certainly strong enough to withstand all manner of drilling, chipping and grinding, processes which enabled the frugal to extend the life of many samian vessels. Recorded methods include gluing or riveting pots back together, filing down broken rims and flanges, and even completely altering a vessel by chipping and/or filing off unwanted portions in order, for example, to use the inverted base and footring as a small pot. In his paper about samian in London Marsh (1981, 229) listed as many as nine ways in which samian had been altered or re-used. The final use

of many broken pots would have been as counters, discs, spindle whorls, tesserae or spinning tops.

Recent excavations at Springhead in Kent (CTRL Event Codes ARCSP00 and ARCSHN02, Mills forthcoming) produced over 3900 sherds of samian weighing about 51kg, amongst which were several curious pieces two of which, with the kind permission of London and Continental Railways, will be discussed here.

The base of one East Gaulish form Drag 43 or Drag 45 mortarium was found in layers pre-dating Temple 2 (ARCSHN02, 12567, 12595), presumably in a second or third incarnation, as around the broken edge were four sets of slots cut for leaded repairs. Several of the edges appeared quite smooth as if the base was re-used later still perhaps after the repair failed. The base of this broken mortarium formed a shallow dish. The worn and smoothed chipped edges on closer inspection showed that one projecting part of the edge was blackened by burning (see Fig 30.1). It was thought possible that this projection had supported a wick so that the vessel might be used as an open lamp, hence the localised burning. This recalled another bowl, a Ritterling 12 of pre-Flavian manufacture from Whitcombe in Dorset (Simpson 1990, 79 and fig 13, 2) which had had large chips removed from the flange to form a 'beak' which was blackened by burning, the discolouration extending over the broken edges. This vessel was otherwise complete. The Whitcombe vessel accompanied a burial, in the Durotrigian tradition, of a young woman and was also accompanied by local coarse wares and a Déch form 67 samian jar. Ritual 'killing' of samian pots which accompany burials is well attested, but often amounts only to a small chip being removed from the rim (Bird forthcoming; Mills forthcoming), so it seems unlikely that the chipping of the flange of this vessel falls into that category. The only other vessel of which I am aware that may have been altered to function as an open lamp, is the base of a Central Gaulish dish from excavations at Tort Hill East on Ermine Street (Mills 1998, 68–9) which was trimmed to form a small footring dish. The footring had been deliberately notched, and this notch was blackened, the inference being that it had

Fig 30.1: Drag form 43 or 45 base (Trier) from Springhead, Kent (ARCSHN02 12567), in its final form as an open lamp. Stippling indicates area of sooting and burning. (Scale 1:2). Drawn by N Griffiths

Fig 30.2: Underside of Drag form 18/31 base (Lezoux) from Springhead, Kent (ARCSHN02 17755), showing wear patterns (stippled). (Scale 1:2). Drawn by N Griffiths

Fig 30.3: Plastic plate by Tobar Ltd sold for plate-spinning. (Scale 1:2). Drawn by N Griffiths

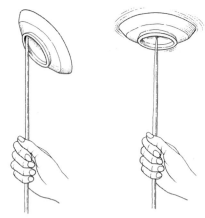

Fig 30.4: a) Plate-spinning: the starting position; b) Plate centred on stick, spinning at full speed. Drawn by N Griffiths

held a wick and thus been used as a lamp. This example differs from the previous two however in having a notch to hold the wick rather than a projection along which a wick might have lain.

It seems probable that the final use of each vessel was as a lamp. At least 100 years (and many miles) separate these examples, and I am not aware of any other published examples of samian which may have been re-used as lamps. There is little to link the examples in terms of site type, vessel form or date but perhaps there is a class of object here worth looking out for in future.

Another area which has recently been investigated is use-wear patterns. Edward Biddulph has undertaken experiments on reproduction samian cups of Drag forms 27 and 33 in an attempt to characterise the use to which heavily worn examples may have been put (Biddulph 2008). Heavy use of samian vessels as evidenced by the loss of slip in patches or bands is widely recognised and is part of the evidence which is used to suggest that some vessels lasted in use for a very long time. This heavy wear is often associated with the secondary use of vessels in their cut down or altered forms and probably often relates to the final use of many vessels. The suggestion by the Leeds Indexers (Brian Hartley, pers comm) that the children of Roman Britain were (?deliberately) obliterating potters' stamps by spinning the broken bases of Drag form 18/31 and 31 dishes as tops is one such example.

It was with these thoughts in mind that I recorded the wear patterns on the samian from Springhead. Along with

the usual patches in the sides of bowls, heavily worn cup interiors and bands within footrings, one combination of wear patterns seemed somewhat unusual (although I am sure that I have seen it within other assemblages but not noted it). It always occurred on incomplete examples of forms Drag 18/31 and Drag 31: the central point of the underside of the pot was worn, but so too was a band at the junction of the footring and the base (see Fig 30.2).

Other than the catch-all explanation of 'stirring' the activity which might have caused this combination of wear patterns evaded me until recently when my son attended a circus skills workshop. One of the skills on offer was plate-spinning. Here a plastic plate (Fig 30.3) with a central kick is spun on top of a stick. The procedure is as follows: – in order to get the plate going it is first balanced by the footring on the stick which is then whisked in a circular motion so that the plate rotates on the tip of the stick around the junction of the footring and the plate base (Fig 30.4a). Once enough speed is gained the plate can spin with only the central point in touch with the stick (Fig 30.4b). Given that form follows function it seems entirely possible that forms Dr 18/31 and 31 are of the ideal shape for plate-

spinning. The wear recorded at Springhead could have arisen from this activity.

There is, to my knowledge, no independent evidence to support this theory. In Roman Britain there were, however, fairs and festivals at which street entertainers would have been commonplace. The temples and springs at Springhead with its pilgrims, travellers and traders would surely have been such a venue. Gymnasts, jugglers and performing dogs all appear on first-century decorated samian from South Gaul as depicted by Oswald (1936–7) in his figure-types 961–965. Surely then a plate-spinner is not such a far-fetched concept. It is tempting to imagine the scene and the Celtic curses which blued the air as a plate-spinner practised, for it is certain that such skills need practice to perfect (indeed current evidence cannot yet suggest that the skill *was* perfected, as to date the known examples of dishes with a worn central spot on the under-side and a ring around the top of the footring are from incomplete vessels!).

In conclusion I would like to say that as archaeologists we should never close our minds to human possibility. After all, in our studies we are trying to reveal the people of the past and how they lived their lives, be they potters or plate-spinners.

Acknowledgements

It is with humble thanks that I offer this, my first paper, in honour of Brenda. With both wisdom and humour she has guided and cajoled me during the last decade, in my attempts to recognise samian fabrics and comprehend the decorative schemes of countless potters. I am certain I would not have learnt so much without her kind help. I am also most grateful to Nick Griffiths for the illustrations.

Bibliography

Aitken, G M, and Aitken, G N, 1990. Excavations at Whitcombe, 1965–1967, *Procs Dorset Nat Hist Archaeol Soc* 112, 57–94

Biddulph, E, 2008. Form and function: the experimental use of Roman samian ware cups, *Oxford J Archaeol* 27(1), 91–100

Bird, J, forthcoming. Catalogue of samian ware, in E Biddulph, The Roman Cemetery at Pepper Hill, Southfleet, Kent, *CTRL Integrated Site Report Series*, Archaeology Data Service

Darling, M J, 1998. Samian from the city of Lincoln: a question of status?, in *Form and fabric. Studies in Rome's material past in honour of B. R. Hartley* (ed J Bird), Oxbow Monogr 80, 169–77, Oxford

Hartley, B R, 2005. Pots for tables; tables awaiting pots: an exercise in speculative archaeoeconomy, in *An archaeological miscellany: papers in honour of K F Hartley* (eds G B Dannell and P V Irving), *J Roman Pottery Stud* 12, 112–16, Oxford

Marsh, G D, 1981. London's samian supply and its relationship to the development of the Gallic samian industry, in *Roman pottery research in Britain and north-west Europe* (eds A C Anderson and A S Anderson), Brit Archaeol Rep Internat Ser 123, 173–238, Oxford

Mills, J M, 1998. Samian, in P Ellis, G Hughes, P Leach, C Mould, and J Sterenberg, *Excavations alongside Roman Ermine Street, Cambridgeshire 1996*, Birmingham University Field Archaeology Unit Monogr 1, Brit Archaeol Rep Brit Ser 276, 68–71, Oxford

Mills, J M, forthcoming. The samian, in *Settling the Ebbsfleet Valley: High Speed 1 Excavations at Springhead and Northfleet, Kent – the Late Iron Age, Roman, Anglo-Saxon and Medieval Landscape* (eds P Andrews, E Biddulph and A Hardy), Oxford-Wessex Monogr 3, Salisbury

Oswald, F, 1936–7. *Index of figure-types on terra sigillata ('samian ware')*, Univ Liverpool Ann Archaeol Anthropol Suppl 23–4

Simpson, G, 1990. Samian from Burial 8, in Aitken and Aitken 1990, 79

31 Graffiti on samian in London

Charlotte Thompson

Incidences of graffiti on Roman pottery have long been noted, and the relatively high quantity in the London area highlighted recently in synthetic analyses of incidences of graffiti (Evans 1987; RIB 2.7 and 2.8). The present study focuses on post-firing graffiti on samian. This eliminates the graffiti or pre-firing 'batch' marks seen on vessels such as the coarseware products from the Rowlands Castle kilns in Hampshire, and by excluding amphorae this also discounts tally marks. While there are examples of coarsewares bearing graffiti, such as a pre-firing inscription

Site code	Address	Number of sherds	Sherds with graffiti
179BHS89	179-191 Borough High Street, SE1	12164	22
GYE92	Guildhall Art Gallery, Guildhall Yard; Portland House, 72–73 Basinghall Street, EC2	21481	6
ONE94	1 Poultry, 1-19 Poultry, 2–38 Queen Victoria Street, 3–9, 35–40 Bucklersbury, Pancras Lane, Sise Lane, EC2, EC4	42116	26
KWS94	Regis House and Ridgeway House, 39, 40–46 King William Street, 4–12 Monument Street, 17–28 Fish Street Hill, The Canterbury Arms, EC4	28053	8
GSM97	10 Gresham Street, 2–12 Gresham Street, EC2	73543	35
FER97	Plantation House, Chesterfield House, 26–38 Fenchurch Street, 1–16 Mincing Lane, 23 Rood Lane, 53 Great Tower Street, EC3	58578	15
OBL97	Britannia House, 16–18 Old Bailey, EC4	7464	4
SRP98	Spitalfields (Ramp), Spital Square, 280 Bishopsgate, E1	4591	2
GHT00	Blossom's Inn; 30 Gresham Street, 20–30 Gresham Street, EC2	60647	14
AUT01	12 Arthur Street, EC4	2140	2
SUF94	Suffolk House, 5 Laurence Pountney Hill, 154–156 Upper Thames Street, EC4	2831	2
BBB05	Bow Bells House, Bread Street, EC4	21380	3

Table 31.1: The twelve London sites on the database containing most graffiti on samian

Code	Expansion
1	Generic flagon
1B	Ring-necked flagon
1H	Flagon with continuous body
1/2	Generic flagon or jar
2	Generic jar
2A	Bead-rimmed jar
2B	Short-necked jar
2C	Necked jar with carinated shoulder
2E	Round-bodied necked jar with burnished shoulder
2F	Black-burnished-type everted-rimmed jar
2FX	Late version of everted-rimmed jar
2T	Necked jar
2V	Storage jar
2/3	Jar or beaker
3	Generic beaker
3J	Bag-shaped beaker
4	Generic bowl
4DR29	Drag form 29 bowl
4DR37	Drag form 37 bowl
4DR38	Drag form 38 bowl
4H	Rounded-rimmed black-burnished-type bowl
4M	Black-burnished-type flanged bowl
4/5	Bowl or dish
5	Generic dish
5DR15/17	Drag form 15/17 dish
5DR18	Drag form 18 dish
5DR18R	Drag form 18 dish with rouletting
5DR18/31	Drag form 18/31 dish
5DR31	Drag form 31 dish
5DR32	Drag form 32 dish
5DR36	Drag form 36 dish
5DR42	Drag form 42 dish
6	Generic cup
6DR24	Drag form 24 cup
6DR24/25	Drag form 24/25 cup
6DR27	Drag form 27 cup
6DR33	Drag form 33 cup
6DR35	Drag form 35 cup
6RT8	Ritt form 8 cup
7DR45	Drag form 45 mortarium
7HOF	Hooked-flange mortarium
9A	Lid
9RT13	Ritt form 13 inkwell

Table 31.2: List of form codes and their expansions used in the text

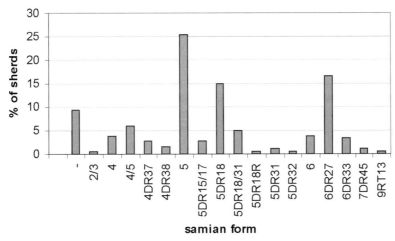

Fig 31.1: Chart showing forms of 181 samian sherds with graffiti on the MoLAS database

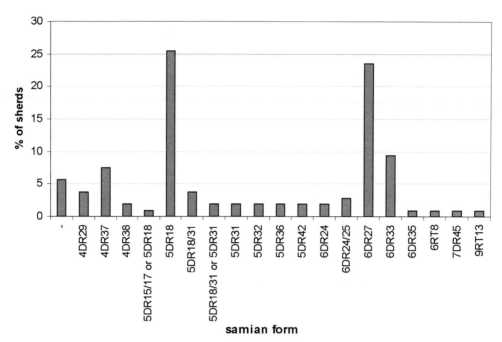

Fig 31.2: Chart showing forms of sherds with graffiti listed in RIB 2.7 and Britannia (vols 27–36)

Fig 31.3: Map showing in grey all sites excavated in and around the City of London and Southwark. Pink dots show concentrations of findspots of graffiti on samian

on a greyware vessel from Regis House (KWS94) reading 'good luck [to...]' (Hassall and Tomlin 1996, 450, no. 25), these will only be touched on briefly in this study.

Initially, a distinction was made between samian marked with a name or word, those marked with numbers, and those marked with a simple 'X'. However, as much of the material is from unpublished excavations and the graffiti have not

always been seen by an epigraphy specialist this approach led to a large grey area of single and pairs of letters which in some cases could be parts of names or words. Furthermore, should the ubiquitous 'X' be interpreted as a simple marker or the number 'ten'? At Usk the high incidence of 'X' was interpreted as ownership marks (Hassall 1982, 48). For the purposes of this study it was therefore considered

Fig 31.4: Distribution of graffiti on samian dated c *AD 50–100*

Fig 31.5: Distribution of graffiti on samian dated c *AD 120–250*

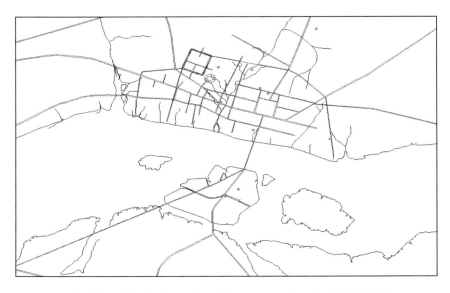

Fig 31.6: Distribution of graffiti on samian dated c *AD 150–300*

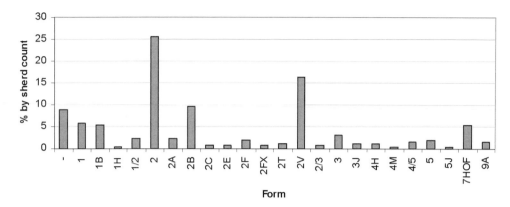

Fig 31.7: Coarseware forms (excluding amphorae) with graffiti marked on them in the MoLAS database

unrealistic to draw a reliable distinction between different categories of graffiti. This is not to suggest that there is no difference between samian marked with 'X' and those marked with a name or word, but it could be argued that the marking of samian with any sort of graffito actually implies the same intention: marking the vessel out.

Datasets

The study draws on two datasets: the first is the Museum of London Archaeology Service (MoLAS) Oracle database of material from the City and Southwark recorded since 1992. At the time of writing the MoLAS Oracle database contained details of 786,163 Roman pottery sherds, of which 79,349 were samian. Of these, 181 samian sherds were noted as being marked with graffiti. A second dataset comprises the London and Southwark data from RIB 2.7, the corpus of graffiti on samian in Britain (which excludes 'X' unless it is considered to be a number), and to cover material since its publication, the data from the 'Inscriptions' section in *Britannia* from 1994 to 2005 (vols 25–36) has also been added.[1] The MoLAS dataset includes all types of graffiti, whereas the RIB and *Britannia* data exclude 'X'. The numerical forms assigned to different classes of vessel by Marsh and Tyers (1978) have been used here as these are the framework for the MoLAS form series; the forms mentioned in the text are listed in Table 31.2.

Forms

Traditionally, samian forms are somewhat idiosyncratically divided into 'decorated' and 'undecorated' categories. The defining factor for 'decorated' samian is whether the vessel was made using a mould impressed with *poinçons*: vessels decorated *en barbotine* are classed as undecorated.

Work by Croom at Arbeia and Evans' synthetic study showed a far higher proportion of undecorated samian than decorated samian marked with graffiti (A Croom, pers comm; Evans 1987, 198). The 181 examples of samian with graffiti on the MoLAS database include just two instances of decorated forms marked with graffiti (Fig 31.1). Both

are Drag form 37 bowls, one from 10 Gresham Street (GSM97), and the other from Bow Bells House, Bread Street (BBB05). So the pattern of non-decorated samian being more likely to be written on, as noted elsewhere in Britain, is replicated in London.

The bias of plain forms being marked with graffiti is also seen in the data from RIB (2.7, table ix). Here plain wares, especially dishes, dominate the 758 examples of samian with graffiti and Drag form 37 bowls are the most commonly marked decorated ware (60 of the 72 examples).

A breakdown of the London data in RIB 2.7 and *Britannia* has a slightly different profile to the MoLAS data (Fig 31.2). The dataset combining the two is equally split between cups and dishes (both 40% each) with 13% marked on bowls. Interestingly, without the data from *Britannia* this is more weighted towards cups (42%) and slightly less towards dishes, which make up 36%. The MoLAS data (Fig 31.1) is more biased towards dishes (50%), and cups make up just a quarter of the dataset. Of some note is the Ritt form 13 inkwell with graffiti recovered from 168 Fenchurch Street, EC3 (FEH95); there is only one example of this form in the RIB 2.7 and *Britannia* dataset. Whilst the MoLAS dataset has just two examples from decorated vessels (both Drag form 37 bowls, mentioned above), there are twelve examples from the combined dataset for London. One explanation could be that some of the examples in RIB 2.7 were recovered from building work in the City in the first half of the 20th century and it is possible that there may have been a bias towards the curation of decorated samian.

This does not, however, explain the lack of decorated samian vessels in the MoLAS dataset. What effect the inclusion of all graffiti, including 'X', in the MoLAS dataset plays is unclear. It may account for the bias towards dishes, but it certainly does not account for the lack of marked decorated samian in the dataset.

Function

Samian (other than inkwells) is usually interpreted as table ware; in other words, it was directly associated with eating

as opposed to food preparation or storage. The forms have differing functions, as cups and beakers are associated with drinking and dishes and bowls with food. The single example of a samian mortarium with graffiti is in the RIB 2.7 dataset (there are no examples in the MoLAS database). The use of samian mortaria has sometimes been interpreted as indicative of communal usage or communal eating: certainly an example of pre-firing graffiti on a mortarium saying 'mixing-bowl for the barrack-room of Messor' (Hassall 1982, 48, fig 6 no. 44) supports this theory. The marking of plain samian dishes and cups or beakers has also been seen as indicative of the communal use of dishes 'even in civilian contexts' (RIB 2.7, 7).

Location of material

It will come as little surprise that in the survey of graffiti in Britain, London has the most incidences of graffiti on samian (RIB 2.7, table viii). Excavations in the City of London and Southwark by MoLAS over the past decade have been extensive; the grey dots on Fig 31.3 show locations of work. The pink dots show the location and relative quantity of samian with graffiti found. What is immediately noticeable is the concentration of sites with graffiti on samian within the Roman city walls, and a further concentration in Southwark. Of some note is the lack of graffiti on any waterfront sites even though large quantities of samian were recovered from excavations (Fig 31.3). This correlates with the supposition that the graffiti are related to consumption rather than supply. At Regis House (KWS94) and Suffolk House (SUF94), 20% of the sherds are samian – mostly 1st century La Graufesenque samian. From these sites just three sherds with graffiti were recovered. Similar patterns are seen at Three Quays House (LTS94) where most of the sherds are 2nd/3rd century Central Gaulish samian, New Fresh Wharf (NFW74) and St Martins House (SM75) where there was a high proportion of new Central and East Gaulish samian, as well as other imported wares (Symonds 2001, 85–92), but no graffiti on the samian.

The data from RIB 2.7 and *Britannia* cannot be shown on the maps as the findspots are not described with sufficient accuracy. However, there is a cluster from the Bank of England site and on King William Street, both in the City. As much of this material was collected during construction work in the first half of the 20th century, it has not been created from a systematic retrieval of material, and clusters in reality show where building took place rather than anything else. It should be noted that the largest group of material in this dataset is from unknown findspots.

In order to show distribution chronologically, the quantity of sherds is not shown, only findspots. Most of the fabrics of the MoLAS dataset have been analysed and it is clear that an overwhelming number are 1st century AD La Graufesenque samian (75%). A chronological breakdown based on fabric source is shown on Fig 31.4 (La Graufesenque samian (*c* AD 50–100)); Fig 31.5 (Central Gaulish samian (*c* AD 120–250)) and Fig 31.6 (East Gaulish Samian (*c* AD 150–300)). A slight geographical shift to the east can be seen, but, as the bulk of the samian is dated to the 1st century, the distribution may be unduly affected by the relative scarcity of the later material.

The 1st century material is evenly spread over the City and Southwark with few significant clusters other than one along Watling Street in Southwark and along the road leading to the north-west of the City, as well as from the site of the Cripplegate Fort. With regard to Southwark, Perring goes so far as to suggest a parallel between this area and Sheepen, 'a busy suburb largely dedicated to the needs of the army' (1991, 18). If one follows this suggestion then the cluster along Watling Street could be linked to the military traffic on its way to the north and west. However, Watling Street was a main thoroughfare and a developed area and the samian graffiti may simply reflect civilian use.

There are fewer findspots for the material dated *c* AD 120–250 than for the first century AD, and there is a marked reduction in the number for Southwark. Again, there are findspots along the road up to the north-west side of the City, but also there are a number within that quadrant of the City.

The findspots for the later East Gaulish samian primarily show a reduction in the number of sherds with graffiti found. There is just one findspot in Southwark and those in the City are in the central area – this time there are none on the road that leads to the north-west area of the City.

Coarsewares

On the MoLAS database, a total of 91 examples of graffiti on coarsewares are noted: the forms present are shown on Fig 31.7. A further 32 examples of marked coarsewares are listed in the RIB 2.8 dataset.

It is not surprising that proportionally more samian is marked with graffiti than coarsewares in the MoLAS dataset – 0.23% of the samian, as against just 0.01% of the coarsewares. This pattern is also seen in the RIB 2.8 dataset where the ratio of samian to coarsewares is almost 3:1 for London (table vii). The most common mark on the coarsewares in RIB 2.8 is 'X', but these have been excluded in the survey unless they represent the number 10 (RIB 2.8, 16); the MoLAS data includes all post-firing marks on coarsewares.

The RIB 2.8 data for all of Britain shows a strong bias towards jars being marked (40%) but less so for London (28%), and there is also a dissimilarity for beakers which represent 11% of the whole assemblage for Britain but make up 28% of the London data. Bowls/dishes are more common on average in Britain (23%) but only account for 16% of the London data. This is a stark difference to the MoLAS dataset where nearly 62% of the examples are from jars, and the next most common coarseware form to be marked is flagons (14%). Beakers, bowls/dishes and mortaria each represent 5% of the MoLAS dataset. This is a contrast to the marked wares (excluding samian) in Evans' survey: an average for jars with graffiti for all types of sites all over Britain was 30% (1987, 199, fig 6). He also found that vici tended to be rich in bowls/dishes and

flagons, whereas rural sites tended to have more jars (Evans 1987, 199): thus London appears to fit the profile of a rural site rather than the vicus it may technically have been. In some ways this is also reflected in the RIB 2.8 coarseware data as there are more towns and villas and fewer military sites with graffiti on coarsewares when compared to the samian equivalent (RIB 2.8, 20 and table vii).

Discussion

The distribution of graffiti on samian in London and Southwark overwhelmingly supports the idea that post-firing graffiti are primarily associated with consumption rather than supply. The lack of material from the waterfront sites known for samian storage, and the lack of samian with graffiti found associated with the pottery 'shop' at No. 1 Poultry (ONE94) emphasises this (Rayner in prep).

A connection between samian and the military, and indeed graffiti on samian at military sites, has been long recognised. Not only have military sites yielded a high proportion of graffiti (RIB 2.7, table viii), but finds such as a mortarium with pre-firing graffito 'mixing-bowl for the barrack-room of Messor' (Hassall 1982, 48, fig 6 no. 44) show an explicit link. Evans (1987, 196) argues that the high incidence of samian with graffiti in association with military sites is an indication of military standards as it reflects that a certain level of literacy was required. This link is again highlighted by a remarkable piece from Ospringe, Kent dated *c* AD 180–250 by associated pottery, which is inscribed 'Lucius, Lucianus, Iulius(?), Diantus, Victor, Victoricus, Victoriana (their) common dish' (RIB 2.7, no. 2501.306).

London is clearly not a military settlement but had trading and administrative functions; indeed, Tacitus describes London in the mid 1st century AD as a place known for commerce (*Annals* 14.32). Although not covered in this survey, a high proportion of the marks on amphorae were surely meant for merchants, as in the case of the Camolodunum form 186 amphora painted with 'Best young tunny, (matured) two years, 80 (the product) of Gaius Ascius Probus' (Tomlin and Hassall 2000, 440–1, no. 32) from No. 1 Poultry. Monteil's recent survey of inkwells in London (2008) suggests that ink writing was initially the preserve of traders and the military, but the number of inkwells found in London spreads rapidly during the Flavian period. This all indicates that at least some of the population was literate and that graffiti and literacy were not only connected to military activity.

London is listed as one of twelve locations which are known sites of early forts or military bases but few of the graffiti examples can be shown to date so early (RIB 2.7, table viii). Historical records of military movements show that no legions were permanently stationed in London but a high incidence of military finds as well as the early development of London as a town suggests an elusive military presence. The Cripplegate fort (Howe and Lakin 2004) and possible rampart at Plantation Place, Gresham Street (FER97; Pitt *et al*, forthcoming) are clear

indications of military activity, and structures such as the well and water-lifting equipment at Blossoms Inn are again suggestive of a military presence (Watson in prep). However, there is no clear link between the samian with graffiti and any known military structures. Recent work on the assemblages associated with the fortification at Plantation Place indicated that the make-up of the material was no different to that found elsewhere in London, other than a disproportionately high quantity of Baetican amphorae (Thompson forthcoming). The surprisingly small quantity of the later Roman Cripplegate fort material is also similar to City assemblages of a comparable date (Seeley 2004).

Assessment of the type of graffiti listed in RIB 2.7 (tables ii and iii) indicates that over half are marked with personal names. Furthermore, of these 379 names, 79 are nominative masculine, 41 are nominative feminine, 156 are genitive masculine and three are genitive feminine (RIB 2.7, table i). It is worth noting that the ratio of female nominative to genitive names marked on coarsewares is very different at 3:1 (samian is 8:1 – RIB 2.8, 18). That there are any female names represented is of some interest as women are so often missing from the written records. Despite the notable lack of feminine genitive names, the female names are suggestive of female literacy (otherwise why write them), and there are plenty of examples of female literacy in the Roman world such as political campaign posters made by women in Pompeii (Savunen 1995). The examples with female names inscribed also sits ill at ease with a simplistic link between graffiti on samian and the military.

When looked at as a proportion of the total number of sherds, there is an overwhelming preference for marking samian rather than coarsewares. This has been interpreted by some as an indication of the high intrinsic value accorded to this ware (eg Hassall 1982, 48). Conversely, it has been suggested that samian arrived in London with little carriage charge, thereby rendering it more cheap and available there than in other parts of Britain (Perring 1991, 19). However, the very high incidence of graffiti on samian found in London suggests otherwise, as samian appears to be just as valued (even if it was cheaper) in London as elsewhere. In some ways it is hard to accept the idea that graffiti on samian dishes and cups is simply a reflection of the communal use of samian, even in civilian contexts (RIB 2.7, 7). Whilst it is possible that the presumed higher price of samian and finewares may provoke someone to write their name or mark out a vessel, this does not explain the marking of coarsewares with graffiti, as not all the examples on coarsewares are to do with the vessel's contents and many are marked with names. Certainly most incidences of graffiti illustrate the desire to mark out property as one's own, but furthermore strongly suggest that some pottery, and samian in particular, was regarded as an item with intrinsic value, rather than simply as a disposable functional object.

Note

1 Relevant data as follows: Hassall and Tomlin 1996, 449–51 nos 16–20 and 26; Tomlin 1997, 464 no. 30

and 465, fig 6; Tomlin and Hassall 1999, 382, no. 16; Tomlin and Hassall 2000, 442, nos 37–8; Tomlin and Hassall 2003, 375, nos 26–29

Acknowledgements

This article was inspired by a lecture given by Alex Croom of Arbeia Museum at the Study Group for Roman Pottery conference in 2003. David Bowsher of the Museum of London Archaeology Service kindly prepared the GIS plots of data. Fiona Seeley, also of MoLAS, and Adam Corsini of the London Archaeological Archive and Research Centre were both invaluable in providing me with information and data.

Bibliography

Brigham, T, and Woodger, A 2001. *Roman and medieval townhouses on the London waterfront: Excavations at the Governor's House, City of London*, Mus London Archaeol Service Monogr 9, London

Cool, H E M, 2004. *The Roman cemetery at Brougham, Cumbria: excavations 1966–67*, Britannia Monogr Ser 21, London

Evans, J, 1987. Graffiti and the evidence of literacy and pottery use in Roman Britain, *Archaeol J* 144, 191–204

Hartley, K F, and Wright, R P, 1973. The graffito, in S A Castle and J H Warbis, Excavations on Field No. 157, Brockley Hill (Sulloniacae?), Middlesex 1968, *Trans London Middx Archaeol Soc* 24, 106

Hassall, M W C, 1982. Inscriptions and graffiti in G C Boon and M W C Hassall, *Report on the excavations at Usk 1965–1976; The Coins, Inscriptions and Graffiti*, University of Wales Press, 47–62, Cardiff

Hassall, M W C, and Tomlin, R S O, 1996. Roman Britain in 1995. II Inscriptions, *Britannia* 27, 437–57

Howe, E, and Lakin, D, 2004. *Roman and medieval Cripplegate, City of London: archaeological excavations 1992–8*, Mus London Archaeol Service Monogr 21, London

Marsh, G, and Tyers, P, 1978. The Roman pottery from Southwark in *Southwark Excavations 1973–4* (eds J Bird, A H Graham, H Sheldon and P Townend), Joint Pub 1, London Middx Archaeol Soc and Surrey Archaeol Soc, 533–82

Monteil, G, 2008. The distribution and use of samian inkwells in Londinium, in *Londinium and beyond. Essays on Roman London and its hinterland for Harvey Sheldon* (eds J Clark, J Cotton, J Hall, R Sherris, and H Swain), Counc Brit Archaeol Res Rep 156, 177–83, York

Perring, D, 1991. *Roman London*, London

Pitt, K, Harward, C, and Dunwoodie, L, forthcoming. *Excavations at Plantation Place: the Roman Sequence*, Mus London Archaeol Service Monogr, London

Rayner, L, in prep. The Roman pottery, in J Hill and P Rowsome, in prep, *Excavations at No. 1 Poultry: the Roman sequence*, Mus London Archaeol Service Monogr, London

RIB 2.7 = Collingwood, R G, and Wright, R P, 1995a. *The Roman inscriptions of Britain* 2, Instrumentum Domesticum *(personal belongings and the like)*, Fasc 7, *Graffiti on samian ware (*terra sigillata*)*, (*RIB* 2501.1–880) (eds S S Frere and R S O Tomlin), Stroud

RIB 2.8 = Collingwood, R G and Wright, R P, 1995b. *The Roman inscriptions of Britain* 2, Instrumentum Domesticum *(personal belongings and the like)*, Fasc 8, *Graffiti on coarse pottery cut before and after firing, stamp on coarse pottery*, (*RIB* 2502–2505) (eds S S Frere and R S O Tomlin), Stroud

Savenen, L, 1995. Women and elections in Pompeii, in *Women in Antiquity: new assessments* (eds R Hawley and B Levick), London

Seeley, F, 2004. The Roman pottery, in Howe and Lakin 2004, 108–11

Symonds, R, 2001. The Roman pottery, in Brigham and Woodger 2001, 85–92

Thompson, C S, forthcoming. The pottery, in Pitt *et al* forthcoming

Tomlin, R S O, 1997. Roman Britain in 1996. II Inscriptions, *Britannia* 28, 455–72

Tomlin, R S O, and Hassall, M W C, 1999. Roman Britain in 1998. II Inscriptions, *Britannia* 30, 375–86

Tomlin, R S O, and Hassall, M W C, 2000. Roman Britain in 1999. II Inscriptions, *Britannia* 31, 433–49

Tomlin, R S O, and Hassall, M W C, 2003. Roman Britain in 2002. II Inscriptions, *Britannia* 34, 362–82

Tyers, P, 1996. *Roman pottery in Britain*, London

Watson, B, in prep. *Excavations at Blossom's Inn*, Mus London Archaeol Service Monogr, London

32 The sizes of samian vessels and dining: evidence from Roman London

Gwladys Monteil

I first met Brenda in London in October 2001. She had kindly agreed to travel from Leeds on her birthday to listen to a seminar I was giving on preliminary results from my doctoral research. To say that I was nervous is an understatement. I was new to Britain and to samian ware research, and talking in front of an audience with Brenda Dickinson and Geoffrey Dannell was an intimidating prospect. I needn't have worried for her comments were kind, encouraging and helpful. Her knowledge and encyclopaedic memory for potters has never ceased to amaze me since. To those who know Brenda, her humility is inspiring. She is a kind and generous person, an extraordinary scholar and it is a great pleasure to contribute to this volume for her birthday.

Introduction

The existence of samian services and the presence of discrete vessel sizes have long been recognised but their implications for dining have yet to be examined across assemblages (Loeschcke 1909; Drexel 1927; Vernhet 1976; Tyers 1993; Webster 1996; Polak 2000). Recently, some researchers have attempted to address issues of consumption: Biddulph (2005) with a survey of wear patterns on samian vessels, Willis' pilot study (1998; 2005) of samian distribution in Roman Britain, and Dannell's investigation (2006) into the possible uses of cups.

While researching samian ware distribution in Roman London, I observed that previously undetected ratios between the numbers of cups and dishes and the different sizes of samian forms in consumption groups gave some indication of how they might have been used together – a significant advance in understanding the dynamic of samian services over time. The sample on the basis of which the following article is based comes from a range of sites in Roman London. Two excavations provided large South Gaulish groups enabling a survey of rim diameters for material from Roman London and comparison with the results from Usk (Tyers 1993) and Vechten (Polak 2000): the samian assemblage from excavations at the General Post Office, 81

Newgate Street (GPO75 and POM79) and the samian group from the pre-basilican levels at Leadenhall Court (LCT84). Large groups of samian ware from warehouse deposits from the waterfront of Roman London (NFW74 and SM75 at New Fresh Wharf and LTS95 at Three Quays House) have allowed the same type of diameter analysis to be extended to Central and East Gaulish samian vessels.

This analysis will provide new evidence for sizes in later samian vessels and will show that the trend in diameters for samian cups and dishes persists through changes in supply. The evidence about sizes is later used to differentiate the range of types present and illustrate the detailed numerical organization of a selected number of samian assemblages in Roman London of the 1st and 2nd centuries AD.

Samian types, sizes and function

The range of samian forms produced in each of the different production centres has been extensively studied and the common samian repertoire is familiar to most Roman archaeologists. Despite the abundance of typologies and catalogues, the difficulty of attributing function to samian vessels persists (Willis 1998, 113; Dannell 2006). Little is known about how samian vessels were used and why some forms were selected and used (Willis 1997, 41). A limited amount of epigraphic evidence is available on vessels in the Roman world, most of it found in production centres. However limited, the ancient terminology and some graffiti contribute to our understanding of vessels in the Roman Empire. Studies in standardization of Roman pottery, especially samian, have a long history (Rottländer 1966; 1967; 1969; more recently Polak 2000), but these works are mainly concerned with chronological and production issues, firing processes and ease of stacking in transit. The question of standardization has also been tested against Roman units of measurement (Rottländer 1966; 1967; 1969; Orton 1980, 209–10; Tyers 1993; Polak 2000). While standardization of samian vessels is often seen as a consequence of the rationalization of a semi-industrial production and an essential requirement for long-distance

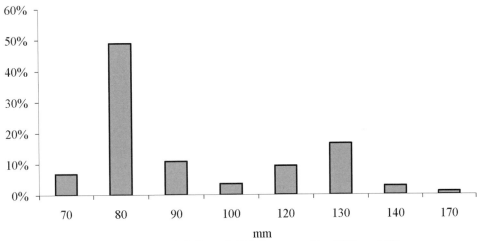

Fig 32.1: South Gaulish Drag 24/25 diameters (rim EVEs = 2.78)

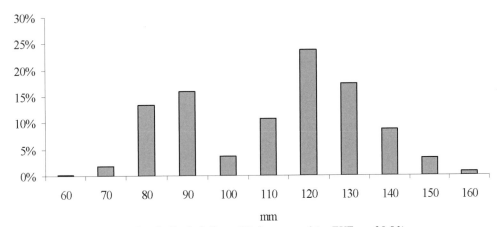

Fig 32.2: South Gaulish Drag 27 diameters (rim EVEs = 30.91)

transport, the issue of sizes in domestic groups and their implication remains under-researched. Sizes ultimately relate to function, use and eating habits. Typological similarities between forms, a selected number of samian groups from graves and an Egyptian papyrus suggest a formalized 'ideal' of dining but little is known of how this ideal was interpreted and manipulated by consumers. The role played by plain samian forms has rarely been at the forefront of samian studies in domestic groups and the published work is limited to the 1st century AD (Tyers 1993; Polak 2000 with the exception of Willis 1998). Is for example the number of cups to a plate consistent across time and space and what can it tell us about eating habits? Are samian services visible in samian assemblages? A survey of rim diameters of some of the samian forms can shed light on the sizes present and the possible functions fulfilled and how they might have been used together.

Cups

Dannell has recently extensively surveyed (2006) the vast array of South Gaulish samian types grouped under this

term. The exact correlation between the antique names and the modern terminology is far from certain and is still debated. Marichal suggests that the vessels called Drag 24/25 correspond to the *acitabli* and the ones labelled Drag 27 to the *paradixi* (Marichal 1988, 83, 90). Polak is however doubtful that *paradixi* and *acitabli* correspond to these two types 'because they are as numerous as *catili* in the dockets' and are likely to be more general terms. Polak prefers to see *paradixi* as all medium-sized cups regardless of the type and the *acitabli* as small cups produced in three sizes; thus the *paradixi* are larger than the *acitabli* (Polak 2000, 131, n 8). Drexel had already suggested that the main difference between *paradixi* and *acitabli* was centred on size rather than type (1927, 52). Dannell seems to favour *acetabula* for the Drag 27, *paropsides* for Drag 24/25, Ritt 8 and the later Drag 35, and *licuiae* for the Ritt 5 and 9 and the Drag 33 (2006, 162). Whichever correlation is accepted, *paradixi* and *acitabli* are among the vessels listed in one of the Vindolanda tablets found in Room VIII of the *praetorium* in period 3, which was identified as a kitchen (Bowman and Thomas 1994, 162, no. 194, and 163). *Acitabli* originates from *acetabulum*, a vinegar-bowl

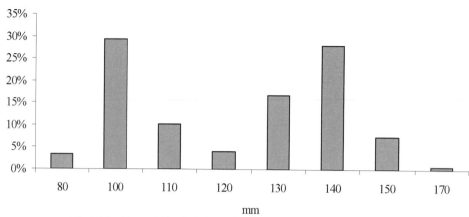

Fig 32.3: Central Gaulish Drag 27 diameters (rim EVEs = 2.93)

and *paradixi* from *paropsides*, possibly a dish for fine food or dessert or a side-plate (Strong 1966, 129; Bowman and Thomas 1994, 163–4; Dannell 2006, 152). Two other types of cup are mentioned in the work of Marichal, the Ritt 8 and the Drag 33. While Ritt 8s are traditionally classified as cups it was suggested by Marichal that they could be *panna triantales*, small bowls, and the deeper Drag 33, *licuias*, '*creuset*' (Marichal 1988, 88–9).

A limited amount of experimental work has shown that the Drag 27 can successfully hold a small amount of liquid 'without spillage' (Tyers 1993, 137). Some of the other forms traditionally labelled 'cups' such as the Drag 35 or the Walters 80 are, due to their shallowness, more problematic. It might be more appropriate to see these shallow forms as side dishes or '*coupelles*'.

As far as function is concerned, samian cups are often classified as drinking-related forms (Vernhet 1991, 25; Evans 1993, 95) and in some contexts as evidence of individual wine-drinking practices in contrast to beakers thought to be more communal vessels involved in beer-drinking (Cooper 1996, 90; Meadows 1997, 26). It has also been suggested that the shallowness of these vessels was adapted to the Roman habit of eating and drinking in a reclining position (Evans 1981, 529). More recent research based on wear patterns found on the inside of two types of samian cups, the Drag 27 and the Drag 33, seems to suggest very idiosyncratic uses of some examples (Biddulph 2008).

While epigraphic evidence and research into classical resources remain essential, statistical analysis of the rim diameters present for all samian cups in the London sample provides complementary evidence to the study of the types. All the cups are discussed by type and origin in a broad chronological order. For each type, the relative percentages taken up by each diameter were calculated and are presented in histograms. All the figures are based on rim-EVEs (Estimated Vessel Equivalents).

Drag 24/25. The earliest type of cup with a sufficiently high rim EVEs figure is the Drag 24/25 of which all of the examples are South Gaulish. A bi-modal distribution of diameters is visible with two main sizes, one at 60–90mm and another one at 120–130mm (Fig 32.1). The relative quantities taken up by each of these sizes are, however,

unequal. Almost half of the examples from London are small with a diameter of 80mm. The rest of the examples are distributed among the other diameters with another concentration between 120 and 130mm.

This bi-modal distribution and the sizes for this type fit well with the results from Usk (Tyers 1993, 135). The relative proportion of small and large examples of the Drag 24/25 is, however, different from Usk where more examples of the large version of Drag 24/25 were recovered. To what extent this is significant is difficult to say. The EVEs figure for the Drag 24/25 in London is smaller than the one in Usk and the presence of so many small Drag 24/25s in this sample might be related to the small number of examples.

Drag 27. The second most popular type of samian cup is the Drag 27. The EVEs figure for the examples from La Graufesenque is large in this sample and gives some confidence to the statistical analysis of the rim diameters.

The separation of the rim diameter value into two groups noticed for the Drag 24/25 is again very clear for the Drag 27 (Fig 32.2). Two sizes occur with a small version between 60 and 100mm and a second larger module between 110 and 160mm. These two groups of diameters fit well with the findings from Usk where the Drag 27 diameters were also grouped into two units (Tyers 1993, 135). The relative quantities taken up by each size broadly parallel the findings from Usk with larger Drag 27s outnumbering the small ones. The distribution between the two sizes is, however, more levelled in London whereas at Usk Drag 27s with a radius of 60mm clearly dominate the profile (Tyers 1993, 135, fig 69).

It is clear that the main types of South Gaulish samian cup, the Drag 24/25 and 27, come in two sizes in Roman London, a small and a large one. At Vechten, three sizes were observed for all South Gaulish cups but one is rare (Polak 2000, 99). The main range of sizes recorded there were small and large cups and it concurs with Usk and London with diameters between 60 and 100mm and between 110 and 160mm.

Central Gaulish Drag 27s are rare but they do occur (Bet and Delor 2000, 464–6). In London, the total EVEs figure is small but the distribution of the rim diameters present is again bi-modal (Fig 32.3). Two sizes are present

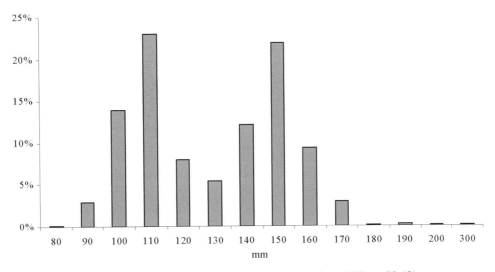

Fig 32.4: Central Gaulish Drag 33 diameters (rim EVEs = 50.43)

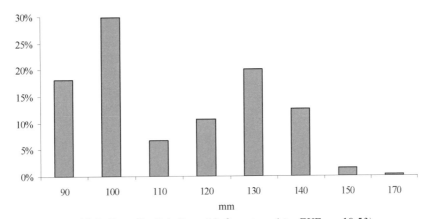

Fig 32.5: East Gaulish Drag 33 diameters (rim EVEs = 19.53)

at 80–120mm and 130–170mm. More large examples are present than small ones in London.

Drag 33. Examples of the South Gaulish Drag 33 are insufficient in this sample to conduct a reliable analysis of diameters. Polak has suggested that there were four sizes: 100, 130, 170 and 200mm (2000, 103). Some examples for which diameters were recorded in London broadly correspond to the diameters recorded in Vechten but most of the Drag 33s in the present sample do not strictly fit into the sizes defined by Polak, with examples at 90, 120, 140 and 150mm. Large examples with diameters of 200mm are absent.

Central and East Gaulish Drag 33s are far more common than their South Gaulish predecessors and the sample is sufficiently large to conduct a diameter analysis. Central Gaulish examples of Drag 33 seem to occur in two major classes of diameter: 90–120 and 140–170mm. There is no clear division between the two classes as examples with a diameter of 130mm make up slightly more than 5% of the total and without further analysis of complete profiles, it is impossible to classify them as small or large. The two modules could also overlap.

The bi-modal distribution noticed for the Drag 27 is nonetheless still visible for Central Gaulish Drag 33s (Fig 32.4). There seems, however, to be a fairly large number of Drag 33s with unusually large diameters (180, 190, 200 and 300mm). Their relative quantities are small but the presence of diameters as large as 300mm might appear surprising for what are traditionally called cups. This irregularity also shows in production series: certain examples can present a diameter of 250mm (Bet *et al* 1989, 40). Very large examples of this form were not an introduction of the Central Gaulish potters, since, out of the four sizes distinguishable in the South Gaulish examples in the Vechten sample, two are large (Polak 2000, 103). Increased diameters could be significant if related to the parallel increase in volume of some of the contemporary dishes (eg Drag 31).

Considering that the East Gaulish fabric group encompasses a rather varied and dispersed number of production centres (Trier, Rheinzabern, La Madeleine, etc), the presence of a bi-modal distribution of the East Gaulish Drag 33 diameters is remarkable, with two *foci* at 90 and 100mm and a more diffuse distribution between 110 and 150mm (Fig 32.5).

In terms of chronological evolution in the sizes of samian cups, some general trends can be detected. South Gaulish cups have examples with small diameters (60–70mm) that are not present in later types. On the basis of the present sample, it is clear that the two main sizes of Central Gaulish cups are larger than their South Gaulish counterparts. Although this could suggest an increase in the sizes of samian cups produced through time, East Gaulish cups are closer to South Gaulish examples in terms of diameters than contemporary Central Gaulish examples. East Gaulish Drag 33 examples are noticeably smaller than Central Gaulish ones. There is therefore no evidence of a systematic and clear chronological increase in the sizes of samian cups or at least their diameters. More data need to be gathered, in particular on the range of cup diameters produced by the different East Gaulish centres. Beside variations from one production centre to another, there is overwhelming evidence to suggest that the bi-modal distribution of diameters for samian cups is a trend that persists through time, changes in types and suppliers. Two main sizes were available for each of the samian cups surveyed. Does this necessarily mean that different sizes of cups were used differently? Assuming that *acitabli* and *paradixi* correspond to the same type of cups produced in two different sizes (Polak 2000, 131), the distinction is probably significant.

Dishes

Dishes also include a variety of types, from shallow platters such as Drag 15/17 and Drag 18, to deeper, chronologically later forms such as Drag 31 and Curle 15. The graffiti found at La Graufesenque refer to two sizes, *catini* and *catili*, dishes and plates (Marichal 1988, 85–6). Within the broad dish category most samian specialists distinguish between standard and rouletted versions. In Lezoux most samian dish types come in two versions, '*assiette*' and '*plat*' (Bet and Delor 2000, 462). The French terminology makes a distinction between plates and dishes because it assumes a difference in the way they were used in terms of eating habits. *Assiettes* (plates) are usually meant for individual consumption of food while *plats* (dishes) are used for the service of food (Bats 1988, 24). The differentiation between a samian plate and a dish is based on size and often the presence of a rouletted circle on the base. In Britain, however, there is a certain inconsistency in the terminology and nomenclature used to describe samian dishes. What 'platters' and 'dishes' mean or correspond to in samian ware is still controversial (Willis 1998, 112). The problem of definition is well exemplified by the series grouped under Drag 18, 18/31 and 31 numbering (*cf* Polak 2000, 65–66 for a good summary of the origin of the problem). Over time the series evolves from a shallow platter in the pre-Flavian period (Drag 18) to a deep-walled form in the 2nd century AD (Drag 31). Drag 31 is bigger than Drag 18, the diameter is larger and the walls much deeper, with Drag 18/31 lying somewhere in the middle without well-defined criteria. In Britain Drag 18/31 and Drag 18/31R are seen

as a transition between dish and bowl, while Drag 31 and its rouletted counterpart Drag 31R are classified as bowls (Webster 1996, 34–5). In the latest typology by Bet and Delor (2000), the distinction between plate and dish for Drag 31 and Drag 31R is seen as more meaningful than a change in terminology to bowl.

The confusion in labelling is problematic because it is usually accepted that a bowl fulfilled a different function from a dish or platter. In other words a platter cannot hold the same type of food as a deeper receptacle such as a bowl. Some see the increase in the depth of samian dishes as pragmatic, a reflection of changes in food. Regional and provincial variations in the frequency of these dishes should be compared to animal bones and environmental analysis (G Dannell, pers comm). Others see the function associated with the different chronological evolution of samian dishes as consistent through time and changes in fashion (Willis 1998, 112–3; R Symonds, pers comm). Other explanations are more challenging and relate changes in some fineware dish sizes to eating habits (Hawthorne 1997; 1998). Hawthorne has argued that the increase in African red slip ware dish sizes was related to a change to a communal attitude to foodstuff in Africa rather than food per se or a crisis in supply (Hawthorne 1997). His further study of Gaulish samian form sizes also related the decrease in the number of samian sherds in circulation in the 2nd century AD to changes in sizes and volume of vessels rather than a decline in supply (1998, 167–8). Until an Empire-wide survey is conducted, the question remains open.

For samian dishes, studies at La Graufesenque (Marichal 1988, 85), Usk (Tyers 1993) and Vechten (Polak 2000, 74–80) have shown that there are several sizes present in what is usually grouped under the blanket term 'dish'. This type of distribution in dish diameters is not new: Paul Tyers has shown that the diameters of Drag 18 and 15/17 from Usk had a distribution with a main mode with a long trail (1993, 133–4). The study of South Gaulish vessels from Vechten also showed a variety of sizes present. For Polak, there are two sizes of standard dishes and four sizes of rouletted dishes (Polak 2000, 74–5, 92). There is a comparative sample now available from Roman London and several trends can be detected.

Drag 15/17 and Drag 18. There were very few complete profiles for the South Gaulish dish types in the groups analysed during this project. Because the samian dishes from London are far more fragmentary than at Vechten, it was not possible to systematically distinguish standard examples from rouletted ones in order to test the rim-diameter for each type. The rim EVEs figures for all examples of a type were therefore grouped regardless of the presence or absence of a rouletted circle.

The existence of a variety of significant sizes within the same types of South Gaulish samian dishes has been substantiated by the sample from London. The majority of the diameters for both Drag 15/17 and 18 centre around 160–180mm. There is a muted but long trail towards large sizes with some very large examples of the Drag 15/17 with diameters of 320 to 340mm (Figs 32.6 and 32.7).

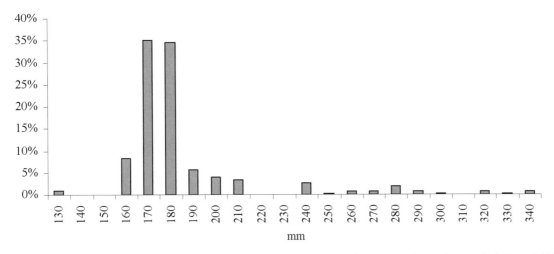

Fig 32.6: South Gaulish Drag 15/17 diameters (combined rim EVEs for Drag 15/17 and Drag 15/17R = 8.39)

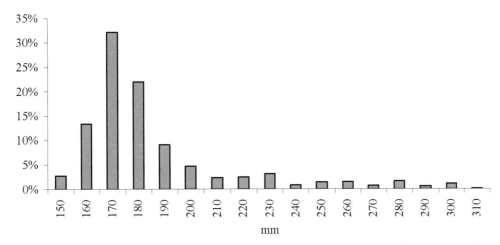

Fig 32.7: South Gaulish Drag 18 diameters (Drag 18 and Drag 18R combined rim EVEs = 28.8)

The quantitatively dominant group of rim-diameters (160–190mm) corresponds to one of the standard dish categories defined by Polak (2000, 74). For all types of South Gaulish standard dishes, Polak has identified two main sizes, one being small, with diameters around 135mm, and one being larger, with diameters around 170mm. The latter figure corresponds to Polak's group B, some examples of which can be as large as 190mm (Polak 2000, 75, fig 6.14) as in the present assemblage.

Beside the main group of diameters, some examples of the Drag 15/17 have very small diameters in London (*c* 130mm) and they correspond to the small standard dishes as defined by Polak. They are rare in London and this suggests that the size was going out of fashion. This is confirmed by the examples of Drag 18 for which this small size is absent in London (Fig 32.7). For the Drag 18s, the main size present in Roman London is the one around 170mm. The rarity of small 'standard dishes' is not particular to London (Polak 2000, 76); they are virtually absent from Usk although there a few Drag 18s have radii below 80mm (Tyers 1993, 135, fig 68).

Beside the examples with diameters between 150 and 190mm, there are several examples with large diameters. The range is wide from 200mm to 340mm (Figs 32.6 and 32.7). If we turn again to Vechten where complete profiles are available for these forms, the analysis there emphatically demonstrates that the first size cluster for the rouletted versions is between 210 and 240mm (Polak 2000, 92). There are several examples with diameters of 200mm in London and it is difficult to ascertain whether they are standard or rouletted dishes since there may be some overlap between the two.

Distinguishing a rouletted example from its standard version is notoriously difficult when one is confronted with an example without the base, but if the diameters of well-preserved examples are systematically recorded, it becomes clear that the larger examples are most certainly the 'dish' version of a form, whether rouletted or not. Rather than focusing on the symptomatic presence of rouletting, diameter should be the defining factor. Examples of the South Gaulish forms Drag 15/17 and Drag 18 whose diameters are superior to 200mm should be classified as dishes rather than plates. The absence of Drag 18Rs was noted at Usk (Tyers 1993, 133) but some of the Drag 18s from that site have radii of 110mm or more (*ibid*, 134), which would make them rouletted dishes.

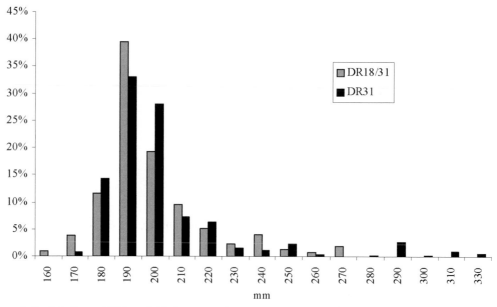

Fig 32.8: Central Gaulish Drag 18/31 and 31 diameters from examples with complete walls (Drag 18/31 rim EVEs = 7.24, Drag 31 rim EVEs = 10.7)

More importantly, this has relevance when analysing the composition of samian assemblages where ideally plates should be differentiated from dishes. Considering the high level of standardization in the production of samian plain ware, such large differences in diameters surely mean that the large examples were intended to fulfil a different purpose (serving) from the smaller ones (ie an individual plate). This also has implications on our understanding of the use of samian forms and the idea of services, the number of participants during a meal and formalized dining customs.

Drag 18/31 and 31. Most continental samian specialists see the label 'Drag 18/31' as too subjective and confusing to be meaningful (Polak 2000, 66; Bet and Delor 2000, 470). They all prefer to use Drag 18 for the 1st century examples of the form whether South or Central Gaulish (Bet and Delor 2000, 470, no. 058A and P). The label Drag 31 should be used for 2nd century examples originating from Lezoux (Bet and Delor 2000, 470, nos. 054, 055, 056). In Britain the 'Drag 18/31' is seen as a helpful chronological marker (Webster 1996, 35) but Bet and Delor do not consider the distinction between Drag 18/31 and 31 as chronologically meaningful (Bet *et al* 1989; Bet and Delor 2000, 470). The types 054, 055 and 056 in the latest Lezoux typology are all contemporary Central Gaulish productions of the 2nd century AD (Bet and Delor 2000, 470). The main difference between the two forms lies of course in the depth of their walls, with the Drag 31 being much deeper, and as mentioned earlier the form is often classified as a bowl rather than a dish (Webster 1996, 34). In Lezoux two versions are distinguished, with the 055 being shallower than the 054 (Bet and Delor 2000, 468).

Studies of diameters for Central and East Gaulish Drag 18/31 and 31 are lacking but two large waterfront groups

from London, Three Quays House and New Fresh Wharf provide an extensive body of quantified evidence. As already noted for South Gaulish dishes, it is difficult to distinguish a standard version of a dish from its rouletted version if faced with a small fragment. Following the successful results of the analysis of South Gaulish dish diameters in distinguishing small from large examples, the same survey was done with Central and East Gaulish Drag 18/31 and 31. Rim EVEs figures for Drag 18/31 and 18/31R were added as were EVEs figures for Drag 31 and 31R. Wall height was used to distinguish Central Gaulish Drag 18/31 from 31 and their relevant diameters tabulated separately (Fig 32.8).

The main range of diameters for Central Gaulish Drag 18/31 and 31 is close, with the bulk of both samples between 190 and 200mm. Each form has a long trail towards larger diameters, although the range for Drag 31 is broader than Drag 18/31 with diameters as large as 330mm. There are more examples of larger Drag 31 and Drag 18/31. These long trails towards larger diameters probably correspond to the 'dish' version of the forms, customarily labelled Drag 18/31R and 31R. Published complete examples from Lezoux suggest that form 054/Drag 31 has a diameter of 180mm and form 056/Drag 31R a diameter of 270mm (Bet and Delor 2000, fig 4, no. 246).

An exact position at which small versions of the form make way for the larger ones is not immediately clear on Fig 32.8 as the transition is gradual and overlap is possible. 240mm might, however, be proposed as a possible pivotal point where Central Gaulish Drag 18/31 correspond to rouletted dishes and 250mm when Drag 31 also correspond to larger rouletted examples. This by no means constitutes the final answer on the question; a Central Gaulish Drag 31R from St Magnus for example has a diameter of 240mm

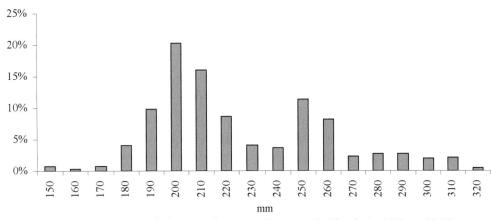

Fig 32.9: East Gaulish Drag 31 diameters (New Fresh Wharf, rim EVEs = 21.61)

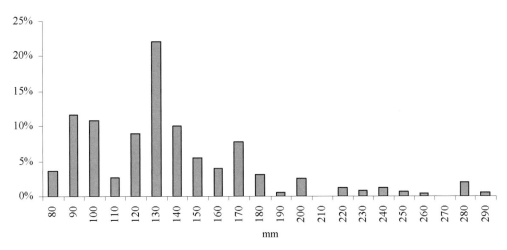

Fig 32.10: South Gaulish Drag 35/36 diameters (rim EVEs = 7.96)

(Bird 1986, 177, 2.180). This should ultimately be tested against larger and more complete assemblages, in particular groups from Central Gaul.

The results of the above survey are limited in their impact on systematically distinguishing Central Gaulish Drag 18/31 from 31. Their range of diameters is similar and without a significant portion of the wall it remains difficult to assign a sherd to one or the other. The group from Three Quays House is exceptional in its preservation and most normal assemblages do not offer the luxury of complete profiles. Admittedly, the differences do not seem to have major chronological implications but they might have fulfilled different roles in dining. The analysis of diameters is marginally more successful as it provides quantified evidence that Drag 18/31, 18/31R, 31 and 31R correspond to well-defined sizes. This is not in itself a major revelation; most Roman pottery specialists are aware that indeed rouletted Central Gaulish Drag 18/31 and 31 are larger than their standard counterparts (Webster 1996, 33–4). However it hopefully makes clear that a more detailed recording of diameters provides a way in to identifying Central Gaulish 'standard' dishes from their 'rouletted' versions when confronted with small fragments. This is not to say that the rouletted circle should be ignored but the

above survey focuses on distinguishing plates from dishes in samian assemblages, and rims provide a more reliable body of evidence in this respect than rouletting.

The range of diameters present in East Gaulish Drag 31s is similar to the Central Gaulish one in many respects but the average size of the East Gaulish standard Drag 31 is slightly larger (Fig 32.9). The relative quantity of large examples, most probably rouletted versions, is also more prominent. The range of East Gaulish Drag 31s can be broken down into three classes. A minor proportion of them have small diameters between 150 and 170mm. The next group, quantitatively dominant, increases in size with diameters between 180 and 240mm. Finally a third group with larger diameters appears between 250 and 320mm. This last group almost certainly covers the rouletted versions of the form. In terms of identification, distinguishing between East Gaulish standard and rouletted versions seems easier on diameters alone than for Central Gaulish examples. The decisive diameter in differentiating East Gaulish Drag 31 from their rouletted counterparts is 250mm.

Drag 35, 35/36 and 36 series. Being an unstamped series, these three types were left out of the Vechten study of diameters and because they were present in small numbers,

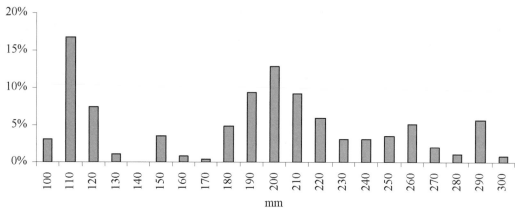

Fig 32.11: Central Gaulish Drag 35/36 diameters (rim EVEs = 11.79)

the samian report from Usk only paid scant attention to this set (Tyers 1993, 136). It is unfortunate as there are sizes at work, implicit in the terminology but rarely studied systematically.

Looking at Fig 32.10 where all the forms are shown regardless of the traditional classification, it is far from easy to distinguish clear groups based on size. It also illustrates how difficult the distinction might be when confronted with a small part of a vessel. The distribution of diameters in the tripartite manner fits well with the classic terminology that distinguishes three sizes. The majority of the group fits in the medium range (110–160mm) and this makes it difficult to distinguish clearly between 'cup' and 'plate' for this form. From 170mm, South Gaulish examples seem to trail off ending with examples as large as 290mm in diameter.

Central Gaulish examples are by comparison larger than South Gaulish ones with a better distinction between small and large examples (Fig 32.11). French terms for Central Gaulish examples of this series are to a certain extent better adapted to the form with Drag 35 being a '*coupelle*' and Drag 36 a '*coupe*' (Bet *et al* 1989, 39). In its latest revision of the Central Gaulish plain samian typology, three sizes are implicit in the labelling where Drag 35 is still called a '*coupelle*' and Drag 36 can occur both as a '*coupe*' and a '*plat*' (Bet and Delor 2000, 464).

In London, two sizes can be distinguished between 100 and 170mm although small diameters (100–120mm) have a far larger relative proportion of the total than the examples with diameters between 130 and 170mm. The medium size dish with diameters between 180 and 220mm is especially clear. There is also a long trail of larger diameters starting at 230mm up to examples as large as 300mm.

As for the South Gaulish Drag 35/36 series, the different sizes of the Central Gaulish Drag 35/36 series were catalogued on the basis of their rim diameters and the sizes highlighted by the histograms above. The value in distinguishing between small and large Drag 35s might appear artificial for the Central Gaulish series but two sizes are clear enough on the graph if not represented in the same quantity. Two groups were therefore defined, small Central Gaulish Drag 35 (100–130mm) and large Central Gaulish

Drag 35 (150–170mm). The rest was divided into Central Gaulish Drag 35/36 (180–220mm) and Central Gaulish Drag 36 (230–300mm).

In conclusion it is essential to distinguish small from large dishes because they are likely to have been used differently. Dishes with smaller diameters, the 'standard' dishes identified by Polak, are plates meant for the individual consumption of food. Quantitatively, the type dominates all the groups quantified by EVEs in London. Hawthorne's analysis of the increase of Gaulish samian ware unfortunately provides limited evidence as it refers to 'bowls' without defining which samian types are included. I am not arguing with the theoretical underpinnings of his analysis or his conclusions: some samian vessels do increase in size in the 2nd century AD as has been demonstrated above. My problem is with the lack of precision in Hawthorne's approach to the samian repertoire of the 2nd century AD. Which forms in Webster's classification were used to create Hawthorne's figure on Gaulish bowls is not clearly explained (1998, 167, fig 3). Webster is himself lacking in consistency in his samian classification of what should constitute a bowl or a dish and several loose categories are used, for example shallow dishes and small bowls (1996). Platter-like dishes exist in late samian repertoire albeit in small numbers (Walters 79, Lud Tg). Admittedly all these finer points of terminology and consistency might be the concerns of modern ceramic specialists but the range of forms available once Central Gaulish potters take over the market is complex in its array of types and sizes (Bet and Delor 2000). A model based on a simple switch from individual to communal eating habits does not account for the complexity of samian assemblages of the 2nd and early 3rd centuries AD. While an all-encompassing 'bowl' category might be sufficient to illustrate the increase in vessel volume, it is unsatisfactory for the purposes of this survey.

Using samian sets and services

Beyond each individual form, the organization of samian assemblages in dining sets and services has a long scholarly tradition. The pairing of plain forms, in particular cups and dishes, into sets or services has long been at the core

of plain samian analysis. As far back as 1909 Loeschcke grouped the samian forms from Haltern into four services on the basis of typological similarities and sizes. In the latest typology of Arretine terra sigillata, the authors are however sceptical about the concept of samian service and depart from Loeschke's original classification based on sizes because 'these definitions … have to some extent outlived their usefulness' (Kenrick 1990, 46–7). While it is to some extent true that too strict labelling impedes analysis rather than enhances it, the very narrow and typological approach of this work focuses solely on aiding identification rather than considering the role of vessels in dining.

The most current definition of the word 'service' in samian studies relates to strict parallels in the shape and decoration of certain samian forms. The word 'set' is often used for these forms (Webster 1996, 26). The notion of services based on strict typological similarities between certain cups, bowls and dishes originates in the study of samian material from production sites. It was Vernhet, with the definition of six services (A to F) with barbotine decoration on the rim produced at La Graufesenque, who systematized the recognition of strict and consistent parallels between samian types (Vernhet 1976; 1986, fig 3). In the most recent typology from Central Gaul, dishes and cups with the same shape and rim are still grouped into 'services' (Bet and Delor 2000, 465–8). Webster follows the strict typological approach but labels them samian sets (1996, 26). These samian series suggest a highly formalized idea of dining and are in many respects dinner sets. The Drag 35 and 36 series with barbotine decoration on the rim are the best known and the more common of these sets. They might have been used in partnership with the plain bowl Curle 11.

While the similarity between some samian dishes and cups suggests strict sets, most of the samian types of cups and dishes do not resemble each other. The term 'evolutionary' service coined by Polak (2000, 73) refers to these dishes and cups without typological parallels but with similar chronologies. Most Roman pottery specialists are familiar with these pairings, which are often used as chronological markers (Millett 1987, 96; Tyers 1993, 137). Certain contemporary cups and plates were produced in similar quantities at Lezoux and despite morphological differences, it is suggested that they might have been produced to be used in pairs (Bet *et al* 1989, 40; Bet and Delor 2000, 468).

Beyond morphological and typological issues, there is evidence for the use of a strict number of samian vessels. On the basis of a papyrus inventory of the plate of a wealthy Roman in Egypt, it has been suggested that the basic *ministerium* was structured in sets of four: four *catini*, four *paropsides* and four *acetabuli* (Drexel 1927, 51; Strong 1966, 129). As already noticed by Polak (2000, 68), this numerical ideal is to some extent verified in selected burial groups where plain samian dishes and 'cups' occur in sets of four (Biddle 1967, 235; Niblett and Reeves 1990, fig 3; Bayard 1993, 70–3).

The descriptive approach adopted by Polak for the samian material at Vechten and the chronological variations in form proportions, while innovative, is also very pessimistic about the significance of the differences in the ratios of forms and the concept of samian services (Polak 2000, 70 and 73). According to Polak, it is not safe to make statements on *the* samian service on the basis of finds recovered from settlements because it changes over time. Those very differences in ratios are, however, interesting and significant since they allow us an insight into how samian forms were used. While the samian service might correspond to numerical as well as typological ideals in some contexts, it does not necessarily have to be a chronologically and geographically static and predictable entity.

A new way of looking at samian assemblages uses the evidence relating to sizes highlighted in the previous section through the study of rim EVEs. When large and small examples of each type of dish and cup are distinguished, the composition of samian assemblages becomes multi-faceted. All the evidence about sizes of dishes was used to distinguish small and large versions of each type. The differences between standard and rouletted dishes were thought significant enough in terms of eating habits and table layout to justify a systematic distinction when diameters were available. When used in the survey of samian groups from the General Post Office site (GPO75) therefore, the small version of a dish is differentiated in the terminology with a P next to its usual code (eg Drag 18(P)). The large version, regardless of the presence of a rouletted circle, is distinguished by the addition of a D (eg Drag 15/17(D)).

As a working hypothesis, a classification organized around three sizes was implemented during the recording of South Gaulish Drag 35/36 series. For the purpose of the analysis of samian assemblage composition from the General Post Office and Leadenhall Court sites, South Gaulish Drag 35 corresponds to vessels with a diameter between 80 and 100mm, South Gaulish Drag 35/36 corresponds to vessels between 110 and 160mm and South Gaulish Drag 36 is for vessels with diameters between 170 and 290mm.

The following analysis is mostly based on the samian assemblage from occupation at the site of the General Post Office (81 Newgate Street, GPO75 and POM79). Ten phases were defined by the excavators (Perring and Roskams 1991) but structural activity stops at the end of period VIII (Roskams 1982, 30). Samian assemblages from phases I to VIII (AD 50 to the Antonine period) are analysed in the next section. The samian group from the pre-basilican levels at the Leadenhall Court site (LCT84) will provide complementary evidence.

Samian assemblages of the 1st century AD

Samian data from the pre-Boudican period are combined with data from phase IV (AD 60/1–70) and the figure amounts to 11.54, still a relatively small figure. Phase IV on the site of the General Post Office corresponds to the

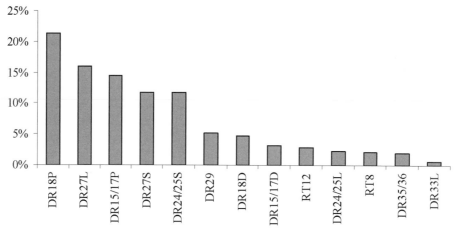

Fig 32.12: Forms for phases I–IV at the General Post Office site. Pre-Flavian (rim EVEs = 33.35)

Roman Ceramic Phase 1B as defined in the dated corpus of early Roman pottery from London (Davies *et al* 1994, 186). The material includes some re-deposited residual material following the Boudican revolt (*ibid*). This high level of residuality does limit the conclusions that can be drawn for the pre-Boudican period in terms of different eating habits because some of the samian material recovered from phase IV was in use in phases I to III.

The general ratio of cups to dishes is approximately one to one for this period at the General Post Office site and this contrasts with the contemporary samian assemblage from Usk where the ratio is two to one (Tyers 1993, 130) and with Vechten where the ratio was also two to one in the middle of the 1st century (Polak 2000, 70). This might be related to the small size of the sample from London and the presence of residual material. At Vechten the chronological distribution of vessels is based on stamps and does not take residuality into account. Alternatively, it could relate to a different approach to how samian vessels were used. Assuming that the roundhouses found in phases I–III were actually houses rather than 'outhouses' (*contra* Perring and Roskams 1991, 101) and might have corresponded to a more indigenous settlement, the dearth of imported wares and samian in the period might be seen as related to different eating habits, or 'status' (Grew 2001, 20). Leaving aside the location of the site away from the centre of the town as an explanation for differences, the ratio of samian cups to dishes suggests that they might have been used differently than at Usk, a legionary fortress. The western suburb was highlighted as showing different quantities of samian ware in the period (Monteil 2005, 56–72), a pattern of consumption confirmed by the EVEs figure. Samian decorated bowls are represented by a small percentage of Drag 29s and bowls in general do not figure well in the profile. The proportion of the Ritt 12 is similar to the one at Usk but there the percentages are based on plain forms only (Tyers 1996, table 3, 131). The Drag 29s present in the period have diameters between 210 and 360mm and the relatively small number of decorated bowls in the phase might have as much to do with how they were used (Willis 1997, 41) as indicating a lack of disposable wealth.

When looking at the different plain forms (Fig 32.12), quantitatively Drag 18 and 15/17 have a similar share of the total, an unsurprising result considering the date range, during which Drag 15/17 is a predominant type. The ratio of Drag 24/25 to Drag 15/17 is different to the ratio of Drag 27 to Drag 18. The share of Drag 15/17(P) is similar to the sum of the shares taken by Drag 24/25 small and large. Some of the larger examples of Drag 15/17(D) are in a South Gaulish marbled fabric, a yellowish fabric. The presence of a 'yellowish' dish is interesting but puzzling. Marbled South Gaulish samian is rare in London and the spatial distribution of the fabric does not shed much light in terms of an answer. Despite a general ratio of cup to dish of one to one, the relationship of Drag 27 to Drag 18(P) is slightly different with more Drag 27s than Drag 18(P) with almost equal quantities of small and large Drag 27s. The general ratio of cups to dishes at the General Post Office site changes slightly especially when calculated on plates. Based on EVEs for the period the ratio is 0.98 when plates and dishes are taken together and of 1.20 when based on cups : plates only.

The samian form profile from the Flavian phase at the General Post Office site is broader in its array of forms (Fig 32.13). Several types are probably residual, the Ritt 1 in particular. New forms also appear with the beaker Déch 67, the bowl Curle 11, the cup Ritt 9 and the decorated Drag 37. Some of the samian plain forms seem to become more formalized with, for the most common pair, Drag 18 and 27, a ratio of 1.55 Drag 27s for one Drag 18 plate, with roughly half of the cups being small and the other half being large. Drag 33 appears in two sizes in the profile and might have been used with some of the Drag 18s. The percentage taken up by the Drag 33s when both sizes are combined could also suggest a two to one relationship with some of the Drag 18s. Webster has suggested that Drag 35/36 and Curle 11 might have worked as a set (1996, 46) and this finds an interesting parallel in this Flavian profile where there are more Drag 35/36 (ie 'plates') and a similar proportion of Drag 36 dishes and Curle 11 bowls. The sizes of the Drag 29s are still large between 200 and 300mm while the Drag 37s are smaller (150–250mm).

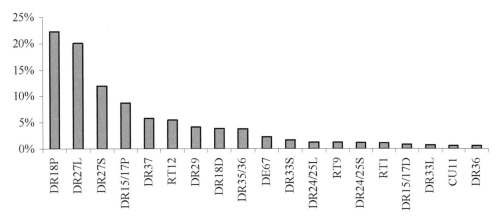

Fig 32.13: Forms for Phases V–VI. Flavian (rim EVEs = 33.35)

What I find the most interesting about this assemblage is how reminiscent it is of contemporary plain samian groups from several graves in Britain and beyond. In this period Drag 18(P) and Drag 27s come to the fore quantitatively. While not identical, the numerical organization of Drag 18 plates and the two sizes of Drag 27 'cup' is reminiscent of a burial group of 13 samian vessels at Winchester (Grave II: Biddle 1967, 235), from which four Drag 18 plates, six large Drag 27 cups, two small Drag 27 cups and a Drag 18R dish were recovered. The formalized setting of the goods in Grave II is of interest in itself, with the Drag 18R positioned on a shale trencher alongside a single medium-sized Drag 27, two iron knives, a bronze spoon and pig bones (*ibid*, 231). The rest of the grave goods, the other pieces of the samian service, a single large rough-cast beaker, a ceramic flagon, a glass jug and a bronze jug, were laid on either side of the trencher (*ibid*, 232). The layout confidently positions the Drag 18R as a serving vessel and casts doubt on Drag 27s as drinking vessels, at least the large ones. The latter are more likely to also act as serving vessels, perhaps for condiments and/or sauces. Assuming that one plate corresponds to one participant at a meal, the relationship between the numbers of Drag 27s to a plate makes it unlikely that they were used as drinking vessels, unless two types of drink were involved.

The relationship of two Drag 27s to a single plate Drag 18 is paralleled in several other burial groups in Roman Britain and the northern part of the Empire. The samian group from a rich cremation burial in Verulamium also fits with this model with two Drag 27s to a Drag 18 but with a clearer distinction of sizes for Drag 27s (Niblett and Reeves 1990, fig 3). In this case there are four small Drag 27s and four large ones. Another burial from Nijmegen displays a comparable but larger group with eight Drag 18s, four large Drag 27s and eleven small Drag 27s (Koster 1993, 293). A complete samian service of 13 vessels has also been found in an isolated grave near a villa at Trinquies in northern France dated to the beginning of the 70s AD (Bayard 1993, 70–3). Most of the plates and cups recovered from these funerary contexts show little or no use (Niblett and Reeves 1990, 144; Biddle 1967, 234). The samian sets probably acted as part of an indication of status either for

the Gallic aristocrat (Woolf 1998, 192) or the British elite members in Winchester and Verulamium.

Beyond status, some of the British burial practices have been classified as 'continuing and developing late pre-Roman Iron Age customs' with 'signs of a superficial adoption and acceptance of Roman ways of life' (Struck 2000, 87; Biddle 1967, 246–8). There is nonetheless what looks like a desire to abide to the strict etiquette of the *ministerium*, the numerically 'ideal' serving set which fits well the rest of the graves' assemblages that exhibit 'a high degree of *romanitas*' (lamps, writing equipment: Eckardt 2000, 115).

What to make of the same numerically 'ideal' samian service in a domestic everyday setting on the General Post Office site along Newgate Street in Roman London? A desire to display social status is unlikely to provide a satisfactory explanation, since there are no finds or structures at the site that suggest a particularly rich settlement. The differences with the samian assemblage from the previous phase are not dramatic but the arrangement of cups, plates and dishes seems to become highly formalized. In the Flavian period strip buildings with possible shops on the street frontage appear on the site (Perring and Roskams 1991, 102). Domestic comparative material is scarce: Vechten is the only group where such ratios have been calculated. The ratio of Drag 27 to Drag 18 seems still to be two to one at Vechten (Polak 2000, 72) despite the general ratio of cups to dishes decreasing to a ratio of one to one in the Flavian period. Patterned wear was systematically recorded when analysing the samian assemblage from the General Post Office site. Cups are the only category beside mortaria that show internal wear. The internal slip was worn away suggesting grinding or mixing (Biddulph 2008, 97). Half of them are South Gaulish, the others Central and East Gaulish vessels. The identifiable forms are either Drag 27 or Drag 35. In terms of sizes, only four out of the 11 provide a complete profile, two with large diameters (140, 150mm) and two with small (90, 100mm), which implies mixing occurred in both sizes. The figures are low considering the size of the assemblage; only 11 examples out of 523 recorded show internal wear and clearly more work especially comparison with other assemblages is

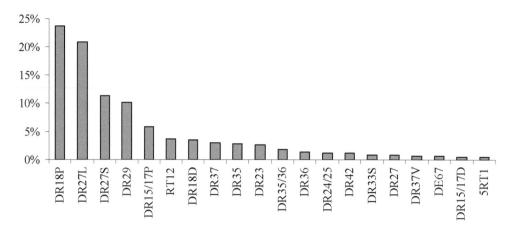

Fig 32.14: Forms for the Leadenhall Court site (LCT84, pre-basilica levels, total rim EVEs = 38.04)

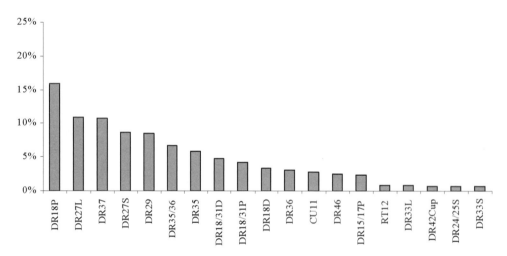

Fig 32.15: Forms for Phase VII at the General Post Office site. AD 100–120 (Total rim EVEs = 20.59)

needed, but the 'cups' are the only vessels with the internal patterned wear in the group of the General Post Office site. It has been noticed on other cups both in London and other sites in Roman Britain (J Evans, pers comm; Biddulph 2005; 2008).

On its own, the ratio of two Drag 27s to one Drag 18 from the General Post Office samian group is exciting, but it finds an interesting parallel in the profile for the samian group from the pre-basilican levels at Leadenhall Court (Fig 32.14). The ratio between Drag 24/25 and Drag 15/17 is slightly different with fewer examples of the cups than the dishes and, in contrast to the General Post Office site, only small examples. The ratios of forms are very similar in particular the Drag 27s and Drag 18, Drag 24/25 and Drag 15/17. The settlement at Leadenhall Court is also peripheral to the main urban development in the 1st century AD (Milne and Wardle 1993).

Samian assemblages of the 2nd century AD

In the 2nd century AD the relative share of each type present decreases and it is accompanied by a wider range of forms. Some of them are certainly residual: Ritt 12 and all of the

Drag 15/17s are South Gaulish. The general ratio of cups to dishes is again consistent with the previous period at roughly 1:1, but the ratio of cups to plates increases. Based on EVEs for the period the ratio is 1.03 when plates and dishes are taken together and 1.42 when based on cups : plates only. This is partly related to the presence of Drag 46 and a small version of the Drag 42 on the histogram without their traditionally associated dishes. A Martres-de-Veyre Curle15 is present in the period but the rim corresponds to a small rim EVEs figure of 0.02, insufficient to appear on the profile.

Whilst the Flavian period has comparative material for some samian 'sets' found *in situ* in the graves described above, by contrast this period lacks such groups. The profile for period VII is still evocative of the Flavian sets recovered from graves with two Drag 27s to a Drag 18 and two sizes of Drag 27s clearly visible. The Drag 35/36 series is present for the first time in all its array of sizes with apparently more small examples than large ones. Drag 18/31 plates and dishes have broadly similar shares of the total EVEs.

The post-Hadrianic phase, period VIII corresponds to the Roman Ceramic Phase 5 defined in the early Roman

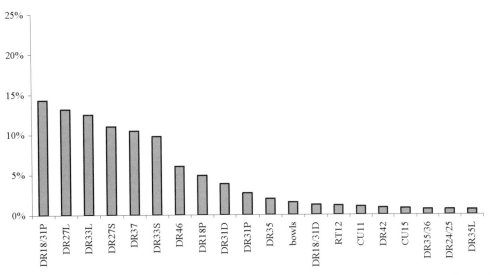

Fig 32.16: Forms for Phase VIII at the General Post Office site. (Post-Hadrianic). The total rim EVEs figure for phase VIII combines samian data from period 1, phases 3, 4 and 5 from GPO75 and POM79. Rim EVEs = 14.52

pottery Corpus dated to the early Antonine period (Davies *et al* 1994, 213, 221). Whilst the *terminus post quem* was relatively straightforward to define thanks to the Hadrianic fire, the end of activity on the General Post Office site was problematic. The presence of a single Central Gaulish stamp was used as the main argument in defining this *terminus ante quem* as *c* AD 160 although it was admitted that the end date could be later (*ibid*). The re-assessment of this group would probably tend to reinforce a later end date for this phase, taking into account the presence of a Central Gaulish Drag 38 (context 7400).

The plain forms profile is complex with some residual material from the clearing of the Hadrianic fire debris and a total of six samian fabrics present. The range of samian types is larger and the relative frequency of some forms is reminiscent of the Flavian period with two Drag 27s to a Drag 18/31 (Fig 32.16). Drag 33s make their entry in force into the samian assemblage, an increase particularly clear when compared to phase VII (Fig 32.15). Present in two sizes, the vast majority of Drag 33s come from Central Gaul but with a small proportion from South Gaul. This does not necessarily mean that this type of 'cup' has completely supplanted the Drag 27 since quite a large proportion of Drag 27s are contemporary. There are more Drag 18/31 plates than Drag 18 and most of the Drag 18/31 plates and dishes are Central Gaulish (Les Martres-de-Veyre and Lezoux) with some originating from South Gaul. It is interesting to see that the numerical relationship of Drag 27 to Drag 18 is repeated with the new cup, the Drag 33.

The pair composed of Curle 15 and Drag 46 is also interesting, with more cups than dishes. Two Curle 15s originate from the Montans industry, one with a diameter of 190mm and the other larger with a diameter of 240 mm. Four Drag 46s are present in the group, one from Montans, one from La Graufesenque and two from Lezoux; their

diameters are all between 120 and 140mm.

There is therefore no strict numerical model for samian 'services' in the 1st and 2nd centuries AD in London. The general ratio of cups to all dishes is fairly consistent at around one to one but the ratio of cups to plates varies more markedly from one period to the next. When examining the pairs highlighted in the literature as forming 'sets', whether typological or 'evolutionary', it can be seen that they all work on very different numerical relationships. The pre-Flavian assemblage has equal quantities of Drag 24/25 and Drag 15/17(P) and slightly more Drag 27 than Drag 18(P). Later there is clear and consistent evidence for the presence of more Drag 27s than Drag 18s and Drag 18/31s. Two sizes of Drag 27 were systematically used. This organization of Drag 27 and Drag 18, 'cups', plates and dishes in sets of four is reminiscent of several samian vessel groups from burials. Interestingly the two to one relationship between the most common type of cups and plates is replicated in the 2nd century AD when Drag 33s become popular. There are more Drag 33s than Drag 18/31s and they are present in two sizes. Finally an altogether different relationship was noticed. Defined as a set on the basis of strict similarities in shape, Curle15s and Drag 46s from GPO75 are in this sample organized around a four to one relationship.

The role played by different modules of the Drag 35/36 series evolves over time with a clear domination of the small sizes (Drag 35/36 and 35). The large dish, Drag 36, and the bowl, Curle 11, are present in all of the profiles but in small quantities. Assuming that all of these forms acted as a dining 'service', the relative frequency of each form is consistent with more 'plates' and 'side-plates' than serving dishes and bowls. The samian dining set is therefore exceptional in its complexity from AD 50 to AD 160. The associated eating habits and dining customs must have been as complex in their array of rules, courses and settings.

Conclusion

I hope to have shown that by recording diameters and analysing samian assemblages in more detail, a fascinating array of cups, plates and dishes emerge. The detailed analysis of the array of forms usually labelled 'cups' has proved the most fruitful. Despite recent doubts on the usefulness of the concept of services in samian studies (Kenrick 1990, Polak 2000), this analysis has shown that it is a useful notion since it re-centres the analysis on the minutiae of consumption as opposed to only production processes. It provides a model by which to assess samian assemblages both in their array of forms and in the sizes present. Though there is no strict numerical model for samian 'services' in the 1st and 2nd centuries AD in London, when examining the pairs highlighted in the literature as forming 'sets', whether typological or 'evolutionary', it can be seen that they all work on very different numerical relationships ranging from one to one to four to one ratios. By recording diameters and analysing samian assemblages in more detail, a fascinating set of insights into the usage of cups, plates and dishes can emerge. That dining was complex is not a surprise (Hawthorne 1998; Dunbabin 1993), but it is possible to understand it better by implementing this kind of methodology. I do believe that we need to pay particular attention to the sizes of vessels and the context in which they were used. The strong parallel between the ratio of Drag 27 to Drag 18 in several grave groups and the Flavian assemblage from the General Post Office site is perhaps the best example of what such recording can achieve. The absence of patterned wear on decorated bowls from this site suggests they were not used for mixing. Though representing a small percentage, internal wear only appears on cups on this site.

Regarding the question of the increase in sizes of samian dishes over time and how significant this is in our understanding of eating habits, the sample from Roman London creates as many questions as it answers. Both standard and rouletted dishes do get larger and the 'cups' do not disappear from the repertoire. Central and East Gaulish cups continue to occur in two sizes. In the post-Hadrianic group from the General Post Office site, there are more Drag 33s than Drag 18/31s and they are present in two sizes. Evidence from Lincoln and Alcester suggests that the ratio of cups to standard dishes was still two to one in some late 2nd and 3rd century samian assemblages. The samian assemblage from The Park excavation in Lincoln 'with a strong late 2nd to mid 3rd century bias' has slightly more than two Central Gaulish Drag 33s for one Drag 31 and the same ratio for East Gaulish examples (Darling 1999, 75).

Acknowledgements

This article is based on research done for my PhD and I would like to express my gratitude to both of my supervisors, Dr Ian Haynes and Dr Robin P Symonds for their encouragement and help. Particularly warm thanks go to the Roman pottery specialists from the Museum of London Specialist Services and the team at the London Archaeological Archive and Research Centre for their welcome and support.

Bibliography

Bats, M, 1988. *Vaisselle et alimentation à Olbia de Provence (v.350 – v.50 av. JC). Modèles culturels et catégories céramiques*, Revue Archéologique de Narbonnaise, Suppl 18, Paris

Bayard, D, 1993. Sépultures et *villae* en Picardie au Haut-Empire: quelques données récentes, in *Monde des morts, mondes des vivants en Gaule rurale. Actes du Colloque ARCHÉA/AGER (Orléans, Conseil Régional, 7–9 février 1992)* (ed A Ferdière), Revue Archéologique du Centre de la France Suppl 6, Tours

Bet, P, Fenet, A, and Montineri, D, 1989. La typologie de la sigillée lisse de Lezoux, I^er–III^e siècles. Considérations générales et formes inédites, *Société Française d'Etude de la Céramique Antique en Gaule, Actes du Congrès de Lezoux*, 37–54, Saint-Paul-Trois-Châteaux

Bet, P, and Delor, A, 2000. La typologie de la sigillée lisse de Lezoux et de la Gaule centrale du Haut-Empire. Révision décennale, in *Société Française d'Etude de la Céramique Antique en Gaule, Actes du Congrès de Libourne*, 461–84, Saint-Paul-Trois-Châteaux

Biddle, M, 1967. Two Flavian burials from Grange Road, Winchester, *Antiq J* 47, 225–51

Biddulph, E, 2005. Samian ware: new experiments show that samian ware may not have been so special, *Current Archaeol* 196, 191–7

Biddulph, E, 2008 Form and function: the experimental use of roman samian ware cups, *Oxford J of Archaeol*, 27 (1), 91–100.

Bird, J, 1986. The samian ware, in L Miller, J Schofield and M Rhodes, *The Roman Quay at St Magnus House, London*, London Middx Spec Pap 8, 139–85

Bowman, A, and Thomas, D, 1994. *The Vindolanda writing tablets (Tabulae Vindolandenses II)*, London

Cooper, N J, 1996. Searching for the blank generation: consumer choice in Roman and post-Roman Britain, in *Roman Imperialism: post-colonial perspectives* (eds J Webster and N Cooper), Leicester Archaeol Monogr 3, 85–98, Leicester

Dannell, G B, 2006. Samian cups and their uses, in *Romanitas. Essays on Roman Archaeology in honour of Sheppard Frere on the occasion of his ninetieth birthday* (ed R J A Wilson), 147–76, Oxford

Darling, M, 1999. Samian: site evidence, in C Colyer, B J J Gilmour and M J Jones, *The defences of the Lower City. Excavations at The Park and West Parade 1970–2 and a discussion of other sites excavated up to 1994*. The Archaeology of Lincoln, 2(2), 72–6, York

Davies, B, Richardson, B, and Tomber, R, 1994. *A dated corpus of early Roman pottery from the City of London*, The archaeology of Roman London 5, Counc Brit Archaeol Res Rep 98, York

Drexel, F, 1927. Römische Sigillataservices, *Germania* 11, 51–3

Dunbabin, K M D, 1993. Wine and water at the Roman *convivium*, *J Roman Archaeol* 6, 116–41

Eckardt, H, 2002. *Illuminating Roman Britain,* Monographies Instrumentum 23, Collection dirigée par M Feugère, Montagnac

Evans, J, 1993. Pottery function and finewares in the Roman north, *J Roman Pottery Stud* 6, 95–118

Grew, F, 2001. Representing Londinium, in *TRAC 2000: proceedings of the tenth annual Theoretical Roman Archaeology Conference, London 2000* (eds G Davies, A Gardner and K Lockyear), 12–24, Oxford

Hawthorne, J W J, 1997. Post processual economics: the role of African Red Slip Ware vessel volume in Mediterranean demography, in *TRAC 96: proceedings of the sixth annual Theoretical Roman Archaeology Conference, Sheffield 1996* (eds K Meadows, C Lemke and J Heron), 29–37, Oxford

Hawthorne, J W J, 1998. Pottery and paradigms in the early western Empire, in *TRAC 97: proceedings of the seventh annual Theoretical Roman Archaeology Conference, Nottingham 1997* (eds C Forcey, J Hawthorne and R Witcher), 160–72, Oxford

Kenrick, P M, 1990. Principles of the *Conspectus* and guide to the reader, in E Ettlinger, B Hedinger, B Hoffman, P M Kenrick, G Pucci, K Roth-Rubi, S Schneider, S Von Schnurbein, C M Wells and S Zabehlicky-Scheffenegger, *Conspectus Formarum Terrae Sigillatae Italico Modo Confectae*, Materialien zur Römisch-Germanischen Keramik, Heft 10, 44–7, Bonn

Koster, A, 1993. Ein reich ausgestattetes Waffengrab des 1. Jahrhunderts n.Chr. aus Nijmegen, in *Römerzeitliche Gräber als Quellen zu Religion, Bevölkerungsstruktur und Sozialgeschichte* (ed M Struck), Archäologische Schriften Des Instituts für Vor- und Frühgeschichte der Johannes Gutenberg-Universität, Band 3, 293–6, Mainz

Loeschcke, S, 1909. Keramische Funde in Haltern, *Mitteilungen der Altertums-Kommission für Westfalen* 5, 101–322

Marichal, R. 1988. *Les graffites de La Graufesenque*, Gallia Suppl 47, Paris

Meadows, K I, 1997. Much ado about nothing: the social context of eating and drinking in early Roman Britain, in *Not so much a pot, more a way of life. Current approaches to artefact analysis in archaeology* (eds C G Cumberpatch and P W Blinkhorn), Oxbow Monogr 83, 21–35, Oxford

Milne, G, and Wardle, A, 1993. Early Roman development at Leadenhall Court, London and related research, *Trans London Middx Archaeol Soc* 44, 23–169

Millett, M, 1987. Boudicca, the first Colchester Potters' Shop, and the dating of Neronian samian, *Britannia* 18, 93–123

Monteil, G, 2005. *Samian ware in Roman London*, unpub PhD dissertation, Birkbeck College, Univ London

Niblett, R, and Reeves, P, 1990. A wealthy early Roman cremation from Verulamium, *Antiq J* 70, 441–6

Orton, C, 1980. *Mathematics in archaeology*, Cambridge

Perring, D, and Roskams, S, 1991. *The early development of Roman London west of the Walbrook*, The Archaeology of Roman London 2, Counc Brit Archaeol Res Rep 70, London

Polak, M, 2000. *South Gaulish* terra sigillata *with potters' stamps from Vechten*, Rei Cretariae Romanae Fautorum Acta Suppl 9, Nijmegen

Roskams, S, 1982. *Excavations at Post Office/81 Newgate Street EC1 site code GPO75*), unpub Museum of London archive report

Rottländer, R C A, 1966. Is provincial Roman pottery standardized?, *Archaeometry* 9, 76–91

Rottländer, R C A, 1967. Standardization of Roman provincial pottery II: function of the decorative collar on form Drag 38, *Archaeometry* 10, 35–45

Rottländer, R C A, 1969. Standardization of Roman provincial pottery III: the average total shrinking rate and the bills of La Graufesenque, *Archaeometry* 11, 159–164

Strong, D E, 1966. *Greek and Roman gold and silver plate*, London

Struck, M, 2000. High status burials in Roman Britain (first–third century AD) – potential interpretation, in *Burial, Society and Context in the Roman World* (eds J Pearce, M Millett and M Struck), 85–96, Oxford

Tyers, P, 1993. The plain samian ware, in W H Manning, *Report on the excavations at Usk 1965–1976: the Roman pottery*, 123–43, Cardiff

Vernhet, A, 1976. Création flavienne de six services de vaisselle à la Graufesenque, *Figlina* 1, 13–27

Vernhet, A, 1991. *La Graufesenque, céramiques gallo-romaines*, Millau

Webster, P, 1996. *Roman samian pottery in Britain*, Counc Brit Archaeol Practical Handbook in Archaeology 13, York

Willis, S, 1997. Samian: Beyond dating, in *TRAC 1996: proceedings of the Sixth Annual Theoretical Roman Archaeology Conference Sheffield* (eds K Meadows, C Lemke and J Heron), 38–54, Oxford

Willis, S, 1998. Samian pottery in Britain: exploring its distribution and archaeological potential, *Archaeol J* 155, 82–133

Willis, S, 2005. *Samian pottery, a resource for the study of Roman Britain and beyond: the results of the English Heritage funded samian project. An e-monograph*, Internet Archaeol 17 (http://intarch.ac.uk/journal/issue17/willis_toc.html)

Woolf, G, 1998. *Becoming Roman. The origins of provincial civilization in Gaul*, Cambridge

33 Stuffed dormice or tandoori chicken in Roman Britain?

Margaret Darling

Introduction

Stuffed dormice: Stuff with pork forcemeat, minced dormice from all its parts, pepper, nuts, laser, and stock. Stitch up and put on a tile in the oven, or bake them, stuffed, in a clay oven (Apicius 8.9).

Bread was the staple food of both Greeks and Romans, as in the Middle East. Cooking in the hot ashes of a hearth is the most primitive method (Ovid, *Fasti* 6.315–6), but the method *sub testu* as described by Cato (*De Re Rustica*, 74–5) involves the use of a ceramic object, an oven called in Latin a *testum* or a *clibanus* (the latter from Greek). Recent strange fragments passing over my work table have prompted research into such objects in Roman Britain, and since I have shared with Brenda mutual passions for music and food, an offering on the latter will hopefully be more interesting than a discourse on coarse pottery. It has, indeed, proved to be a fascinating subject to research.

That we view the cooking pot as an extremely conservative vessel pales into insignificance when the cooking apparatus is considered, the type of which, whether oven or brazier/cooking stand, may relate to ethnic origins. Thus, when you sit in Britain, an outpost clinging to the edge of the Roman Empire, how 'romanized' are you and what does your cooker reveal about you?

The Mediterranean evidence

The first impression is the extreme rarity of any Roman clay ovens in Britain, and a short foray into continental literature shows that fragments of portable ovens, whether termed *clibani* or *testa*, are generally rare, outside the Mediterranean. The names *clibanus* and *testum* both describe a simple cooking cover, which was heated over a fire. The fire was then swept away and replaced by food to be cooked *sub testu* (the origin of the term *testum*), under the cover, on which hot coals could be piled to maintain the heat. Such a simple cooking method not only goes back to prehistoric times but is also widespread in the Mediterranean and East, and survives widely today (Frayn

1978, 30; Scheffer 1981, 107; Cubberley *et al* 1988). Whitehouse (1978) notes that Cato's *testu* or *testum* appears to have been the forerunner of the *testi* used in Italy from the 13th century to the present day, which are remarkably like similar early cooking covers found in Greece and Etruria. Since the use of a cooking cover is known in the British Isles in the medieval period and later (Cobbett 1926, 204), its use in the Roman period seems possible. Italian examples and literary references to their use are explored in detail by Cubberley, Lloyd and Roberts (1988), and the shapes and sizes can be expected to vary across the Roman Empire. This exploration excludes the brick-built bread ovens of Pompeii and those found at the rear of the ramparts of Roman forts (the general type probably better termed a *furnus*), a type also still used in Greece and other parts of the Mediterranean today. But there is the setting to be considered – an oven for household/barrack use, or to cater for larger numbers? For whom is it catering, and to cook what?

The use of a baking cover is well known in ancient Greece, such as a sophisticated example from the Agora in Athens, where a shallow brazier on a stand could be turned into an oven by the addition of a domed top with a cleverly designed partial base, allowing draught to reach the underlying fire (Sparkes 1962, 127, pl V, 1, fig 2), the probable name being ἰπνός. A simpler dome-shaped cover with a handle occurs in Greece (Sparkes 1962, pl IV, 2), and is seen on Iron Age sites in Italy, as at Murlo (Boulomié 1972, 98, pl 7, 1071–8), and in Slovenia (Gabrovec *et al* 1970, Abb 4, 13; 7, 1). (Fig 33.1, 1, 3–4). The Greek examples are named πυιγεύς, and termed *testu* in Latin, and it is probably to this that Cato refers. The use of the Greek name *clibanus* by Latin writers appears to refer to a vessel used for cooking *sub testu*, and may have been simply a substitute for *testum* at a time when all things Greek were fashionable (Cubberley *et al* 1988, 101). The later Roman cover now conventionally regarded as a *clibanus* (Cubberley *et al* 1988, figs 1–2) (Fig 33.1, 6) and used as a prototype by some Roman re-enactment groups, differs typologically from the earlier simple domes,

and is an inverted carinated bowl with a flange half-way down the wall, the flange serving to retain the hot coals piled on top (sometimes with circular holes in the top and below the flange for ventilation). In other examples the wall may be more domed but the flange remains (Cipriano and De Fabrizio 1996, fig 8; Di Giovanni 1996, fig 26), and there are clearly regional variations (eg Fig 33.1, 5). Indeed, an inverted samian bowl Drag form 38 without a footring is remarkably like a *clibanus*, albeit a small example. The essential point about the *clibanus* or *testum* is that they are cooking covers for baking *sub testu* breads or dishes for household use. Their sizes varied greatly, rim diameters varying chronologically, 1st and 2nd century clibani in Italy ranging from *c* 350–500mm, 3rd century examples *c* 240–300mm, and smaller later, suggesting different uses and/or locations over time (Cubberley *et al* 1988, 110). It would be useful if a decision were made to use the term *clibanus* or *testum* only for such covers that could be used to cook *sub testu*, in a Greco-Italian or Mediterranean way. Other cooking devices may be braziers (better termed cooking stands) or, less specific, portable cookers. Such a division may help our understanding of the ethnic influences within the provinces.

These objects are relatively rare, even in Italy, although rarity in Italy may be illusory if a type of African red slip ware vessel was also used (Cubberley *et al* 1988, 114). A cursory search of the literature revealed a *clibanus* from Reims (Deru and Paicheler 2003, 352, fig 2) of 2nd century date, but even this was an import from Italy, not a local French product. An example of a vessel with a pronounced curved flange and an opening, resembling a *clibanus* (although reconstructed differently), occurs at Nijmegen and further searches of the literature may reveal more (Holwerda 1941, pl XI, 514; *cf* Cubberley *et al* 1988, fig 2, no. 7). The rarity away from Italy is stressed by Deru and Paicheler (2003, 352, n 9) who note that the examples known from Gallia Narbonnensis can be counted on the fingers of one hand. Away from Italy, types vary considerably, as shown by a hand-made portable oven from the Crimea (Sebastopol, Ukraine: Kovalevskaja and Sarnowski 2003, 234, fig 7), which shows little resemblance to the Italian *clibani* illustrated by Cubberley *et al* (1988), and is more a portable cooking stand/brazier than an oven (*cf* Bronze Age examples from Hungary: Scheffer 1981, 74, figs 43–4).

The evidence from Britain

Most of the evidence for the mode of cooking from Roman Britain consists of hearths, usually at ground level, but whether for heating and/or cooking or other purposes can be difficult to determine. Tiled hearths (as at Caister-on-Sea, in Room 2: Darling with Gurney 1993, 18, fig 11) would be suitable for *sub testu* cooking, for ease of replacing the embers with bread for baking. In the absence of an extensive search for ovens, two examples of ovens built on the lines of a pottery kiln may be noted, one at the Leadenwell villa, Bourton-on-the-Water (O'Neill 1935, 260), probably

in a separate structure, as was the siting of two ovens from Lullingstone (Meates 1955, 102–4), while others at Frocester were located inside a multi-room building (Price 2000, fig 5.3). There is, however, a remarkable group of vessels from a hearth of late 1st to early 2nd century date in Cambridge, containing two abandoned casseroles with lids, one containing fresh water mussels, the other hare bones (Alexander and Pullinger 1999, 31, pl 77, nos 454–5, pls 78–9). The hearth lay within the area of the fort.

Given the rarity of *clibani* in France, it is not surprising that the few examples claimed to be *clibani* from Britain also differ, and have a varied typology. The best known example from Britain is that from the works-depot of *Legio XX* at Holt (Grimes 1930, 184, fig 60, 9) (Fig 33.2, 10), a barrel shape open at top and bottom, similar to an Indian *tandoor*. An example from Prestatyn (Blockley 1989, fig 87, 75) (Fig 33.2, 11) is a similar barrel-shape to the Holt oven, and indeed may be a product of the Holt kilns. The most recent finds are fragments from the excavations in 2004–05 of the amphitheatre at Chester, in an oxidized fabric (www. chester.gov.uk/amphitheatre/files/amph issue 9). According to the web site, these include a thumb-impressed rim fragment, wall sherds with distinctive finger-wiping, and base fragments one of which has the edge of a knife-cut opening. No further details are yet available, but since the three noted all appear on either the Holt or Prestatyn examples, it seems very likely to be of the same type.

The tannur

While there are rival claims for the origin of this type of oven from the Near East and the Indus Civilization, there seems no reason why it should not date from the earliest agricultural communities. Its occurrence is so widespread: South Russia, common in the Near East and Mediterranean and at Harappa and Mohenjo Daro in the Indus Civilization (mature period 2900–1900 BC). Every language in the area has a similar name for it, such as Urdu *tannūr* and *tandūr* (the latter identical in Arabic), Turkish *tandir*, and the basic name may have come from Avestan *tanûra*, and Akkadian *tinuru*. Curiously the name is different in Sanskrit, *kandu* which, given the inclusion in Sanskrit of words from earlier languages, Munda and Dravidian (Sharma 2005, 107), may have been the term in the Indus Civilization. The oven type has an amazing survival, occurring in Indian restaurants worldwide, and in use as the *khubz* in Baghdad today. You can even buy one, shipped from India, on the Internet.

The type occurs in the Athenian Agora (Sparkes 1962, 130, pl V, 6), where this barrel type is the largest terracotta heater, and is viewed as a brazier, with pots placed in the upper opening. These are rare in comparison to other types of brazier (Sparkes 1962, pl V, 3–4). A close parallel for the Prestatyn oven comes from San Giovenale, Italy, in Scheffer's study of cooking in Italy, 1400–400 BC (Scheffer 1981, fig 2, type IIIA; 52, figs 28–9) (Fig 33.2, 12). It is hand made, with incised lines or finger-impressions all over the exterior, differing from the Greek examples in being wider at the bottom. This is the smaller of the two variants

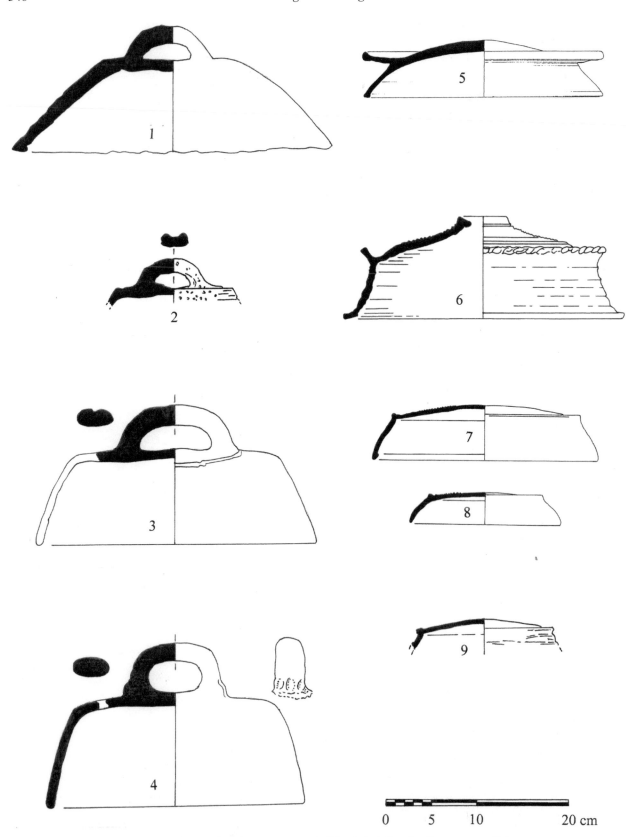

Fig 33.1: Domed cooking covers and clibani. 1:4 (for details see appendix)

of Scheffer's type III, at 293mm high, while the Prestatyn example is 580mm. The larger type IIIB stands 400mm high (Scheffer 1981, 52, figs 30–31), and an example from Acquarossa (Fig 33.2, 13) has finger-impressed cordons and handles on the sides (cordons could strengthen large coil-built pots). This type is uncommon, even taking into account the difficulty of distinguishing fragments from cooking pot sherds (Scheffer 1981, 72), a problem likely

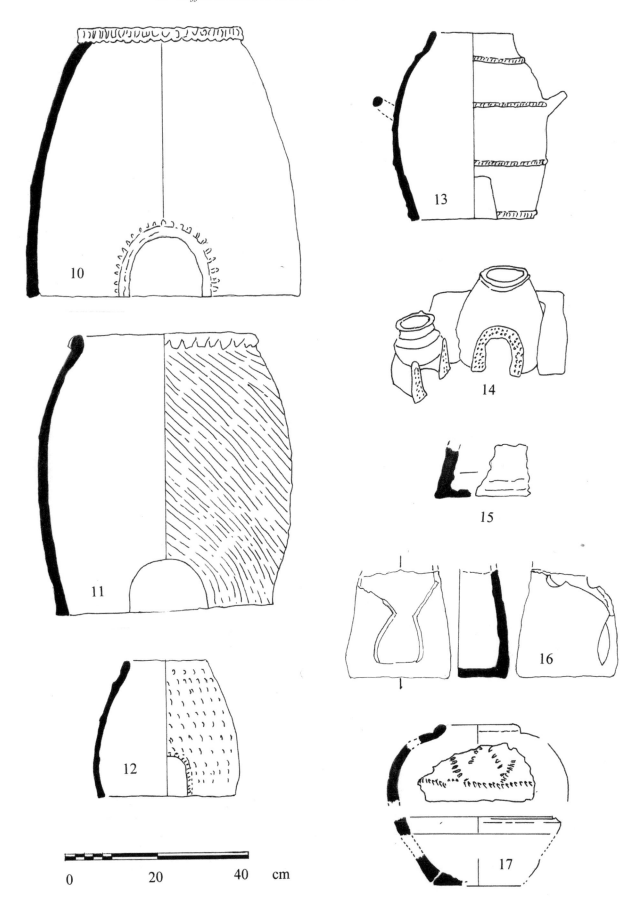

Fig 33.2: Tannur ovens and other 'ovens' from Britain. 1:8 (for details see appendix)

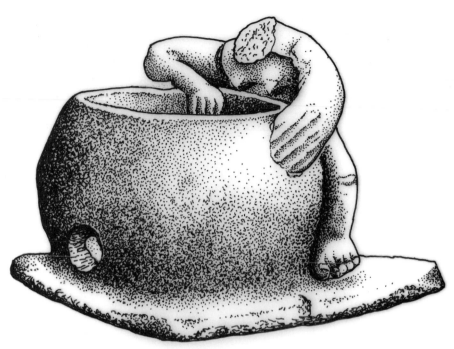

Fig 33.3: Drawing of a Cypriot terra-cotta, showing a woman (now headless) putting bread into a tannur type oven, 5th century BC, Metropolitan Museum of Art, New York, inventory no. 2122. Drawn by David Hopkins

to be also the case with finds in coarse or tile fabrics from Roman Britain. Their appearance in Etruria seems to be in the middle of the 7th century BC or slightly later. Since they occurred side by side with other cooking stands or braziers, a specialised function is likely, and an oven of this type, grouped in close juxtaposition with a separate cooking stand, occurred at the Iron Age site at Norşuntepe, Turkey (Scheffer 1981, 72; 78–80, fig 51) (Fig 33.2, 14). An earlier example occurs in Anatolia in the middle Bronze Age, 1900 BC, at Kültepe (Kanash), a trading post on routes for metal ores and other goods from Anatolia to Mesopotamia, where the combination of the domed oven beside a cooking stand also occurs (Lloyd 1965, 188, fig 8), and this combination is still used by the Bedouin of Iraq (see below). That a type of bread was baked in them is shown by a Cypriot terracotta model of the 5th century BC (Scheffer 1981, fig 87) (Fig 33.3), which shows a woman either pasting dough onto the wall of the oven, or removing baked breads, in the manner of Indian *tandoori* breads.

There are also anthropological analogies. This type of oven was common in the eastern Mediterranean, the Middle East and beyond, and *tanurs* (or *tannurs*) are still used by the Bedouin in Iraq, alongside portable hearths (*manaqil*) (Ochsenschlager 1974, 168). As with the related Indian *tandoor,* these are heated by an internal fire, and while also used for cooking meat and fish, the oven is primarily for baking bread, the pieces of dough being flattened against the inside of the *tannur*, as shown by the Cypriot terracotta model. The *Los Angeles Times* (1 December 2007) even reports that there has been a resurgence in the use of this type of traditional oven for baking bread, the *khubz,* in Baghdad, which emphasizes the use of the type for baking quantities of bread. Moreover, since the fire

remains inside and can be tended (unlike the *clibanus*), the heat can be maintained for a considerable time, which suggests that the ovens from Chester and Wales are likely to have been primarily for producing bread for a number of people over a period of time. The examples from Holt and Prestatyn are from military contexts, and if the amphitheatre example is the same type, the term 'bread and circuses' inevitably springs to mind. The terms *clibanus* or *testum* for such ovens are incorrect as the cooking is not *sub testu*, and while the term 'barrel cooker' is descriptive, a more appropriate term to acknowledge its antiquity is a name such as *tannur* or *tandoor*.

Whether they were also used as braziers, as in 6th and 5th century BC Athens, seems debatable. The internal diameter of the top openings of the Holt and Prestatyn examples lies in the region of 300–380mm, so that use as a brazier would require pots with a large girth. While there are vessels illustrated from Holt which might fit, they form a varied range of types including a bowl also used as a saggar for firing the glazed wares, and a copy of Hayes type 197 cooking pot (Grimes 1930, nos 212, 221). Clearly examination of site pottery for signs of burning would show if vessels had been placed on top of these barrel cookers, in the manner of the vessels from the Athenian Agora. But there are some vessels at Holt which appear to be intended to be placed on a smaller brazier or cooking stand, such as the deep dish and bowl with lugs (Grimes 1930, fig 69, no. 138; fig 73, no. 218). Indeed, the bowl no. 218, a single example, is noted as being slightly blackened by fire, possibly suggesting its use on a cooking stand before being incorporated into the kiln structure where it was found.

The ovens from Prestatyn and the Chester amphitheatre

are likely to have come from the Holt depot or other local kilns, and this adds extra emphasis to the strange nature of the pottery production at Holt, and the origins of some of the potters in the eastern empire, explored by Greene (1977). Although the basic type occurs sparsely in Etruria, it is unclear whether it continued later in Italy. The Romans certainly knew of the *tannur* oven, as Festus (Lindsay 1913, 142M) tells us of a Syrian bread which, *before* being cooked in a *clibanus*, used to fall into the coals, a clear reference to the hazards of cooking in a *tannur,* and also a reference to food being cooked on the sides of the oven. Curtis considers the use of *tannur* ovens by the Romans unlikely in the absence of evidence to the contrary (2001, 368). Thus it may be suggested that the Holt oven and its offspring indicate the deeper ethnic influence of potters of eastern origin, not directly relating to contemporary cooking in Italy. Indeed with its African type cooking pots (studied by Vivien Swan (1999)), Holt must have been a very cosmopolitan place.

Other British 'ovens'

Turning to the '*clibanus*' from Catterick, this fragment of part of a base and an inward sloping wall is in a tile-like fabric, thick-walled (to 260mm), indicating a large heavy object (no indication of possible diameter is given). Unusual features are the presence of a base, heavily sooted internally, and the sloping wall (Williams and Evans 1991; Evans and Williams 2002) (Fig 33.2, 15). Given the apparent development of the *clibanus or testum* from the domed covers of the Greeks and Etruscans, the presence of a floor presents difficulties in viewing this as a *clibanus*. An integral base would impede the replacement of the fire with the food for baking. With only a small fragment of a large vessel, conclusions are limited, since we have no evidence for any access to replace the fire with the food. The wall slopes in the opposite direction to all known *clibani* or *testa,* and the fragment seems more likely to come from a cooking stand. There is a deep brazier from the Athenian Agora (Scheffer 1981, 83, fig 59) with a base and a large rectangular opening for dealing with the fire and circular vents, but this is a small vessel and fairly rare.

A possible parallel comes from the site of Murlo in Tuscany (Poggio Civitate, Sienne), at the end of the 7th and 6th century BC, which has produced fragments of some strange braziers with bases, all incomplete, with circular holes in the wall (Bouloumié 1972, 76, pl 1–2) (Fig 33.2, 16). The bases are relatively thick-walled, sloping inwards above the base, as in the Catterick example, with an opening for draught and tending the fire just above the base, circular holes above, but no certainly identified upper parts, although Bouloumié concludes they probably had a plain upright top. There is another type of brazier (Bouloumié 1972, Pl 5, 1064) of the same cylindrical shape, also with circular ventilation holes, but this has no base, and is unlike other fragmentary braziers from the site, which are more jar-like in form (Bouloumié 1972, pl 5–6, figs 8–12; these may be fragments of braziers, such as Sparkes 1972, pl VI, 4

and 5). Bouloumié was unable to find exact and convincing parallels, and the major problem with these objects from Murlo is the presence of an integral base and ventilation holes in the wall. He concludes that these furnace-braziers are closer to Greek models, and may be a local adaption of a perhaps much earlier prototype of Mediterranean or oriental origin (Bouloumié 1972, 80, 83).

Could the Catterick fragments be part of one of the braziers from North Africa explored by Swan (1999, ills 12, 13; 8, nos 81, 83), where there was an integral fire-basket with holes in the wall below providing the draught? There is an African type cooking pot from Catterick (Evans 2002, fig 135, SS22 (considered a continental import)), but the tile fabric of this example seems unsuitable for such a brazier. Thus the Catterick example is an anomaly, but seems more likely to be from a cooking stand than a *clibanus*, since the integral base makes baking *sub testu* impossible, unless it is very large and has wider access than the openings on the Murlo examples, which are only to provide draught and for tending the fire. An interesting aspect of cooking in Catterick is the presence from the site of quantities of barley which, being fully cleaned, seems unlikely to have been horse food, but could have been ground to make barley bread or cakes (Cool 2006, 78; Huntley 2002, 439). Although barley bread was considered a punishment ration (Suetonius, *Augustus* 24.2), perhaps cakes were acceptable to a garrison recently arrived from the Danubian area (Wilson 2002b, 452), and a cooking stand rather than a bread oven might be used. However, the fragmentary nature of this cooker leaves the question open.

The Caerleon example, a large jar in two pieces (Fig 33.2, 17), is even stranger and unlike any other known type of oven (Compton *et al* 2000). While it is likened to the fragment from Catterick (*ibid*, 304), the only likeness lies in the presence of a base, and even here the type of base, concave rather than flat, differs, while the globular form contrasts with the inward sloping wall of the Catterick fragment. It is difficult to see how this two-piece object with a fixed base and comparatively narrow top opening worked. Given the vessel shape and the decoration on the 'rim' sherd, associating it with the upper part, the top seems the only place for the opening, as reconstructed. Does the 'sooting' on parts of the interior indicate a fire inside as on the fragment from Catterick? While some 'sooting' could be the remnants of carbonized food, the nature of the interior base seems unsuitable for placing food for baking, while space for the provision of draught near the base appears to be too restricted, although holes in the manner of the African braziers (Swan 1999, ill 8, nos 81, 83; ills 12, 13) would be feasible. There is, however, also burning on the exterior of the base, which could suggest it was placed on a hearth. The only two-piece oven appears to be the type seen in the Athenian Agora, a brazier with a cover (Sparkes 1962, 127, fig 2; pl V, 1), but the Caerleon pot is totally different. There are unpublished fragments from the fort at Usk, one of which seems likely to be of the same type as the Holt example (Compton *et al* 2000, 304) which might shed further light. A final point concerns the coil-built

construction and the view that it is a two-piece object. The *tandoor* oven is classically made with rings of clay, which are notched and allowed to dry in position before the next wet clay ring is placed, the notching intended to ensure a sound join. Is it possible that the rough reeding of the 'rim' of the lower section (Compton *et al* 2000, 305) is in fact a form of keying?

Clibani in Britain?

Thus none of these examples indicate clearly the presence of *clibani* in Britain. There is the question of the Pompeian red ware dishes and their many copies in coarse and mica-dusted fabrics on early Roman military and urban sites, often with burnt bases. These are found at Pompeii with carbonized bread *in situ*, but a dish would appear to be unnecessary for baking in the large brick-built ovens, as shown by the occurrence of bakers' peels (also shown on the relief from the Tomb of Eurysaces in Rome (Lamer 1915, fig 145), and the use of a dish is more likely to occur in a household. And, with the addition of their lids, the burnt undersides would suggest food being baked on a brazier (as suggested by Swan, 1999, 419) or on a grid-iron on an ordinary hearth in the household. There is even an analogy with the Iraqi Bedouin, who have a clay disc, the *tabag*, used for cooking, where two are sometimes used together, sandwiching the food between them and sealed by fuel heaped against the outer edges (Ochsenschlager 1974, 167). This brings to mind the 'chapatti discs' found in Oxfordshire and Warwickshire (Cool 2006, 41), or 'pizza plates' known from sites in Yorkshire, very shallow dishes or flat plates in coarse fabric, as found around a stone-built bread oven at West Heslerton, considered to be a seasonal ritual site (Darling and Precious forthcoming b). But if we accept the term *clibanus* to approximate to the coarse ware examples known from Italy and the Mediterranean to cook *sub testu*, no definite examples are known from Roman Britain. There are, however, kites to be flown.

A particularly important fragment is a large thick lid with a thumb-grooved handle in shell-gritted fabric from the 1st century military site at Longthorpe (Fig 33.1, 2; Dannell 1987, fig 45, 117D). This came from a charcoal-filled hollow cutting part of the stokehole of the surface-built kiln 9 (Dannell and Wild 1987, 43). Other finds included a Hod Hill fibula, a Neronian South Gaulish Drag 29, and Longthorpe pottery, dated Claudio-Neronian. The purpose of these hollows appears to have been to take burning or burnt material from the kilns (Dannell and Wild 1987, 57) and thus they belong with the pottery-making phase, making this find especially important. In any Romano-British context, this lid would be highly unusual, especially the thick very functional handle with a thumb-groove (as in an example from Slovenia (Fig 33.1, 3; Gabrovec *et al*, 1970, Abb 7, no. 1)). There seems little doubt that this is part of one of the early domed covers, a *testum*, later to be referred to as a *clibanus*. As noted, these occur in Greece, on Iron Age sites in Italy and in Slovenia, and the form of the medieval *testi* is very similar to these early domed

covers. This handled type appears rare in Etruria, often only recognized by their handles (Potter 1976, fig 82, no. 388), and handles do not appear on the later clibani considered by Cubberley (1988, 103), but its occurrence in Slovenia, close to Pannonia, may be relevant to Longthorpe, where the garrison is considered to have been part of *Legio* IX from Pannonia (Frere and St Joseph 1974).

The example of a possible *clibanus* from Nijmegen, noted above (Holwerda 1941, pl XI, 514), has a small opening in the top as on some Italian examples, and draws attention to a sherd from Catterick, in Nene Valley colour-coated ware with a similar opening (Evans 2002, fig 141, SS108). This has a surviving diameter of 220mm, and is difficult to associate with any other known form, so could it be the top of a *clibanus*? It is also curiously similar to enigmatic sherds of lids from the coastal fort at Caister-on-Sea (Darling with Gurney 1993, fig 145, nos 301–2), both in an unusual cream fabric, one without an opening, but with a very strange top, tentatively identified as a lid, and the other fragment from a similar top with impressed decoration, similar to the rouletting found on an example from Matrice, Italy (Cubberley *et al* 1988, fig 1, no. 5). To connect either of these to a *clibanus* form is clearly speculative, but the fabric suggests these were probable imports from the continent.

This brings to mind another sherd from the excavations at Caister-on-Sea. Amongst the tail-end of sherds, unidentified for vessel form, was a strange sagging base very similar to a Hayes type 23 A/B in a colour-coated fabric, considered to be from a late Nene Valley kiln (Fig 33.1, 9; Darling with Gurney 1993, fig 145, no. 298). This came from a general layer of debris, of mixed dates, although generally late Roman. It has been suggested that the African red slip form 23B (Hayes 1972, 45, fig 7), could have functioned as a *clibanus* or baking cover (Cubberley *et al* 1988, 114), since the blackening of the rim, and on the sagging base, could be expected from use in cooking if inverted on a hearth, the pronounced cordon keeping hot ashes in place on the upper surface (Fig 33.1, 7–8). It has also been noted that coarse ware copies of the form at Cosa are blackened in the same places (Dyson 1976, 144–5, fig 57, nos. LS33–LS35). The coarser fabric, suitable for extreme heat, and the absence of a lid to enable the form to function as a casserole, are further factors. The fragment from Caister-on-Sea is notably burnt on the exterior only, and is also in what is conventionally regarded as a fine ware, although Nene Valley colour-coated bowls and dishes are frequently found with sooting. This particular form of African red slip ware is one of the sparse finds of this ware in Britain listed by Joanna Bird in 1977 (274, fig 20.2, Perrin 1981, 57, fig 30, 369 from York), more having been found since (Monaghan 1997, 901). Moreover this and related types were copied at York (Perrin 1981, 59) and, as Swan notes, African types are fairly widespread on military sites of varying dates. Examples are spread over many sites in the North (Swan 1992), such as Bar Hill and Cramond (Antonine Wall), Rudchester, Bewcastle, Halton Chesters, Corbridge (Hadrian's Wall), and also occur in Wales at Holt

(Grimes 1930, fig 74, 224) and Caerleon. These are mainly casseroles and platters broadly of the Pompeian red ware type, the platters having a stronger showing in Scotland than normal on sites in North Africa. The vessels similar to Hayes form 23B appear to be confined to York, although two locally made dishes similar to Hayes form 23A occur at Bar Hill (Swan 1992, fig 5, nos 102–3; 1999, ill 2, no. 10). It is interesting that the most copied African red slip ware types appear to be the most popular traded types, such as Hayes forms 23B and 197 (Ikäheimo 2005, 513), and there is a feeling of déjà vu, remembering the extensive copying by grey ware potters of the superb hand-made BB1 cooking pots of Dorset. The original vessels in both cases were prized for their suitability for cooking.

The African red slip form 23B and its copies have been discussed in connection with the casseroles (of Hayes form 183–4), with the view that the flange above the rounded base is to stabilise the vessel on a grid-iron (Swan 1992, 14, no 30). But the casserole forms like Hayes 183–4, 197–8, also with rounded bases, do not have prominent cordons, and it may be assumed that they were bedded in a hearth, or on a brazier, of which examples have been found at Bearsden (Swan 1999, 414, ill 8). It seems more acceptable that the function of the small flange, with the ridging on the domed base, was to retain the hot ashes when the vessel was inverted over the food to be baked. Recent work on African red slip vessels from late Roman deposits of the Palatine East excavations in Rome suggests that the function of the corrugations was not only to resist thermal spalling, but also to strengthen the thermal shock resistance of the vessels (Schiffer *et al* 1994, 208–11; Ikäheimo 2005, 512).

There may be, therefore, some slight evidence for the use of *clibani* in Roman Britain, the handle from Longthorpe being the most positive evidence for coarse ware versions, but also African red slip ware forms 23A/B and their copies (the copies only from military sites) and a possible Nene Valley colour-coated example, leaving the 'lids' as questionable tops from *clibani*. As noted, 1st century Pompeian red ware dishes and their copies could have been used as a type of oven, like the burnt locally-made example at Longthorpe (Dannell 1987, fig 45, 114). Basically any large dish or bowl could be heated over a fire, and inverted over a heated tile or tiled-hearth to be an effective cooker, as suggested by Alcock (2001, 28, fig 9). The apparent absence of such ovens may be more apparent than real, and bearing in mind the fugitive nature of signs of burning, rare or non-existent, noted by Scheffer on cooking stands from Acquarossa (1981, 107), identification is problematical. Many early lids are domed, as at Camulodunum (Hawkes and Hull 1947, pl 85, 1–5, 11, 15, 19), and at Baldock (Rigby 1986, fig 120, 196–8, with no. 198 burnt and having a rilled surface). But lids of all types are likely to have burning, so positive identification as a cooking cover is elusive.

Other ovens

Since the published so-called '*clibani*' from Britain seem to belong to different types of ovens or braziers, confined apparently to military sites, are there any other clay ovens for bread making, especially bearing in mind that the distribution of clay ovens in Italy is predominantly rural, the urban populations buying their bread from the bakers using the large brick bread-ovens? The start of my interest in the subject came from a curious fragment from excavations (by Archaeological Project Services) on a rural site at Wygate Park, Spalding, Lincolnshire in 2005, in a deposit dated to the late 2nd to early 3rd century (Darling forthcoming). The site had a saltern phase, followed by agriculture, with a higher average content of samian than usual in the area, and a relatively high level of tablewares later which, with metal working evidence, suggests it may have been part of a larger establishment. The fragment in question came from a post-saltern context. This thick, heavy rim from an exceptionally large 'vessel' in shell-gritted fabric appears to be from an oven (Fig 33.4). It is hand-made, diameter estimated at *c* 860mm, and features two rows of fingered decoration, with a vertical cut 135mm deep, presumed to be a single opening; this opening is delineated by a raised frame, but neither the depth nor the width can be defined. Traces of burning on the exterior could be from the firing or from usage, and there is no burning on the interior of this rim fragment. It appears to belong to a group of similar vessels identified in south Lincolnshire and Cambridgeshire, all sharing the same fabric and features, fingered below the rims, some showing a vertical opening in the rim. The best example of the form is one from Grandford (Potter and Potter 1982, fig 33, 220), diameter *c* 850mm, one of four examples, the earliest example dated *c* AD 150 to the early to mid 3rd century. A further example came from excavations at West Deeping (Wood forthcoming, no. 34), a rim with a vertical opening, and part of the base, with a similar profile to that from Grandford, diameter *c* 900mm, with the same fingered impressions. This came from contexts only broadly dated as late Iron Age/1st to late 4th century AD.

The largest number of these vessels was found in excavations at Chesterton, along the line of Ermine Street (Perrin 1999, figs 1–2; fig 52, 510, 512; fig 74, 502, 506–13), one with the edge of a raised frame delineating the opening (to *c* 110mm deep), others with similar fingered decoration, diameters *c* 900–1000mm. The dating ranges from mid to late 2nd to 3rd century. They came from a number of different barns and adjacent yards, which contained burnt oven bases (*ibid*, figs 36 and 38), and some were associated with fragments of a possible griddle and flat semi-circular plates, interpreted as possibly part of oven-floors or associated warming stands (*ibid*, fig 74, 501, 503–5). Other fragments have come from excavations in the area of Ermine Street near Castor on a site that contained two Romano-Celtic temples (Darling 1999, fig 52, no. 54), and from a late Iron Age farmstead and Romano-British site at Haddon in the same area (Hinman 2003, fig 32, C12–3), both from contexts dated mid 2nd century or later.

Fig 33.4: Fragment of a large oven from excavations at Wygate Park, Spalding, Lincolnshire, by Archaeological Project Services, hand-made in shell-gritted fabric. 1:6. Drawn by David Hopkins

Further fragments are known from Market Deeping, Maxey (May 1981, 54, fig 10, 25), and Denver in Norfolk, on the line of the Fen Causeway (Gurney 1986, fig 80, 486), and there are numerous references by Brian Hartley, during his work on pottery from the Fenland survey, to other finds of large shell-gritted 'circular pans', and a rim with oblique finger marking from 'an enormous pan 3ft [*c* 910mm] in diameter' in the Fenland (Phillips 1970, 282), which may indicate that they were widespread in the area.

The manufacture of these large ovens would be the work of a skilled potter, needing special firing, as would be available in the Nene Valley, and the shell-gritted fabric would be consistent with a source in that area. The absence of notable burning is not conclusive since the fire would have been removed after the cover had heated and, as noted, can be rare, even on cooking braziers. The association of the fragments at Chesterton with barns containing oven structures and fragments of other cooking furniture is also relevant (Perrin 1999, 62, figs 34–8). All finds to date of these large objects have been very fragmentary, the diagnostic sherds being the rims. Thus the full profile is unknown, with only a tiny fragment of the edge of a possible top from West Deeping; neither is the width and height of the opening known. This has been reconstructed partly using the evidence of the *tannur* ovens despite the fact that they are a different type (used for draught and re-fueling), and mostly based on the width considered necessary to insert and retrieve loaves, estimated to vary from 220–300mm (the sizes of pizzas played a role in this, varying from 200 to 305mm). These ovens appear to be a regional type, but were there others, perhaps in tile or other coarse fabrics, from other areas?

The distribution of *clibani* in Italy appears to have been predominantly rural, from large estates downwards (Cubberley *et al* 1988, 110), as in the medieval period (Whitehouse 1978, 147). The finds noted from Lincolnshire and area come from sites associated with salt-making and/

or farming, and sites on major roads, such as the cluster on Ermine Street, and two on the Fen Causeway. It is, therefore, possible that these larger examples in Britain, closer to the bakers' ovens or *furni* of Pompeii, were intended to cater for the provision of bread for a number of people, such as workers on an estate or saltern, travellers at posting houses on major roads, visitors to temples, as at Castor and, as with possibly the fragments of a different type, for spectators at the amphitheatre at Chester. The sloping wall and the absence of a base indicates that this was not used in the same manner as a *tannur*, but appears to be to cook *sub testu*. It is not a *clibanus*, and may be better termed a portable *furnus*. Baking for a number of people outside the home is likely to produce different types of ovens, particularly in the provinces.

Conclusions

It would appear that the only more positive evidence for cooking covers, *clibani*, as characterised by the coarse ware examples from Italy (covers to be used in *sub testu* cooking for small numbers), is the handle fragment from Longthorpe. But the possibility that the African red slip ware Hayes form 23A/B and their copies, and perhaps other 'fine wares', were used as *clibani*, opens up the search. The *clibanus* is essentially an oven for a household, and would be more likely to occur in an urban setting or a villa, and perhaps in a kitchen serving army officers. Since many ordinary coarse ware bowls could be used as *clibani*, the only identification of such usage would come from traces of burning, although these, as shown by Scheffer (1981), may be fugitive. The use of cooking stands or braziers as in the African examples (Swan 1999, ill 12, 13) would conserve fuel and be safer for use inside buildings such as timber barracks, but the ethnicity of the soldiers has a bearing. Identification of fragments of these stands would be difficult, since many could crumble into unrecognizable

fragments recorded only as 'fired clay'. Thus, the chances of identifying either fragments of oven or cooking stands are fairly low, as with the fragments of ovens from South Lincolnshire and Cambridgeshire, in the same shell-gritted fabrics used for cooking pots and storage vessels, only identified on diagnostic sherds.

What is notable is that all the evidence gathered for such ovens comes from military sites occupied by foreign troops. The early Longthorpe handle indicates a type known in 6th and 5th century BC Athens, in Iron Age Etruria, but also in early Slovenia, and probably superseded by later types in Italy. At Holt, Prestatyn and perhaps Usk, the evidence indicates a type of large oven from the East, of very great antiquity, again not common in Roman Italy, suitable for making quantities of bread as needed for soldiers. The influence of the potters of eastern origin, explored by Greene (1977), extended to the ovens. The possibility of African red slip ware form 23 being used as a *clibanus* extends the date range, although these are not common, while the fragment of a possible *clibanus* from Caister-on-Sea, a fort where foreign troops with Danubian connections were stationed (Darling with Gurney 1993, 247) dates to the 3rd to 4th centuries. The fabric is possibly of Nene Valley origin, adding an interesting new type to the repertoire.

The absence from urban centres may be just chance or lack of recognition, since the subject of Roman ovens has not been at the forefront of ceramic studies. Their rarity in Britain is not really surprising in view of their apparent paucity in Gaul, since climate is a major factor in cuisine, and links between Britain and northern France seem more likely than direct links to Italian and Mediterranean cooking. This rarity may be more apparent than real since, as noted, body fragments could easily be missed in coarse or tile fabrics (as at Longthorpe, Catterick and Spalding), tile often being largely disregarded in older excavations, and a small sherd with a hole cut for draught for a fire could be mis-identified as part of a lamp chimney. The large ovens from south Lincolnshire and area are likely to have had a restricted regional distribution, and other areas may have had different solutions to catering, particularly in rural areas, as on large estates, or adjacent to religious sites. Further research may suggest that the ovens resembling pottery kilns served the same purpose, catering for a number of people. Fragments of large 'vessels' in tile fabric have been found in Lincoln (Darling and Precious, forthcoming a) in the strip-buildings south along Ermine Street for which no industrial use can be demonstrated, but more evidence is needed to be certain any were related to ovens.

Are these objects really that rare, or were the cooking methods in Britain different? In the east of England, the cooking pots used by *Legio* IX in Lincoln were those of the preceding Iron Age. These continued in use, and were copied in different fabrics until usurped by BB1 cooking pots from Dorset. These in their turn were copied by wheel-throwing grey ware potters, although in certain areas, shell-gritted jars, and lid-seated jars, ultimately leading to Derbyshire ware, both derived from Iron Age prototypes, continued. The next major change was the appearance of shell-gritted dales wares (in north Lincolnshire), again copied by grey ware potters, who gradually changed to a simpler type of lid-seated jar in a coarser fabric, coupled with a resurgence in the use of shell-gritted fabrics. Therefore the people of the east of Roman Britain remained wedded to the jar form. Although this brief survey is restricted geographically, according to the region, this adherence to the jar seems constant. A similar conservatism occurs in northern France (Tuffreau-Libre 1980). While the oven shows the most extreme conservatism from the Neolithic and Bronze Age to the modern day, the humble cooking pot changes little over time as a functional vessel. As Cool notes (2006, 39), 'the ubiquity of cooking jars ... suggests that stewing would have been one of the principal cooking techniques'. Thus the rarity of the *testum* or *clibanus* may not be surprising, but *where* they occur can be interesting. What it says about the 'romanization' of Britain is another story, but an important one.

So, no stuffed dormice seemingly in danger in Britain. But bread must have remained the staple – if only to soak up all those stews... Next time you have a pizza or tandoori chicken, remember these cooking methods came from antiquity, back to the Dawn of Civilization. If you have struggled through this paper, Brenda, I do hope you enjoyed it as a gift. Now back to that recording of Prokofiev's Violin Concerto...

Acknowledgments

I am particularly grateful to Ian Rowlandson who, on seeing some of the illustrations prepared for this paper, drew my attention to the Longthorpe handled lid. Having examined the pottery from Longthorpe in detail many years ago, I had completely forgotten it!

Bibliography

Alexander, J, and Pullinger, P, 1999. *Roman Cambridge: excavations on Castle Hill 1956–1988*, Proc Cambridge Antiq Soc 88

Alcock, J P, 2001. *Food in Roman Britain*, Stroud

Bats, M (ed), 1996. *Les céramique commune de Campanie et de Narbonnaise (1er s. av. J.-C. – II^e s. ap. J.-C.). La vaisselle de cuisine et de table. Actes Journées d'Étude, Naples 27–28 May 1994*, Coll Centre J. Bérard 14, Naples

Bird, J, 1977. African red slip ware in Roman Britain, in Dore and Greene 1977, 269–78

Blockley, K, 1989. *Prestatyn 1984–5: an Iron Age farmstead and Romano-British industrial settlement in North Wales*, Brit Archaeol Rep Brit Ser 210, Oxford

Bouloumié, B, 1972. Murlo (Poggio Civitate, Sienne): Céramique grossière locale. L'Instrumentum culinaire, *Mélanges de l'École Française de Rome* 84, 61–110

Cipriano, M T and De Fabrizio, S, 1996. Benevento. Il quartiere ceramico di Cellarulo: prime osservazioni sulla tipologia ceramica, in Bats 1996, 201–23

Cobbett, W, 1926. *Cottage economy* (ed G K Chesterton), London

Cool, H E M, 2006. *Eating and drinking in Roman Britain*, Cambridge

Compton J, Evans, E, Sell, S H, and Webster, P, 2000. Other ceramic objects, in E Evans, *The Caerleon canabae. Excavations in the civil settlement 1984–90*, Britannia Monogr 16, London, 303–5

Cubberley, A L, Lloyd, J A, and Roberts, P C, 1988. Testa and clibani: the baking covers of classical Italy, *Papers Brit School Rome* 56, 98–120

Curtis, R I, 2001. *Ancient food technology*, Brill

Dannell, G B, 1987. Coarse pottery, in Dannell and Wild 1987, 133–68

Dannell, G B, and Wild, J P, 1987. *Longthorpe II: The military works-depot: an episode in landscape history*, Britannia Monogr 8, London

Darling, M J, 1999. The Roman pottery from Sites 7 and 8, in Network Archaeology 1999, *Peterborough to Luton 1050mm Gas Pipeline: archaeological evaluation, excavation and watching brief 1998*, Rep 135 (2) for Entrepost UK on behalf of Transco, 6–16

Darling, M J, forthcoming. The Iron Age and Roman pottery, in M Wood and R Hall, *Salt and settlement. Excavation of a changing Romano-British landscape at Wygate Park, Spalding, Lincolnshire*, Lincs Heritage Archaeol and Rep Ser 9

Darling, M J, with Gurney, D, 1993. *Caister-on-Sea: excavations by Charles Green, 1951–55*, East Anglian Archaeol Rep 60, Dereham

Darling, M J, and Precious, B J, forthcoming a. *A corpus of Roman pottery from Lincoln*, Lincoln Archaeol Stud

Darling, M J, and Precious, B J, forthcoming b. The Roman pottery, in Powlesland, D, *West Heslerton, Yorkshire*

Deru, X, and Paicheler, J-C, 2003. Un 'four-couvercle' d'origine italique à Reims (Marne, France), *Rei Cretariae Romanae Fautorum Acta* 38, 351–2, Abingdon

Di Giovanni, V, 1996. Produzione e consumo di ceramica da cucina nella Campania romana (II aC–II dC), in Bats 1996, 98–9, fig 26

Dore, J, and Greene, K (eds), 1977. *Roman pottery studies in Britain and beyond. Papers presented to John Gillam, July 1977*, Brit Archaeol Rep Suppl Ser 30, Oxford

Dyson, S L, 1976. *Cosa. The utilitarian pottery*, Memoirs American Acad Rome, 33

Evans, J, 2002. Pottery from Catterick Bypass excavations and Catterick 1972 (Sites 433 and 434), in Wilson 2002a, 250–351

Evans, J, and Williams, D F, 2002. Portable oven (clibanus), in Wilson 2002b, 201–4

Federico, Raffaella, 1996. La ceramica comune dal territorio dei Liguri Baebiani, in Bats 1996, 183–200

Frayn, J, 1978. Home baking in Roman Italy, *Antiquity* 52, 28–33

Frere, S S, and St Joseph, J K, 1974. The Roman fortress at Longthorpe, *Britannia* 5, 1–129

Gabrovec, S, Frey, O-H, and Foltiny, S, 1970. Erster Vorbericht über die Ausgrabungen im Ringwall von Stična (Slowenien), *Germania* 48, 12–33

Greene, K, 1977. Legionary pottery, and the significance of Holt, in Dore and Greene 1977, 113–32

Grimes, W F, 1930. *Holt, Denbighshire: The works-depot of the Twentieth Legion at Castle Lyons*, Y Cymmrodor 41, London

Gurney, D A, 1986. *Settlement, religion and industry on the Roman fen-edge: three Romano-British sites in Norfolk*, East Anglian Archaeol 31

Hawkes, C F C, and Hull, M R, 1947. *Camulodunum*, Res Rep Soc Antiq London 14

Hayes + no. = vessel type numbers in Hayes 1972

Hayes, J W, 1972. *Late Roman pottery*, British School at Rome, London

Hinman, M, 2003. *A late Iron Age farmstead and Romano-British site at Haddon, Peterborough*, Brit Archaeol Rep Brit Ser 358, Oxford

Holwerda, H H, 1941. *De Belgische waar in Nijmegen*, The Hague

Huntley, J P, 2002. The plant remains, in Wilson, 2002b, 439–45

Ikäheimo, J P, 2005. African cookware: a high-quality space filler?, in *LRCW I Late Roman coarse wares, cooking wares and amphorae in the Mediterranean: archaeology and archaeometry* (eds J M Gurt i Esparraguera, J Buxeda i Garrigós and M A Cau Ontiveros), Brit Archaeol Rep Internat Ser 1340, 509–20, Oxford

Kovalevskaja, L, and Sarnowski, T, 2003. La vaisselle des habitants d'une maison rurale de l'époque romaine dans la Chôra de Chersonèse Taurique, *Rei Cretariae Romanae Fautorum Acta* 38, 229–35, Abingdon

Lamer, H, 1915. *Römische Kultur im Bilde*, Leipzig

Lindsay, W M, 1913. *Sexti Pompei Festi. De uerborum significatu quae supersunt cum Pauli Epitome. Thewrewkianis copiis usus edidit*, Leipzig

Lloyd, S, 1965. The early settlement of Anatolia, in *The Dawn of Civilisation* (ed S Piggott), 161–94, London

May, J, 1981. The later prehistoric and Romano-British pottery, in W G Simpson, Excavations in field OS 124, Maxey, Cambridgeshire, *Northants Archaeol* 16, 47–59

Meates, G W, 1955. *Lullingstone Roman Villa*, Maidstone

Monaghan, J, 1997. *Roman pottery from York*, The Archaeology of York 16 (8), Counc Brit Archaeol, York

Ochsenschlager, E, 1974. Mud objects from Al-Hiba. A study in ancient and modern technology, *Archaeology* 27, 162–74, New York

O'Neill, H, 1935. Bourton-on-the-Water, *Trans Bristol Gloucester Archaeol Soc* 57, 260

Perrin, J R, 1981. *Roman pottery from the colonia: Skeldergate and Bishophill*, The Archaeology of York 16 (2), Counc Brit Archaeol, London

Perrin, J R, 1999. Excavations by E Greenfield, in J R Perrin, Roman pottery from excavations at and near to the Roman small town of Durobrivae, Water Newton, Cambridgeshire, 1956–58, *J Roman Pottery Stud* 8, 46–136

Phillips, C W, 1970. *The Fenland in Roman times*, Royal Geogr Soc Res Ser 5, London

Potter, T, 1976. *A Faliscan town in South Etruria*, British School at Rome, London

Potter, T W, and Potter, C F, 1982. *A Romano-British village at Grandford, March, Cambs*, Brit Mus Occas Paper 35

Price, E, 2000. *Frocester. A Romano-British settlement, its antecedents and successors, Vol. 1 The site*, Gloucester and District Archaeol Res Group, Stonehouse

Rigby, V, 1986. The stratified groups of Iron Age and Roman Pottery, in I M Stead and V Rigby, *Baldock: The excavations of a Roman and Pre-Roman settlement, 1968–72*, Britannia Monogr 7, 257–379, London

Scheffer, C, 1981. Cooking and cooking stands in Italy, 1400–400 BC. (Acquarossa, II, part 1), *Acta Inst Rom Reg Suec* 38, Stockholm

Schiffer, M B, Skibo, J M, Boelke, T C, Neupert, M A, and Aronson, M, 1994. New perspectives on experimental archaeology: surface treatments and thermal response of the clay cooking pot, *American Antiquity* 59, 197–217, Washington

Sharma, R S, 2005. *India's ancient past*, Oxford University Press, New Delhi

Sparkes, B, 1962. The Greek kitchen, *J Hellenic Stud* 82, 121–37

Swan, V G, 1992. Legio VI and its men: African legionaries in Britain, *J Roman Pottery Stud* 5, 1–33

Swan, V G, 1999. The Twentieth Legion and the history of the Antonine Wall reconsidered, *Proc Soc Antiq Scotland* 129, 399–480

Tuffreau-Libre, M, 1980. *La ceramique commune gallo-romaine dans le Nord de la France*, Lille

Whitehouse, D B, 1978. Home baking in Roman Italy: a footnote, *Antiquity* 52, 146–7

Williams, D, and Evans, J, 1991. A fragment from a probable Roman clibanus from Catterick, North Yorkshire, *J Roman Pottery Stud* 4, 1991, 51–3

Wilson, P R, 2002a. *Cataractonium: Roman Catterick and its hinterland. Excavations and research, 1958–1997, Part 1*, Counc Brit Archaeol Res Rep 128, London

Wilson, P R, 2002b. *Cataractonium: Roman Catterick and its hinterland. Excavations and research, 1958–1997, Part 2*, Counc Brit Archaeol Res Rep 129, London

Wood, M, forthcoming. The Late Iron Age and Roman pottery, in J R Hunn and D J Rackham, *Excavations at Rectory Farm, West Deeping, Lincolnshire*

Appendix

Catalogue

Fig 33.1 Domed cooking covers and clibani. 1:4

1　Domed cooking cover from Murlo, Italy, reconstructed after Boulomié 1972, Pl 7, nos 1071–1072

2　Handle from a domed cooking cover from Longthorpe, after Dannell 1987, fig 45, no. 117d

3　Domed cooking cover from Stična, Slovakia, after Gabroveć *et al* 1970, Abb 7, no. 1.

4　Domed cooking cover from Stična, Slovakia, after Gabroveć *et al* 1970, Abb 4, no. 13.

5　*Clibanus* from Pompeii, after Di Giovanni 1996, fig 26, no. 2431a

6　*Clibanus* from Matrice, Italy, after Cubberley *et al* 1988, fig 2, no. 6

7　African red slip ware Hayes type 23B, after Hayes 1972, fig 7, no. 24

8　African red slip ware Hayes type 23A, after Hayes 1972, fig 7, no. 11

9　Fragment of a possible *clibanus* in a Nene Valley colour-coated fabric, from Caister-on-Sea, after Darling with Gurney 1993, fig 145, no. 298

Fig 33.2 Tannur ovens and other 'ovens' from Britain. 1:8

10　*Tannur* oven from the works depot of *legio* XX at Holt, after Grimes 1930, fig 60, no. 9

11　*Tannur* oven from Prestatyn, after Blockley 1989, fig 87, no. 75

12　*Tannur* oven from San Giovenale, Italy, after Scheffer 1981, fig 29

13　*Tannur* oven from Acquarossa, Italy, after Scheffer 1981, fig 31

14　*Tannur* and cooking stand group from Norşuntepe, Turkey, after Scheffer 1981, fig 51

15　Fragment of a '*clibanus*' from Catterick, after Evans and Williams 2002, fig 328

16　Fragment of a cooking stand or brazier from Murlo, Italy, after Boulomié 1972, pl 2, no. 1067

17　Fragment of an 'oven' from Caerleon, after Compton *et al* 2006, fig 74, no. 1

Fig 33.4

18　Fragment of a large oven from excavations at Wygate Park, Spalding, Lincolnshire, by Archaeological Project Services, hand-made in shell-gritted fabric.